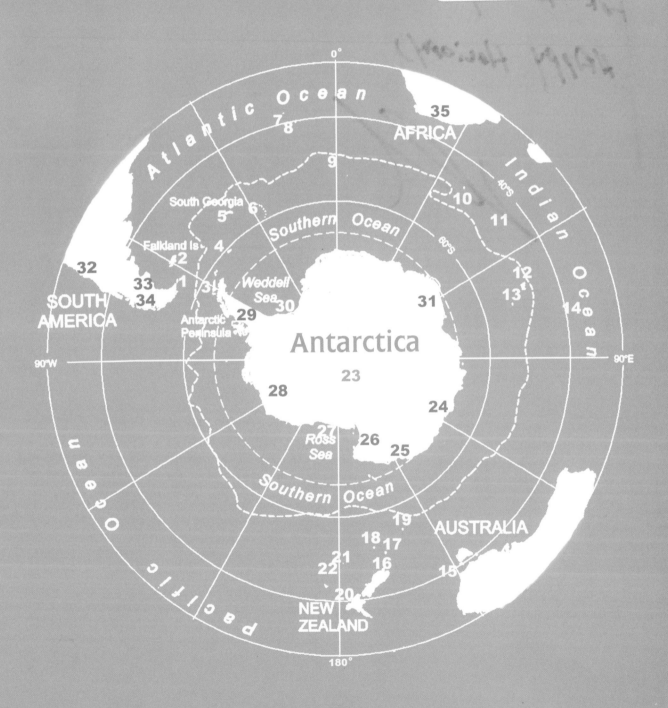

Happy Birthday my love! Yes, this book was purchased second hand. Here's to you, and all the facts you know, and could ever know, about the penguin.
Check page 80.

Love,
Minxie ♡

Penguin-Pedia

Penguin-Pedia

Photographs and Facts from One Man's Search
for the Penguins of the World

David Salomon

Brown Books Publishing Group
Dallas, Texas

Penguin-Pedia: Photographs and Facts from
One Man's Search for the Penguins of the World

Brown Books Publishing Group
16250 Knoll Trail, Suite 205
Dallas, Texas 75248

www.BrownBooks.com

(972) 381-0009

ISBN 978-1-61254-015-3
Library of Congress Control Number 2011932108

Printed in the United States of America
10 9 8 7 6 5 4 3 2 1

For more information, please visit www.Penguin-Pedia.com
or www.Facebook.com/PenguinPedia.

Fifty cents of the proceeds from each
book will go to the Dallas Zoo.

Contents

vii • Acknowledgments
1 • The Penguin Family
7 • Where to Find a Penguin
12 • Penguin History and Research
17 • Emperor
33 • King
49 • African
63 • Galapagos
77 • Humboldt
91 • Magellanic
105 • Yellow-eyed
119 • Little
131 • Adélie
145 • Chinstrap
159 • Gentoo
173 • Erect-crested
185 • Fiordland
197 • Macaroni
209 • Rockhopper
223 • Royal
235 • Snares
247 • The Penguin Body: The Amazing Machine
259 • Where to Find a Penguin in a Zoo or in the Wild
277 • Glossary
281 • Bibliography

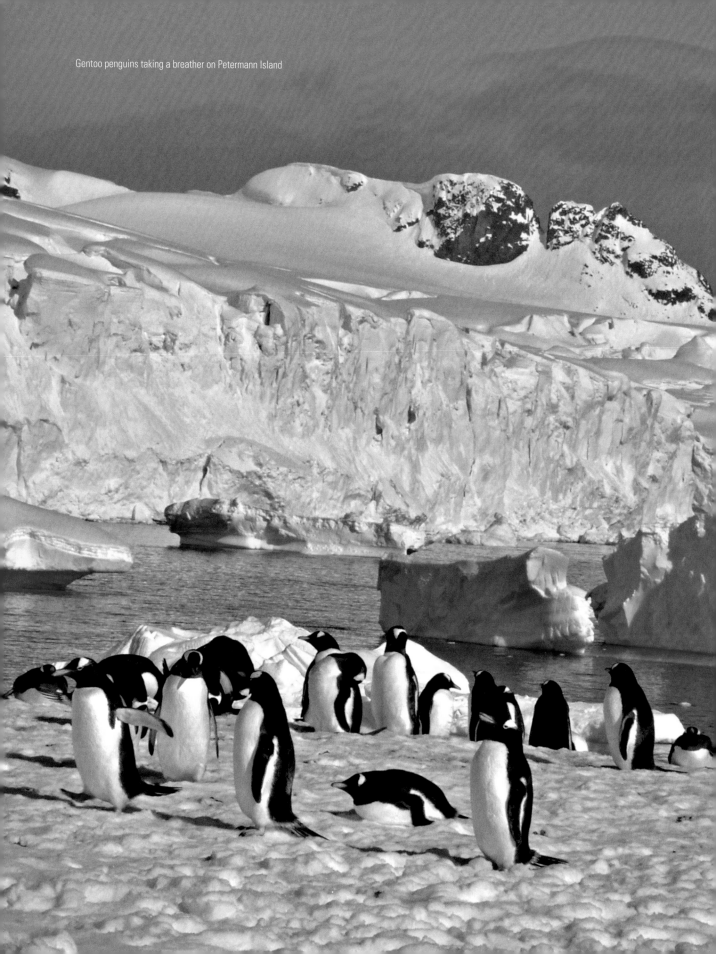

Gentoo penguins taking a breather on Petermann Island

Acknowledgments

This book could not have been conceived without the cooperation of all seventeen penguin species. I cannot remember how many times I was thinking to myself, "What would happen if I reached the other side of the world and the penguins were simply not there?" Yet on every trip, I found them just where they were supposed to be, doing what they normally do and in many cases modeling for me. It was as if they tried to assist me with the book.

I am grateful to the following researchers, scientists, and penguin lovers who took the time to review all the different chapters and make sure all my facts were correct. These wonderful people are: Dr. Michaël Beaulieu (Adélie, Emperor, and Penguin Body); Dr. Jessica Kemper (African); Dr. Andres Barbosa (Chinstrap); Mr. Dave Houston (Erect-crested, Snares); Dr. Jan Murie (Fiordland); Dr. Hernan Vargas (Galapagos); Dr. Heather Lynch (Gentoo); Dr. Roberta Wallace (Humboldt); Dr. Klemens Pütz (King, Rockhopper); Dr. Phillip Seddon (Little); Dr. Jonathan Green (Macaroni); Dr. Marcelo Bertellotti (Magellanic); Dr. Rory Wilson (Magellanic); Dr. Cindy Hull (Royal); and Dr. Hiltrun Ratz (Yellow-eyed).

The following people and organizations assisted in my research and photography or provided me with invaluable information: Dr. Robert Crawford, Dr. Peter Dann, Dr. Eric Woehler, Dr. Juan Moreno, SANCCOB (especially Vanessa Strauss and Dr. Richard Sherley), the Jacksonville Zoo and Gardens, the Detroit Zoo, Dr. Karen Waterfall of the Indianapolis Zoo, Amy Graves and the Tennessee Aquarium, Genie Burns and Arden Richardson with the Dallas World Aquarium, and the Edinburgh Zoo.

Thanks to my son, Oren, Meggan Dunham, and Brad Walker for helping me edit the text and convert my chapters and pictures into an attractive book that I was able to present to a publisher.

Thank you also to the dedicated team at Brown Books Publishing for the beautiful job they did, especially Jessica Kinkel.

And last but not least, thanks to Caroline Brown, who spent many hours searching for information and data about penguins and researchers.

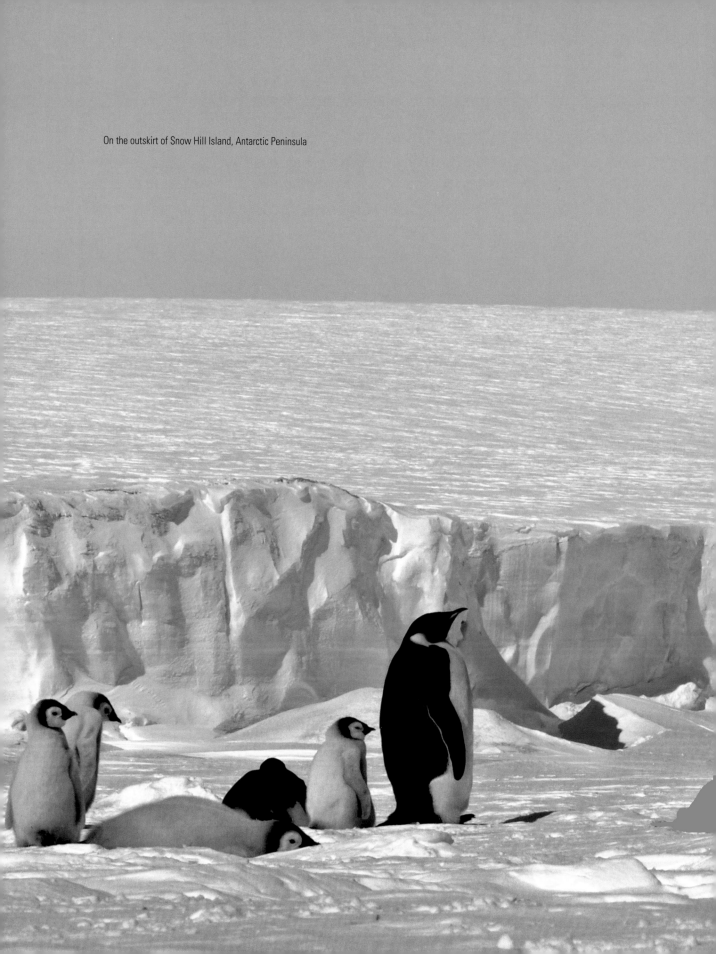

On the outskirt of Snow Hill Island, Antarctic Peninsula

The Penguin Family

Spheniscidae

Genus

Large Group: *Aptenodytes*

Brush Tailed: *Pygoscelis*

Banded: *Spheniscus*

Crested: *Eudyptes*

Yellow-eyed: *Megadyptes*

Little: *Eudyptula*

Latest Population Estimates
 Individuals: 55,000,000–60,000,000
 Breeding Pairs: 23,000,000–26,500,000

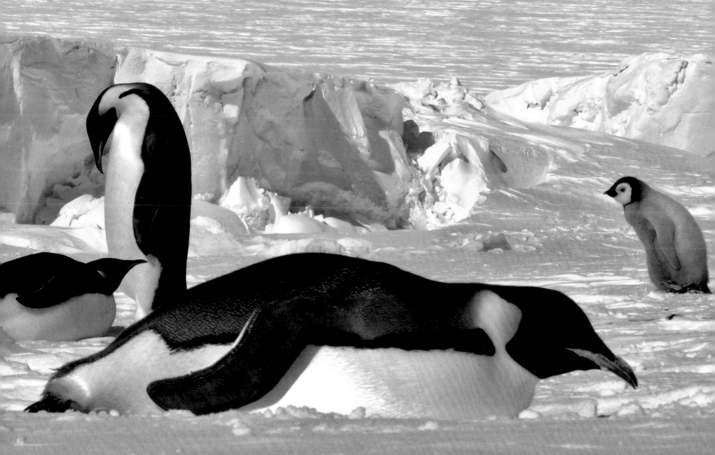

David's Observations: We Love Penguins

Penguins effortlessly evoke human love and attention! What makes them so loveable? Of course, each person finds something different to like. Some say that it's the fact that penguins stand upright on two feet like us, some say it's the funny way they walk, and still others say it's how gracefully they move. Watching a penguin waddle at its slight stature prompts the thought of a baby learning to walk, and who doesn't like babies?

There are also those people who look beyond the penguin's cute black-and-white tuxedo to know and admire the adaptation and hardship penguins live through. Others marvel at the penguin's charming behavior and life in communities—a life that is filled with love and dedication, but that might also contain divorces and even jealous arguments that lead to fights and injury.

Penguin colonies are located in remote areas, but once you arrive at a rookery, the penguins are there for you to watch (with a few exceptions). They do not fly away, and many do not run away from people unless the humans get too close, so their lives on land are an open book. It is obvious that each individual penguin has its own personality, its own spouse and chick(s), and its own nest. From close range their life on land looks in many ways like ours, so it is easy and natural to admire and love them.

The first time I ever saw penguins on the southern shores of Chilean Patagonia, I was struck by their social structure and abundance of emotions. I walked around them for hours, taking pictures and watching them through the lens of my Nikon. They gathered on the beach, exchanged verbal messages, played with each other, and even fought. As they landed on shore, they joined the others on the crowded beach, announced their arrival, and later walked toward their nest to join their mate and chicks. I was amazed by the love and affection that I saw between mates. They touched each other's bodies, moving their flippers like they wanted to hug. The pairs reminded me of teenagers in love.

I was enchanted, to say the least. To me they appeared to be a large group of busy, miniature people. They seemed very comfortable being around me, just like a bunch of friends.

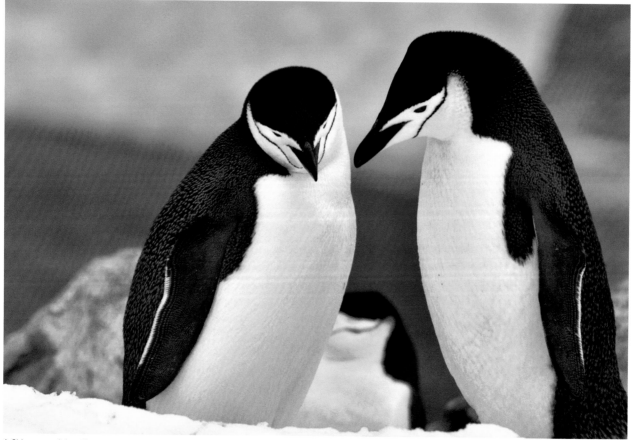

A Chinstrap pair bonding

Large Penguins/*Aptenodytes*

Common Name	Scientific Name	IUCN Status	Average Length
Emperor	*Aptenodytes forsteri*	Least Concern	47 in (120 cm)
King	*Aptenodytes patagonicus*	Least Concern	35 in (89 cm)

Banded Penguins/*Spheniscus*

Common Name	Scientific Name	IUCN Status	Average Length
African	*Spheniscus demersus*	Endangered	28 in (71 cm)
Galapagos	*Spheniscus mendiculus*	Endangered	22 in (55 cm)
Humboldt	*Spheniscus humboldti*	Vulnerable	26 in (67 cm)
Magellanic	*Spheniscus magellanicus*	Near Threatened	28 in (71 cm)

Yellow-eyed Penguins/*Megadyptes*

Common Name	Scientific Name	IUCN Status	Average Length
Yellow-eyed	*Megadyptes antipodes*	Endangered	29 in (74 cm)

Little Penguins/*Eudyptula*

Common Name	Scientific Name	IUCN Status	Average Length
Little	*Eudyptula minor*	Least Concern (All Other Subspecies) Endangered (White Flipper)	16 in (41 cm)

Brush Tailed Penguins/*Pygoscelis*

Common Name	Scientific Name	IUCN Status	Average Length
Adélie	*Pygoscelis adeliae*	Least Concern	28 in (71 cm)
Chinstrap	*Pygoscelis antarctica*	Least Concern	29 in (74 cm)
Gentoo	*Pygoscelis papua*	Near Threatened	32 in (81 cm)

Crested Penguins/*Eudyptes*

Common Name	Scientific Name	IUCN Status	Average Length
Erect-crested	*Eudyptes sclateri*	Endangered	25 in (64 cm)
Fiordland	*Eudyptes pachyrhynchus*	Vulnerable	23 in (58 cm)
Macaroni	*Eudyptes chrysolophus*	Vulnerable	28 in (71 cm)
Rockhopper	*Eudyptes chrysocome*	Vulnerable (Southern) Endangered (Northern)	21 in (53 cm)
Royal	*Eudyptes schlegeli*	Vulnerable	28 in (72 cm)
Snares	*Eudyptes robustus*	Vulnerable	23 in (58 cm)

What Is a Penguin? A Penguin Is a Bird

Biologists classify penguins as birds, without any doubt. The penguin—unable to fly, a superb diver, and a walker on earth—does not appear, at first, to be a bird. Yet a penguin is covered in feathers, lays eggs, builds nests, and is warm-blooded. It is a bird that migrates huge distances encompassing thousands of miles, but does so by diving and swimming. Still not convinced that the penguin is a bird? Take a walk around any large penguin colony and see the old feathers on the ground and smell the vast amount of guano, and this will surely remove any remaining doubts—a penguin is a strange bird unlike any other, but it is a bird nonetheless!

What Is *Penguin-Pedia?*

I came home from that trip to Chilean Patagonia struck by "penguin-mania" and started on my long journey to become a friend of the penguins. First, I wanted to know the basics: Where do they come from? Who are they? What are they?

I spent almost two years flying to remote places like the Falkland and Galapagos Islands and taking cruises across the southern ocean on boats of all sizes. My mission was to personally take photos of all the seventeen penguin species and gain personal, firsthand knowledge about these graceful birds.

One question led to another, and the more I knew, the more amazed I was. Finding answers to these questions, however, was not an easy task. That is when the idea for the *Penguin-Pedia*, a comprehensive book of penguin information with pictures, came about. The driving idea behind the *Penguin-Pedia* is that knowledge is a prerequisite for help. Several of the species are in a dire state, and if we want to help them, we first must educate ourselves and learn who these penguins are, what they do, and why they are suffering. *Penguin-Pedia* is my contribution, which I hope can help us all, especially younger generations, to gain knowledge and better understand the penguins, their needs, and the dangers they are facing. I tried to capture pictures that project the penguins' beauty and emotions, but the pictures also help in understanding their hardships. Better knowledge and awareness will be the first small step in helping these adorable little characters.

This book is being launched together with the website www.Penguin-Pedia.com. The site is continuously updated with new photos, news about penguins, interesting research, and even penguin merchandise. You can find more information on our facebook page, www.Facebook.com/PengiunPedia, and our YouTube Channel, www.YouTube.com/PenguinDavid14. We all love penguins, and hopefully this book and these websites will bring us closer to these beautiful birds.

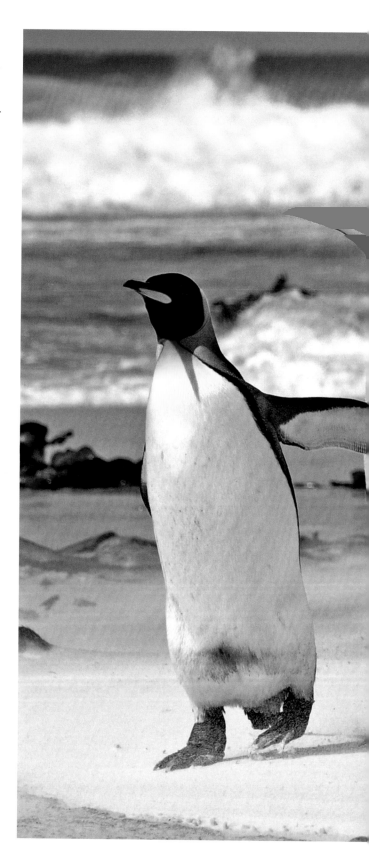

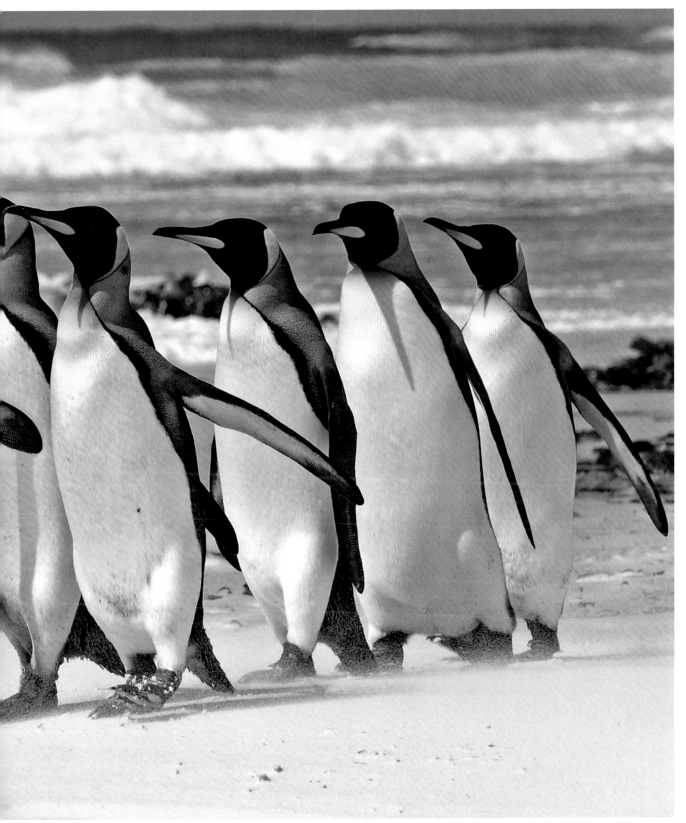

King penguins marching to sea in the Falkland Islands

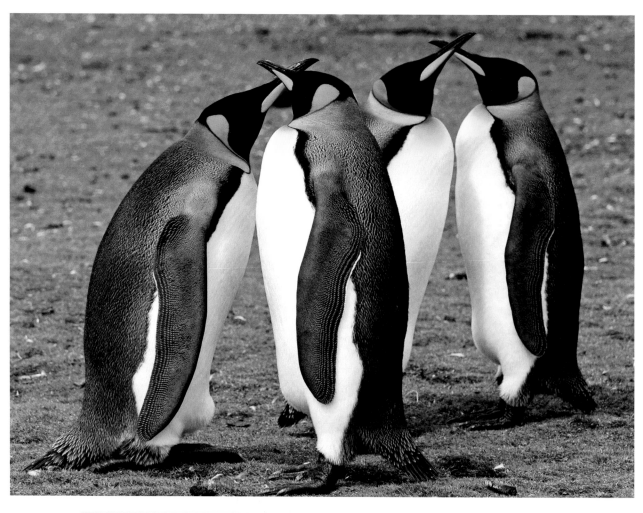

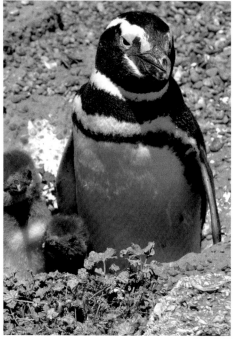

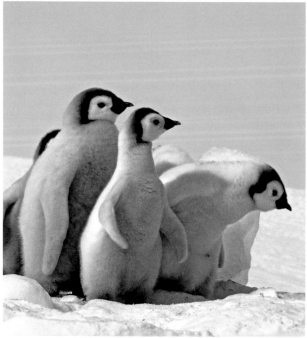

Top: King penguin pairs forming bonds on Macquarie Island, Australia

Far right: A group of Emperor chicks

Right: A Magellanic parent with its two chicks

Where to Find a Penguin

Meeting a penguin is easy. Wild penguins reside in the Southern Hemisphere. To show their love for the cute creatures, the Northern Hemisphere residents of Europe, America, and Asia flock to the many zoos and aquariums they have built to house captive penguins. However, if you feel that the real fun is in meeting a wild penguin, there are many options—some easy and not very expensive while others are difficult, daring, and costly.

Below are a wide variety of options and prices. Travel is calculated from the Dallas–Fort Worth Airport in Texas, and the cost for one person traveling for one week is estimated in US dollars. The price includes airfare (unless otherwise noted), and the fare calculated is the cheapest, most restricted economy ticket for travel in the month of February; the price also includes the average cost of a hotel for five nights, a small car rental and other transportation costs, and the entrance fee to the penguin colony.

Take a Plane to Meet the Penguins

The following are destinations that you can reach by flight on a regularly scheduled airline. Once you land in any of these locations, you can reach a place to view penguins either by car or by boat (a one- to two-hour ride).

The closest: Fly from Dallas, Texas, USA, to Quito, Ecuador. Then fly from Quito to Baltra Island, Galapagos.

THE CLOSEST LOCATION to the United States to meet a penguin in the wild is the Galapagos Islands. To get to the Galapagos, go to Quito, Ecuador, and take the direct flight to Baltra Island, Galapagos. Once on the main island, you need to take a two-hour boat ride to Isabela Island. Once there, you can charter a smaller boat at the dock, at about $30 per hour, to get closer to the Galapagos penguins.

Cost: $2,000 (a car is not needed or included)

The Easiest: Fly from Dallas, Texas, USA, to Cape Town, South Africa.

THE EASIEST destination to reach from the United States is Boulders Beach, South Africa. Just take a flight to Cape Town, rent a car, and drive about 20 miles south. After you've checked into the motel at Boulders Beach, the African penguins will be waiting for you across the street. They are there all year round.

Cost: $2,900

The Largest South American Colony: Fly from Dallas, Texas, USA, to Buenos Aires, Argentina. Then fly from Buenos Aires to Trelew, Argentina.

THE LARGEST OF THE EASIEST-TO-REACH COLONIES is in Punta Tombo, located in Patagonian Argentina. This is home to the largest Magellanic penguin colony (over 200,000 pairs). From Buenos Aires, fly to the city of Trelew and rent a car. Drive south on the national highway to Punta Tombo. Once in the area, do not miss the Peninsula Valdés, a few hours to the north, where several colonies of Magellanic can be found. The largest and best colony to photograph is called San Lorenzo, reached via a dirt road. Since very few roads exist on Peninsula Valdés, it is hard to get lost there.

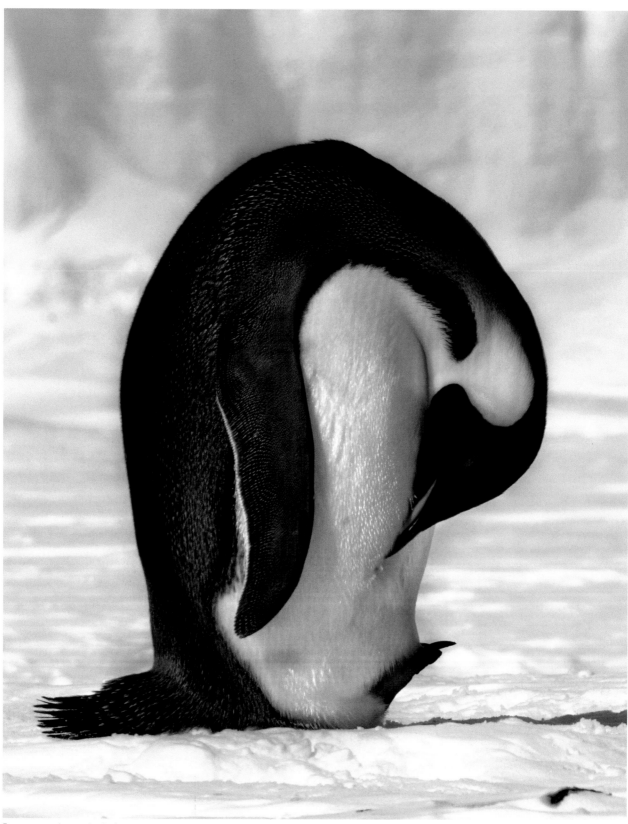

Emperor penguin warming its feet

Reminder: Magellanic penguins are migratory; they do not stay at the colony all year round. Adjust travel plans accordingly.

Cost: $2,800 (including entrance fees to Punta Tombo, San Lorenzo, and the $100 entry fee to Argentina)

Difficult and dangerous: Fly from Dallas, Texas, USA, to Santiago, Chile, or Buenos Aires, Argentina. Then fly to Ushuaia, Argentina. From Ushuaia take a boat to the coastal islands of Argentina.

Easy but less exciting: Fly from Dallas, Texas, USA, to Santiago, Chile. Then fly from Santiago to Punta Arenas, Chile.

AN EASY-TO-GET-TO, LESS EXCITING PLACE TO VISIT is the Magellanic colonies on the Chilean side of Patagonia. Fly to Santiago, Chile, and connect to Punta Arenas. From there, drive to one of the several smaller colonies of Magellanic penguins. The easiest one to reach is called the Otway Sound. If you take a boat you can reach the beautiful Magdalena Island, where over 50,000 pairs breed.

Cost: $2,800 (including the $100 entry fee to Chile)

WHILE IN CHILE, you can take a flight to the northern part of the country and look for Humboldt penguins. It is difficult to access the Humboldt colonies because most are located on small islands.

Cost: Add $1,200 to the cost above

DIFFICULT AND DANGEROUS to reach are the coastal islands of both Chile and Argentina in the Tierra del Fuego region. These islands are home to several other species, such as Rockhopper and Macaroni penguins. The islands are very remote, and landing on them is extremely difficult. Getting to this area requires substantial preparation, and there is always the possibility that the weather will spoil your plans.

Cost: $5,000 minimum (varies depending on if you charter a boat or helicopter)

Short and pretty: Fly from Dallas, Texas, USA, to Lima, Peru. Drive from Lima to Paracas, Peru. Take a boat to the Isla Ballestas.

A SHORT-TRAVEL-DISTANCE, EASY-TO-REACH, AND PRETTY DESTINATION at which to see Humboldt penguins are the Islas Ballestas in Peru. Fly to Lima, Peru, and rent a car. Drive five hours south. When you reach the city of Paracas, you will find several boat tours to the Islas Ballestas. Landing on the island is prohibited, but the boats get very close to the penguins. This place is amazing not only for the penguins, but for the sheer amount of other birds living there. You can also continue south and visit Punta San Juan. This sanctuary is closed to visitors, and prior arrangement must be made if you want to enter. Peru is a great tourist destination with many grand attractions.

Cost: $2,000

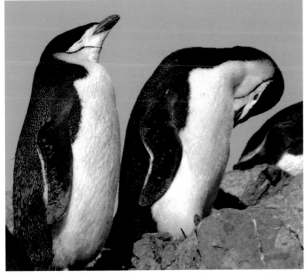

Chinstraps enjoy a bright day

The best place: Fly from Dallas, Texas, USA, to Santiago, Chile. Then fly from Santiago to Punta Arenas. Fly from there to Stanley, East Falkland Island. Take small planes to all the different Falkland Islands.

THE BEST PLACE TO SEE PENGUINS is, without a doubt, the Falkland Islands. You can arrive by air on a flight that only happens once a week from Punta Arenas, Chile. Travel between islands is done by smaller, local airlines that use small propeller planes. There are very small lodges on the smaller islands. For the money and comfort, the Falkland Islands are by far the most accessible and enjoyable way to see four different species of penguin from four different genuses: Magellanic, Rockhopper, King, and Gentoo. The colonies are large and the number of visitors is small. This is probably also the best place to photograph penguins. The best travel agent on the islands is Sally Ellis. Her e-mail address is se.itt@horizon.co.fk.

Cost: $4,900 (includes seven nights in the Falklands and an additional three days for travel)

Easy but involved: Fly from Dallas, Texas, USA, to Auckland, New Zealand. From Auckland fly to Dunedin.

AN EASY BUT INVOLVED TRIP is one to New Zealand's South Island. Fly into Auckland and from there fly to Dunedin. There you can rent a car and encounter three different species of penguin. The Little can be seen at Oamaru, the Yellow-eyed at Penguin Place on the Otago Peninsula, and the Fiordland about a five-hour drive to the west coast. There is no doubt that they are all extremely shy, making it very difficult to photograph them. Also, it is important to check what time of year these penguins are ashore before taking your trip—otherwise you might miss seeing them. New Zealand is a very pretty country, and once there you will want to stay longer.

Cost: $2,900 (you need at least five nights in New Zealand to reach all three species)

Easy to Reach: Fly from Dallas, Texas, USA, to Melbourne, Australia.

EASY TO REACH is Australia, where you can meet the Little penguins. Fly into Melbourne, Australia, and look for Phillip Island colony. The Little is not as gracious as other penguins. It hides during the day, running to and returning from the ocean under cover of darkness, making it very hard to photograph. Caution—you better find other things to do, as well. Seeing the Little on one evening will leave you plenty of time to enjoy beautiful Australia.

Cost: $2,500

Exotic but difficult: Fly from Dallas, Texas, USA, to Johannesburg, South Africa. From Johannesburg fly to Windhoek, Namibia. Drive from there to Luderitz, Namibia, and take a boat to Halifax Island, Namibia.

EXOTIC BUT DIFFICULT is a trip to Namibia to see the African penguins. Fly to Johannesburg, South Africa, and then connect to Windhoek, the capital of Namibia. Once there, rent a car and drive 500 miles (800 km) south to Luderitz. Once in Luderitz, look for the two boat operators that offer trips to Halifax Island. Landings on Halifax are prohibited, so viewing the colony is done from the boat. The trouble is only worth it if you are already in the area on a safari.

Cost: $3,900

Live on a Boat for a Week and Meet Penguins on Ice

Antarctic Criuses: Fly from Dallas, Texas, USA, to Santiago, Chile, or Buenos Aires, Argentina. Then fly to Ushuaia, Argentina. From Ushuaia take a cruise to Antarctica.

Sub-Atlantic Cruise: Fly from Dallas, Texas, USA, to Auckland, New Zealand. From Auckland travel to Invercargill, New Zealand. Here you can take a cruise which tours many of the sub-Antarctic Islands.

ANTARCTIC CRUISES take you to the bottom of the world to see penguins on ice. What was once a luxury that a select few could afford has now become a popular and more affordable vacation after the collapse of the Soviet Union. Russian ships that were built to navigate in the Arctic have been retrofitted into luxury passenger cruise ships and are crisscrossing the southern oceans, taking passengers to multiple destinations, many of which are home to penguins. There are several companies that own or lease the ships, and they offer a large variety of destinations, durations, services, and, of course, prices. The most popular, shorter, and cheaper "Antarctic cruises" actually never reach Antarctica but only stop in South Shetland Islands.

Do not worry about semantics—there are plenty of Gentoo penguins breeding on those islands, and Adélie and Chinstrap penguins can also be seen. Longer cruises reach the Antarctic Peninsula and some even circle Antarctica and land on the mainland. One should understand that an Antarctic expedition requires passing through the Drake Passage, a waterway that is considered one of the roughest seas. Also, landing on land is done via inflatable miniboats called Zodiacs, and the weather is always a bigger factor than the operators care to acknowledge. In my opinion, if you are physically fit, an Antarctic cruise is unquestionably an adventure of a lifetime. As for penguin sightings, those cruises that include South Georgia and the Falkland Islands will get you more penguins of different species than other destinations.

Cost: $5,000–$40,000 (for a shared cabin, plus the airfare to Argentina or Chile)

CRUISE TO THE SUB-ANTARCTIC ISLANDS SOUTH OF NEW ZEALAND, including Auckland and Campbell Islands (home to the Yellow-eyed), the Snares Islands (where Snares penguins breed), Antipodes and Bounty Islands (where you can see Erect-crested and Rockhopper penguins), and Macquarie Island (where four species breed—Royal, King, Gentoo, and Rockhopper penguins). Most islands are under the control of New Zealand, except Macquarie, which is part of Australia. Bluff, New Zealand, is the port of choice for the few cruise ships visiting those Islands. *Heritage Expedition* has different cruises that cover most of the islands where penguins breed. These cruises cost $8,000 to $25,000 a person. One big, disappointing reality is that the government of New Zealand does not allow landings on Snares, Bounty, and Antipodes Islands. Therefore, pictures of the Snares and Erect-crested penguins can only be taken from the sea (in a Zodiac). While the sea can be just as rough as on an Antarctic cruise, the Sub Antarctic Islands feature different climate and terrain than Antarctica.

Cost: $5,000–12,000 (for a shared cabin, plus the airfare to New Zealand)

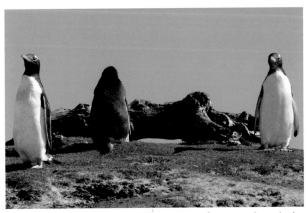

Gentoos coming and going

Penguin History and Research

Taxonomic Classification: Genus and Species

The scientific or taxonomic name of the penguin's entire family of species is *Spheniscidae*. In this book we will call them penguins, and we will call the almost uncontrollable love a person feels toward them penguin-mania.

At the beginning of chapter 1, readers can find a full classification chart in biological terms of all species as recognized today, for a quick reference at any time. Throughout the book we will use the common names: King, Emperor, Gentoo, etc. Their scientific names can also be found at the beginning of each chapter.

The penguin family, *Spheniscidae*, is divided into six distinct genus and seventeen species. Some researchers dispute the species count, but for the purpose of this book, we accept the notion that there are seventeen species.

Why Do We Call Them Penguins?

Whether genetically related or not, some auk species resemble penguins. One distinct and unfortunately extinct species in particular was the Great Auk, which lived in the Northern Hemisphere. The last of the Great Auks was hunted down to be barbecued in 1844, but not before it was responsible for giving the penguins their name.

The name "penguin" is thought to be a derivative of the Latin word *pinguis*, meaning fat. That extinct North Atlantic Great Auk was flightless and unusually fat. It was given the scientific name *Pinguinus impennis* and nicknamed "penguin" by sailors of the great Conquistador era. When some of the same sailors later ventured into the Southern Ocean and landed in places like the Falkland Islands, they mistook the birds they saw for the Great Auk and called them by the same nickname, penguin. They promptly moved to treat the poor southern birds with the same aggression and cruelty as they had treated the northern Great Auks. First they snatched their eggs, and later they developed a taste for penguin meat.

History

My search for information about penguins led me to a very informative book called *The Penguins*, written by T. D. Williams and published in 1995 by the Oxford University Press. I discovered that for a long time it was considered to be the penguin Bible. Explaining origination, Williams writes that penguins are ancient birds that roamed the southern half of our planet for tens of millions of years. He points to fossils discovered at sites in New Zealand and Australia, as well as in Seymour Island, that were

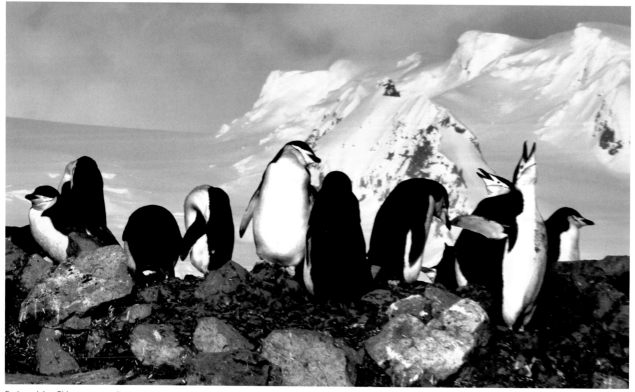

Early-arriving Chinstrap penguins

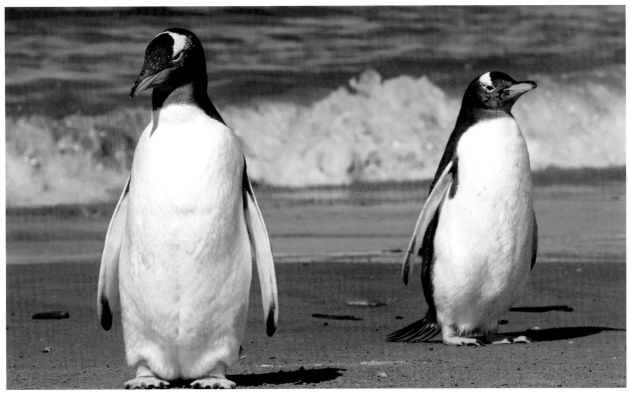

Gentoo penguins drying off in the Falkland Islands

tested and found to be about 40 million years old (Jenkins 1974). The older theory accepted by Tony D. Williams and George G. Simpson before him suggests that penguins evolved during the Cretaceous period (140 to 165 million years ago), at the end of the dinosaur period. It is hypothesized that penguins evolved from flying birds like diving petrels or auks, and some scholars suggest that penguins predate the flying bird (Lowe 1939). To date, no fossil of an animal that would have been an intermediate of a penguin and a flying bird has ever been found, and all confirmed penguin and penguin predecessor discoveries, from the oldest on, show the animals having flipper-like structures and heavy, solid bones suited for diving—not flying.

Current and extinct, there are more than forty different recognized penguin species.

Classical researchers like Simpson, Richdale, and Warham spent time studying the biological, physiological, and behavioral characteristics of penguins, and based on this type of information they compared them to birds like auks, albatrosses, petrels, and flightless cormorants to place them in an evolution sequence.

DNA Research

Research took a huge leap forward with the discovery of the gene and the advance of highly sophisticated computer-generated DNA testing methodology. This exciting technology injected new energy into the search for the penguin's origin. DNA testing

indicated that recent finds of two separate fossils of ancient penguins were from about 60 to 80 million years ago. "Penguin Zero," as we will call him, was already flightless and had a bone structure that supports flippers; most likely it was a diving bird. To give a prospect of time it should be noted, in comparison, that the first fossils of primitive humans or *Homo habilis* are from between two and three million years ago.

With the new DNA technology being applied, researchers are still facing millions of years in gaps between samples of penguin remains, creating problems in completing the puzzle. No definite answer to whether or not the penguin evolved from a flying bird can be constructed. Geneticists also cannot pinpoint the exact biological origins of the penguin, or which exact family of birds the penguin evolved from. Since it happened about 70 million years ago and there are gaps of 20 million years between fossil finds, we might never know the answer for certain.

What is interesting to note is that, except for some areas in the Galapagos Islands where the Galapagos penguin might venture a few short miles north of the equator, there are no living penguins, nor penguin fossil finds, in the northern half of the world. This renders the penguins, live and ancient, as strictly Southern Hemisphere residents, but precise reasons for this geographical limitation remain a mystery. The pioneer of DNA research for penguins was O'Hara, whose 1989 research paper, "An Estimate of the Phylogeny of the Living Penguins," has

become the most accepted study on the subject. It sets the order of the evolution among the existing penguin species. In contrast to researching extinct species, studying current living species can be done with almost perfect certainty because there are ample DNA samples available from the living birds. The DNA studies confirm without a doubt that penguins are monophylogenetic, meaning they are a distinct family in which all current species are members.

Family trees are good estimates for the diversion or evolution dates in which each species broke off from the other. They conclude that the basal father of all penguins (Penguin Zero), extinct and extant, lived around 71 million to 68 million years ago somewhere in the geographical area of what was then an ancient southern continent named Gondwana (Baker et al. 2006; Slack et al. 2006). At that particular time, that old continent was already in the process of breaking up into the currently known land masses of Australia, New Zealand, Antarctica, and parts of South America.

A descendant of Penguin Zero, a larger-bodied bird, is the ancestor of all the extant penguins. It lived around 34.2 million to 47.6 million years ago, and we will call this bird "Penguin One." Scientists believe that about 40 million years ago the *Aptenodytes*, father of Emperor and King penguins, diverged from that common ancestor and started the creation process of a different penguin species. That first of the *Aptenodytes* was then one member of the species and only much later split to create the separate two species of the King and the Emperor. This diversion of the *Aptenodytes* from the common ancestor corresponds to a major extinction event caused by a cooling age settling on earth that the heavier ancestor could not survive.

The evolution of the family (only extant species listed) is shown in the chart below.

With that said, we are left with the big question surrounding the penguin's history. Are penguins a primitive bird that preexists the flying bird, or are they the descendants of a flying bird? Because no fossil evidence can point to any penguin ancestor ever having bone structure that can support flying, I would like to differ from most other researchers who believe penguins evolved from some type of flying bird. Until a fossil of a transitional animal with a wing structure that is not a flipper is found, it cannot be assumed

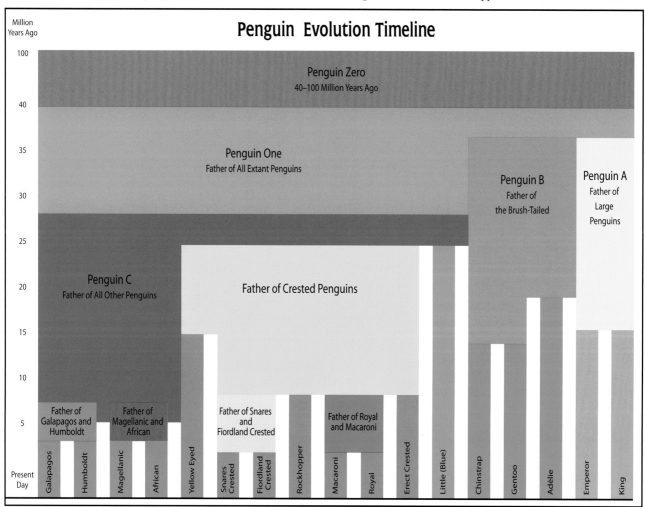

that any penguin ancestor was ever able to fly. At this stage we should just accept that a definite answer is still elusive and might not be resolved for some time, if ever.

Early Treatment of Penguins

At first, penguins and eggs were used to feed hungry sailors. Penguin killing escalated rapidly when those sailors realized that the penguins, more specifically their fat, could be used as a makeshift fuel source for slow ships with dwindling wood or coal supplies. However, penguin oil was not top quality and not as easy to produce, so attention quickly shifted to seals and other marine mammals. During the eighteenth and nineteenth centuries, huge quantities of seals and marine elephants were killed, thereby actually helping the penguins to survive by eliminating some of their predators and competitors for food.

As the killing of penguins and seals was outlawed and conservation efforts started, scientists who had started paying attention to the alarming decline in some penguin species populations began to count penguins all over the Southern Hemisphere. It does not take a genius to figure out that human activities, good and bad, influenced and continue to influence the penguin's ability to thrive or even survive. Man is putting the penguin's ability to further adapt to the test.

The fact that penguins have existed in some form or another for more than 70 million years proves that penguins are masters of survival and are veterans of outliving major extinction events that wiped out most other animal species on earth, such as the dinosaur. The penguin's unique and long history attracts much attention in the global warming debate. Adding interest to the discussion is the endangered status of several penguin species and fears that those species, or even the entire penguin family, might one day become extinct. That leads researchers to think that the current "global warming" might turn out to be more severe, speedy, and damaging than all the other extinction events that took place in the past 70 million years.

Will humans prove to be the species that is eventually responsible for the penguin's demise? To avoid a positive answer, the need to conserve the environment, as well as to protect the penguins from direct and indirect harm by man, is urgent. Otherwise, we may be asking where penguins disappeared to instead of where they come from.

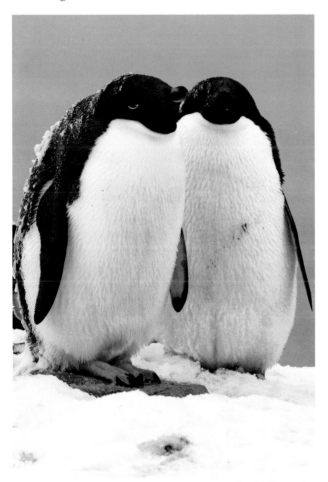

Two Adélie penguins

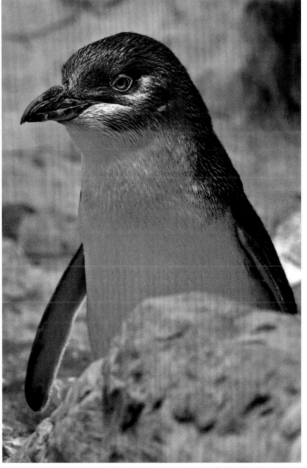

A Little penguin hiding at the Dallas World Aquarium

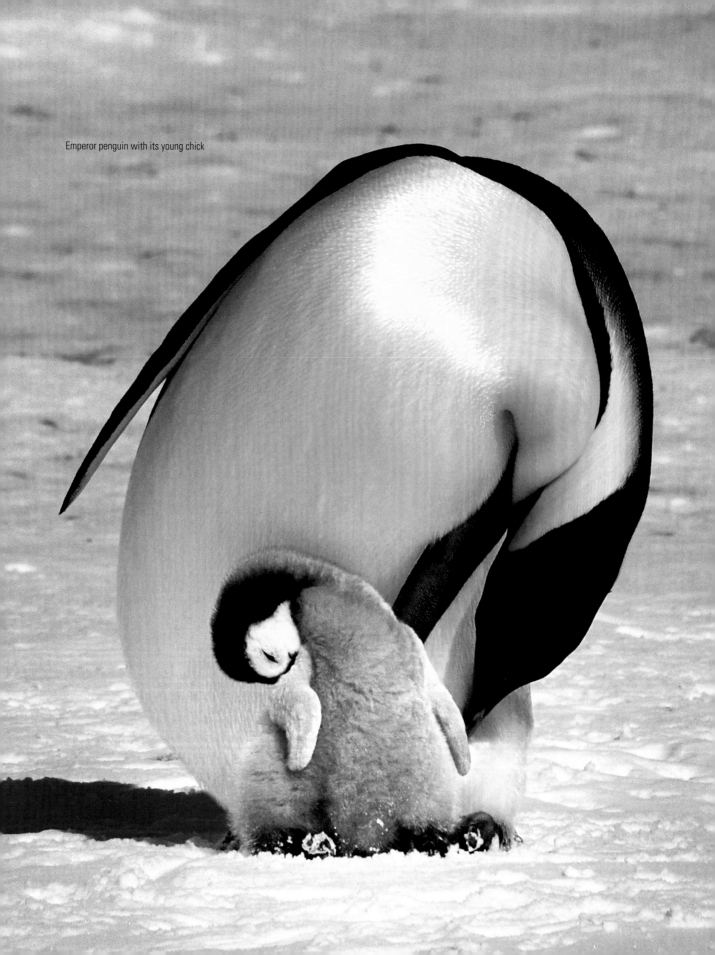

Emperor penguin with its young chick

Emperor Penguin
Aptenodytes forsteri

Genus: *Aptenodytes*

Other Genus Members: King penguin

Subspecies: None

IUCN Status: Least Concern

Latest Population Estimates
Individuals: 475,000
Breeding Pairs: 200,000

Life Expectancy: 20–25 years on average, with few reaching 40 years

Migratory: Yes, they are absent from the colony from January to April.

Locations of Larger Colonies: On the fast ice around the Antarctic Continent; Cape Crozier, Terre Adélie, Cape Washington, Coulman Island in Victoria Land, Halley Bay, Coats Land, and Queen Maud Land

Colors
Adults: Black, white, yellow, and orange.
Bill: Black and pink to orange
Feet: Black
Iris: Dark brown to black
Chick Down: Mostly silver, black and white head
Immature: Similar to adults, black parts faded to gray, yellow less bright

Height: 44–48 in/112–122 cm

Length: 45–51 in/115–130 cm

Normal Clutch: One egg per nest

Max Chicks Raised per Pair per Year: 1

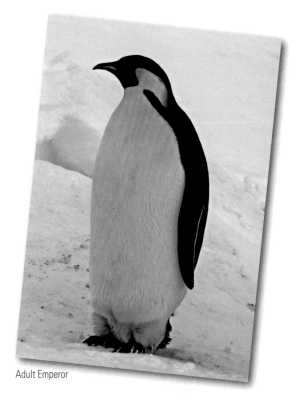
Adult Emperor

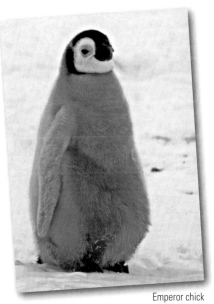
Emperor chick

17

David's Observations

*E*mperor rookeries can be found on the ice around the Antarctic continent. Many miles of ice separate the colony from the ocean, but the rookeries are also quite a distance from true land where boats are able to dock, so you must hire a helicopter to reach these remote locations. I signed up for the Quark cruise, justifying the expense by focusing on the long list of promised landings that would allow me to take pictures of many other penguin species in addition to Emperors.

I was full of hope and joy when the Kapitan Khlebnikov, carrying ninety-seven passengers and the red and blue helicopters, lifted anchor and began sailing south. The first days of our journey were uneventful because we encountered unusually calm waters. Later we passed several magnificent icebergs, and by nightfall the ship stopped in front of what looked like an endless sheet of ice. The crew began breaking the ice and we slowly advanced several miles closer to Snow Hill Island and the Emperors.

By sunrise, the weather had turned to fierce wind and snow, and the helicopter flights could not commence—we would be stuck on board until conditions were more favorable. The weather improved the next day, but the Russian crew claimed that it was still too windy to fly. We were then notified that the ice had closed in on us and that we were stuck. On the fourth long day of being stuck, when the weather finally seemed perfect, the crew members still claimed that flight was impossible. After a major confrontation with some of the passengers and with the BBC camera crew that joined us, the crew finally decided to launch the helicopters.

We landed on the most beautiful Antarctic day imaginable. The walk from the landing site to the rookery was a treat, light-ing conditions were perfect, and the penguins were plentiful. The sun was out and we actually sweat under the polar suits, even as we lay on the ice to take pictures.

That one heavenly day was followed by a few more days of the expedition crew claiming we were stuck in the ice, forgetting their ship was designed to break said ice. However, to no one's surprise and without any change in weather or ice condition, exactly eighty hou rs before our expected time of arrival in Ushuaia, Argentina, the engines began roaring and the ship was cutting ice once again. We made port on schedule, but never attempted to land anywhere else on our route, as was originally promised. All those other penguin species I had expected to photograph on the trip would have to wait one more year.

For all the trouble and frustration I endured aboard the Kapitan Khlebnikov, watching an Emperor penguin rookery was still the treat of a lifetime. When you reach the colony, the penguins reciprocate the friendliness shown toward them. If you sit or lay on the ice they will soon move toward you, or even touch you—a magical experience. In a few minutes they lose interest and continue along with their normal routine, but still allow you to photograph them from close range. At times I had the impression they were actively modeling for me.

The Emperors are the most gracious animals I have ever met. Their chicks are the cutest, most loveable creatures. The only thing that bothered me was the visible food shortage; chicks and adult alike were desperately displaying signs of hunger. I have no doubt that viewing Emperors on the ice will be the most impressive sight I will ever encounter. The day I spent in the frozen, natural heaven will be with me forever!

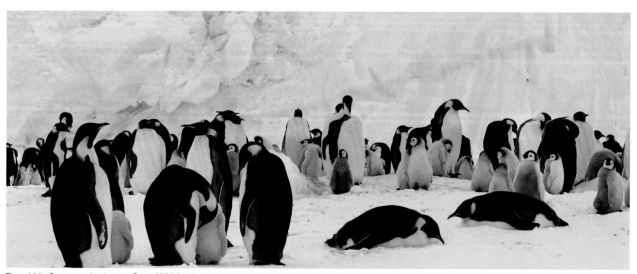

The middle Emperor subcolony on Snow Hill Island

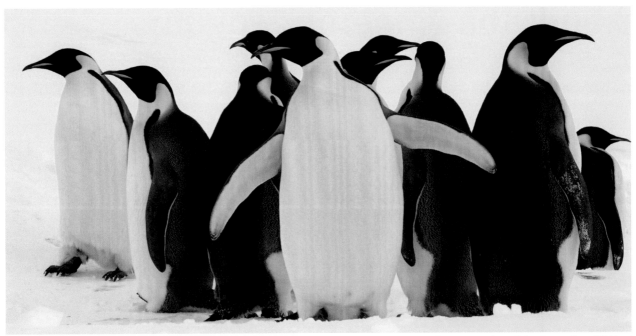
A group of adult Emperor penguins at their colony on Snow Hill Island

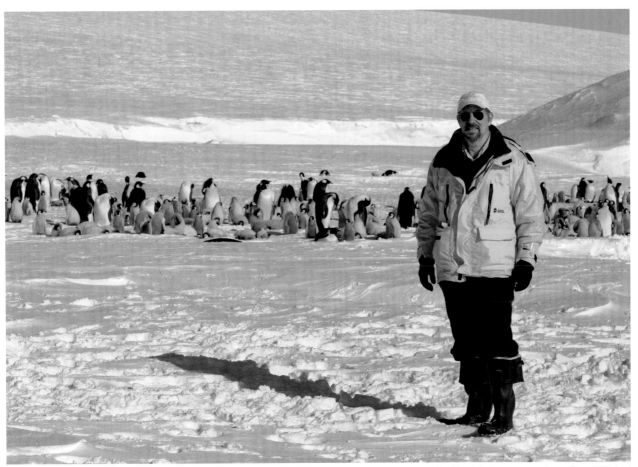
David and the Emperor penguins on Snow Hill Island

About the Emperor Penguin

Population Trend

Holding steady. This might come as a surprise, considering the harsh weather conditions Emperors endure during their breeding.

Habitat

When you think of penguins living in icy Antarctica, you are thinking of the Emperor penguins. Most of their breeding grounds are on the fast ice that surrounds the continent. The ice forms when the ocean surface freezes, usually in the fall, but the ice may melt and disappear when temperatures rise during the summer. Emperors set their rookeries in some of the coldest, most remote places on earth, and are the only birds known to breed on solid ice. Therefore, the Emperors' well-being depends on the shape of the ice and the temperatures that keep the water frozen.

There are at least forty-six known colonies surrounding Antarctica (7th International Penguin Conference, unpublished). Six of the rookeries, which contain as many as 60,000 pairs, are in the western Ross Sea in places like Cape Crozier, Beaufort Island, Franklin Island, Cape Roget, Cape Washington, and Coulman Island (Kooyman and Mullins 1990). Other colonies are at Adélie Land, Géologie Archipelago, and Cape Co lbeck. One colony much farther north, outside Snow Hill Island and closer to South America, is the breeding ground for approximately 4,000 pairs. In a surprise discovery, a Source using satellite photos to count Emperors found at least three colonies on frozen land.

Appearance

The adult Emperor penguin is the most gracious of all penguins. Like the King, it features yellow to orange colors beside the standard black back and white underbody. Two of the most striking features of this majestic bird are the yellow, almost orange patches around each side of the neck, as well as at the colorful base of the beak. The head is mostly black, broken by two large curves starting at the ear and connecting to the chest, which fade from orange to yellow to white from the ears downward. The chest and underbody are almost all white at the bottom, with yellow intertwining on the upper chest. The bill is mostly black

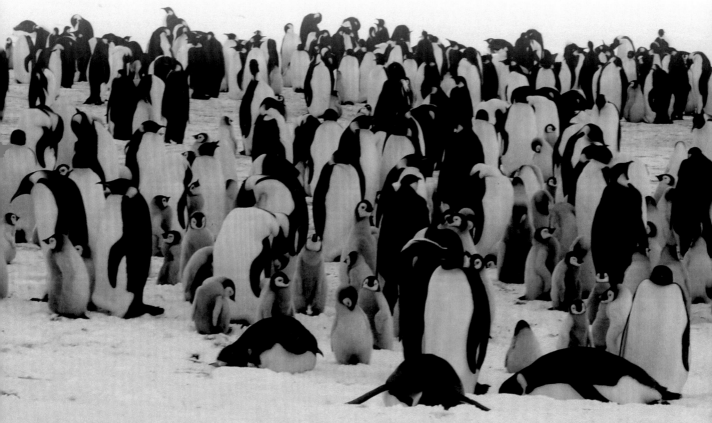

The main Emperor colony on Snow Hill Island

except for the striking orange to pink line closer to its base. The feet are black with large nails, and the legs can be stained with pink patches. The flippers are black on the outside to the edges and white on the underside.

Immature Emperors are not very different from the adults, but the bright orange and pink are less defined.

Chicks

Chick Emperors hatch with short down, but soon they develop their thick, beautiful down, which is mostly gray in color. Their plumage makes them adorable subjects and Emperor chicks are therefore the most published of all penguins. Their magnificent heads show a field of black surrounding two white circular patches that connect under the chin. Around the eyes and inside the white patch there is a much smaller black circle. Chicks stand on their parents' feet for about forty days to insulate themselves from the ice. They join a crèche after this time, which allows both parents to shuttle in and out the water and return with food.

At about six months of age the youngsters will begin shedding their down, but before they have fully shed, the chicks fledge. They swim far away in a northerly direction for their maiden trip, reaching distances of up to 1,700 miles (2,735.9 km). During the crucial first months at sea, and with no help from their parents,

they gain experience, develop faster deeper diving capabilities, and learn how and what to hunt (Kooyman et al. 2008).

Breeding and Chick Rearing

Like all penguins, Emperors require the full participation and energy of both parents throughout the breeding process. Even if just one of the parents abandons the nest, voluntarily or not, it is a guaranteed death sentence for the chick. To make things even more difficult, Emperors are one of the few birds that breed in winter—and not just any winter, but the harshest winter anywhere on earth!

To begin the breeding season, Emperors arrive at their home rookeries by early April, jump from the chilly water onto the even colder ice, and begin marching. The distance between the water and the rookery determines the length of their journey, and since they travel at about one mile per hour (1.6kmph), it can take three days to reach their rookery.

Unlike most other penguin species, Emperor penguins do not use a nest and are not territorial.

Emperors rarely mate with their partner from the previous year, so the first order of business upon reaching the colony is to choose a mate. Females take the initiative in this matter, while the males tend to follow along.

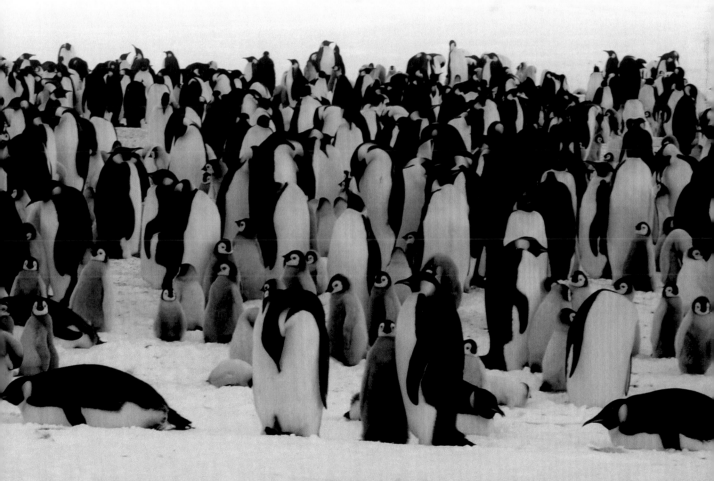

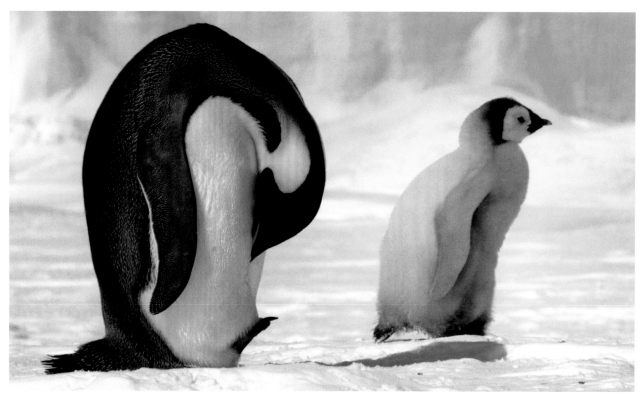

An Emperor chick and parent right after feeding

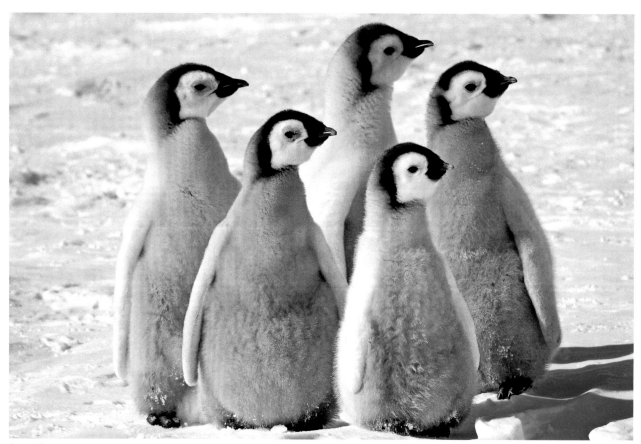

A small Emperor crèche

Early in May, the female lays one egg and transfers it into her mate's care so that she can run back to the sea to end her forty-day fast. She forages for sixty-five to seventy-eight days while the male incubates the egg. The male is present when the egg hatches and he initially feeds the chick with a white, milky substance he produces. Soon after the chick hatches, the female arrives with food (fish, squid, and krill) stored in her stomach for the chick.

About seventy-seven percent of the eggs laid will hatch. A third of the eggs that fail to hatch are the result of infertility. Forty-five percent are lost to the aggression of other Emperors, and the rest are dropped during the egg exchange between the mates or lost due to other causes (Williams 1995).

Exhausted after his 110- to 120-day fast, the male heads back to the sea, where he stays for twenty-four days trying to satisfy his devastating hunger and rebuild his body. Upon return, he promptly sets the chick on his feet, taking over the feeding for eight more days. After several more exchanges between the two parents, the "guard" stage comes to an end and the chick joins a crèche.

Soon both parents leave for feeding trips, each returning every eight days or so to feed the chick. A parent can only recognize its chick vocally, and the identification process is complicated because all of the chicks are extremely hungry and several chicks answer the adult call at once. Only after the parents have assured themselves that the begging chick is their own will they feed it.

When a chick reaches about 140 days of age, its parents cease their feeding duties and the chick prepares to fledge. Only about one in four of the chicks that fledge will actually live to see the age of one.

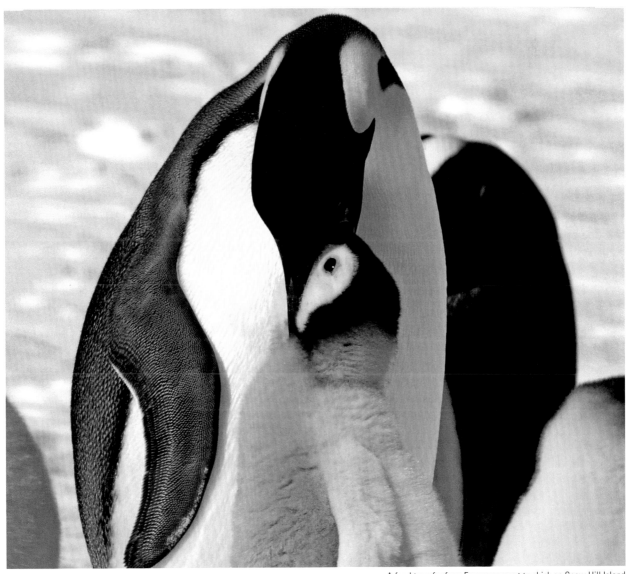

A food transfer from Emperor parent to chick on Snow Hill Island

23

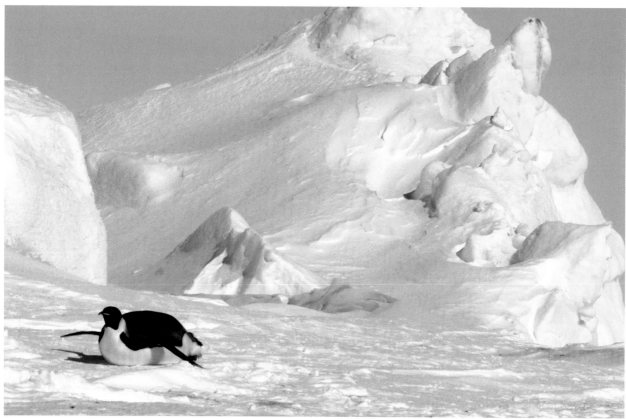
An adult Emperor tobogganing toward the colony

Foraging

Emperor penguins use different tactics during different types of foraging trips. Male foraging behavior differs from that of females and juveniles. Even Emperors from different rookeries forage differently! The only logical explanation to all the tactical variations is the Emperors' awareness of their energy needs, as well as their need to be in a certain location at a specific time to relieve their mates or begin molting. To meet time and caloric requirements, they travel the route most readily available to fill up with sustenance and return home.

During breeding, when one mate must stay behind to look after the chick, the traveling mate tries to stay closer to the colony. The female forages much longer and can travel around 700 miles (1126.5 km), zigzagging to hunt for prey. Males have only twenty-five days to hunt and only travel a total distance of 350 miles (563.3 km), but they hunt and catch with more intensity to overcome the food shortage created by their 110-day fast. The premolting trip lasts about forty-two days, and Emperors cover a much larger territory. Both sexes take days in between to rest on icebergs during foraging trips.

Emperors are very efficient divers, and once in feeding area they spend about 70 percent of the time moving vertically, looking for prey, and less than 15 percent of the time moving horizontally, catching the prey. The rest of the time is used to rest with their heads above the water. Emperors can swim up to nine miles per hour (14.9 kmph) on average.

Most shallow dives take the Emperor between two and a half and four minutes, but deeper dives can last up to twelve minutes. Despite their amazing deep-diving capabilities, Emperors prefer to stay around the continental shelf where the water is more shallow. Only 5 percent of these dives are more than 600 feet (182.9 m) deep (Wienecke et al. 2007).

The deepest dive recorded of an Emperor is 1,850 feet (563.9 m), and the longest is 21.8 minutes. Strangely enough, the longest dive was a shallow one, and probably the result of the holes in the ice above closing and forcing the penguin to look for another, less simple exit point (Wienecke et al. 2007).

What are the Emperor penguins foraging for? A detailed Source done by Cherel and Kooyman in 1998 suggests that fish, by mass, constituted 85 to 95 percent of the Emperors' diet at Cape Washington during breeding season. Crustaceans, mainly krill, ranked second at 5 to 11 percent by mass, and no fresh squid was found.

Molting

When chicks reach a certain size, their parents leave them on their own to depart for the premolt trip. Emperors must increase their weight by 50 percent in order to be ready for molting.

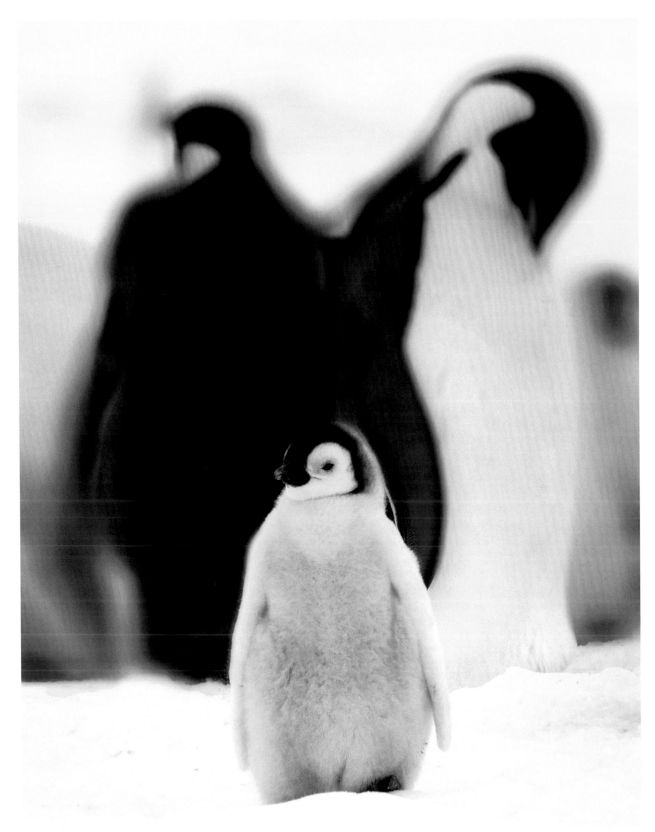

A young Emperor chick stays close to its parents

At the conclusion of this trip, most return to the shelf-ice area where they breed, while others find a totally different location, depending on the ice condition, to begin molting. Molting on the ice lasts about thirty-five days, and weight loss can exceed 50 percent. Immature Emperors and unsuccessful breeders normally molt earlier.

Nesting

Emperors do not nest; they must position the egg, as well as the chick, on top of their feet and cover it with a fold (a pouch of the abdominal skin) while they stand on the freezing ice. Because they are not territorial, they do not stand on one part of the rookery, but move as often as huddles dictate.

Relationships

Emperors breed and molt in such harsh conditions that they would never be able to survive the winter were it not for their community protection system, the huddle. To save energy they all form a large circle, standing extremely close to each other.

The configuration resembles a football huddle, except that this penguin huddle consists of thousands of birds instead of a few teammates. It is not clear who is chosen to stay on the outside at first, or why. But no matter who begins the huddle on the outside, they are shifted into a warmer spot in a few minutes' time. The shifting from outside to inside continues throughout the huddle and allows the entire colony to share their individual body heat to protect the chicks, as well as the adults, from wind and freezing.

The constant movement throughout the huddle does not afford the Emperors the opportunity to become territorial, avoiding most fights. Perhaps because of this, Emperors are more amiable and less aggressive than any other species of penguin. Emperor penguins communicate a great deal through body language. To show appeasement they point the bill upward or away from the neighboring bird and open the flippers. Confrontation is shown by pointing the bill directly at the other bird with the neck stretched and the flippers down.

The first order of business upon reaching the colony is to choose a mate. Females take the initiative, while the males tend

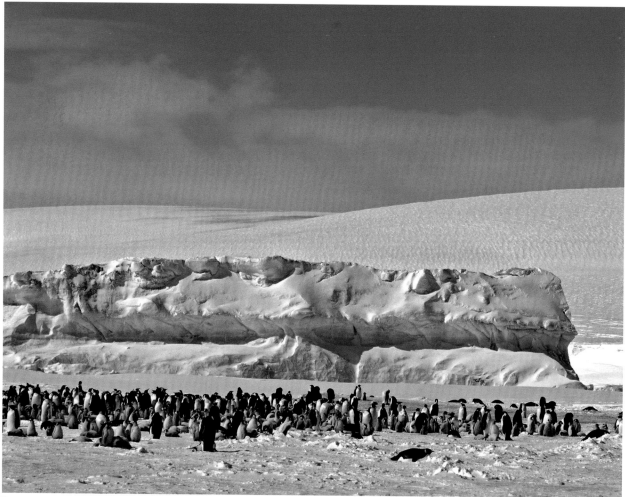

The location in the middle of the subcolony in Snow Hill is behind a trapped iceberg

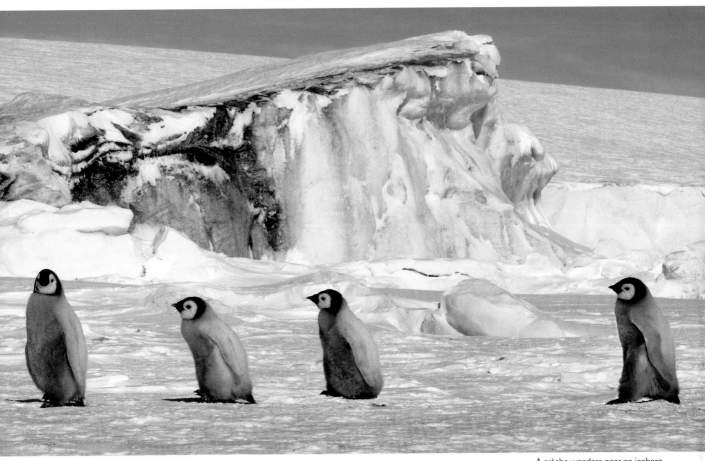

A crèche wanders near an iceberg

to follow along. As they become more comfortable, the male sometimes leads the female on a walk called a "waddling gait," where they may stop and lay on the ice to touch each other. Later they will stand and begin mutual preening, or just rest their heads on their mate's neck. Regardless of all the love and affection, they rarely mate with the same partner beyond one breeding season.

Emperor penguins are the only species known to feed strange chicks. This is done mostly by failed breeders, mainly those whose chick recently died. Some failed breeders, especially females, will go even further and attack an incubating or brooding parent, trying to steal their egg or kidnap their chick. Such aggressive attempts in many cases end up with the breakage of the egg or death of the young chick (Angelier et al. 2006).

Vocalization

Emperors have two different voice sources, a feature they share with their relatives the King penguins. Because they lack individual nests, Emperors rely entirely on voice recognition to find their chick or mate in their crowded colony. They use both voice systems simultaneously, which researchers believe widens their sound spectrum and variety while helping them to recognize their chicks. The two systems produce different frequencies: one is

a shorter wavelength that travels better over long distances, while the other is a longer wavelength that travels shorter distances, able to better penetrate the densely packed rookery full of bodies.

Chick calls during crèche age are frequently whistling or humming sounds that could be classified as songs. These songs are accompanied by exaggerated nods of their cute heads, up and down, as they beg for food.

Adults use trumpet-like calls with the bill pointed up to contact each other on land. Repeated short syllables in a rhythm, also referred to as the "Emperor Song," are calls of ecstasy or relief. Oddly, mates remain silent through most of their common stay in the colony, from the date they form their bond until the female lays the egg and leaves on her foraging trip. This silence is presumably meant to keep unmated females from stealing the males that are already spoken for. Distress calls consist of very complicated patterns of repeated bits of sound and are accompanied by bill-pointing, neck-stretching, and an aggressive stance.

Dangers

Emperors are far from fragile and rarely face dangers on the ice. Their safety can be attributed to three factors: their size, the habi-

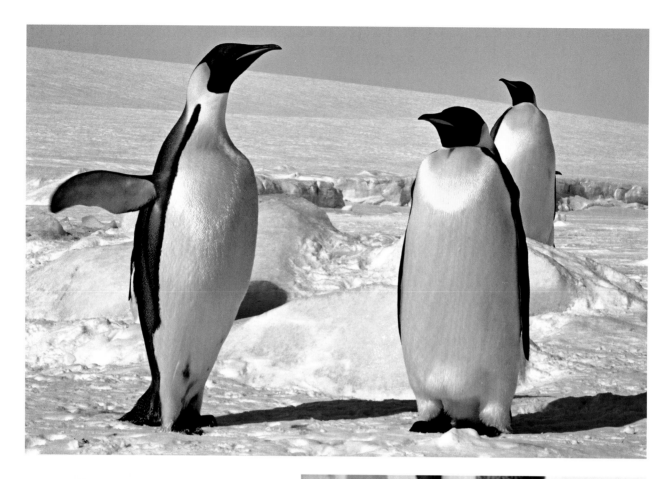

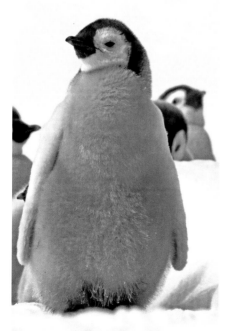

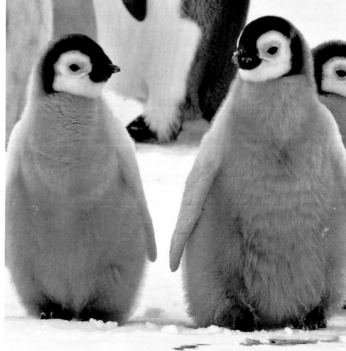

Top :Emperor adults communicating

Right: "Emperor chicks are the most loveable creatures"

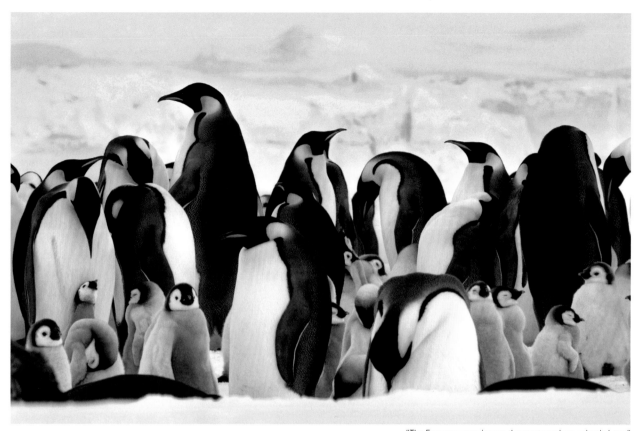

"The Emperor penguins are the most gracious animals I met"

tat, and minimal human contact. The Emperor's size makes it less vulnerable to predators. The habitat (on ice) where Emperors colonize is so remote and far from the water that almost no other living animal, except a few birds, will venture there—though giant petrels do take some eggs and small chicks, mostly from less experienced breeders.

Most Emperor breeding failures are actually caused by their fellow penguins: either a mate's careless transfer of the egg, or when a disgruntled neighbor's aggressive action slides or breaks the egg.

The biggest danger the Emperors face is the melting of the ice shelf around Antarctica as global warming continues to advance. Without the ice to breed on, no one can say what will happen to the Emperor breeding cycle and whether the species will adopt a different breeding behavior or slowly disappear.

Conservation Efforts

Emperors do well on their own and researchers Source them extensively, so in the future we will be able to help them when they need us. Emperors are not currently high on the list of species in need of assistance and conservation efforts. Nevertheless, the very real threat of fast-melting Antarctic self ice makes any conservation effort that reduces global warming a direct benefit to the Emperors.

Interesting Research

Emperor huddles are unique and baffling; scientists have long been puzzled at how emperors manage to fast for very long periods, yet still maintain enough energy to keep their bodies' temperature inside the critical zone and to survive the extremes their habitat presents.

A group of scientists, including Ancel, Gi lbert, Robertson, Le Maho, and Beaulieu, have spent several winters in Pointe Géologie, Dumont d'Urville, in Terre Adélie writing several research papers about the huddles. The research group noticed that Emperors resorted to two different types of huddles. The first, the "loose" huddle, is when the birds cover each other's backs but stay at a density of about three birds per ten square feet (0.9 m²). At this density the penguins did not touch each other and only received wind protection. The second, the "tight" huddle, is characterized by a much higher density of up to eight birds per ten square feet (0.9 m²), which causes each bird to actually touch its neighbor and transfer body heat.

Many penguins were fitted with measuring devices, and it was determined that temperatures, not wind, triggered the huddle and influenced the type used. Temperatures of 14°F (-10°C) caused a loose huddle to form. If the temperatures fell farther, to about −11.2°F (-22°C), the birds formed a tighter huddle, allowing heat transfer from one penguin to another. It was calculated

that a tight huddle could save 25 percent of the energy needed by Emperors to survive the extreme cold. This energy savings increases their ability to endure their fasting period and continue incubation until the chick hatches.

Wind was determined to influence the direction of the huddle movement. After the birds tried first to use an ice-hill or iceberg to form a natural barrier against the wind, they turned their backs to the wind and formed a protective huddle. However, high wind in warmer temperatures did not cause Emperors to begin forming a huddle.

The researchers also tried to discern why mates do not lose each other during the chaotic huddle. There is no doubt that most penguin species use their nest location as a recognition aid, but since Emperors do not have nests and are constantly in motion during huddles, recognizing their mate is considerably more difficult. If this lack of a nest were not vexing enough, Emperor pairs only exchange vocal calls *before* their bond is formed—which means that they do not use their voices to find one another.

A shortage of breeding males means that unpaired females actively try to attract committed males until the males start incubating. It is believed this is the reason pairs remain silent after the bond is formed and until the female transfers the egg to the male and leaves to forage. So how do pairs keep in touch without voice recognition or a nest to meet at after the huddle?

Results show that the male primarily initiates the pair's entrance into the huddle, and the female just follows along. About 85 percent of the time the mates are lined up, one in front of the other, during the huddle and therefore never lose sight of each other. Researchers concluded that the male Emperor and his mate synchronize their behavior during the huddle and therefore minimize the need to use vocal calls.

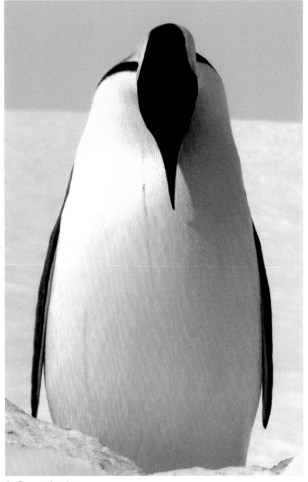

An Emperor bowing

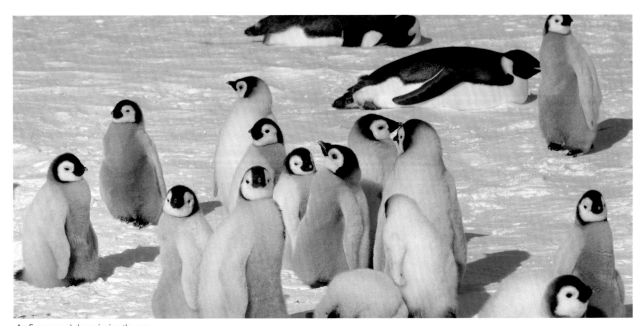

An Emperor crèche enjoying the sun

Charts

Weights	Source 1	Source 2, 3	Source 5
Breeding Male Arrival	80.9 lb/36.7 kg	83.8 lb/38 kg[2]	84.1 lb/38.2 kg
Breeding Female Arrival	62.6 lb/28.4 kg	68.3 lb/31 kg[2]	65 lb/29.5 kg
End First/Long Fast Male	54.5 lb/24.7 kg		50.3 lb/22.8 kg
End First/Long Fast Female	52.9 lb/24.0 kg		50.9 lb/23.1 kg
Premolt Unsexed		50–86 lb/23–39 kg[3]	78.7 lb/35.7 kg
Postmolt Unsexed		35–53 lb/16–24 kg[3]	43.2 lb/19.6 kg
Fledging Chicks	29.8 lb/13.5 kg		
Egg	1.04 lb/0.47 kg	0.9–1.1 lb/0.4–0.5 kg[3]	
Lengths	**Source 1**	**Source 2**	**Source 5**
Flipper Length Male	14.3 in/36.2 cm	11.8–15.7 in/30–40 cm	13.8 in/35 cm
Flipper Length Female	13.7 in/34.7 cm		13.6 in/34.5 cm
Bill Length Male	3.2 in/8.2 cm	3.2 in/8.1 cm	3.2 in/8.1 cm
Bill Length Female	3.1 in/8.0 cm		3.2 in/8.1 cm
Toe Length Male	4.0 in/10.1 cm		3.9 in/10 cm
Toe Length Female	2.8 in/7 cm		4.1 in/10.3 cm

Source 1: Williams 1995—Pointe-Géologie, Antarctica. Source 2: Beaulieu, personal communication (2010)—Adélie Land, Antarctica. Source 3: Kooyman et al. 2004—Ross Sea, Antarctica. Source 4: Groscolas and Cherel 1992—Adélie Land, Antarctica. Source 5: Boersma and Richards 2009—Not Specified.

Biology	Source 1, 2	Source 3, 4	Source 5, 6, 7, 8, 9, 10
Age Begin Breeding (Years)	4–6 (5 Average)[1]	4–5[3]	5[5]
Incubation Period (Days)	65[1]	65[3]	
Brooding (Guard) Period (Days)	45–50[1]	Average 70[3]	40[6]
Time Chick Stays in Crèche (Days)	95–100[1]	Average 70[3]	100[6]
Fledging Success (Chicks per Nest)	0.58–0.7[1]	0.0–0.8[3]	
Mate Fidelity Rate	15%[1]	15–20%[3]	14%[5]
Date Male First Arrives at Rookery	Late Mar.[1]	Late Mar.–Early Apr.[3]	Late Mar.–Apr.[6]
Date First Egg Laid	Early May[1]	Early May[3]	Mid-May[6]
Chick Fledging Date	Late Dec.[1]	Dec.[3]	Mid-Dec.[6]
Premolting Trip Length (Days)	45–60[1]	29–40[3]	22–38[7]
Date Adult Molting Begins	Dec. 1–11[1]	Dec.[3]	
Length Molting on Land (Days)	30–40[1]		37[8]
Juvenile Survival Rate First 2 Years	25–30%[1]		
Breeding Adults Annual Survival	95%[1]	70–95%[3]	95%[5]
Average Swimming Speed	1.8–6.0 mph/2.9–9.7 kmph[1]	2.0–6.2 mph/3.2–10 kmph[3]	4.5 mph/7.2 kmph[9]
Maximum Swimming Speed	7.5 mph/12.1 kmph[1]	8.9 mph/14.4 kmph[3]	6.3 mph/10.1 kmph[9]
Deepest Dive on Record	1476 ft/450 m[1]		1850 ft/564 m[7]
Farthest Dist. Swam From Colony	3000 mi/4828 km[1]		310.7 mi/502 km[10]
Most Common Prey	Silverfish[2]	Silverfish[4]	Krill[10]
Second Most Common Prey	Krill[2]	Squid[4]	Silverfish[10]

Source 1: Williams 1995—Pointe-Géologie, Antarctica. Source 2: Kooyman et al. 2004—Ross Sea, Antarctica. Source 3: Beaulieu, personal communication (2010)—Adélie Land, Antarctica. Source 4: Robertson et al. 1994—Mawson Coast, Antarctica. Source 5: Davis and Renner 2003—Various Locations. Source 6: Jouventin et al. 1995—Adélie Land, Antarctica. Source 7 (First Use): Wienecke et al. 2004—Mawson Coast, Antarctica. Source 7 (Second Use): Wienecke et al. 2007—Auster, Antarctica. Source 8: Groscolas and Cherel 1992—Adélie Land, Antarctica. Source 9: Sato et al. 2005– McMurdo Sound, Antarctica. Source 10: Kirkwood and Robertson 1997—Auster, Antarctica.

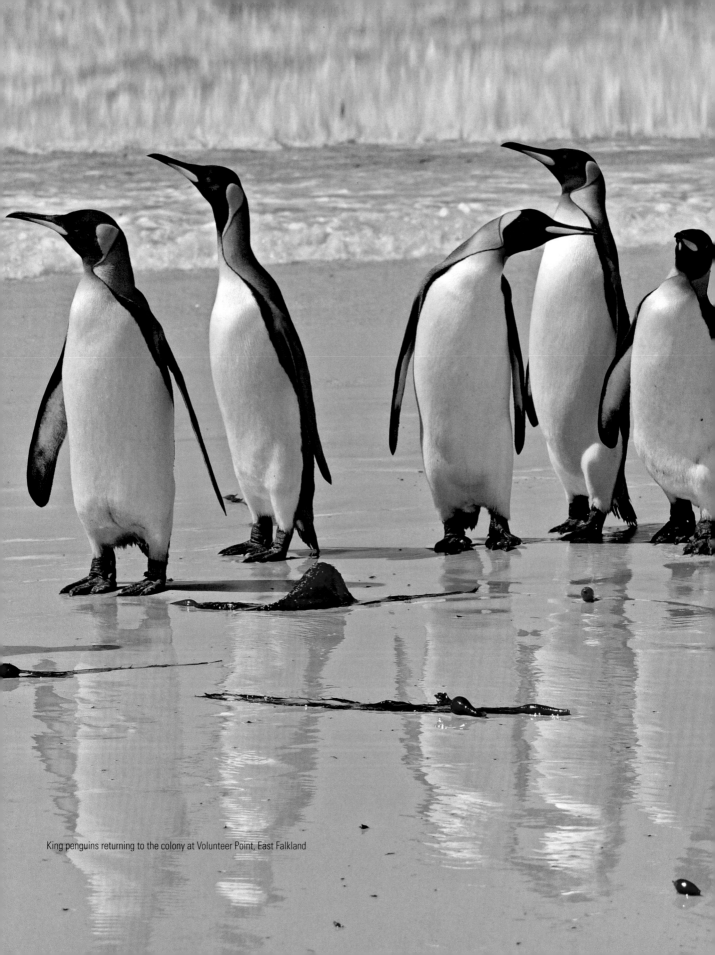

King penguins returning to the colony at Volunteer Point, East Falkland

King Penguin
Aptenodytes patagonicus

Genus: *Aptenodytes*

Other Genus Members: Emperor

Subspecies: *Aptenodytes patagonicus patagonicus,* found in South Georgia and on the Falkland Islands, and *Aptenodytes patagonicus halli,* found on Kerguelen Island, Macquarie Island, Crozet Island, Heard Island, and the Prince Edward Islands

IUCN Status: Least Concern

Latest Population Estimates
Individuals: 4.5 million
Breeding Pairs: 1.7–2.03 million

Life Expectancy
Wild: 20 years on average
Captivity: 30 years or more

Migratory: Most are absent during the winter months, but some adults are always present on land.

Locations of Larger Colonies: Crozet Island, Prince Edward Island, South Georgia Island, Kerguelen Island, and Macquarie Island

Colors
Adults: Dark blue to silver, white, orange, and yellow
Bill: Black and orange to pink
Feet: Black
Iris: Light brown to green
Chick Down: Faded brownish gray at first, then changes via molt to chocolate brown
Immature: Same as adult, but colors are lighter or more faded

Height: 31–35 in/78–90 cm

Length: 33–37 in/85–95 cm

Normal Clutch: One egg

Max Chicks Raised per Pair per Year: 1

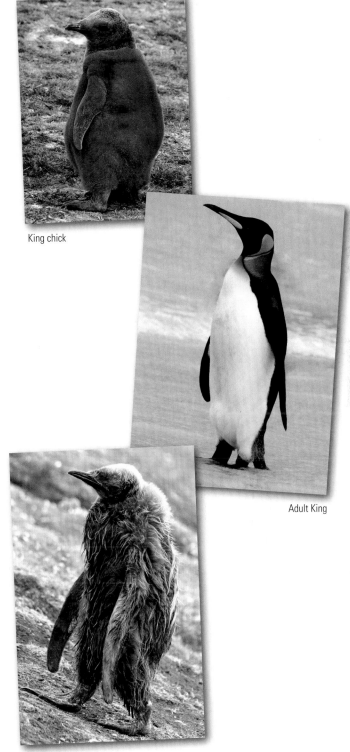

King chick

Adult King

An older King chick

David's Observations

*I*first met the Kings in the Falkland Islands (see Gentoo, chapter 14). King penguins are beautiful and gracious, yet their personalities are full of conflicts. Their courting is the most passionate of all penguins, and their open affection is amazing. Still, they stand packed so close to each other that every movement or call triggers a bill pointing, noisy agonistic call, or even a fight. Kings appear robust and walk with authority, their bills perpendicular to their body, which reminds me of impor-tant businesspeople on their way to work, the yellow on their chest resembling a tie. It is interesting to see how they leave the colony and start walking toward the ocean alone, but by the time they are ready to enter the water, there are surrounded by a group of ten to twenty friendly penguins. No matter how roughly they treat each other inside their colony, they are united on the beach. Being there with them was like visiting a family. I could see it all: love, quarrels, and duties.

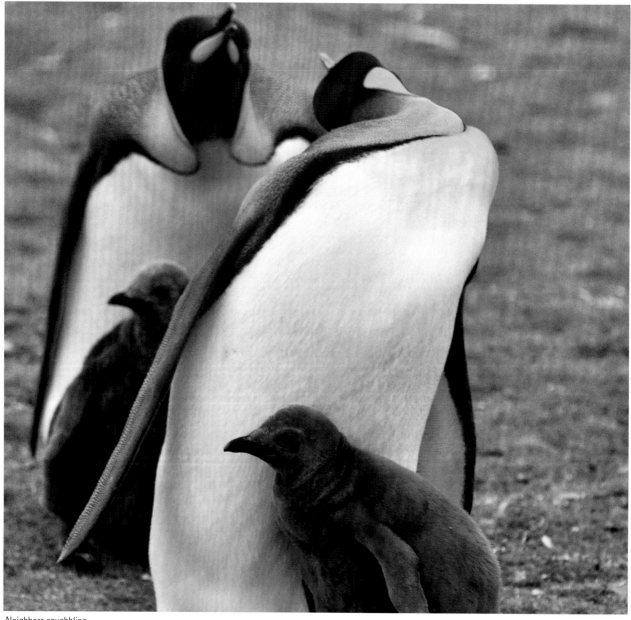

Neighbors squabbling

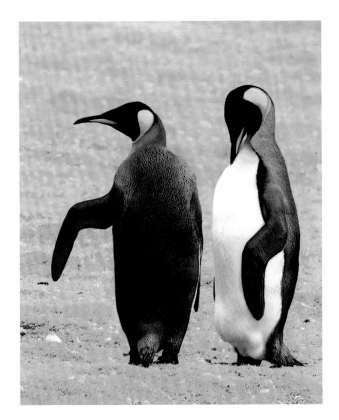

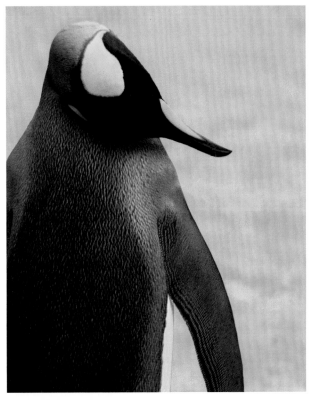

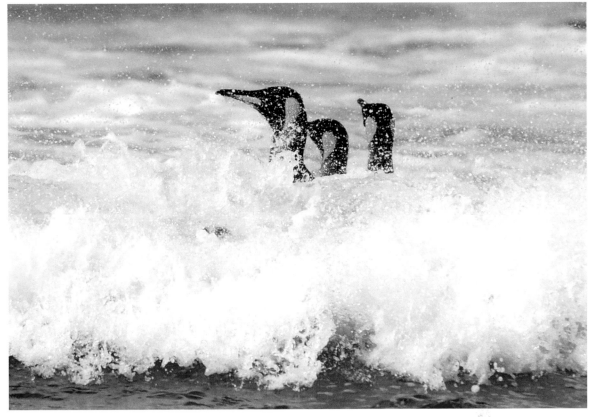

Top left: A pair of Kings bonding

Top right: A King penguin showing off its flexibility

Left: Kings leaving for a foraging trip in the Falkland Islands

About the King Penguin

Population Trend

Holding steady. Studies made by Delord et al. suggest that the King penguins' population at Crozet Island has been rising for the past forty-five years. Other large colonies do not share this trend, implying that colony size is limited to food availability. A third of the King breeding population does not breed at any given breeding season, so it is more difficult to estimate the size of their population than other penguin species.

Habitat

King penguins breed in a range from 45° S to 55° S on islands surrounding Antarctica in the South Atlantic, South Pacific, and South Indian Oceans. Notable rookery locations of this species include: South Georgia Island with 450,000 pairs (South Georgia Management Plan 2002), Prince Edward (and Marion) Island with 225,000 pairs, Crozet Island with 450,000 pairs, Kerguelen Island with 260,000 pairs, Macquarie Island with 70,000 pairs, the Heard Islands, and the easier-to-reach Falkland Islands.

The King penguin's swimming range is immense; it travels vast distances throughout the southern oceans when it is not breeding. A Norwegian group released several Kings in northern Norway in August of 1936, and birds were spotted in the area several times in the 1940s, though none have been seen since 1949. This colorful species is in great demand by zoos and can be seen at SeaWorld in San Diego and Orlando, as well as at zoos in Indianapolis, Detroit, and St. Louis. Elsewhere it can be found in Scotland, Germany, Switzerland, Asia, and Australia.

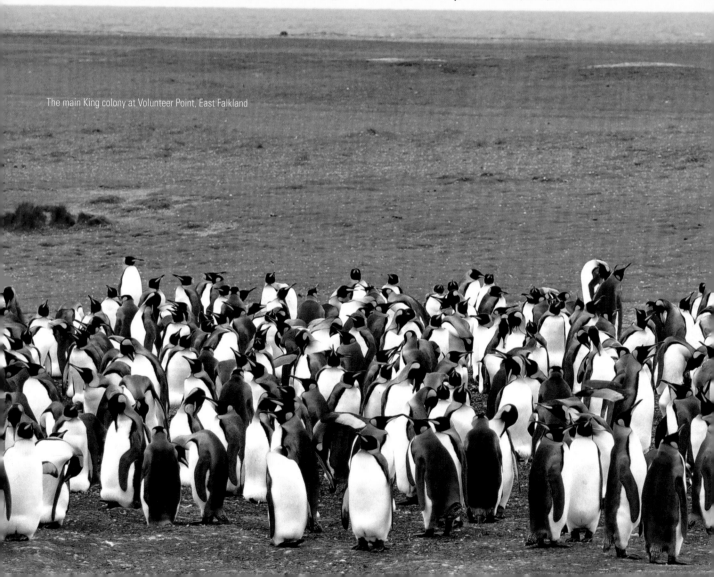
The main King colony at Volunteer Point, East Falkland

Appearance

The adult King penguin is the second largest of all penguin species, and many count it as the prettiest with colors that are more vivid than those of its larger relative, the Emperor penguin. There is little difference between the male and female appearance, although the latter are slightly smaller. The King penguin's back is steel blue to gray in color and the back of its head is black and well-defined from its pale lower back. The patches on the side of the head next to the ears are a striking orange color, which gives the King its royal appearance. The underbody is white and turns from light orange to a bright solid orange going up to the chest. The narrow, curving bill is black with an elegant orange line on the lower mandible, and the bill is the longest of any living penguin. The feet are mostly black, and the flippers are black on the outside and mostly faded white on the underside.

Immature Kings are similar to adults, but their orange patches are much paler, as is the orange line on their bills. At the age of three they begin sporting adult plumage.

Chicks

King chicks are almost naked when born and remain on a parent's legs for ten days after birth to keep warm. Soon they grow a thick down, faded dark gray in color, which helps them regulate their own body temperature. Later their down color changes to a chocolate brown, and they continue to wear that down throughout the harsh winter. At about thirty to forty days of age, chicks move into a crèche. During their first days in the crèche, the young chicks benefit from both parents shuttling food. As the chicks gain weight and winter sets in, both parents disappear, leaving the young chicks to fend for themselves in the crèche for several months.

It has always been assumed that the crèche provides a safer environment for the chicks than being alone because it is easier for them to defend themselves in numbers against skua and giant petrels. It turns out that the crèches only help the stronger chicks against predation. Larger chicks try to make their way to the center of the group. The closer to the center they are, the

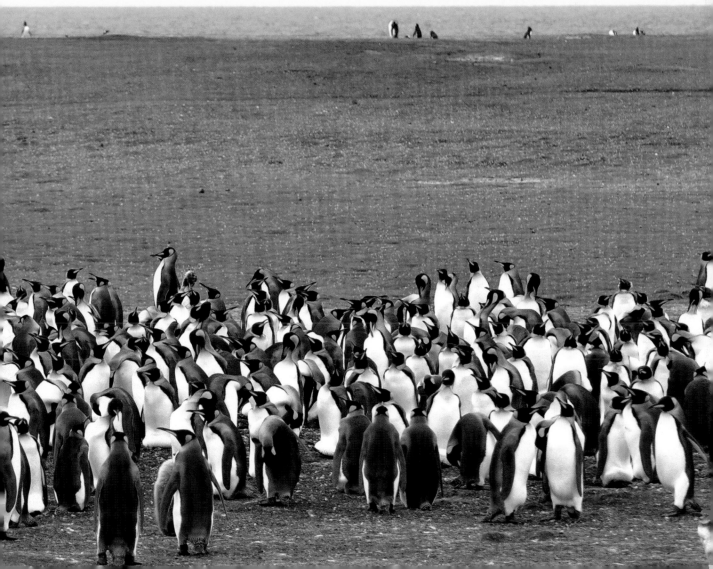

better protection they receive from attacking birds or treacherous weather. As the weather worsens, the size of the crèches tends to increase, as does the number of fights. During times of extreme cold, the King's crèche utilizes a strategy that resembles the huddle of the Emperor penguins to increase chances of survival. However, it lacks order or courtesy. Their crèche favors the stronger, larger chicks and seems to sacrifice the smaller, weaker ones.

King chicks take the longest to fledge, and surviving hunger and severe weather alone is difficult for them. Unfortunately, only chicks that hatch before February have a chance to gain the necessary twenty-five pounds (11.3 kg) of weight that allows them to survive the winter (Cherel and Le Maho 1985). The survival rate for those born later is almost zero. After their parents return, the chicks quickly recover the weight they lost over winter, shed their down, and fledge.

Breeding and Chick Rearing

The King's breeding cycle is the longest and most complicated of all the penguin species, lasting from thirteen to fourteen months. As a result, King Penguins might try to breed twice every three years instead of yearly, and a vast majority of breeding adults will have one successful and one failed breeding cycle every two years.

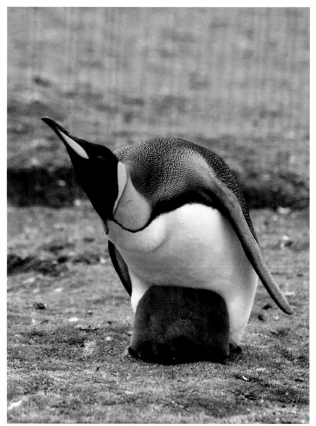

Too big to fit in the pouch

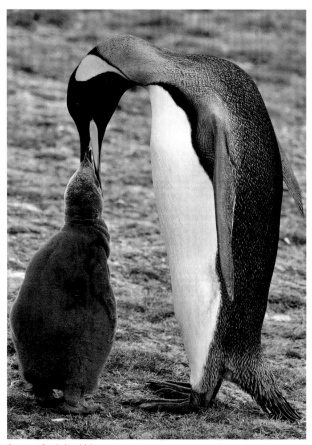

A parent feeds its chick

Researchers divide this breeding pattern into two cycles, A and B. During Cycle A, in South Georgia, they begin mating in late October; however, couples who breed in Cycle B may not begin courting until March. Such a mating schedule leaves some adults at the colony year round. Cycle B chicks rarely survive to fledge (Olsson 1996), and if they do they are usually underweight and perish shortly after entering the water. Breeders that just breed once every two years (skipping Cycle B) are more productive. It is not known why some parents breed during Cycle B when they could wait a few months and have a much higher chance of successfully fledging a chick. It was suggested that the parent's investment in Cycle B is not as large as in Cycle A.

King Penguins lay one white to pale green egg. It is soft at first but hardens within days. They do not keep a nest, so the egg is secured on a parent's legs and covered by a skin pouch. Parents take fourteen- to sixteen-day turns holding the egg while the other parent forages. After hatching and during the guard phase, the chick hides within the skin pouch of their parent. This lasts for five to six weeks. If the parent has food, they will shove a fish into the chick's throat as it opens its mouth and tilts its head back. As the chick calls for food, neighbors begin to point bills at each other, and the chick must feed in the middle of a noisy commotion.

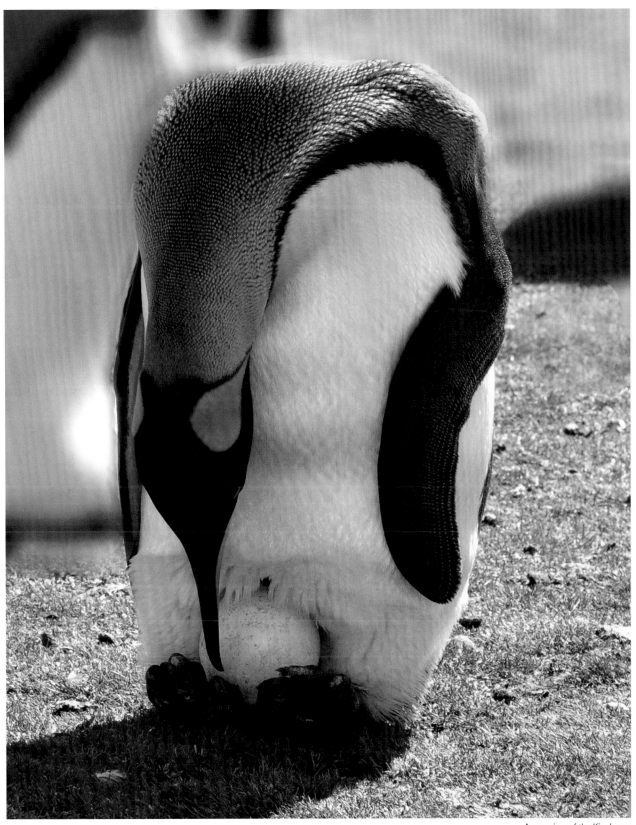

A rare view of the King's egg

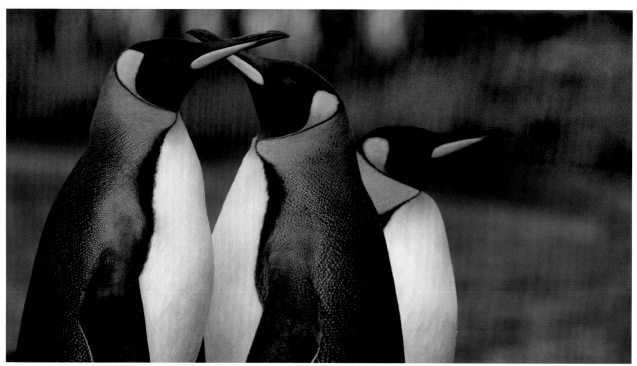

"King penguins are beautiful and gracious"

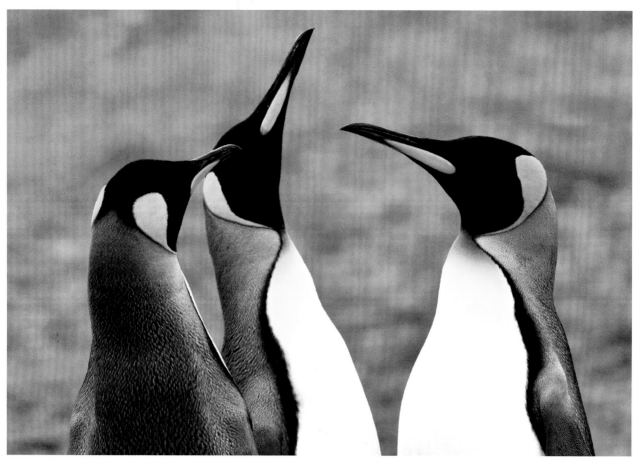

Meeting at the beach on Macquarie Island

As the guard phase comes to an end, chicks join a crèche. In the beginning, both parents return frequently to feed the chick. After a few feedings, the parents disappear, leaving their young chick to fast for months. They return just three to four times during the five-month-long winter, and sometimes neither shows up for three consecutive months at a time. As the weather gets milder, both parents return. They feed the chicks often so they can gain weight quickly and fledge. Fledging success is 0.3 to 0.5 chicks per nest, one of the lowest of any species of penguin (Williams, 1995).

Foraging

King penguins' diet and foraging habits are well documented. They constantly change their routine; they dive shallow at night with little success, then very deep during the day with much better results. Kings often dive deep, unlike their Emperor cousins who prefer shallow dives. The King penguins dive to over 750 feet (228 m) on a regular basis, and the average deep dive lasts five to seven minutes. They swim at an average speed of 5.25 miles per hour (8.4 kmph) (Froget et al. 2004). They forage close to the colony at warmer times, and then in the winter they can swim 1,250 miles (2,000 km) away.

The fish King penguins eat are not all that big, presumably because they possess a narrow beak. They might catch over 450 prey items per day to satisfy their energy requirements. They also must have a speedy stomach to digest them all (Pütz and Bost 1994). Kings prefer smaller fish, mainly lantern fish, but downgrade to squid (cephalopods) when necessary. Unlike most southern ocean predators, this species avoids krill most of the time. Still, if nothing else is available they may prey on crustaceans as a last resort. Their energy needs are gigantic and their calendar is very demanding, so they try to satisfy those needs as quickly and efficiently as possible, by whatever means available.

When caring for a chick, a King must ingest approximately 4.8 pounds (2.2 kg) of food per day just to maintain body weight at sea and replenish the energy needed to dive. An extra 1.3 pounds (0.6 kg) per day is required to gain lost weight, allow for body-building, and restore lost reserves. This does not even include the food needed to feed a hungry chick. During the chick-rearing period, a King must consume seven to eight pounds (3.2–3.6 kg) of food each day to meet all these needs (Halsey et al. 2007).

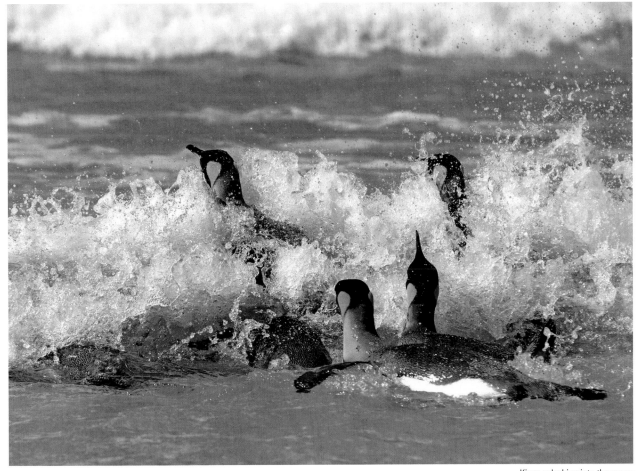

Kings splashing into the ocean

Molting

Unlike any other species, King penguins molt before breeding and not after. Because they breed in two cycles over three years, they may molt at a different time every other year. After the long winter foraging trip, the Kings that did not breed the summer before, those that had a failed nest, and those that are younger land on shore to begin molting. The successful breeders' molting schedule is contingent upon their chicks' development and may occur in December, January, or another summer month (in the Southern Hemisphere, the seasons are the opposite of the Northern Hemisphere).

The duration of molting varies, like most other King characteristics. An average molt on land lasts eighteen to twenty-nine days, with some molts lasting up to thirty-two days, depending on the month in which it occurs. Feather loss starts four days after landing, on average. Weight loss is massive and can easily exceed 50 percent of a King's premolt weight, which consists mainly of fat. After the molt they depart for a two- to three-week recuperation trip and return to breed again.

Nesting

Kings, like their cousins the Emperors, do not utilize nests. Instead, they keep the egg or young chick atop their feet and cover it with a protective pouch of skin. Even though they have no nest, they are territorial. While breeding, they remain in a specific five-square-foot (0.46 m²) radius at the rookery as if guarding an invisible nest. They protect the egg and the chick on that specific piece of land, and the male partner even tries to return to that same spot during the next breeding cycle. Territory is very important to Kings, and they defend their space aggressively. They breed very close to each other, and each colony contains thousands of pairs, sometimes even hundreds of thousands.

Relationships

King penguins fight often. They forget about their chicks for months and rarely stay with the same breeding partner. Divorce rates are upward of 80 percent (Olsson 1998). Disturbances between guarding adults are endless and consume a great deal of energy and time. The entire breeding season resembles one huge never-ending brawl between hundreds of pairs of adults sitting on their eggs and chicks. Each adult returning from sea must pass hundreds of other adults with almost no space in between. Until it reaches the location of its mate and chick, nearly every penguin it passes points its bill at the returning adult.

Furthering their perplexing image, King penguins are also the most romantic of all penguins and can spend days courting.

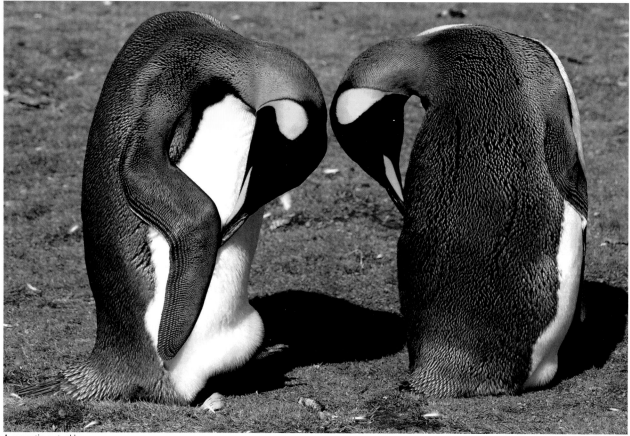

A romantic mutual bow

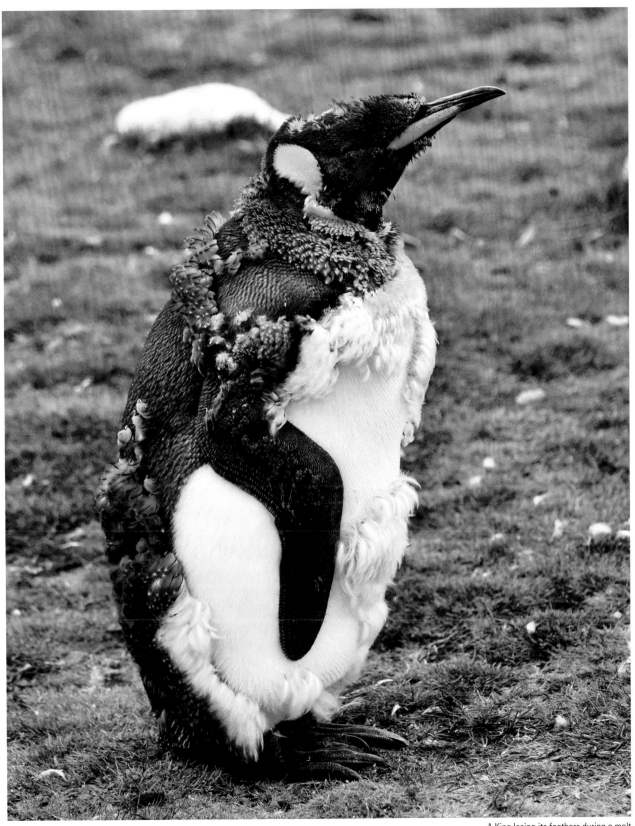

A King losing its feathers during a molt

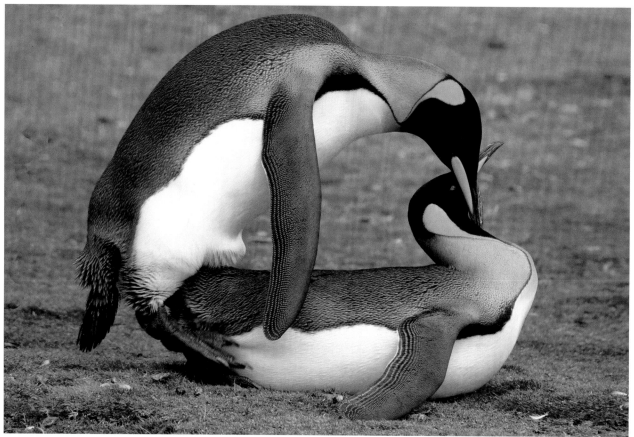

A pair of Kings copulating

Their fights subside as they approach the sea, where they appear very peaceful and united.

Courtship begins with ecstatic displays as males point their bills upward and raise their flippers to entice a mate. The female responds with a head shake if she reciprocates, and then both shake their heads vigorously in unison. To impress his mate, the male walks as he swings his head from side to side. The female bows to her mate, and then both birds bow to each other, sometimes for hours. The King penguin's grace and beauty is magnified by displaying a bowing posture with the head turned downward and to one side.

Individual males do try to return to the same general area where they bred the prior year, and if they are not able to do so, they try to stay at the same elevation, at the very least. All male rituals and calls aside, it is the female that chooses a mate. Early arriving females, which have a greater chick survival rate, tend to choose heavier males with more color pigments, especially ultraviolet, in their bill (Dobson et al. 2008).

King penguins share islands and mix socially with other penguin species such as Gentoo, Magellanic, and Royal penguins. When crossing paths with penguins of another species they walk around with their heads up, not really showing much attention or aggression to their smaller family members.

Vocalization

Like Emperors, King penguins also possess a dual voice system. The combination of the long and short wave sounds creates a beautiful voice with great spectrum and variety. The variety is needed for mates to recognize each other and for parents to identify their chicks. Voice recognition is believed to be the main tool used during the fourteen-month breeding cycle, in which gaps last for months where mates do not see each other or their chick. To make contact with one another, they move their heads straight upward while sounding out a loud call for about a half or full second. Sexual calls are very long and involved and utilize both voice systems, resulting in a beautiful song.

Chicks call by whistling a variable-scale song. Each chick uses a distinct call and parents usually answer with a song of their own, and as the replies continue, the duet may last for a while.

Agonistic calls are short trumpeting sounds accompanied by nervous head movements and bill pointing directed toward the opponent. After this initial warning, the King will then lower its bill to shoulder level and move its head in a circle, ending with a peck at the opposing bird. Often, they move their heads and bills without even sounding a call, because their body language says it all.

Dangers

The King penguin's predators at sea are leopard seals and killer whales; however, losses at sea are low compared to those of other species. On land, seabirds like skua, giant petrel, and sheathbill attack and pick off the weaker chicks during the days of their fast, or they attack injured, dying penguins.

Kings are fairly durable and know how to stay out of harm's way, so the biggest losses are among chicks left for months alone at the colony during the winter without food. Nature seems to be on the King penguin's side, and despite the low survival rate of the young, the population trend of the King penguin is one of the healthiest of any penguin species.

Conservation Efforts

Kings are a favorite of researchers, and scientists are interested in gaining a better understanding of their habits and shortcomings, as well as of other penguins. Researchers hope to learn about their needs and threats and influence the public and government to find ways to prevent harm to these beautiful birds. Because King penguins are out of man's reach for the most part, not many conservation projects are needed as long as the global warming pattern doesn't escalate. One exception to this trend is Macquarie Island, where the Australian government just began an expensive project to eradicate the rabbits introduced by settlers, sealers, and penguin killers in the past. The government is trying to restore the island to what it once was, at great cost, to enhance quality of life for the penguins and other species living there.

Interesting Research

King penguins are at the center of penguin research, and with GPS technology it is now possible to locate penguins during their long foraging trips. The King's life on land is well-studied and easy to observe. However, underwater behavior is very difficult to source, and to answer questions about underwater life without the ability to physically observe Kings, researchers must devise indirect, imaginative studies.

Researchers Pütz and Bost installed a measuring device inside a King's stomach. To do this they force-fed the penguin a self-contained device that included a temperature sensor, clock, and other recording tools. The penguin was then tagged and set free with the device inside its stomach. The tagged penguin dove and caught fish, and when it returned, they flushed its stomach to recover the device and analyze the data stored on it, along with any remaining food contents. The main theory behind this source is that because fish are cold-blooded, their cool body temperatures would slightly drop the temperature of the penguin's stomach when they are consumed. Therefore, every time the penguin swallowed a fish, the measuring device inside the stomach would record a slight temporary lowering of the stomach temperature. The bigger the fish consumed, the lower the temperature would temporarily drop. The results found were just as interesting as the method used to obtain them. The source showed that Kings prefer to hunt during the day, contrary to previous studies, and it was estimated that they ate a whopping eight pounds (3.6 kg) of fish daily. Also surprising was the King's prey preference for small fish, rather than larger fish as previously suspected.

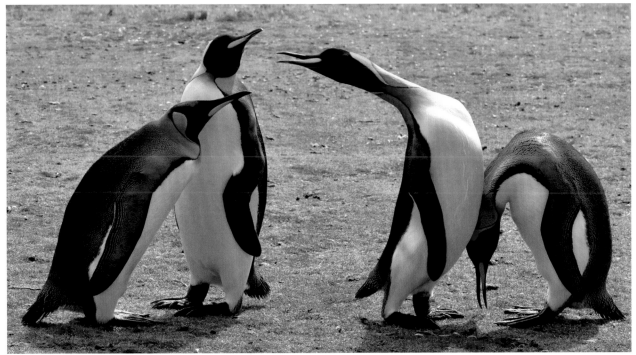

Two pairs of King penguins fighting

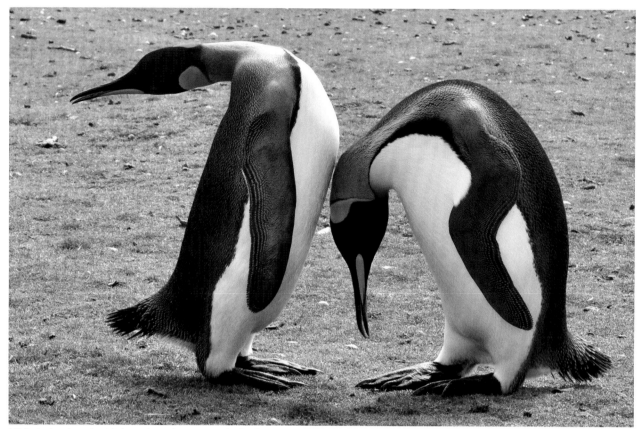

While the female on the right bows, her male counterpart fends off an intruding neighbor.

Kings fight tough and often, and two different approaches have been documented when sourceing their territorial fights.

The first, "Aggressiveness in King Penguins in Relation to Reproductive Status," was written by Cote in 2000. In his source, Cote shows that the more central breeding locations require the most energy and fights to defend them; presumably more energy is spent for a better anticipated outcome (fledging success). Also, as the parents move forward in their breeding cycle they become more invested and fight harder to protect their offspring and territory. The Central Location Breeding Theory states that colonial birds, like penguins, prefer central locations because they afford the best chances of breeding success. Cote's source concludes that fights grow more intense toward the center of the colony because this is where the best breeding location exists. Cote did not source survival rates of chicks, as he just assumed that the Central Breeding Theory is accurate. Instead, he suggested that further research might be necessary to connect those fights to a specific outcome and probably missed the main point.

In 2009, Descamps, Le Bohec, Le Maho, Gendner, and Gauthier-Clerc picked up where Cote's source left off. In their paper "Relating Demographic Performance to Breeding-site Location in the King Penguin," they revealed something that could teach many scientists (including Cote) an interesting lesson. They chose to ignore past assumptions and added a new parameter to their research. Instead of just measuring mortality rates of chicks by location alone, they also measured mortality rates by hatching date.

Kings lay their egg in different months over long periods of time, which differentiates them from most other penguins. Descamps et al. (2009) aimed to understand what, if any, effect a chick's hatching date has on its chances of survival. They found that the date Kings lay their eggs is far more important to their chicks' survival than the location where they lay. For chicks born on the same dates, survival rates were almost uniform in all locations throughout the colony.

According to Descamps, early breeding is directly correlated with successful breeding with regard to King Penguins. More experienced, older birds show up early and claim a spot directly in the then-empty center. They are more successful breeders because they are early, not because they are in a central location. As for the Central Location Breeding Theory, it seems to apply to other birds, not Kings. Cote's argument that central location needed to be further studied was correct, not because his findings about the intensity of the fights support previous theories, but because they prove the opposite. After Descamps' source, no one is sure why King penguins fight so much over territory. Perhaps it's just the way of Kings.

Charts

Weights	Source 1, 2 (*halli*)	Source 3 (*halli*)	Source 4 (*patagonicus*)
Begin Breeding Male	30.0 lb/13.6 kg[1]	32.4 lb/14.7 kg	35.3 lb/16.0 kg
Begin Breeding Female	26.0 lb/11.8 kg[1]	28.7 lb/13.0 kg	31.5 lb/14.3 kg
Premolt Male		41.2 lb/18.7 kg	40.8 lb/18.5 kg
Premolt Female		37.7 lb/17.1 kg	36.2 lb/16.4 kg
Premolt Unsexed	36.8 lb/16.7 kg[2]		
Postmolt Male	21.2 lb/9.6 kg[1]	23.4 lb/10.6 kg	29.8 lb/13.5 kg
Postmolt Female	19.2 lb/8.7 kg[1]	21.6 lb/9.8 kg	25.6 lb/11.6 kg
Fledging Chicks	19.8 lb/9 kg[2]		
Egg	0.67 lb/304 g[2]	0.6–0.7 lb/272.2–317.5 g	0.7 lb/317.5g
Lengths	**Source 1, 5 (*halli*)**	**Source 2 (*halli*)**	**Source 4 (*patagonicus*)**
Flipper Length Male		14.2in/36.1 cm	13.5 in/34.3 cm
Flipper Length Female		13.8in/35.1 cm	13.0 in/33.1 cm
Bill Length Male	5.0 in/12.7 cm[1]	4.9in/12.4 cm	5.4 in/13.7 cm
Bill Length Female	4.7 in/11.9 cm[1]	4.7 in/11.9 cm	5.1 in/13.0 cm
Foot Length Male			7.3 in/18.5 cm
Foot Length Female			7.0 in/17.8 cm
Foot Length Unsexed	6.7 in/17.0 cm[5]		

Source 1: Gauthier-Clerc et al. 2001—Possession Island, Antarctica. Source 2: Williams 1995—Crozet Islands. Source 3: Olsson, personal communication (2010)—Unspecified. Source 4: Stonehouse 1956—South Georgia Island. Source 5: Halsey et al. 2007—Possession Island, Antarctica.

Biology	Source 1	Source 2, 3, 4	Source 4, 5, 6, 7, 8
Age Begin Breeding (Years)	Most 5+		2–8[5]
Incubation Period (Days)	51	54–55[2]	
Brooding (Guard) Period (Days)	30–40	38–44[2]	31[5]
Time Chick Stays in Crèche (Days)	270–350	290–350[2]	
Fledging Success (Chicks per Nest)	0.3–0.5	0.65[2]	0.36[6]
Mate Fidelity Rate	Less Than 20%		22%[7]
Date Male First Arrives At Rookery			
Date First Egg Laid	Not Fixed	Nov.–Dec./Mar.–Apr.[2]	Nov.[6]
Chick Fledging Date	Sept.–Oct.	Late Dec. and Feb.[2]	Dec.[6]
Premolting Trip Length (Days)	20–30	14–21[2]	
Date Adult Molting Begins	Sept.– Feb.	Sept.–Mar.[2]	Oct. 17[6]
Length Molting on Land (Days)	18–29	30–34[2]	22–31[5]
Juvenile Survival Rate First 2 Years	40% or less	83%[3]	40.3–50.1%[5]
Breeding Adults Annual Survival	70–98%	97.7%[3]	90.7–95.2%[5]
Average Swimming Speed	5–6 mph/8–9.7 kmph	4.7 mph/7.6 kmph[4]	3.4 mph/5.5 kmph[8]
Maximum Swimming Speed	6.7 mph/10.8 kmph	6 mph/9.7 kmph[4]	7.6 mph/12.2 kmph[8]
Deepest Dive on Record	1130 ft/344.4 m	997.4 ft/304 m[4]	Over 984.3 ft/300 m[8]
Farthest Dist. Swam From Colony			1391.3 mi/2239 km[7]
Most Common Prey	Myctophid Fish	Cephalopods[2]	Myctophid Fish[4]
Second Most Common Prey	Gempylidae Fish		Nototheniidae Fish[4]

Source 1: Williams 1995—Crozet Islands. Source 2: Stonehouse 1956—South Georgia Island. Source 3: Olsson 1996—South Georgia Island. Source 4: Kooyman et al. 1992—South Georgia Island. Source 5: Weimerskirch et al. 1992—Possession Island, Antarctica. Source 6: Descamps et al. 2002—South Georgia Island. Source 7: Bried et al. 1999—Possession Island, Antarctica. Source 8: Culik et al. 1996—Possession Island, Antarctica.

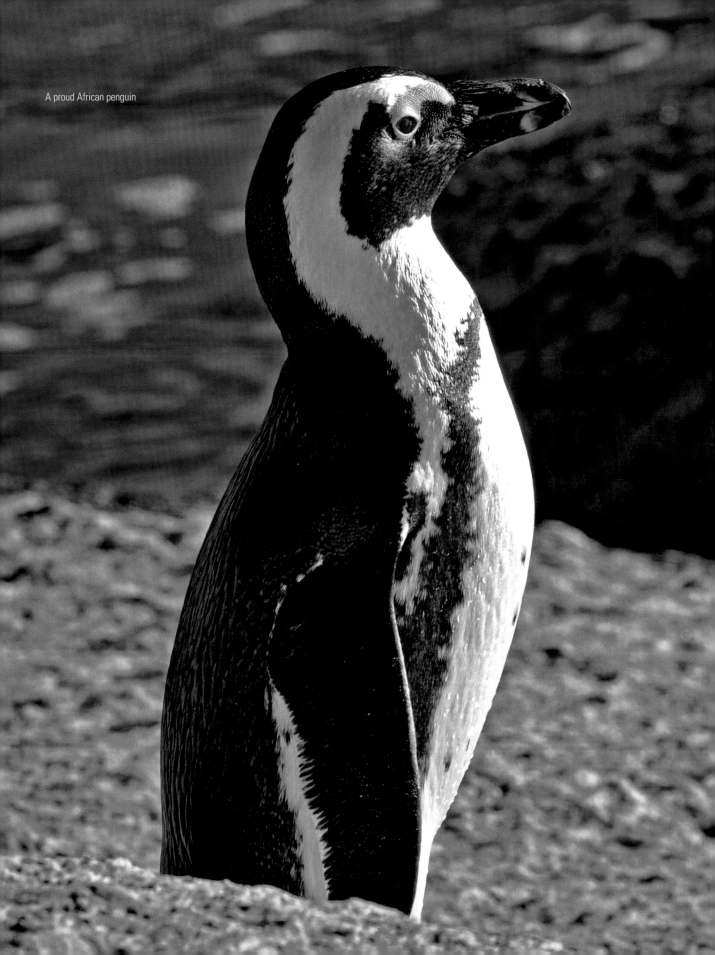

A proud African penguin

African Penguin
Spheniscus demersus

Genus: *Spheniscus*

Other Genus Members: Magellanic, Humboldt, and Galapagos

Subspecies: None

IUCN Status: Endangered

Latest Population Estimates
Individuals: 70,000
Breeding Pairs: 26,000

Life Expectancy
Wild: 10–12 years on average, longest recorded 27 years (Whittington et al. 2000)
Captivity: 25 years on average, longest recorded 39 years (New England Aquarium)

Migratory: No, they are a sedentary species.

Locations of Larger Colonies: St. Croix Island, Dassen Island, Robben Island, and Boulders Beach, South Africa; Mercury Island, Namibia

Colors
Adults: Black, white, and pink
Bill: Black with a gray ring
Feet: Black with pink or white patches
Iris: Dark brown or gray
Chick Down: Brown to gray
Immature: Gray to black, dirty white

Height: 24–27 in/61–69 cm

Length: 27–28 in/68–72 cm

Normal Clutch: 2 eggs per nest

Max Chicks Raised per Pair per Year: 4

The African penguin is also known as the Jackass or Black-Footed penguin.

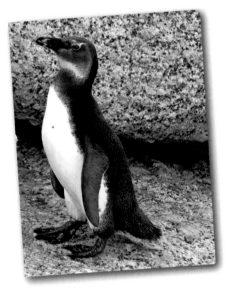
Immature African

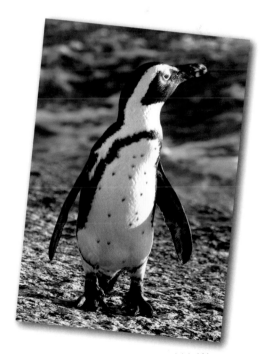
Adult African

David's Observations

*V*isiting the African penguin colony in Boulders Beach, South Africa, I got the impression of a very relaxed, peaceful, and happy penguin. During my visit, the fights that I had so commonly seen when visiting other penguin species appeared to be rare among the Africans. The hunger that was also very visible in other species was similarly not an issue; it must have been a good food year for them.

Their community ties are reinforced every morning as the penguins join each other in a long line and head to the beach, waddling along in groups of twenty to forty. They pass by human onlookers and at times stop, as if to pose for a photo. The most amazing experience was watching them go through their early morning ritual of preening before entering the water together.

African Penguins begin swimming just after sunrise and tend to return just before sunset. When they reach the edge of the water, they let a tall wave sweep them into the ocean. After a minute or two of submersion, sometimes they have a change of heart and jump right back onto the rock above. They then spend about twenty more minutes preening, warming up, and getting ready. As the time to enter the water again nears, they get very excited and push one another toward the edge of the rock and into the waves. Again, they wait for a big wave to take them into the water, but this time they immediately disappear beneath the water like torpedoes, leaving behind a white trail of bubbles or a juvenile who at the last moment decides to remain ashore. The journey home is much less dramatic. The Africans, their stomachs full of food for their offspring, take only a few minutes to dry off and begin their quick walk back toward their nests.

It is heartbreaking that the vigorous impression I got from the happy colony at Boulders Beach is contrary to the actual dire state and real extinction danger of the African penguins in the wild.

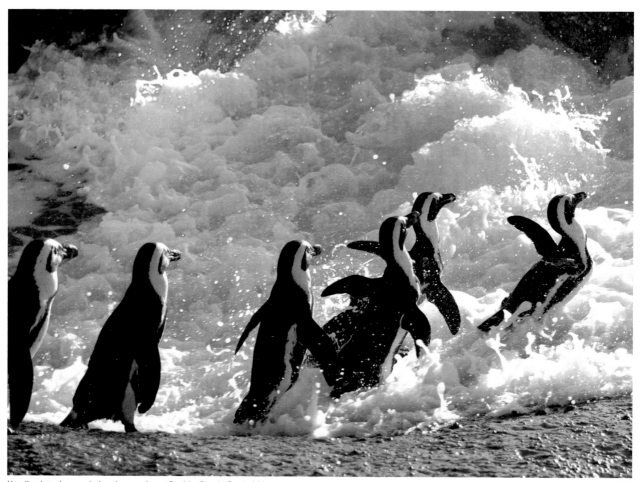

Heading into the sea during the morning at Boulder Beach, South Africa

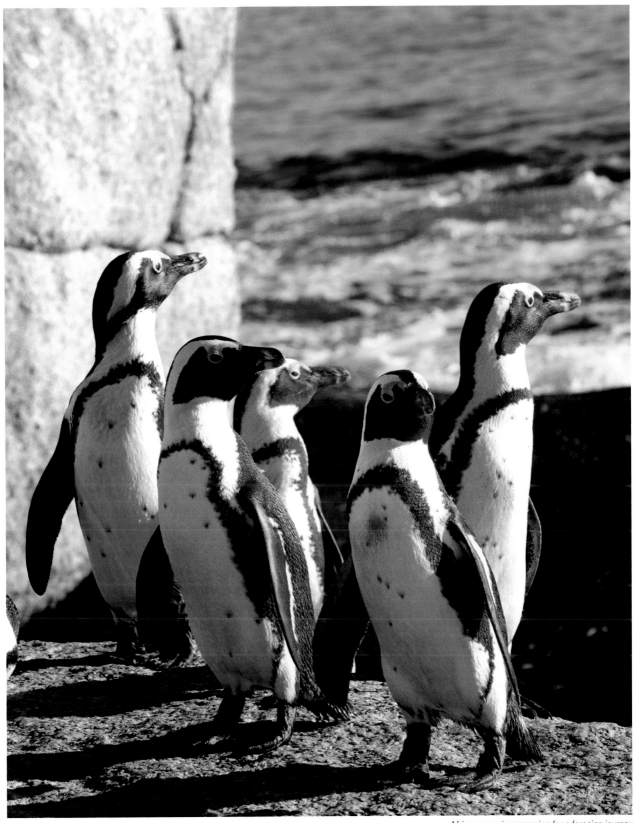

African penguins preparing for a foraging journey

About the African Penguin

Population Trend

Alarming decline. The 2009 population estimates of 26,000 breeding pairs marks a catastrophic decline from 57,000 pairs in 2004–2005 and 1.3 million individual birds in 1930 (IUCN 2009; Crawford 2007). It is hard to count African penguins because their breeding is spread out year-round, and many breed twice a year. However, researchers have improved their methods and have spent much time to ensure a precise count.

The most disturbing statistics come from Dassen Island, where it was estimated that the 1.45 million African penguins in adult plumage who lived there in 1910 have been reduced to about 55,000 as of the year 2000, and have been declining ever since (Wolfaardt et al. 2009b). Matching life expectancy charts with breeding success at Robben Island sadly concludes that more Africans die each year than are recruited as new breeders, which explains the population decline (Crawford et al. 2006). If this trend continues, the African penguin could become extinct in the wild within the next fifty years.

Habitat

As their name suggests, African penguin colonies are on the southern edge of Africa and nearby islands. They breed on both sides of the Cape: on the west side (Atlantic Ocean) they are found as far north as Hollams Bird Island at a latitude of 24°50' S, while on the east side (Indian Ocean) they reach a latitude of 33° S.

There are twenty-nine known breeding sites on islands like Saint Croix, home to the biggest colony, and Dassen Island, an-

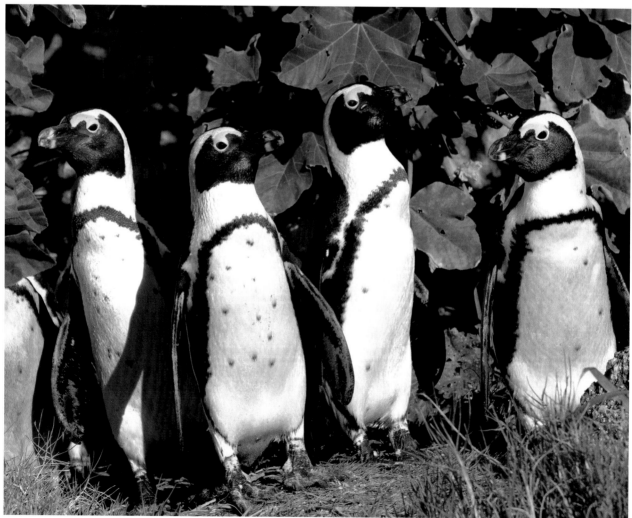
Africans grouping together on the way to Boulder Beach

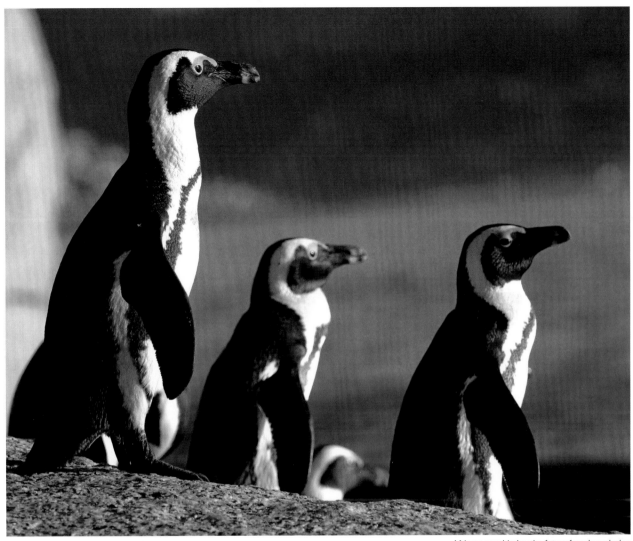

Africans considering the future foraging mission

other large colony, as well as on Dyer, Mercury, Ichaboe, Possession, Halifax, Robben, Sinclair, and Marcus Islands. There are also colonies on the mainland of Namibia, as well as on the mainland of South Africa. The most famous breeding ground is at Boulders Beach, some twenty miles south of Cape Town. At Boulders Beach the friendly penguins feel they are part of the oceanfront development.

African Penguins adapt well to captivity. Because they are used to warmer weather than most penguins, their habitat is relatively easy and cheap to construct and maintain in a zoo, which is why they are the most popular and widely exhibited of all the penguin species.

Appearance

The adult African penguin, like its fellow *Spheniscus*, is characterized by its black and white bands. The back is black and the underbody is mostly white. Its most striking features are its two contrasting bands: one white, which circles the black head to meet the white chest, and the other black, which wraps around the white underbody like an upside down "U."

The head is mostly black, except for an almost perfect semicircle-shaped white band. The white band is broken by a straight black line that extends from the back of the head to meet the bill. The eyes are surrounded by pink patches resembling curved teardrops extending toward the bill. African Penguins also show some black spotting on their chests and other white areas. The number, location, and pattern of these dots vary from penguin to penguin, making it possible to distinguish individual birds. The feet are black, stained with pink to white patches, and have large claws. The flippers are black on the outside with a slight white trim on the leading edge, and on the underside are mostly black with some white patches mixed in. The bill is almost completely black except for a faded white band about a third of the way from the tip.

The immature African is light gray to brown in color on the back, neck, and head, rather than the adult black, with no pronounced bands present.

Chicks

At birth, a chick weighs an average of 0.16 pounds (71.7 g) (Williams and Cooper 1984). The African chick is helpless and cannot even maintain its own body temperature until it reaches the size of about one pound (400 g) at the age of ten to fourteen days (Seddon et al. 1991). The parents cover the chick and shield it from the weather until it can maintain its own body temperature. Within two weeks, the chick's brownish-colored down has fully grown. At the age of four to six weeks, most, but not all, chicks gather in small groups called crèches but still remain inland. Fledging takes place when the chick is about 80 days old, although a few larger chicks may fledge a week sooner. Chicks face two distinct periods of high mortality, the first from age zero to thirty-four days. During this period, especially during the first fifteen days, many chicks die from hypothermia, predation, accidents involving careless parents, and burrow collapse. The second period of danger for the chicks starts at age forty-two days and lasts until fledging. During this period, starvation caused by a parent's inability to feed them is the common cause of death (Seddon et al. 1991). Cooper (1977) estimated that in its first seventy days after hatching, a chick requires about fifty pounds (22.5 kg) of anchovies to reach a normal size and weight.

Breeding and Chick Rearing

Unlike most other penguins, African Penguins do not have a fixed breeding calendar and may breed at any time of the year. Breeding onset peaks from October to December in Namibia, and this period seems to produce the most successful nesting (Williams 1995). A third of the couples even try to breed twice a year, most often after a failed first attempt. In South Africa, breeding onset peaks in April and May but then continues at a slower pace during the rest of the winter.

The female lays two white eggs, usually two days apart. During incubation, the parents take turns sitting on the eggs, alternating daily. Fledging success varies widely by location and season from year to year, depending on the availability of food. A 0.32 to 0.97 (mean value 0.62) chick per year success rate was measured at Robben Island between 1989 and 2004, excluding the disastrous oil spill year of 2000 (Crawford et al. 2006). The St. Croix success rate was measured to be 0.71 chicks per pair, meaning that three out of four eggs laid will hatch, and two out of those three chicks hatched will expire before they can fledge (Randall et al. 1987). Of those that fledge, only one out of two were expected to survive their first year of life. Crawford et al. (2006) showed a direct relationship between the abundance of prey and breeding success; in years where prey was plentiful, mean breeding success was 0.73 chicks per pair, while during the lean years parents averaged 0.43 chicks per pair.

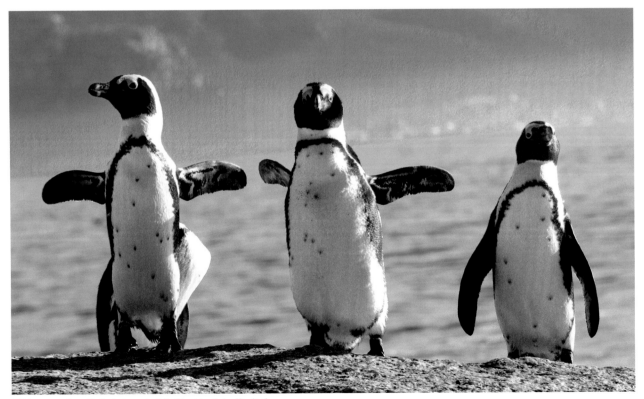

"African penguins with their stomachs full of food for their offspring"

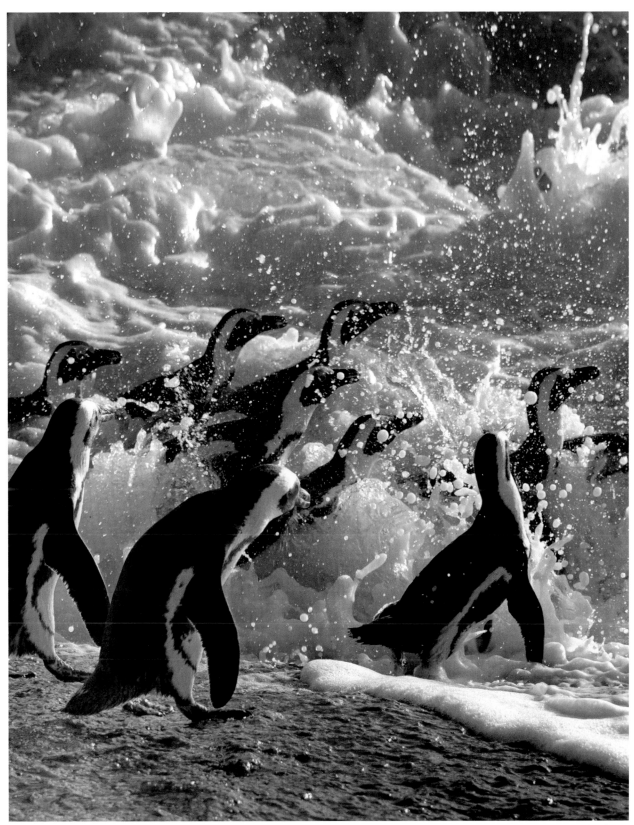

Allowing the waves to wash them into the sea, the Africans leave for a forage

Foraging

African penguins swim in groups, taking advantage of the Benguela Current and its cool temperature, which is rich with fish as far north as the African continent. They prefer shoaling fish like anchovies and sardines, which represent two-thirds of their diet when available. Their energy requirements are substantial. Unfortunately, their primary food source is declining because of commercial fishing, among other reasons.

African adults tend to swim in close proximity to their nests, within twenty-five miles (40.2 km). If food is unavailable, this range will extend up to a fifty-mile (80.5 km) radius. Non-breeding adults and juveniles also stay close to land, generally traveling within a twenty-mile (32.2 km) radius, as they require less food than breeding adults (Wilson 1985). More recent studies resulted in an even narrower range, six miles (10 km) at Dassen Island and twelve miles (18.5 km) at Boulders Beach (Peterson et al. 2006). African penguins rarely dive deeper than 100 feet (30.5 m), though the deepest recorded dive is 429 feet (130.8 m) (Wilson 1985). The average dives, according to Peterson, last 52 seconds in the bay and 48 seconds at open sea, while the longest dive lasted 142 seconds. The longer dives indicate that the penguin is busy catching prey. The African penguin's top short distance speed was 6.3 mph (10 kmph), while its average commuting speed was recorded at 2.7 mph (4.3 kmph) (Peterson et al. 2006). In one recorded journey, a premolt trip which lasted 134 hours, or five and a half days at sea, an African penguin ingested a total of 27 pounds (12.2 kg) of food, averaging 4.8 pounds (2.2 kg) per day.

Molting

Because the African penguin does not follow a regular schedule like most other species, molting can take place at any time of the year, although peaks were observed in December on Robben and Dassen Islands (Wolfaardt et al. 2009a). The intervals between molts can be irregular until the fifth or sixth year of their lives (Kemper et al. 2008). In a colony, the younger and non-breeding birds tend to molt earlier. Premolting and postmolting foraging cycles last between twenty and forty days. While most will return to shore almost nightly during this period, some might not return for up to thirty days. Molting on land lasts about sixteen days. Many birds molt on the beach, taking advantage of the breeze. Detailed counts of molting birds on the beach suggest that many African penguins molt elsewhere on locations away from their breeding colony. Their calendar is so irregular that molting and breeding can be closer together than the time needed for the premolt feeding trip, or the two periods may even overlap, and the molt can start before the breeding cycle comes to an end. The chance of a successful nesting under such circumstances is very low. If a molt occurs too close to or during nesting, the well-being and survival of the adult bird is at high risk.

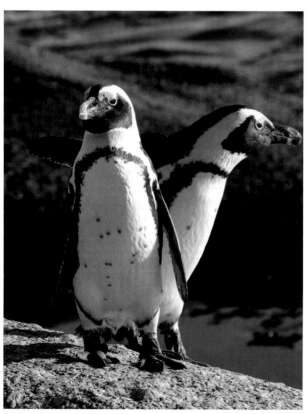

A pair of African penguins

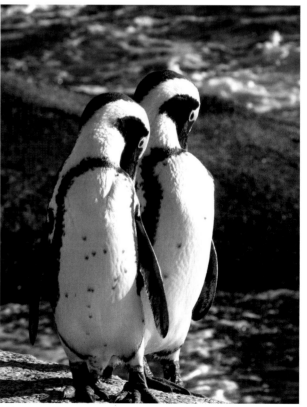

Africans preening

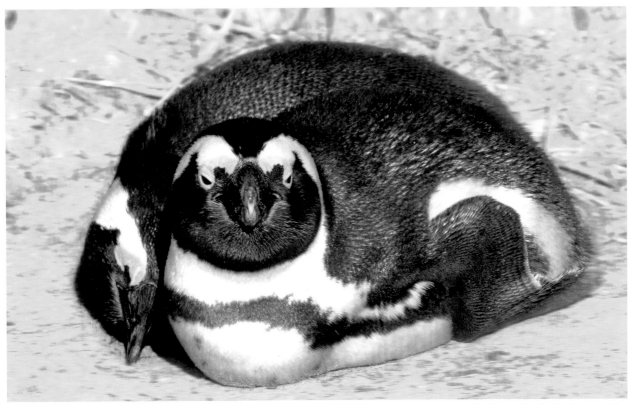

A pair shows its affection for one another

Nesting

Nesting generally takes place in one of two ways: in a burrow, which is usually dug under thick bushes or in the shade of low-branching, leafy trees, or just on the open surface. To construct their nests, the penguins use their nails or flippers to dig into sand, guano, and even under concrete sidewalks.

The African penguin resides in a region with a fairly hot climate, so a successful nesting site requires good shade to protect the chicks from heat stroke and hide them from land predators. When available, nests may also be padded with or surrounded by grass, roots, twigs, and leaves. Nests are typically established about three to six feet (1–2 m) apart. New couples are more likely to be forced into an uncovered location and breed alfresco, which has a lower success rate.

Relationships

The African adult does not leave the colony for an extended period of time, and breeding can start at any time. Therefore, the onset of courting and bonding is not synchronized. In new couples, the male arrives at the nest site first and shows off his assets by moving his bill and flippers to entice a potential mate. The female arrives later and walks around her prospective mate, inspecting him. The mutual displays intensify, some "opera" singing takes place, and the pair starts moving around the colony, though they stay together on the landing area. They move closer

to each other to touch bills and bodies, an affection that lasts the entire length of the breeding and chick-rearing period. Almost all couples return to their same nest and partner each year if both survive (La Cock and Hanel 1987).

Some African Penguins can also be quite aggressive. The young, non-breeding males are particularly hostile, as they do not respect older birds and get into fights.

Penguins in general recognize each other, as well as their chicks, by hearing the other penguin's voice. Seddon et al. (1991) investigated the question "When do chicks develop a distinct enough voice ('peep') that their parents can distinguish them from other chicks?" It was observed that for the first two weeks, a displaced chick positioned inside a foreign nest was not recognized as a foreign chick and was fed as if it was hatched within that nest. Three-week-old chicks, when positioned by the researchers at a different nest, were never fed, as they were recognized as foreign. Therefore, researchers concluded that sometime between two and three weeks of age the chicks develop their own unique voice signature.

Vocalization

Vocalization is vital to communication and recognition among African penguins, just as it is with other penguin species. The most common call is the bray, similar to that of a donkey, which inspired the African's nickname, "jackass penguin." Different

"accent" brays are used to advertise before mating, communicate with a mate upon nest relief, and build bonds between mates. When using a bray to bond with a mate, the African points its head up to the sky and opens its flippers to the side, slowly. Every vocal call is accompanied by a particular posture or display. The same call stands side by side or back to back, each braying in turn or sometimes in unison, neither looking at each other nor pointing their bills in their mate's direction.

Yet another frequent call is a warning bark (some call it aggressive bray), directed toward an intruder or a disturbance. If the intruder does not back away or does not try to appease the caller, a bill duel and a fight surely follow. Throbs, which are soft calls, are used for enforcing the bond and later during nest reliefs. A haw is used while foraging and can be described as a contact call (Thumser and Ficken 1998). The chick's calls are called peeps.

Dangers

Fur seals attack adults, while seabirds snatch eggs and unguarded chicks. Jackals and even hyenas pose a threat on land to the penguins. However, the primary factor in the consistent and rapid decline of the African penguin population over the past hundred years is human activity.

The African penguin's habitat overlaps with human populated areas of Africa, and busy shipping lanes run through their swimming range. Overfishing of sardines and anchovies has steadily reduced the African's food supply, and they also face competition for prey from an increasing seal population. Oil spills around Africa's southern tip have wreaked environmental havoc and claimed even more penguin lives. In 1994 and 2000, spills harmed and killed many African penguins, prompting fears that the species may be wiped out if such catastrophes continue to occur.

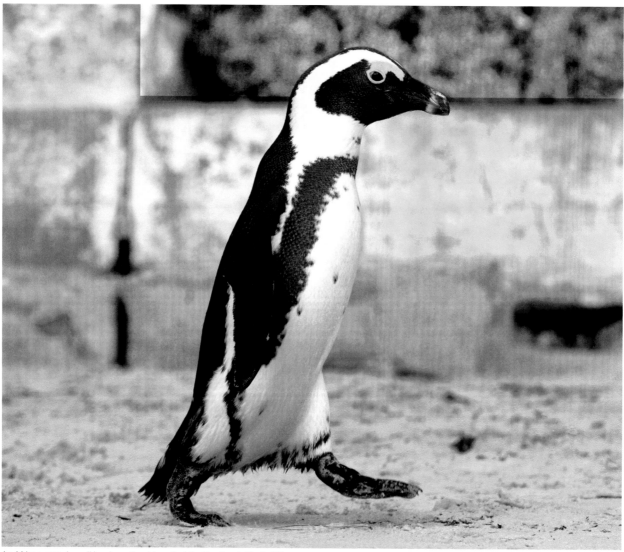

An African penguin walking down the sidewalk at Boulder Beach, South Africa

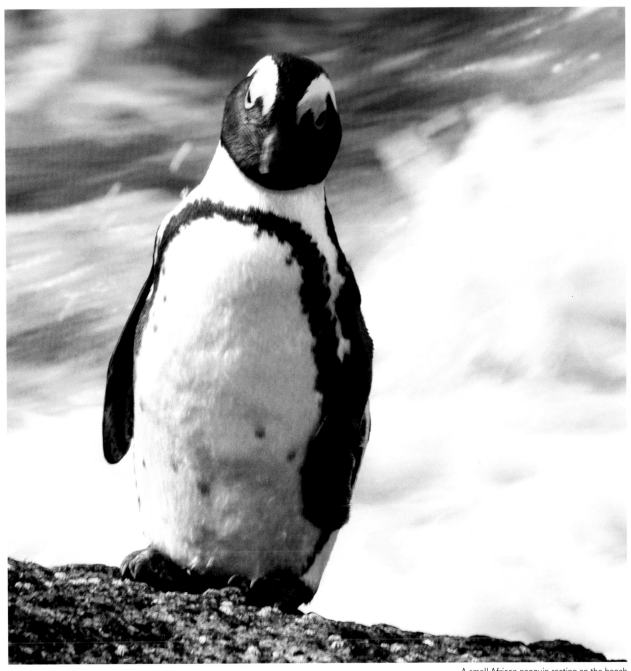

A small African penguin resting on the beach

Animals introduced by humans, such as dogs, feral cats, rats, and mice, often damage nests, destroy vegetation, and kill penguins. Previous human practices of egg harvests, guano-mining, and hunting have taken a heavy toll, as well.

Proportionally, African penguins are disappearing faster than most penguin species. Ever since egg collection was outlawed in 1967, their two primary causes of death are starvation and pollution. The dangers are real and are continuously killing penguins; as a result, this penguin's future in the wild is very uncertain.

Conservation Efforts

South Africa and Namibia take an active approach in trying to reverse the decline of the African penguin population. There is a coordinated effort among the government, academia, and penguin lovers to do all they can to save this species. It is clear that single acts alone, like a prohibition on collecting eggs, cannot reverse the trend, and a comprehensive plan is now in effect. The Southern African Foundation for the Conservation of Coastal Birds (SANCCOB) in Cape Town actively searches for injured

or oil-covered birds needing to be cleaned and nursed back to health. After the birds recover for four to five weeks, they are released back into the wild.

In the aftermath of the disastrous oil spill in 2000, SANCCOB launched its largest mobilization effort to date, drawing volunteers from all over the world to work endless hours to save oil-covered African penguins. Twelve thousand volunteers worked almost 50,000 shifts and handled about 38,500 penguins. Twenty-two thousand penguins and chicks were treated after they were oiled. Many more were lifted from the water before they were exposed to the oil and were put back at sea many miles away. Most penguins were saved, and the mortality rate was calculated to be only 10 percent. Despite the best efforts of SANCCOB and its volunteers, the decline of *S. demersus* appears irreversible. Most experts point to the need for more regulation of the commercial fishing industry and warn that unabated fishing will guarantee the demise of the species in the wild.

Interesting Research

Can African penguins smell their prey? Most researchers believe penguins do not have a keen sense of smell, but it has been suggested under simulated conditions that African penguins do smell fish. However, these findings still do not explain how a penguin can smell prey, or whether they sense something else present that humans cannot (Cunningham et al. 2008).

Another study found that penguins, especially those that have had peaceful encounters with humans in the past, do not exhibit increased heart rate when humans approach their nests during chick rearing. These findings confirm that African Penguins are not threatened when people watch them. However, the most interesting part of this study was the method of evidence collection. In order to measure the birds' heart rate, the researchers placed artificial eggs with an infrared sensor into the penguins' nests without them noticing. The poor penguins sat on the eggs diligently, as if they were real ones just waiting to hatch (Nimon et al. 1996).

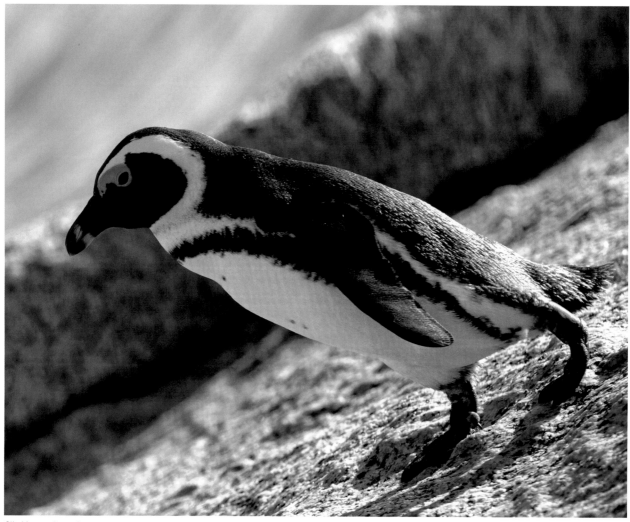

Climbing up the rocks

Charts

Weights	Source 1	Source 2, 3
Breeding Male		7.3 lb/3.31 kg[2]
Breeding Female		6.5 lb/2.94 kg[2]
Premolt Unsexed	8.8 lb/4.0 kg	9.5 lb/4.3 kg[3]
Postmolt Unsexed	5.3 lb/2.4 kg	5.1 lb/2.3 kg[3]
Hatching Chicks		0.16 lb/73.0 g[3]
Egg 1	0.24 lb/109.0 g	
Egg 2	0.23 lb/104.0 g	
Lengths	**Source 1**	**Source 2**
Flipper Length Male		7.5 in/19.1 cm
Flipper Length Female		7.1 in/18.0 cm
Bill Length Male		2.4 in/6.1 cm
Bill Length Female		2.2 in/5.6 cm
Bill Depth Unsexed	0.9 in/2.3 cm	
Foot Length Unsexed	7.3 in/18.5cm	

Source 1: Williams 1995—Cape Province, Dassen Island, and Marcus Island, South Africa. Source 2: Hockey et al. 2005—Robben Island, South Africa. Source 3: Cooper 1977—Dassen Island, South Africa.

Biology	Source 1	Source 2, 3, 4, 5, 6	Source 7, 8, 9, 10
Age Begin Breeding (Years)	3–6	4[2]	
Incubation Period (Days)	38	38[3]	
Brooding (Guard) Period (Days)	40	30[4]	
Time Chick Stays in Crèche (Days)	35–40	30[4]	
Fledging Success (Chicks per Nest)	0.5–2.8	0.46[2]	
Mate Fidelity Rate	64%	94%[2]	
Date Male First Arrives At Rookery	Peak Jun. & Dec.	Highly Variable[3]	
Date First Egg Laid	Highly Variable	Highly Variable[3]	
Chick Fledging Date	Highly Variable	Variable[3]	
Premolting Trip Length (Days)	20–30	35–63[3]	35[7]
Date Adult Molting Begins	Peak Apr.–May	Highly Variable[3]	
Length Molting on Land (Days)	14–18	20[3]	18[8]
Juvenile Survival Rate First 2 Years	At Least 12.5%	51% (Year 1)[2]	32% (Year 1)[9]
Breeding Adults Annual Survival	70–88%	80–82%[2]	68.6%[9]
Average Swimming Speed	1.9–3.7 mph/3–6 kmph	3 mph/4.8 kmph[5]	2.6 mph/4.25 kmph[10]
Maximum Swimming Speed	9.2 mph/14.8 kmph	7.7 mph/12.4 kmph[5]	6.4 mph/10.3 kmph[10]
Deepest Dive on Record	429 ft/130.8 m	426.5 ft/130 m[5]	
Farthest Dist. Swam From Colony	95.4 mi/153.6 km	15 mi/24.2 km[5]	
Most Common Prey		Anchovy[6]	Anchovy[10]
Second Most Common Prey		Sardine[6]	Sardine[10]

Source 1: Williams 1995—Crozet Island. Source 2: Crawford et al. 1999, Crawford et al. 2006—Robben Island, South Africa. Source 3: Marion 1995—Various Locations. Source 4: Seddon and Van Heezik 1993—South Africa. Source 5: Wilson 1985—Cape Province, South Africa. Source 6: Peterson et al. 2006—Boulders Beach, South Africa. Source 7: Randall 1983—St. Croix Island, South Africa. Source 8: Cooper 1977—Dassen Island, South Africa. Source 9: La Cock and Hanel 1987—Dyer Island, South Africa. Source 10: Peterson et al. 2006—Robben Island, South Africa.

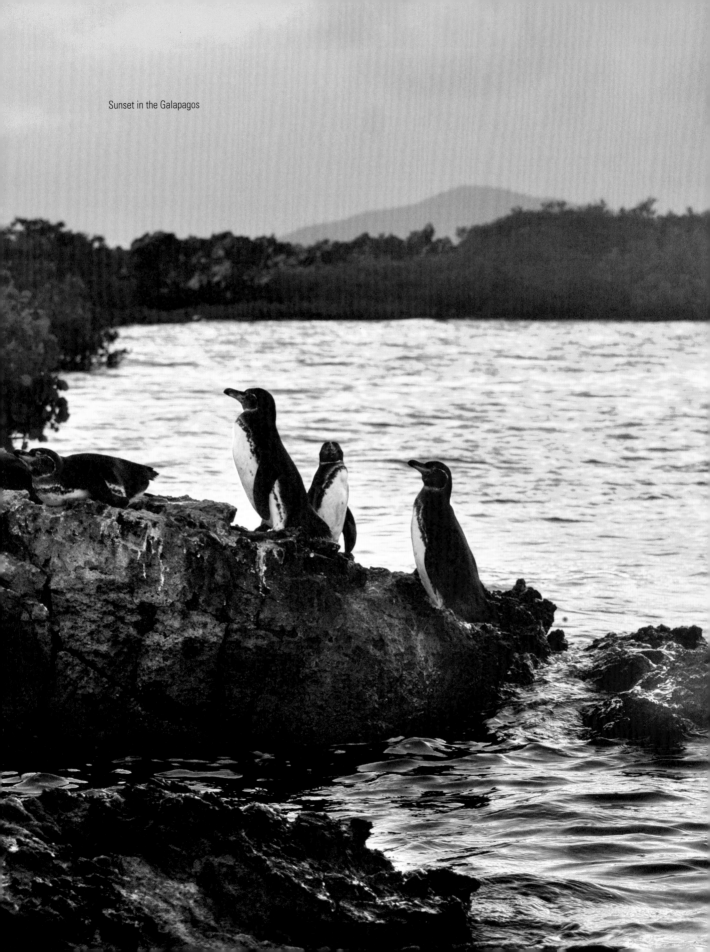

Sunset in the Galapagos

Galapagos Penguin
Spheniscus mendiculus

Genus: *Spheniscus*

Other Genus Members: Magellanic, Humboldt, and African

Subspecies: None

IUCN Status: Endangered

Latest Population Estimates
Only 1,000–1,500 individuals; large variations in population year to year can be caused by El Niño

Life Expectancy
9.5 years on average, but a few can reach up to 20 years

Migratory: No, they are a sedentary species.

Locations of Larger Colonies: Isabela and Fernandina Islands, Galapagos Islands, Ecuador

Colors
 Adults: Black, white, and pink
 Bill: Black, gray, and white
 Feet: Black
 Iris: Brown to red
 Chick Down: Brown or dark gray
 Immature: Black, white, gray, and pink

Height: 19–21 in/47–54 cm

Length: 20–23 in/50–58 cm

Normal Clutch: 2 eggs per nest

Max Chicks Raised per Pair per Year: 4

Adult Galapagos

Immature Galapagos, premolt

David's Observations

If you live in the United States, the nearest wild penguin to you is the Galapagos. Reaching Santa Cruz, Galapagos, with a regular-service airline was quick and cheap. From there a quiet two-hour boat ride got me to Isabela, where most of the Galapagos penguins breed. At the dock I hired a boat driver named Henry, and it took only five minutes for us to reach the main penguin location—where a grand total of zero penguins were present. As the thermometer climbed to over 90° F (32.2° C), I realized how strange it felt searching for penguins in such hot, tropical weather.

Later, as the afternoon arrived, we encountered two to four penguins resting on different lava rocks in the middle of the bay, and as the sun was setting, as many as fifty adults and a few immature returned from their daily foraging and were preening. Henry maneuvered his boat with proficiency and care as close as he could to the island. The penguins never showed any sign of stress or fear, and they were unusually cordial toward each other and friendly to us. Occasionally they jumped into the water to cool off and then returned to their previous position on the rock. The biggest problem, as Henry stated it, is that most visitors only come to Isabela to meet the penguins. The penguins do their part by staying on the rocks, but their dwindling numbers scare Henry and anyone else whose livelihood depends on these fragile, beautiful birds. "I am glad you came now," Henry said. "If you'd waited five more years, it is quite possible you would have missed them."

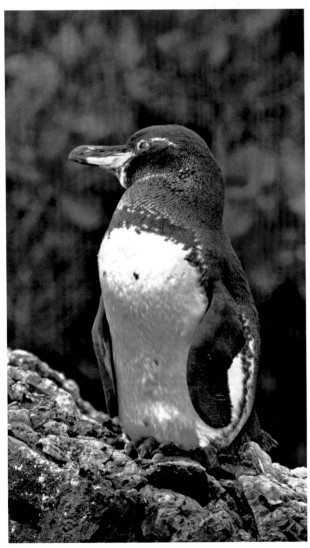

An adult Galapagos rests on the rocks

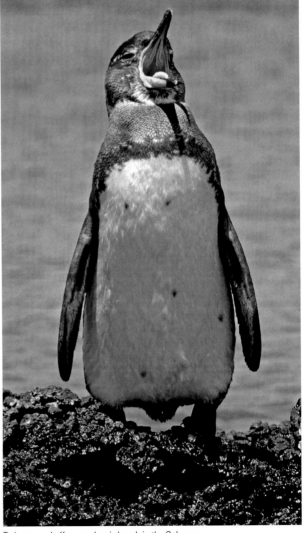

Trying to cool off on a volcanic beach in the Galapagos

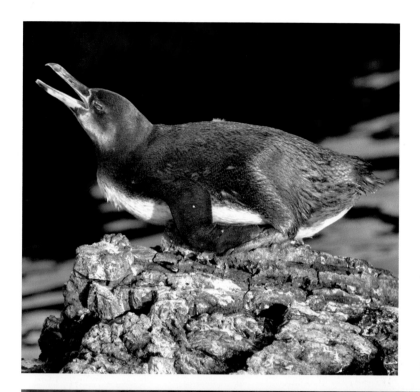

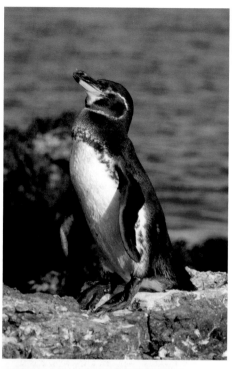

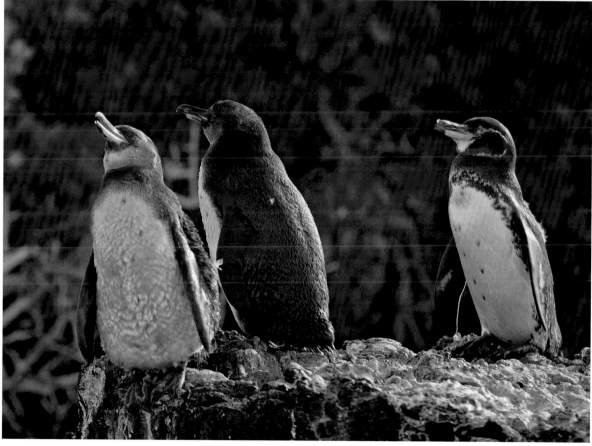

Top left:
An immature
Galapagos
lying on the
rocks

Top right:
An adult
Galapagos
penguin

Left: An adult
and two
immature
catching the
afternoon
breeze

"The penguins
do their part by
staying on the
rocks"

About the Galapagos Penguin

Population Trend

Close to extinction. Fewer Galapagos individuals are left than any other penguin species. Their population is on the decline and suffers greatly from many adverse conditions created by man and weather. This species probably never enjoyed great numbers, and it is doubtful that the population ever exceeded tens of thousands. Hernán Vargas estimated the population to be from 1,000 to 1,400 in 2004, but his later estimate in 2009 was about 1,800 individuals (Vargas et al. 2005). At least 70 percent of the population was lost in the past twelve years, and the Galapagos penguin cannot afford any further losses. It is estimated that in the El Niño year of 1983, 77 percent of the population perished. Unless some drastic actions are taken to help the Galapagos penguins, they will surely become extinct.

Habitat

The Galapagos penguin lives on the equator, though when people think of penguins they rarely imagine the balmy tropics as a penguin habitat. They breed on the small, isolated Galapagos Islands, which are 525 miles (845 km) west of Ecuador and considerably north of any other penguin species. The majority breeds on Isabela and Fernandina Islands and few breed on Santiago and Bartolomé. Since these islands are just a few miles south of the equator, with parts of Isabela Island actually stretching north of the equator line, so it can be said that the Galapagos penguins do dive, at times, in the Northern Hemisphere. While there are none of this species on exhibit in any zoos, it is clear that putting them in zoos may be a critical step in their future survival.

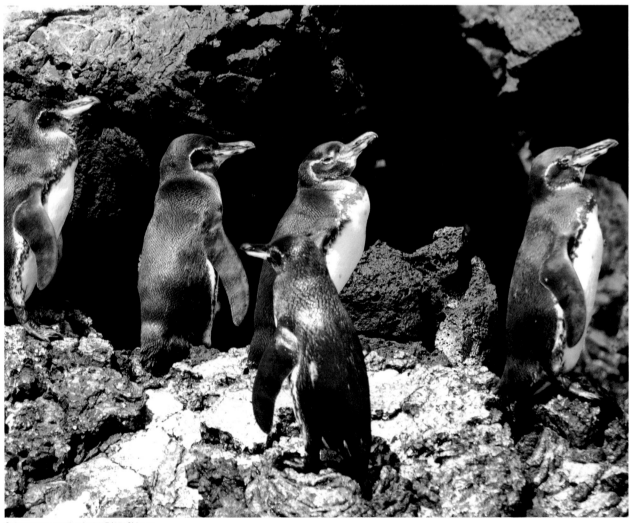

Galapagos penguins in 95°F (35°C) heat

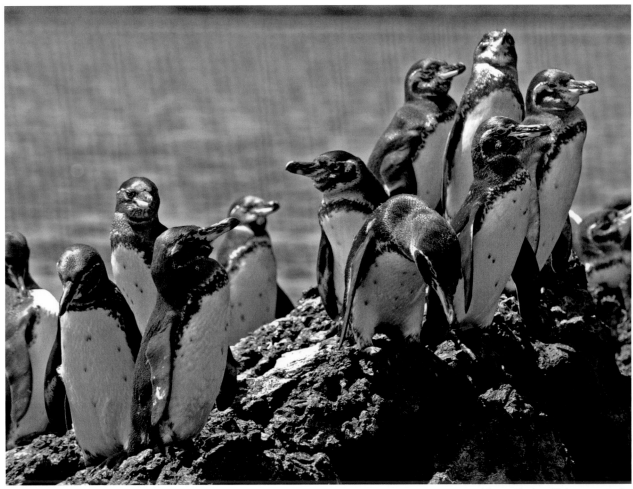

A large gathering of Galapagos penguins

Appearance

The Galapagos penguin looks similar to the Magellanic, African, and Humboldt penguins, except it is noticeably smaller than the rest of the genus. On adult Galapagos, the head is black and the chin white. One very thin white band goes over the eye, behind the ear, and to the back of the head, turning into what looks like a fancy necklace as it closes in the front part of the neck. On the face there are minor pink featherless patches of skin around the eyes and under the bill. This feature is more noticeable during breeding season. The neck is black, brown when worn, and the underbody is white. One black band appears on the upper breast and curves like a horseshoe down the sides but is not well-pronounced like that of the Magellanic. The borders are blended with white and look uneven or broken. Like the African and Humboldt, Galapagos have distinct black dots on their underbody. These black dots vary from one Galapagos to another, allowing researchers to identify specific individuals. The flippers are black on the outside as well as on most of the underside, where a pinkish-white heavy line is also present. The bill has a complicated, albeit unattractive, color scheme. The upper mandible is gray with a black hook at the tip. The lower mandible is black, gray, and pink with black again at the tip. When combined with the black hook on the upper mandible, it appears as though there is a black ring around the tip of the bill. The feet are black with a few pink spots.

Immature Galapagos have no bands and have a mostly black back with a faded gray to brown head and neck. There are also no pink bald patches on the face, and the irises are pink to red rather than the adult brown to red.

Chicks

Chicks are born without the ability to regulate body temperature, but in contrast to most other penguin chicks, the danger facing them is heat stroke. Still, the remedy is the same as in other species, where the brooding parent covers the chick with its own body until the chick grows a down that will protect it. In less than two weeks, the chick is able to regulate its own body temperature, but it still remains under constant guard for two more weeks. As the chick reaches thirty to thirty-five days of age, both parents

leave. The chick does not join a crèche, but instead remains near the nest waiting for its parents to return with food every day. At sixty to sixty-five days of age the chick reaches adult size and is ready to fledge. The vast majority return to their parents' colony to molt and, later, breed. After the first molt at age six to twelve months, they obtain adult plumage. The survival rate of Galapagos chicks in a non–El Niño year in the first year of life is one of the highest of any penguin species.

Breeding and Chick Rearing

Galapagos penguins are very efficient breeders. Like the African and Humboldt penguins, there is no defined annual breeding period, though peaks were observed in April through May and August through September (Vargas et al. 2006). Studies show that molting and breeding tend to be tied to water temperature, and as the water becomes cooler, breeding activity increases. Since the population is under distress, 50 percent of pairs breed twice a

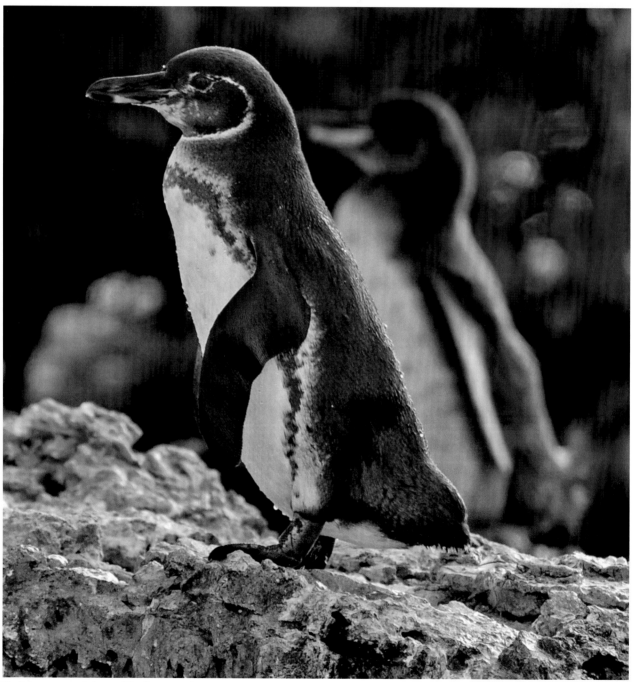

The Galapagos penguin is one of the shortest species

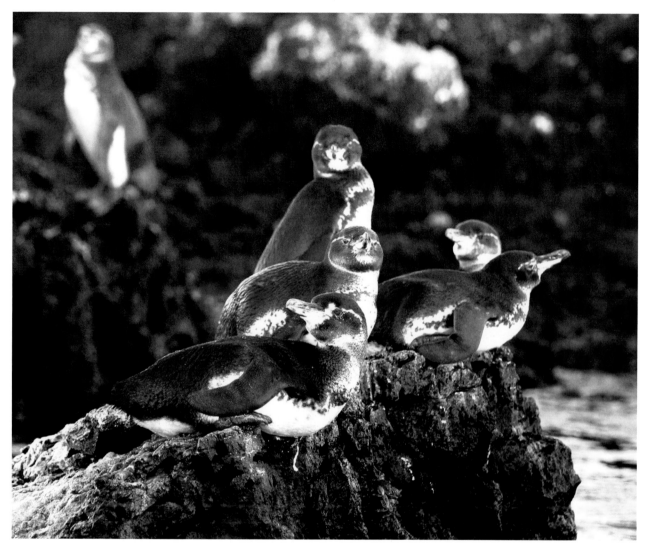

The Galapagos spend only a short time diving and many hours resting

year, and the rest breed twice in a fifteen-month period. This busy breeding schedule sometimes collides with molting, and if either mate begins molting, breeding gets postponed.

The female lays two eggs of similar weight. Incubation lasts 38 to 40 days, and unlike with other species it commences in earnest immediately after the first egg is laid. Both parents take equal turns minding the egg, typically lasting one day, during incubation, and one parent forages while the other incubates.

Galapagos penguins are dedicated parents and enjoy less hostile land predation; therefore, the nest success rate normally averages a high 1.3 chicks per nest. Because many families go through two breeding cycles a year, an experienced, dedicated pair might fledge three or even four chicks per year. This varies widely from season to season depending on the volatile water temperature and its effect on food availability. A major El Niño year can devastate nest success and crash it to an absolute zero.

Foraging

Galapagos penguins are sedentary, preferring to stay close to home and return to their colony nightly. They take full advantage of the Equatorial Undercurrent, also known as the Cromwell Current (Palacios 2004). Their preferred food is shoaling fish, such as anchovies, sardines, and the local mullets. These fish tend to swim in cooler water closer to shore. The most detailed study to date, by Steinfurth et al. (2008), concluded that most birds typically dive within one mile of their colony. It is not known for certain why the Galapagos penguins do not venture farther away, but two theories exist. The first is that the Galapagos Islands area is infested with sharks, most of which stay deeper in the ocean, and the penguins avoid those predators by staying closer to shore. The second theory plainly states that they do not need to dive far during non–El Niño years, when water temperature is such that enough sardines and anchovies populate the shore areas.

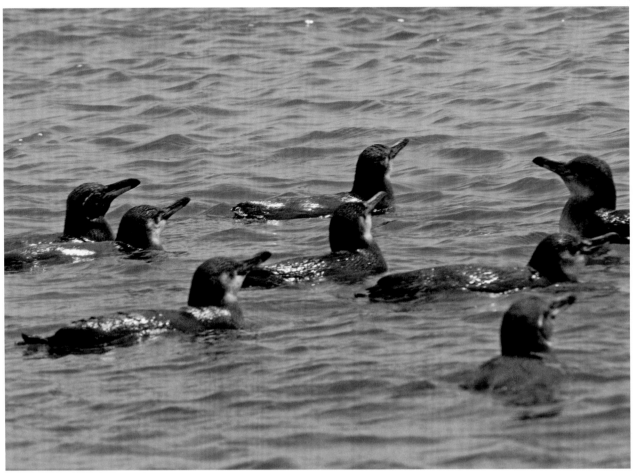

Galapagos penguins on their way to forage

Living in a very small community keeps food supply sufficient and mitigates the need to forage often or far. It is rare that these penguins venture farther than three miles (4.8 km) away from their nest or 0.7 miles (1.1 km) off the shore line. These figures crown the Galapagos the laziest of all forager penguins. Most dives are also very shallow at less than nine feet (2.7 m) deep, with birds rarely dipping below 25 feet (7.6 m). The deepest dive on record was by a female who dove to 162 feet (49.4 m), but it can be assumed that the male potential might exceed 180 feet (54.8 m). This is another clear sign that the Galapagos penguins do not need, or care, to push the limit to find prey.

Most Galapagos penguins leave the shore by six in the morning and return by half past two in the afternoon. An average trip lasts a comparatively quick 8.4 hours. During normal feeding conditions almost all birds are back on shore and preening themselves by five in the afternoon. Preening and cleaning are serious activities, and adults may spend an hour or two each afternoon preening and then jumping into the water to cool off from the staggering heat. They turn and twist in the water, then preen some more before heading back to the nest.

Molting

As if it is not enough trouble to molt once a year, many Galapagos adults molt twice. Because there is no calendar to follow, there is also no set time for molting. Premolt foraging trips occur two to four weeks prior to molting in order for the penguin to gain at least one pound of body weight (0.45 kg). The average land phase of the molt lasts a short thirteen to fifteen days, during which time 30 to 40 percent of body weight is lost. The overwhelming tropical heat and sun are difficult for the Galapagos penguins to handle during molting because they cannot enter the cool ocean, so the birds spend most of the time shaking or sleeping and trying to lower body metabolism while standing.

Nesting

Galapagos penguins nest two hundred feet (61 m) or less from the sea, which sometimes subjects them to flooding during high tide. The nest is placed on the rocky ground at a rudimentary level or burrowed in the soft, volcanic rock under a decent-sized layer of guano. Some birds just find one of many open holes in the roughly shaped volcanic rocks. The higher-quality nests

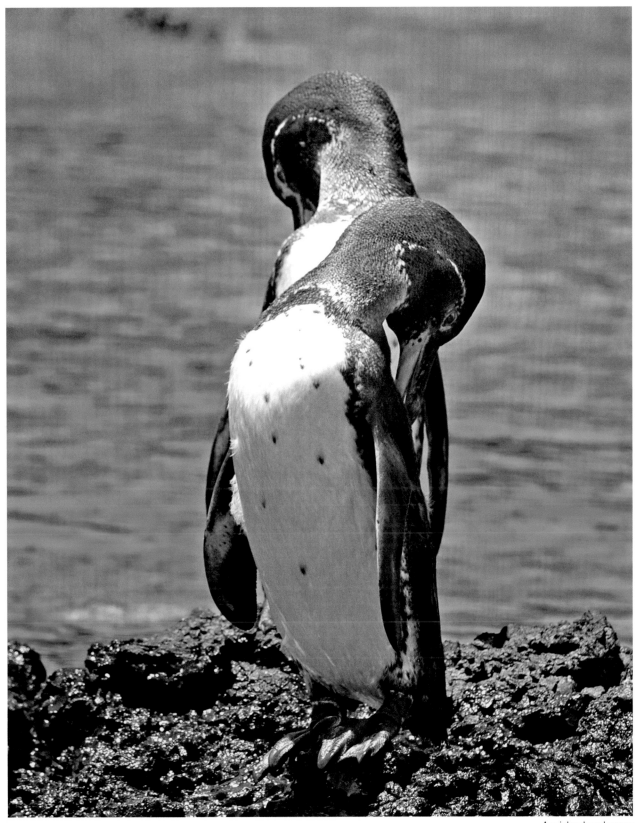

A pair bonds and preens

are padded with seaweed, leaves, twigs, or small bones. Unlike other species, Galapagos penguins stay in or next to the nest even during non-breeding periods.

Relationships

Monogamous, loving Galapagos penguins follow the tranquility of their habitat and are not aggressive with each other or neighboring birds. They stand for many hours on the lava rocks next to other penguins or the Blue-footed Booby. Mates spend much time preening each other as well as their chicks. Mate fidelity is very high at almost 90 percent. They use their flippers to pat each other, like hugging, and in contrast to other *Spheniscus*, who often get into aggressive bill duels, Galapagos penguins touch each other with their bills as if trying to kiss.

A Galapagos agonistic display includes raising the neck and neck feathers and pointing the bill at the opposing bird while showing aggression. A more pronounced posture involves raising the flippers behind the neck and pointing the head upward.

Vocalization

Galapagos penguins are less noisy and use their voices less than other species. When vocalizing, a donkey-like bray is used. It has two parts: a low pitch followed by a higher-pitched bray. Braying is used most often by males to identify and call their female mates. A similar, shorter bray is used when changing the guard during incubation and chick rearing. Another call is used mostly at sea to coordinate group diving.

Dangers

This species seems to enjoy a natural environment with almost no predators. After witnessing the panic one seal can cause among Magellanic penguins, it was strange to see seals swimming next to Galapagos penguins as if they were best of friends. Ecuadorians say that in the Galapagos Islands, animals copy the natives' behavior and are gentle with each other. To counter their tranquil relations with other penguins and the lack of native predators, these fragile penguins are endangered by natural occurrences and man. Ongoing volcanic eruptions cause a chain of negative reactions, and the El Niño phenomenon is the Galapagos penguin's main cause of death because it raises the water temperatures and chases away the fish the penguins prey on. In severe El Niño occurrences, when the water temperature rises about 9°F (5°C), no successful breeding can take place and a substantial number of adult penguins perish. Such a massive loss can take twenty years

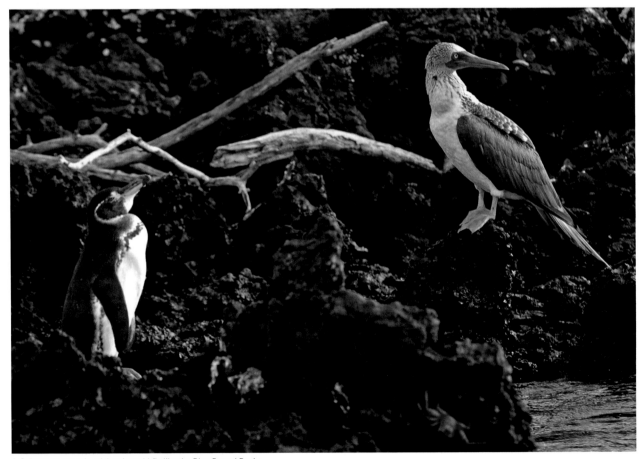

A Galapagos penguin wishes it could fly like the Blue-Footed Booby

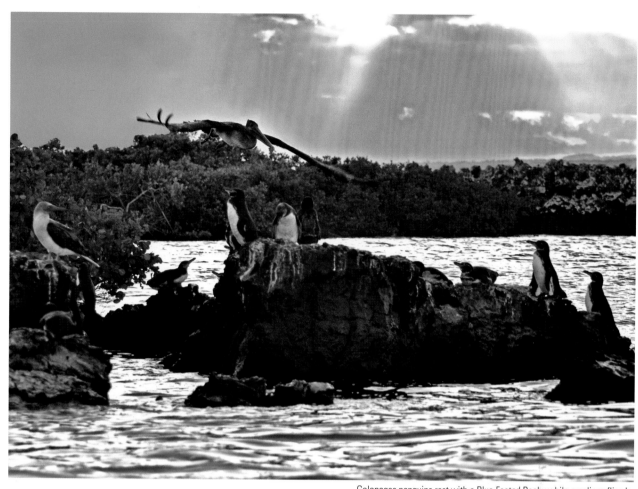

Galapagos penguins rest with a Blue-Footed Booby while a pelican flies by

of better, cooler water temperatures to recover from. Scientists are not all in agreement, but some say global warming increases the frequency of El Niño events at the times when the Galapagos penguin can least withstand them.

Galapagos penguins have struggled for centuries with these natural threats and their unstable numbers; fortunately, they have managed to avoid extinction thus far.

However, the recent wave of newcomers and subsequent construction causes problems to all endangered species on the Galapagos Islands, and the penguins are no exception. The human population has increased tenfold and has brought with it unwanted air, water, and land pollution, not to mention pets, rats, and other domestic animals that all pose an unprecedented threat to the fragile population of the Galapagos penguins.

Conservation Efforts

If you read the official documents of the government of Ecuador, you might think that all the local wildlife is well protected, especially the Galapagos penguin. When you arrive at or leave the Galapagos Islands, extensive searches of luggage take place.

There is even a volume of published guidelines and actions from the government and other institutions. All these measures are in place, but their enforcement is very lax, and their effectiveness all but vanishes in the face of large migrations of new people to the Galapagos Islands. The islands are not very big, and penguin colonies are very close to marinas and villages. Many recreational and fishing boats contaminate the water, and tourists roam the area, most adhering to the strict rules but a few doing just as they please with no thought of consequences. To combat uncertain weather conditions and volcanoes, Galapagos penguins need to be separated from people in practice, not just in theory or promise.

Time is running out for the Galapagos penguin. It is becoming clear that the only way to save the species is to create a protection zone and barriers around some of its breeding grounds, or else build a large, seminatural zoo in the Galapagos just for these penguins. Such a preserve will curtail the penguins' movements and will also require adding fish to assure good feeding. Keeping one hundred breeding pairs in such a controlled habitat is a radical act that has never before been attempted, so its details, cost, and outcome are uncertain.

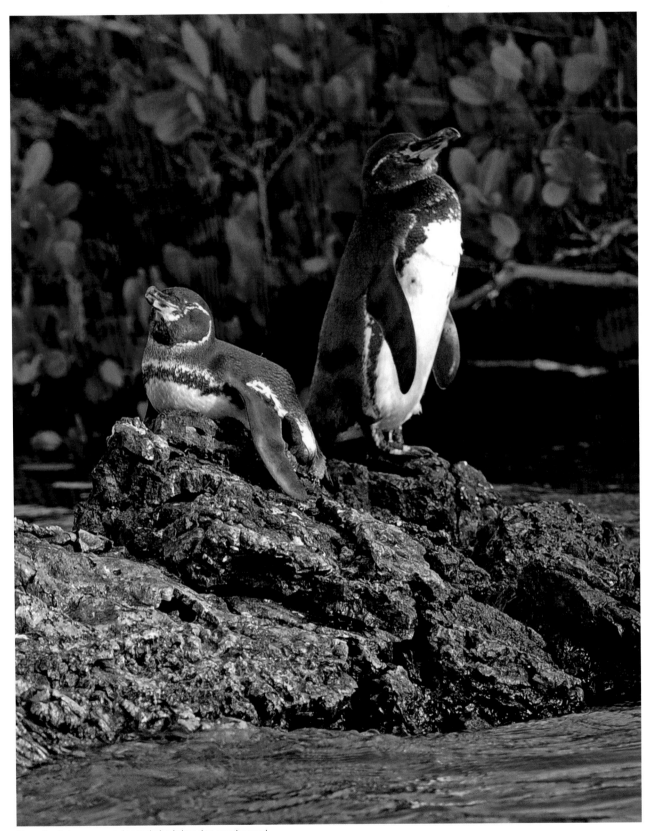

The entire Galapagos penguin population is less than two thousand

Charts

Weights	Source 1	Source 2, 3, 4
Breeding Male		5.1 lb/2.3 kg[2]
Breeding Female		4.2 lb/1.9 kg[2]
Incubation Male	4.4 lb/2.0 kg	
Incubation Female	4.2 lb/1.9 kg	3.5 lb/1.6 kg[3]
Premolt Male	5.7 lb/2.6 kg	
Premolt Female	5.5 lb/2.5 kg	5.3 lb/2.4 kg[3]
Midmolt Male	3.7 lb/1.7 kg	
Midmolt Female	3.7 lb/1.7 kg	
Postmolt Male		3.7 lb/1.7 kg[3]
Fledging Chicks		3.3 lb/1.5 kg[4]
Lengths	Source 1	
Flipper Length Male	4.6 in/11.8 cm	
Flipper Length Female	4.5 in/11.4 cm	
Bill Length Male	2.3 in/5.8 cm	
Bill Length Female	2.1 in/5.4 cm	
Foot Length Male	4.0 in/10.2 cm	
Foot Length Female	3.7 in/9.5 cm	

Source 1: Boersma 1976—Isabela Island, Galapagos, Ecuador. Source 2: Travis et al. 1995—Isabela Island and Fernandina Island, Galapagos, Ecuador. Source 3: Marion 1995—Galapagos, Ecuador. Source 4: Williams 1995—Galapagos, Ecuador.

Biology	Source 1	Source 2, 3, 4
Age Begin Breeding (Years)	2–4	3[2]
Incubation Period (Days)	38–40	38–42[3]
Brooding (Guard) Period (Days)	30-35	
Fledging Success (Chicks per Year)	0.0–1.3	1.1[2]
Mate Fidelity Rate	89%	
Date First Egg Laid	Jun.–Sep. and Dec.–Mar.	Varies[3]
Chick Fledging Date	Peak Oct.	Peak Nov.–Dec.[3]
Premolting Trip Length (Days)	7–28	
Date Adult Molting Begins	Varies	Varies[3]
Length Molting on Land (Days)	10–15	10–15[3]
Juvenile Survival Rate First 2 Years	0.317	
Breeding Adults Annual Survival	87% (M) 82% (F)	90%[2]
Deepest Dive on Record		170.9 ft/52.1 m[4]
Farthest Dist. Swam From Colony		14.6 mi/23.5 km[4]
Most Common Prey	Mullet and Sardine	Fish[3]

Source 1: Williams 1995—Galapagos, Ecuador. Source 2: Parque Nacional Galapagos 2005—Galapagos, Ecuador. Source 3: Boersma 2009—Galapagos, Ecuador. Source 4: Steinfurth et al. 2008—Isabela Island, Galapagos, Ecuador.

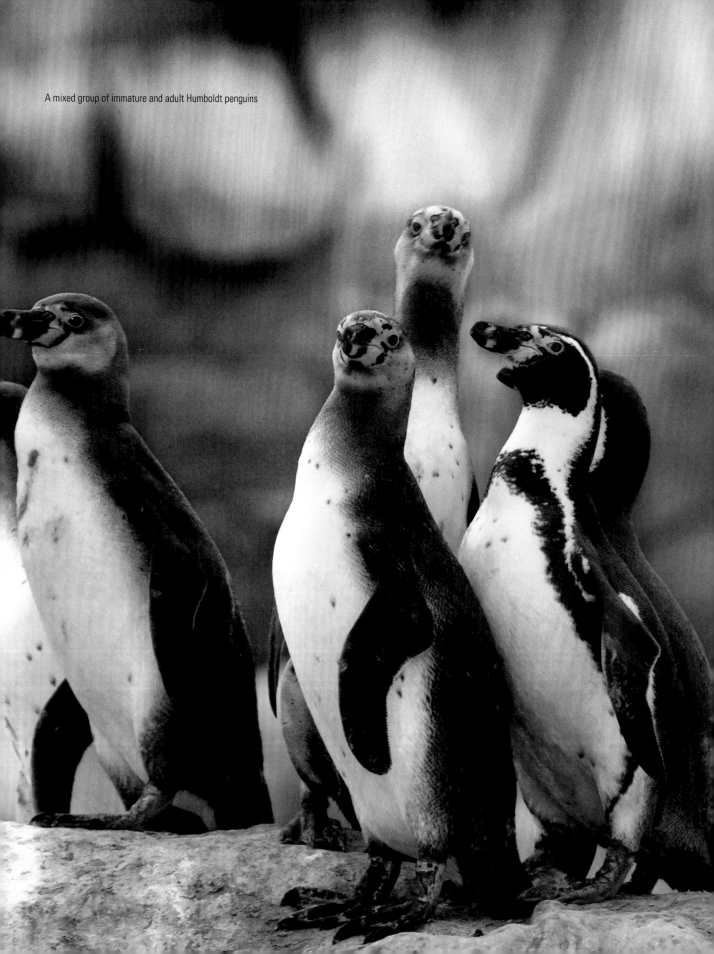

A mixed group of immature and adult Humboldt penguins

Humboldt Penguin
Spheniscus humboldti

Genus: *Spheniscus*

Other Genus Members: Magellanic, African, and Galapagos

Subspecies: None

IUCN Status: Threatened

Latest Population Estimates
Individuals: 40,000
Breeding Pairs: 15,000

Life Expectancy
Wild: Up to 20 years; average 10–12
Captivity: 30 years

Migratory: In Peru, they are sedentary. In Chile, they are absent from March to August.

Locations of Larger Colonies: Isla Chañaral, Chile; Punta San Juan, Peru

Colors
Adult: Black to dark brown, white, and pink
Bill: Black with a gray ring
Feet: Black with gray or pink patches
Iris: Brown with red ring in adults, gray in chicks
Chick Down: Gray to silver with creamy white beneath
Immature: Brown to gray and faded white

Height: 24–26 in/61–65 cm

Length: 25–27 in/64–69 cm

Normal Clutch: 2 eggs per nest

Maximum Chicks Raised per Pair per Year: 4

The Humboldt penguin is also known as the Peruvian penguin.

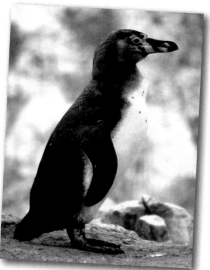
Immature Humboldt penguin

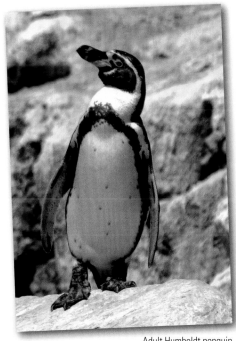
Adult Humboldt penguin

David's Observations

It is difficult to encounter a Humboldt penguin on the mainland. The few big colonies, such as Punta San Juan, for example, are protected by walls and guards that prohibit visitors from entering the reserve. The best way to meet a Peruvian penguin is by taking a short boat ride. I drove the car I rented in Lima for five hours until I arrived at the center of the city of Paracas. It did not take long before a local boat owner noticed my camera equipment and offered to take me to Islas Ballestas. After thirty minutes of heated negotiations about the fare and only twenty-five minutes in the boat, I was in front of several miniature islands that are home to more birds than one can count. Some, such as the pelican, are very large; others are much smaller. Some are plain black while others are very colorful. It took time to notice that some did not actually have wings, just flippers, perhaps because so many of the birds were standing upright. The Peruvian boat driver navigated his craft within a few feet of the rocks. Some birds flew away, but the Humboldt did not move. Some penguins were molting and visibly suffered from the 90°F (32.2°C) heat. First-year immature penguins were walking about and from time to time entered the water. Thousands of flying birds were taking off and landing, creating great noise and activity in stark contrast to the timid behavior of the Humboldt. The penguins appeared skinny and uncomfortable in the hot, dry weather. They were few in number and far apart, but still traveled in groups when they entered the water. At times they looked at a pelican taking off or landing as if they wished they could fly themselves, if for nothing else than to cool off.

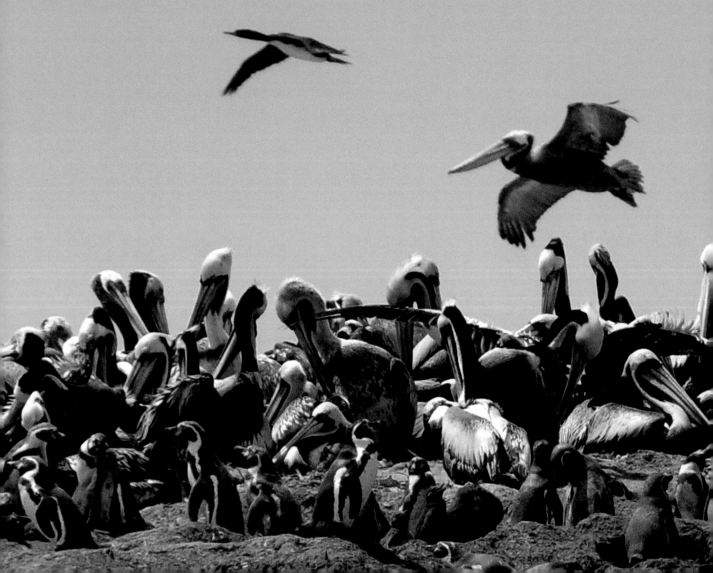

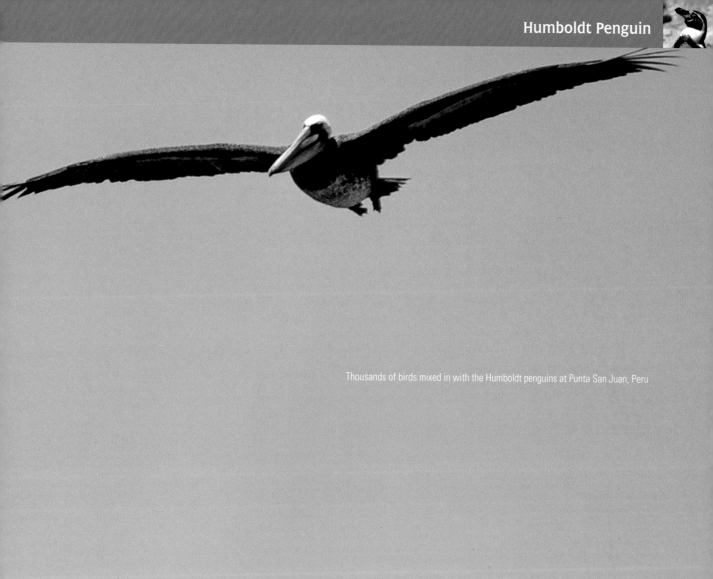

Thousands of birds mixed in with the Humboldt penguins at Punta San Juan, Peru

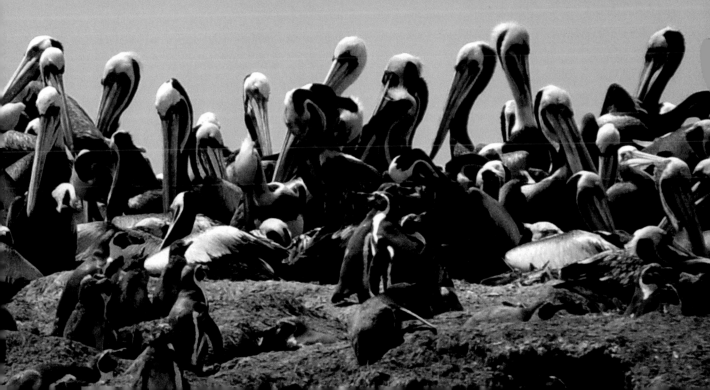

About the Humboldt Penguin

Population Trend

Alarming decline. The number of Humboldt penguins in the wild is a subject of great controversy. For fifteen years, the consensus was that the population totaled between 5,000 and 8,000. However, one very detailed survey headed by Lloyd Davis, a renowned penguin researcher, determined that approximately 22,000 adult Humboldt penguins, 3,600 chicks, and 117 juveniles were living on the island of Chañaral in the first week of February 2003. Davis concluded that prior counting methods were outdated and missed most of the penguins on that island. Because the Humboldt, in its northern range, is not a synchronous breeder, many of the adult penguins might not breed or be present in a given day, which makes counting heads complicated.

This dramatic surplus did not materially change the fact that the Humboldt population has dropped drastically from the million or more that lived in the late 1800s.

Over the past fifteen years, their population in most colonies seems to have stabilized, but any new major El Niño occurrence can decimate their numbers. Thankfully, like their cousins the African and the Magellanic penguins, they are very adaptive to life in captivity. Over three thousand Humboldt penguins are living in over 150 zoos all over the world and are the second most common penguin species (after the African penguin) found in zoos.

Habitat

Humboldt penguins get their name from the Humboldt Upwelling, which is a very cold underwater current present along the west coast of South America. The Humboldt Current, which is very rich in fish, extends from Antarctica along the coast of Chile, into Peru, and farther north. They breed on the shores of both Peru and Chile and on islands close to the continent. There are

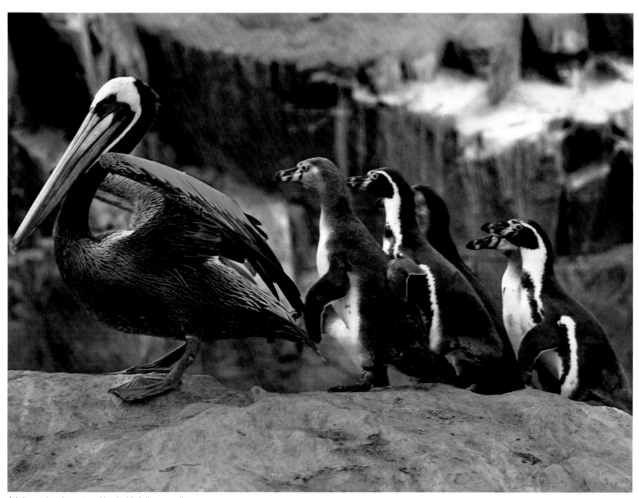
Adults and an immature Humboldt follow a pelican

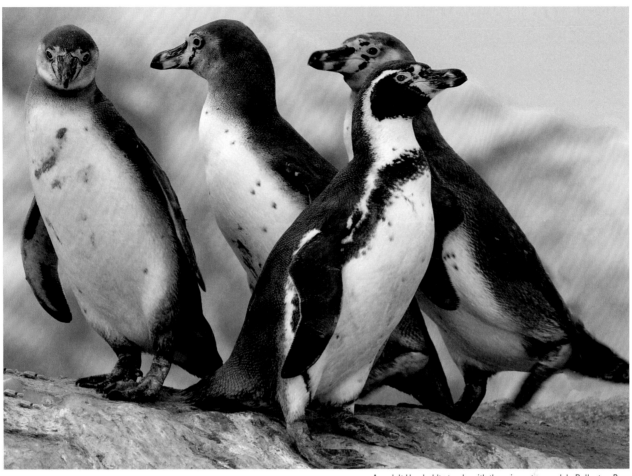

An adult Humboldt stands with three immature on Isla Ballestra, Peru

two breeding environments for this penguin, the northern range in Peru and northern Chile and the southern range in central Chile, which includes the large colony of Isla Chañaral.

When it steps ashore in the northern range, this penguin actually resides in the desert, which is not exactly a place you would expect to find it! The northern Chilean desert is a very hot place where summer temperatures can reach over 100°F (37.8°C). Some areas are so dry they might not get any rain for ten consecutive years. The southern range is also in a warm weather area, but has moderate temperatures and rainy seasons.

Their habitat encompasses the widest latitude range of any penguin species, starting from the tropical island of Foca, at 5° S in Peru, to Punihuil Island, at 42° S in Chile (Araya 1988). Only Galapagos penguins breed farther north than Humboldt penguins.

In Peru, rookeries are found in Punta San Juan, which is home to the largest breeding colony of about 1,500 breeding pairs, and also in San Juanita Islet, the Ballestas Islands, the Chincha Islands, Pachacamac Island, and Isla Asia. In Chile, researchers counted fourteen colonies, but recently breeding only takes place in ten.

Appearance

The adult Humboldt penguin, like others of its group, features a mostly black back and white underbody, as well as a black and white head and neck with contrasting black and white bands. Humboldt penguins are very similar in look and size to Magellanic penguins, the main difference being much larger pink patches around the bill and some noticeable differences in the black bands; the Magellanic has two bands and the Humboldt just one across the lower neck. The black band around the white underbody is much wider around the chest and narrows along the sides, stretching the full body length of the penguin. The head is mostly black, broken by two expanding white half circles going from the eyes toward the neck. The eye is surrounded by a pink, flashy-looking patch that is also present around the base of the bill and sometimes other small parts of the face. The chest and underbody are almost all white, except for the contrasting black band. The Humboldt, like African and Galapagos penguins, has black dots on its chest and other white areas. Unlike all other color features present, these dots vary in number, location, and configuration from one penguin to another, making each individual distinguishable.

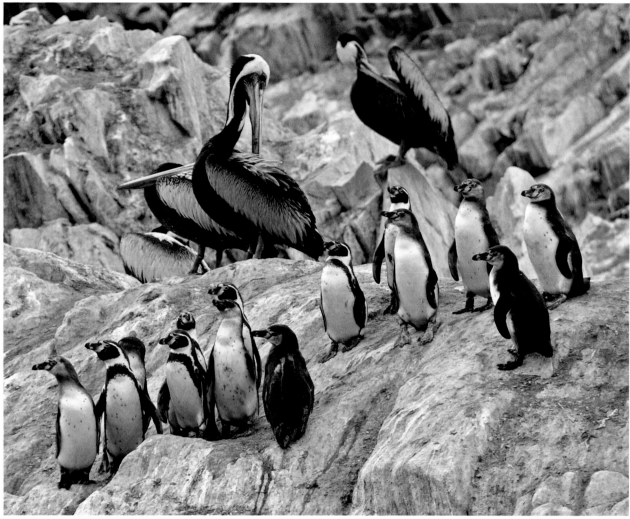

A lively show of birds on Isla Ballestra, Peru

The bill is almost all faded black except for gray areas and a lighter ring located about a third of the way up the bill. The feet are also mostly black but may be stained with pink to white patches without any particular pattern. The flippers are black on the outside with a gray to white edge, and they are lighter with white parts on the underside. The irises are brown to red in color.

Immature Humboldt penguins have a brown to dark gray back, neck, and head, and no bands are present.

Chicks

Chicks are born with faded silver-gray feathers. Within one or two weeks they start to sport a thicker down that makes them thermally independent. The down is their protection against the hot weather in the Chilean and Peruvian deserts. Four to six weeks later the down starts to shed and their juvenile plumage appears.

Unlike some other species, chicks do not form a crèche. After the guard phase they wait for their parents alone or with their sibling a short distance away from the nest. Chicks fledge seventy-five to eighty-five days after they hatch. If it survives the first year at sea, the youngster most likely returns to its natal rookery to go through its first molt at twelve to twenty-three months of age. After the molt, the chick looks just like its parents, except that the black dots on the chest have a somewhat different configuration. Almost all offspring return to breed at the colony in which they were born.

Breeding and Chick Rearing

Like African and Galapagos penguins, the other *Spheniscus* under threat of extinction, Humboldt penguins do not have a distinctive breeding calendar. A peak in the onset of breeding takes place in April and May. In the northern range, almost all pairs that failed to fledge a chick during the peak will try a second time in Sep-

tember and October. About half of the successful parents will have two breeding cycles in one year, trying to fledge as many chicks as they can up to the maximum possible of four. Most breeding adults molt in January, and therefore almost no breeding commences between November and February (Paredes et al. 2002). In the southern range, most pairs only breed once. After the chicks fledge, the adults leave the colony for an extended foraging trip. Many do not return until the following year to begin the breeding cycle (Dr. Roberta Wallace, personal communication).

The female lays two eggs, typically two or three days apart. Parents take daily turns sitting on the egg so that each parent can forage regularly. If the fish they feed on move offshore, shifts can be stretched one or two days longer. There is a difference of a day or two between the hatching of the each egg (Cooper et al. 1984). Once hatched, chicks stay in the nest for three to four weeks, their parents alternating guard duty. As the chicks grow, both parents can leave at once to forage and return almost daily to feed the chicks.

Nesting success varies widely, with a maximum of 1.3 chicks per nest. Those that breed twice in one year can double their productivity, but few couples in Peru managed to fledge four chicks in a year (Paredes et al. 2002). Best results are achieved in higher elevations; those close to the beach suffer from sea swelling and flooding that sweep away the eggs (or young chicks). Unfortunately, a severe El Niño occurrence can cause a total failure in breeding throughout the colony, dropping the success rate to 0.1 chicks per nest or even less. Parents can be forced to abandon the colony to search for prey hundreds of miles away. Perhaps a sign of the stress imposed on the Humboldt penguins to survive and/or of their genetic proximity to the Magellanic, researchers in the Metalqui Islands have observed a breeding pair comprised of a Humboldt male and a Magellanic female, attending two chicks (Simeone et al. 2009).

Foraging

Humboldt penguins in the northern range are sedentary and remain close to their colony year-round. They dive in close proximity to their colony, typically between five and twenty miles, depending on whether their prey moves farther offshore. In the southern range, Humboldt penguins are migratory and leave the colony after the breeding cycle is completed. The average underwater dive is at a speed of 2.1 miles per hour (3.4 k mph). If speed is needed, they can accelerate to almost seven miles per hour when porpoising, with a top recorded speed of 6.9 miles per hour (11 k mph) (Culik and Luna-Jorquera 1997).

Penguins generally prefer to attack their target from below, as they try not to cast a shadow over their target and thereby warn it of their approach. Most dives last from one to two and a half minutes, and the longer of the Humboldt dives are also deeper and faster, suggesting they plan ahead. Their dives are unusually

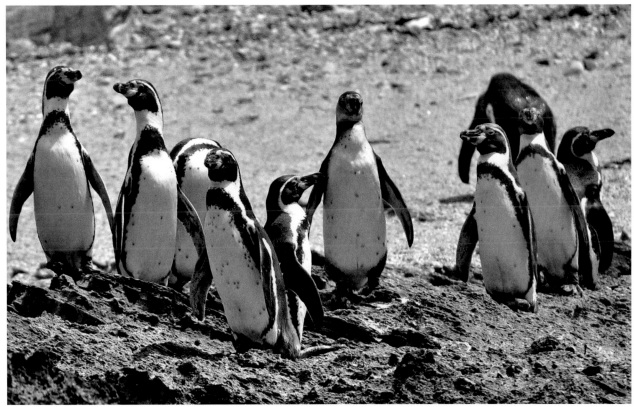

A group of Humboldt penguins near the beach in Punta San Juan, Peru

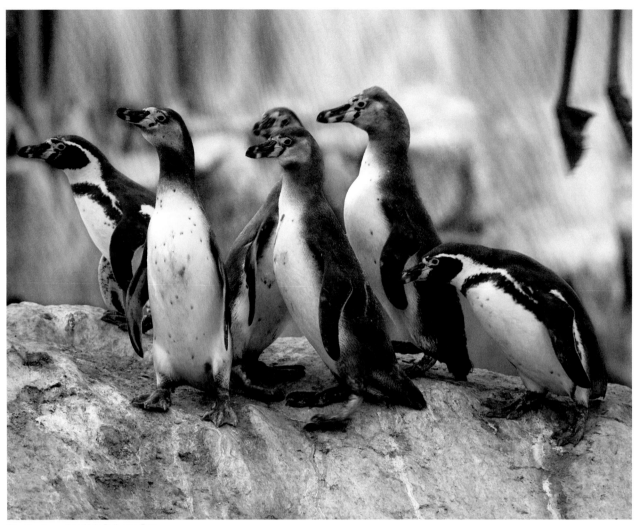
Climbing the rocks of Isla Ballestra, Peru

shallow for penguins, and they rarely venture below ninety feet (27 m) deep. The deepest dive recorded by a Humboldt was only 177 feet (54 m), with the longest dive recorded at 165 seconds. This is unusual, because at the speed they dive, they should be able to dive to the 500 feet (152 m) range (Luna-Jorquera and Culik 1999).

The Humboldt utilizes two very distinct foraging strategies. The first is used when normal, cooler water temperatures exist and the second during El Niño years. During normal years, Peruvian penguins swim in groups and prey almost exclusively on shoaling smaller fish, mostly Araucanian herring (anchovies), silversides, and garfish. Together these fish represent almost two-thirds of the Humboldt's diet. The biggest hardship they face is that their preferred fish are also favored by humans. Fishermen in South America are hunting for the exact same fish, depleting the Humboldt penguin's supplies rapidly and aggressively (Herling et al. 2005).

During El Niño years, the water temperatures in the Pacific Ocean and other seas increase for unknown reasons. This increase in water temperature only lasts for a few months but causes the climate worldwide to become stormy and the fish to migrate deeper or southward to cooler waters. Thus, as its preferred prey disappears from its range, the Humboldt resort to a secondary strategy. They start increasing the distance they swim from the colony and their chicks, at times staying at sea overnight and traveling forty to fifty miles away (65–80 km). If they still cannot find fish there, they begin swimming farther and farther away. At a certain point, it becomes impossible to return and relieve their mate. When this occurs, the waiting partner, after some time, is forced to give up the entire nest. Peruvian Humboldt penguins were recorded traveling up to 600 miles (965 km) away during the El Niño year of 1998. At one point almost all the breeding adults took off from the colony in search of prey. They did not return to their nests for weeks, leaving all the chicks to die of starvation (Culik et al. 2000).

Molting

In Peru, once the second brood of chicks has entered the sea and fledged, the adults take a two- to four-week premolt foraging trip. The majority of Humboldt penguins molt in January in Peru and February in Chile. January and February are the hottest months of the year and it makes molting a very difficult experience. The land phase of the molt takes between two and three weeks. While molting, they do not stay next to their nests but instead gather on rocks close to the ocean to take advantage of the sea breeze. On the rocks they are surrounded by other molting penguins but also by many flying birds. They sleep most of the time as their bodies try to maintain a low metabolism, but they still manage to lose 30 to 55 percent of their premolt body weight. To regain the weight lost, they take another extensive foraging trip, postmolt, which normally lasts two to four weeks.

Nesting

Humboldt penguins nest on rocky islands, coastal beaches, and inlets. Some use burrows dug in guano, which seems to offer the best cover from the sun to allow optimum temperatures for the chicks. It also affords better protection from predators looking to prey on the eggs or young chicks. Normally, more experienced breeders will bring leaves, loose feathers, and seaweed to pad the nest. In the absence of guano, the Humboldt penguin is forced to build a surface nest dug in softer ground or to look for caves closer to the ocean (*Birdlife International*, 2003). Nesting success rates fall with non-guano nests and with those close to water locations.

Relationships

Humboldt penguins are affable, both in the wild and in captivity, compared to other penguin species. Almost all couples that survive return to their nest and partner the following year. The mating process commences upon the return of the female from her postmolt foraging trip. The male initiates and calls first, advertising by standing very straight next to the old nest site, flippers pushed back and neck and head stretched toward the sky. The female returns her own, almost identical call. As they get comfortable, the pair starts touching each other while standing or lying down together. They begin mutual preening, and afterward they hug some more or exhibit coordinated movements of the neck and head that resemble dancing without foot movement.

They start looking for nest building materials, which get them very excited. The bonding phase lasts about ten days and then the first copulation takes place. Humboldt penguins are less aggressive with each other than most other species. Their colonies do not resemble a battleground during the beginning of the mating season like their Magellanic cousins. However, fights and bill duels do take place, and a few can escalate into bloody conflicts.

Many of the calls and signs used during bonding sound and look similar, from a distance, to those used in fighting. The differences are the intensity of the move, the distance between the two birds, and the direction the bill and eyes are pointing. Pointing the bill directly toward another bird signals aggression, but pointing it away from another bird signals appeasement.

Vocalization

Humboldt penguins use their voice and calls mostly for peaceful activities such as recognition, mating, nest relief, and dive coordination. Their most recognizable call is a bray, similar to that of the African penguin, performed by both sexes. When this species becomes nervous or scared they cling closer to each other and bray with a lower-intensity call. While diving at sea, they use a contact call that is a shorter version of the bray. In a dispute, a yell will be given while one bird gets closer and the opposing birds point their bills toward each other.

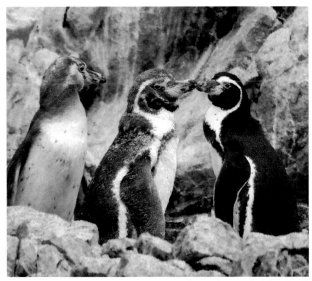
The center penguin is in midmolt

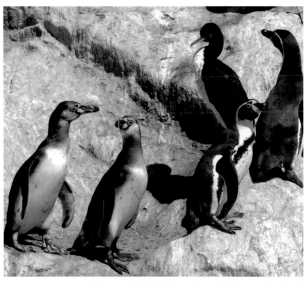
A group of Humboldt penguins on their way to the beach

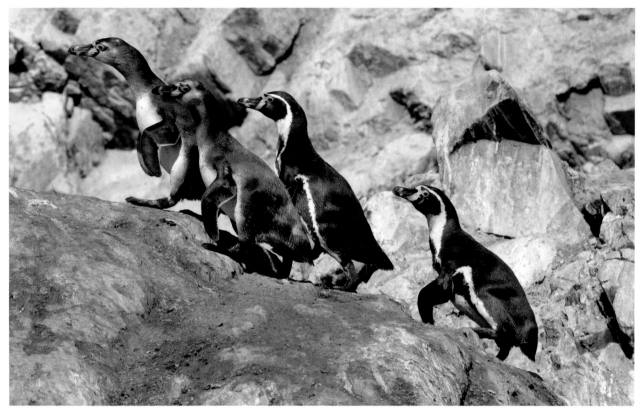

"Skinny and uncomfortable in the hot, dry weather"

Dangers

Man represents the biggest danger facing the Humboldt penguins. Like other species that live closer to human settlements, they suffer a great deal from the direct and indirect actions of human activities. Egg collections, guano harvesting, over-fishing and just plain killings drove the Humboldt penguins close to extinction. It is a severe crime to hunt a penguin or fry a penguin egg nowadays, both in Chile and Peru, but in some areas it is still legal to harvest the rich and valuable guano, which is used as a high-grade fertilizer. Harvesting the guano around a penguin colony, even if it does not kill the penguin or the chick, reduces the chance of the replacement nest to be successful by 50 percent. Commercial fishing is another terror for Humboldt penguins. First, there is the physical danger of suffocating after being caught in fishing nets, and even greater damage is being done by reducing the available prey as humans and penguins continue to hunt the same fish simultaneously.

As with its northern cousin, the Galapagos penguin, the Humboldt is greatly affected by El Niño. A strong El Niño decimates breeding success, and also causes the adult population to plummet.

In addition to the above dangers, Humboldt penguins' nests are also subject to attacks by flying birds, like gulls, mostly against eggs and very young chicks. In populated areas, feral cats, rats, and dogs are a large threat. At sea, sea lions prey on the Humboldt.

Conservation Efforts

The Humboldt penguins need help if they are to survive in the wild. In the past several years, a few universities and zoos have become earnestly involved in trying to save this species. Researchers from the Saint Louis Zoo, the Chicago Zoological Society, the Brookfield Zoo, the University Of Illinois College Of Veterinary Medicine, the Center for Environmental Sustainability (CSA), and Cayetano Heredia University in Peru all collaborate in studies to help the Humboldt penguin. The walls around the Punta San Juan colony in Peru were fortified, closing the site to visitors and the most damaging of man's introduced animals. Still, the hardest part of the conservation fight is to establish fishing-free zones around the Humboldt rookeries. A shrinking fish (food) supply hurts the penguin's long-term survival chances and becomes an especially acute danger when El Niño is present. There is a school of thought which claims that until such sizable fishing-free zones are established and enforced, saving the Humboldt penguin will be impossible.

In the meantime, scholars are trying to better comprehend the hardships and dangers facing the Humboldt. For example, if it is possible to pinpoint why most juveniles never survive their first years, we might be able to help increase the survival rate of those young penguins.

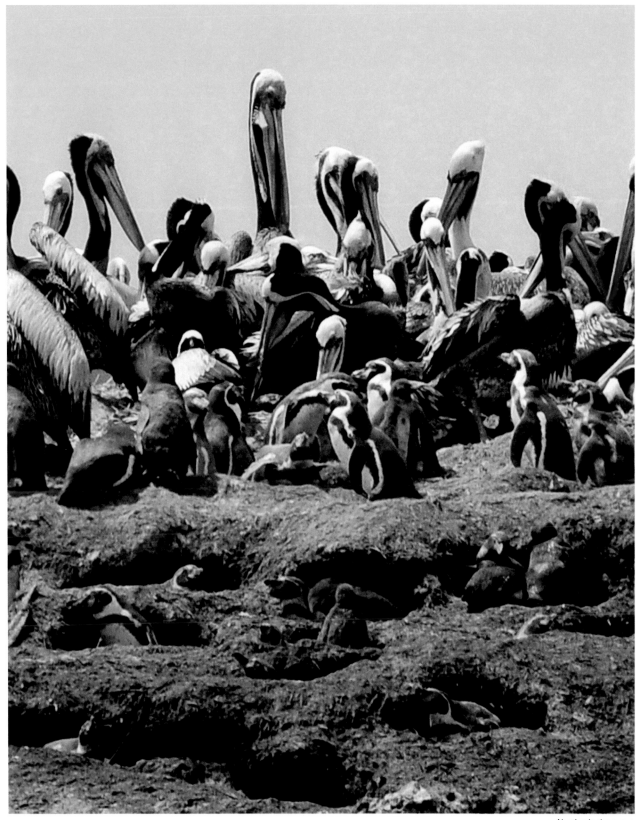

Nesting in the guano

Interesting Research

Schwartz, Boness, Schaeff, Majluf, Perry, and Fleischer (1999) wrote a research paper called "Female-Solicited Extra-Pair Matings in Humboldt Penguins Fail to Produce Extra-Pair Fertilizations." In the paper they intimately describe the sexual behavior of Humboldt penguins, including extra-pair relationships. Their amazing findings suggest that the female carries the ball in the pair's relationship, its formation, its maintenance. The male just follows the wishes of the female, even at the critical moment when the male is on top of the female during copulation, because if she decides she does not want to continue, the male gives up the effort and waits for another, better opportunity.

Females are the force behind the bond for life between the pair, but they are also responsible for two-thirds of the infidelities that are a common occurrence among the Humboldt penguins. In other words, a female will fight with another female over her mate, bond with him, and then promptly stop by another nest and have an extra-pair encounter with another male. Like nothing ever happened, she then returns to her nest and partners with her mate for life. Yet, the most interesting part of this study is that Schwartz et al. also carried out a genetic source of both the parents and the chicks in order to establish which male the chick's father was. Although 50 percent of the nests experienced an extra-pair relationship before the egg was laid, the genetic tests showed that none of the chicks were born of an "outside" father. All the chicks tested were sired by their guarding fathers, which put great doubt into what the purpose behind all the extra-pair cheating is.

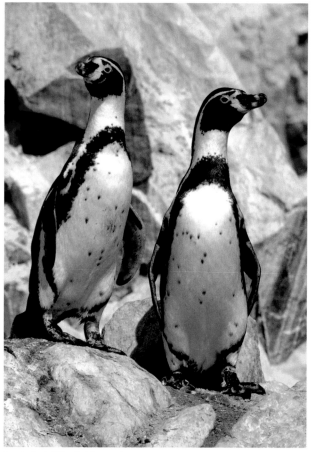
A pair of adult Humboldt penguins

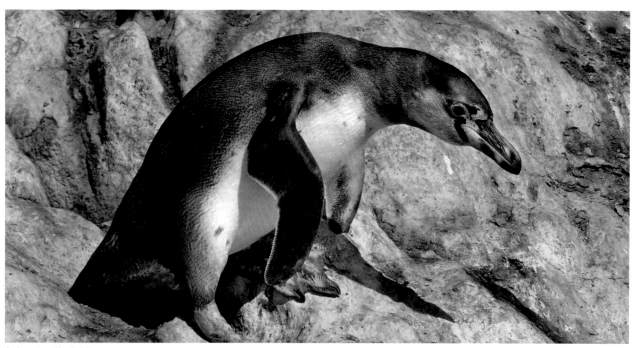
An immature Humboldt

Charts

Weights	Source 1	Source 2	Source 3
Average Male	10.8 lb/4.9 kg	10.4 lb/4.7 kg	10.6 lb/4.8 kg
Average Female	9.9 lb/4.5 kg	8.8 lb/4.0 kg	9.5 lb/4.3 kg
Lengths	**Source 2**	**Source 3**	**Source 4**
Flipper Length Male	6.14 in/15.6 cm	6.9 in/17.4 cm	8.5 in/21.7 cm
Flipper Length Female	5.9 in/14.9 cm	6.5 in/16.6 cm	8.2 in/20.9 cm
Bill Length Male	2.6 in/6.5 cm	2.5 in/6.4 cm	2.6 in/6.5 cm
Bill Length Female	2.4 in/6.1 cm	2.4 in/6.1 cm	2.4 in/6.1 cm
Bill Depth Male	1.0 in/2.6 cm	1.2 in/3.0 cm	1.1 in/2.8 cm
Bill Depth Female	0.9 in/2.3 cm	1.06 in/2.7 cm	0.98 in/2.5 cm
Head Length Male	5.3 in/13.5 cm	5.6 in/14.2 cm	
Head Length Female	5.0 in/12.7 cm	5.5 in/14.0 cm	

Source 1: Williams 1995—Captivity. Source 2: Zavagala and Paredes 1997—Punta San Juan, Peru. Source 3: Zavagala and Paredes 1997—(Captivity) Metro Washington Park Zoo, Portland, Oregon. Source 4: Wallace et al. 2008—Islote Pájaro Niño, Chile.

Biology	Source 1	Source 2	Source 3, 4, 5
Age Begin Breeding (Years)		2–5	
Incubation Period (Days)	42	42	42[3]
Brooding (Guard) Period (Days)		25	
Time Chick Stays in Crèche (Days)		50	
Fledging Success (Chicks per Nest)	1.30	0.62–1.31	0.94 (4-year avg.)[3]
Mate Fidelity Rate	60%	90% (Captivity)	
Date Male First Arrives At Rookery	Mid-Mar.		Mar.[3]
Date First Egg Laid	Mar.–Dec. (Peak Apr. and Sept.)		End Mar.–Dec.[3]
Chick Fledging Date		Peak Aug.	Peak Dec. and Jul.[3]
Premolting Trip Length (Days)		14–21	14[3]
Date Adult Molting Begins	Jan.–Mar.		Jan.–Mar.[3]
Length Molting on Land (Days)	21		21[3]
Juvenile Survival Rate First 2 Years		0.2	
Breeding Adults Annual Survival		0.7	
Average Swimming Speed		2.3–6.5 mph/3.7–10.5 kmph	3.8–4.3 mph/6.1–6.9 kmph[4]
Maximum Swimming Speed		6.5 mph/10.5 kmph	
Deepest Dive on Record		177 ft/53.9 m	173.9 ft/53 m[4]
Farthest Dist. Swam From Colony		560 mi/901.2 km	42.7 mi/68.7 km[4]
Most Common Prey		Anchovy	Fish[5]
Second Most Common Prey		Sardine	Crustacean[5]

Source 1: Paredes et al. 2003—Punta San Juan, Peru. Source 2: Williams 1995—Various Locations. Source 3: Zavalaga and Paredes 1997—Punta San Juan, Peru. Source 4: Luna-Jorquera and Culik 1999—Pan de Azúcar, Chile. Source 5: Herling et al. 2005 –Pan de Azúcar, Chile.

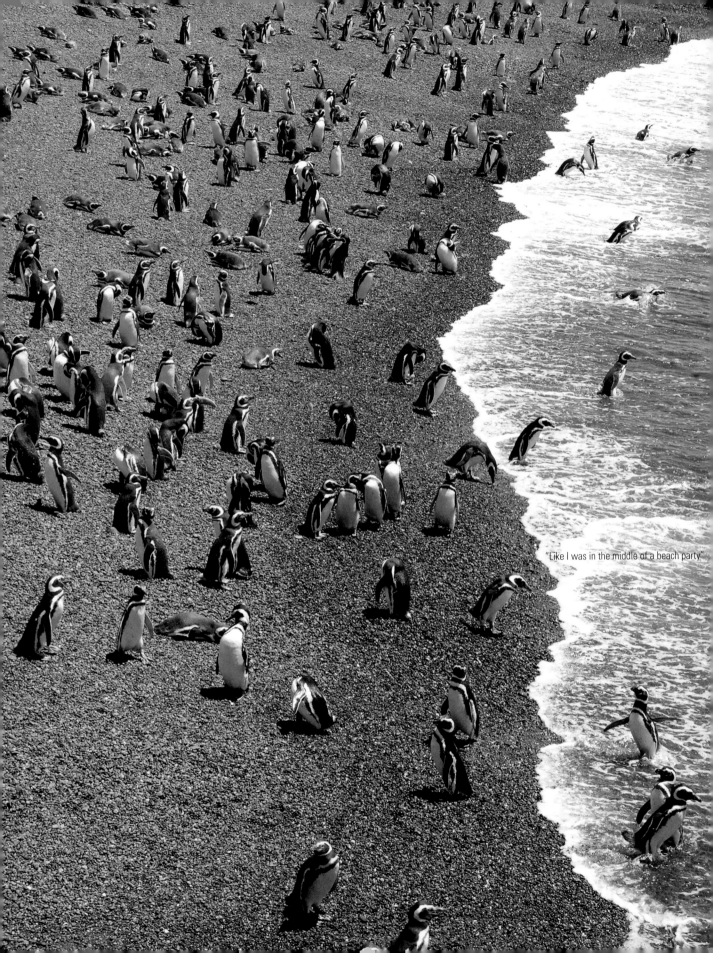

"Like I was in the middle of a beach party"

Magellanic Penguin
Spheniscus magellanicus

Genus: *Spheniscus*

Other Genus Members: Humboldt, African, and Galapagos

Subspecies: None

IUCN Status: Near Threatened

Latest Population Estimates
 Individuals: 3.5–4.0 million
 Breeding Pairs: 1.3–1.6 million

Life Expectancy
 Wild: Average 10 years, some live to 15–20 years
 Captivity: Longest 35-plus years

Migratory: Yes, they are absent from the colony from April to August.

Locations of Larger Colonies: Punta Tombo, San Lorenzo, and Cabo Virgenes, Argentina; Magdalena Island, Chile; Falkland Islands

Colors
 Adult: Black, white, and pink
 Bill: Black with a gray to white band closer to the tip
 Feet: Black with pink patches
 Iris: Brown, sometimes with a red ring
 Chick Down: Brown
 Immature: Black with gray, white, and pink patches

Height: 24–26 in/61–66 cm

Length: 26–28 in/65–72 cm

Normal Clutch: 2 eggs per nest

Maximum Chicks Raised per Pair per Year: 2

The Magellanic penguin is also known as the Patagonian penguin.

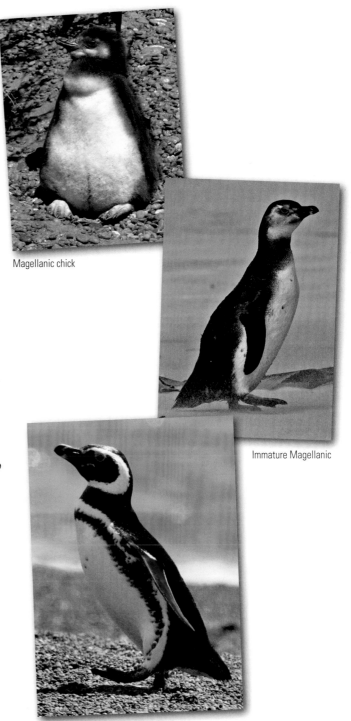

Magellanic chick

Immature Magellanic

Magellanic adult

David's Observations

*T*he first penguin I ever met was a Magellanic. I drove the forty-mile (64 km) distance from Punta Arena, Chile, to the Seno Otway colony and instantly fell in love with the majestic birds. Later I flew to Trelew, Argentina, and drove to the large Punta Tombo colony. While in the area and actually photographing whales, I discovered the San Lorenzo colony. After getting stuck for hours on a muddy road in a private ranch on Peninsula Valdés, I was picked up by the owners and was able to take the guided tour. The intimate viewing of the penguins combined with the great hospitality (also good food) of the owners of that ranch made for some of the most enjoyable penguin watching I have had anywhere.

Visiting the Magellanic at different times of the year causes you come away with completely different impressions of this penguin. Come during the early chick guarding phase, and the colony looks like the most peaceful, loving place on earth. Yet if you come again a year later in late September, that same loving colony looks like a madhouse. Fights are everywhere, faces are bleeding, birds are nervous, and many bray loudly for lost mates. Aggression is the main theme in early spring.

Then, late in the breeding season during February, just before the chicks fledge, thousands of peaceful penguins again crowd the beach. Only a passing seal makes them disperse. The entire colony spends long hours enjoying the sun, getting in and out of the water, and creating lively, happy noises. It made me feel like I was in the middle of one big beach party.

A Magellanic chick in San Lorenzo, Argentina

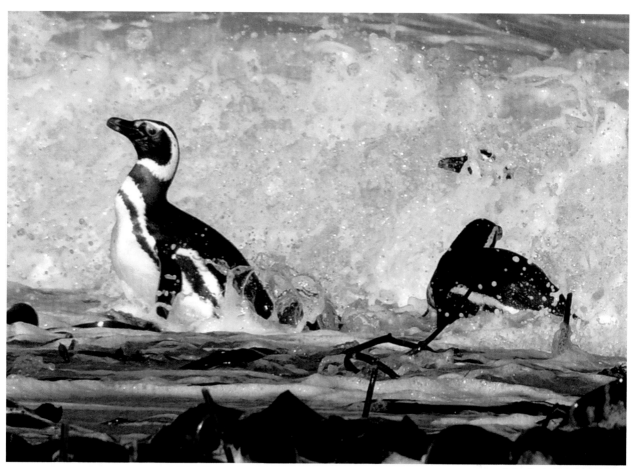

Swimming in the Falkland Islands

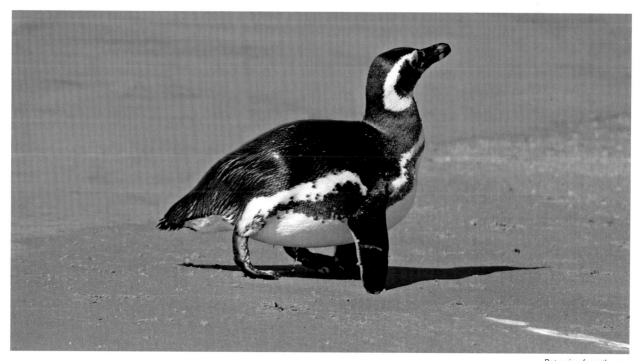

Returning from the sea

About the Magellanic Penguin

Population Trend

Holding steady. Population trends vary widely in the different ranges of Magellanic habitats. Overall, numbers are in stable condition in most South American locations and are even growing in specific colonies. On the other hand, their existence in the Falkland Islands is in peril, with numbers there declining. A clear trend is emerging in which very large colonies like Punta Tombo are losing population, while smaller colonies are gaining population. The suspected cause is food shortages due to too many penguins competing for fixed or decreasing food supplies.

Habitat

Magellanic penguins are migrating birds, just like many flying birds, except that they migrate by swimming. They possess the most amazing navigation capabilities, enabling them to travel, in some cases, 2,000 miles (3,219 km) in the water and later return to the exact same spot they departed from.

Around April, the breeding Magellanic adults leave the Patagonia and Falkland shores to swim north to Peru and the central Brazilian coast. Near September they swim the return leg of the trip, landing at the beach and settling right into the same nest they used the year before. The mileage traveled on their winter journey round-trip can easily exceed 4,000 miles (6,437 km).

During the summer, Argentina, with sixty-three breeding sites and at least 800,000 breeding pairs, is home for most of the Magellanic nests. These penguins nest in places like Punta Tombo, Caleta Valdés, San Lorenzo, and Cabo Vírgenes. Of the thirteen known sites in the southern islands of Chile, Magdalena Island is the largest colony. The Falkland Islands also contain at least eight sites. The largest of these is on Sea Lion Island, which is home to about 100,000 breeding pairs.

Magellanic penguins are very adaptive to captivity and can be found in many zoos around the world.

Appearance

The Magellanic adult, like other banded penguins, features mostly a black back and white underbody, as well as a black and white head and neck. The only other color present is in the pink featherless patches on the face and feet. The most visible markings are the white band around the mostly black face and the black around the white underbody. The front of the neck and chin are two-thirds black, complemented by the almost perfect white band that extends near the eyes and by irregular pink patches near the bill and eyes. Some describe the color pattern as two inverted black horseshoes on a white bac kground, but pictures do it far better justice than words ever could. The underbody is almost all white with a few black dots spread across the chest. Some individuals

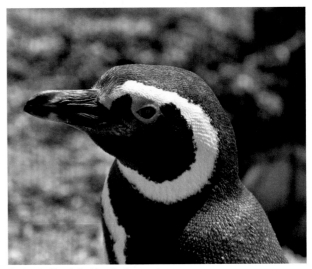
The banded head of a Magellanic penguin

have more dots than others, and some do not have them at all. The bill is almost all black except for traces of faded yellow to faded white toward the end. The feet are also mostly black, while the legs are stained with pink and white patches. The flippers are black on the outside and a faded white on the underside.

Immature Magellanic colors are lighter, with a brown to black back turning white at the underbody, but without any clear bands. The lack of well-defined bands makes the juveniles appear quite different from adults.

Chicks

Chicks are born blind and without the ability to maintain the necessary body temperature on their own. A parent must sit on them and thermally protect them for first seven to ten days. The Magellanic penguin lives in strikingly different weather conditions, so depending on where they breed, there is a substantial danger of the chick freezing or dying of heat stroke. Sometimes both extremes occur in the same location, like in certain parts of Patagonia, where the temperature can vary by 45°F within the same day.

Chicks wear a brown down. When it thickens, it enables them to maintain their own body temperature and wander outside the nest. Once the youngster reaches thirty days of age, both parents can leave to forage. Most chicks join a crèche, while some remain next to the nest alone or join the crèche much later. Seven and one quarter pounds (3.3 kg) is considered a good fledging weight for the Magellanic chick. When their weight is less than six and a half pounds (2.9 kg), their chances of surviving the first year at sea are low. Even at a proper weight, only 20 to 30 percent of the chicks that fledge survive to breeding age.

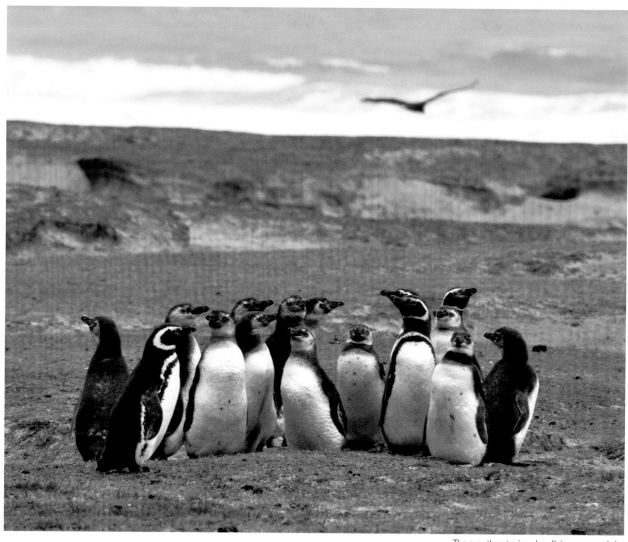

The ever-threatening skua flying over a crèche

In January, less than one year after they fledge, the juvenile goes through its first catastrophic molt. Upon completion it attains an adult appearance, complete with black and white bands.

Breeding and Chick Rearing

Magellanic penguin breeding is very synchronous; almost all eggs in the colony are laid within two weeks of each other. The length of the breeding cycle varies from one geographic area to another, and fledging success varies widely by location, season, and year, depending mostly on food availability. In Punta Tombo, where food is more difficult to come by due to the large size of the colony, chicks fledge when they are about 120 days old. In contrast, fledging takes place at sixty to seventy days of age in the Chilean colonies of Magdalena and Otway, which are blessed with a rich supply of food. While a one-chick-per-nest success rate is considered healthy, the average, in most colonies, is only between 0.5 and 0.65 chicks per nest.

Breeding season begins with the arrival of the males in early September to claim their old nest from the previous year. Females show up a few days later and almost always rejoin their former mate. As things settle down, the courting ritual takes place, the bonds are reaffirmed, and the female lays two eggs, usually two days apart.

The male fasts for two to three weeks during the nest fights and until the eggs are laid. The female incubates for the first shift of twenty-one days. The male then relieves her for a shorter shift, and the female returns in time to see the eggs hatch.

During chick brooding, parents take daily or bi-daily shifts, depending on the proximity of the food source to the colony. As chicks become old enough to join a crèche, both parents can enter the ocean every day and return to feed the chicks in the afternoon. The chick enters its fast growth phase, and ten days before fledging the parents stop feeding their chick all together.

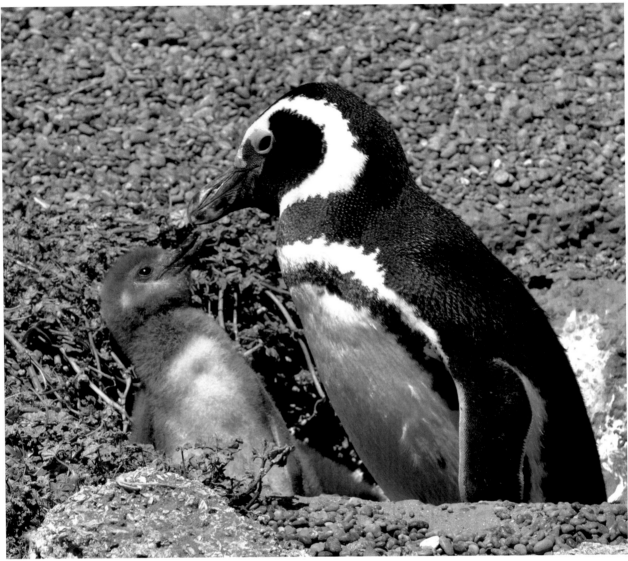

A hungry chick begs for food in San Lorenzo, Argentina

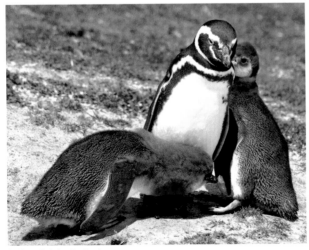

Siblings fighting for food

Raising a chick to fledging requires two experienced and dedicated parents, as obstacles are everywhere. Yorio et al. (2001) studied Magellanic breeding at Isla Vernacci in Argentina during the 1999–2000 season. They reported that 90 percent of the nests started with two eggs but that about 36 percent of the eggs were lost before hatching. Eggs were preyed upon by avian birds, lost to flooding, or broken due to damage inflicted by other animals, aggressive single penguins, or, more seldom, a lazy parent. After the chicks hatched, two new dangers were apparent and claimed more young lives: heat exposure and starvation. Magellanic foraging habits and diet seem to be affected by unstable food supplies around the breeding areas, and as a result almost one-quarter of the chicks starve to death. Only 47 percent of the chicks hatched survived to fledging, and fledging success rate for this study was at 0.56 chicks per nest.

Foraging

Magellanic penguins swim in groups and prey on a variety of small fish, depending on location and availability. Secondary preferences are squid and krill. In the Magdalena Island colony, the preferred prey is sprats, but in other locations it might be anchovies, hake, sardines, or smaller cod. If these fish are not present, the Magellanic will downgrade to cuttlefish, squid, and krill. When hungry they will catch krill, even though some stomach content studies express doubt on whether or not they can fully digest it.

The size and location of the colony directly correlates to the type of prey hunted and the distance at which foraging takes place. When the colony is larger, food is depleted faster in areas close to the colony, so foraging trips tend to be longer and can extend overnight. In smaller, more dispersed rookeries there is less need to travel far (Radl and Culik 1999). Magellanic penguins will also travel farther to find food during the guarding phase. When they launch a short trip they begin later in the day, and when it's longer they begin much earlier. The penguins seem to have a pretty good idea where to go even before they enter the water. Underwater dives last up to 120 seconds and, in extreme cases, may last up to 180 seconds.

When the distribution of prey is normal, trips extend about ten to twenty-five miles from the colony, but in extremely poor food conditions, Magellanic travel up to 190 miles (305 km) on one trip. Most dives are less than 150 feet (45.7 m) deep, and the deepest recorded dive was only 318 feet (96.9 m), hardly impressive for a penguin. Very flexible, the Magellanic constantly changes its habits and tactics as it adapts to prey distribution.

Molting

In March, after the chicks fledge, the Magellanic go into a two- to three-week premolting trip. The biology of the molt begins while they are at sea. As the molt progresses, the penguins must go on land and stand there for nineteen to twenty-two days. Swimming during a molt is not possible because the penguin's skin is punctured and not waterproof. In a colony the younger and nonbreeding tend to molt two to three months sooner.

Molting is a traumatic event, and the individual must be fit and at a proper weight to survive it. The energy demands are extensive, and lack of sufficient body mass at the start of the molt can cause death, as happens from time to time in the Falkland Islands. During the molt the penguins just stand for days trying not to move or expend energy. Their metabolisms slow down, and most prefer to sleep to pass the time.

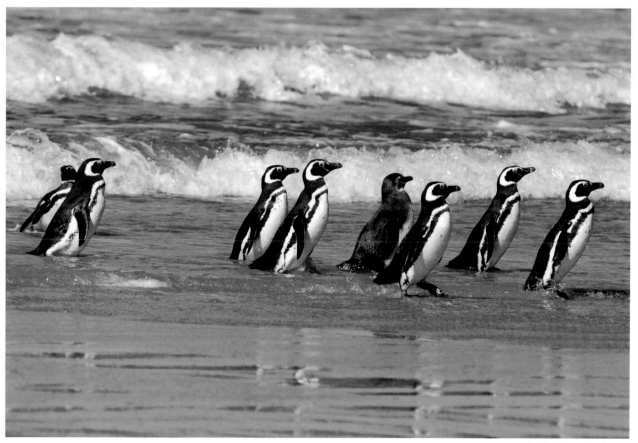

Arriving from a foraging trip

Nesting

Magellanic penguins dig a burrow with their nails and sometimes flippers, frequently locating their nest under the shade of a plant or a big rock and often adding padding materials. Nests are close to each other, just three feet (0.9 m) apart, and there is a noticeable difference in neatness and quality of materials from one to the next. After all the nest fights, most couples stay close to their neighbors, sometimes three nests under one bush, to help each other fight the ever-threatening skuas. Still, there are those pairs that prefer to be 50 feet (15.2 m) or more from the nearest nest.

Relationships

Relationships among fellow Magellanic penguins depend on the season. At the beginning of the breeding season they are extremely aggressive toward each other. Males come ashore first and are quick to get into fights with each other over nest locations. If the returning male finds another individual on its nesting ground, a bill duel or a fight will instantly break out. Magellanic penguins are more aggressive than most other species of penguin; males and females fight extensively during the early part of the breeding season, normally with their own sex. The end result is many fights and a colony full of injured faces in early October.

These penguins seem to follow Marquess of Queensberry rules as they fight, allowing the opponent to withdraw and avoid too much bloodshed. First, they call, announcing their intention to fight. Next, they point their bill at their opponent and move their head and eyes rapidly. If the intruder does not leave, a bill duel ensues. During a bill duel, both penguins catch and hold each other with their bills, causing them to interlock. It is a sort of prefight strength test and causes no injury. Quite often, the weaker penguin will give up, even though it can take several rounds to produce a clear winner. A real fight, which may be short but can inflict some serious injuries, involves beak bites and massive flipper smacks.

Females mostly fight and injure other females over their choice of mate. It should be noted that a severely injured penguin is a prime target for flying birds like petrels or skua. These birds are constantly on the lookout for weak and bleeding penguins to attack. However, in the end about 85 percent of returning males assume last year's nest (Boersma 2008), and an even higher percentage of females retain their old mate.

In short order the fights are forgotten and the colony becomes a peaceful breeding ground. It is time for the softer side of the Magellanic personality to appear. They are very affectionate, displaying and calling for their mate for days to affirm their relationship. They preen each other, walk together, hug, and touch to assure their mates from last year of their renewed commitment. Yet after the first nest reunion, the female may stop at another

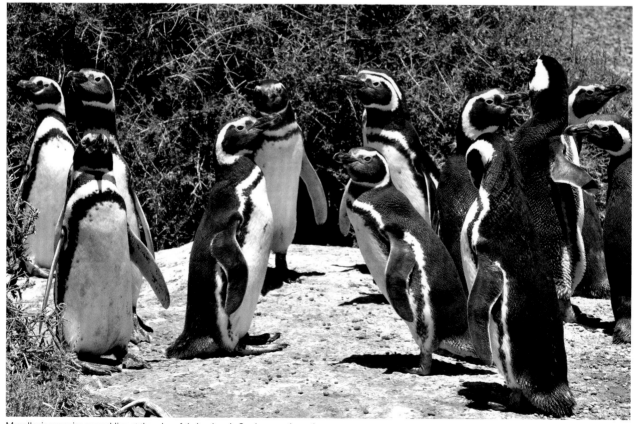

Magellanic penguins assembling at the edge of their colony in San Lorenzo, Argentina

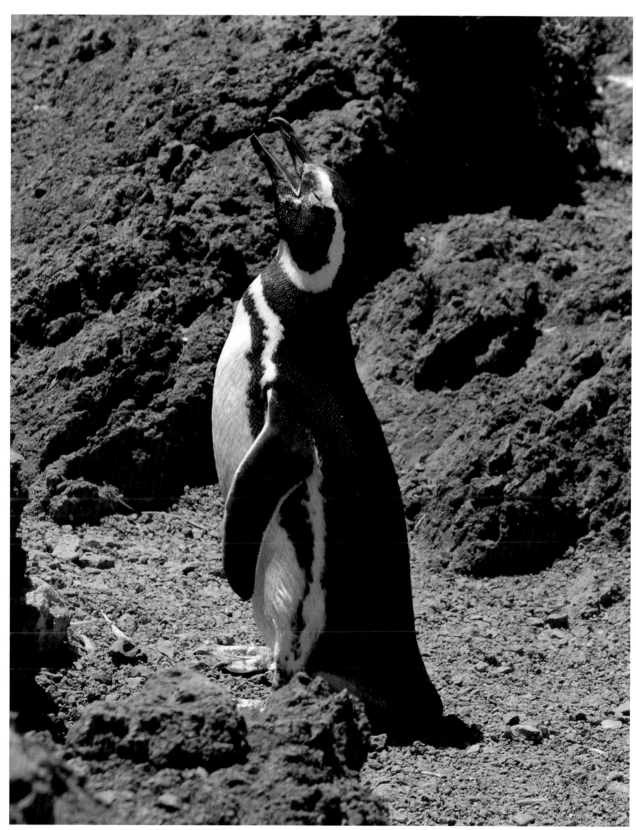

A parent calling to its chick in Punta Tombo, Argentina

male's nest and cheat on her mate, the same one she fought so hard to retain in the first place! Cheating is a frequent event, but its biological reason is not really understood by researchers.

Vocalization

Use of voice by the Magellanic penguin is common. The basic call sounds like a bray, similar to that of the African penguin. The same call with slight variations is used for different reasons, mainly advertisement and recognition. Sometimes a single bray is used, but more often there are a series of brays. At times a few males will stand next to each other braying, their heads pointing to the sky, but to be considerate of each other they might trade off, and one finishes braying before another one begins. Brays are more common with males, and there is more noise during the mating period and fights associated with the beginning of the nesting in October than after the eggs are present.

Dangers

It could easily be said, as it is with most other genus members, that the Magellanic penguins' biggest threats are a direct result of man's actions. They find themselves in competition with humans over the fish they prefer. They also swim in the middle of busy shipping lanes, and, until recently, between 20,000 and 40,000 Magellanic penguins died every year from residues dumped by seamen. Laws are now on the books to banish and severely punish such acts, but enforcing them midsea is not always easy.

Fur seals prey on Magellanic penguins and will attack younger, less experienced members of the colony. Older penguins manage to escape using porpoising and other tactics to avoid the faster-swimming seals. Loss to seal attacks is on the rise because the seal population is growing. Seabirds like skua and kelp gulls snatch eggs or even unguarded young chicks. Cats, rats, ferrets, and dogs are becoming an increasing predator problem on land.

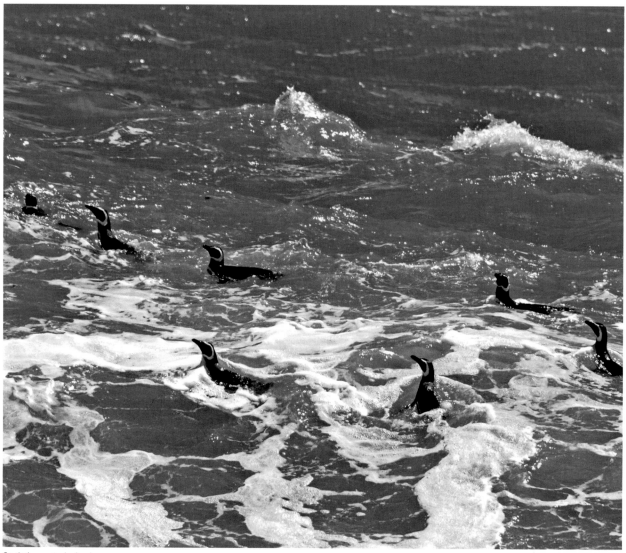

On their way to dry land

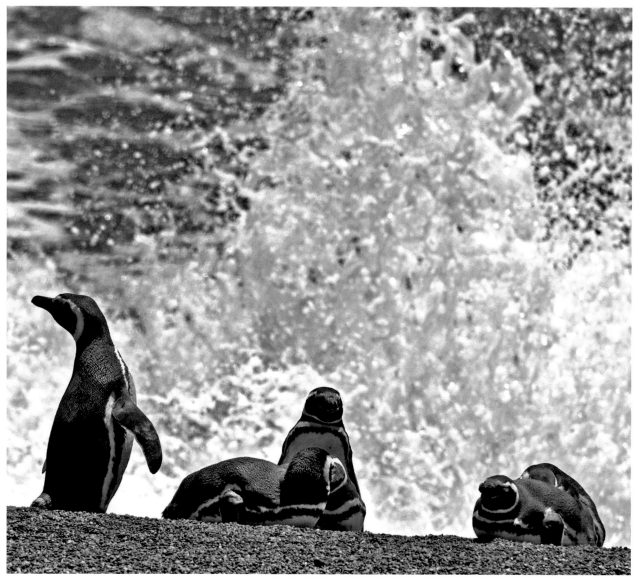

Resting by the water

Conservation Efforts

The old days of frying penguin eggs or killing penguins for sport or oil are long gone. Today, everywhere that Magellanic penguins breed, there are international treaties and local laws that impose severe penalties for such crimes. However, these alone are not enough. Governments and scientists need to work hand-in-hand to lessen the dangers facing penguins.

The Magellanic Penguin Project in Argentina is a project that combines both government and academia. It is a joint project of the Wildlife Conservation Society, the Province of Chubut, the University of Washington, and other universities and researchers. The joint effort was launched in 1982 after a Japanese company sought a concession to harvest Magellanic penguins in Argentina, which alarmed penguin lovers the world over. The project trains next-generation conservation biologists, gathers the scientific information to inform decision-makers, and helps in the protection and management of Magellanic penguin colonies.

The local and federal governments of both Chile and Argentina have open ears to concerns raised by researchers working for the project. They try to control access to the larger penguin colonies and tread a fine line by allowing visitors, but keeping them at a reasonable distance from the breeding grounds and beaches. In Punta Tombo, Argentina, there are clearly marked paths and even bridges so that a visitor can walk around, but not be in the way of, the breeding parents when they go on- or off-shore. The biggest violators of visitation rules are the penguins themselves, as they are constantly building their nests closer and closer to the visitor areas.

Interesting Research

Renison, Boersma, Van Buren, and Martella wrote an article called "Agonistic Behavior in Wild Male Magellanic Penguins: When and How Do They Interact?" The paper describes in detail the nest possession conflicts between Magellanic males in the largest colony of Punta Tombo. The paper establishes that the males are in charge of the nest choice, and that they prefer to return to last year's nest, particularly if last year's breeding was successful. This is not always easy, since other males might try to steal a nest to improve their location and chances of success.

The interesting point Renison et al. shows is that male fights conform to the recognized human psychological theory called Game Theory. Game Theory claims that humans will invest larger effort and energy to pursue a larger prize. The researches proved the male penguins' behavior conforms to the Game Theory. The better the location of the nest and the more shade above it, the more aggression takes place to secure it. For a hollow, uncovered nest, a bill duel was sufficient, but for a prime location, a big, bloody fight was necessary to settle the issue. In other words, Renison et al. found that human and penguin psychology has some common ground.

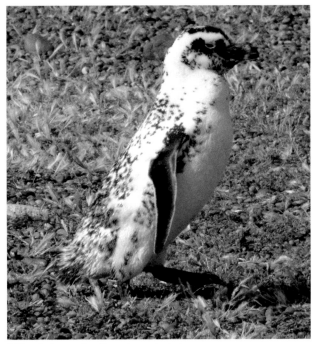
A Magellanic penguin with an abnormal coloring

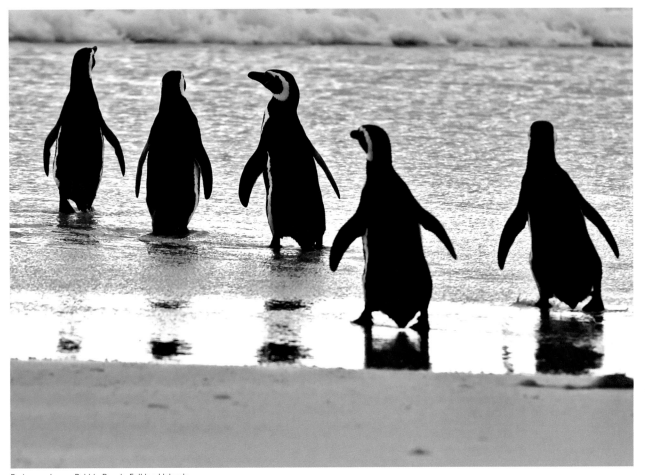
Early morning on Pebble Beach, Falkland Islands

Charts

Weights	Source 1	Source 2	Source 3, 4
Breeding Male Arrival	11.0 lb/5.0 kg	9.9 lb/4.5 kg	9.0 lb/4.1 kg[3]
Breeding Female Arrival	10.1 lb/4.6 kg	8.2 lb/3.7 kg	7.5 lb/3.4 kg[3]
Premolt Male	17 lb/7.7 kg		8.4 lb/3.8 kg[3]
Premolt Female	14.3 lb/6.5 kg		7.0 lb/3.2 kg[3]
Postmolt Male	7.1 lb/3.2 kg		9.0 lb/4.1 kg[3]
Postmolt Female	5.1 lb/2.3 kg		7.7 lb/3.5 kg[3]
Fledging Chicks	5.7–6.4 lb/2.6–2.9 kg	6.4 lb/2.9 kg	
Egg 1	0.28 lb/127.0 g		0.28 lb/127.0 g[4]
Egg 2	0.27 lb/124.7 g		
Lengths	**Source 1**	**Source 2**	**Source 4**
Flipper Length Male	7.7 in/19.6 cm	6.6 in/16.8 cm	7.7 in/19.6 cm
Flipper Length Female	7.3 in/18.5 cm	6.2 in/15.7 cm	7.3 in/18.5 cm
Bill Length Male	2.1 in/5.4 cm	2.3 in/5.8 cm	2.3 in/5.8 cm
Bill Length Female	1.9 in/4.9 cm	2.1 in/5.3 cm	2.1 in/5.3 cm
Bill Depth Male	0.9 in/2.3 cm	0.9 in/2.3 cm	1.0 in/2.5 cm
Bill Depth Female	0.8 in/2.0 cm	0.8 in/2.0 cm	0.9 in/2.16 cm
Foot Length Male	4.7 in/11.9 cm		
Foot Length Female	4.5 in/11.4 cm		

Source 1: Williams 1995—Punta Tombo, Argentina. Source 2: Bertellotti et al. 2002 and personal communication (2010)—Patagonian Coast of Argentina. Source 3: Jacksonville Zoo, personal communication 2010—(Captivity) Jacksonville, Florida. Source 4: Scolaro et al. 1983—Punta Tombo, Argentina.

Biology	Source 1	Source 2, 3	Source 4, 5, 6, 7
Age Begin Breeding (Years)	3–5	4–5[2]	4[4]
Incubation Period (Days)	39–42	39[3]	40[4]
Brooding (Guard) Period (Days)	26–32	21[3]	
Time Chick Stays in Crèche (Days)	40–50	40–50[3]	
Fledging Success (Chicks per Nest)	0.4	0.75 (10-year avg.)[3]	0.56[4]
Mate Fidelity Rate	85–90%		
Date Male First Arrives At Rookery	Early Sept.		Early Sept.[4]
Date First Egg Laid	Oct.5–15	Oct. 12–Nov.1[3]	Oct 14[4]
Chick Fledging Date	Feb.	Early Feb.[3]	Jan. 10– Mar. 5[4]
Premolting Trip Length (Days)	2–3 Weeks		
Date Adult Molting Begins	Late Feb.		Early Mar.[4]
Length Molting on Land (Days)	13		19[4]
Juvenile Survival Rate First 2 Years	Less Than 30%	43%[2]	42%[5]
Breeding Adults Annual Survival	82–95%	95%[2]	
Average Swimming Speed	4.7 mph /7.6 kmph		3.1–3.6 mph/5.0–5.8 kmph[6]
Maximum Swimming Speed	5.5 mph/8.9 kmph		
Deepest Dive on Record	295.3 ft/90 m		318.2 ft/97m[5]
Farthest Dist. Swam From Colony			188.3 mi/303 km[7]
Most Common Prey	Fish	Squid[3]	Anchovy[7]
Second Most Common Prey	Squid	Fish[3]	Spart[7]

Source 1: Williams 1995—Punta Tombo, Argentina. Source 2: Scolaro et al. 1983—Punta Tombo, Argentina. Source 3: Otley et al. 2004—Falkland Islands. Source 4: Yorio et al. 2001—Golfo San Jorge, Patagonia, Argentina. Source 5: Peters et al. 1998—Punta Norte, Peninsula Valdés, Argentina. Source 6: Radl and Culik 1999—Magdalena Island, Chile. Source 7: Wilson 1996, Wilson et al. 2007—San Lorenzo, Peninsula Valdés, Argentina.

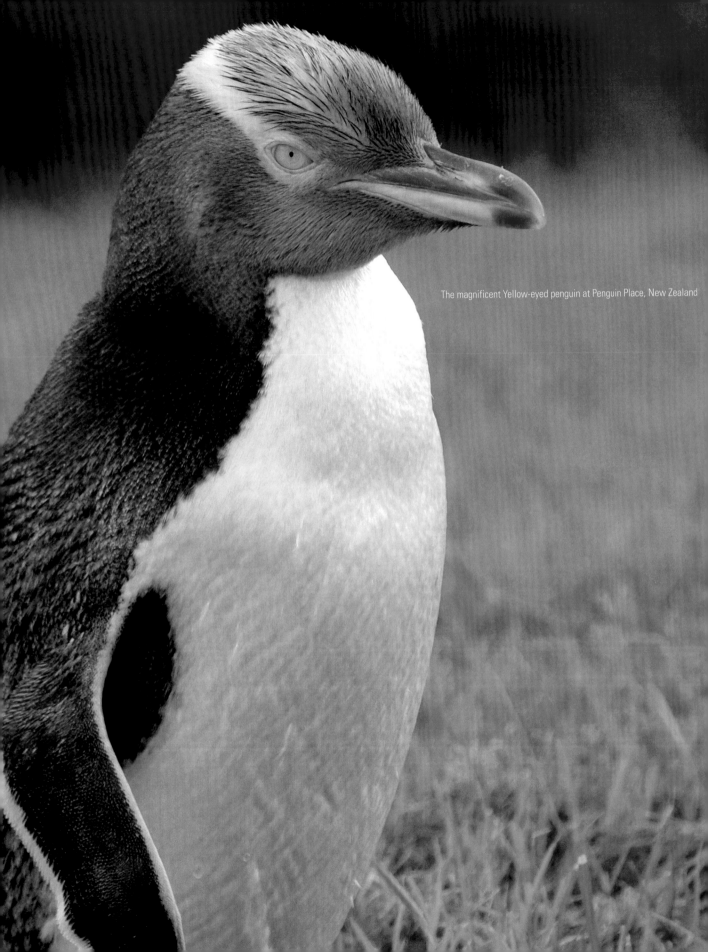

The magnificent Yellow-eyed penguin at Penguin Place, New Zealand

Yellow-eyed Penguin
Megadyptes antipodes

Genus: *Megadyptes*

Other Genus Members: None

Extinct Genus Members: One, 200–300 years ago

Subspecies: None

IUCN Status: Endangered

Latest Population Estimates
Individuals: 5,000–6,000
Breeding Pairs: Less than 2,000

Life Expectancy
Males, 10.8 years and females, 8.7 years
(Setiawan et. al. 2005)
Longest Life Recorded: 32 years; second longest, 28 years

Migratory: No, they are a sedentary species.

Locations of Colonies: Campbell Island, Auckland Island, Stewart Island, and southern coast of South Island, New Zealand

Colors
Adult: Black, light yellow to bright yellow, white, and/or pink
Bill: Orange, white, and brown/black
Feet: Pink
Iris: Yellow
Chick Down: Chocolate Brown
Immature: Similar to adult, but less yellow; iris is gray at first, slowly turning yellow within about five months of fledging.

Height: 24–29 in/61–73 cm

Length: 25–30 in/65–76 cm

Normal Clutch: 2 eggs per nest

Maximum Chicks Raised per Pair per Year: 2

The Yellow-eyed penguin is also known as the Hoiho penguin.

Yellow-eyed chick

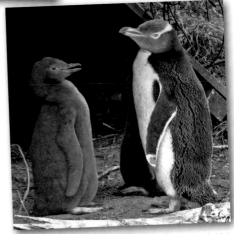
Yellow-eyed parent and chick

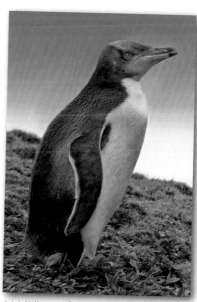
Adult Yellow-eyed

David's Observations

In order to see my first Yellow-eyed penguin, all I needed to do was rent a car in Dunedin, New Zealand, and take a short drive to Penguin Place on the nearby Otago Peninsula.

It was difficult to photograph a Yellow-eyed because of its un-penguin-like desire to be alone. Waiting on a beach all afternoon and evening, I observed a total of only five penguins. As they returned from the sea, I watched them dry and preen. It was strange to see the wide distance, at least 200 feet (61 m), that they kept from each other. This was a sharp contrast to the other crowded penguin colonies I had visited in the past. At Penguin Place, the viewing tunnels, along with a bit of luck, allowed me to capture photographs of a handful of chicks and adult Yellow-eyed penguins.

After visiting Penguin Place, I joined the Heritage Expedition Cruise to reach my next destination, the Campbell and Auckland Islands. At Auckland we encountered a mated pair. I lay fairly close to them and after some time what I believe to be the male took a walk toward me. He stopped about two feet (0.6 m) away from where I was to inspect me.

He opened his flippers and moved his head, as if he expected me to reply. Embarrassed that I could not answer, I just moved my head to the side. When he realized that I was not a match, the male simply walked away.

I spent almost the entire day walking in search of any sign of more penguins. About to give up, I stumbled upon a single, beautiful Yellow-eyed returning to the beach. I was able to quickly photograph the penguin. During my entire visit to one of the largest colonies of Yellow-eyed penguins, I met a grand total of three penguins. I was even less successful at Campbell.

The penguins' yellow eyes were magnificent, and the yellow arc that crowns their head gave them a royal grace. The Yellow-eyed penguins' tall height and smooth walk left a lasting impression on me. Upon leaving the colonies, I remembered the vast distance they kept from each other and the heartbreaking looks on their faces, which gave me the ominous impression that the Yellow-eyed penguins have already accepted their pending extinction.

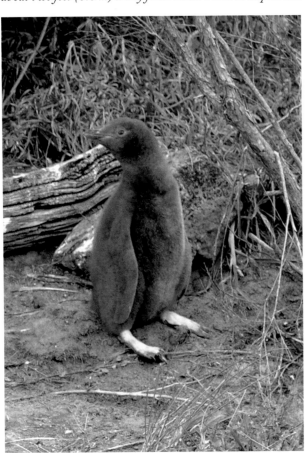

A Yellow-eyed chick wandering around the nest

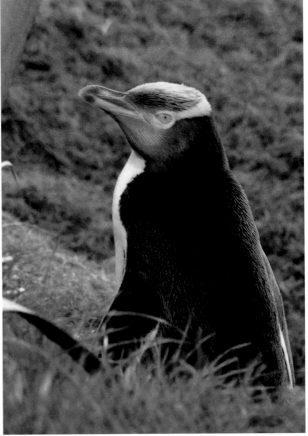

A single Yellow-eyed returns home

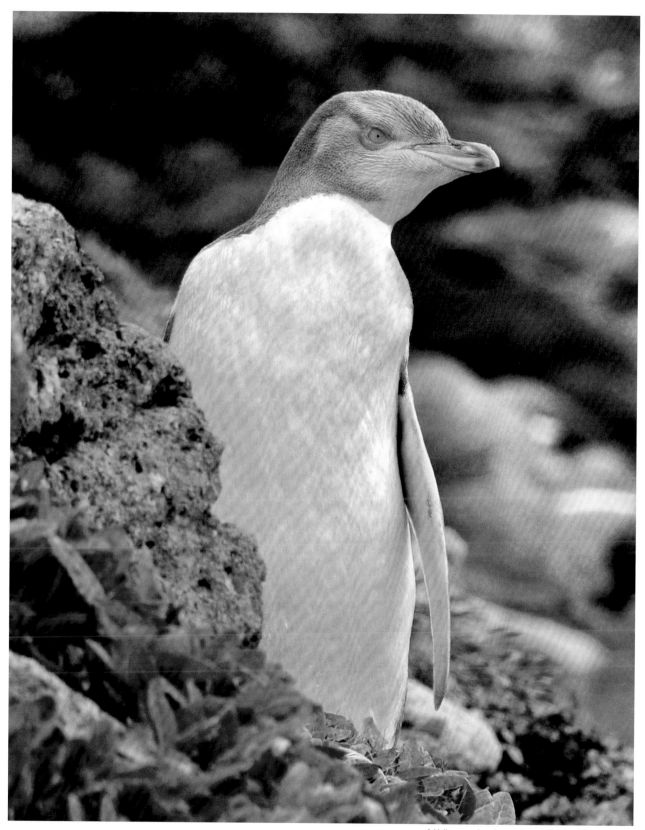

A Yellow-eyed posing on Campbell Island, New Zealand

About the Yellow-eyed Penguin

Population Trend

Decline. The Yellow-eyed penguin's existence is fragile. Their numbers have declined, with only about 5,000 adults remaining in 2006. Due to a poor feeding and breeding season in 2008–2009, it is hypothesized that their total world population has been even further reduced.

Habitat

Yellow-eyed penguins are few and widespread. About 800 live on the southern third of the South Island of New Zealand, from Banks Peninsula to the southern tip, and farther south on Stewart Island. The highest concentration is found on the Otago Peninsula. Campbell and Auckland Islands have the largest population, with 1,200 to 1,300 individual penguins. Numbers can change 20 to 40 percent from one year to the next. Yellow-eyed penguins cannot be found in zoos as they do not adapt to or tame well in captivity.

Appearance

The Yellow-eyed is the fourth tallest penguin, with the ability to grow over 30 inches (76 cm) in height. Females are slightly smaller but nearly impossible to distinguish from their male counterparts. A pale yellow arc rounds both of their eyes and connects at the back of their head. If looked at from above, it might appear as though the penguin is wearing a yellowish crown. The rest of the head, and especially the forehead, appears as black lines stretched over a yellow background. The throat is yellowish to white in color. The rest of the underside of the body is white except for two patches of black near and under each flipper. Their most striking characteristic is their pale yellow eye color, for which they are named. Yellow-eyed penguins have pink feet. Their bill possesses a complicated but very pretty color scheme, orange at the tip and up to one-quarter of the bill. The higher mandible is white and gray with low orange lines, while the lower mandible is white.

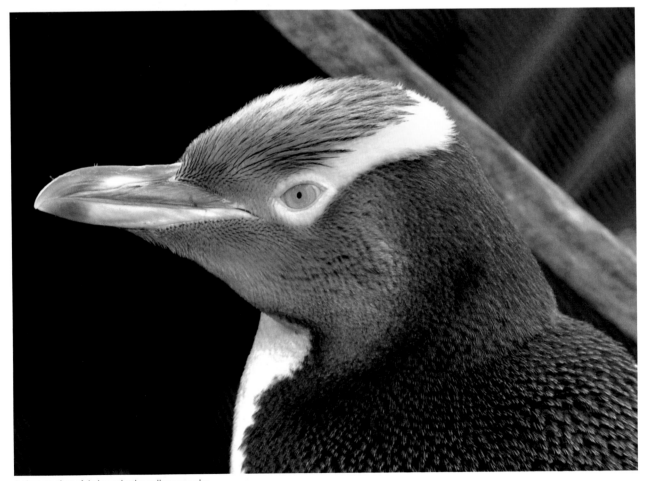

A close-up view of their captivating yellow eye color

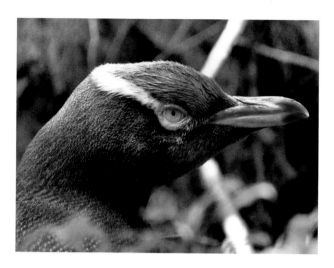

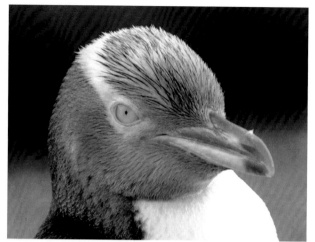

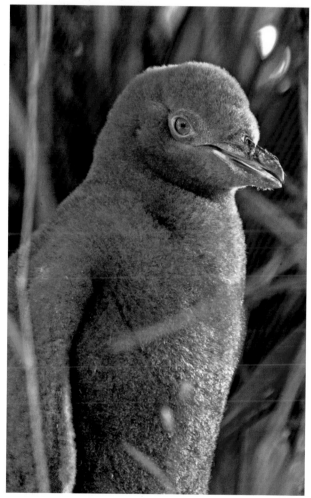

Immature Yellow-eyed penguins appear very similar to adults but with less yellow on their head. They have gray irises for up to five months after fledging.

Chicks

Yellow-eyed penguins are hatched with cute feathers and black eyes. After two to three weeks they develop a fine, fully grown, brown secondary down. Until the secondary down has fully grown, the chicks cannot maintain a stable body temperature, and the parents must take turns brooding them in the same manner they incubate the eggs. Their nests are hundreds of feet apart, so they are relatively alone from an early age on. When they reach a weight of twelve pounds (5.4 kg), the chicks get into the water and fledge. The survival rate after their first extended foraging trip is only 30 to 40 percent, and just half of those will survive to begin breeding (Dr. Hiltrun Ratz, personal communication). They go through their first molt when they reach fifteen months of age and begin breeding at two to four years of age. This usually occurs in close proximity to their natal colony.

Breeding and Chick Rearing

Yellow-eyed penguins do not depart from their colony for an extended winter trip, so there is no arrival date and the start of the breeding season is not very pronounced, though some courtship behavior can be observed during and after the molt. Females start breeding at the age of two, sometimes a year older. Few males start at three, and most breed for the first time at the age of four, with few waiting until they are six. As a result, younger females often pair with older males. Courting accelerates in August and early September, and the pair picks a nesting site in their territory. The same nesting site is not necessarily used each year, and the males fight intensively over the large territory they claim. Sometimes the females even become involved in the real estate brawls. Nest materials are gathered, and the pair will build a nest deep under the vegetation. Unlike other penguins, the Yellow-eyed prefers

Top left: Hiding in the forest

Top right: "A Yellow-eyed penguin shows off its beautiful bill"

Above: Chicks do not have yellow eyes like their parents

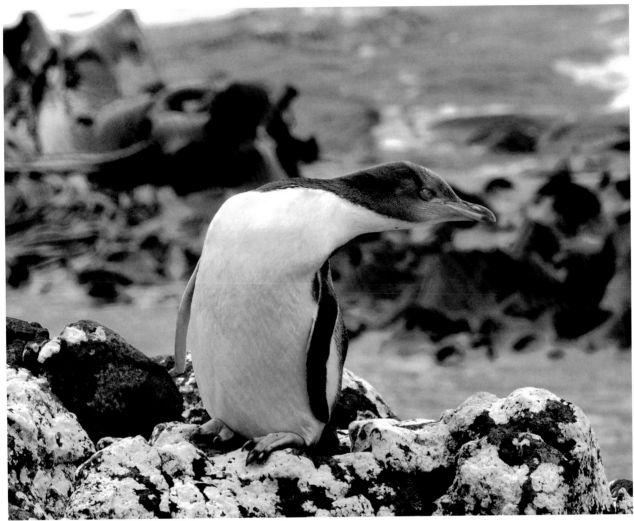

A Yellow-eyed who just returned to land on Campbell Island, New Zealand

seclusion and can build its nest hundreds of feet away from its nearest neighbor.

Within weeks the female will lay two eggs, two to four days apart. The breeding period of the Yellow-eyed penguin is very synchronized, and the entire colony will lay eggs within a three- to four-week period. The parents share the incubating and chick-rearing duties almost equally. At first, the parents brood the chicks with their bodies covering the chick to provide thermal protection; later, the chicks stand on their own. For the first five to eight weeks after hatching, the chicks remain within ten feet (3 m) of the nest and are under the constant supervision of one parent. The other parent forages and brings food to feed the chicks. Nest changes are very frequent, and Yellow-eyed penguins do not fast during breeding. As the chicks grow and reach the age of five to six weeks, both parents may leave at once. At this stage chicks might walk some distance from the nest during the day but will return to the nest in the afternoon in anticipation of their parents returning with their meal.

Yellow-eyed parents, unlike the crested penguins, do not try to reduce their brood, but instead struggle to fledge two chicks. Parents are not known to take their chicks with them to the beach, and one day in late February, a parent arrives at the nest and cannot find one of the chicks. It calls the chick several times and searches the territory looking for it. When the mate arrives, the search for the chick intensifies with more calls and ground searching, while the fledgling is swimming away to start a new life as a juvenile.

The entire breeding season lasts 150 days longer than that of most other penguins, except Kings and Emperors.

Foraging and Diet

Yellow-eyed penguins are also sedentary, inshore divers. Because they are not social, they walk to the ocean and dive alone. Breeding adults return to their territory most days, as the rich waters allow them to forage close to home. Foraging trips measured at Boulder Beach, New Zealand, averaged fourteen hours long daily, with

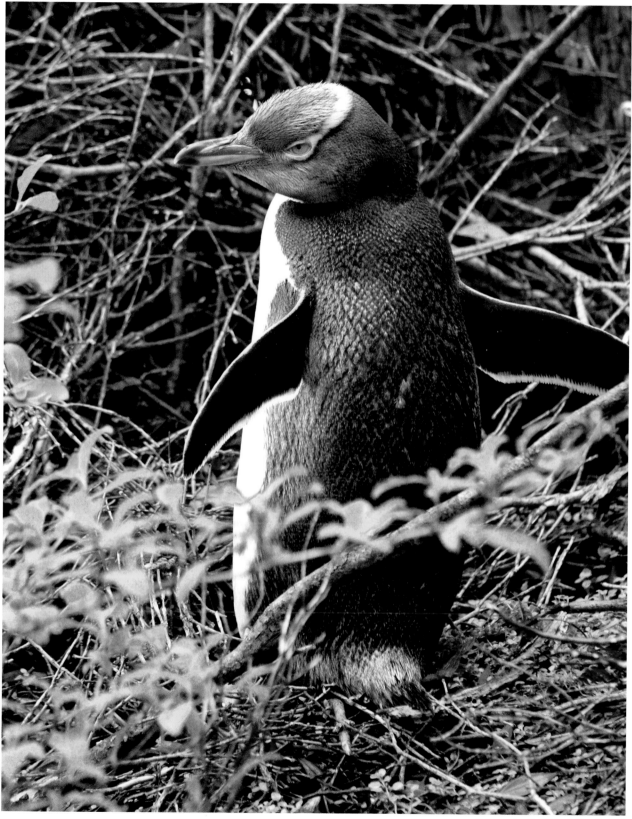

Hiding on Auckland Island, New Zealand

the maximum distance traveled averaging less than eight miles (12.9 km) (Moore 1999). The deepest dive recorded by a Yellow-eyed was 551 feet (168 m) deep (Moore et al. 1997).

Yellow-eyed penguins prefer to consume small fish, but if it's available they eat squid (cephalopods), as well. Penguins have a very efficient and fast-moving digestive system. Their stomachs only contain the last portion of food they ate just before returning to shore, in addition to what they have reserved for their chick's meal.

A 1997 study was done by Moore and Wakelin in New Zealand in which the stomach contents of multiple Yellow-eyed penguins were flushed out. It was found that, on average, a breeding adult returned to its nest with 66 items of prey in its stomach. There were vast differences in the number of prey found in their stomachs between trips. They ranged from as few as three fish recovered, to as many as 1,575 small prey recovered. The quantity and quality of prey items recovered from a penguin's stomach is a good indication of what is available to them rather than their preference. For example, one blue cod weighs as much as 35 red cods. The Yellow-eyed penguins prefer the bigger blue cod, but when those are unobtainable, they cannot afford to be picky. Sprat is also believed to be an important part of their diet (Dr. Hiltrun Ratz, personal communication). During the breeding season, they are bound by time constraints and must catch the prey most readily available to them, fill their stomachs, and rush home to their nesting site (Moore and Wakelin 1997).

Molting

Soon after the chicks fledge, the Yellow-eyed penguins will enter into a fattening-up premolting period that might last from one to six weeks, depending on food availability. In a good food year, birds are able to add weight while still feeding the chicks, and some might start the molt only days after the chicks have fledged (Dr. Hiltrun Ratz, personal communication). Instead of embarking on an extended trip, as many of the other penguin species do, they stretch the duration of their daily foraging trips by several hours, and at times they might stay at sea for several days. They dive harder and eat more in hopes of reaching their maximum weight, almost eighteen pounds (8.2 kg) for males, to ensure their survival during the molting period. The molt starts with new feathers growing under the skin; this takes place while the penguin is still at sea. The portion of molting that takes place on land lasts about twenty-four to twenty-eight days, sometimes less. During this time the old feathers are pushed out, new feathers emerge, and at the end the penguins spend a few days waterproofing the new feathers before they can re-enter the ocean. While they cannot eat during the land phase of the molt, they do need and drink water from the rain, streams, or lakes, or

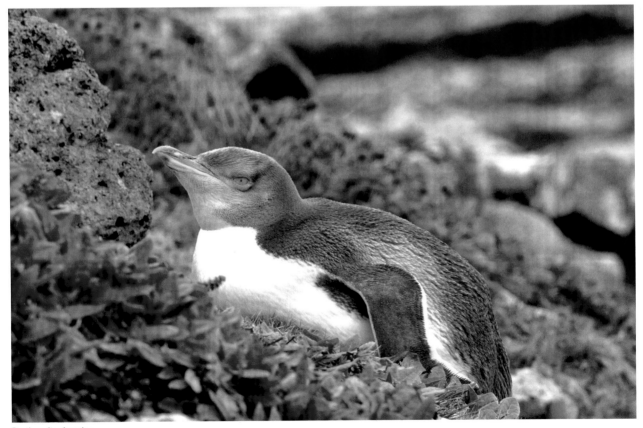

Resting after foraging

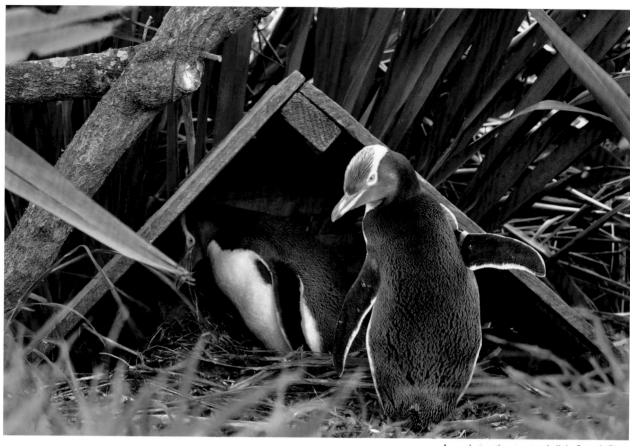

A wooden nesting structure built by Penguin Place

even salty water from the sea. At the conclusion of the molting period, the penguin will have lost eight to ten pounds (3.6–4.5 kg), or about half of its weight when it landed to start the molt.

Dangers

The fact that Yellow-eyed penguins prefer to be alone puts the individual penguin at a higher risk of danger, as it forgoes the protection that is provided by the group. Humans who eliminate the thick vegetation needed for the species to breed successfully cause reduction in the penguins' breeding success. People and penguins also compete over the shrinking stock of fish in the sea. Stationary fishing nets spread across the water by fishermen accidentally trap and kill penguins. The worst damage inflicted by people is from the pets, pests, and animals they have introduced into the penguins' habitat. Dogs, feral cats, stoats, and ferrets, especially, are the leading cause of fatal injury to Yellow-eyed penguin chicks and occasionally the adults.

One action by man that has actually benefitted the Yellow-eyed population is sealing. In the past, by drastically reducing the sea lion population, humans lessened the chances of Yellow-eyed penguins being eaten by their most feared predator at sea. Now that sealing is outlawed, however, its prohibition helps prevent

the extinction of sea lions but is resulting in greater loss of penguins. It appears that once a sea lion notices the routine the penguins follow, it is able to ambush and take several victims in a short period. Sharks and barracuda also feed on the Yellow-eyed penguins at sea.

Another serious threat to the Yellow-eyed penguin is an unidentified disease that became apparent in the 2004–2005 season. The disease kills chicks during their first three weeks of life. Extensive necropsy and pathology work performed by wildlife veterinarians at Massey University were unable to determine what triggered the outbreak, and thus researchers failed to discover an effective treatment (Dr. Hiltrun Ratz, personal communication).

Other species may suffer similar dangers, but these threats are magnified for the Yellow-eyed because of their very small population size. A few consecutive years of reduced prey availability, combined with increased taking at sea by sea lions and/or continued outbreaks of the chick disease, could threaten the species' existence. The Yellow-eyed penguin's inability to adapt to zoo life makes the possibility of their extinction very real, the same fate that befell one of their close genetic relatives a few hundred years ago.

Conservation Efforts

The perilous state of the Yellow-eyed penguin has captured the hearts of many people around the world. Conservation efforts are managed by three different entities: government, universities, and private individuals. The government of New Zealand has the most power and responsibility of the three, and it creates projects and assists in private works in order to preserve this precious species. The most important role of the government is to regulate people's interaction with the bird. It controls tourist traffic through the Campbell and Auckland Islands and limits the number of people allowed to come ashore. Government inspectors are hired to accompany every cruise ship and make sure people are not interfering with the wildlife.

In addition to conservation activities, every few years the New Zealand Department of Conservation issues a special conservation and recovery plan for the Yellow-eyed penguin, which they call the *Hoiho* (noise shouter). The "Hoiho Plan" cites specific recommendations regarding the Yellow-eyed penguin and charts the legal, environmental, and field actions to be taken by the Department of Conservation and the entire government to help increase their population. McKinlay wrote the plan covering the years 2005 through 2010.

Several universities, mainly the University of Otago at Dunedin, New Zealand, donate a considerable amount of time and money to investigating the Yellow-eyed penguin's unique behavior. They hypothesize what affects the birds' survival and what can be done to help it. Ten to fifteen years ago, such research was concentrated on the penguins' life on land, but now technology has enabled us to reach penguins under the water, opening up a whole new world to researchers. New GPS units, as well as waterproof video cameras, are beginning to shed light on the penguins' underwater activities. Of course, knowing an endangered animal's behavioral patterns is only half the battle; this information will be useless if a solution to their disappearance cannot be found.

Some of the breeding sites of the Yellow-eyed penguin are located on land which has been owned by penguin-lovers, like Howard McGrouther. Mr. McGrouther owns Penguin Place on the Otago Peninsula and has launched his own private conservation effort. At Penguin Place, they have constructed an elaborate viewing system of tunnels, dug in the hills near the shore where the penguins breed. These tunnels are covered by military-type camouflage nets, leaving four-inch (10 cm) viewing slots to watch and photograph the penguins. From the penguins' point of view through the viewing tunnel, the people appear to be four inches (10 cm) in size and have parts of their face missing. By lowering the perspective height of the visitors, the stress and fear felt by the penguins when they see humans is greatly reduced. This allows habituation by the penguins and for closer viewings without negatively impacting the animals. Penguin Place has turned this finding into a means of fundraising for Yellow-eyed penguin conservation by charging tourists to use their tunnels to view the

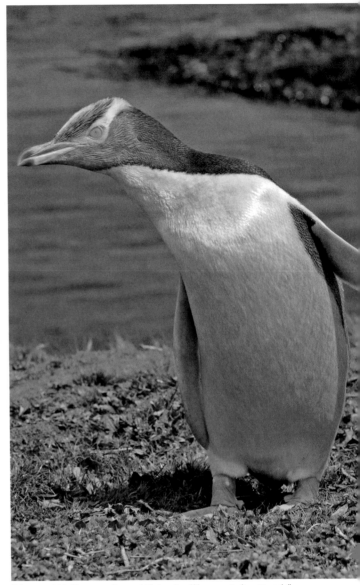

"He opened his flippers and moved his head as if he expected me to reply"

penguins in small, guided groups. Some of the money raised has gone into hiring a full-time scientist to monitor the penguins. It has also funded the planting of over 20,000 plants and trees to rejuvenate the destroyed vegetation that the Yellow-eyed penguins so desperately need to survive. Penguin Place puts forth great effort to eradicate the penguins' land predators, who were introduced by humans, and also provides wooden frames to be used as nest sites. Similar, smaller projects are taking place in other sections of the Yellow-eyed penguins' habitat on the New Zealand South Island. It will be extremely frustrating to conservationists if, despite their huge efforts, the Yellow-eyed penguins become extinct.

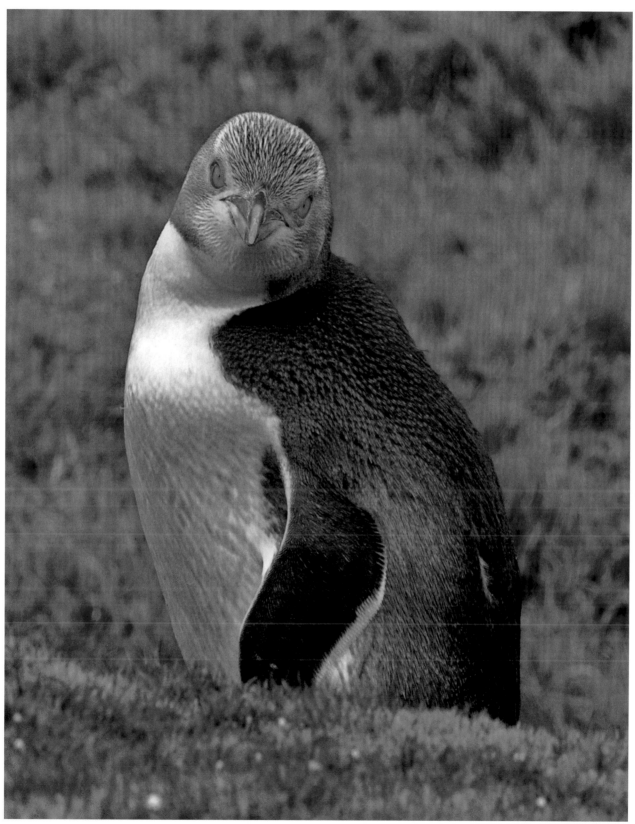

A well-fed Yellow-eyed

Interesting Research

Most penguin researchers live far away from the penguins' natural habitat, and some have never even seen a penguin in the wild. These researchers must arrange for a grant to travel for a few weeks or even months to study the penguins. They live at remote research stations located within the penguin's habitat. These scientists have access to sizable colonies, allowing them to catch individual penguins and tag them to conduct their research. They can recognize their subjects by reading the number off the tag and recording data on the corresponding subject. Otherwise, they could never really get to know the individual penguins, since all members of the species look so similar.

At Penguin Place, research is done differently. Each penguin is assigned a name, and Dr. Hiltrun Ratz, the resident scientist at Penguin Place, knows them all individually. Because there are fewer than twenty breeding pairs and their nests are so far apart, each pair is easily distinguished. Penguin Place builds wooden A-frame shelters for the penguins to nest in. Each penguin's history, diseases, past mates, offspring, and other information are documented by the Penguin Place scientist. All of their individual needs are tended to, down to regular wellness check-ups and monitoring of the molt. Dr. Ratz visits the penguins regularly during their entire breeding and molting period, observing them closely. Her methods are hands-on, intense (when necessary), and unlike those of most penguin researchers. She is at times the Yellow-eyed penguin's private researcher, doctor, or friend—perhaps all three simultaneously.

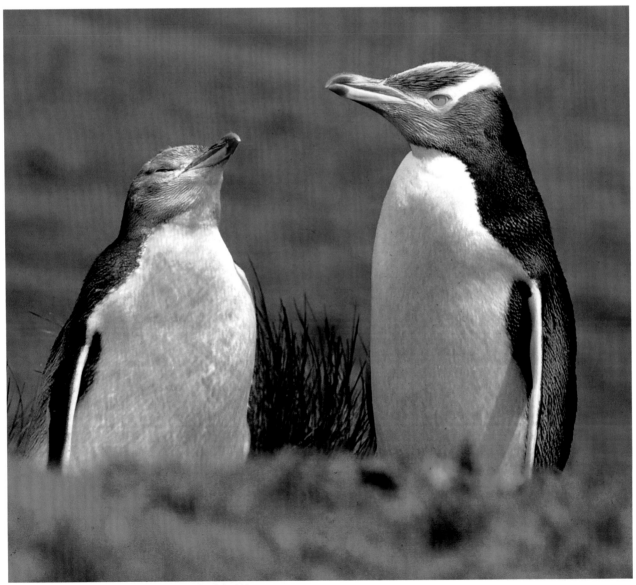

The male on the right decided to walk toward David and check him out

Charts

Weights	Source 1	Source 2, 3
Breeding Male Arrival		12.1 lb/5.5 kg[2]
Breeding Female Arrival		11.2 lb/5.1 kg[2]
Breeding Arrival Unsexed	11.0–13.2 lb/5.0–6.0 kg	
First Incubation Male		11.9–12.1 lb/5.4–5.5 kg[3]
First Incubation Female		10.4–11.2 lb/4.7–5.1 kg[3]
Premolt Female		18.7 lb/8.5 kg[2]
Premolt Unsexed	15.4–17.6 lb/7.0–8.0 kg	
Postmolt Male		9.7 lb/4.4 kg[2]
Postmolt Female		9.3 lb/4.2 kg[2]
Postmolt Unsexed	7.7–9.9 lb/3.5–4.5 kg	
Fledging Chick	11.0–13.2 lb/5.0–6.0 kg	12.3–13.0 lb/5.6–5.9 kg[2]
Egg 1	0.28–0.33 lb/127.0–150.0 g	0.25–0.30 lb/113.4–136.1 g[3]
Lengths	**Source 1, 2**	**Source 4**
Flipper Length Male	8.5 in/21.6 cm[2]	
Flipper Length Female	8.11 in/20.6 cm[2]	
Bill Length Male	2.2 in/5.6 cm[2]	
Bill Length Female	2.1 in/5.3 cm[2]	
Head Length Male	5.5–5.9 in/14.0–15.0 cm[1]	5.8 in/14.7 cm
Head Length Female	5.3–5.6 in/13.5–14.2 cm[1]	5.4 in/13.8 cm
Foot Length Male	5.3 in/13.5 cm[2]	5.3 in/13.4 cm
Foot Length Female	5.1 in/13.0 cm[2]	4.9 in/12.5 cm

Source 1: Ratz, personal communication (2010)—Penguin Place, Otago Peninsula, New Zealand. Source 2: Williams 1995—Otago Peninsula, New Zealand. Source 3: Richdale 1949—Otago Peninsula, New Zealand. Source 4: Efford et al. 1996—Otago Peninsula, New Zealand.

Biology	Source 1, 2	Source 3	Source 4, 5, 6
Age Begin Breeding (Years)	2–4[1]	3–4	2–3[4]
Incubation Period (Days)	40–42[1]	43.5	
Brooding (Guard) Period (Days)		49	42[5]
Time Chick Stays in Crèche (Days)	43–58[1]	47–53	
Fledging Success (Chicks per Nest)	Varies[1]	0.3–0.6	1.52–1.66[4]
Mate Fidelity Rate	94%[1]	92–96%	
Date Male First Arrives At Rookery	Not Defined[1]		Not Defined[5]
Date First Egg Laid	Mid-Sept.[1]	Late Sept. (Sept. 24)	Late Sept.–Oct.[5]
Chick Fledging Date	Feb.[1]	Late Feb.	Early Mar.[5]
Premolting Trip Length (Days)	Not One Trip[1]		
Date Adult Molting Begins	Mar.–May[1]	Late Mar.	
Length Molting on Land (Days)	Approximately 28[1]	24	
Juvenile Survival Rate First 2 Years	36%[1]	26%	21%[5]
Breeding Adults Annual Survival	80–90%[1]	86–87%	89–92%[4]
Deepest Dive on Record	419.95 ft/128 m[2]		
Farthest Dist. Swam From Colony	35.42 mi/57 km[2]		
Most Common Prey	Opal Fish[2]	Fish	Blue Cod[6]
Second Most Common Prey	Blue Cod[2]	Squid	Opal Fish[6]

Source 1: Ratz, personal communication (2010)—Penguin Place, Otago Peninsula, New Zealand. Source 2: Moore 1999—Otago Peninsula, New Zealand. Source 3: Williams 1995—Otago Peninsula, New Zealand. Source 4: Ratz and Thompson 1998—Otago Peninsula, New Zealand. Source 5: Van Heezik 1990—South Island, New Zealand. Source 6: Browne et al. 2011—Stewart Island, New Zealand.

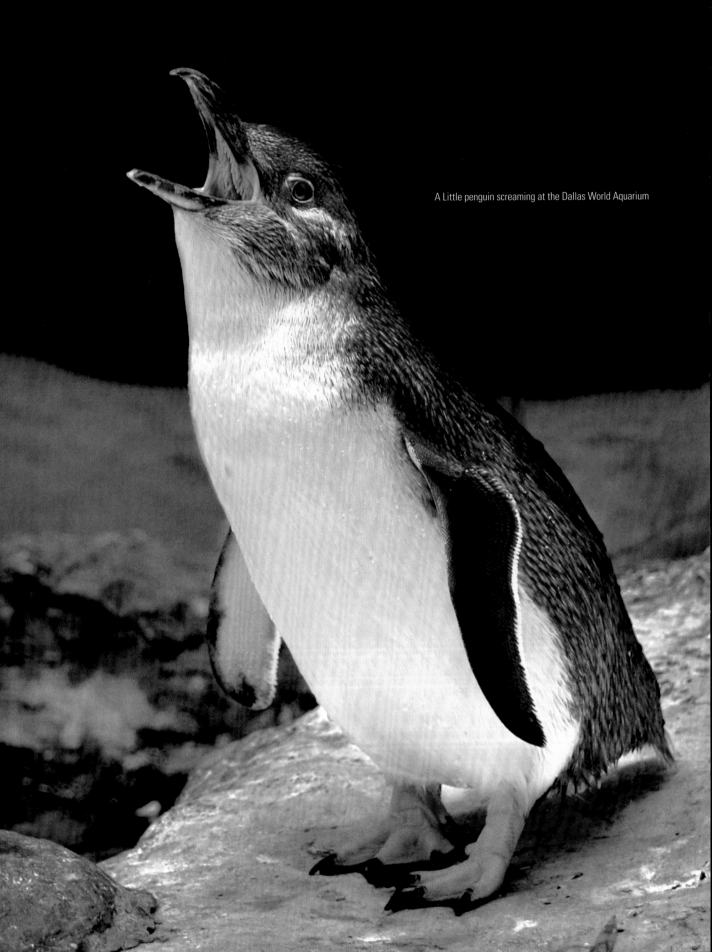
A Little penguin screaming at the Dallas World Aquarium

Little Penguin
Eudyptula minor

Genus: *Eudyptula*

Other Genus Members: None

Subspecies
Past: Southern (Blue), Australian, Chatham, Cook Straight, Northern, and White Flipper (some researchers consider the white flipper a color variation and not a subspecies)
Present: the Chatham and Northern New Zealand are one subspecies, and all the rest are a second

IUCN Status
Least Concern: Blue and other subspecies
Endangered: White Flipper

Latest Population Estimates
Individual Birds: 1.2 million
Breeding Pairs: 500,000
White Flipper Subspecies: Only 15,000 individuals

Life Expectancy
Wild: 6–20 years
Captivity: 20–25 years
Longest Recorded: 26 years

Migratory: No, they are a sedentary species.

Locations of Famous Colonies: Oamaru, Chatham Island, and Banks Peninsula, New Zealand; Phillip Island and Penguin Island, Australia

Colors
Adult: Black, white, and gray
Bill: Black
Feet: Light pink to off-white with black claws
Iris: Gray
Chick Down: Brown
Immature: Black, white, and gray

Height: 13–15 in/33–39 cm

Length: 14–17 in/36–43 cm

Normal Clutch: 2 eggs per nest

Maximum Chicks Raised per Pair per Year: 2

The Little penguin is also known as the Blue, Fairy, and Korora penguin.

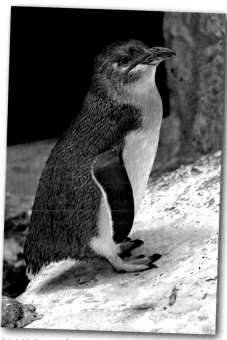
Adult Little penguin

David's Observations

It is very easy to get to a Fairy penguin colony but very difficult to photograph its inhabitants. Already in New Zealand, I chose to stop at the Oamaru Penguin Parade, a big business that thrives on people's affection toward penguins. Just after I paid the entrance fee, I was told that taking pictures is absolutely not allowed for fear that a flash may accidentally be deployed. There was no way I could convince the manager

that I know how to operate a camera in order to change his mind. Instead, I was invited to come back during the day to take pictures. Of course, the Blue penguin hides during the day inside the wooden boxes provided as shelter, and photographing them in those conditions is nearly impossible.

Then it occurred to me that some penguins must be independent enough not to follow the parade organizers' pre-

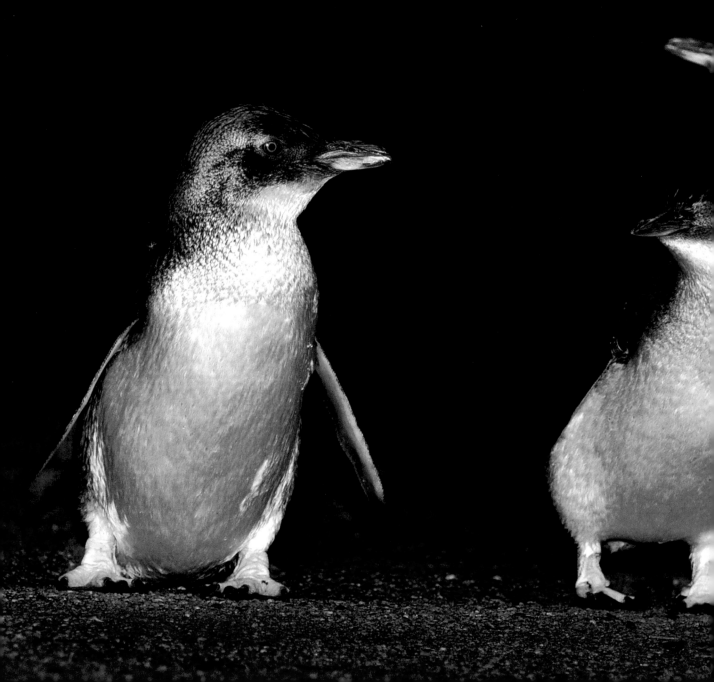

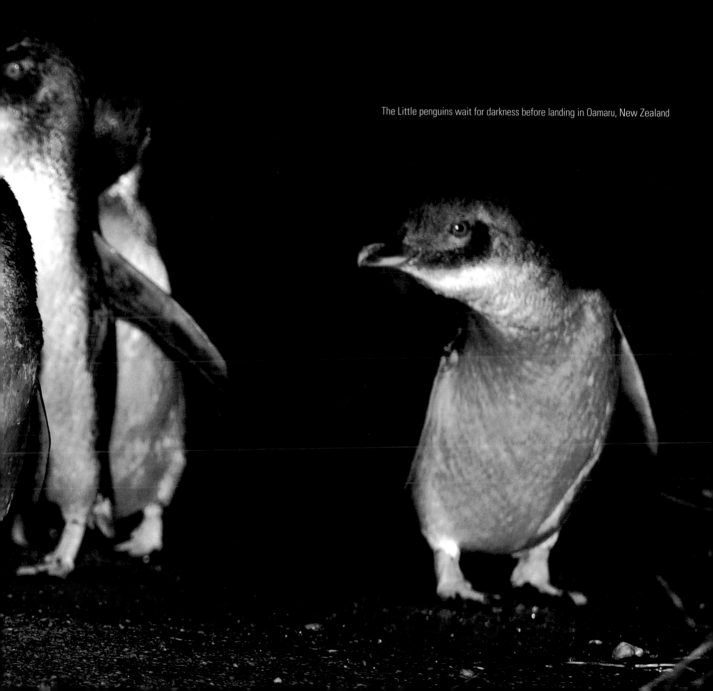

arranged path. I went outside and noticed a crowd gathering down the road. It was dark, and taking pictures without flash or a light was impossible, so I watched the penguins as they ran from their landing site into gaps under the older port buildings, hiding in the dirt and then suddenly rushing out in pairs, screaming and bill dueling, pushing each other to the ground and then returning to their dirty holes. Others, presumably

parents carrying food for their chicks, did not wait all that long before running quickly to cross the road, disappearing in the dark toward the direction of the colony. These Little penguins certainly are different from any other species I met, not only in size, but also in their utter lack of grace.

The Little penguins wait for darkness before landing in Oamaru, New Zealand

About the Little Penguin

Population Trend

Holding steady. Despite its miniature size and the overlap of its habitat with human settlements, the Little penguin population is holding steady range-wide. The White Flipper subspecies, however, is endangered and rapidly losing population at a rate of 70 percent in the last fifty years.

Habitat

The Little penguin nests in colonies throughout New Zealand, where it is thought to have evolved, and also appears across the ocean in South Australia. Like most other penguins, it colonizes smaller islands, but it is also found on mainland locations near developed human communities. In New Zealand, Little penguins settle on Oamaru, Otago Peninsula, and Chatham Island. Banks Peninsula is home to the White Flipper. In Australia, you see them on Cape Otway, London Bridge, Pennshaw, St. Kida, Phillip Island, Gabo Island, Lion Island, Middle Island, Granite Island, and Penguin Island. Little penguins do well in captivity and can be seen in many zoos and aquariums.

Appearance

The Little penguin is the smallest and possibly the least pretty of all penguins. Adult Littles have a dark, slate blue- to black-colored back, and part of their head also shares this color. The shade of blue depends on the subspecies. Their underbody is white mixed with gray on both sides of the chest and neck. The mixture of white and gray on the borders extends up the entire throat to the bottom of the bill and turns gray reaching up to the ears. The bill is all black except the bottom part of lower mandible, which is gray or even white. The feet are pink with black soles. The flippers are black on the outside with some lighter areas on the underside.

The White Flipper subspecies have a white band on both edges of either fin, and their feet are white.

Immature Littles are similar to adults except that some colors are lighter, and they show much more gray and less white on their underbody and throat areas.

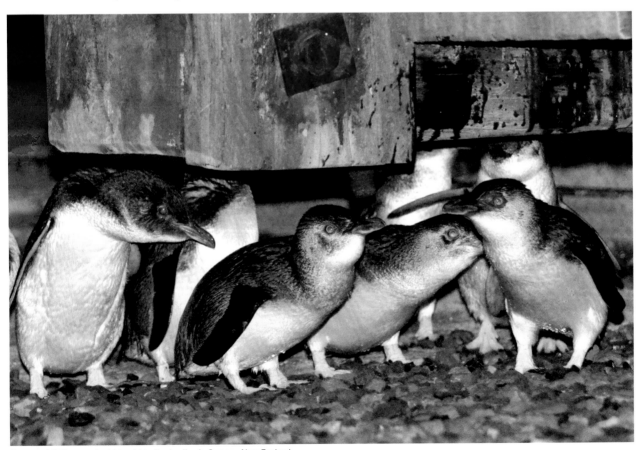

A group of Little penguins hides right after landing in Oamaru, New Zealand

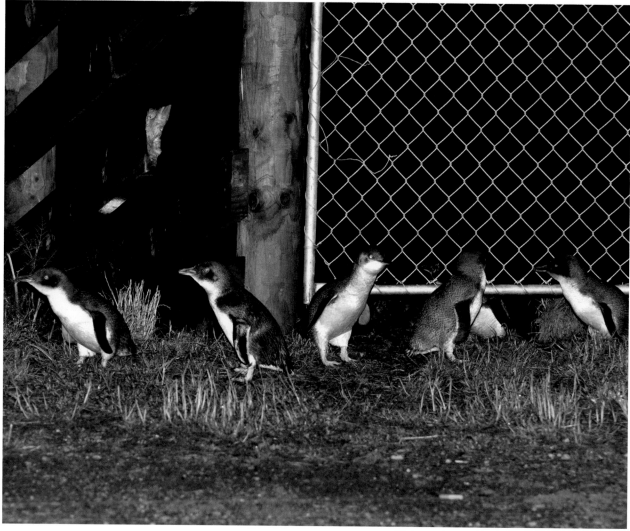

"Little penguins certainly are different from any other species"

Chicks

Little penguin chicks are born at an average weight of only 1.28 ounces (36 g) and are not able to regulate their body temperature until they are ten to fourteen days old. They stay under the parents' constant guard and are fed daily for three to four weeks after hatching. Later, both parents leave for the day and the chicks stay in pairs, if two are alive, or alone inside or near the nest, waiting for the parents to return and feed them.

Chicks fledge at about fifty-five days of age after their initial molt, at an average weight of 2.2 pounds (1 kg) for the first chick and two pounds (0.9 kg) for the younger sibling. A study that spanned no less than thirty-six years discovered that only 17 percent of the fledging chicks survive the first year at sea, though it greatly improves to 71 percent and 78 percent during the second and third year (Sidhu et al. 2007). They return to molt a year later around their natal colony and become breeders between the ages of two and three.

Breeding and Chick Rearing

The Little penguins' breeding calendar is the most unpredictable, asymmetric breeding process of any penguin. The existence of six different subspecies and the fact at least a quarter of the pairs, mostly those that failed to fledge a chick, have a second or even third clutch cause dates to become widespread. On Phillip Island in Australia, Dann et al. did a large study that lasted 36 years and discovered that the first egg from the first clutch was laid between mid-September and mid-November, their spring season. No one knows for certain why the onset of breeding gets moved around, but a reasonable theory suggests the exact timing is correlated to the abundance of prey, which may relate to water temperatures. The earliest and latest dates of the entire study period, though sixty days apart, fell within two consecutive years: 2002 and 2003. Yet at Granite Island, the mean egg-laying date was June 24, in the midst of the winter season.

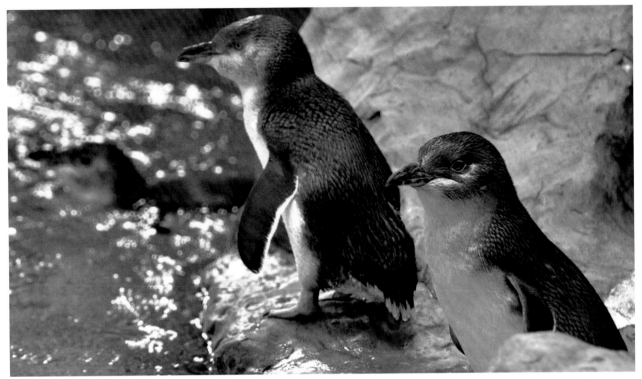
A group of Little penguins at the Dallas World Aquarium

To start the new breeding season, the male arrives at the nest site first and stands in front of it, waiting for his old mate to join several days later, or for a new mate if he is divorced or a first-year breeder. The pair takes about 30 days to court, build the nest, bond, copulate, and embark on several separate foraging trips before the female lays two eggs two and a half days apart. Each egg weighs about 1.9 ounces (53.9 g). The female then leaves for her first incubation-period foraging trip while the male remains to incubate.

Little penguins incubate 35.5 days on average, and mates split these shifts almost equally (Chiaradia and Kerry 1999). Each parent leaves for five to eight feeding trips that last up to nine days. The duration of the trips is a function of the body condition of the foraging parent and its success in finding prey. Normally, if one parent takes longer to return, it requires the second to use more time in its next trip. There is a short window of time before one parent causes the other to desert the nest. Little penguins are too small to endure long fasts.

Little penguins are dedicated breeders and do not reduce the brood. If both chicks die prematurely they try breeding again, even though second and third clutch success rates are very low.

Dann analyzed 20 years of data and concluded that productivity increases from ages two to eight; older and more experienced birds are more productive because they lay earlier, change mates and nests less frequently, and skip breeding less often. After reaching the age of eight, birds' productivity decreases noticeably. Success rates were much higher when the pair clutched two eggs,

as two-thirds of those that clutched one egg failed to fledge a chick. Mates with a longer bond and higher nest fidelity were more successful, but divorces were not correlated with last year's productivity failure. All the above parameters have been shown to affect male productivity more than female productivity. Breeding success rates vary from 0.3 to 1.2 chicks per nest. The average at Phillip Island over thirty years is a respectable 0.97 chicks per nest (Dann et al. 2000).

Foraging

Little penguins are nocturnal and prefer to leave and return from the sea only when it is dark. They are also relatively sedentary and rarely leave the colony for extended periods. Most adults leave before sunrise, return after sunset for daily foraging trips, and do not stay on land during light hours. Despite their nocturnal behavior, many Little penguins do not return to the colony on nights with thick fog and low visibility (Chiaradia et al. 2007a). The influence of fog and bad visibility on penguins should have been expanded, as it could have shed light on their navigational capabilities, as well as their limitations.

Little penguins dive in small groups, many times fewer than ten birds. Their departure and arrival times are the most synchronized of all penguin species; the entire contingency of divers on any given day enters and exits the water within seventy-five minutes to avoid the daylight. During incubation this daily routine is broken, and the female and male both take longer trips at sea that average three to five days.

Resting inside a wooden nesting box at Penguin Place, New Zealand

Nesting

The male Little penguin selects the nest site, which he digs or refurbishes. Types of nests vary by location. They prefer underground burrows that are darker inside, and better nests are under the thick grass roots, which make the burrow more secure. Nests are normally padded with leaves and typically occur about six feet (1.8 m) apart. Many organizations build wooden artificial houses that are openly adopted by the Fairy, as the houses can provide better shade and darkness.

Relationships

The Blue penguin is considered the most primitive of all penguins. It is a sedentary resident that is nocturnal and shy of sunlight. Upon returning to the colony in the evening, it quickly runs into temporary underground hiding and gets dirty from the mud as it visibly cowers under cover. After some rest it will swiftly run out of the underground cover and rush either to its nest or to another intermediate cover. Its discomfort with light causes it to hide deep in the nest when it remains on land in the daytime during the breeding period. It is very uncomfortable with other animals and humans. Sometimes, if its flippers go unnoticed, it resembles a rat more than a penguin.

Little penguins are mostly monogamous. Mate fidelity is very strong, but average yearly divorce rates are difficult to calculate because many birds often skip breeding. The divorce rate when both partners were breeding the following year is 17 percent according to Reilly and Cullen (1981), but only 3 percent according to Bull (2000). As is the case with most loyal penguins, nest fidelity is very high, as well.

Little penguin dives are typically less than sixty feet (18 m) deep and last for an average of thirty-five seconds. Deep dives are usually about 100 feet deep (31 m), and the deepest recorded dive was at 227 feet (69.2 m). Their ability to dive deep is constrained by their small size and inability to store large quantities of oxygen. They adjust to their inability to dive deep by diving in shallow waters where prey is present near the surface.

Their prey varies from location to location. In south New Zealand they prey mainly on small fish like sprat and anchovy, and on Phillip Island they prefer pilchard fish, but in other locations krill is more important. The availability of prey and the amount of effort needed for catching it affect breeding success. Years with poor breeding success at Phillip Island are usually associated with the absence of pilchard in the diet.

Molting

The sixteen-day land phase of the molt takes place after the chicks fledge, which varies year to year. On Phillip Island, molting takes place between mid-February and mid-March most years, but can differ greatly in other locations. The loss of weight during the land phase can exceed 40 percent.

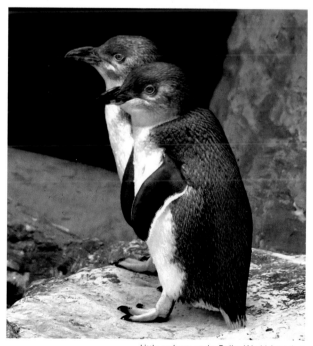

Little and cute at the Dallas World Aquarium

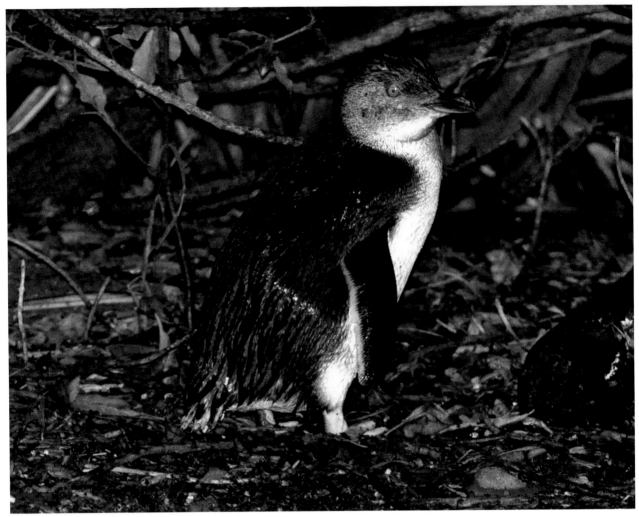

Getting ready to run home at night

Females prefer heavier and older males to mate with, and while it is the female that makes the final decision to bond, the male initiates the union by advertising extensively as the mating and breeding season gets underway. Advertising calls are very intense, with the entire body stretched upward, the head pointed up, and the flipper at times spread out and moving nervously up and down. After a series of vocal calls and ecstatic displays, some done in concert with others, and when the whole colony seems alive with dance, a choice is finally made and the mates are established. Fairy penguins are aggressive and nervous little birds, so bill duels and fights are common and frequent. Before a full-blown fight breaks out, pushing and shoving takes place in the transient, underground hiding spot until both opposing birds stand out in the open, raise their flippers and neck, stretch their body, and yell or bray to warn the other of their intention to fight. More often than not, neither bird concedes, but instead both rise up to push the other with their white underbody. They

then spread their flippers and a bill duel erupts, with bill pecking to follow. Fights tend to go on for several rounds, and many are caused by single, young males attacking non-breeding females or juveniles.

Vocalization

Little penguins are nervous and noisy, as if trying to compensate with loud noise for their smaller size. Researches think that noise levels are related to their poor visual abilities on land at night. Like other penguins, their calls and sounds are distinctive from one individual to another.

Male advertising calls are loud brays. Different brays are used for nest relief and bonding displays, while grunts and beeps are used for agonistic postures. Studies showed that females have the ability to distinguish between the calls of different males before mating. It was discovered that the main frequency of a male's call is related to his weight (Miyazaki and Waas 2003). Females

interpret those calls to gain knowledge about the size, weight, or strength of the calling male, and this is thought to play a role in their mating decision process.

Agonistic calls consist of roaring grunts and various beeping sounds. Many individuals seem to beep at the same time, and the entire group erupts with loud noise after landing at night and resting somewhere underground. Males sound a special call during territorial disputes, and there is also a contact call used near or at sea. Chicks sound only a high-pitch beep at first and develop adult sounds closer to fledging age.

Dangers

Seals are Little penguins' largest threat at sea, and skuas, gulls, and sheathbills attack eggs, chicks, and weak or injured adults on land. Their communal lifestyle and group diving help most adults to evade predators while diving. More than most other penguin species, Little penguins are greatly endangered by the activities of animals introduced by humans like rats, feral cats, and dogs. Because their colonies are in many cases in the middle of populated cities and in close proximity to ports and constructed sea channels, marine and industrial pollution are large threats. Oil spills, like the 1995 spill of the *Iron Baron* off the northern coast of Tasmania, bring devastation. Fishing depletes their food supply, and fishing nets also cause many deaths by suffocating the penguins. Climate changes also harm the Little penguins to a greater extent than they do most other penguin species.

Conservation Efforts

The Little penguin may not be as pretty or graceful as other penguin species, but it has captured the hearts of many groups in New Zealand and Australia. Several of these groups are resolved to enhance the common space they share with the Fairies that border their communities. Penguins are sensitive to environmental changes, but the Little penguin is more sensitive than most, not only because of its smaller size, but also because it is nocturnal and extremely nervous about human presence. Communities that desire to protect their penguin neighbors usually devise a multi-year conservation plan. A typical program begins with studies to monitor population of individuals, breeding pairs, eggs, and fledging chicks. Having concrete numbers is very important, because if population and other parameters measured are found to increase, the program can be considered a success. The program may also establish a mortality register to understand the causes of death the Little penguins are up against. Studies can point to actions that need to be taken, starting with simple tasks like erecting barriers to protect the penguins from introduced animals, cars, and people, especially during the breeding period. Other actions include caution signs on roads and wooden nest houses. Later in the program, participants may associate with researchers who visit the colony every so often to do population counts and assess the Little penguins' living conditions and overall health. There is also a need to educate young students in school, and also adults, about the danger the Little penguins face when people approach their nests, the danger of spilling chemicals into the ocean, or just simple awareness to not drive over a penguin on the roads they cross. Some programs also monitor the water in the bay area to theorize any pending environmental change. The action list can grow or shrink according to the resources a group has available.

A sample program is one that has been in place for over forty years on Phillip Island in Australia. A small colony of penguins became the center of a preservation effort that now includes the parade and other sources of income that fuel the $12 million budget that helps upgrade the lives of the penguins and other animals that reside on the reservation. The Phillip Island research and data collection is one of the most comprehensive data banks to exist on any wild animal or penguin anywhere. The information gained is helpful in the complicated task of preserving all penguins, not just Littles. The big effort at Phillip Island has produced results, and now about 650 adult penguins cross the gate every day at Phillip Island, a population that is greater than it was in 1980.

When all the elements of a good conservation plan are added up, it proves to be a complicated task that requires the dedication and support of many individuals. The efforts are many times fruitful, and several urban locations have shown an increase in breeding pairs, proving that Little penguins and humans can make good neighbors after all. It is also a big lesson for the Ecuadorian government and the research institutions that are caring for the Galapagos penguins, because if such a well-funded, detailed plan is not adopted for the Galapagos very soon, we might lose them to extinction.

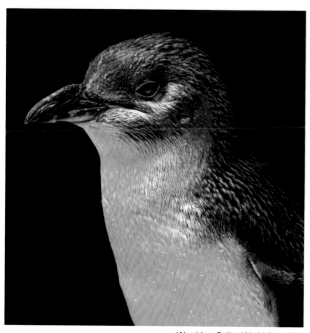

Watching, Dallas World Aquarium

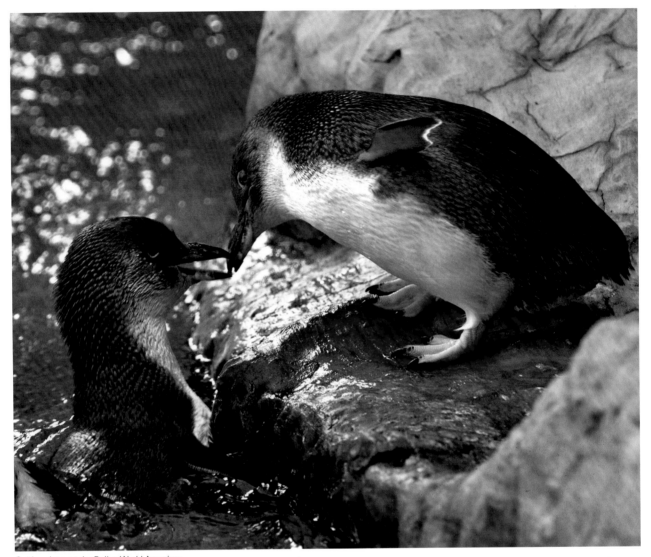

Getting closer at the Dallas World Aquarium

Interesting Research

Hull et al. (1998) took advantage of the unfortunate 1995 oil spill in northern Tasmania, Australia, to determine the efficiency of translocation of Little penguins. Many penguins were affected, and a huge rescue operation took place in which 1,894 Fairy penguins were brought ashore. These oil-covered penguins were cleaned and fed in a penguin hospital. Scientists believe that prolonged hand-feeding of wild animals reduces their ability to later rejoin their natural environment, as their abilities might be reduced during captivity.

The problem in this particular situation was that the penguins had recovered from the disaster, but the sea near their habitat was still contaminated and unfit to resume habitation in.

The scientists then decided to examine a translocation strategy, and a sample group of the rescued birds was dropped about 225 miles (362 km) away from their colony. Twenty-five penguins were tracked by radio transmitters attached to their body, while airplanes were dispatched to collect the signals. Three penguins traveled the distance back to the colony in three days, at which time the cleanup was still underway. The main group release was therefore moved eighty miles (129 km) farther away. Of the 863 penguins released, 56 percent were back to the colony within four months. The study concluded that translocation of penguins to remove them from a damaged environment can save many lives and is probably a better strategy than prolonged captivity. The penguins are smart enough to find their way back, sometimes faster than man could clean up the mess that prompted their emergency removal in the first place.

Charts

Weights	Source 1, 2	Source 3, 4	Source 5, 6, 7
Breeding Male Arrival	2.4 lb/1.1 kg[1]	2.6 lb/1.2 kg[3]	2.9 lb/1.3 kg[5]
Breeding Female Arrival	2.0 lb/0.9 kg[1]	2.2 lb/1.0 kg[3]	2.4 lb/1.1 kg[5]
Premolt Male	2.9 lb/1.3 kg[1]	2.9 lb/1.3 kg[3]	3.7 lb/1.7 kg[6]
Premolt Female	2.6 lb/1.2 kg[1]	2.5 lb/1.14 kg[3]	3.1 lb/1.4 kg[6]
Postmolt Male	2.4 lb/1.1 kg[1]	2.4 lb/1.1 kg[3]	2.0 lb/0.9 kg[6]
Postmolt Female	2.2 lb/1.0 kg[1]	2.2 lb/1.0 kg[3]	1.8 lb/0.8 kg[6]
Fledging Chicks	2.1–2.5 lb/0.95–1.1 kg[2]		2.2–2.4 lb/0.98–1.1 kg[7]
Egg 1	0.11–0.12 lb/49.9–54.4 g[1]	0.12 lb/54.4 g[4]	
Egg 2	0.11–0.12 lb/49.9–54.4 g[1]	0.12 lb/54.4 g[4]	
Lengths	Source 1	Source 8	Source 9
Flipper Length Male	4.7 in/11.9 cm		
Flipper Length Female	4.6 in/11.7 cm		
Bill Length Male	1.4 in/3.6 cm	1.5 in/3.8 cm	1.5 in/3.8 cm
Bill Length Female	1.3 in/3.3 cm	1.4 in/3.6 cm	
Bill Depth Male	0.6 in/1.5 cm	0.6 in/1.5 cm	0.6 in/1.4 cm
Bill Depth Female	0.55 in/1.4 cm	0.5 in/1.3 cm	
Head Length Male		3.9 in/9.9 cm	3.8 in/9.7 cm
Head Length Female		3.7 in/9.4 cm	

Source 1: Williams 1995—Stewart Island, New Zealand. Source 2: Numata et al. 2004—Oamaru and Motuara Islands, New Zealand. Source 3: Dann et al. 1995—Phillip Island, Australia. Source 4: Kemp and Dann 2001—Phillip Island, Australia. Source 5: VGDSE 2009—Phillip Island, Australia. Source 6: Croxall 1982—Not Specified. Source 7: Numata et al. 2000—Oamaru and Motuara Islands, New Zealand. Source 8: Hocken and Russell 2002—Otago Peninsula, New Zealand. Source 9: Arnould et al. 2004—Phillip Island, Australia.

Biology	Source 1	Source 2, 3, 4, 5, 6, 7	Source 8
Age Begin Breeding (Years)	2–3	2[2]	
Incubation Period (Days)	33–43	30–38[3]	36
Brooding (Guard) Period (Days)	20–30	18–38[3]	21
Time Chick Stays Unguarded (Days)	20–35		35
Fledging Success (Chicks per Nest)	0.23–0.94	1.18[3]	
Mate Fidelity Rate	82%	60–100%[4]	
Date Male First Arrives At Rookery	N/A		Return Periodically
Date First Egg Laid	Jun.–Oct.	July–Oct. (Peak Aug.)[3]	Peak Mid-Oct.
Chick Fledging Date	Aug.–Dec.	Oct.–Dec. (Peak Nov.)[3]	Mid-Jan.
Premolting Trip Length (Days)	7–91 (40 Average)		21
Date Adult Molting Begins	Jan.–Mar.		Feb.–Mar.
Length Molting on Land (Days)	15–20		16–18
Juvenile Survival Rate First 2 Years	68%	17% (yr. 1)71% (yr. 2)[5]	
Breeding Adults Annual Survival	61–88%	83%[5]	
Average Swimming Speed	0.9–3.3 mph/1.5–5.3 kmph	4.0 mph/6.5 kmph[6]	
Maximum Swimming Speed	5.4 mph/8.64 kmph	8.5 mph/13.7 kmph[6]	
Deepest Dive on Record	220 ft/67 m	218.8 ft/66.7 m[7]	
Farthest Dist. Swam From Colony	441 mi/710 km	61 mi/98 km[6]	
Most Common Prey	Squid		Fish
Second Most Common Prey	Fish		Squid

Source 1: Williams 1995—Various Locations. Source 2: Chiaradia and Kerry 1999—Phillip Island, Australia. Source 3: Heber et al. 2008—Westport and Punakaiki, New Zealand. Source 4: Rogers and Knight 2006—Lion Island, New South Wales, Australia. Source 5: Sidhu et al. 2007—Phillip Island, Australia. Source 6: Bethge et al. 1997—Marion Bay, Tasmania, Australia. Source 7: Chiaradia et al. 2007—Phillip Island, Australia. Source 8: Gales and Green 1990—Tasmania, Australia.

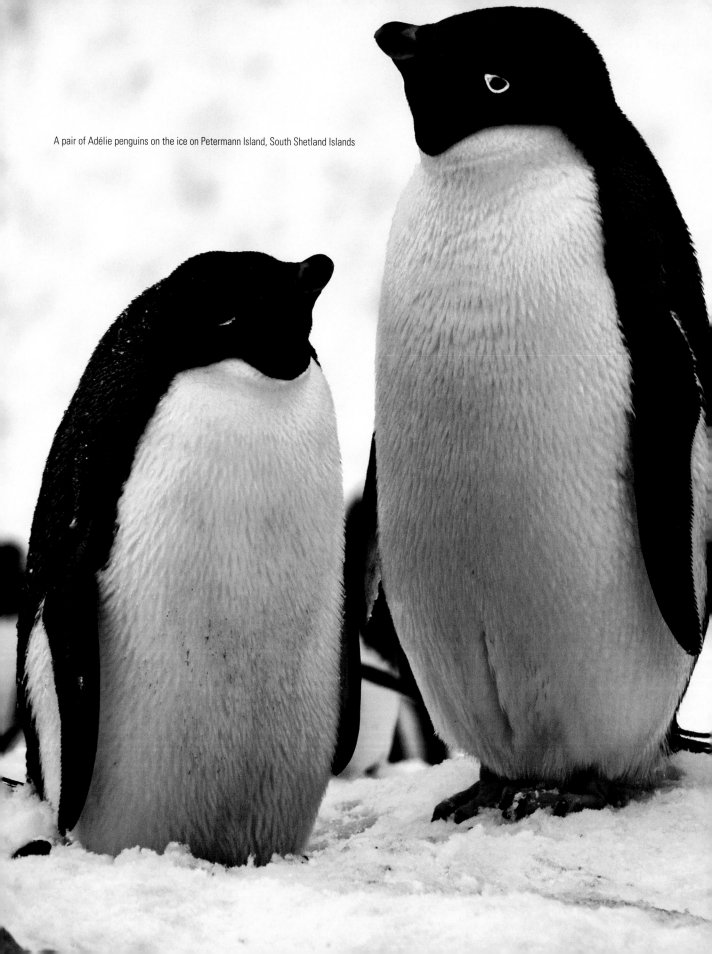

A pair of Adélie penguins on the ice on Petermann Island, South Shetland Islands

Adélie Penguin
Pygoscelis adeliae

Genus: *Pygoscelis*

Other Genus Members: Gentoo, Chinstrap

Subspecies: None

IUCN Status: Least Concern

Latest Population Estimates
Individuals: About 6.5 million
Breeding Pairs: 2.75 million

Life Expectancy
10 years, with a few living up to 20 years
(Clarke et al. 2003)

Migratory: Yes, they are absent from the colony
from April to September.

Locations of Larger Colonies
Cape Adare, Terre Adélie (Adélie Land), Cape
Royds, Cape Crozier, and Esperanza Bay

Colors
Adult: Black to brown, white, and pink
Bill: Black/gray with brick red
Feet: Faded pink with black soles
Iris: Brown
Chick Down: Gray and white
Immature: Black and white

Height: 24–27 in/61–69 cm

Length: 27–29 in/69–74 cm

Normal Clutch: 2 eggs per nest

Maximum Chicks Raised per Pair per Year: 2

Adult Adélie penguin

131

David's Observations

I visited the Adélie penguins while on an Antarctic cruise on the Ocean Nova. Within minutes of leaving the mother ship on a small rubber boat called a Zodiac, we were on Petermann Island, where we were promised we would meet Adélies. There were many penguins coming out of the ocean, but we soon realized they were all Gentoo penguins and not Adélies. It appears that in the northern range, especially in the South Shetland Islands, they are being pushed south by Gentoo penguins, who are stealing their nests.

As we climbed up a large hill in deep snow, farther and farther from the beach, we encountered the Adélie penguins. Many were already incubating on the snow; others were running around the small colony waving their flippers up and down. They were having trouble finding pebbles in the snow, so they resorted to stealing stones from each other's nests.

They seemed to feel comfortable with our presence. They were less noisy than the Gentoo penguins and did not waste too much energy on fights. Adélie penguins move their flippers and heads more than any other penguin I visited, allowing for interesting, vivid, and expressive photos.

Adélie moves are the most dramatic

An Adélie bowing its head

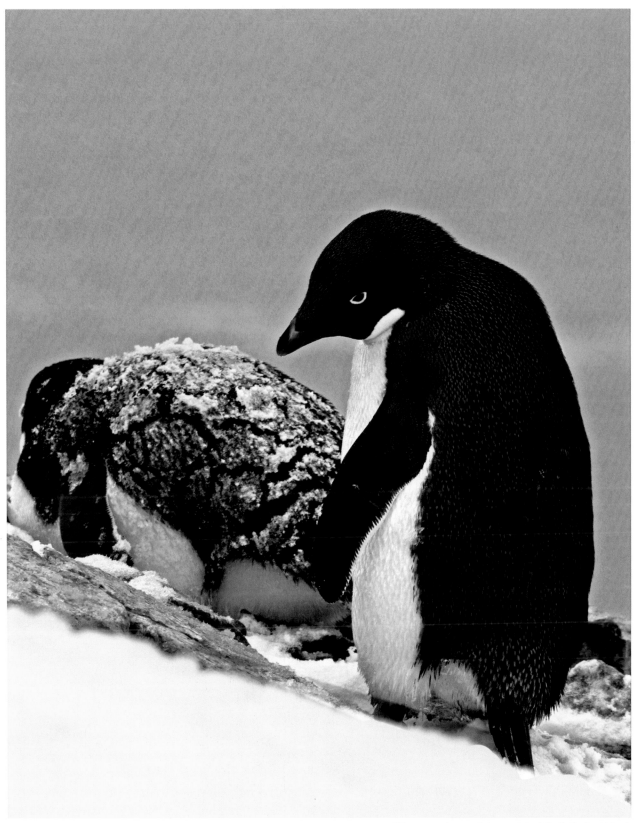

After a snow storm on Petermann Island, South Shetland Islands

About the Adélie Penguin

Population Trend

Increasing to holding steady. The Adélie penguin population trend is healthy and grew almost its entire range throughout the 1980s and early 1990s. It is estimated that during the twenty-first century they have maintained their former numbers.

Habitat

Adélie and Emperor penguins are the only penguins to breed in masses on the Antarctic continent south of the peninsula, and only Emperors breed farther south than the Adélie. The range is very wide, with the most southern colonies at Cape Royds at latitude 77° S, and the farthest north at South Sandwich Island, latitude 54° S.

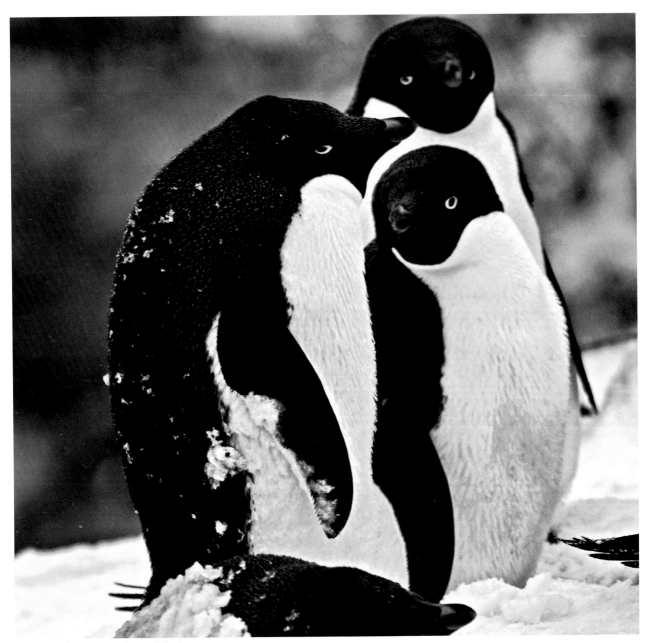

This adult is planning on stealing a neighbor's stone

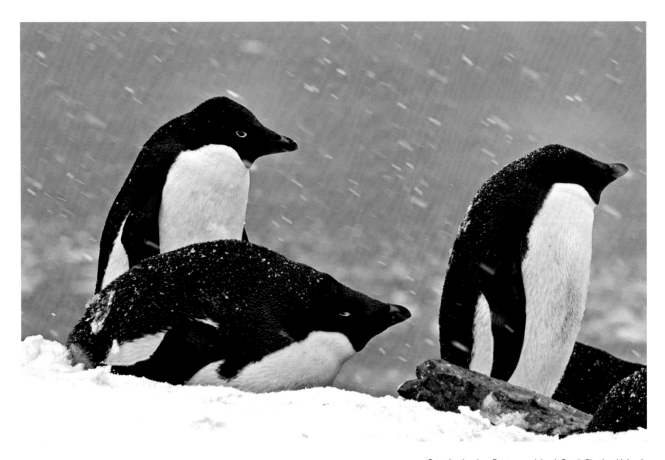

Snowing hard on Petermann Island, South Shetland Islands

Large colonies are located in deep south Antarctica in the Victoria Land region, which contains about 750,000 pairs. They can also be found in Cape Adare (250,000 pairs), MacRobertson Land (200,000 pairs), Terre Adélie, Cape Royds, Cape Crozier (150,000 pairs), Cape Bird, and Wilkes Land. In the Antarctic Peninsula the breeding sites are Palmer Land, Graham Land, and Esperanza Bay (Hope Bay) (120,000 pairs), as well as the South Shetland Islands and islands on the east side of the peninsula. Farther from the continent, fewer breed on Atlantic island groups like the South Orkney and South Sandwich Islands.

Appearance

The adult Adélie penguins have a white ring patch around their eyes, in the middle of a mass of black on their head. Their back and upper body are black to very dark brown (when worn), with a white underbody that meets the black at the neck. The Adélie penguin's bill is black with a brick-red base. Their flippers are black on the outside with a white edge. The underside of the flipper is a white to pink color. The adult's feet are pink with black soles, and the iris of their eyes is brown. Immature Adélie penguins have a black eye ring, in contrast to the adult's white ring. The immatures also have a white chin.

Chicks

At birth, chicks wear a down of gray to silver with a darker color on their heads. The down has some individual variations in shades of gray or silver. They stay in the nest for the first two weeks until they are able to maintain their own body temperature. Later they venture out of the nest, and at age three to four weeks they join a crèche, at which point they grow a secondary down of a darker color. At a relatively young age of forty-five to fifty-five days, the chicks fledge (Williams 1995). Average weight at fledging at Cape Crozier was 7.2 pounds (3.3 kg) for single chicks and 6.8 pounds (3.1 kg) if two chicks survived (Ainley and Schlatter 1972). That was 1.5 pounds (0.68 kg) less than the weight of fledging chicks at Cape Royds. They return to molt the following year and breed at age three to four for females and a year later for males.

Breeding and Chick Rearing

Adélie penguins are dedicated breeders, and their breeding cycle is quick and simple. The male arrives in late September to mid-October, with the female following shortly after. The first egg is laid, depending on location, at the end of October to the middle of November. Neither adult leaves the colony from arrival until the

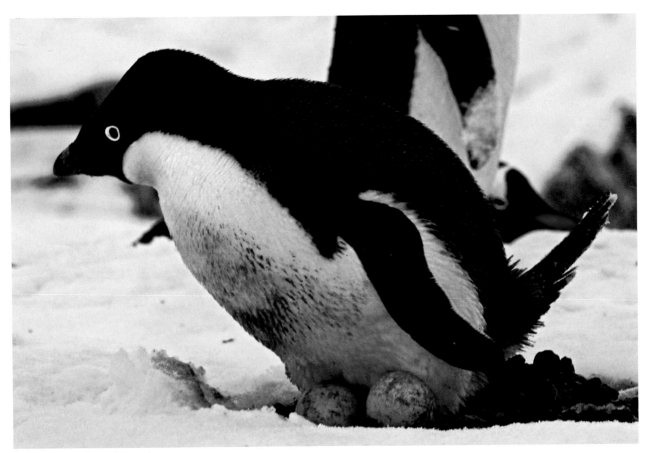

The difficult task of incubating eggs in a snow storm

female lays the two eggs, causing the female to fast for eighteen to twenty-two days. First egg weight is typically about 4.4 ounces (124.7 g), while the second is 10 percent lighter (Vleck and Vleck 2002).

Incubation starts in earnest after the second egg is laid and takes thirty-two to thirty-six days. First to incubate is the male, while the female starts her long feeding tour of eleven to fourteen days. Icy conditions have a major effect on Adélie breeding; if bad ice persists, the female's first tour can last up to twenty days, since more time is spent crossing the icy planes. Upon the female's return, the male, who has been fasting for an average of thirty-seven days, goes for his turn at sea. If the female arrives late, the male will stay at the nest for up to two more weeks before he will abandon it. After each parent's long trip is completed, they both alternate for shorter shifts while the other is at sea until the eggs hatch. Adélies seem to have some difficulty in coordinating incubation shifts. This trouble was observed by Davis (1988), who noted that during the third female shift, considerable numbers of females were delayed by many days, leaving the male with no other choice but to abandon the nest. The study noticed that such a failure was almost universally followed by the late females also arriving late at the nest the following year at the onset of the next breeding season. The males were quick to choose another female,

avoiding mating with a female that failed them the prior year. For the first 20 to 24 days after hatching, one alternating parent will brood the chicks while the other forages and feeds the chicks. The parents are constantly switching roles. After the chicks join the crèche, both parents go foraging, and each returns every one to three days to feed the chicks.

Average success per nest is a healthy 1.2 chicks in a good year (Beaulieu et al. 2010). When the shelf ice expands, the success rate might only be 0.5 chicks per nest. In a terrible ice year, the whole colony might be forced to abandon breeding midseason, causing the entire chick population to perish.

Older Adélie mates were discovered to raise heavier chicks (Ainley and Schlatter 1972). Presumably, breeding experience aids parents. This trend is measurable between age three to six but it levels off after age seven. The more mature parents are also much more successful in protecting and raising both chicks to fledging.

Foraging

Adélie penguins are very versatile foragers, and research results confirm that they adapt to local prey conditions. Their strategies vary from location to location, sometimes from year to year, and even males of the same location might follow a different strategy

from females. Clarke et al. (1998) demonstrated that female Adélie penguins, especially during chick feeding periods, require an entirely different foraging routine from males. Females spent 30 to 100 percent more time foraging, dove up to seventy miles farther away from the colony, and also preyed mostly on krill. Males stayed closer to the colony, within thirteen miles (21 km), and consumed much more fish.

The dependence of one partner on the other is immense. To prove such relationships, Beaulieu et al. (2009, 2010) formulated a study by fitting one partner of the nest with a dummy device that increased water friction and made diving harder. The results, as expected, showed that the artificially handicapped bird had to adjust its pattern by staying closer to the shore, increasing the duration of foraging trips by an average of 70 percent. Still, they lost 60 percent more weight than normal birds. The unaffected partners, who were free to dive without obstruction, also suffered consequences. They did not increase the duration of their foraging trips, but instead stayed closer to shore. The change in their foraging behavior may be a way to compensate for the longer fasting periods they had to undergo on the nest while maintaining a stable body mass.

In addition to the effort to capture prey, penguin parents, throughout the breeding cycle, need to make a decision whether to allocate food to their offspring or use it for their own benefit. Takahshi et al. (2003) showed that the length of the foraging trip has no relationship to the amount of food delivered to the chicks. It is the body size and weight of the female that influences how much food will be made available to the chicks upon landing. Trip duration varies significantly from location to location and year to year, depending on what condition the parent was in at the beginning of the breeding season and how soon it can recover from the long fast. Recovery depends on what prey is present, its quality, and how far the penguin must travel to reach it. The wide variation in foraging trip durations among individual Adélie penguins suggests that some are better foragers than others and that an individual's ability plays a role in predation success, which, in turn affects breeding success and chick size.

Tierney et al. (2009) obtained results of diet composition for eleven consecutive years, separating the results between males and females. Again, great variation was found among individuals and years. In most years, the female's diet was dominated by Antarctic krill, but males consumed more fish. Tierney also found

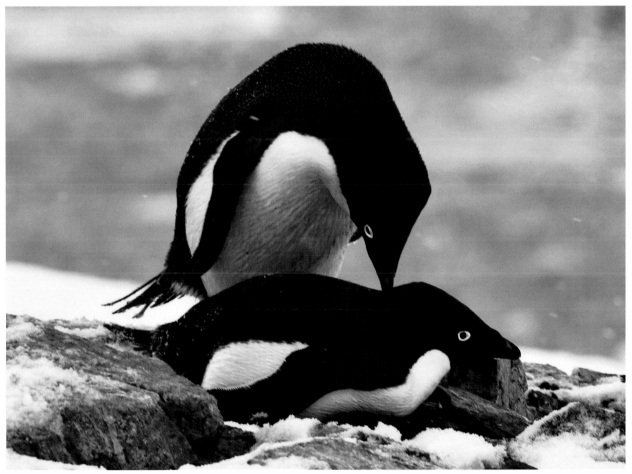

An Adélie preens its mate

a strong correlation between years of high krill mass and higher reproductive performance. It was also found that at times they were preying on other types of krill, Antarctic silver fish, amphipods (fish), and cephalopods (squid).

At Palmer Station in 1993, Chappell et al. found that most dives lasted between one and two minutes, with the longest at 2.7 minutes. The average depth Adélie penguins dove was 80 feet (24.4 m), with the deepest dive at 321 feet (97.8 m). The records observed elsewhere are 590 feet (179.8 m) deep and 4.25 minutes long. Most of the preying is done during daytime, but some is also done during the night, which is not dark during the Austral summer. What is striking about the Adélie penguins is their intensity and the long time spent underwater in contrast with the time they come in contact with air. When not breeding, they swim far away from the colony. First-year fledging juveniles were tracked 300 to 1,000 miles (482–1,610 km) away from their natal colonies (Clarke et al. 2003).

Molting

Soon after the chicks fledge, Adélie penguins go on a two- to three-week premolting trip. The biology of the molt starts while they are at sea with the initial growth of feathers under the skin and invisible from the outside. Penney (1967) described the on-land portion of the molt to consist of three premolt stages, four molt stages, and one postmolt stage. The first premolt act is when the visibly fat Adélie penguin lands and finds a snowy slope in the direction that shelters it from the wind, joining other penguins normally not at their colony. A day and half later the

second premolt phase starts when the flippers start swelling and the feathers on the flippers lose their sheen. The swelling can make the flipper double in thickness, and during the third phase the rest of the body feathers start standing out.

During the first "molt phase" loose feathers start falling off, but no new plumage is visible. During the two days of the second phase, about a quarter of the new plumage appears and the rate at which old feathers fall off accelerates. During the third stage, which lasts four days, almost the entire new plumage appears, and only extreme parts of the head and legs are left with old feathers for the fourth phase.

During the postmolt single stage that lasts three to four days, the birds are fully covered with the new plumage but take their time before entering the water to preen and waterproof their new feathers.

The entire process on land lasts for nineteen to twenty-one days, 19.8 days on average, during which they lose about 6.6 pounds (3 kg) or 45 percent of their premolt heavy weight (Penney 1967). During the premolt as well as the molt phases, birds spend hours sleeping, preening, or shaking and are easily provoked into displaying aggression. They consume ice for hydration, sometimes even if it is dirty with their feces or old feathers.

Nesting

In the colonies that are on the Antarctic continent, Adélie penguins nest deep inland and walk twenty to sixty miles before they settle. Because huge patches of fast ice can move in or out, the distance they walk to reach the colony may not be the same after

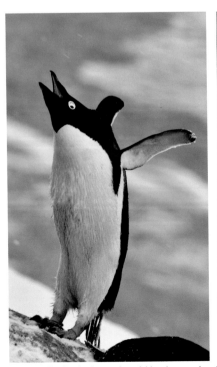
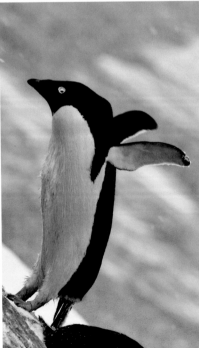
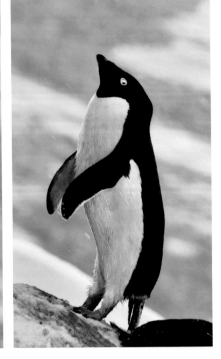

"Adelies allowing for interesting, vivid and expressive photos"

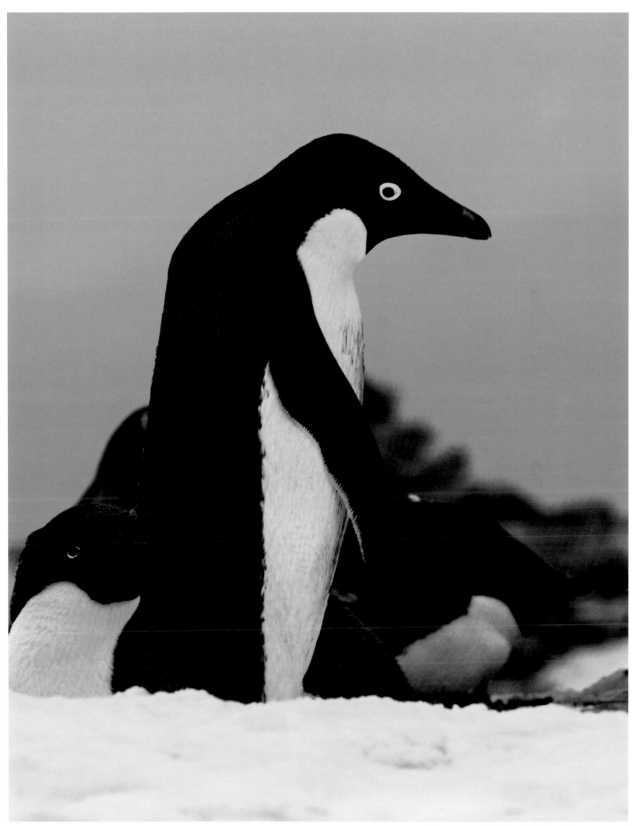

"They seemed to feel comfortable with our presence"

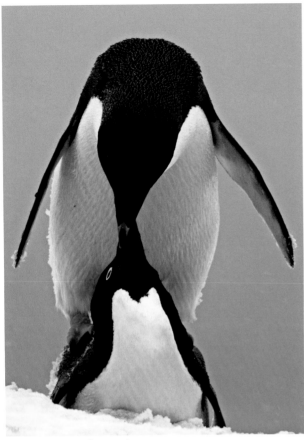

A pair of Adélie penguins mounting

exact stone. Adélie penguins are known for trying to save time by stealing pebbles from a neighboring nest. Then there is the most interesting of pebble games, when a female will pick up a stone from her own nest and bring it in front of a strange male who is waiting alone at his nest for his mate to return. The male, thankful for the pebble, responds with a quick encounter with the visiting female. Minutes later his own female will return to their nest as if nothing ever happened.

Adélie penguins can be aggressive with each other, especially during the nest-establishing period following their return from the winter foraging trip. The colony is loud and fights break out everywhere. It is interesting that many of the agonistic displays they use against each other are also directed against the skua. Most fights follow a set pattern, starting with bill pointing, rotation of the head with the bill pointed toward the opponent, closing the distance, a yell, waving the flippers, getting into position, and then either starting a bill duel or pecking the opponent.

Vocalization

The Adélie penguin's vocal repertoire is divided into calls associated with different displays and behavioral settings. One call is the agonistic "growl" used during territorial disputes; it is accompanied by a look to the sides, giving an intruder warning that the occupant intends to defend its territory. A much shorter repeated "growl" is an imminent sign of attack, and the growling continues throughout the duration of the fight. A second common call, a sexual call, is a soft humming sound used by the pair during bonding and later. A third trumpeting call is used in early bond formations as well as for nest relief. A fourth call is a contact call, which is often used at sea and is a short sound resembling a bark. Chicks have a beeping call that they use often after they reach the age of three weeks.

Dangers

Leopard seals take large numbers of Adélie penguins at sea. Leopard seals study the penguins' routine and then hide behind small icebergs waiting for the breeders to return from sea. They usually attack the adults in the transition phase between water and land, where they are much more versatile than the penguins. The leopard seals also inflict serious damage on the young fledgling that has entered the sea for the first time. Young chicks and eggs are constantly assaulted and preyed upon by the skua, petrels, and other large sea birds on land. Because chicks fledge at a younger age than other penguins and at times fledge underweight, they have difficulty adapting to their independence and fail to catch enough prey to stay alive. Their bodies wash on shore, many with visible signs of malnutrition. Weather and its effect on the sea-ice negatively influence chick mortality rates during breeding season. Lack of availability and lower quality krill and fish affect adults and can cause large-scale breeding failures.

they start breeding. Nests are in close proximity to the neighbors and colony sizes can be larger than 100,000 nests. The nest is constructed from small pebbles and is neither impressive nor in a defined shape. Pebbles can be added at any time, even after the chicks have left the nest.

Relationships

Adélie penguins are less likely to remain in a relationship year after year, and their divorce rate is higher than that of Chinstraps or Gentoos. Their nest fidelity, mostly regarding females, is lower as a result.

Like all other penguins, the display variety is rich. During the male advertising display, the penguin stands up straight on top of the nest or on a pile of stones, with its head looking toward the sky. It swings its flippers sideways while yelling. This ecstatic display demonstrates the male's physical body condition to the females (Marks et al. 2010). If a female, either last year's mate or a new one, answers him, they exchange signals until the male starts arranging the first stones for the nest. Bond reinforcement displays include pointing of bills upward together, pulling the flippers backward, and mutual preening.

While there is no shortage of pebbles in Antarctica, many fights take place because two or more birds try to posses the same

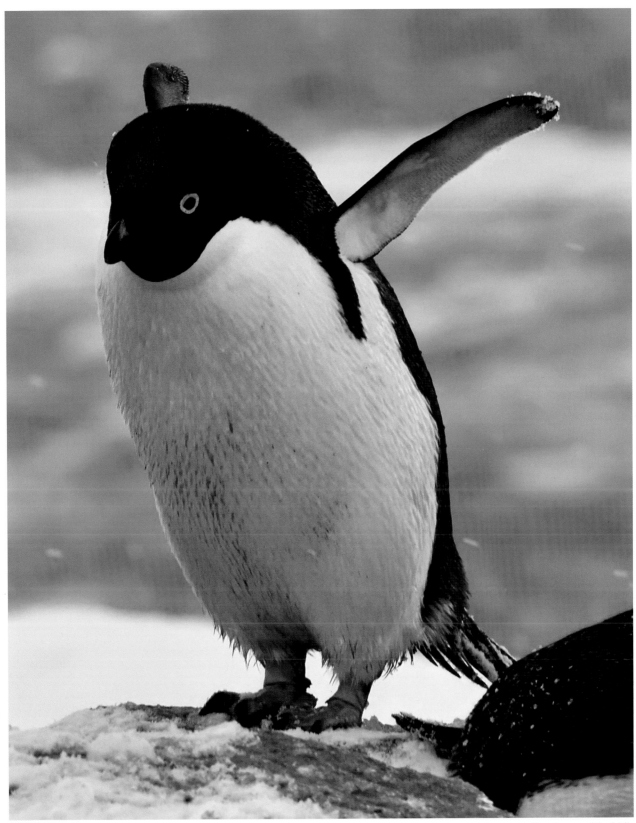

The wingspan of the Adélie

Conservation Efforts

Adélie penguins are not a major concern of conservation groups, which are busy defending other, more endangered species. Their proximity to many research stations makes them a favorite for research studies, helping in scientists' understanding of their life cycle and biology.

Interesting Research

Anyone visiting penguin colonies notices many chicks running after adults and begging for food. They make calls, nod their heads, and invest a great deal of time nudging one adult after another for something to eat. What are the chances of a hungry chick in the middle of a huge Adélie colony receiving food from a strange adult? According to Beaulieu et al. (2009) in the paper "Alloparental Feeding in Adélie Penguins: Why Is It Uncommon," the chances are next to none.

In an Adélie colony, at any given time there are numbers of non-breeding adults, either males that did not find a mate or couples that lost both chicks or eggs. The study followed a pattern of chicks begging strange adults for food. Chicks begging for food usually stand near the nest and start begging the first adult they see. More often than not, these are the adults nesting at the next nest and who are busy feeding their own chicks. As a result only 4 percent of the approached adults were willing to feed the begging chick at least one item.

Beaulieu's study showed that adult Adélie penguins are not interested in chicks they did not clutch. No one knows for sure what the reasons are, but the authors of the paper suggest four reasons. First, most pairs do have at least one chick to feed, and the availability of an unsuccessful adult breeder in the colony is small. Second, the chicks utilize a flawed strategy by not directing their begging at non-breeding adults. Third, the chicks are begging late into the breeding season, when chick feeding requirements are high and while the adults are also in need of more calories as they are preparing for the molt. Lastly, levels of parental hormones associated with breeding in penguins have been found to be low in males that experienced failed nests. Therefore, they did not have an interest in the hungry chicks.

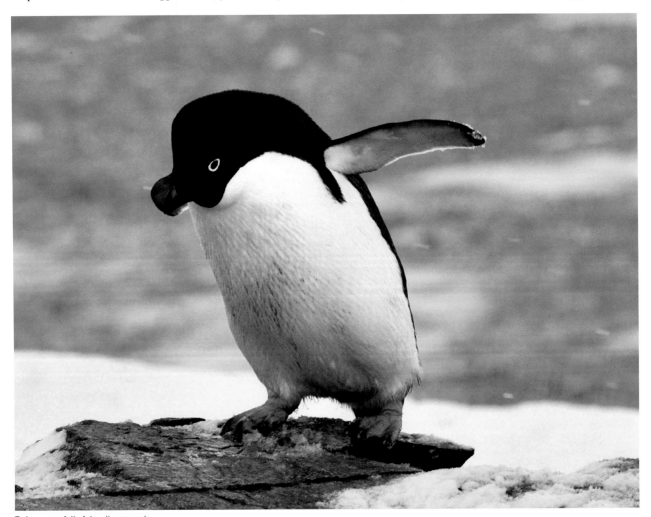
Trying not to fall of the slippery rock

Charts

Weights	Source 1	Source 2, 3, 4, 5	Source 6, 7, 8
Breeding Male	9.9–13.2 lb/4.5–6.0 kg	11.9 lb/5.4 kg[2]	10.4 lb/4.7 kg[6]
Breeding Female	8.2–11.0 lb/3.7–5.0 kg	10.4 lb/4.7 kg[2]	9.7 lb/4.4 kg[6]
Incubation Male		9.7 lb/4.4 kg[2]	9.0 lb/4.1 kg[6]
Incubation Female	6.6 lb/3.0 kg	8.6 lb/3.9 kg[2]	8.1 lb/3.7 kg[6]
Premolt Male	13.2–17.6 lb/6.0–8.0 kg	14.8 lb/6.7 kg[3]	13.2 lb/6 kg[7]
Premolt Female	13.2–17.6 lb/6.0–8.0 kg	14.8 lb/6.7 kg[3]	11.9 lb/5.4 kg[7]
Postmolt Male	9.9 lb/4.5 kg	8.2 lb/3.7 kg[3]	7.3 lb/3.3 kg[7]
Postmolt Female	8.8 lb/4.0 kg	8.2 lb/3.7 kg[3]	6.0 lb/2.7 kg[7]
Fledging Chicks	6.6–9.9 lb/3.0–4.5 kg	6.2–7.0 lb/2.8–3.2 kg[4]	4.4–6.6 lb/2.0–3.0 kg[8]
Egg	0.18–0.33 lb/82.0–150.0g	0.25–0.28 lb/113.0–127.0 g[5]	0.25–0.27 lb/113.0–122.0 g[7]
Lengths	**Source 1**	**Source 2, 9**	
Flipper Length Male	7.1–8.3 in/18.0–21.0 cm	7.6 in/19.3 cm[9]	
Flipper Length Female	7.1–7.9 in/18.0–20.0 cm	7.4 in/18.8 cm[9]	
Bill Length Male	1.4–1.7 in/3.6–4.3 cm	1.6 in/4.0 cm[9]	
Bill Length Female	1.3–1.6 in/3.3–4.1 cm	1.5 in/3.8 cm[9]	
Foot Length Male		1.3 in/3.3 cm[2]	
Foot Length Female		1.7 in/4.3 cm[2]	

Source 1: Beaulieu, personal communication (2010)—Dumont d'Urville, Antarctica. Source 2: Williams 1995—King George Island, South Shetland Islands. Source 3: Penney 1967—Wilkes Station, Antarctica. Source 4: Salihoglu et al. 2001—Torgersen and Humble Islands, Antarctica. Source 5: Williams 1995—Various Locations. Source 6: Chappell et al. 1993—Palmer Station, Antarctica. Source 7: Marion 1995—Various Locations. Source 8: Ainley and Schlatter 1972—Cape Crozier, Antarctica. Source 9: Williams 1995—Mawson Station, Antarctica.

Biology	Source 1, 2	Source 2, 3, 4	Source 5, 6, 7, 8, 9, 10
Age Begin Breeding (Years)	2–4[1]	3–4[3]	3–4[5]
Incubation Period (Days)	30–36[1]	33–35[3]	32–34[5]
Brooding (Guard) Period (Days)	20–30[1]	18–27[3]	
Time Chick Stays in Crèche (Days)	20–30[1]	19–37[3]	
Fledging Success (Chicks per Nest)	1.2[1]	0.69–1.06 (9-year avg.)[2]	0.71[6]
Date Male First Arrives At Rookery	Late Oct.[1]	Mid-Oct.–Nov.[4]	Late Oct.[6]
Date First Egg Laid	Nov. 15[1]		Mid-Nov.[6]
Chick Fledging Date	Feb.[1]	Early Feb.[4]	Late Feb.[6]
Date Adult Molting Begins	Early Feb.[1]	Feb.– Mar.[4]	
Length Molting on Land (Days)	15–25[1]		
Juvenile Survival Rate First 2 Years		78%[3]	50–57%[7]
Breeding Adults Annual Survival	About 80%[1]	86.2%[3]	86.9%[7]
Average Swimming Speed	1.1–8.9 mph/1.8–14.4 kmph[1]		4.5–8.3 mph/7.2–13.2 kmph[8]
Maximum Swimming Speed	8.9 mph/14.4 kmph[1]		8.2 mph/13.2 kmph[8]
Deepest Dive on Record	590.6 ft/180 m[1]		590.6 ft/180 m[9]
Farthest Dist. Swam From Colony	78.3 mi/126 km[2]		68.4 mi/110 km[10]
Most Common Prey	Krill[2]	Krill[3]	Krill[10]
Second Most Common Prey	Fish[2]	Antarctic Silver Fish[3]	Antarctic Silver Fish[10]

Source 1: Beaulieu, personal communication (2010)—Dumont d'Urville, Antarctica. Source 2: Irvine et al. 2000—Béchervaise Island, Antarctica. Source 3: Ainley and Schlatter 1972—Cape Crozier, Antarctica. Source 4: Penney 1967—Wilkes Station, Antarctica. Source 5: Borboroglu 2010—Not Specified. Source 6: Clarke et al. 2003—Mawson Coast, Antarctica. Source 7: Clarke et al. 2003—Béchervaise Island, Antarctica. Source 8: Chappell et al. 1993—Palmer Station, Antarctica. Source 9: Whitehead 1989—Prydz Bay, Antarctica. Source 10: Watanuki et al. 1997—Dumont d'Urville, Antarctica.

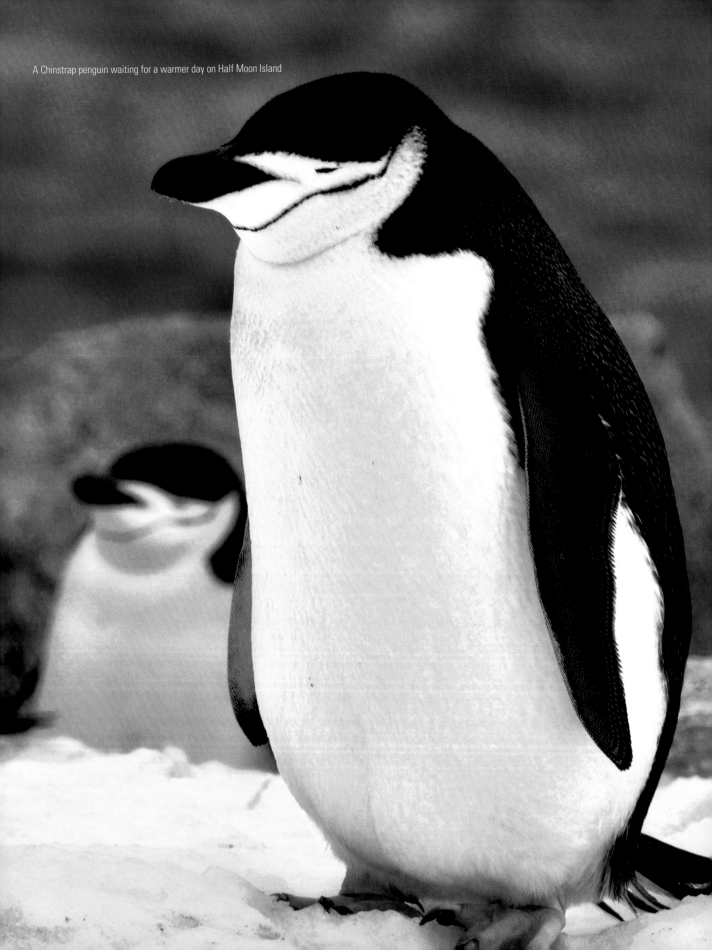

A Chinstrap penguin waiting for a warmer day on Half Moon Island

Chinstrap Penguin
Pygoscelis antarctica

Genus: *Pygoscelis*

Other Genus Members: Adélie and Gentoo

Subspecies: None

IUCN Status: Least concern

Latest Population Estimates
Individual Birds: 17–18 million
Breeding Pairs: 7.5 million

Life Expectancy
Chinstraps can live up to 20 years in the wild; however, the average lifespan is less than 12 years

Migratory: Yes, they are absent from the colony from April to October.

Locations of Largest Colonies: South Sandwich Islands, South Shetland Islands, and the South Orkney Islands

Colors
Adults: Black, white, and pink
Bill: Black
Feet: Pink with black soles
Iris: Brown to reddish
Chick Down: Gray
Immature: Dark spots on face, darker than adults

Height: 26–28 in/66–71 cm

Length: 28–30 in/71–76 cm

Normal Clutch: 2 eggs per nest

Maximum Chicks Raised per Pair per Year: 2

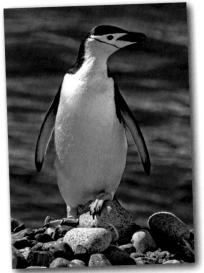
Adult Chinstrap penguin

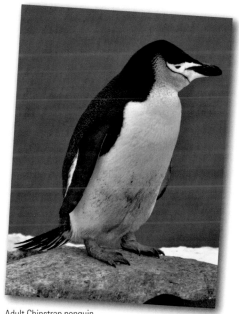
Adult Chinstrap penguin

David's Observations

I got to see Chinstrap penguins in mid-November during an Antarctic cruise I took on the We arrived at the Half Moon Island colony on a bright sunny day, but snow was fresh and deep. The Chinstrap penguins were nesting on the rocks at high elevations. Some birds were already incubating their eggs while others were mating, and a few unlucky birds were still alone and advertising. Watching how they struggled to find a snow-free rock on which to nest was a reminder of why this species needs to nest at a distance from the shore. The colony was calm, fights were rare, and many birds were in the midst of their nest building. Some Chinstrap penguins were adding pebbles around an incubating partner. It appeared that the easiest way to obtain a pebble was to steal it from an incubating bird, sneaking up from behind and grabbing it. The losing bird cannot do much, because it must stay on the eggs.

Chinstrap penguins are very photogenic. They are not afraid of humans, hugging, bowing, and mounting right in front you. Their elegant black lines make great pictures and also add a very emotional and loving stance, especially when they lower their heads to bow. During the week we were visiting, no birds departed the colony. At times one bird would start an advertising call, pointing his head up to the sky. Within minutes, many fellow Chinstraps were doing the same, as if they were a choir practicing in front of the cameras. The sun was shiny, temperatures were in the 70s, and the entire colony appeared to have one great spring party. It was hard to leave these friendly, loving, elegant birds and not know when I would be able to meet them again.

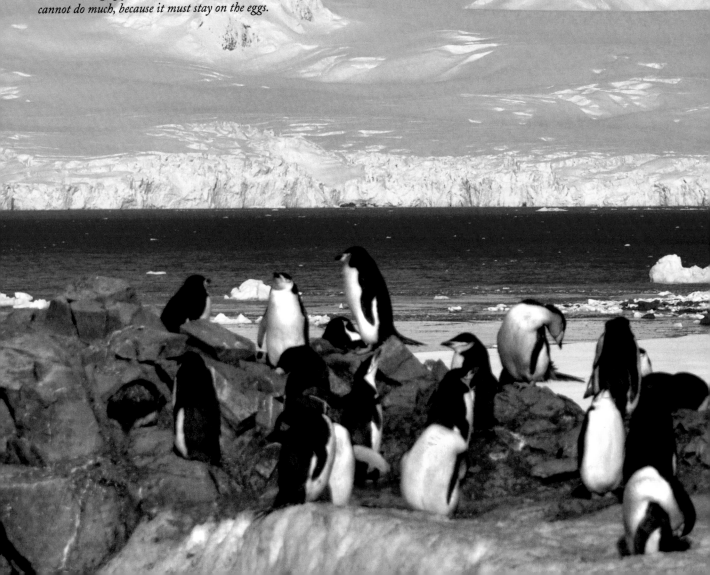

Enjoying a beautiful sunny day on Half Moon Island, South Shetland Island

About the Chinstrap Penguin

Population Trend

Holding steady to slightly decreasing. Counting Chinstrap penguins is an extraordinary task because of their sheer numbers. Their colonies are numerous and scattered over a large geographic area. It is well documented that their population increased for the most of the twentieth century, but the population has become more dynamic recently. Over the past twenty years, different locations have reported different patterns; some colonies, like those on South Shetland Islands, are declining rapidly. However, new colonies spring up and others keep steadily growing. The Chinstraps are the second most populous penguin, behind the Macaroni (Woehler and Croxall 1997).

Habitat

The many Chinstrap colonies can be generally found between the latitude of 56° S and 65° S. This penguin breeds on many islands off the Antarctic Peninsula, notably the South Shetland Islands including Livingston, Seal, Half Moon, Deception, King George, and Penguin Island. They also breed on the western coast of the mainland's peninsula at three different locations. Colonies also exist on the islands farther east, like South Orkney, South Georgia, and South Sandwich, where their largest colony is located. The Chinstrap penguin's habitat is heavily populated with other penguin species, occasionally requiring confrontation with penguins from other species that have tried to claim their nests. The Chinstrap arrives later than other brush-tailed penguins and is smaller than Gentoos, both of which are characteristics that put them at a disadvantage when competing for nests.

During the winter, Chinstrap penguins spend a very long period of seven to eight months in the water diving. In most cases they don't go very far, staying within 100 miles (161 km) of their colony. Nevertheless, several were documented reaching up to 1,000 miles (1,609 km) away, visiting with other Chinstrap friends in faraway locations.

Appearance

The Chinstrap penguin's most striking features are its narrow black line running from one ear to the other, under the chin (hence the name); the black patches surrounding both eyes; and a black head top that looks like a tight hat. The chest and underbody are all white; the white extends the entire front of the neck, up the chin, and covers half of the face, just above the eye and bill. There

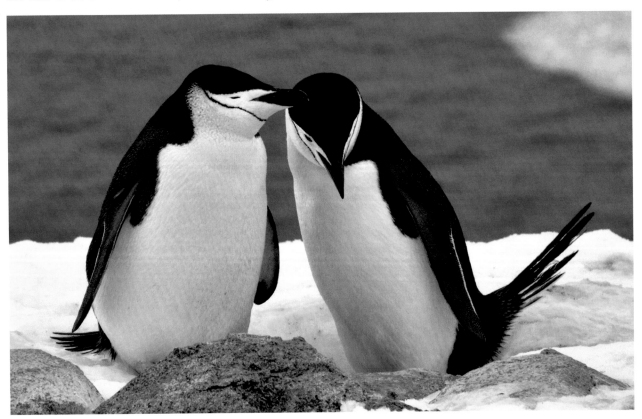

A romantic Chinstrap pair

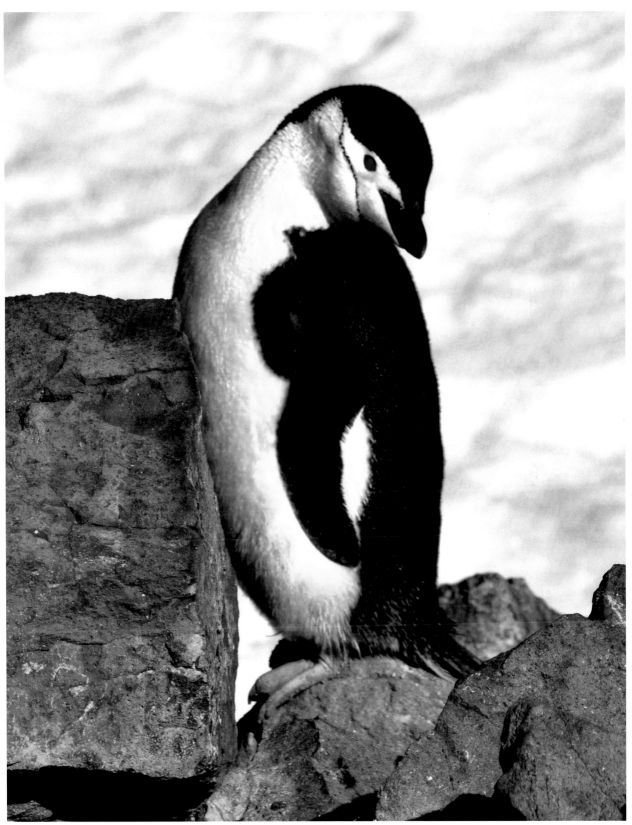

Advertising high up on the rocks

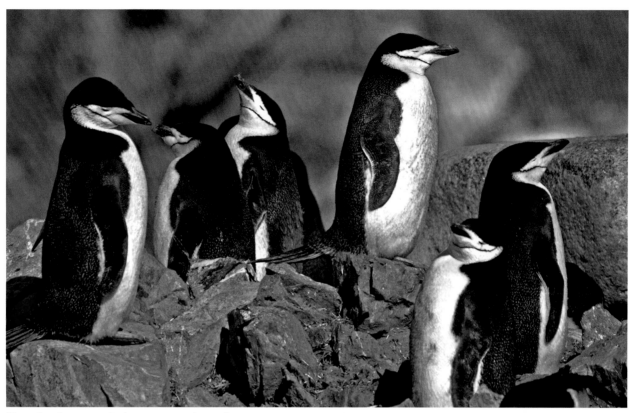

"The entire colony appeared to have one great spring party"

is also a quarter moon–shaped extension of white toward the ear. Because the white extends so far on the head, the black areas make the Chinstrap penguin appear like it is wearing a Jewish Kippa. The bill is almost all black, with some gray present, and is surrounded by all-white plumage, making it more illustrious than other penguins. The feet are mostly pink with big black claws. The flippers are black on the outside with fine white lines along the outer edge. The inside of the flipper is mostly white with a few pink patches.

Immature Chinstrap facial features are not as well defined as those of the adults. Juveniles' colors are a grayish to silver back and white underbody, but they do have some black spots on their faces.

Chicks

Chinstrap chicks wear a gray down when they hatch. The chicks only stay with the parents at the nest for the first three to four weeks. They then move into a crèche that normally contains from forty up to two hundred chicks. Some chicks prefer a smaller group, and so there are crèches that contain only four or five chicks.

Crèche amalgamation occurs with other penguins and birds. It is not always clear how the crèche protects the single chick. Many consider protection against the avian skua predator the main benefit of the crèche. Yet watching a skilled skua taking

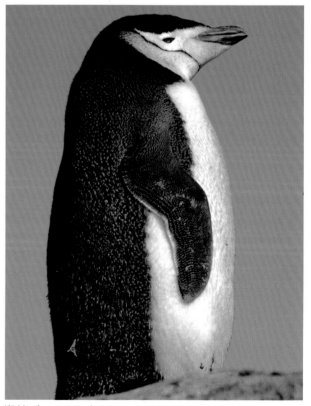

Waiting for a mate to show up

a Chinstrap chick creates the impression that there is very little chance for escape, no matter how many other small chicks are around it. A nearby adult can scare the skua away from the chicks much more easily, and this fact alone should favor parental guardians for the chick over a crèche arrangement.

The chicks stay in the crèche for approximately thirty days. They wander around the colony with their peers until their parents stop feeding them and they fledge, at about fifty-five days of age. The juveniles fledge at very early age, resulting in a higher threat of death within weeks of their entry into the ocean.

Breeding and Chick Rearing

Chinstraps are highly synchronized and fast breeders, but they spend minimal amounts of time guarding their chicks (compared to other penguins), usually less than four weeks. These penguins are bound by very difficult, icy weather conditions, forcing them to start breeding late. They seem to be in a hurry to complete the breeding cycle before the ice returns. In times of stress, excessive ice, or food shortages, they might abandon their nests altogether.

The male, after almost eight months at sea, arrives first in late October or early November. His first order of business is to claim the nest. The female shows up three to five days later. By late November to early December, the female lays two eggs, three to four days apart. Both parents take turns incubating the eggs; the mother sits on them for the first six days. It takes thirty-six to thirty-eight days for the egg to hatch, which usually occurs in late December through mid-January. About 60 to 70 percent of the nests experience the hatching of both chicks. Egg losses are generally due to preying birds, floods, or bad nest relief by a parent.

During the first three weeks of the chick's life, the parents shuttle often, each at least once every two days. The pair strives to feed each chick two meals a day, normally one from each parent. As the chicks grow bigger, the parents decrease the feeding frequency but compensate with bigger quantities of food (Penteriani et al. 2003). During the crèche phase, both parents still feed their own chicks (no others) but have no other physical interaction with them.

Fledging success varies based on location and weather severity for that year. When a large area of sea-ice persists close to a colony, foraging parents must spend longer amounts of time crossing the ice on their way to the sea. As a result, many chicks die of starvation before the parent can return. Normal fledging success rate is between 0.56 and 1.02 chicks per nest (Williams 1995). The U.S. field camp on Livingston Island reported a 1.11 chick fledging rate per nest as its ten-year average, but they also reported a catastrophic rate of 0.33 chicks fledged per nest in 2008 (AMLR 2008). In 2006, Rombolá reported a rate of 0.67 to 1.35 chicks fledged per nest over their five-year study at South Orkney Island.

The approximately ninety-day-long breeding cycle, from lay until fledge, is remarkably quick. It allows the adult Chinstraps to have a much longer than average time at sea to rebuild and regain the mass they lost.

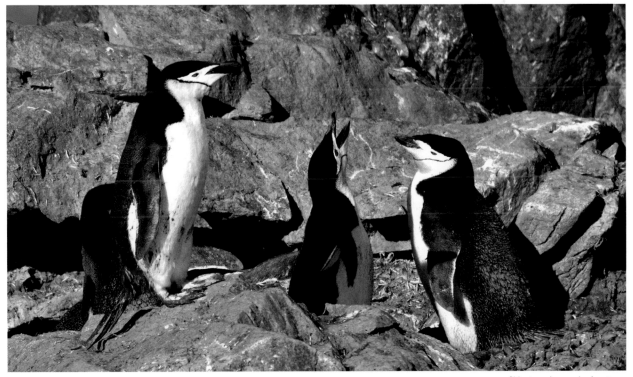

Chinstraps in search of partners

Foraging

Chinstrap penguins are inshore foragers, simple and practical. They do their foraging in shallow water most of the time. Their habitat is within an area with a good and fairly steady presence of krill, which they prefer to consume. Krill are present in larger quantities throughout the Southern Ocean. They are colorful, slower than fish, and swarm in large groups. On the other hand, krill have less fat and calorie content per pound than fish because of their shells.

The dominance of krill in the Chinstrap diet is the conclusion of many studies analyzing their stomach contents. There should be a note of caution about stomach studies during chick feeding periods because penguins digest food at such a rapid rate it is possible that their stomach contents upon returning to shore might not be the adult's normal diet, but rather what the chicks need. It is possible that the Chinstrap diet contains larger quantities of fish and squid, as some studies found high quantities of their indigestible remains. Chicks might be fed mostly krill, because some krill types contain large quantities of natural growth hormones.

Like any other penguin, the Chinstrap will swallow as many prey items as it can. Under normal conditions it will use its simple foraging patterns during the day and in shallow water as long as the krill are providing sufficient nutritional value (depending on the krill size). Those simple dives are about one minute long, with rare dives lasting into the three-minute range. Dives usually average 70 feet in depth and rarely are below 140 feet (42.7 m) (Lishman and Croxall 1983). The deepest dive recorded was a respectable 587 feet (179 m), showing that when in need, the Chinstrap penguin can go down deep (Mori 1997).

Some years the krill does not reach its normal size, and smaller krill contain less calories and nutritional value. When this occurs, Chinstraps resort to a different plan. They will extend their foraging trips overnight and dive far deeper. Deeper dives indicate searches for lantern fish. Lantern fish are deep swimmers during the day, well below the Chinstrap penguin's diving depth range. However, at night these fish rise higher in the water column where the penguins can reach them. It appears that this species possess much better night vision than most other penguin species. While other penguins' dives at night are shallower, Chinstrap penguins actually dive deeper than during the day to resolve krill shortages (Miller and Trivelpiece 2008).

In 1999, Wilson and Peters suggested that the average foraging trip during breeding is 10.6 hours long, ranging less

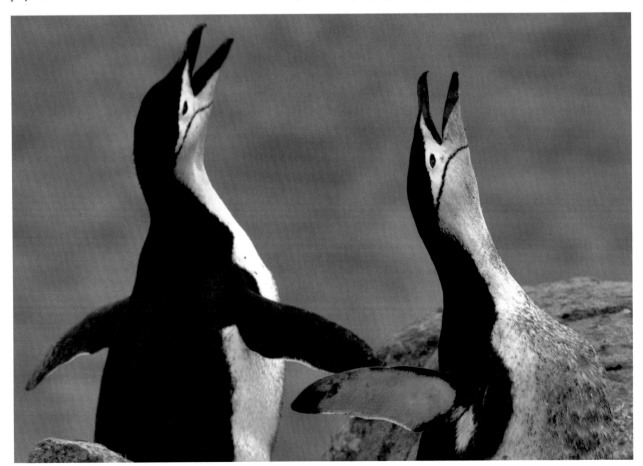

Mutual advertising before tying the knot

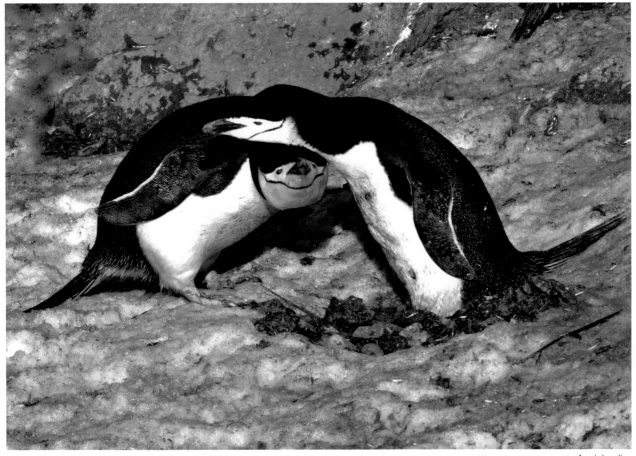

A pair bonding

than twenty miles. They also found that 80 percent of the dives were less than one hundred feet (30.5 m) deep and mean speed underwater was 5.5 miles per hour (8.9 kmph). Their conclusion was that the Chinstrap is an inshore diver and that it spends most of its diving time close to the surface.

Molting

Chinstrap penguins hurry to molt so they can return to the ocean for their seven-and-a-half-month extended foraging trip. After their quick breeding cycle, they do not need a long premolt trip. They return to land in late February and conclude their molt in only twelve to fourteen days.

By the middle of March, fitted with new plumage, they are back in the ocean. Their time spent on land from their arrival at the beginning of breeding season until after their molt is the shortest of any species. First-year juveniles molt two to four weeks earlier than the adults.

Nesting

The Chinstrap penguin's round nest is built from small stones. The nest weight on an average is about 11.2 pounds (5.1 kg) (Barbosa et al. 1997). It seems that building the nest is an

ongoing and continuous project, as they keep bringing and piling stones even after the chicks have hatched. Like anything else in Chinstrap life, after all that work the nest is still very plain and just big enough to raise two chicks.

Chinstraps prefer big inland colonies, stretching for what seems like forever on slopes that normally do not accumulate much snow and are located quite a distance away from the ocean. They build nests in close proximity to their neighbors, about twenty-four inches apart. They mix with other species and breed in close quarters with Gentoo penguins, Adélie penguins, and also flying sea birds like cormorants.

The size of the colony matters for Chinstrap penguins, as seen in the breeding success rates on Deception Island, which were better in large colonies than smaller ones. Location within the colony had little influence on their survival rates. The Central Breeding Theory, which states that chicks raised in the center of the colony have better chance of survival, could not be proven for the Chinstrap (Barbosa et al. 1997).

Relationships and Vocalization

The Chinstrap penguin's voice was described as a crowing or queer buzzing. Like all other penguins, each display is associated

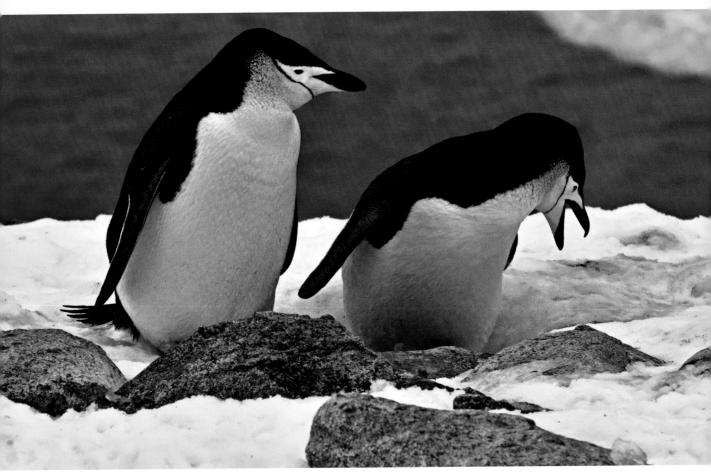

A Chinstrap turns its head away as a sign of respect

with a certain vocal call. Ecstatic displays include advertising, which involves a straight body with the head pointing to the sky. This posture is accompanied by a short call that is repeated many times and grows louder as the length and intensity of the body vibrations increase. This call greatly differs between individual birds. It is an up-and-down song, going from middle frequencies to higher ones and then quickly reverting to lower frequencies. It is normally followed by extensive bowing.

Bowing is followed by its own call, which is different than the initial mutual call, as if it is a softer song (or a verbal exchange). The softer call is preferred once recognition is established (Bustamante and Márquez 1996). Bowing can be repeated many times, and the processes might take a while; birds at this time will get closer to each other, allopreen, and touch. At other times one bow is enough, and the nest change will be executed quickly in order for the hungry penguin to rush to the ocean to feed.

During the crèche phase, chicks must call while at the nest in order for the parent to recognize and feed them. Their song is more like an inverted beep, going up quickly and then slowly down to a lower frequency. Their lower frequency is relative because the young penguin voice has much a higher pitch than the adults. During the crèche phase, the chicks' begging for food

is the dominant sound at the colony as parents force a feeding chase upon their offspring. In a feeding chase, the adult, after recognizing its chick, takes off running away from the colony, forcing the chick to follow it. Only after some distance will the parent stop and get itself into position to shove the food into the tired chick.

Chinstraps fight more frequently during certain periods. Male fights are common during nest-claiming periods, and female fights break out a week later when they first arrive. They project short agonistic calls before bill duels. Pecks and flipper slaps are used if the duel does not resolve the dispute, and some fights result in injuries.

Moreno et al. (2000) investigated the possibility that ex-pair encounters could lead to a male caring for an unrelated chick. They even checked whether the size of the colony might affect the result. Again, like in other species, the chicks always were of the same genetic makeup as the male, leaving intact the mystery of the reason and purpose of ex-pair encounters.

Dangers

Leopard seals at sea and in the transition point from sea to land present the biggest danger to the Chinstrap penguin. The leopard

seal inflicts substantial damage to the Chinstrap population, especially during chick feeding periods, when the penguins enter and exit the water. One explanation for the fasts the adults preserve during chick rearing could be to minimize the danger of facing the seals by lowering the number of landings on shore. The Chinstraps seem to have more trouble than other penguins escaping the seals, particularly during their juvenile years.

Skuas and petrels are constantly looking for a lazy parent so they can attack young chicks. Gulls and sheathbills also snatch eggs and sometimes weak chicks, as well as dying or injured adults.

As with all penguins, shortage of food can cause massive harm, especially taking into consideration that during the premolting season there are about 17 million Chinstrap penguins that need at least three to four pounds (1.4–1.8 kg) of krill a day, totaling 50 to 60 million pounds (25,000–30,000 tons). Decrease in krill size can also cause grave problems for the chicks and adults because smaller krill contain a fraction of the nutritional value of bigger krill. This problem is magnified because the krill's shell is not digestible and does not provide calories.

Conservation efforts

Because their population is large and was presumed steady, there are not too many publicized projects to protect Chinstrap penguins. However, there is a growing interest from the public, as well as from researchers, to understand their lives and hardships. They have colonies near many scientific outposts and are popular subjects to study. It helps that their stay on land is the shortest of any penguin species, which makes it easier to conclude the studies before the arrival of the harsh winter months. Chinstrap researchers are noticing a reduction in nest numbers in recent years. To gain a better understanding of the population dynamics, a credible census is in order. A census will be the first major conservation project for the Chinstrap penguin, but it will not be easy to accurately count a species that has millions of nests in notoriously ragged and remote terrain.

Interesting Research

Many variables exist in crèche formation, and researchers have proposed infinite theories to explain the reasoning and benefits behind penguin crèches. Penteriani et al. (2003) reviewed many variables, some never before considered. They looked at the parents' physiological condition, as well as the social behavior of the chicks and others at the colony. This included observing aggression by adolescent Chinstraps, predators and presumed threats, the chick's physical measurements, date of hatching, and other causes. Penteriani et al. concluded that it is too simplistic to choose one cause or one benefit to justify the crèche's formation. Instead, they see that many forces are at play, including the conflicting interests of the parents, their chicks, and the other

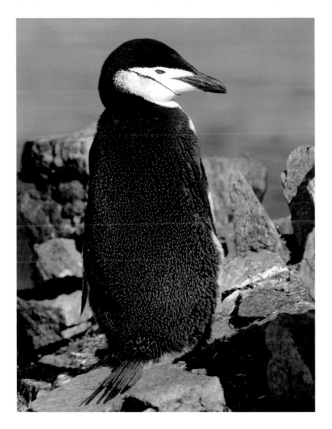

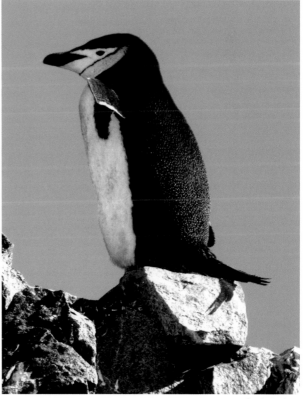

On the lookout

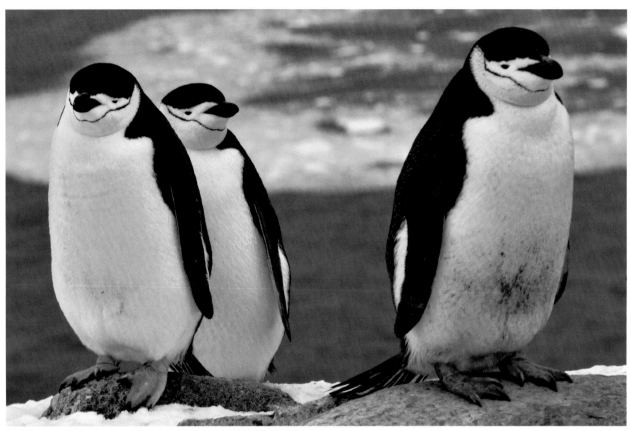

Fat Chinstraps shortly after they arrived on Half Moon Island, South Shetland Islands

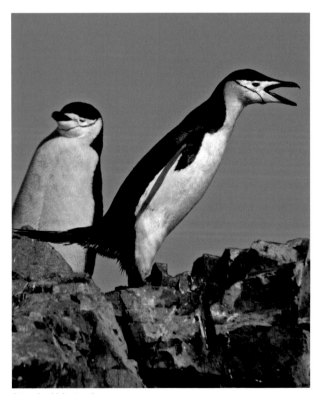

Attracting high attention

chicks within the crèche, as well as of older nonbreeding and aggressive Chinstrap penguins. All of these factors contribute to the chick's decision to join a crèche. When one day the chick finds itself in a situation where it is alone, temporarily abandoned by parents that have both left for a foraging trip, a crèche seems like the safest idea. Life histories, behavior, social needs or social skills, local conditions, and body characteristics all might play a role in why a lone chick finds comfort in joining a crèche.

It is amazing what scientists who find themselves somewhere at the edge of the end of the world can come up with. Good studies cost a lot of money. A waterproof mini-GPS that can track a penguin in the water costs several thousand dollars and might be lost at sea. It is much cheaper to use basic tools, like a tape measure, and try to create a study that might catch the eye of a publisher.

This is what Meyer-Rochow and Gal (2003) did with their research. Their paper is titled "Pressures Produced When Penguins Pooh—Calculations on Avian Defecation." Yes, they actually spent their time measuring how far Chinstrap poo travels and calculated the actual pressure the penguin applies to eject it. Luckily, they did not provide the serious journal readers with a free sample.

Charts

Weights	Source 1	Source 2	Source 3, 4
Breeding Male Arrival	8.6 lb/3.9 kg		
Breeding Female Arrival	8.2 lb/3.7 kg		
Breeding Unsexed		9.0 lb/4.1 kg	8.6 lb/3.9 kg[3]
First Incubation Male	7.9 lb/3.6 kg		
First Incubation Female	7.5 lb/3.4 kg		
Premolt Unsexed		11. 2 lb/5.1 kg	
Midmolt Unsexed			9.7 lb/4.4 kg[3]
Postmolt Unsexed		6.2 lb/2.8 kg	
Fledging Chicks	5.5–7.1 lb/2.5–3.2 kg	6.4–6.8 lb /2.9–3.1 kg	7.3 lb/3.3 kg[4]
Egg 1	0.26 lb/116 g		
Egg 2	0.25 lb/112.2 g		
Lengths	**Source 5**	**Source 6**	**Source 7,8**
Flipper Length Male	7.5–7.6 in/19.2–19.4 cm	7.6 in/19.3 cm	7.1 in/18 cm[7]
Flipper Length Female	7.0–7.3 in/17.8–18.5 cm	7.4 in/18.7 cm	7.1 in/18 cm[7]
Bill Length Male	1.9–2.0 in/4.9–5.0 cm	1.9 in/4.9 cm	2.0 in/5.0 cm[8]
Bill Length Female	1.8–1.9 in/4.6–4.7 cm	1.8 in/4.6 cm	1.8 in/4.5 cm[8]
Bill Depth Male	0.7–0.8 in/1.9–2.0 cm	0.8 in/2.1 cm	0.7 in/1.9 cm[8]
Bill Depth Female	0.6–0.7 in/1.7–1.8 cm	0.75 in/1.9 cm	0.6 in/1.7 cm[8]

Source 1: Williams 1995—Deception Island, South Shetland Islands. Source 2: Croll et al. 1991—Seal Island, South Shetland Islands. Source 3: Barbosa, personal communication (2010)—Not Specified. Source 4: Moreno et al. 1999—Deception Island, South Shetland Islands. Source 5: Mínguez et al. 1998—Deception Island, South Shetland Islands. Source 6: Amat et al. 1993—Deception Island, South Shetland Islands. Source 7: Williams 1995—South Shetland Islands. Source 8: Williams 1995—Signy Island, South Shetland Islands.

Biology	Source 1	Source 2, 3, 4, 5	Source 6, 7, 8, 9, 10
Age Begin Breeding (Years)	2 (at the youngest)		
Incubation Period (Days)	33–39	33–37[2]	
Brooding (Guard) Period (Days)	20–30	28[2]	20[6]
Time Chick Stays in Crèche (Days)	30	21–28[2]	26[6]
Fledging Success (Chicks per Nest)	0.42–0.86		0.71–0.83[6]
Mate Fidelity Rate	82%		
Date Male First Arrives At Rookery	Nov.	Oct.–Nov.[2]	
Date First Egg Laid	Late Nov.–Early Dec.	Nov. 7–18[3]	Dec. 19[6]
Chick Fledging Date	Late Feb.–Early Mar.	Late Feb.[2]	
Premolting Trip Length (Days)	14–21		14–21[7]
Date Adult Molting Begins	Early Mar.–Apr.		Mid-Mar.[7]
Length Molting on Land (Days)	13		
Average Swimming Speed		2.98 mph/4.8 kmph[3]	5.4 mph/8.7 kmph[8]
Maximum Swimming Speed		4.47 mph/7.2 kmph[3]	6.9 mph/11.1 kmph[8]
Deepest Dive on Record		587.3 ft/179.0 m[4]	334.64 ft/102.0 m[9]
Farthest Dist. Swam From Colony		932.1 mi/1500.0 km[3]	
Most Common Prey	Krill	Krill[5]	Krill[10]
Second Most Common Prey	Fish	Amphipod[5]	Fish[10]

Source 1: Williams 1995—South Shetland Islands. Source 2: Borboroglu 2010—Not Specified. Source 3: Trivelpiece et al. 1986—South Shetland Islands. Source 4: Mori 1997—Seal Island, South Shetland Islands. Source 5: Lynnes et al. 2004—Signy Island, South Orkney Islands. Source 6: Barbosa et al. 1997—Deception Island, South Shetland Islands. Source 7: Croll et al. 1996—Seal Island, South Shetland Islands. Source 8: Culik and Wilson 1994—Ardley Island, South Shetland Islands. Source 9: Williams 1995—Signy Island, South Orkney Islands. Source 10: Rombolá et al. 2006—Laurie Island and South Orkney Island, South Orkney Islands.

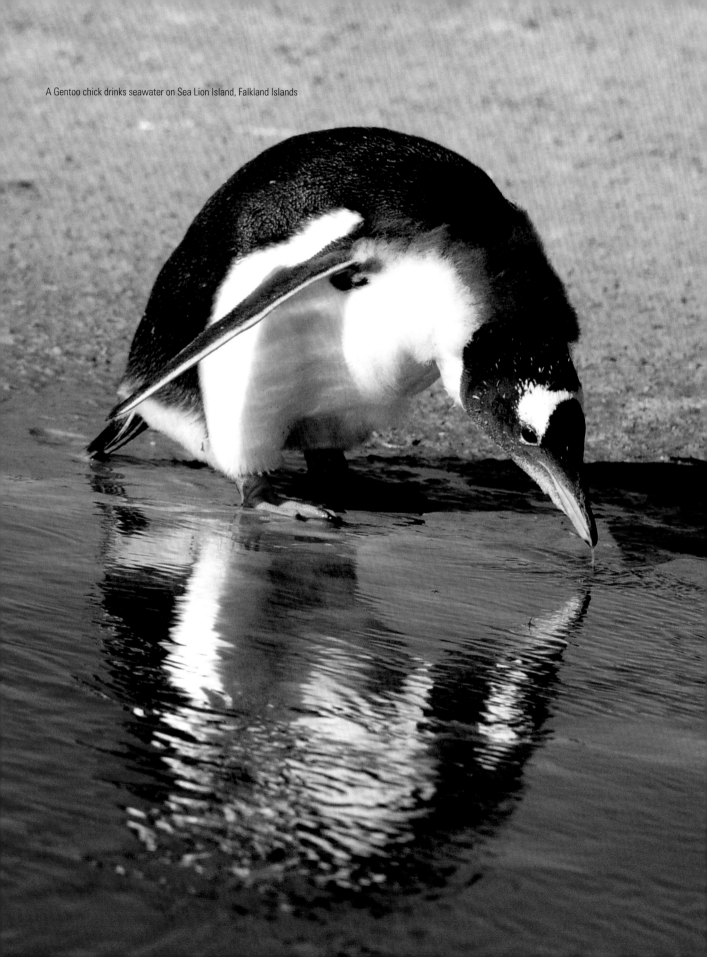

A Gentoo chick drinks seawater on Sea Lion Island, Falkland Islands

Gentoo Penguin
Pygoscelis papua

Genus: *Pygoscelis*

Other Genus Members: Chinstrap and Adélie

Subspecies: *Pygoscelis papua papua* (northern) and *Pygoscelis papua ellsworthii* (southern and smaller in size)

IUCN Status: Near Threatened

Latest Population Estimates
Individuals: 950,000
Breeding Pairs: 387,000 (Lynch 2011)

Life Expectancy
Wild: 10–15 years
Captivity: 30 years

Migratory: Some are migratory, like those in southern locations, while others are sedentary.

Locations of Largest Colonies: South Georgia Island, Falkland Islands, Kerguelen Island, Heard Islands, Crozet Islands, South Sandwich Islands, South Orkney Islands, and Macquarie Island

Colors
Adult: Black, white, and orange
Bill: Orange and black
Feet: Orange to light yellow
Iris: Brown
Chick Down: Gray and white
Immature: Same as adults, though black appears dark brown

Height: 28–31 in/71–78 cm

Length: 31–33 cm/78–84 cm

Normal Clutch: 2 eggs per nest

Maximum Chicks Raised per Pair per Year: 2

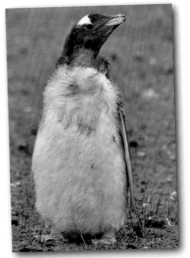
A Gentoo chick molting

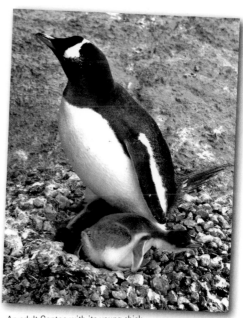
An adult Gentoo with its young chick

159

David's Observations

*T*he best way to meet a Gentoo penguin is to fly to the Falkland Islands. The Falklands are 600 miles (965 km) east of Argentina and were the cause of the 1982 Argentinean invasion and war, which is the reason you must take a flight from the Chilean port city of Punta Arena rather than from Argentina itself. Commuting between islands is done via a local air service that uses a small, eight-seat plane appropriately called the Islander. At Sea Lion, an outer island populated by one lodge, the airport is in the back yard, and so are the Gentoo penguins. As in so many other places, the Gentoo colony is joined with that of the Magellanic.

Waking up early to the chilly Falkland air on a summer morning and running to the beach to photograph Gentoo penguins is an experience well worth the effort. They gather on the beach and preen while talking, preparing to enter the water. Unlike many other penguins, they are very efficient in the order by which they enter the water. Gentoo penguins always check to see what is happening around them. If you are low to the ground and stationary, they will come and touch you. They hang around in fairly large groups that can exceed one hundred penguins with no apparent leader at the helm, but if one of them decides that it is time to take off, many will join.

I returned late in the afternoon, waiting to see them come home from a day of foraging.

I looked as far as I could see out to sea; all of a sudden I saw movement over the water, as if a bunch of low-flying birds had arrived. A second later they would disappear and reappear as they traveled forward like a group of freestyle swimmers, weaving their bodies in and out of the water. Their porpoising must have been exhausting as they jumped into the air and plunged back to the water, laboring their way back to the beach. I soon realized they had noticed my presence, as they disappeared under the water for a while. When they washed ashore it was a few hundred feet away. Just as they dried off and began their short walk back to the colony, the next group was already plowing in and out of the water. I walked back to the lodge, seeing them waddle alongside me, and I wondered how much energy these birds must consume in a day full of activity.

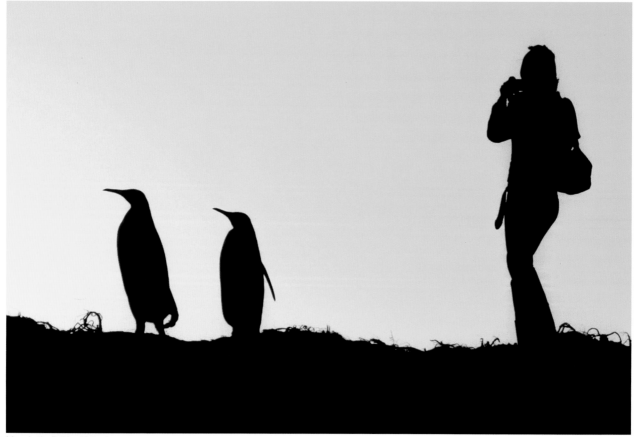

Mora in the Falkland Islands

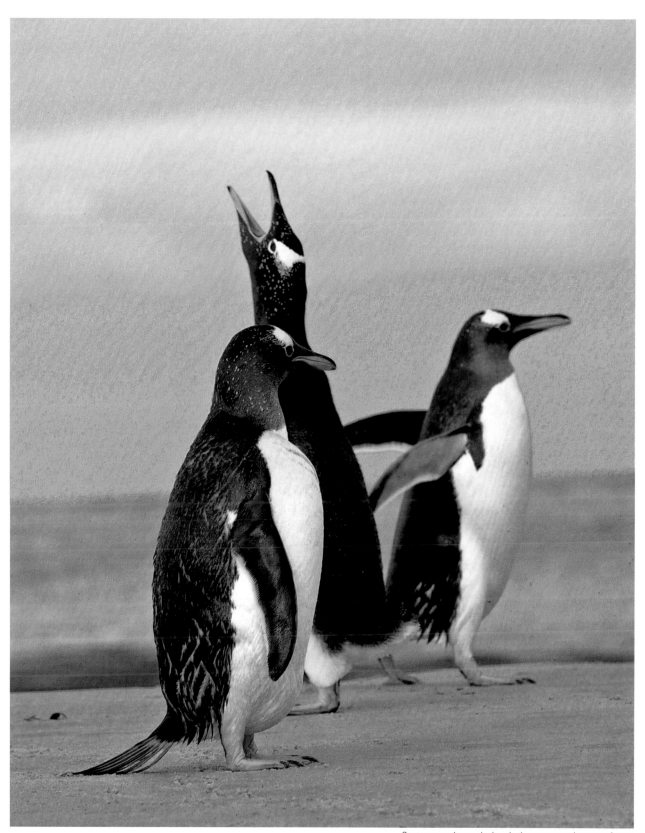

Gentoo penguins on the beach about to enter the sea to forage

About the Gentoo Penguin

Population Trend

Holding steady in many areas. However, the Gentoo population swings widely, making short-term assessment difficult. In the Falkland Islands, the 65,000 pairs counted from 1995 to 1996 represent a 45 percent decline from the 1932 census, but there is some doubt that the previous census was accurate. Recently, many branches of the Gentoo population are holding steady or even growing. Most bigger colonies are losing some breeding population to smaller colonies, proving that food supplies are finite and can support only a limited number of foragers. Gentoo penguins are different from most other species because they are only partially synchronous. Their breeding routine changes from location to location and even from year to year at the same location, making it difficult to ascertain an accurate population count.

Habitat

Gentoo penguin colonies are spread over a large geographic area, and can be found in a circle around the southern part of the globe and Antarctica in a wide band as far north as 46° S and as far south as 65° S. Colonies of the *P. papua* subspecies can be found on the Falkland Islands, South Georgia, Heard Island, Kerguelen Island, Macquarie Island, Staten Island, Marion Island, and Crozet Island. Colonies of the *P. ellsworthii* subspecies can be found on the Antarctic Peninsula, the South Shetland Islands, South Orkney Island, and South Sandwich Island, as well as on as many as a hundred tiny islands in the vicinity of the Antarctic Peninsula. Gentoo penguins, more than any other species, feel comfortable setting their small colonies just on the outskirts of another species' colony. They are found next to Magellanic, Chinstrap, Macaroni, Adélie, and King penguins; presumably

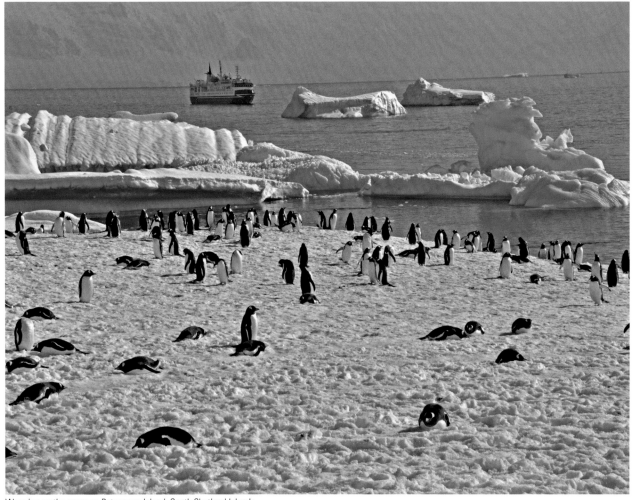

Warming on the snow on Petermann Island, South Shetland Islands

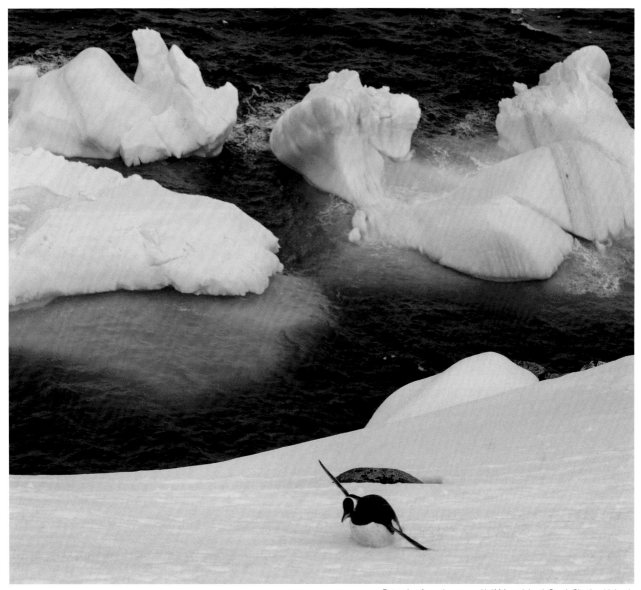

Returning from the sea on Half Moon Island, South Shetland Islands

this tactic aids against avian predation of the eggs and young chicks. They adapt well to captivity and can be found in North American, European, and Japanese zoos.

Appearance

The Gentoo penguin's group name in Latin is *Pygoscelis*, meaning "brush-tailed." Looking at an adult, the three most noticeable parts are its long tail, bright orange feet, and orange-to-red bill. Most of the Gentoo penguin's body is either black, dark brown when worn, or a very clean white. The lower chest and underbody are white. The back, head, and neck are all black except for two white patches ending with dots, as well as a thin white circle around each eye that looks as if they are wearing makeup. The

white patch continues toward the back of the head. The bill is almost all orange except for some black on the upper mandible. The feet have big, black nails and are mostly orange, though inner parts of the web may have pale yellow patches. The flippers are black on the outside with a white trim on the edge, and are almost completely white on the underside except for a few black patches on the ends.

Immature Gentoo penguins are very similar in size and appearance to adults. The chin and throat are whiter and the intensity and distribution of the color above the eye patches is less concentrated. Also, the bill color may be duller, and the black may be dark brown.

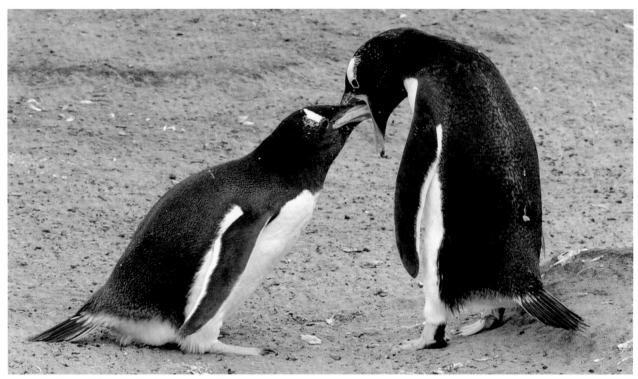

A parent feeds its chick in the Sea Lion Island colony, Falkland Islands

Chicks

Chicks fully develop a gray down on their back with a white down on their front about ten days after they are born. The two chicks stay in the nest under close parental guard for about a month. Thereafter their habits vary widely depending on location and year. As both parents leave, the chicks may join a small crèche that they stay with for forty to sixty days, but in some locations they stay alone and a crèche is not formed. During the crèche phase, chicks are fed by their parents at a higher frequency. At about forty-five to fifty-five days of age they molt their down and begin sporting juvenile plumage. Juveniles reach adult size at sixty to sixty-five days of age.

The majority of chicks on the Falklands fledge in early February. They spend two to three weeks foraging with adults before jumping into the icy water for their first solo long foraging trip (Polito and Trivelpiece 2008). Chicks on Crozet return to molt from December to January of the following year, and the vast majority of the survivors, upon reaching two to three years of age, become breeders in their natal colony.

Breeding and Chick Rearing

Gentoos are dedicated breeders. Because they are nesting over a vast geographic range and in noticeably different air and water temperatures, their breeding calendar varies greatly depending on location. On the Falkland Islands, the main breeding season is in the summer, with an average egg-laying date of October 30. However, breeding is not solidly synchronized, as it is in the other

genus members the Adélie and Chinstrap penguins; Gentoo might lay eggs until January if breeding fails the first time.

In the South Indian Ocean colonies of Marion, Crozet, and Kerguelen, breeding takes place in the winter. Egg laying on Crozet is not synchronized and also continues for a few months. Failed pairs in Crozet might even try for a second clutch in late spring (Otley et al. 2005).

On the Falklands during the average thirty-seven-day incubation period, parents take turns incubating for two to three days at a time while the other parent forages. The hatching success rate depends mainly on the timely return of the foraging partner. Failure to return within four or five days can cause the incubating breeder to abandon the nest. The brooding period is characterized by constant and even more frequent guard changes because by then the egg has hatched and the danger of breakage has subsided. The average turn of guarding duty is then reduced to about one day per parent.

Gentoo parents are more responsible than those of most other penguin species, and they do all they can to raise two chicks to fledging instead of favoring one chick over its sibling. Their caring does not stop when the chicks first fledge and enter the water. For a period of two weeks, the juvenile chicks join the adult diving groups to gain experience at sea. During that period they enter the water for short two-hour trips at first, and later they remain for the full length of the adult swim. It is not known if the parents actually swim alongside their chicks, but parents have been observed feeding their chicks after returning from the ocean,

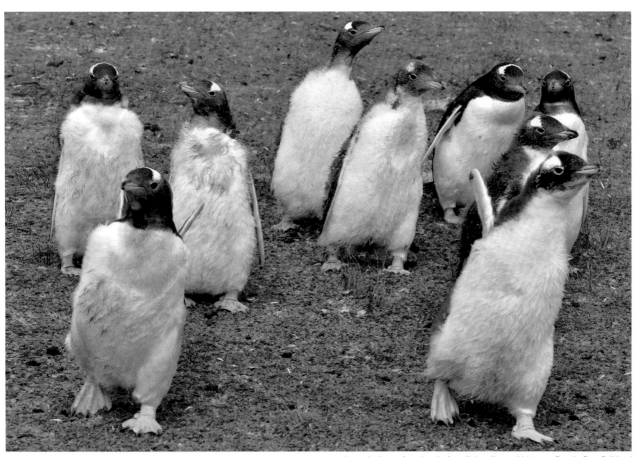

A crèche just a few days before disbanding on Volunteer Beach, East Falkland

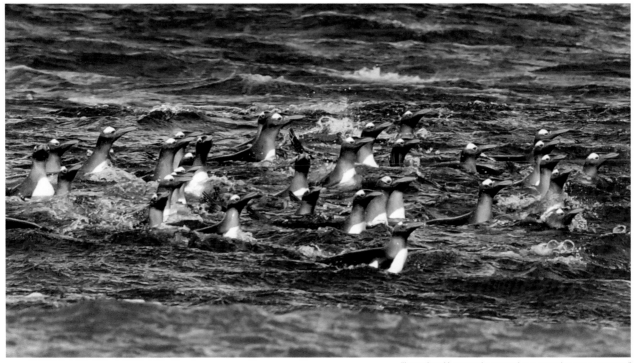

"I wondered how much energy these penguins must consume"

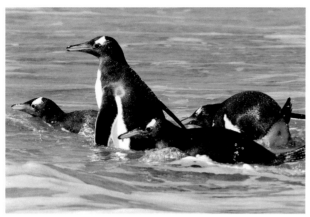

Gentoo penguins swimming

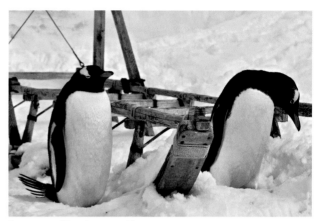

Gentoos possibly trying to use skis

thus supplementing the chick's food intake while the chicks learn how to forage on their own. Such behavior is not noted in any other species and gives Gentoo juveniles a substantial survival advantage over other penguin species (Polito and Trivelpiece 2008).

Success rates vary from location to location, with a 0.9 chick-per-nest average for a normal food year on the Falklands and other Atlantic locations. South Indian Ocean locations experience a lower success rate of about 0.7 chicks per nest. A poor foraging year can spell disaster and lower the success rate to 0.3 or lower.

Foraging

Gentoo penguins are hardworking foragers. For most of the year this penguin is sedentary, preferring to return to its colony every night. Except for the fledging, young immature Gentoo do not embark on very long or far foraging trips. They are opportunistic hunters and eat what they find close to them. They swim and dive in groups as small as 20 and as large as 150. The group meets on shore, enters the water and porpoises together, and washes ashore united.

The invention of camera equipment that can be worn by a penguin is transforming the study of penguins' diet. One study (Takahashi et al. 2008) in the Antarctic Peninsula island of King George during the December to January chick-rearing period found that the average foraging trip lasted 5.4 hours and included 119 dives (only dives deeper than 15 feet [4.6 m] counted). The average dive was about 120 feet (36.6 m) deep, and the deepest was 335 feet (102.1 m). Thirty-seven percent of dives were either "U" or "W" shaped, most likely indicating that a penguin was catching prey. In 25 percent of total dives the camera showed the presence of krill, and in this study, Gentoo penguins almost exclusively preyed on krill. Other studies done at different times in the same location showed a much bigger reliance on small fish for sustenance. As the study volume grows, the variety of results grows as well.

Due to multiple conflicting results, researchers agree that Gentoo penguins eat differently at varying locations but also at the same location during varying seasons. They eat small fish,

cephalopods, or crustaceans, sometimes a combination of all three. In the southern parts of the range krill is the more frequent choice, but in the northern range small fish are preferred.

During the chick-rearing period foraging trips are relatively short because the foraging mate tries to get back to the nest every night to relieve its partner, and they hunt within ten to fifteen miles (24.1 km) of their colony. The winter trips can be much longer and many will dive for a few days, stop at another Gentoo colony to rest, and then go back to the water. These longer trips can take them in circles with no clear direction for hundreds of miles. The deepest dive recorded for a Gentoo penguin was 690 feet (210.3 m) (Bost et al. 1994).

Molting

Parents cease their feeding obligation to their offspring two weeks after their chicks enter the water for the first time. The premolt foraging period lasts twenty to thirty days in south Georgia, and almost twice as long in Crozet. Molting takes place at different times in different locations from early December to late March and is only partially synchronized. The on-land duration of the molt is twenty-one days on average. Weight loss ranges from 40 to 55 percent; however, it should be noted that Gentoo penguins, under normal food conditions, come into the molt at least 20 percent heavier than normal.

Nesting

Gentoo colonies are small, and in many cases they border on different species' larger colonies. They use two different nests in different areas of the range. In the south, the nest is made of small stones and is seventeen to twenty inches (43.2–50.8 cm) wide. On the Falklands and other northern locations, the nest is a burrow dug in sandy soil close to the beach, padded with dried vegetation, seaweed, twigs, and sometimes loose feathers. The male is in charge of gathering materials for the nest, while the female constructs it. It is not uncommon for a fight to break out between neighbors over a stone or a twig. Strangely, compared to other nesting penguins, the entire colony may relocate a few

hundred yards for no apparent reason. Gentoo are known to steal the nests of other species, especially in the southern part of their range. Because they are larger than the Adélie and Chinstrap, they just scare off their victims and settle in the other penguin's old nest.

Relationships and Vocalization

Gentoos are friendlier than most other species. They forage in a united fashion, and their interaction with each other on the beach and in the colony is mostly peaceful. They are less aggressive with strange juveniles, and they are also at peace with penguins of other species, except for when they fight over a nest location early in the breeding season.

They are very devoted parents and even teach their chicks about life in the ocean, something no other species has been observed doing. Almost all couples that survive the previous year return to the same nest and the same partner the following year. Mutual signs of affection are common between mates, who bow and touch while standing or lying next to each other. The romance and bonding period for the Gentoo penguin is short, and the time mates spend together at the nest site is even shorter.

Gentoo penguins use their voices more than most penguin species, and the rookery is often a very noisy place, sounding somewhat like a group of busy ducks. They use at least three different types of calls for different occasions: contact, courting, and agonistic.

Contact calls are short, chopped, and low-pitched sounds used to identify a mate or offspring.

Courting calls are more elaborate and loud. Gentoo penguins repeat courting and bonding calls for days at a time. The agonistic or threatening signal is a nervous hissing sound that accompanies rapid head movement.

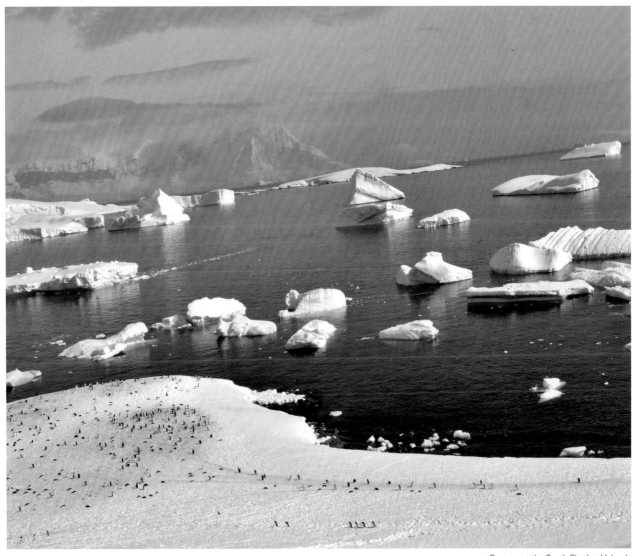

Gentoos at the South Shetland Islands

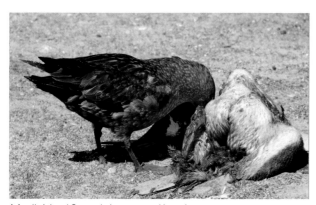
A fatally injured Gentoo being consumed by a skua

Dangers

The main cause of mortality of both eggs and young chicks is due to skua, caracaras, and other large birds. Gentoo parents have proven very ineffective at defending against these flying birds. An interesting strategy that the skuas and caracaras use is to wait until a parent begins feeding a chick, and then to land very close and scare the feeding parent by raising its wings and creating a loud noise. The noise distracts the chick and interrupts the transfer of fish to offspring, causing the food to fall to the ground. In a split second the flying bird spreads its wings, makes a frightening noise, and grabs the fallen fish. The penguin family just watches, perhaps thinking it is better to lose the fish than their own lives.

Sea lions and leopard seals are the biggest threat to Gentoo penguins at sea, especially in southern locations. Experienced Gentoos can typically navigate their way out of danger, but juveniles and postmolt adults are more likely to fall prey to these larger sea mammals.

Incompetence of breeding parents, mainly during incubation, causes numerous eggs to break, and flooding ocean swells can wash away eggs. Man's actions and introduction of alien species also cause Gentoo penguin deaths, more so on the Falklands than in other areas where humans are too far away to influence their lives.

Conservation Efforts

The Falkland Islands represent the battleground for Gentoo conservation efforts. Conservation is necessary in the Falklands because of the proximity of the penguin colonies to human activity. Conservation is also necessary because traditionally the harsh human existence on islands so far south was used as a pretext to neglect preservation of the wildlife. Since early days, hunting penguins and eggs has been a profitable business. Today, searching for oil, farming, selling tours, and overfishing all take precedence over the preservation of penguins.

There is no question that the government of the Falklands would like to protect its wildlife, but it remains to be seen if they are willing to pay the price for such conservation efforts. Several groups, most from outside, are currently accusing the Falkland

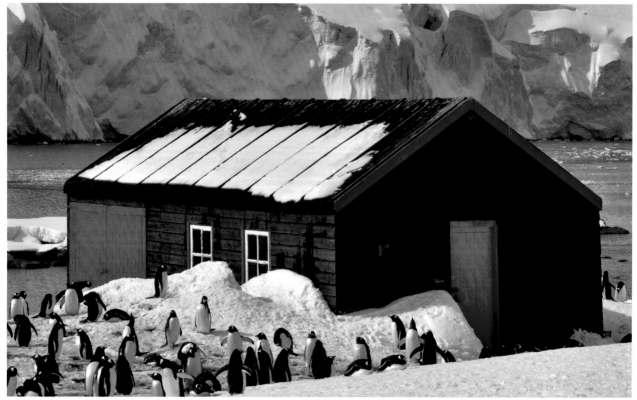
A British research station at Port Lockroy, Antarctic Peninsula

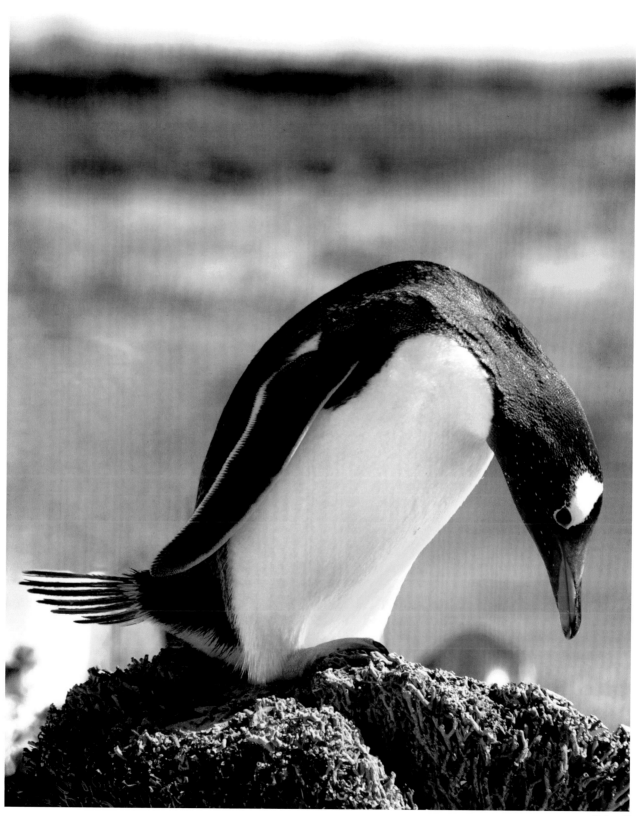

Drying off

government of turning a blind eye to the situation, and they blame the government's policies of overfishing and oil exploration for the rapid decline in both Rockhopper and Gentoo populations. The government is designating areas as national parks and limiting some human activities to protect penguins, but some still wonder if it is enough.

Interesting Research

Relatively speaking, it is not that difficult to study penguins during the breeding period once you are on location. At least half of each pair is on land, mostly standing at the nest. With the exception of the Little, Yellow-eyed, and Fiordland penguins, these birds are an open book at this period.

What penguins do and where they go after the breeding season ends has intrigued researchers for centuries, until the invention of the waterproof GPS made further study possible. As GPS and video technology become available to researchers, many secrets of penguin life are being revealed. Tanton et al. (2004) worked on a project with the Gentoo penguins at South Georgia Island, and the biggest surprise of the study was how boring the Gentoos are and how little they change during their winter break from the breeding season. This finding is in sharp contrast to research focused on other species of penguin. What Dr. Tanton found was that Gentoo penguins in South Georgia abandon the colony during the winter, but stay very close, venturing only six to twenty miles (9.7–32.2 km) from their departure point. They forage similar hours to when they breed and return ashore every night. Some days they are just lazy or not hungry and stay ashore the whole day and night.

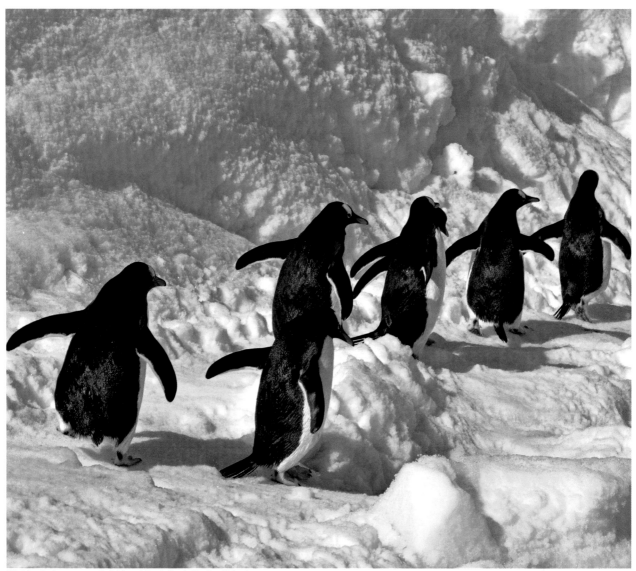

Climbing in the snow on Half Moon Island, South Shetland Islands

Charts

Weights	Source 1 (*papua*)	Source 2, 3 (*papua*)	Source 4, 5, 6 (*ellsworthii*)
Breeding Male Arrival	12.3 lb/5.6 kg	15.4 lb/7.0 kg[2]	12.8 lb/5.8 kg[4]
Breeding Female Arrival	11.2 lb/5.1 kg	14.6 lb/6.6 kg[2]	11 lb/5 kg[4]
First Incubation Male	12. 8 lb/5.8 kg	13.8 lb/6.25 kg[2]	
First Incubation Female	11 lb/5.0 kg	13.2 lb/6.0 kg[2]	
Premolt Male	17.6 lb/8.0 kg		
Premolt Female	16.5 lb/7.5 kg		
Premolt Unsexed		15.9 lb/7.2 kg[2]	
Postmolt Male	14.3 lb/6.5 kg		
Postmolt Female	12.3 lb/5.6 kg		
Postmolt Unsexed		10.1 lb/4.6 kg[2]	
Fledging Chicks	13–14.9 lb/5.9–6.75 kg	11.9 lb/5.4 kg[3]	10.7–11 lb/4.86–5 kg[5]
Egg	0.12 lb/54.4 g		0.18–0.2 lb/84–90 g[6]
Lengths	**Source 1 (*papua*)**	**Source 7 (*papua*)**	**Source 8 (*ellsworthii*)**
Flipper Length Male	9.2 in/23.4 cm	10.1 in/25.6 cm	6.7 in/17.1 cm
Flipper Length Female	8.7 in/22.2 cm	9.8 in/24.8 cm	6.6 in/16.8 cm
Bill Length Male	2.2 in/5.6 cm	2.5 in/6.3 cm	1.9 in/4.9 cm
Bill Length Female	2.1 in/5.4 cm	2.3 in/5.8 cm	1.8 in/4.6 cm
Bill Depth Male	0.7 in/1.7 cm	0.8 in/1.95 cm	0.7 in/1.8 cm
Bill Depth Female	0.6 in/1.5 cm	0.7 in/1.73 cm	0.6 in/1.6 cm
Foot Length Male			4.6 in/11.6 cm
Foot Length Female			4.3 in/10.9 cm

Source 1: Williams 1995—South Georgia Island. Source 2: Otley et al. 2005—Volunteer Beach, Falkland Islands. Source 3: Reilly and Kerle 1981—Macquarie Island, Australia. Source 4: Otley et al. 2005—Antarctic Peninsula. Source 5: Polito and Trivelpiece 2008—Admiralty Bay, King George Island, South Shetland Islands. Source 6: Cobley and Shears 1999—Port Lockroy, Antarctica. Source 7: Williams 1995—Crozet Islands. Source 8: Renner et al. 1998—Ardley Island, South Shetland Islands.

Biology	Source 1 (*papua*)	Source 2, 3, 4, 5 (*papua*)	Source 6, 7, 8, 9
Age Begin Breeding (Years)	2–4	2–5[2]	
Incubation Period (Days)	37	33–37[3]	34[6]
Brooding (Guard) Period (Days)	30	25[3]	29[6]
Time Chick Stays in Crèche (Days)	60	63[3]	60[7]
Fledging Success (Chicks per Nest)	1	0.71–0.75[3]	1.0–1.3[6]
Mate Fidelity Rate	36%		90%[7]
Date Male First Arrives At Rookery	Mid-Oct.	End Jun.–Mid-Jul.[2]	Sept–Oct[7]
Date First Egg Laid	Nov. 6	Jun. 23[2]	Oct–Nov[7]
Chick Fledging Date	Mar.	Jan.–Feb.[3]	
Date Adult Molting Begins	Feb.–Apr.	Mid-Dec.–Mid-Feb.[2]	
Juvenile Survival Rate First 2 Years	59%	27–38%[2]	
Breeding Adults Annual Survival	75–89%	85%[2]	
Average Swimming Speed			4.0 mph/6.48 kmph[8]
Deepest Dive on Record	544.6 ft/166 m		695.5 ft/212 m[9]
Farthest Dist. Swam From Colony	65.2 mi/105 km	1242.74 mi/2,000 km[4]	
Most Common Prey	Crustaceans	Fish[5]	Krill[7]
Second Most Common Prey	Fish	Crustaceans[5]	Fish[7]

Source 1: Williams 1995—South Georgia Island. Source 2: Williams 1995—Crozet Islands. Source 3: Lescroël et al. 2009—Kerguelen Island. Source 4: Clausen and Pütz 2003—Kidney Cove, Falkland Islands. Source 5: Williams 1995—Marion Island, Prince Edward Islands. Source 6: Cobley and Shears 1999—Port Lockroy, Antarctica. Source 7: Williams 1995—King George Island, South Shetland Islands. Source 8: Culik et al. 1994—South Shetland Islands. Source 9: Adams and Brown 1983—Marion Island, Prince Edward Islands.

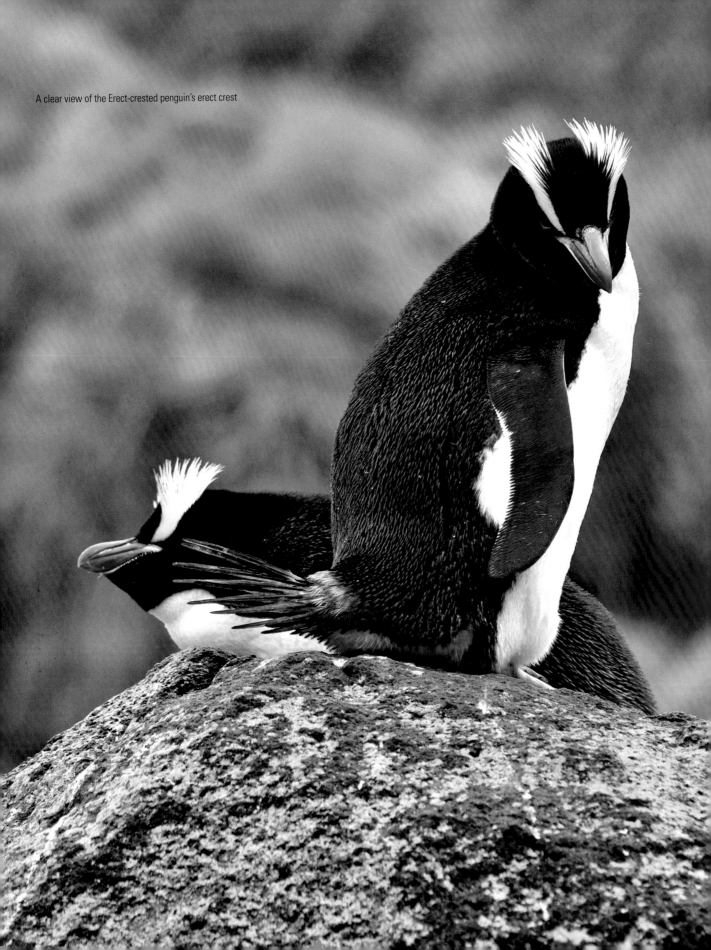

A clear view of the Erect-crested penguin's erect crest

Erect-crested Penguin
Eudyptes sclateri

Genus: *Eudyptes*

Other Genus Members: Royal, Rockhopper, Snares, Fiordland, and Macaroni

Subspecies: None

IUCN STATUS: Endangered

Latest Population Estimates
Individuals: 200,000
Breeding Pairs: 85,000

Life Expectancy
Average: Less than 10 years
Longest: 18 years

Migratory: Yes, they are absent from the colony from April to September.

Locations of Colonies: Bounty Islands (47°45' S, 179°3' E) and Antipodes Islands (49°40' S, 178°46' E) off New Zealand

Colors
Adult: Black, white, yellow crest, pink patches, and brown
Bill: Brown
Feet: Pink fading into white, brown soles
Iris: Brown, almost but not quite red
Chick Down: Chocolate and dirty white
Immature: Pale crest, gray neck. Face white and gray, dull bill

Height: 22–25 in/56–64 cm

Length: 24–27 in/61–69 cm

Normal Clutch: 2 eggs per nest

Maximum Chicks Raised per Pair per Year: 1

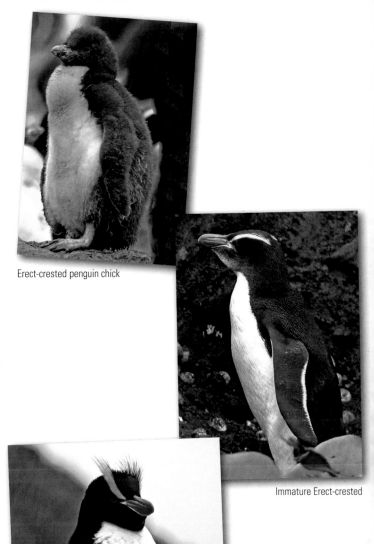

Erect-crested penguin chick

Immature Erect-crested

Adult Erect-crested

David's Observations

Of the many voyages I undertook to write this book, the trip to Antipodes Island was the most daring. After being rebuffed by the government of New Zealand and denied a direct landing permit, I was referred to Captain Henk, the operator of a fifty-foot (15 m) yacht named Tiama. Henk is the operator of choice for most research teams trying to reach the remote New Zealand Sub-Antarctic Islands. He agreed to take me along on his next planned voyage under one condition: I could not bring my boots, as there was no chance I could set my feet on the island. The photographs, he said, could only be taken from an inflatable boat. I met Henk, the researchers, Steve the crewman, and the Tiama at Bluff. The Tiama is a small yacht, not a cruise ship, but the Southern Ocean was very cooperative and the weather magnificent. After almost three days of sailing we arrived in front of the beautiful Antipodes Island.

I had been photographing for a couple of hours when all of a sudden the motor of the inflatable boat went silent. Henk was pulling the starter rope over and over while I raised my head from my camera viewfinder, trying to assess the situation. We were on a tiny, motorless, yellow inflatable boat not too far from imposing rocks and lively penguins. For someone inexperienced like me, the shore looked like the safest bet. Henk, after giving me a two-second lesson on how to row a boat, assured me that the shore was the most dangerous option for us. Instead, we paddled as hard as we could toward the open sea, away from the dangerous rocks. Henk found time to call the Tiama, which had anchored half a mile (0.8 km) away. Steve lifted the anchor and was alongside us within fifteen minutes, which felt more like an eternity. The Tiama never looked so large and steady as when ropes were thrown down to us and we were able to climb to safety.

The Erect-crested Penguin appears almost identical to the Snares in looks and behavior, with the crest being the only exception. Groups of penguins, twenty to forty at a time, were constantly getting in and out of the water in difficult landing areas. Penguins plunged into the water on top of each other, while on land they stepped on top of each other, trying to free themselves from the kelp on the beach. Once on shore, they only waited a short time before climbing up the hill to feed their chicks. The chicks were in small crèches and, though grown, were still dressed in their down, and the down was covered in a mess of mud and guano. I saw one non-breeder that was in very early stages of its molt. There were also a few Rockhopper penguins mixed in the bunch; one even joined a foraging group as they headed to sea. It was a busy colony, with penguins following their normal routine. Some pairs were courting and bonding, even though it was at the very end of the breeding season, just a few short weeks before the chick fledge. Apparently it is never too late for penguins to bond. I had a great day with lovely penguins; I just wished there was an easier way to get to see them.

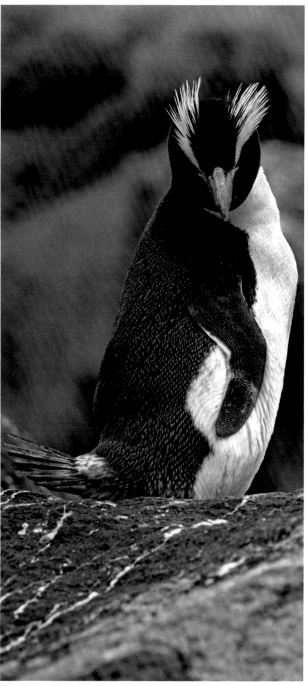

An Erect-crested adult showing off its crest

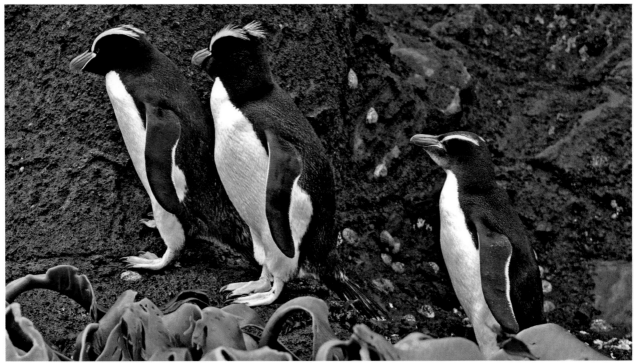

Recently landed back on Antipodes Island, New Zealand

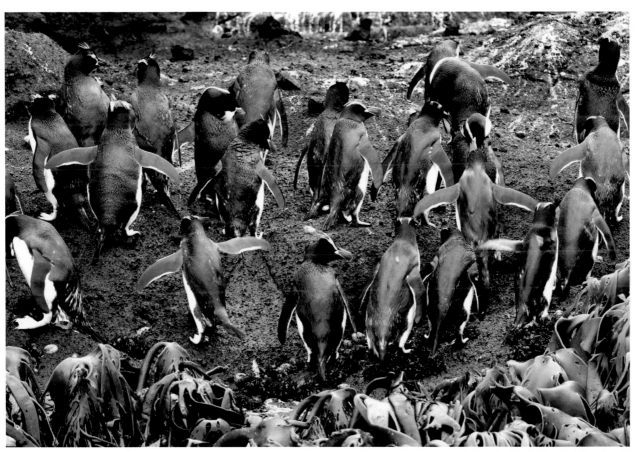

The challenge of landing on the rocks of Antipodes Island, New Zealand

About the Erect-Crested Penguin

Population Trend

Severe Decline. Solid information on their population is scattered. Surveys done by the New Zealand government in 1978, 1998, and 2008 used different techniques to gather data and might not be compatible with each other. If the surveys are correct, the Erect-crested population on both islands has declined dramatically since the 1978 survey. On Bounty Island, the population has decreased from 115,000 breeding pairs to only about 28,000. On Antipodes Island, what were once 100,000 breeding pairs have decreased to between 49,000 to 57,000 pairs. The fact that the Erect-crested might not breed every year complicates counting, as do other factors.

Habitat

The Erect-crested penguin breeds on two small, isolated island groups about 500 miles east of New Zealand. These are the

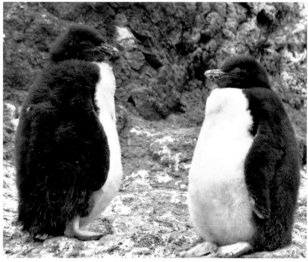

A pair of Erect-crested chicks

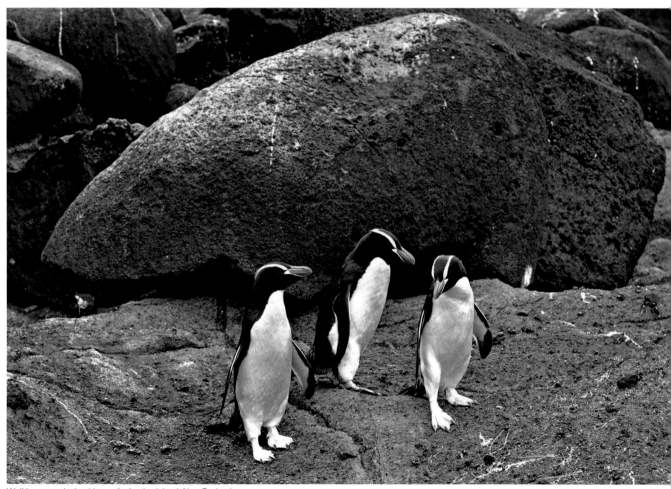

Walking around a boulder on Antipodes Island, New Zealand

Antipodes Islands, whose largest island is about six square miles, and the Bounty Islands, which are less than one square mile in area. Landing on these islands is prohibited by the New Zealand government.

Appearance

The Erect-crested penguin's appearance resembles the Snares and Fiordland, except that this penguin is larger and has a different and very distinct crest. Their wide crest is their most noticeable feature and the origin of their name. It begins above the bill and rises up toward the back of the head. Unlike that of the Snares penguin, the crest looks like two parallel lines when viewed from above. This penguin has control over its crest and can raise and lower it at will. Starting at the base of the crest and continuing in the other direction are pink, featherless skin lines that surround the bill. The bill has a less prominent orange or red color than the bills of other crested penguins. The iris also differs from that of other crested penguins, and is brown rather than a striking red. The rest of the head, back, and chin are black. The transition from black to white at the top of the neck is similar to that of the Snares and looks like a baby bib. The flippers are proportionally longer for their body size and are colored white on the inside, with a wide, black edge that widens even further around the tip. The feet are pink to white with black soles. Immature Erect-crested penguins are thinner than adults, with a smaller bill, a much smaller crest, and gray coloring on the face and neck.

Chicks

Erect-crested chicks have a chocolate brown–colored down on their backs and are white to a faded cream color in front. They stay under the male's guard for the first three weeks after hatching, and the mother feeds the chick during this time. At

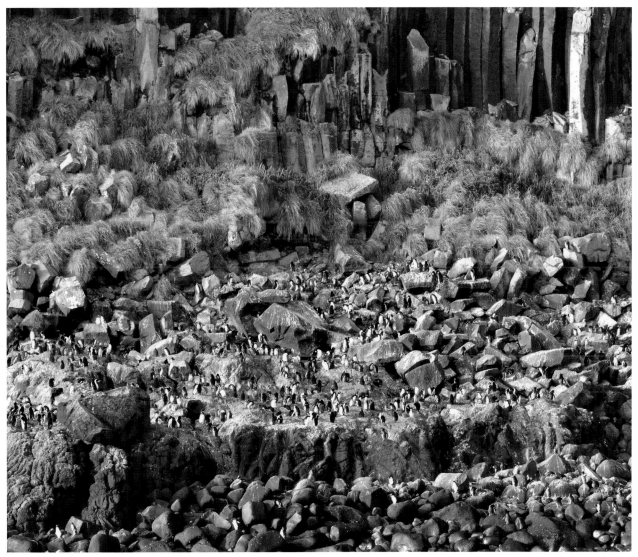

A sub-colony on Antipodes Island, New Zealand

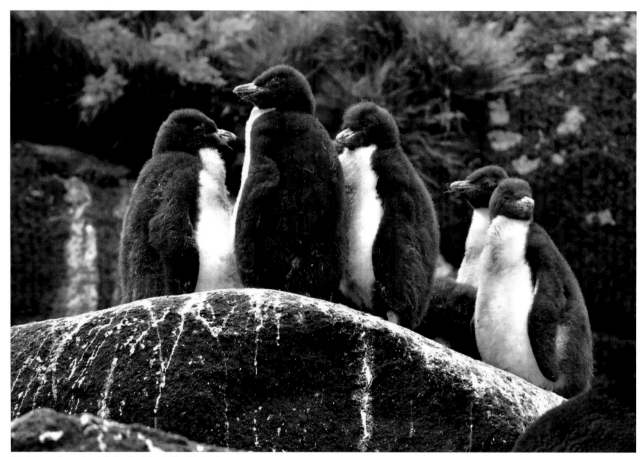

A crèche on the rocks of Antipodes Island, New Zealand

about three to four weeks of age the chick joins a small crèche. Peak fledging occurs around January 30, and the average weight at fledging is eight pounds (3.6 kg) for males and six and a half pounds (3 kg) for the females. By February 12 the last chick has fledged (Warham 1972). They will return to their natal colony around January or February of the following year to molt and will begin to breed when they reach four to six years old.

Breeding and Chick Rearing

Erect-crested penguins have rarely been researched, but in 1941, Richdale conducted the only major breeding study from courting to the arrival of the eggs. Richdale discovered a few Erect-crested penguins on the South Island of New Zealand. The pair studied never actually hatched an egg or produced a chick.

In 1972, Warham aimed to do a full study, but he ended up arriving on Antipodes about three and a half months after the onset of the breeding season. During the breeding season of 1998–1999 Davis, Renner, and Houston were present on Antipodes Island from courtship to late incubation.

According to Warham, the breeding season starts around September 5 with the arrival of the early males to claim their old nest. Here they will await the arrival of their mate. Most females

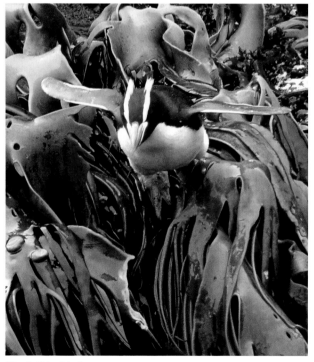

Literally flying into the ocean

arrive later and join their last year's mate, who is waiting in the nest.

The first, smaller egg is usually laid in early October; the second egg is much larger and follows about five days later. The first egg is almost always lost within a day or two of the arrival of the second egg. This is probably because of the mechanical difficulties of maneuvering a large and much smaller egg under the brood patch (David Houston, personal communication). Incubation is estimated at around thirty-five days, only because this is the average between Snares and Fiordland penguins. If this is a correct estimation, it means the hatching date should be around November 17, which is still about sixty days before Warham arrived. Davis measured the eggs' weight. The much smaller, first egg weighed 0.18 lb (82 g), and the second, larger egg weighed 0.33 lb (151 g).

Due to the manner in which the period of incubation is shared, the guard and crèche phases were not recorded and have not been further studied. Erect-crested share duties of incubation similar to the Snares or Fiordland penguins. The breeding season, measuring from the day the first egg is laid until fledging, lasted an estimated 120 days.

Foraging and Diet
No study is available.

Molting
Nonbreeders begin arriving at Antipodes Island in January and molt before the breeders. Within days of the chick fledging, the breeders take to the ocean for their premolt trip to fatten up. When they return from the sea, they molt on land for twenty-six to thirty days on rocks close to the shore. Males lose about half of their weight, decreasing from 15.4 lb (7 kg) to 7.8 lb (3.5 kg), and females weight changes from 12.9 lb (5.9 kg) to 6.5 lb (3 kg) on average (Warham 1972). An interesting observation by Warham was that the birds lost about 10 percent of their weight every five days, but the weight loss tapered off toward the end of the molt as they exhausted their fat reserves.

Nesting
Erect-crested Penguins nest on the slopes overlooking the ocean at both Antipodes and Bounty. These islands are narrow, so the colonies are close to the sea. The nests are highly dense, averaging about twenty-six inches (66 cm) on center (Warham 1972.) Their

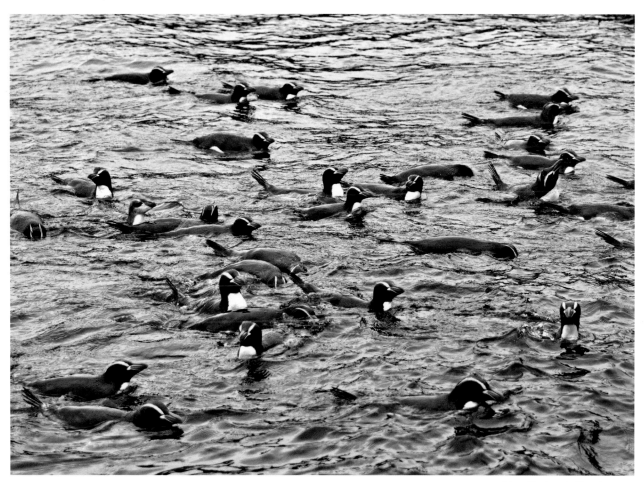

A busy Erect-crested foraging group

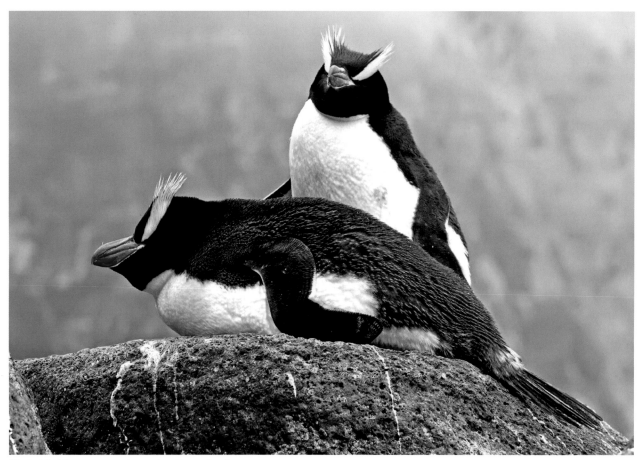

"I just wished there was an easier way to get to see them"

nests are shallow hollows, some with stones on top, and many pairs might use natural holes in the boulders to nest in, or natural caves. Dry grass, small sticks, or leaves might be used as a padding material. Rain is almost a daily occurrence in Antipodes, and the colony is muddy most of the time from the penguins' feces.

Relationships

Erect-crested behavior is similar to that of Snares and other crested penguins. They are affectionate with their mate and chicks, while they can be aggressive with their neighbors and non-breeders. Regardless of their mood on land, as soon as they enter the water all grievances are forgotten. Erect-crested group diving requires a great deal of cooperation. Whenever they raise their heads over the water, it seems that each penguin is looking in a different direction. They sound contact calls and all re-plunge deeper into the sea, the whole group disappearing at once.

Pairs have rituals, including mutual bowing, head lowering and shaking, lifting their head up and quivering, or forward head swinging. Pairs also engage in mutual preening, favoring the partner's head. Before the arrival of the egg, pairs stand next to each other with both heads lowered or in a crossed neck posture. Trumpeting is common during nest changes and when a parent

is searching for the chick, with heads directed toward the sky (Warham 1972).

Carrying stones and grass to the nest is necessary for its construction; however, males continue to bring stones and other materials as presents for their mates at all times, as if they are gifts of appreciation. The same can be said about nest formation just before or during the molt, when it is not used to house eggs. The male gets busy creating a nest while the female stands by showing her love, even though it is clear that the nest will not be used again for many months. Those acts seem to excite the pair to the point that leisure copulation might follow. When compared to Williams and Rodwell's (1992) observations on Macaroni penguins, it is likely that the relationship between pairs actually commences, or requires reaffirmation, during the later part of the concluded breeding period, rather than at the start of the new one.

When passing a neighbor's nest with peaceful intentions, the passing penguin might bow with its head directed to one side and drop its shoulders and neck while standing first, then walking. Erect-crested become aggressive when defending their territory, and will attack the same-sex self-promoters that try to attract their mates and the disrespectful immatures who get too close.

Fighting is an event that escalates. It starts with a stern vocal warning with side movement of the head, many times with the beak directed toward the annoying counterpart. Flippers can be rapidly moved, as if the penguin thinks it can fly, with the bill continuously directed toward the opposing bird's bill. A final yell or several yells sound and one bird tries to peck the opposing penguin in the face or the body, and sometimes even from the back.

Dangers

Like the Rockhoppers, it is believed that the Erect-crested is subject to a major threat decimating their numbers; however, the nature and extent of this danger is still in question. When humans briefly occupied sections of Antipodes and Bounty, they eliminated the seal population therein.

Biologists believe that the most likely but yet unknown cause of the Erect-crested penguins' dwindling population has to do with the ocean's physical composition, which affects prey availability. This is a complex issue because it affects some species, but not others. The closest neighbor to the Erect-crested, the Snares population, is stable. However, the Rockhopper, another closely related species, is in a grave state.

Dangers may include rising water temperature, availability of certain nutrients that disrupts the food chain, rise in acidity and increased pollution, water-borne disease of either plants or animals, or a shift in location of prey. The entire picture is more obscured with Erected-crested penguins because of the scant research about the bird and its habitat. It is safe to say that lack of research and knowledge alone is a major threat to the survival of this species.

Conservation Efforts

Antipodes and Bounty are rugged islands, and landing on them with rubber boats is tricky and dangerous on most days. The New Zealand government has prohibited almost all human visitors on these islands in an attempt to conserve the birds. They do allow select numbers of researchers, but only after the researchers pass a difficult approval process. The islands are home to other rare birds and animals, and the few lucky researchers who have gotten permits thus far, except the Davis group, did not study the Erect-crested penguin. Though Erect-crested penguins are in great need of help, conservation efforts can only start after extensive research takes place, numbers are presented, and the problems are identified.

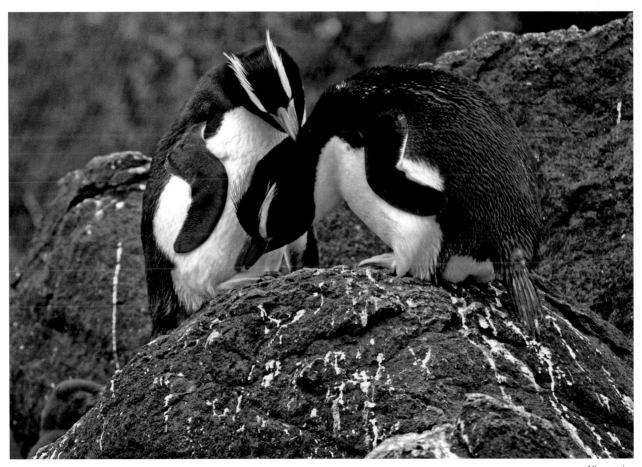

Allopreening

Interesting Research

Erect-crested research is so rare that much of the information about them is derived from the odd trio of penguins observed by Richdale. He discovered two males and a female Erect-crested on the South Island of New Zealand, hundreds of miles west of their normal breeding sites. The trio, and later only the pair, returned to the same location for years, and Richdale recorded their activities on an almost daily basis. Richdale's Erect-crested penguins were lost and atypical; they never were able to hatch a single chick, despite their breeding routine.

Warham (1972), who has described all the crested penguins in New Zealand, was eager to collect his own data. Unfortunately, the bad weather caused his landing at Antipodes to be far too late to achieve what he set out to accomplish. The body of research on the Erect-crested, or lack thereof, is an interesting example of a government's good intentions going foul. There is no doubt that the New Zealand government had good objectives when it enacted the landing and living prohibition for Antipodes, Bounty, and Snares Islands. Unfortunately, such restrictions make research on these species very difficult. The unintended result of the government's overreaching policies is that the Erect-crested life cycle, foraging habits, threats, and other basic information is not well known. The lack of knowledge may possibly be much more detrimental to these lively penguins than any damage done by a group of researchers or a small permanent research station.

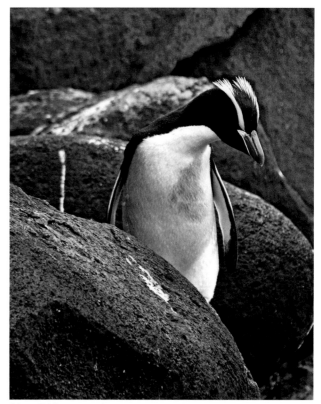
A beautiful Erect-crested

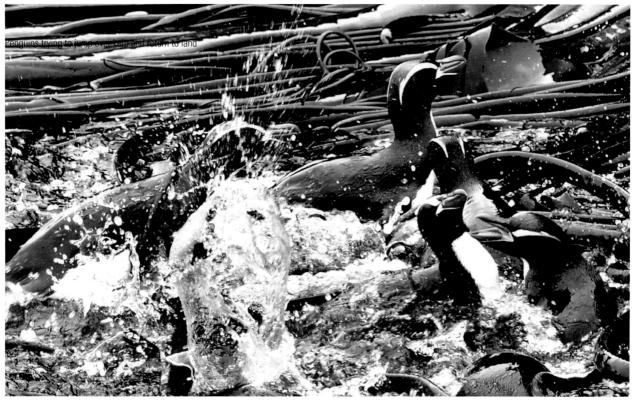
Penguins trying to jump over kelp and return to land

Charts

Weights	Source 1	Source 2
Arrival Breeding Female		12.3 lb/5.6 kg
First Incubation Male	9.9 lb/4.5 kg	
First Incubation Female	7.9 lb/3.6 kg	
Premolt Male	15.4 lb/7.0 kg	
Premolt Female	13.0 lb/5.9 kg	
Postmolt Male	7.9 lb/3.6 kg	
Postmolt Female	6.4 lb/2.9 kg	
Fledging Chicks	6.6–7.9 lb/3.0–3.6 kg	
Egg 1		0.22 lb/98 g
Egg 2		0.33 lb/149 g
Lengths	Source 1	Source 2
Flipper Length Male	8.3 in/21.2 cm	
Flipper Length Female	8.0 in/20.4 cm	
Flipper Length Unsexed		8.7 in/22 cm
Bill Length Male	2.3 in/5.9 cm	
Bill Length Female	2.1 in/5.3 cm	
Bill Length Unsexed		2.0 in/5.2 cm
Bill Depth Male	1.0 in/2.6 cm	
Bill Depth Female	0.9 in/2.3 cm	
Bill Depth Unsexed		0.87 in/2.2 cm

Source 1: Warham 1972—Antipodes Island, New Zealand. Source 2: Richdale 1941—Otago Peninsula, New Zealand.

Biology	Source 1	Source 2
Incubation Period (Days)	35	
Brooding (Guard) Period (Days)	21	
Time Chick Stays in Crèche (Days)	50	
Date Male First Arrives At Rookery	Early Sept.	Late Sept. (Sept. 26)
Date First Egg Laid	Early–Mid-Oct.	Early Oct. (Oct. 7)
Chick Fledging Date	End of Jan.–Feb.	
Premolting Trip Length (Days)	28	40
Date Adult Molting Begins	Early Mar. (Mar. 12)	Mid-Mar. (Mar. 19)
Length Molting on Land (Days)	26–30	24

Source 1: Warham 1972—Antipodes Island, New Zealand. Source 2: Richdale 1941—Otago Peninsula, New Zealand.

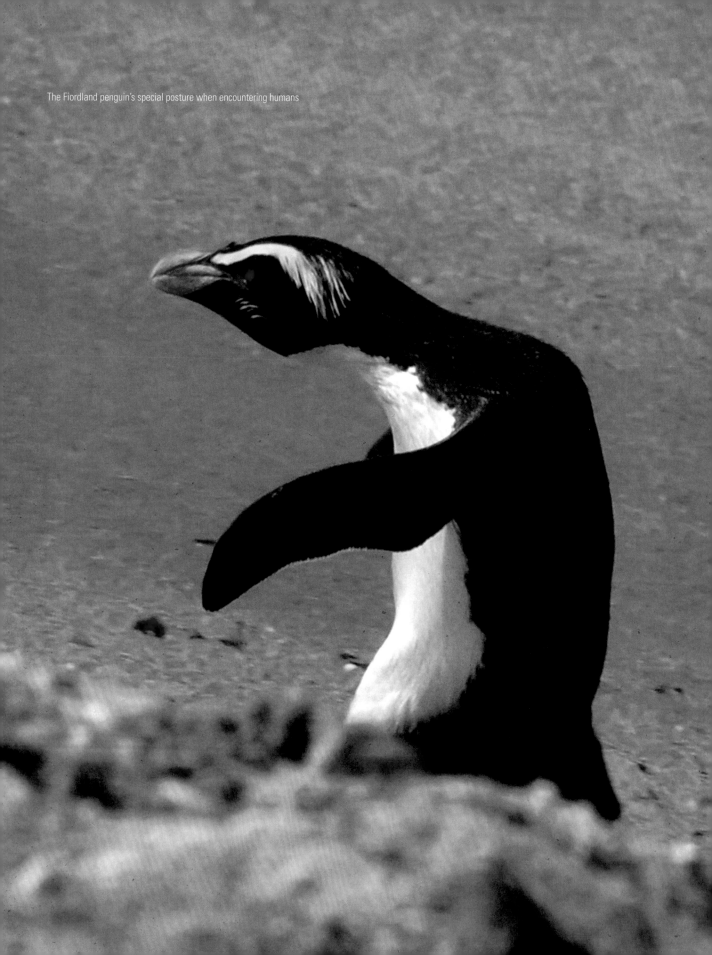
The Fiordland penguin's special posture when encountering humans

Fiordland Penguin
Eudyptes pachyrhynchus

Genus: *Eudyptes*

Other Genus Members: Rockhopper, Royal, Erect-crested, Macaroni, and Snares

Subspecies: None

IUCN STATUS: Vulnerable

Latest Population Estimates
 Individual Birds: Uncertain, but estimated at 6,000 or less
 Breeding Pairs: 2,500

Life Expectancy
 Not studied

Migratory: Yes, they are absent from the colony from April to June.

Locations of Colonies: Fiordland Region on the west coast of South Island, New Zealand, and Stewart Island, New Zealand

Colors
 Adult: Black to dark blue, white, yellow crest, pink, and orange to red
 Bill: Reddish orange, some faded yellow
 Feet: Pink with dark brown to black soles
 Iris: Bright red
 Chick Down: Very dark gray for the first week or two, later gray
 Immature: Smaller with a less yellow crest and grayer head and neck

Height: 21–23 in/53–58 cm

Length: 22–24 in/56–61 cm

Normal Clutch: 2 eggs per nest

Maximum Chicks Raised per Pair per Year: 1

The Fiordland penguin is also known as the Thick-billed and Tawaki penguin.

Adult Fiordland penguin

Immature Fiordland penguin

David's Observations

Lake Moeraki Beach Lodge is a six-hour drive from Dunedin, a city where the other New Zealand penguins, the Yellow-eyed and Little penguins, are in close proximity. The road takes you through one of the prettiest drives in the world. I was greeted at the lodge by Sarah and John and was treated like royalty. The meal John cooked was better than the food at any restaurant I dined at in New Zealand.

The walk from the road to the beach was under the thick cover of the rainforest. Crossing the shallow river four times, I was immediately struck by the fact that not even one penguin was standing on the beach. The sun started to make its way out of the clouds, and the first penguin was dropping off the muddy cliff. He noticed me and quickly climbed back. It took him an additional twenty minutes before he dropped again, this time in a strange posture, running fast and hiding behind rocks until, in less than a minute, he was diving. I waited another hour, but no other penguin showed up. John noticed one getting out of the water near the second subcolony. Using a ridge as a cover I ran to the other side, waiting my turn to take pictures. The penguin once again retreated, this time into the ocean, but a few minutes later, again using its strange posture, ran onto a path in the forest and disappeared. After two more hours there was a rare meeting on the beach when one penguin came upon another as they crossed paths, but both quickly dipped in the water when I raised my head to take a picture. While I lay on the beach for the better part of two days, a constant cloud of small black flies hovering over me, I encountered no more than a dozen penguins, some too far away to photograph.

This penguin is uncomfortable in open areas, taking little to no time drying or preening.

The Fiordland penguin is a loner. It is not friendly to photographers, and its scarcity might point to a troubled present and an even more obscure future.

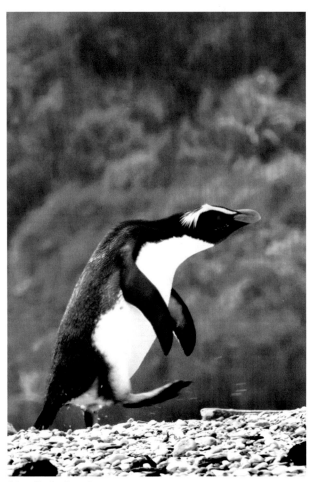

A lone Fiordland runs for cover

Drying off on Moeraki Beach, New Zealand

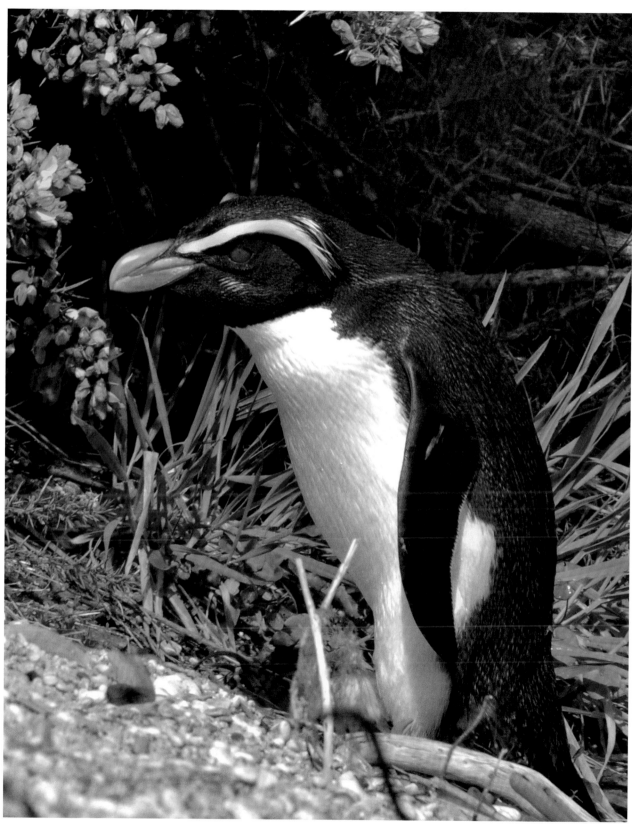

"The Fiordland penguin is a loner"

About the Fiordland Penguin

Population Trend

The Fiordland penguin population is assumed to be stable, but in some locations their numbers are in decline. Their numbers are very obscure. The penguin itself is very shy and nests deep in the dense vegetation of the rainforest, making the task of finding the nest very difficult and time-consuming. It enters and returns from the sea alone, not in a group, and on a very irregular schedule, so the beach is also not a good place to count them.

Habitat

Fiordland penguins breed on the Southern Island of New Zealand in the Fiordland Region, for which they are named, and nearby small islands, from 43° S to 46° S. Specific locations include Jackson Head, Preservation Inlet, Yates Point, Lake Moeraki Beach, Dusky Sound, Solander Island, and Open Bay Island, and a few also breed on Stewart Island. This penguin typically chooses a narrow coastline area, as it is unusually quick in crossing its sandy open path on its way into and under the cover of the dense vegetation. During their feeding trip after their molt they swim far away, and there are consistent counts of Fiordland penguin sightings in Australia during late summer and fall.

Appearance

Fiordland penguins are similar in appearance to their closest relatives the Snares but do not have the featherless pink edges around their bill. Like other crested penguins, their backs are dark blue to black. The long yellow crest pulls over the eyes and aside the ear area. In addition to the main crest, there are smaller yellow stripes toward the center of the head. The back and head are black with shades of very dark blue, and this species is easily

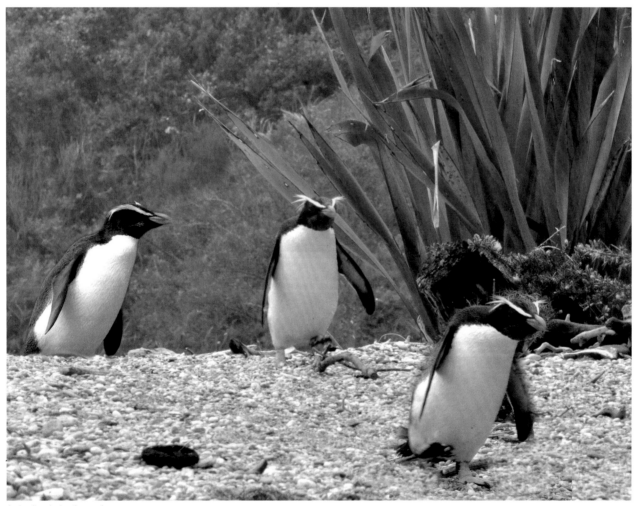

A simulated trio of penguins

distinguished from all other crested penguins by the few white narrow stripes on its cheeks. The underbody is white all the way up to the neck, and it curves in an *S* shape toward the black back above the leg and below the chin. The bill is mostly orange except for a yellow line and areas of gray to black stains. The very long feet are mostly pink with big black nails and black to dark brown soles. The flippers are black on the outside and pink to white on the inside of the center, surrounded by black edges that vary in width. Immature Fiordland penguins have a brown bill, much smaller crest, brown eyes, and gray to faded white chins.

Chicks

The newly hatched chick is blind and covered with primary, inconsistent dark brown down on the back and white on the underbody. The chicks spend the first two weeks on their fathers' feet covered by the brooding pouch. After two weeks, as their body grows the thicker secondary down, they begin venturing out around the nest. At three weeks of age they join a small crèche. They later desert the crèche and become solitary again, waiting most of the day for their parents to return and feed them in the nest vicinity. Later they slowly lose their down, and after the parents stop feeding them they fledge. They molt in January of the following year, many times on the edge of their natal colony, and thereafter they attain the adult color scheme. They then take three to five more years before they begin breeding.

Breeding and Chick Rearing

Fiordland penguins, like other crested penguins, are synchronized in their breeding and only raise one chick to fledging. The main study of their breeding cycle was done by Warham at Jackson Head, New Zealand, in the late 1960s, but very little follow-up research is available. The twenty-week breeding cycle starts in late June or early July as males and, shortly after, females arrive at the colonies appearing heavy and fit. They reaffirm their old bond or find a new mate, and during this period the colony is noisy and fights abound. Attention is quickly turned to fixing the nest. As August rolls around, the female lays two eggs four days apart. The first egg is 20 percent smaller than the second. From their arrival until incubation, the male and female never leave the colony. The eggs are white with some green and brown traces.

The incubation period, which starts in earnest after the second egg is laid, is thirty-one to thirty-five days long. Both parents share the duty of incubation. For the first few days both parents take short turns as they arrange the eggs in a defined pattern before they sit on them. The female, after fasting for about thirty days, leaves for about ten to thirteem days on a foraging trip as the male incubates alone. When the male is finally relieved, he has fasted forty to forty-five days and has lost about 30 to 40 percent of his former weight. Fiordland penguins, unlike other crested penguins, do not discard eggs and instead let both hatch. First and second eggs were lost in equal proportions.

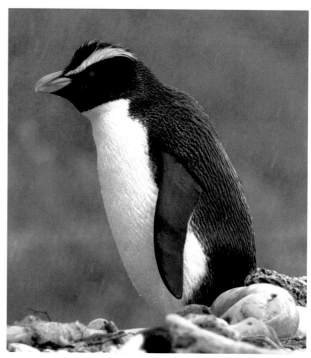

On the lookout for strangers

About 60 percent of the nests hatch at least one egg, and the majority had twins (Mclean 2000). Hatching takes place when the male is incubating, but many times the female is also present. Many of the smaller twins, presumably of the first egg, die or disappear within a day or two. Some parents keep both chicks for two to three weeks, but sooner or later, they give up on feeding the smaller chick. If the larger chick dies first, the smaller chick will be raised to fledging. Warham, throughout his studies, never saw a nest that was able to fledge two chicks, unlike Falla, who in 1966 reported two chicks fledging from one nest.

During the entire guard phase the male is at the nest. At first the chick is on his feet, hiding in a brood pouch until it can maintain body temperature. After two weeks the chick is too large to fit the pouch, but in case of a pending danger, it might stick just its head inside. The female goes back and forth to the sea and feeds the chicks. After about twenty days the chicks join a crèche and both parents take off to feed themselves, as well as to bring food for the chick. This arrangement lasts until the parents suddenly stop feeding the chick a week to ten days before it reaches the age of seventy-five days. After going hungry for a time, the chicks fledge. Average fledging success is about 0.5 per nest.

Foraging

It is presumed that Fiordland penguin prey consists of a mixture of squid, krill, and fish, which are all in rich supply most years and in close proximity to their nesting area. Warham investigated stomach contents of dead chicks and found most had undigested remains of squid, and some had up to 400 undigested jaws of squid.

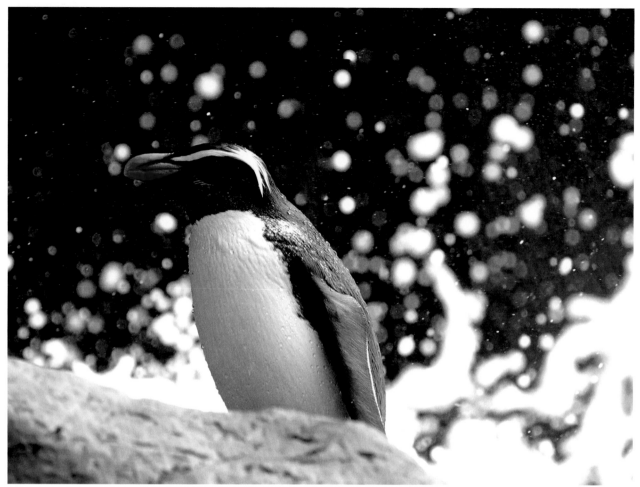

Behind the rocks at Moeraki Beach, New Zealand

Molting

After, or even few days before, the chicks fledge, Fiordland parents are thin and ready to commence their premolt foraging trip. They forage for sixty to ninety days to rebuild body fat and get ready for the catastrophic molt. When they return on shore again in February, some stay on the hills away from the nest, while others reach the nest site, where they molt next to their mate. The land phase of the molt lasts three weeks. They lose about half of their weight during the molt. Immature Fiordland penguins molt before adults but do not always molt in their natal colony.

Nesting

Fiordland penguins nest inland but in close proximity to the beach, sometimes less than one hundred yards (91 m) away, many times on very steep cliffs. This penguin positions its nest under the thick, dense vegetation so it is hidden by one layer of trees and bush, but many times also by broken branches or a fallen tree. If the ground permits, the penguin digs the nest with its feet and also by rotating its body and belly on the ground. The twelve-inch (30.5 cm) nest is usually dug around roots

and in areas where there are bushes growing under the trees. Nests are located at least six to seven feet (1.8–1.2 m) away from each other in very small colonies of ten to eighty nests. On the Open Bay Islands, they nest in caves with earthen or bare rocks, where the nests are in closer proximity to each other. Fiordland penguins prefer to reuse last year's nest if the rain did not wash it away. Stones, small branches, and sticks are assembled to line the nest, though lining is lazy and inconsistent. Padding is done with leaves found on the ground or pulled from branches. Males do most of the nest building, but females help. Nest fidelity is high, but constant heavy rains often force the birds to shift the nest by a few feet.

Relationships

A Fiordland is an extremely shy penguin that is frightened of humans, so it will alter its activities abruptly if it notices one present. Its vocal and display patterns are similar to those of Snares and other crested penguins, but there is a great deal of individualism that is reflected in the voice in the form of an accent and the intensity of the body display accompanying it.

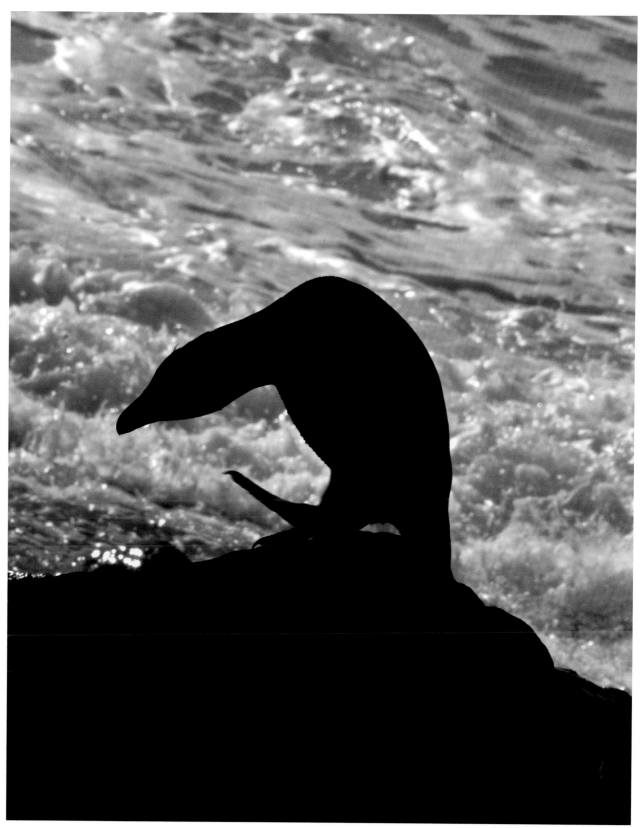

An early morning at Moeraki beach, New Zealand

Sexual displays include advertising, courting, bond reaffirming, nest building, and nest relief. Dominant sexual display is a vertical head-waving and vertical trumpeting, mostly by males, as the female also raises her head. At other times both curve their flippers and their entire bodies as if bowing toward each other, and either gently touch the other's body with the bill or preen their mates. A curving of the flippers and entire body and head with bills to the side is an appeasing posture taken by a penguin when it passes other nests on its way to its own. Mate retention is high when both partners return, and the same can be said for nest fidelity.

As with other penguins, fights are common during the nest reclaiming period, and males vigorously fight any newcomer who tries to park at their established nest. Females and males use force to obtain a mate: females when they encounter another female with their mate, and males if they find themselves unpaired while the rest of the colony is bonding. These fights might involve the whole trio, as mates might aid the side they favor.

During the breeding season, Fiordland penguins, unlike most other penguins, do not dive in a group and rarely congregate together on the beach until very late in the season when they stop feeding the chicks.

Dangers

Fiordlands do not suffer from substantial danger in their natural environment on land. There are no known mammals that prey on this penguin, and bigger, flying birds cannot see its nests or penetrate the dense vegetation. There have been reports that a flightless bird called a Weka destroys eggs and chicks, but it is not certain whether the eggs and chicks are intentionally neglected by the penguin, and the losses are small. The flooding and frequent rainstorms do create a problem, as they might cause the eggs to wash away if the nest is on a slope. Also, the chicks' down becomes ineffective when it is wet; therefore, on a cold night a lone chick can suffer from exposure.

Less is known about the dangers Fiordland penguins face in the water. Local fur seals are known to prey on other penguins, but the Fiordland may not be preyed upon intensively, as the penguin is not frightened by the seal's presence on land. The waters off the Fiordland Region are rich in fish and squid, and

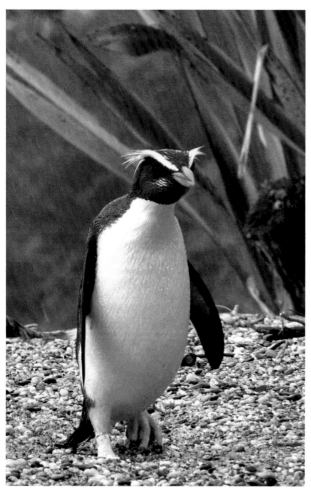

Noticing the photographer

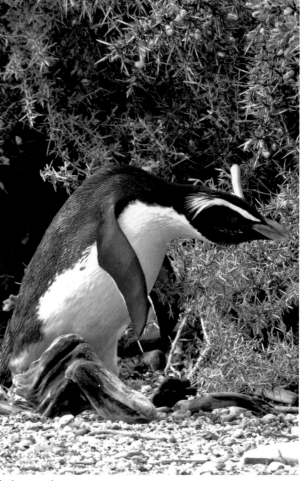

On the run again

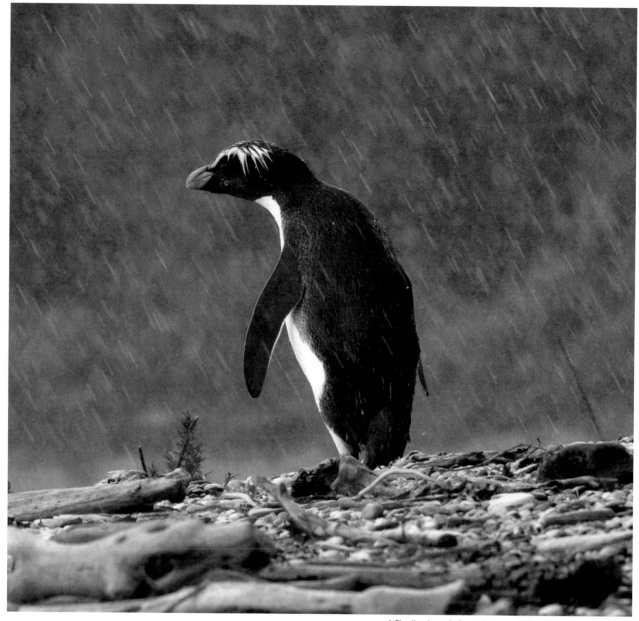

A Fiordland caught in a rainstorm at Moeraki Beach, New Zealand

feeding seems to be easy and can be accomplished without the need to dive too far away.

Conservation Efforts

The New Zealand government's Department of Conservation is active in governing the access to the Fiordland penguins. It does not permit any visitations on the breeding grounds inside the rainforest for fear of damage to the eggs and chicks. That is a very small effort compared to what this species needs. The DOC makes it hard to obtain research permits and is discouraging researchers from getting close to and studying this species. Not knowing the exact population size, trends, and variations from period to period might cause the entire species to disappear before the government or academia notice a problem. The general lack of knowledge about these birds will make any future conservation efforts very difficult to carry out.

Interesting Research

Little work has been done on the Fiordland penguin, and the only outstanding, comprehensive research is the Warham study. Warham studied not just the Fiordland, but also the other crested penguins. His work was done in the late 1960s to early 1970s and is old-school research, where observation and measurements were the main agenda.

A lone Fiordland penguin running into the ocean

Charts

Weights	Source 1, 2	Source 3
Breeding Male	9.9 lb/4.5 kg[1]	9.3 lb/4.2 kg
Breeding Female	8.8 lb/4.0 kg[1]	8.2 lb/3.7 kg
First Incubation Male	6.0 lb/2.7 kg[1]	
First Incubation Female	5.7 lb/2.6 kg[1]	
Premolt Male	10.8 lb/4.9 kg[1]	
Premolt Female	10.6 lb/4.8 kg[1]	
Postmolt Male	6.6 lb/3.0 kg[1]	
Postmolt Female	5.5 lb/2.5 kg[1]	
Fledgling	6.6 lb/3.0 kg[1]	
Chick	0.2 lb/91.1 g[2]	
Egg	0.26 lb/117.9 g[2]	
Lengths	Source 1	Source 3
Flipper Length Male	7.3 in/18.5 cm	
Flipper Length Female	7.0 in/17.8 cm	
Bill Length Male	2.0 in/5.1 cm	2.0 in/5.1 cm
Bill Length Female	1.8 in/4.6 cm	
Bill Depth Male	1.0 in/2.6 cm	1.1 in/2.8 cm
Bill Depth Female	0.9 in/2.3 cm	0.9 in/2.3 cm
Foor Length Female	4.9 in/12.4 cm	
Foot Length Female	4.6 in/11.6 cm	

Source 1: Warham 1974—Jackson Head, South Island, New Zealand. Source 2: Grau 1982—Jackson Head, South Island, New Zealand. Source 3: Murie et al. 1991—Open Bay Islands, New Zealand.

Biology	Source 1	Source 2, 3, 4
Age Begin Breeding (Years)	4	
Incubation Period (Days)	30–36	
Brooding (Guard) Period (Days)	14–21	21[2]
Time Chick Stays in Crèche (Days)	51–55	54[2]
Fledging Success (Chicks per Nest)	0.5	
Mate Fidelity Rate	High	64% (M) 62% (F)[3]
Date Male First Arrives At Rookery	Late Jun.–Mid-Jul.	
Date First Egg Laid	Late Jul.–Aug.	
Chick Fledging Date	Nov.	
Premolting Trip Length (Days)	60–80	
Date Adult Molting Begins	Feb.–Mar.	
Length Molting on Land (Days)	21	
Breeding Adults Annual Survival		71%[3]
Most Common Prey		Cephalopods[4]
Second Most Common Prey		Crustaceans[4]

Source 1: Warham 1974—Jackson Head, South Island, New Zealand. Source 2: Houston, personal communication (2010)—Not Specified. Source 3: St. Clair et al. 1999—Fiordland, New Zealand. Source 4: Van Heezik 1989—Jackson Bay, New Zealand.

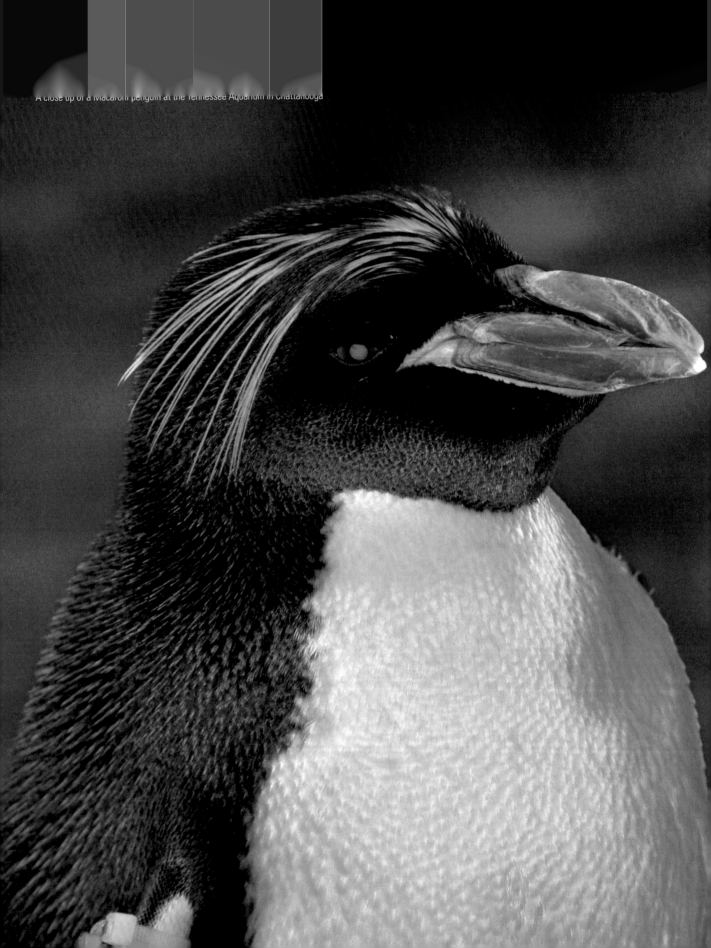
A close up of a Macaroni penguin at the Tennessee Aquarium in Chattanooga

Macaroni Penguin
Eudyptes chrysolophus

Genus: *Eudyptes*

Other Genus Members: Fiordland, Erect-crested, Rockhopper, Royal, and Snares

Subspecies: None

IUCN STATUS: Vulnerable

Latest Population Estimates
Individuals: 20,000,000
Breeding Pairs: 8,500,000

Life Expectancy
Over 12 years

Migratory: Yes, they are absent from the colony from April to October.

Locations of Largest Colonies: South Georgia Islands, Kerguelen Islands, Heard Island, McDonald Islands, Crozet Islands (Île Des Pingouins), and Marion Island

Colors
Adult: White, black, yellow-orange, pink, and gray
Bill: Orange, gray
Feet: Pink, black
Iris: Red
Chick Down: Gray and white
Immature: White, black, gray, yellow, and pink

Height: 24–27 in/61–69 cm

Length: 26–29 in/66–74 cm

Normal Clutch: 2 eggs per nest

Maximum Chicks Raised per Pair per Year: 1

Wild adult Macaroni

David's Observations

The Macaroni penguin is the most populous species, but for someone who lives in Dallas, Texas, it is also one of the most difficult to encounter. I spent days looking for a pair in the Falklands, as well as on other islands near Antarctica. All I encountered was a single Macaroni penguin on Pebble Island and another lone penguin on Half Moon Island. I was so uninspired by my hunt for this species that I finally had to travel to the Tennessee Aquarium in Chattanooga, Tennessee. Thank you to Amy Graves for being so kind and allowing me to photograph the lovely Macaroni penguins of the exhibit.

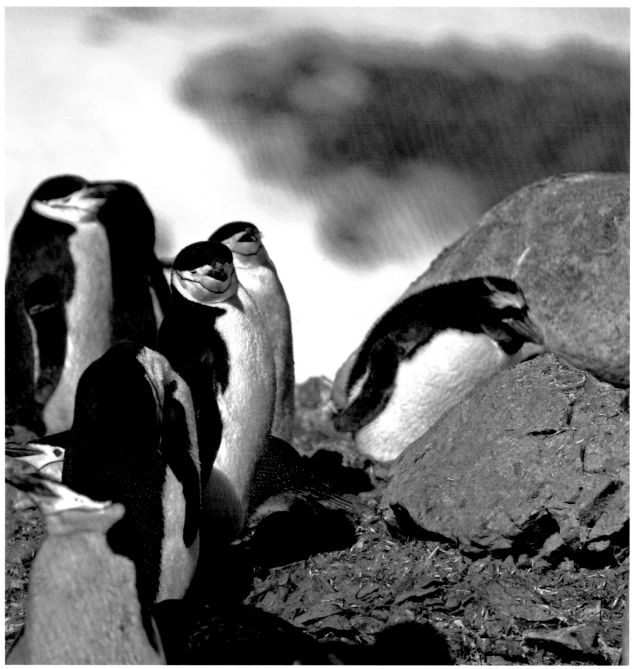

A lone Macaroni penguin nesting with Chinstraps

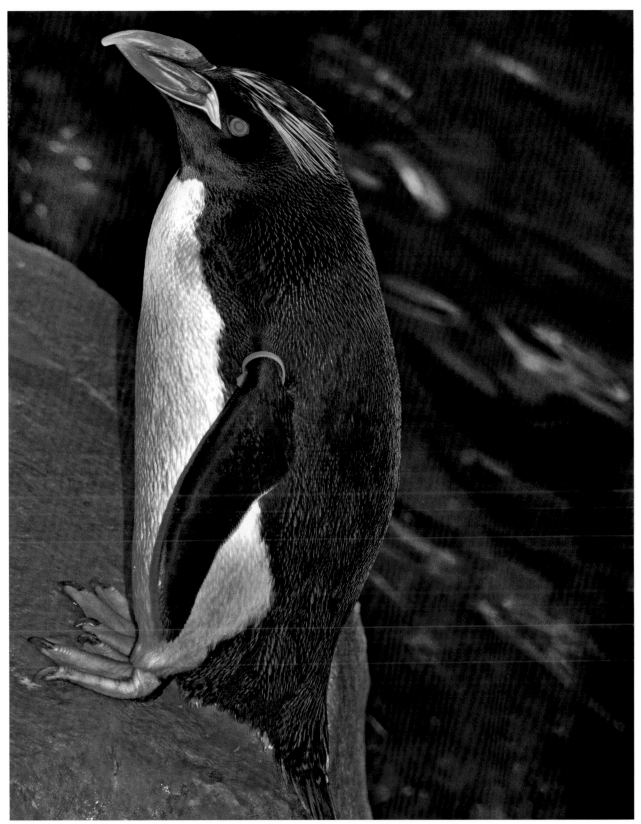

An adult Macaroni penguin at the Tennessee Aquarium in Chattanooga

About the Macaroni Penguin

Population Trend

It was estimated by Woehler in 1993 that world population at the time was 11 million breeding pairs. Several locations showed a marked reduction in population of 30 percent or more over twenty years, which prompted the IUCN to downgrade the Macaroni penguins' status to vulnerable, despite the fact that this is the most common penguin and boasts the largest population of any species.

Habitat

Macaroni penguins breed in many locations, including smaller colonies on islands at the southern tip of South America, bigger colonies around the Antarctic Peninsula, and island groups like the South Shetland Islands. The very large colonies are on island groups to the east of the Antarctic Peninsula, like the South Georgia Islands with the largest population of over two million pairs, South Sandwich Islands, South Orkney Island, Bouvet Island, Prince Edward Islands, Marion Islands, Crozet Islands, Kerguelen Islands, Heard Island, and McDonald Islands.

Appearance

Macaroni penguins are similar in appearance to Royals except for the color on their throat. The back, head, chin, and throat are shiny black when new and dark brown just before the molt. The underbody is white with a sharp and well-defined line between the black and white. The crest, which projects backward, is long, yellow to gold color in color, and begins about half an inch behind the bill. The bill is large and hooks. It is brown to orange in the front with gray near the face and displays red to pink featherless skin in a triangular shape at both sides of the base of the bill. The flippers are black on the outside and have a white edge and white underside, with a wider black edge on the upper part and other black patches. The feet are pink with white and dark patches, and the soles and cowls are black. Immature Macaroni penguins are somewhat smaller, and have very short crests and noticeably smaller bills. Their throats are gray to faded white and have no defined line separating the white and the black.

Chicks

Macaroni chicks are born with a sparse down coat and low fat deposits, which are not enough to maintain body temperatures. If two chicks hatch, there is a significant weight difference between chicks born from the first egg laid (Egg A) versus those born from the second, larger egg (Egg B). Only one chick is raised to fledging, but the Egg A chick is raised to fledging when Egg B or Chick B is lost early, so by fledging time Chick A develops

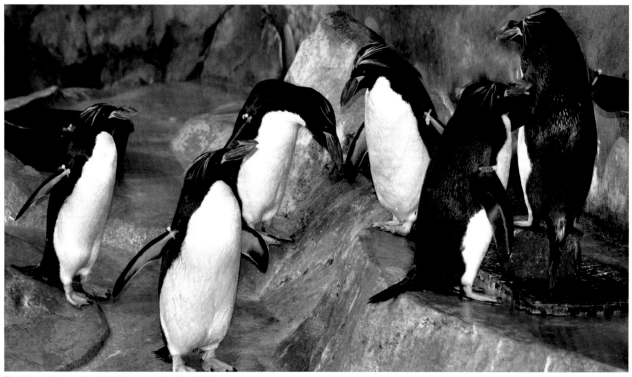

The Macaroni penguins of the Tennessee Aquarium in Chattanooga

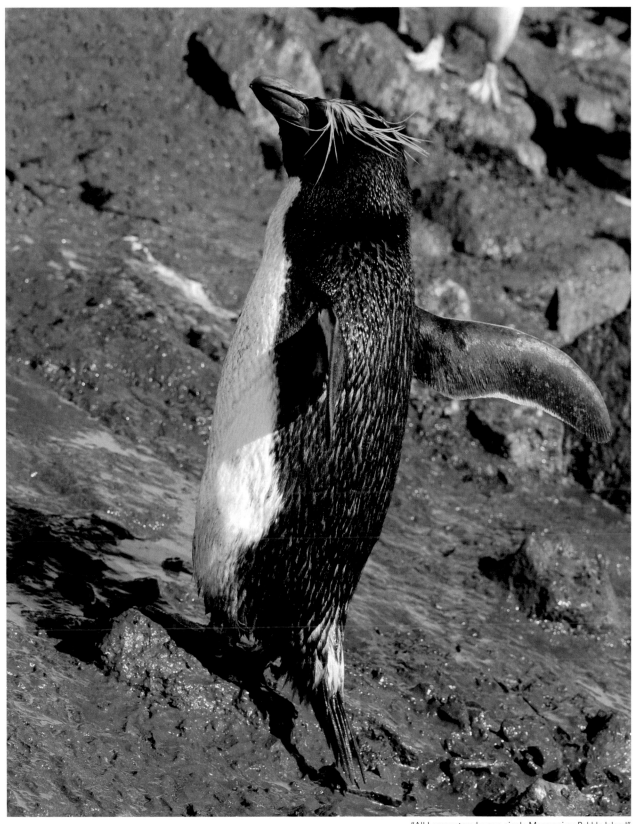

"All I encountered was a single Macaroni on Pebble Island"

to a similar size and weight as chicks born from Egg B (Williams 1990). Chicks remain under their parents' body for two weeks, at which time their down grows and their body gains weight and strength. At age twenty to twenty-five days they join a crèche, and at the relatively young age of fifty-five to seventy days they fledge at a weight ranging from 6.8 to 7.7 pounds (3.1–3.5 kg). Macaroni are slow to sexually mature and only attempt to breed after reaching six to eight years of age (Williams and Rodwell 1992).

Breeding and Chick Rearing

Macaroni penguins are highly synchronous, speedy breeders, and they only try to raise one chick to fledging. Males start arriving at the colony during the middle of October or the first week of November depending on location, and females arrive about a week later. A significant portion of adults that bred one year skip breeding the next year, and some will not even appear at the colony until the time of the molt. Others arrive on time but will not mate, and yet, because there are more males than females,

unpaired males remain unable to find a female mate (Williams and Rodwell 1992). Bond affirmation takes a short time to conclude, and within only eleven to twelve days after the arrival of the female, the first, much smaller Egg A is laid. The second, Egg B, is typically 60 percent larger than the first, and it is laid two to three days later but hatches first.

Both parents experience a long fast, remaining at the nest site until the incubation period is well under way. They share the first incubation shift of nine to twelve days. During this period, the majority of pairs lose Egg A. When the first incubation shift is over, the male leaves for a twelve- to fourteen-day foraging trip, breaking his nearly forty-day fast. When he returns, the female, which has been fasting for about thirty-five days, is in no hurry to leave. Instead, she stays with her mate near the nest for a day or two before departing on a ten- to eleven-day foraging trip, but returns within a day of the chick(s) hatching date.

Males guard the chick for the entire guarding period of twenty-three to twenty-seven days, and since the male has the

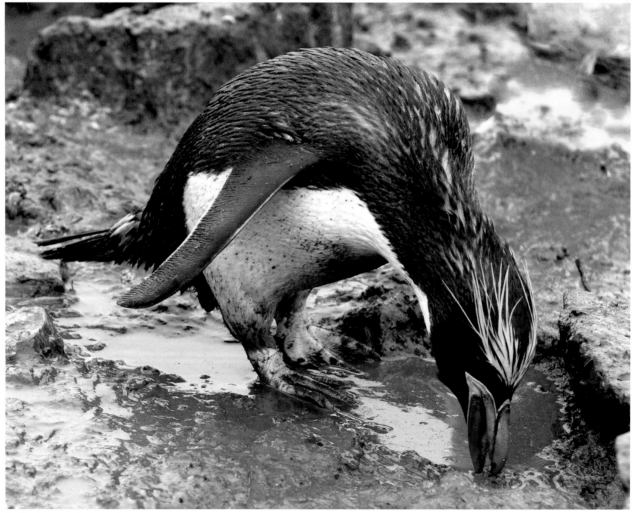

Looking for a stone in the mud

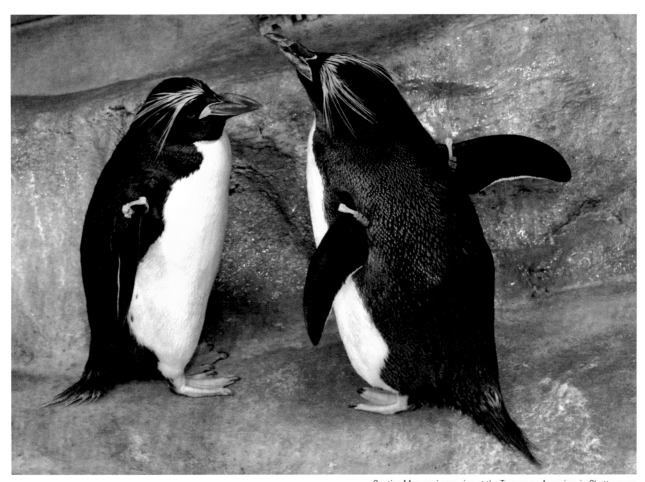

Captive Macaroni penguins at the Tennessee Aquarium in Chattanooga

last incubation shift, he must endure another long fasting period of about thirty-five days. When both parents leave to forage, the chick joins a crèche. At first, the male goes to sea in order to rebuild his body for ten to fifteen days while his female counterpart feeds the chick alone. When the male returns, chick feeding intensifies, and both parents participate to accelerate the chick's growth as it readies itself for fledging at fifty-two to sixty days of age. Because Macaroni penguins usually only raise one chick to fledging, success rates are only 0.44 chicks per nest at Marion Island and 0.49 at South Georgia Island (Williams 1995).

Foraging

The Macaroni penguin is a migratory bird and offshore forager. Its foraging tactics seem to differ depending upon location and activity within the annual cycle. Early studies by Croxall et al. (1988) showed that Macaroni penguins from the South Georgia Islands stayed close to shore, diving to shallow depths of about sixty-five feet (20 m), and exclusively consumed Antarctic krill during the breeding period. Green et al. (1998) found an entirely different diet and foraging habits at Heard Island during the chick-rearing period. In the Heard Island study, they fed

mostly on lanternfish and partially on krill. They dove from 32 to 196 feet (10–60 m). Bost et al. (2009) showed that Macaroni penguins from the Kerguelen Islands traveled within a narrow latitude reaching into the Polar Frontal Zone (47° to 49° S), and within the Frontal Zone some went as far as 2,100 miles (3,380 km) away to the east. They mostly preyed on krill, but not the Antarctic krill, which is commonly consumed during breeding season. Total mileage on foraging trips averaged a staggering 6,500 miles (10,460 km). Interestingly, in the study both females and males deployed similar strategies and traveled similar distances during the winter. Forward speeds were found to be slower when the penguins were farthest away, and no Macaroni penguin ever stepped on land for the entire six-month trip.

Green et al. (2009) conducted a study that focused on the medium-length trips that occur premolt and during incubation and introduced several unconventional ideas. They recognized that normal GPS equipment is bulky, causes drag, and reduces the penguin's ability to dive, so instead they implemented a different method called "behavioral geolocation." In this method, the researchers surgically inserted a chip into the penguin's body. The measurements obtained were less accurate due to the placement of

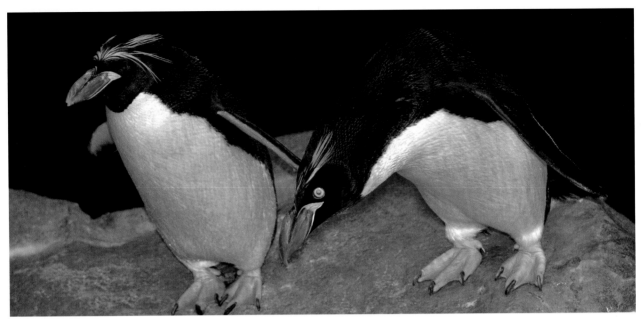

A Macaroni bowing to its partner

the chip under the skin, but the method freed the animal from the bulky GPS drag and allowed it to behave naturally. All penguins in this study group traveled much farther than previously noted from GPS studies. All gained equal weight compared to the birds that were not retrofitted, unlike the birds in the GPS studies. Green found that Macaroni penguins from South Georgia (54° S), when given time, also headed 350 miles (563 km) north into the Polar Frontal Zone, and average swimming speed was 2.9 mph (4.7 kmph).

Cherel et al. (2007) did a study of stable isotope residuals in the penguin body that also suggested that Macaroni penguins consume more fish than most stomach studies have shown. This finding is supported by the Green et al. 2009 study at Heard Island.

Molting

As parents stop feeding their chick in preparation for the chick's fledging, they get ready for the premolting trip. In South Georgia, the premolting trip is unusually short for the crested penguin, lasting about two to two and a half weeks. During the trip they gain back 50 or even 60 percent over their former weight (Williams et al. 1977). As they arrive ashore visibly fat, they stand mostly in pairs away from their nest. The weight loss is staggering, and postmolt a Macaroni penguin weighs less than at any other time during the year. The land portion of the molt process takes up to twenty-two days (Green et al. 2004).

Green et al. (2004) also studied the metabolic rate of molting female Macaroni. Their conclusion was that most of the energy expended by molting females was due to the loss of body insulation during the fast. As body fat, skin protection, and feather insulation were compromised, the penguin's shiver-

ing increased body metabolism. Green also found that energy expenditure per day was not significantly different in female Macaroni penguins during their breeding fast compared to that during molting. Green further suggested that the majority of protein synthesis actually takes place during the premolt feeding trip and, therefore, the bulk of energy expended during the molt is for thermo-regulation and maintaining body temperature, rather than synthesizing proteins to produce new feathers as hypothesized by previous research.

Nesting

Macaroni penguins prefer large colonies and nests located on steep, sloping terrain. They dig a shallow hole in the ground to nest in, and after a good rain the whole thing often looks like a muddy mess. In many locations they just take advantage of dents in a rocky slope, and on grassy beaches they build their nest under tussock plants. They adorn the rim of the nest with small stones and line the nest with grass or leaves when such materials can be found near the colony.

Relationships

Macaroni penguins are aggressive, especially males, in defending their territory against even a humble passing bird. Since their nests are densely placed in large colonies, males fight noisily most of the day during the first few weeks of the breeding season. The colony calms as attention is directed toward incubating the eggs. In 1989, Williams disproved a prior hypothesis suggesting that the high level of male aggression was, in part, responsible for the majority of Egg A disposals from the nest. Williams noted that males became substantially less aggressive immediately preceding the arrival of the first egg. The immatures, which arrive late in

the breeding season to molt, are unusually aggressive. They tend to pick fights with the older birds, never respecting the breeding penguins.

Williams and Rodwell (1992) studied variations in mate fidelity and nest fidelity in Macaroni penguins. They suggested that a Macaroni penguin's first preference is to return to last year's nest and secondly to mate with last year's partner. This explained why all males attempted to regain their nest from the previous year, but only those females that re-mated with last year's male remained at the same nest. Females that found their mate already paired with a different female looked for the first available male and normally ended up breeding only few feet away from their last nest. Divorce often began during the molt of the prior year (Williams and Rodwell 1992).

Vocalization and Chick Feeding

Macaroni penguins are identical except for size, so identification between mates and chick recognition depend primarily on voice recognition, or meeting points. Kings, which keep their territory but have no nest, and Emperors, which are not territorial, depend solely on their voice recognition. Dobson and Jouventin (2003) found that Macaroni penguins use the nest site as a rendezvous site first and their voice as a secondary and final recognition. In the study, the parent returned from the sea and went directly to the nest site that was used to incubate and rear the chick. Once there it only called two or three times, and some did not need to call at all, as the chick was already waiting and begging prior to the adult call. Just one or two chicks arrived within half a minute and immediately started begging. If the chick tried to be sneaky and the adult did not recognize it as his or her own, the adult would then peck it or slap it with its flipper. At times the adult recognized the chick and started feeding it, but stopped several times to call in order to reinforce the vocal recognition ability of the young chick. Feeding only took seven and a half minutes on average and included seventeen servings, during which the chicks kept begging between servings and also after the meal was over. The chicks also followed the parent begging more as it was leaving, but gave up after a short distance. Unlike Kings, which often give a short feeding to a foreign chick, not one adult Macaroni penguin has been observed feeding a foreign chick even a small portion.

Dangers

Weather changes from year to year, influencing food availability and breeding success. Skua, giant petrels, and kelp gulls prey on young crèche-age chicks and eggs. The fact that Macaroni penguins neglect to protect Egg A and the few chicks that hatch from Egg A makes it difficult to assess how many chick losses stem from the avian predators. Antarctic fur seals and leopard seals take adults in the transition from water to land, but Macaroni penguins are less affected by seals than some other species. Ocean pollution and fishing also hurt this species, like all other penguins.

Conservation Efforts

Macaroni penguins, the most abundant species and one that breeds in areas scarcely visited by humans, are not a major target of conservationists. This bird is well-researched and adapts well to zoo life. Like other marine birds affected by global warming, any conservation effort to reduce global warming also benefits this species.

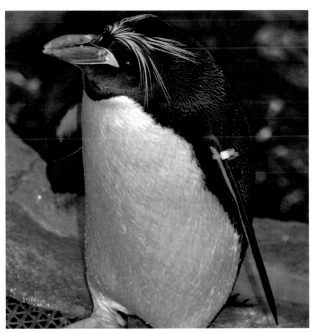

Roaming the aquarium in Chattanooga

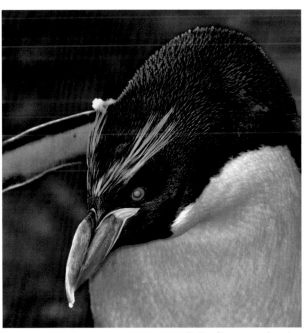

Posing, Chattanooga Aquarium

Interesting Research

Williams and Rodwell investigated questions effecting variations in the return rates of Macaroni and Gentoo penguins in "Annual Variation in Return Rate, Mate and Nest-site Fidelity," written in 1992. The species' survival depends on continued recruitment of new breeders. In Macaroni penguins, breeding is delayed until the female reaches the age of six, and some even wait until they reach eight years of age. Breeding pairs only try to raise one chick to fledging, which produces substantially less chicks per nest than species that attempt to raise two chicks. Therefore, annual breeding is critical to maintain the healthy population of the species. This study showed that in 1987, as much as 14 percent of the birds that bred the prior year were alive and present in the colony at one time during the season, but skipped breeding. 1987 was a very poor year, and only 35 percent of the birds that bred in 1986–1987 attempted to breed in 1987–1988, as compared to the 70 or 80 percent that attempted breeding in other years of the study. Snow and ice conditions were unusually harsh that year, so it is possible some Macaroni penguins just preferred another location.

Of the pairs that bred together during a normal year and had both partners return the following year, about 75 percent joined their mate from the previous year. There was no apparent correlation between fidelity rates and breeding success. When a female divorced and returned to the same breeding site, she was almost always able to breed again, but in a different nearby nest location. However, only 61 percent of males bred the first year after separating. Males were more determined to retain their nest site from the previous year than to find a new breeding partner. It is also more difficult for a male to pair because males are more common than females.

Pair behavior was recorded during the molt, highlighting the importance of considering as many variables as possible in penguin study. Williams and Rodwell noted that 25 percent of Macaroni penguins molted apart from their mate of the newly completed breeding cycle, about half of that percentage with another bird of the opposite sex, and half alone. Seventy-four percent of those that molted separately from their mate did not breed with the old mate again. The following year, two-thirds of the non-returning adults paired with a different mate, many with the bird they molted with at the end of the prior year. A third of the population altogether skipped breeding the following year. The study concludes that the Macaroni penguins' divorce and new bond formation probably starts during the molt of the prior year.

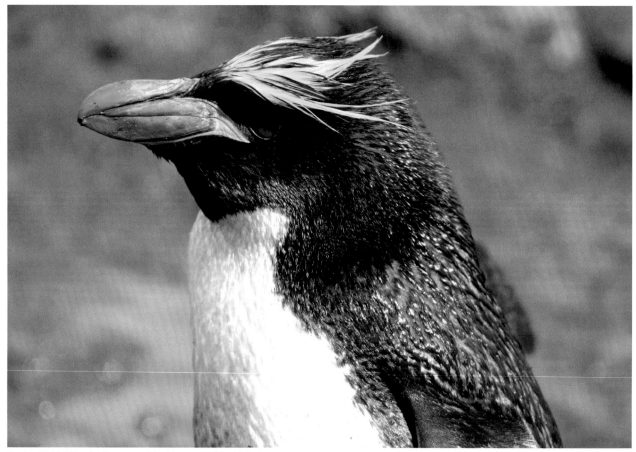

The formidable bill and yellow crest of the Macaroni, Falkland Islands

Charts

Weights	Source 1	Source 2, 3	Source 4, 5
Arrival Breeding Male	10.4 lb/4.7 kg	9.5 lb/4.3 kg[2]	
Arrival Breeding Female	10.6 lb/4.8 kg	9.5 lb/4.3 kg[2]	
First Incubation Male	7.5 lb/3.4 kg	8.6 lb/3.9 kg[2]	
First Incubation Female	8.8 lb/4.0 kg	8.6 lb/3.9 kg[2]	
Premolt Male	14.1 lb/6.4 kg	11.7 lb/5.3 kg[2]	11.2 lb/5.1 kg[4]
Premolt Female	12.6 lb/5.7 kg	11.7 lb/5.3 kg[2]	10.6 lb/4.8 kg[4]
Postmolt Male	8.2 lb/3.7 kg	6.8 lb/3.1 kg[2]	7.3 lb/3.3 kg[4]
Postmolt Female	7.2 lb/3.2 kg	6.8 lb/3.1 kg[2]	6.4 lb/2.9 kg[4]
Egg 1	0.2 lb/90.7 g	0.21 lb/95.3 g[3]	0.21 lb/95.2 g[5]
Egg 2	0.33 lb/149.7 g	0.33 lb/149.7 g[3]	0.33 lb/149.7 g[5]
Lengths	**Source 6**	**Source 7**	**Source 8**
Flipper Length Male		8.7 in/22.1 cm	8.2 in/20.8 cm
Flipper Length Female	6.5–7.0 in/16.5–17.8 cm	8.3 in/21.1 cm	7.8 in/19.8 cm
Bill Length Male	2.1–2.5 in/5.3–6.3 cm	2.7 in/6.9 cm	2.5 in/6.4 cm
Bill Length Female	2.0 in/5.1 cm	2.4 in/6.1 cm	2.2 in/5.5 cm
Bill Depth Male	0.9–1.2 in/2.2–3.0 cm	1.2 in/3.0 cm	1.4 in/3.6 cm
Bill Depth Female	0.9 in/2.3 cm	1.1 in/2.8 cm	1.3 in/3.3 cm
Foot Length Male			3.5 in/8.9 cm
Foot Length Female			3.5 in/8.9 cm

Source 1: Williams 1995—South Georgia Island. Source 2: Davis et al. 1989—Bird Island, South Georgia. Source 3: Williams 1995—Bird Island, South Georgia. Source 4: Croxall 1982—Not Specified. Source 5: Gwynn 1953—Marion Island, Prince Edward Islands. Source 6: Williams 1995—Heard Island, Australia. Source 7: Davis and Renner 2003—Various Locations. Source 8: Williams 1995—Crozet Islands.

Biology	Source 1	Source 2, 3, 4, 5	Source 6, 7, 8
Age Begin Breeding (Years)	5–6	5–6[2]	
Incubation Period (Days)	34.9–35.5	35–37[2]	40[6]
Brooding (Guard) Period (Days)	34–40	25[2]	21[6]
Time Chick Stays in Crèche (Days)	23–25	Approximately 35[2]	40[6]
Fledging Success (Chicks per Nest)	0.96–1.5		0.43[6]
Mate Fidelity Rate	71–79%		
Date Male First Arrives At Rookery	Oct.	Early Nov.[2]	Late Oct.[7]
Date First Egg Laid	Late Nov.	Nov. 25[2]	Mid-Nov.[7]
Chick Fledging Date	Mid–Late Feb.	Late Feb.[2]	
Premolting Trip Length (Days)	12 (F) 14 (M)	14[3]	28–35[7]
Date Adult Molting Begins	Mid-Mar.	Early Mar.[2]	
Length Molting on Land (Days)	24	21[2]	
Breeding Adults Annual Survival	49–78%		
Average Swimming Speed	4.7 mph/7.6 kmph		4.7 mph/7.5 kmph[7]
Maximum Swimming Speed		5.1 mph/8.2 kmph[4]	5.16 mph/8.3 kmph[7]
Deepest Dive on Record		328.1 ft/100 m[3]	534.8 ft/163 m[8]
Farthest Dist. Swam From Colony		1187 mi/1911 km[5]	1468 mi/2362 km[7]
Most Common Prey	Antarctic Krill	Krill[3]	Krill[7]
Second Most Common Prey	Fish	Fish[3]	Fish[7]

Source 1: Williams 1995—South Georgia Island. Source 2: Davis et al. 1989—Bird Island, South Georgia. Source 3: Croxall et al. 1988—Bird Island, South Georgia. Source 4: Clark and Bemis 1979—(Captivity) Detroit Zoo, Detroit, Michigan. Source 5: Green et al. 2009—Bird Island, South Georgia. Source 6: Williams et al. 1977—Marion Island, Prince Edward Islands. Source 7: Brown 1987—Marion Island, Prince Edward Islands. Source 8: Green et al. 1998—Heard Island, Australia.

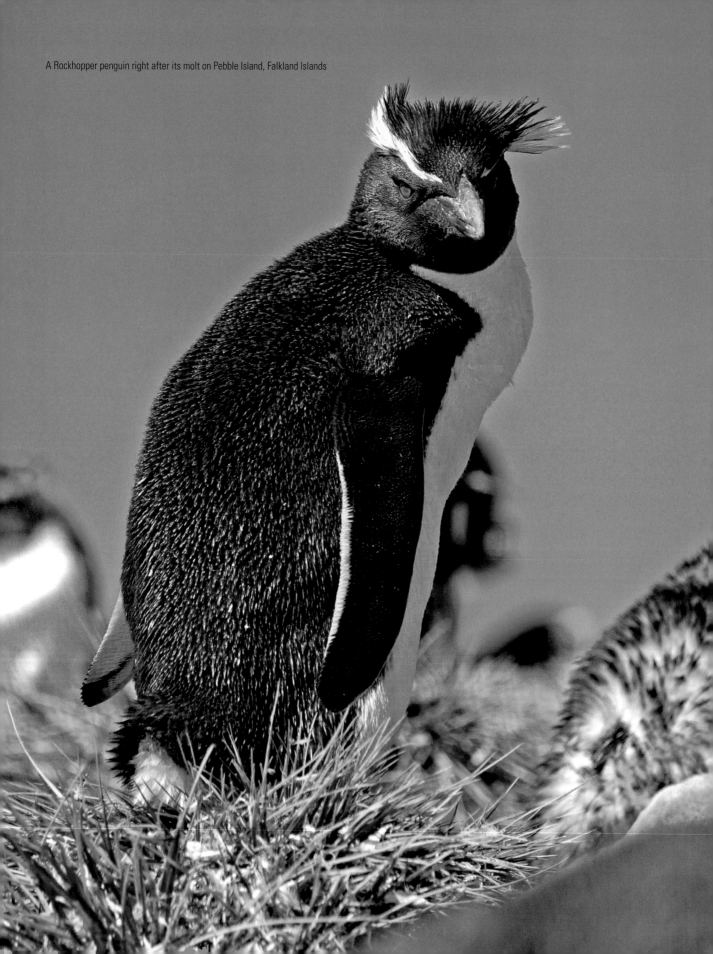

A Rockhopper penguin right after its molt on Pebble Island, Falkland Islands

Rockhopper Penguin
Eudyptes chrysocome

Genus: *Eudyptes*

Other Genus Members: Macaroni, Royal, Erect-crested, Snares, and Fiordland

Subspecies: Southern Rockhopper (*E.chrysocome*) and Northern Rockhopper (*E.moseleyi*)*

IUCN Status:
Northern Rockhopper, Endangered
Southern Rockhopper, Vulnerable

Latest Population Estimates
Individuals: 3.6 million
Breeding pairs: Southern, 1.23 million; Northern, 240,000 (Birdlife International, Workshop 2008)

Life Expectancy
Not well studied—estimated at 10–15 years in the wild; up to 25–30 years in captivity

Migratory: Yes, they are absent from the colony from May to October.

Locations of Largest Colonies
Southern: South Chile, Falkland Islands, and South Argentina
Northern: South Atlantic including Gough Islands and Middle Island of the Tristan da Cunha group; Indian Ocean and Amsterdam Island

*Some further break down the Southern Rockhopper by classifying a third subspecies, the Eastern Rockhopper (*E. filholi*). The Rockhopper classification is the subject of great disagreement among biologists. Some contend that Northern and Southern (plus Eastern) are two separate and distinct species. This book, for several reasons, not least of all the great similarities that exist among all of the above, will consider the Rockhopper as one species that is divided into two subspecies.

Colors
Adults: Black, white, yellow, orange/red, and pink
Bill: Red/orange and black
Feet: Pink with gray patches, black sole with black nails
Iris Color: Bright red
Chick Down: Brown
Immature: Gray, black, and white

Height: 19–22 in/48–56 cm

Length: 20–23 in/50–58 cm

Normal Clutch: 2 eggs per nest

Max Chicks raised per Pair per Year: 1

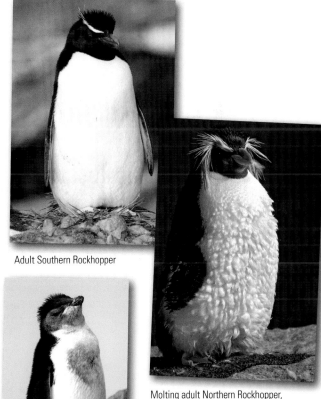

Adult Southern Rockhopper

Molting adult Northern Rockhopper, New England Aquarium

Immature Southern Rockhopper

David's Observations

*R*ockhopper penguins are present in many islands that are also home to different penguin species and other beautiful birds. I observed them on several sub-Antarctic islands like Campbell and Macquarie, where access to them is very restricted (i.e. by boat).

The best place to photograph a Rockhopper penguin is, without a doubt, the Falkland Islands. Here they will be waiting for you on Sea Lion Island and Saunders Island, where the beautiful black-browed albatross are just a few yards away, and even at the East Island, where Stanley and the airport are located. The best place of all is Pebble Island, where there are at least two large colonies to choose subjects from.

Jacqui, the very accommodating hostess of the lodge, understood my enthusiasm for photography and drove me for more than an hour to one side of the island, where we encountered a large colony of Rockhopper penguins in the middle of a rainstorm. After waiting two hours for the storm to pass, I gave up on the idea of being able to photograph anything that day and asked to be driven back to the lodge. My hostess insisted that the end of the storm was near and within an hour I would

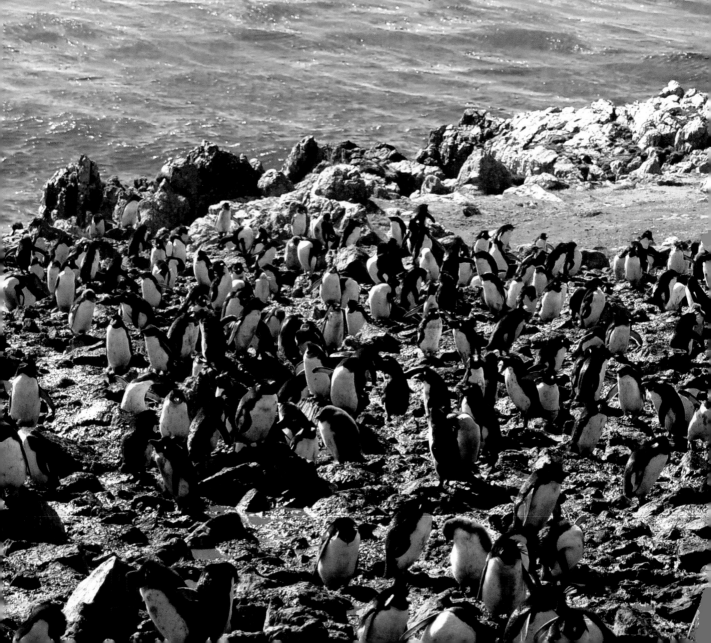

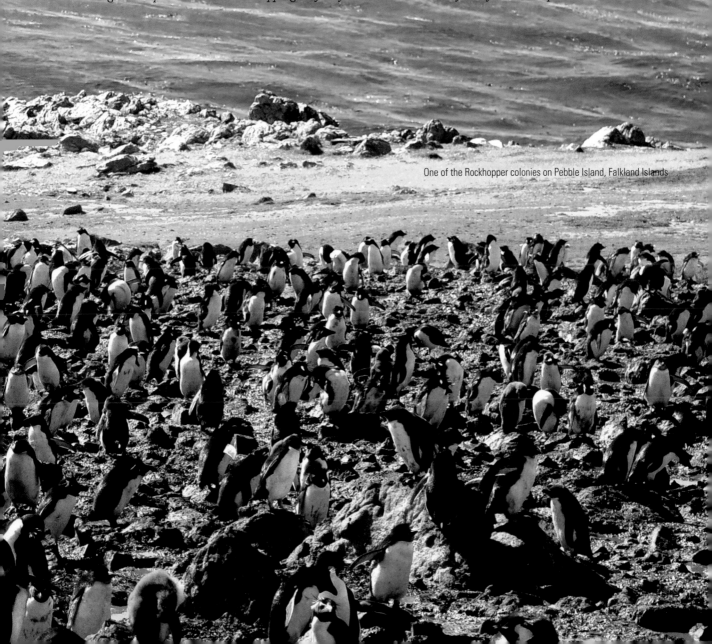

have optimum light conditions. I must say she was one of the best weatherwomen I have ever met, because in thirty minutes the entire colony was flooded with warm rays of sunlight.

I jumped out of the Land Rover and started walking toward the colony, but the mud was difficult to walk on, and I stumbled repeatedly. I then understood what a rainstorm meant for those little birds, and that the mud, for the most part, is made of penguin poop. Dirty and smelly, I followed the penguins toward the sea, taking extra care not to slip. Thousands of them were traveling either up or down the rocks, hopping as if they wished to sprout wings and fly. Some Rockhopper penguins were just standing there, many molting; others were preening. The ocean-to-rock landscape that is the Rockhopper habitat was an amazing sight. By the time I climbed back up the cliff to the car, my blue waterproof suit was all brown from mud, but my camera contained some of my best penguin pictures to date.

Watching the Rockhopper penguins that day, and looking back at the photographs I took, I feel I learned a valuable lesson on how tough it is to be a penguin and how much energy and skill each and every one of them must possess to survive.

One of the Rockhopper colonies on Pebble Island, Falkland Islands

About the Rockhopper Penguin

Population Trend

Alarming Decline. For unclear reasons, the Rockhopper population is in a steep decline. The Birdlife International Conference in 2008 estimated that from 1973 to 2010 the Northern Rockhopper population would fall by 57 percent and that the Southern population would lose 34 percent of its breeding pairs. Bucking the trend, some locations in Chile show an increase in population (Oehler et al. 2007). To understand the severity of the decline, one should consider the situation at Gough Island, home of the Northern Rockhopper, where the population crashed from two million pairs in 1950 to only 65,000 in 2006. A similar downturn occurred at Campbell Island, with pairs dropping from 800,000 to 51,000 from 1942 to 1986. The situation is not much better in the Falkland Islands, where their population experienced a drop from 1.5 million pairs to 210,000 through 2005 and is still declining.

Habitat

Northern Rockhopper colonies are limited to a very narrow range on the South Atlantic Islands group of Tristan da Cunha (Middle and Inaccessible Islands), Gough Island, Indian Ocean Islands of St. Paul, and Amsterdam.

The Southern Rockhopper distribution range is very diverse, circling the globe from 46 to 54° S. It lives in a range of locations, from islands located at the tip of Chile and Argentina up into the Falklands, Kerguelen Prince Edward, Marion, McDonald, Heard, and Crozet Islands, and up to islands south of New Zealand, as well as on Antipodes, Bounty, Auckland, Macquarie, and Campbell Islands. Twenty-eight zoos around the world are home to about 500 Rockhoppers from both subspecies.

Appearance

The Rockhopper adult is the smallest of the crested penguins and the third smallest penguin overall. Their simple, pretty color scheme consists of a mostly black backside and a white underbody. The entire head is black except for a narrow yellow stripe. The color change from black to white occurs at the upper part of the neck, with no transitional section in between. The line where the white meets the black curves a bit around the neck and gives the appearance that the penguin is wearing an elegant baby bib on its chest. The crest is lazy and has a yellow stripe about one centimeter wide beginning at the beak base and extending over the eyes, acting as a base from which the rest of the crest rises. The yellow stripe and the crest appear to be pulled backward like a hasty hairdo, giving the Rockhopper penguin the look of a mad professor, especially when the bird walks. The bright red eyes and

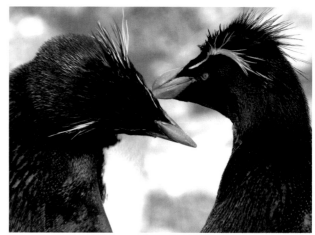
A penguin kiss

the orange beak add elements of beauty, contrast, and color. The flippers are black from the outside and white to pink with black edges on the inside.

Immature penguins look very different from adults; they have no yellow stripes and almost no crest, and the back and flippers border on navy blue rather than black. Their eyes may appear brown. Instead of the clear-cut transition of black to white on the neck, it appears as a mostly gray or dirty white area. The bill is a dirty mixture of black, gray, and pink and is nowhere near the bright orange of adults.

Chicks

Chick Rockhopper penguins develop a brown down and remain under their parents' close supervision for almost four weeks. Later they join a crèche. At about fifty days old, the chicks begin shedding their down. This process takes about ten to twelve days, during which time their parents continue feeding them.

Southern Rockhopper chicks fledge in February at around seventy days of age. The survival rate for chicks the first year of life is below 40 percent. Rockhoppers are slow to sexually mature, reaching sexual maturity at about age five, and many will not attempt breeding before the age of eight, having returned to their natal colony.

Breeding and Chick Rearing

The Southern Rockhopper male arrives after his winter foraging trip and washes on shore in early October, while females arrive about a week later. There is up to a six-week difference in onset dates between the different colonies of Southern Rockhoppers around the world. The male's first order of business is to claim its nest from last year, after which he will bring fresh building materials and lay them in the center of the old nest. When the

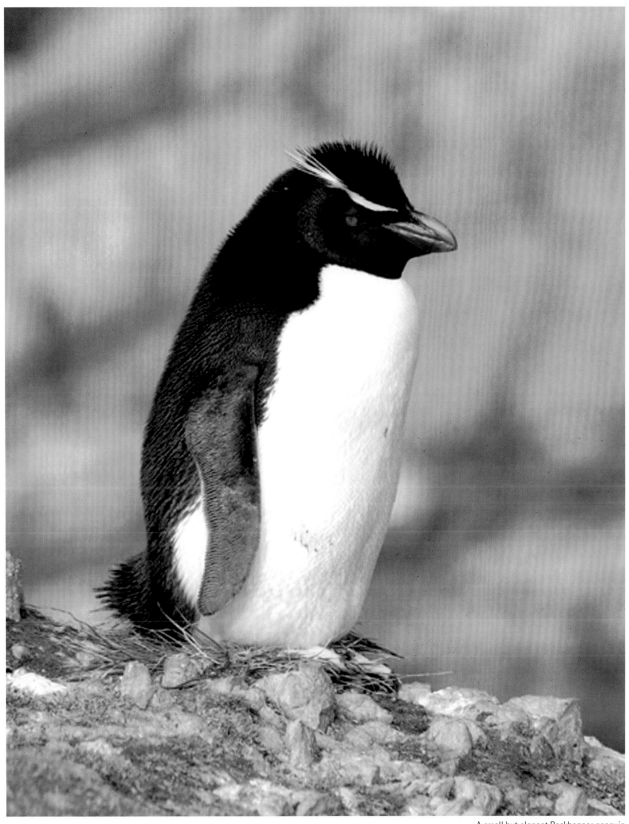

A small but elegant Rockhopper penguin

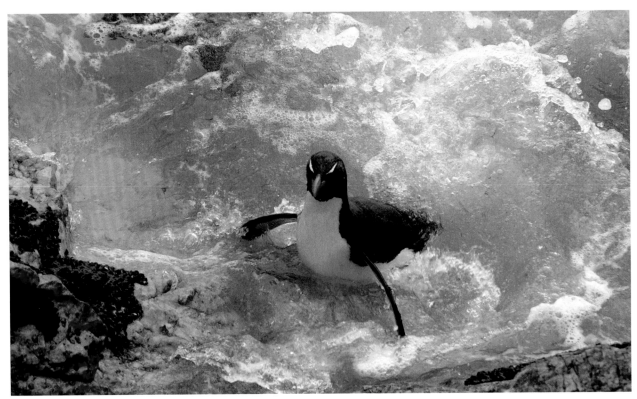

A Rockhopper exiting the rough seas

female arrives, courting and bond reaffirmation begins and can be quite a noisy event. The female then arranges the materials.

Two eggs are laid in the first half of November; the second egg is heavier by about 30 percent (Williams 1995). Right after the second egg is laid, the female takes the first shift of the thirty-five-day incubation period. The male, who by this time has already fasted for nearly thirty-five days, takes off on a grand foraging trip that will last between two and four weeks. When the male returns, he replaces the female and begins his incubation shift. She then leaves on her ten- to fourteen-day foraging trip after fasting for about forty days.

The female returns just before the hatchings take place. Egg B, the second laid, hatches first, even though it was incubated for several days less than Egg A, the first laid. Rockhopper penguins' breeding habits are highly impractical. The ratio between their small size and long fasting period is critical and leaves no room for error. Even the shortest delay in the return of one parent will force the other to abandon the nest to save itself from starvation.

During the early brooding period, which lasts about three weeks, the Rockhopper parents split their family duties in a strange way. The female departs on daily foraging trips, while the male rears the chicks in the nest and protects them vigorously, but not always successfully, against the ever-present and opportunistic skua and other large birds.

Rockhoppers are not capable of raising two chicks and typically reduce the brood in the first ten days after hatching, giving

preference to the stronger B chick. If the B chick expires early, the A chick will be raised to fledging instead. Clausen and Pütz (2002), in a surprising finding, discovered that in some rare instances two chicks from one nest fledged in the Falkland Islands.

Once the chick joins the crèche, the father, who by now has endured a second fast of twenty-five days, goes on a week-long foraging trip to rebuild his body. The mother continues in her daily trips and feeds the chick. When the male returns he rejoins the female, and thereafter they share the feeding responsibilities until the chick fledges at sixty-five to seventy days of age.

Nest success rates vary widely from location to location and in each location from year to year. For Northern Rockhopper penguins the success rate is between 0.28 and 0.52 chicks per nest (Guinard et al. 1998). Southern Rockhopper penguins in the Falkland Islands do a bit better at 0.35 to 0.61 chicks per nest (Clausen and Pütz 2002).

Rockhopper penguins, more often than other species, have been discovered to skip one year or more of breeding. In one study (Hull et al. 2004) that measured breeding factors over three consecutive years, only about 5 percent of the birds studied bred in all three years. Only about 35 percent attempted to breed twice during the same study period. Because of the uneven sex ratio favoring the males, 30 percent of the males never bred at all throughout the whole three-year study.

Foraging

Both Rockhopper species can be characterized as opportunistic foragers that can adapt to changing food availability as well as various foraging conditions throughout the year. They adjust their foraging tactics according to the area, depth, and type of prey, as well as to their own energy needs, as determined by the breeding and molting calendars.

Researchers have several ways to determine a penguin's menu. The classic method is to capture the penguin as it lands ashore and flush out its stomach contents. Recently, scientists invented more advanced methods that identify food contents via sophisticated chemical and atom/isotope analysis. A piece of feather or skin can be analyzed for certain chemical elements, isotopes, and atoms that are specific to a certain type of prey, or even to a specific area, because isotopes are present in the water

and move through the food chain. Combining both methods adds to the accuracy and knowledge of the penguin's diet.

Rockhopper penguins are far from lazy; their average dives last 53 to 193 seconds into a depth of 34 to 145 feet (10.4–44.2 m), repeated at a rate of 14 to 40 dives per hour (Birdlife Conference 2008). However, these averages say very little about how they might dive on any given day. As the number of studies increases, new strategies are discovered, and it seems as if the Rockhopper penguin has a new tactic for each place and season.

Rockhoppers are known to eat any mixture of krill, cephalopods, and fish. However, Southern Rockhoppers in the South Indian and South Pacific Oceans concentrate their efforts on crustaceans (krill), while Northern Rockhoppers off the coast of Chile and Argentina are more focused on cephalopods like squid.

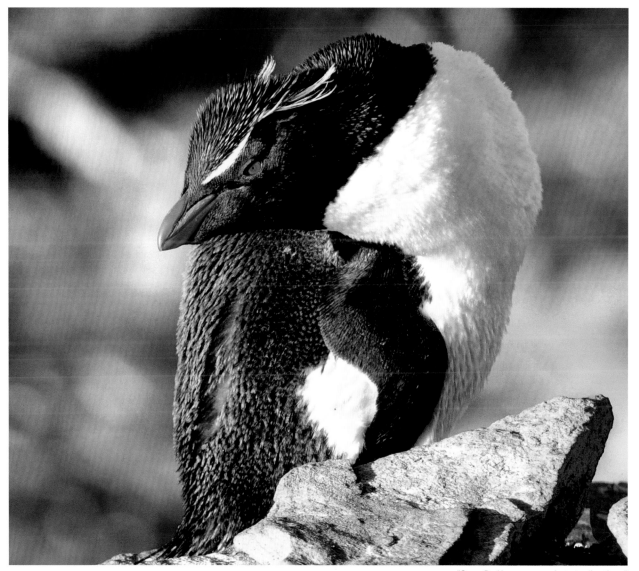

"Some Rockhoppers were just standing there"

Molting

Molting for the Rockhopper penguin is more traumatic and requires more preparation than it does for other penguins, due to its size, very demanding breeding calendar, and the multiple lengthy fasts. As a result, their premolt foraging trip is longer than the average penguin's, up sixty days for the northern subspecies but shorter by about thirty days for the southern. By mid-March most birds are on shore, shaking and shivering near their nest for about twenty-five days. When the molt is complete, the Rockhopper penguin, fitted with a new, very noticeable, shiny plumage, heads to the sea and disappears for its long winter foraging trip. Immature and non-breeders molt earlier, in January and February.

Nesting

Colonies are very large, and nests are in close proximity to each other. Nests are located among tussocks when available on tall, extremely rocky slopes, hence the name Rockhopper. Small caves are also used. A small nest, the perfect size for the small bird, is built by the female with material gathered by the male. Nesting materials include tussock, peat, and pebbles. When the ground is nothing but hard rock, the nests are plain and rest on the rock. Many times Rockhoppers will mix into cormorant and albatross colonies, hoping that the presence of other chicks will spare theirs from the intense avian predatory campaign.

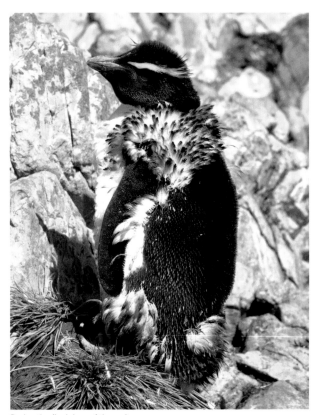

During the final days of the molt

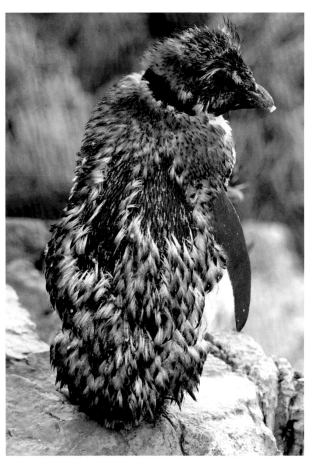

A Rockhopper penguin molting on the rocks

Relationships

Rockhoppers are small, nervous penguins, and everything they do appears abrupt. Even when simply walking they appear nervous and angry. They fight with each other quite often, and in doing so, they move their head forward in the direction of their opponent with their bill open. They do not wait long before starting a duel, biting or pegging the other bird with their bill and finally throwing a flipper slap.

To attract a mate they nervously shake both head and body many times with their head pointed upward. After getting the attention of a potential partner, they bow and begin cross-preening. Later the pair gets closer, and they lay their heads on each other's shoulders, very much like a hug. They gently touch each other's beaks in what can only be described as a penguin kiss.

After they walk around the colony with their heads down for a bit, they reach the nest and the male gently uses his flipper to ask the female to lie on her stomach with her head raised. The male then mounts, holding his female mate in place with his flippers. If she reciprocates, the male continues for a minute or less and then moves to the side or waits for his mate to stand. Afterward, they bow again or assume a very shy, appeasing posture toward each other.

Vocalization

Rockhopper penguins are a vocal bunch and use their voices frequently and loudly. There are four types of calls: contact, sexual, agonistic, and chick recognition. The contact call is a high, short-breaking sound mostly used at sea. The sexual call, also known as an ecstatic call, is intense, nervous, and high-pitched; the faces are not directed at each other, but instead heads point straight up toward the sky with the rest of the body stretching upward. This call may get repeated many, many times, by one mate or both at once. Agonistic calls are a throbbing or hissing sound, high-pitched and growing in intensity as the argument nears a duel. The chick recognition call has two elements that, combined, establish recognition or voice signature. The voice signature is not as simple to recreate as some might think. When the parents' calls are replayed electronically, many chicks do not reply, especially if they do not see an adult at the nest site. Displaying a penguin doll at the nest site instigates more responses, but many older chicks only respond to their parents' call.

Dangers

Something substantial is decimating the Rockhopper population, but no one knows for certain what that "something" is. Many unproven hypotheses are circulated, but no scientist has been able to discover the silver bullet up until now. Lack of a clear culprit just leaves its unusually harsh breeding and molting cycles as the Rockhopper penguin's biggest handicap. Their body is small and reserves are not large, leaving little room for error. Large colonies quickly deplete food supplies in the vicinity of the breeding areas. For all of these reasons, this species might be a victim of its own lifestyle and biology, unable to adapt to the environmental changes.

Scientists try to associate the Rockhopper penguin's violent population downturn with changing water temperatures and acidity, which affect fish population and movements. However, this species of penguin possesses the ability to swim far. Others contend that the Rockhopper's food disappears and that the species is losing in the struggle against an increasing number of predators, while others believe some undetected disease has flared up.

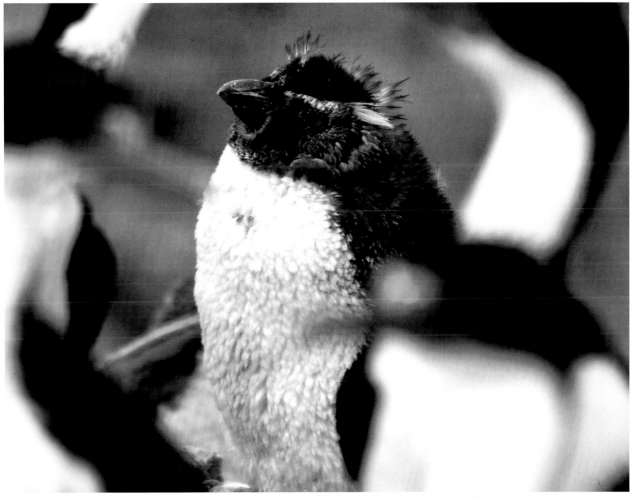

A molting Rockhopper surrounds itself with comrades as part of a survival strategy.

Egg losses are attributed to skua, caracara, gulls, and other avian birds. Rockhopper penguins are small and a poor match for these bigger flying birds, who are able to snatch eggs and newborn chicks almost at will. At sea, fur and leopard seals, sea lions, and other aquatic mammals prey on the Rockhopper. The fur seal population is on the rise as a result of sealing prohibition and might cause bigger penguin losses than in the past. Oil exploration and oil spills cause thousands of penguins to parish every year. Fishermen further deplete their food supply and cause deaths by trapping and suffocating Rockhoppers in their nets.

Conservation Efforts

The decimation of the Rockhopper population is attracting a great deal of attention from the scientific community, but the desire to help is far greater than the actual ability to find the causes or to construct an effective plan to save their species. The Rockhopper situation is disturbing because it demonstrates how a species with a very healthy population can be nearly wiped out, even while the scientific world searches in panic for answers that continuously elude it.

Recognizing the acute stage of the Rockhopper crisis, Birdlife International held a special conference in London in June 2008 with the goal of finding the cause(s) of the situation and formulating an effective remedy. The conference was able to publish a very detailed booklet: "Rockhopper Penguin, A Plan of Research and Conservation: Action to Investigate Population Changes, Proceedings of an International Workshop in Edinburgh 5 June 2008." The first argument that erupted was how many Rockhopper penguins exist at this time, and so the first urgent recommendation was to order a massive population survey in parts of the Rockhopper range that had not been canvassed for decades. In the end, trying to devise a master plan to save the species left the conference attendees with more questions than answers. The large list of recommendations furnished by the conference consisted mostly of requests for more research. Until more concrete research is obtained, not even world attention can solve the mysterious disappearance of the Rockhopper penguin.

Interesting Research

It is widely accepted that the first egg laid, Egg A, is smaller than the second egg laid, Egg B, and therefore the chick from Egg B weighs more at birth. Also, for reasons unknown, Egg B hatches first, even though it is laid several days later.

Saint Clair in a 1996 study investigated the reason why crested penguins tend to hatch Egg B before the Egg A. Saint Clair was trying to establish connections between mass, laying order, and other variables, but in the end not one solid explanation for the strange reversal was discovered.

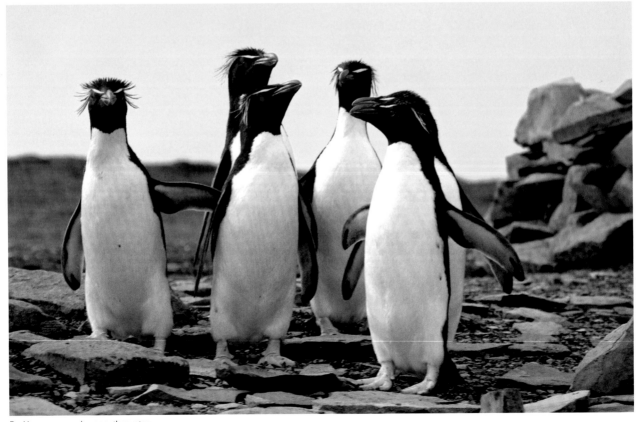

Rockhoppers grouping near the water

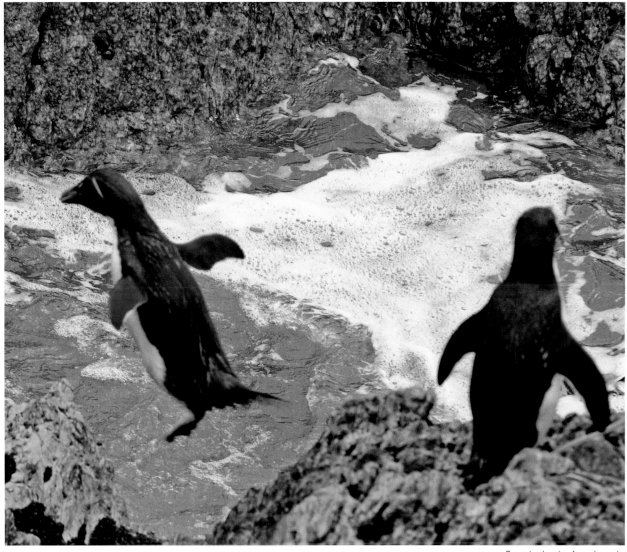

Penguins leaping from the rocks

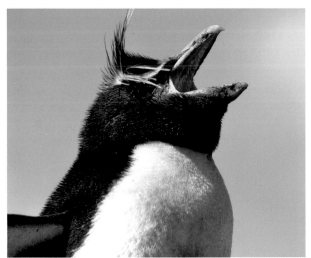

Penguins have no teeth

Poisbleau et al. (2008) learned from Saint Clair's mistake in setting the wrong goals and parameters and decided to turn the tables. Instead of trying to follow the natural order, she tried a different approach. She stole Egg B, or the chick hatched from Egg B, and left Egg A and its hatched chick alone in the nest. To everyone's surprise, the survival rate to fledging of the smaller Egg A chick was equal to the Egg B chick from the control group. In short, when it comes to chances of survival, there is little biologic reason for the crested penguin's preference of the bigger Egg B, because if given a chance the Egg A chick has an equal chance of survival. An interesting side discovery to come out of the Poisbleau study is that some Rockhopper penguins in the Falkland Islands do, in fact, raise two chicks to fledging, a verity previously unobserved.

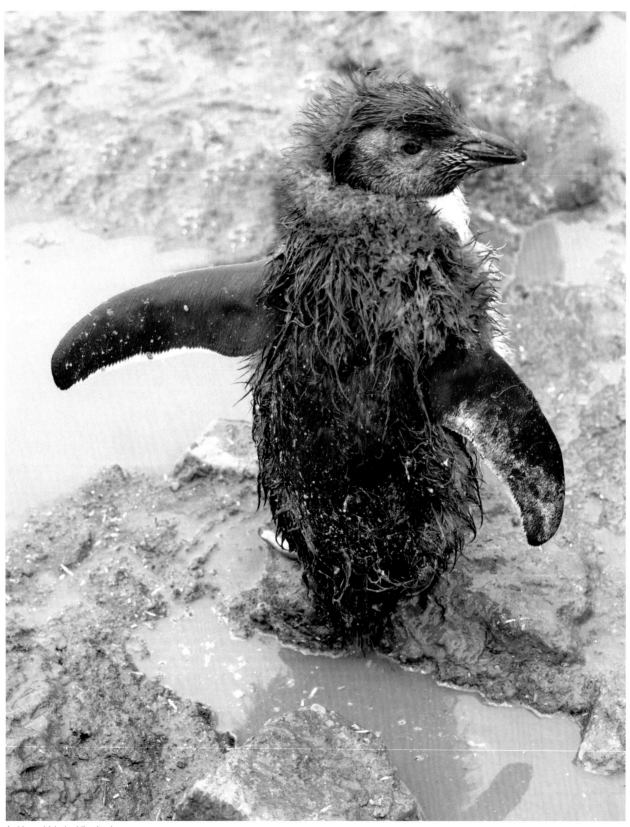

A skinny chick shedding its down

Charts

Weights	Source 1	Source 2	Source 3
After Forage Male		7.5 lb/3.4 kg	9.0 lb/4.1 kg
After Forage Female		6.8 lb/3.1 kg	8.6 lb/3.9 kg
After First Fast Male		5.1 lb/2.3 kg	6.6 lb/3 kg
After First Fast Female		5.5 lb/2.5 kg	5.5 lb/2.5 kg
Premolt Male	9.5 lb/4.3 kg		7.7 lb/3.5 kg
Premolt Female	7.9 lb/3.6 kg		
Postmolt Male	5.3 lb/2.4 kg		5.1 lb/2.3 kg
Postmolt Female	4.9 lb/2.2 kg		
Fledging Chicks	4.9 lb/2.2 kg	4.9–5.3 lb/2.2–2.4 kg	
Egg 1	0.18 lb/80 g	0.19 lb/88.2 g	
Egg 2	0.25 lb/115 g	0.25 lb/115 g	
Lengths	**Source 4**	**Source 5**	**Source 6**
Flipper Length Male	6.9 in/17.5 cm	6.6 in/16.7 cm	6.6 in/16.7 cm
Flipper Length Female	6.6 in/16.7 cm	6. 3 in/16.1 cm	6.6 in/16.7 cm
Bill Length Male	1.8 in/4.6 cm	1.9 in/4.7 cm	1.8 in/4.6 cm
Bill Length Female	1.6 in/4.0 cm	1.6 in/4.1 cm	1.6 in/4.1 cm
Bill Depth Male	0.8 in/2.0 cm	0.8 in/2.1 cm	0.8 in/2.1 cm
Bill Depth Female	0.7 in/1.8 cm	0.7 in/1.8 cm	0.66 in/1.7 cm
Foot Length Male	4.5 in/11.5 cm		
Foot Length Female	4.3 in/11 cm		

Source 1: Williams 1995—Falkland Islands. Source 2: Hull et al. 2004—Macquarie Island, Australia (1993–1994). Source 3: Hull et al. 2004—Macquarie Island, Australia (1995–1996). Source 4: Williams 1995—Gough Island. Source 5: Williams 1995—Campbell Island, New Zealand. Source 6: Warham 1963—Macquarie Island, Australia.

Biology	Source 1	Source 2, 3, 4, 5, 6	Source 7, 8, 9, 10
Age Begin Breeding (Years)	4		2–5 (Avg. 4.5)[7]
Incubation Period (Days)	33–34	33[2]	32–34[7]
Brooding (Guard) Period (Days)	24–26	26[2]	24–26[7]
Time Chick Stays in Crèche (Days)	40–50	41–45[2]	44[8]
Fledging Success (Chicks per Nest)	0.41–0.61(Crozet Is.)	Below 0.6[2]	0.28–0.52[7]
Mate Fidelity Rate	59% (Campbell Is.)	70%[3]	47%[8]
Date Male First Arrives At Rookery	Early Nov.	Oct. 21–24[2]	Early Nov.[9]
Date First Egg Laid	Late Nov.	Nov. 11–16[2]	Late Nov.[9]
Chick Fledging Date	Mar.	Feb. 24–Mar. 10[2]	Late Feb.[9]
Premolting Trip Length (Days)	23–30	28–38[2]	
Date Adult Molting Begins	Apr. 10	Late Mar.[2]	Mid-Apr.[9]
Length Molting on Land (Days)	24–26	24–27[2]	
Juvenile Survival Rate First 2 Years		39%[3]	39%[7]
Breeding Adults Annual Survival		72–84%[3]	84%[7]
Average Swimming Speed	4.7 mph/7.6 kmph	4.6 mph/7.4 kmph[4]	3–6 mph/4.8–9.7 kmph[7]
Maximum Swimming Speed		5.0 mph/8.0 kmph[4]	6.0 mph/9.7 kmph[7]
Deepest Dive on Record		551.2 ft/168.0 m[5]	370.7 ft/113.0 m[10]
Farthest Dist. Swam From Colony	Over 1000 mi/1609.3 km		1250.0 mi/2011.7 km[7]
Most Common Prey	Krill	Krill[6]	Squid[7]
Second Most Common Prey	Fish	Fish[6]	Krill[7]

Source 1: Williams 1995—Heard Island, Australia. Source 2: Warham 1963—Macquarie Island, Australia. Source 3: Guinard et al. 1998—Amsterdam Island. Source 4: Pütz et al. 2006—Marion Island, Prince Edward Islands. Source 5: Tremblay and Cherel 2000—Amsterdam Island (Northern Rockhopper). Source 6: Birdlife International 2008—Kerguelen Island. Source 7: Birdlife International 2008—Amsterdam Island. Source 8: Hull et al. 2004—Macquarie Island, Australia. Source 9: Birdlife International 2008—Marion Island, Prince Edward Islands. Source 10: Schiavini and Rey 2004—Tierra del Fuego, Patagonia (Southern Rockhopper).

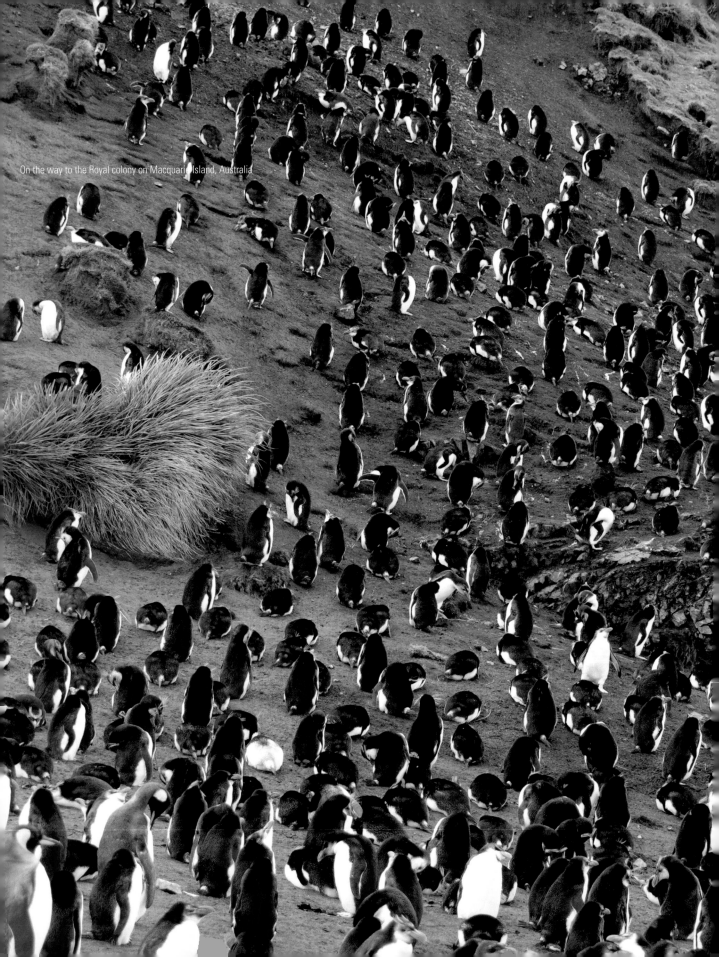

On the way to the Royal colony on Macquarie Island, Australia

Royal Penguin
Eudyptes schlegeli

Genus: *Eudyptes*

Other Genus Members: Macaroni, Rockhopper, Erect-crested, Fiordland, and Snares penguins; some researchers believe the Royal penguin is a subspecies of the Macaroni penguin.

Subspecies: None

IUCN Status: Vulnerable

Latest Population Estimates
Individuals: 2.1 million
Breeding Pairs: 850,000
Estimates are from the 1980s, but it appears that no major changes have occurred since then

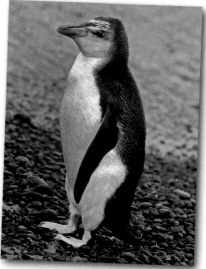
Immature Royal penguin

Life Expectancy
Average: 12 years, but many live longer

Migratory: Yes, they are absent from the colony from April to September.

Locations of Colonies
Endemic to Macquarie Island (54°30' S, 158°57' E), Sub Antarctic, Tasmania, Australia

Colors
Adult: Black, gray, white, orange/red, yellow, and pink
Bill: Orange to red with gray edges
Feet: Pink with dark soles
Iris: Red to bright brown
Chick Down: Brown to dark gray
Immature: Dark gray back with a few very short yellow feathers and gray throat

Height: 25–27 in/64–69 cm

Length: 27–29 in/69–74 cm

Normal Clutch: 2 eggs per nest

Maximum Chicks Raised per Pair per Year: 1

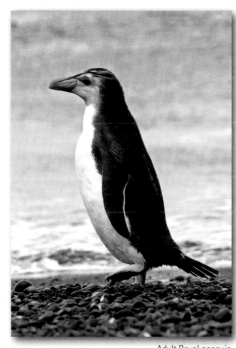
Adult Royal penguin

David's Observations

Getting to Macquarie Island is no easy task. A lucky few win access as approved researchers or employees of the Australian government. The only other way to visit is to take one of the few cruise voyages allowed there each summer. Sailing takes three to four days from the southern tip of New Zealand, or Hobart in Tasmania, mostly over very rough seas. The cruise normally incorporates several other sub-Antarctic islands and costs eight to fifteen thousand dollars. I was able to make it there with Heritage Expeditions on a small cruise ship called the Spirit of Enderby. Chief Nathan Russ and his crew were the most dedicated expedition professionals I have met thus far, and all the effort and funds were well worth it.

As we landed on Sandy Beach, the Royal penguins greeted us in large numbers. The penguins of the crowded, bustling community were at each other's throats. They were all very energetic and moved about quickly, eager to fight each other, the younger adults in particular. They like to use their enormous beaks often, and I noticed bill duels erupting on every corner and even in the water—something I had never witnessed before. I continued toward the colony and discovered that although they are unyielding with penguin strangers, they are loving and caring toward their mates. Pairs will take hours just to touch each other with the same bill they just used for fighting. Reflecting on my experiences with the Royals as I rested inside the Australian Research Center, where we were treated to hot tea and a delicious cake, I just wondered how many similarities exist between those emotional Royals and us.

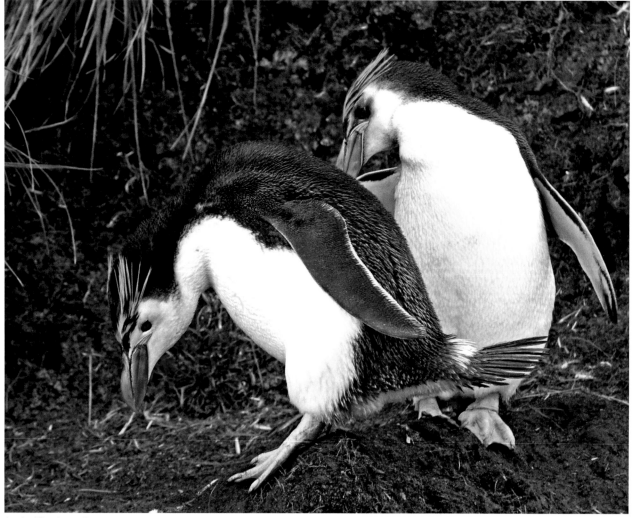

A pair of Royal penguins

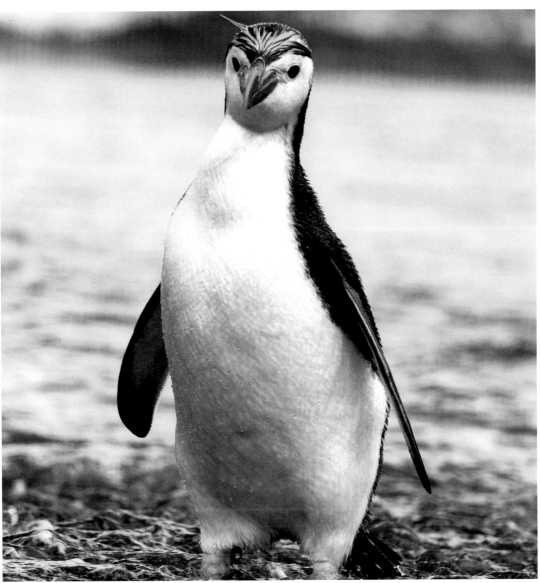

Rising out of the water, Savoy Beach, Macquarie Islands

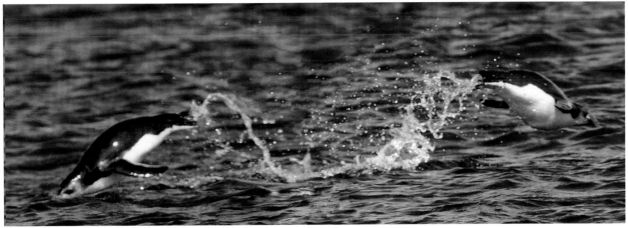

Royals porpoising through the sea

About the Royal Penguin

Population Trend

Unknown, but appears to be holding steady. The Royal penguin breeding population is unchanged at around 850,000 breeding pairs. The information is slightly dated since the last detailed census was 25 years ago, but researchers still accept the same number as the current estimate.

Habitat

Royal penguins only breed at Macquarie Island, which is part of Australia and lies about 550 miles (885 km) south of New Zealand in the sub-Antarctic Pacific Ocean. Besides the few Australian park personnel and very few researchers, the small island is home to three other penguin species: King, Gentoo, and Rockhopper. In winter, the Royal penguins leave the island and swim hundreds of miles away into the Polar Current.

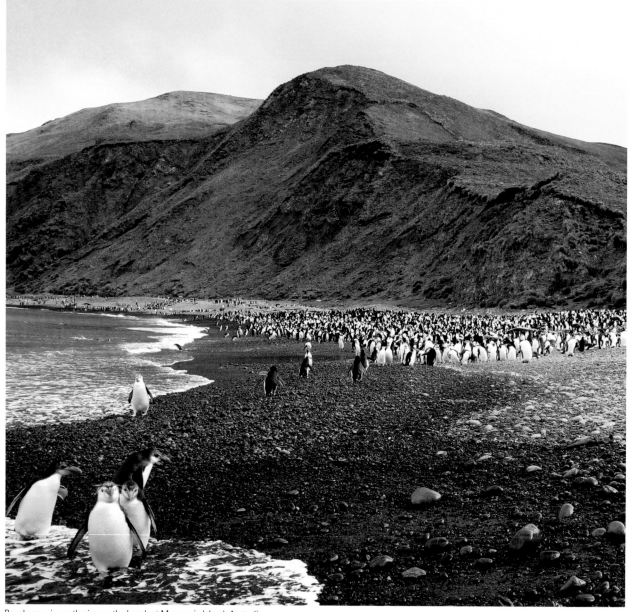

Royal penguins gathering on the beach at Macquarie Island, Australia

Appearance

Royal penguins are similar in appearance to Macaroni penguins, the only difference being the color of their throats. Royals have a white throat and the Macaroni's is black. The Royal adult has a black back that extends to the upper head and continues in a triangle shape up to the bill. Their white underbody, including the throat and the face, reaches over the eyes, where it meets the black triangle on top of the head. A bright yellow crest is intertwined with black plumes starting near the bill and projecting several inches backward, ending at the back of the head. Their flippers are black with white trim on the outside edges, and a dirty white color on the underside. The bill is orange to red in color with slightly dark gray patch at the base. From the bill to the eye, a very distinct pink triangle of bare, featherless skin can be found on each side of the face.

Immature Royal penguins look noticeably different from an adult, with the area around the face a duller black to light gray, and their throat is a dirty gray color instead of white. They are also slimmer than breeding adults, and instead of a crest, only a few very short yellow feathers appear above the bill.

Chicks

Royal chicks sport a brown to dark gray down. After three to four weeks in the nest under their parents' close guard, they move into the crèche. Since adolescent Royal penguins are very aggressive and tend to fight with anyone they meet, it is assumed that the crèche's two main purposes are to protect the chicks from these moody yearlings and provide better defense against the skua and giant petrel. As their down wears off and the chicks grow in size, the crèches disband. Many chicks perform a funny dance, moving their flippers erratically and causing a colony-wide commotion. At about sixty-five days of age the chicks fledge. About 40 percent will not survive their first year at sea, and only 20 to 30 percent will reach the breeding age (Williams 1995). The vast majority of the survivors will return after one year to molt near their parents' nest and, on average, begin breeding five years later.

Breeding and Chick Rearing

Royal penguins are highly synchronous breeders within their colonies. However, they cannot be considered efficient, because they only rear one chick out of the two eggs they lay, and their success rate is lower than that of most other penguin species (Williams 1995). Older breeding males will return to last year's nest in late September to early October, and the females follow about seven days later. After considerable fighting, the noise subsides and the colony settles into a serene state of love and affection between the pairs.

Two eggs are laid in late October, with the first and smaller egg appearing around October 20. The second egg, which is 55

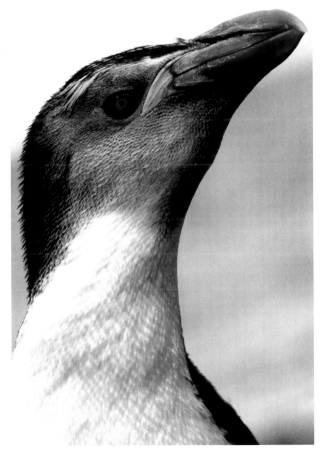

A close-up of an immature Royal penguin

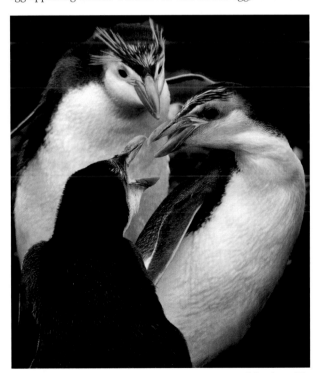

A Royal squabble

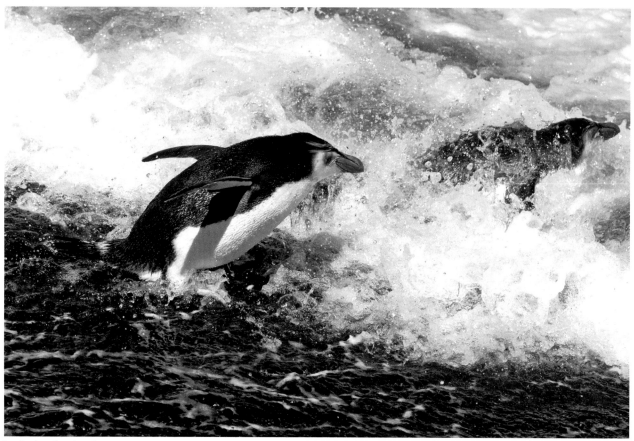

Leaving for a foraging trip

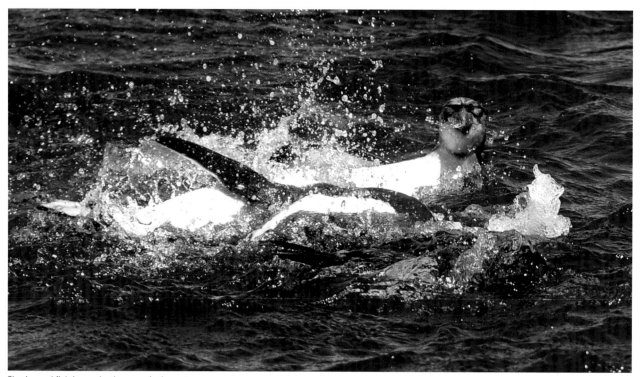

Chasing and fighting each other, even in the water

percent heavier, arrives four to six days later. Typically, unless the second egg is not laid, the majority of first eggs do not hatch. The female in most cases ejects the first egg from the nest or leaves it vulnerable for the skua to prey on. Breeding adults fast for extended periods during bond-forming days and incubations, males longer than females. When the second egg is laid the female incubates it first, so the male, who by this point has fasted for about thirty-five days, can leave on a foraging trip that lasts about two weeks. The male takes over incubating upon his return so the female can take her fourteen-day foraging trip. Normally, both parents are present when the chick hatches.

The male, alone, guards the chick for the first three weeks. The female returns every two to three days to feed her chick but not her mate, who fasts during this period. If two chicks hatch, only one (the larger) will be fed; the second will be left to die. At about twenty days old, the chick joins the crèche. The mother is responsible for feeding the chick every two to three days; the male might help later, until it fledges at about sixty-five days old. The fledging success rate of a Royal chick is normally about 0.3 to 0.5 chicks per nest. Failed breeders will not attempt to breed again during the year that the nest failed.

Foraging

Royal penguins are very skilled divers, and they do not spare any effort. During the breeding season, some Royals venture into the Polar Frontal Zone. In this zone there is very deep water, but their preferred prey stays high in the water column. The Polar Current is colder than the surrounding ocean and usually flows south of Macquarie, but at times this will change and the penguins will follow it along (Shirihai 2002). Other breeders just stay in the vicinity of Macquarie, where competition for prey is more intense. Because they forage for fourteen to twenty days during the incubation period, some Royal penguins are able to travel as far as four hundred miles (645 km) away from Macquarie and still arrive back in time to relieve their mates (Hull 1997). The majority of their foraging activity occurs between 7 a.m. and 6 p.m. During this time they dive at a steady pace, spending approximately 40 percent of the time underwater. From time to time they do stop and rest. The average swimming speed, including periods of porpoising, is 4.2 miles per hour (6.8 kmph), but females swim about one mile per hour (1.6 kmph) faster than males during the incubation period. Maximum swimming speed recorded is clocked at 6.2 miles per hour (9.97 kmph) (Hull 1997).

As soon as the molting period is complete, the migratory Royal penguins leave Macquarie Island on a wide-ranging winter foraging trip. The exact direction and location of their winter whereabouts is unknown; however, sightings have been reported from Tasmania all the way to the edge of Antarctica.

The diet of the Royal penguin, as studied at Sandy Bay, is composed of more than 50 percent krill and also consists of

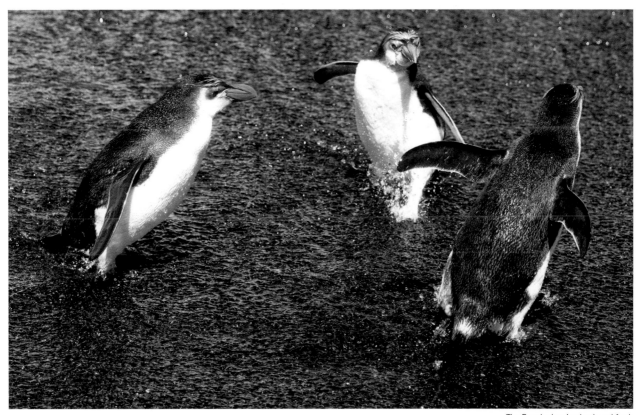

The Royals dancing back and forth

small lantern fish, genus *Myctophidae*, and squid (Shirihai 2002; Marchant and Higgins 1990). Penguins are large consumers of prey, and one research paper calculated that the breeding population of Macquarie Island, 1.7 million adults, consumes 28.5 million pounds (13,000 metric tons) of food during its extended premolt trip (Hull et al. 2001). If the nonbreeders are added to the equation, the Royal penguins consume in excess of 200 million pounds (90,000 metric tons) of prey a year.

Molting

Immediately after their chicks fledge at the end of January, the Royal penguins depart on their premolt foraging trip, which lasts about five weeks. During this trip they gain about 83 grams per day, or 6.6 pounds (3 kg) total. Landing on the beach of Macquarie Island, a healthy male's premolt weight should be approaching fifteen pounds (6.8 kg), while females should weigh close to fourteen pounds (6.4 kg). Upon arrival, the birds stand near their nests, often next to their mate, for up to four weeks, waiting for their old plumage to wear off and their new one to take hold. During this twenty-four- to twenty-nine-day period, the average fasting penguin will lose all of, if not more than, the weight it gained during the premolt foraging trip. By late March, the ordeal is over, and they once again return to where they feel best, the Southern Ocean.

Nesting

All Royal penguins breed on the small Macquarie Island. Subcolonies vary in size, with the largest containing boisterous hundreds of thousands of pairs, while the smallest houses only sixty pairs. Numerous and dense, nests are located once every thirteen square feet (1.2 m²). Colonies start on flat areas in close proximity to the beach, stretching outward to the nearby slopes. Males bring stones and other materials like dry grass and bone to prepare the nest. Females arrange new nests or rearrange their previous nesting site using the materials collected by the male and ready it for the egg. Collecting stones is a male hobby that is not always related to the necessity of building a nest. Many males will continue collecting stones even after the chick is hatched and sometimes until molting begins. In sandy areas parents just lie on the sand, rotating tirelessly to create a hole in the ground to which they might add a few stones and some dry grass later. Others simply lay the eggs atop the sand or mud. Those lazy couples usually end up losing their eggs and rarely succeed in raising a chick to fledging.

Relationships and Vocalization

Royal adolescents are numerous, as they begin breeding relatively late in life, and tend to be very aggressive. The adolescents are ever the center of countless fights with adults as well as younger juveniles, creating the impression that the Royal penguin's fighting never ceases. While their aggression is typically the first trait to be noticed, Royals are surprisingly affectionate as well. Pair bonding rituals are many, and the majority of couples that survive winter at sea reunite.

The first sign of bonding is the quivering of the male body as he noisily swings his head up and down to draw the attention

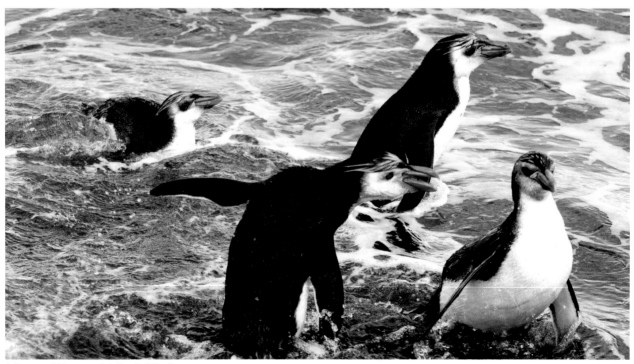

A disrespectful immature is being disciplined

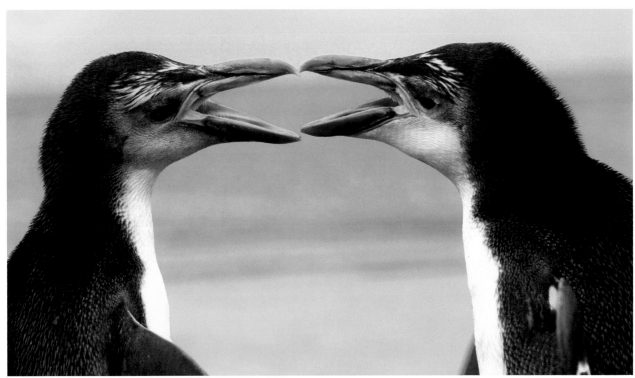

The beginning of a bill duel

of his female counterpart. This proud display is accompanied by vocalization of a loud crying or yelling sound. The female answers in a similar display. Soon thereafter the male brings the female more new stones for the nest in appreciation of her display of affection. Gentle bowing follows, as well as a softer, crying noise. The couple then touches and preens one another, which can last for hours. Sometimes the male and female just stand close together, as if they simply enjoy each other's company, but this nirvana can be disrupted at any moment if the male must fight a younger intruder. The female is just as aggressive towards the adolescents when defending the nest area.

After ample bonding, the male will try to gently push the female into an optimal mating position, using his bill first and then his flippers by moving them rapidly. If the female accepts his advances, she will lie on her belly and the male will mount her. Copulation often occurs continuously almost until the eggs are laid. Some single, non-breeding males force themselves upon younger females, or one-year-olds, as late as the onset of molting.

Occasionally, Royal penguins shake their heads as their bill is turned up, or while stretching their neck. During a nest relief, the returning bird bows gently as its shoulders push forward and its flippers point down, almost perpendicular to the ground. Again, a gentle crying sound may accompany this emotional and touching gesture. After long trips, when vocal recognition is required, the returning bird trumpets with a loud, braying noise while its flippers turn upward. The bird at the nest answers in a similar posture but with its flippers pointing downward. A

passing adolescent might cut in, and then all three can be seen with their beaks open as the reunion quickly turns into a fight with the annoying bystander. Away from their families, Royal penguins are very nervous and prone to fighting, so the first weeks after they return from the long winter trip, the colony is filled with squabbles and some more serious fights. As the eggs are laid, the fighting subsides.

As soon as the last year's immature Royal penguins return to the beaches for their molt, the bill duels and short fights return. They carry on from the beach into the water. These duels are always accompanied by loud yelling, making the colony a busy and noisy place.

When a bird returns to the nest after a long absence, perhaps ready to molt, sometimes it must pass by many nesting neighbors on its way. To avoid aggression from the other Royals, it adopts a pacifistic posture in which the shoulders and head are in a semi-bow position and the flippers are thrust forward. If denied free passage, the returning bird might stop and begin to swing its head up while making noise, but normally no fight will follow and the returning Royal will reassume its pacifistic posture and continue to walk to its nest.

Royal penguins spend considerable time preening, typically in the company of other Royals (usually their mates) and close to the water. Often they will jump into the water just for a dip or turn 360 degrees laying flat on the water, where they might find a reason to pick yet another fight with any disrespectful juvenile nearby.

Dangers

Fur seals kill Royal penguins at sea, as do killer whales and sharks. Skuas and giant petrels consume eggs and chicks on shore. The proximity of local seal herms to their breeding grounds causes hauling elephant seals to destroy nests and crush eggs, as well. Introduced animals such as rabbits and mice once caused indirect damage to the vegetation and the environment that directly affect the Royal penguins. The biggest and least understood threat is the water temperature. The Royal penguin's diet depends on the Polar Current, and as a result of climate change the water gets hotter. If the water heats up, even by a degree or two, less fish will venture into the area near Macquarie, further decreasing their food supply. As the fish swim farther south, the Royals swim farther away from their nests. Chicks begin to die of hunger because the parents can't return to the nest in time.

Conservation Efforts

Royals are Australian citizens, and conservation efforts on Macquarie Island are managed by the Tasmanian State Government. Needless to say, the end to the oiling industry saved the Royal penguins from extinction. At present, the Tasmanian and Australian governments are trying to reverse the environmental devastation left behind by the oilers, who introduced many feral animals to the island. In the last few years a massive program costing several millions of dollars has been carried out to eradicate all feral animals, such as rats, mice, and rabbits, from the island. The eradication became very expensive because of the need to avoid harming the four penguin species and countless birds that reside on the island, while still poisoning and trapping all the unwanted animal pests. Limiting tourism and prohibiting fishing around the island can minimize threats to this species.

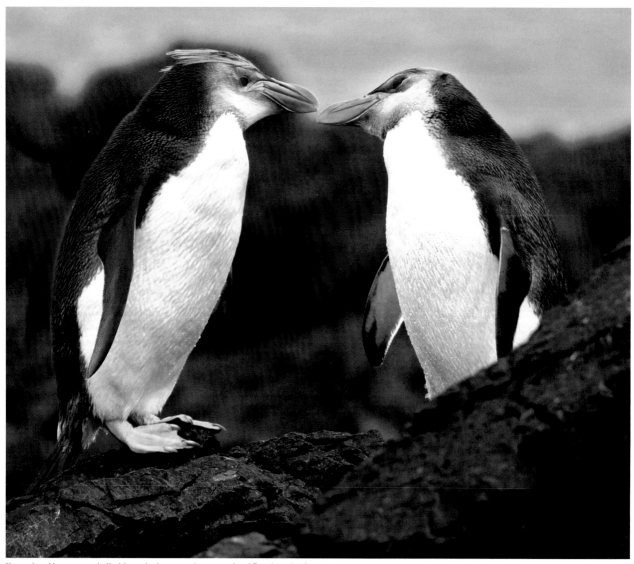

"I wondered how many similarities exist between those emotional Royals and us"

Charts

Weights	Source 1	Source 2	Source 3
Breeding Male Arrival	11.0 lb/5.0 kg	9.5–15.4 lb/4.3–7.0 kg	13.9 lb/6.3 kg
Breeding Female Arrival	10.8 lb/4.9 kg	9.25–13.9 lb/4.2–6.3 kg	13.9 lb/6.3 kg
Incubation Male			9.9 lb/4.5 kg
Incubation Female			8.8 lb/4.0 kg
Premolt Male	15.0 lb/6.8 kg	12.6–17.9 lb/5.7–8.1 kg	14.6 lb/6.6 kg
Premolt Female	15.7 lb/7.1 kg	11.5–17.9 lb/5.2–8.1 kg	14.6 lb/6.6 kg
Postmolt Male	8.8 lb/4.0 kg		8.8 lb/4.0 kg
Postmolt Female	8.4 lb/3.8 kg		8.8 lb/4.0 kg
Fledging Chicks	11.0 lb/5.0 kg		
Egg 1	0.25 lb/113.4 g	0.22 lb/99.8 g	0.21 lb/95.3 g
Egg 2	0.33 lb/149.7 g	0.35 lb/158.8 g	0.34 lb/154.2 g
Lengths	Source 1	Source 2	Source 3
Flipper Length Male		7.4 in/18.9 cm	
Flipper Length Female		7.3 in/18.6 cm	
Bill Length Male	2.7 in/6.9 cm	2.6 in/6.6 cm	2.6 in/6.6 cm
Bill Length Female	2.4 in/6.1 cm	2.4 in/6.1 cm	2.3 in/5.8 cm
Bill Depth Male	1.2 in/3.0 cm	1.1 in/2.8 cm	1.3 in/3.3 cm
Bill Depth Female	1.06 in/2.7 cm	1.02 in/2.6 cm	1.14 in/2.9 cm
Foot Length Male		3.1 in/7.8 cm	
Foot Length Female		3.0 in/7.6 cm	

Source 1: Hull and Wilson 1996, Hull et al. 2001—Sandy Bay, Macquarie Island, Australia. Source 2: Williams 1995—Various Colonies, Macquarie Island, Australia. Source 3: Warham 1971—Bauer Bay, Macquarie Island, Australia.

Biology	Source 1	Source 2	Source 3
Age Begin Breeding (Years)		7–8	
Incubation Period (Days)	33–36	35	
Brooding (Guard) Period (Days)	21	22	
Time Chick Stays in Crèche (Days)	40 (Or less)	40–45	
Fledging Success (Chicks per Nest)	0.38	0.49	
Mate Fidelity Rate		High	
Date Male First Arrives At Rookery	Sept. 25–Oct. 2	Late Sept.	Sept.–Oct.
Date First Egg Laid	Mid-Oct. (16th)	Peak Oct. 20–23	Mid-Oct.
Chick Fledging Date	Late Jan.	Mid-Feb.	Late Jan.
Premolting Trip Length (Days)	30 or More	30–35	36
Date Adult Molting Begins	Early Mar. (10th)	Mar.	Late Feb. (23rd)
Length Molting on Land (Days)	24–29	24–29	28
Juvenile Survival Rate First 2 Years		43%	
Breeding Adults Annual Survival		86%	
Average Swimming Speed			3–4.5 mph/4.8–7.2 kmph
Maximum Swimming Speed			6.2 mph/9.9 kmph
Deepest Dive on Record			741.5 ft/226 m
Farthest Dist. Swam From Colony			372.8 mi/600 km
Most Common Prey		Crustaceans	Small Fish
Second Most Common Prey		Small Fish	Crustaceans

Source 1: Warham 1971—Bauer Bay, Macquarie Island, Australia. Source 2: Williams 1995—Various Colonies, Macquarie Island, Australia. Source 3: Hull 1999, Hull 2000, Hull and Wilson 1996, Hull et al. 2001—Sandy Bay, Macquarie Island, Australia.

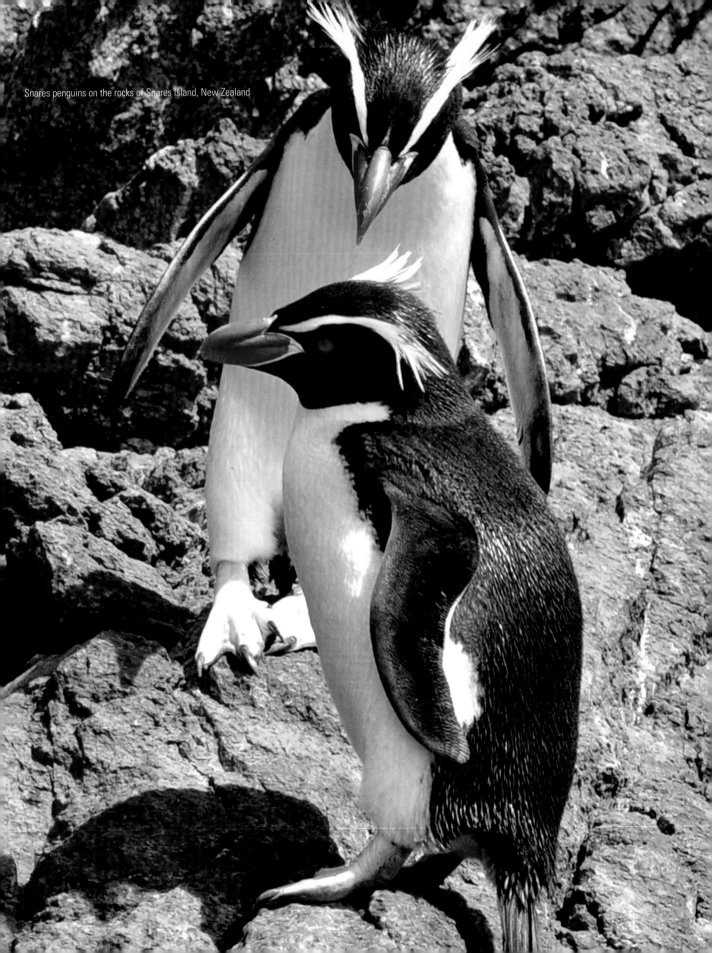

Snares penguins on the rocks of Snares Island, New Zealand

Snares Penguin
Eudyptes robustus

Genus: *Eudyptes*

Other Genus Members: Macaroni, Royal, Erect-crested, Rockhopper, and Fiordland

Subspecies: None

IUCN Status: Vulnerable

Latest Population Estimates
Individuals: 85,000
Breeding Pairs: 31,300

Life Expectancy
Average: 11 years, longest recorded 21 years

Migratory: Yes, they are absent from the colony from April to August

Location of Colonies: Endemic to Snares Island, New Zealand, 48° 01' S, 166° 362' E

Colors
Adult: Black, white, yellow, orange, and pink
Bill: Bright orange and black
Feet: Pink and black above, black below with black toes
Iris: Red, but immature can have brown
Chick Down: Brown
Immature: Black, white, gray, pink, pale orange, and yellow

Height: 20–22 in/51–56 cm

Length: 21–24 in/53–61 cm

Normal Clutch: 2 eggs per nest

Maximum Chicks Raised per Pair per Year: 1

Immature Snares penguin

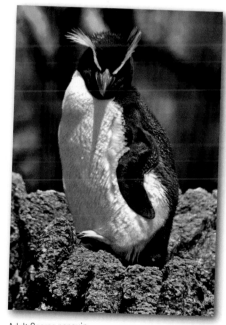
Adult Snares penguin

David's Observations

*T*he New Zealand government's prohibition of tourist landing on the Snares Islands, along with extremely dangerous, persistent winds in the area, makes the islands a tricky destination to visit. I chose to visit the Snares and other sub-Antarctic islands on a Christmas cruise with Heritage Expeditions. This expedition took place several weeks after my big disappointment on an Antarctic cruise in which the boat was stuck in ice for days, preventing me from photographing Adélie and Chinstrap penguins. Knowing the complexity of the weather surrounding the Snares, I just hoped that this expedition could deliver its promised photo opportunities.

I was elated when the beautiful Snares Islands appeared on the horizon. Everything looked great as I was lowered into the water by crane in the first Zodiac. However, I never made it to the island—because a quick change in the wind ruined our adventure. Within minutes we encountered huge waves, and we fought our way back to the ship. I had yet another loss on my hands. Nathan Russ, our young expedition leader, called the attempt off, and within the hour we were headed to the next island on the itinerary. I was sure I had entirely missed my opportunity to photograph the Snares, but Nathan didn't give up so easily. He advanced the rest of the cruise calendar in order to allow for a larger window of opportunity to view the Snares on the way back. On our last day at sea, beautiful, calm weather welcomed us as we approached Snares Island for a second time, thanks to Nathan. Everyone was able to board the Zodiacs and spend time just feet away from the beautiful Snares penguins on Snares Island.

The penguins greeted us with their usual busy acts: happily posing, jumping into the water, preening, or just looking at us. Adam, the Zodiac driver, did all he could to navigate as close as possible to allow me the best photo opportunities. Every aspect of my surroundings, including the bright sun and calm water, made the day a great success. The Snares penguins were very peaceful and loving to each other as I looked on. They were active and healthy, climbing the rocky hill to deliver food to their hungry chicks. It was clear that Snares Island was difficult to navigate for us but is a great habitat for a small contingent of penguins.

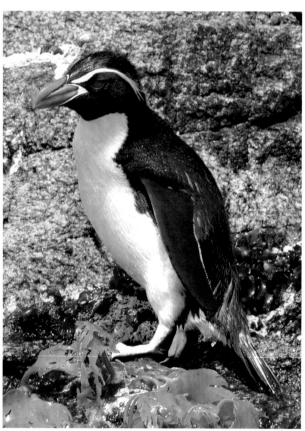
A skinny and wet penguin who just returned from sea

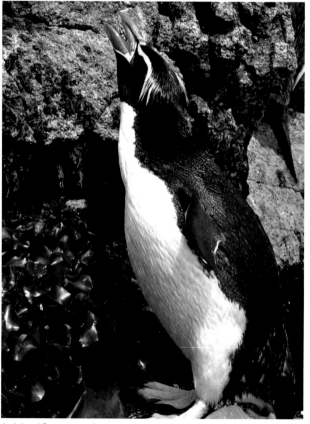
An injured Snares penguin

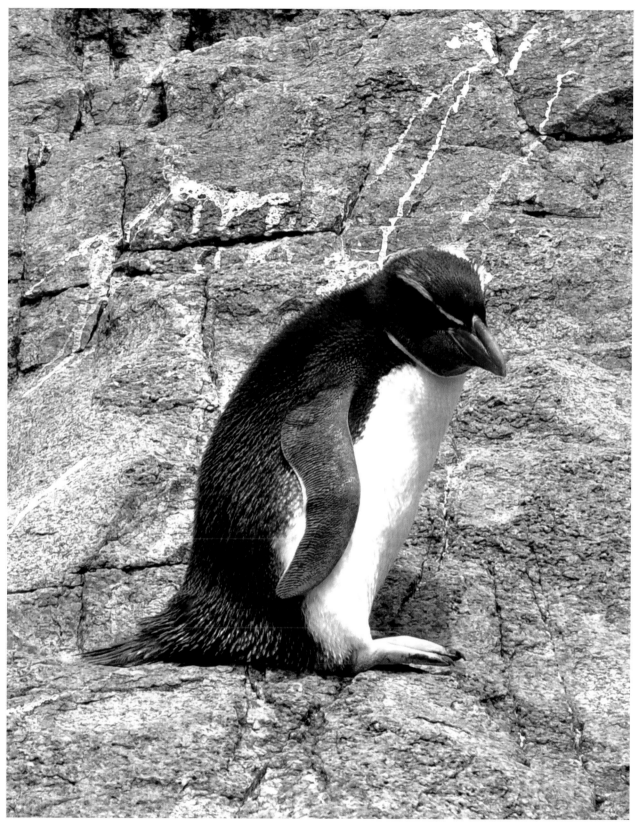

An immature rests on a cliff

About the Snares Penguin

Population Trend

Stable. The most recent census carried out by the New Zealand Department of Conservation found some 25,900 breeding pairs on the main Northeast Island and 5,100 pairs on Broughton Island. That, combined with an estimated 280 pairs on the Western Chain, totals a population of 31,300 breeding pairs. Counts over the past decade have revealed both similar and lower numbers, indicating some annual variation in both recruitment and the number of adult birds attempting to breed.

Habitat

Snares penguins are endemic to Snares Island, which is about 130 miles (209.2 km) south of the southern tip of New Zealand. The total area of the Snares Islands is about 1.3 square miles (3.5 km²). There are two main subcolonies: the largest is on North East Island, and the other is on Broughton Island about a mile (1.6 km) away. A third, smaller colony is on the Western Chain, a group of rocks 3.1 miles (5 km) to the west–southwest. The Snares penguins' terrestrial range is the smallest

of any penguin species. Because of their pest-free status and ecological vulnerability, the New Zealand government does not allow tourist landings on the island.

Appearance

Adult Snares look very similar to Fiordland penguins and can be difficult to distinguish, particularly among juveniles and adults at sea. The back and head are a shiny black color, extending to the front of the upper throat, which turns white at just above the neck. The underbody is white, and the transition between black and white is a clean, pronounced line. The black extends in a semicircle to the white around the base of the flippers. The crest is long and mostly bright yellow beginning at the base of the bill and stretching over the eye toward the back of the head, and the upper scalp sports black, less bushy plumes. The crest stands up when dry and sweeps to one side of the face when wet.

There are featherless, pink bands of bare skin surrounding the bill, and they appear as a pink triangle from a frontal view. Adults sitting on eggs develop brood patches, a featherless skin

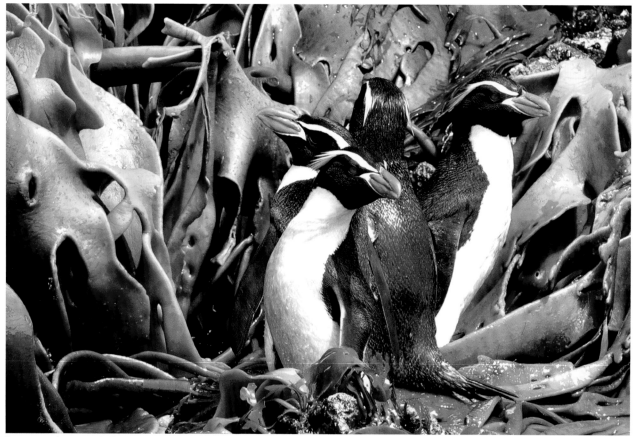

Snares penguins surrounded by kelp

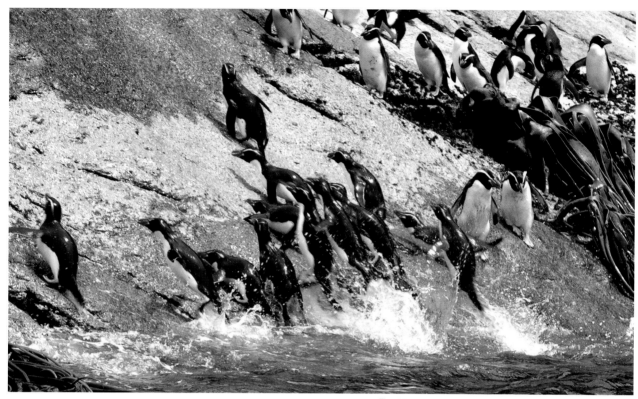

The difficult task of landing on the kelp-covered island after foraging

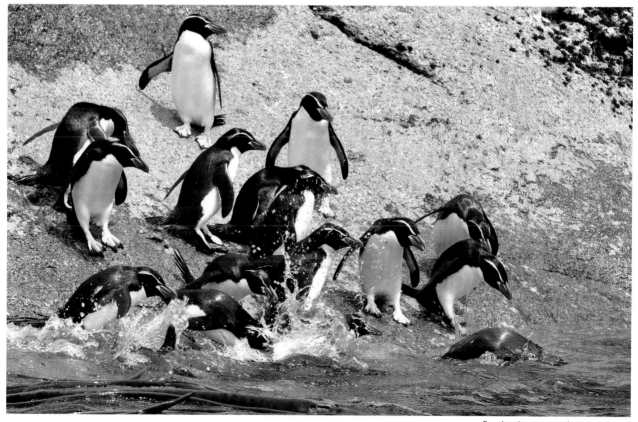

Entering the water on the way to forage

area about midbody, which creates better thermal contact with the egg.

The flippers are black on the outside and have a fine, dull-white edge. The underside is white with some pink and two black patches on each end. The intensity and size of the black patches varies from bird to bird. The bill is a bright orange to red color and is very robust—hence the species name *robustus*. The feet have pink webbing with some black patches, black toes, and a black sole. The irises are red.

Immature Snares penguins are smaller than adults, have almost no crest, and have a gray neck. Their bill is a much duller black to dark brown color, with only small areas of bright brown to orange, and their iris color is brown rather than red.

Chicks

The Snares chick's down on its head, neck, and upper body is chocolate brown. The lower throat, most of the neck, and the underbody are white. The lone chick stays under a parent's guard for three weeks and later moves to a crèche.

In early January the chicks begin shedding their down. They fledge at about seventy to seventy-five days of age and typically weigh about five and a half pounds (2.5 kg) at that time. For a few days prior to fledging, the older chicks wander on the landing sites near the water. During this period they watch the adults depart and return from sea, sometimes entering the water themselves for a minute or two. They continue to gather confidence until one day they swim away, initially within a group.

The few that survive the first year at sea return within ten to eleven months to molt at the Snares Islands. Mortality rates in the first year of life are in excess of 50 percent, but little is known about their whereabouts during that first year. At about six years of age they return to breed at their natal colony.

Breeding and Chick Rearing

Males arrive during the first week of September, about one week before the females. Males exhibit a high nest fidelity rate. Mate fidelity is not well studied, but often a male answers the courting call of a younger female. These early bonds, more often than not, are broken by his angry mate from the year before. After reaffirming or establishing new pair bonds, the female renovates the nest. The first egg, which is slightly blue in color, is laid by the end of September. The second, 30-percent-larger egg appears three to seven days later, and surprisingly it hatches before the first.

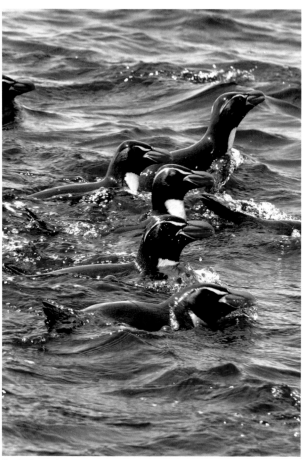

Coming home from a trip to sea

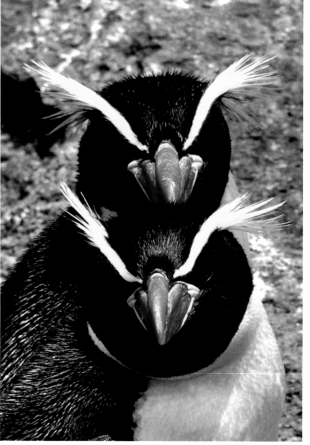

A pair of Snares penguins bond

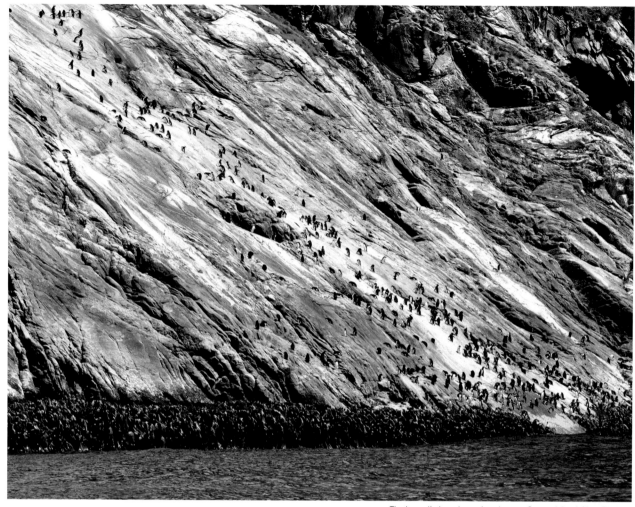

The long climb to the main colony on Snares Island, New Zealand

The first ten days of incubation are shared between both parents. Both remain at the colony fasting with constant nest changes. The male embarks on his first long foraging trip after an average of thirty-seven days of fasting. The female incubates the eggs alone for about twelve days, and then the male returns. He replaces the female, ending her thirty-nine-day fast. The male then incubates the egg until it hatches. Only about half the nests hatch two eggs, but the female, which feeds the chicks during the guard phase, shows preference to the larger chick that hatched from the second egg. Within a week, the smaller chick usually dies of starvation or is snatched by a predator. While the female shuttles daily to collect food for the chick, the male remains at the nest and guards the chick until it joins the crèche. When the chick joins a crèche, both parents spend time at sea. Warham noticed that the female feeds the chick the vast majority of the time, as the male recovers from his second thirty-five-day fast.

The female returns from sea in the afternoon and rushes to the nest, where she sounds a loud call. If her mate is present he greets her with his own call and a bow. A chick, or more often several chicks, depart from the nearby crèche to answer the call. One chick begins a series of bows and answers the adult with a beeping call. Many times the first chick is a stranger, begging an unrelated adult for a meal. The feeding adult is capable of recognizing its own chick and punishes the strange juvenile with the slap of a flipper or even a sharp peck. When the right chick is finally identified, it stands close to its mother, raises its bill, and opens its bill into its mother's bigger bill. She transfers a small ball of prey at a time, resting a minute or two between feedings. After about ten minutes, the happy chick returns to its friends at the crèche. Parents only feed their own chicks, and Warham found that even when her chick perishes, a mother will not feed a strange chick even when she definitely has a meal to give. Fledging success is estimated at 0.5 chicks per nest during a normal year (Warham 1974).

Foraging

Snares penguins forage in small groups of up to twenty birds; typically their dive depth averages eighty-five feet (25.9 m) and they forage not too far from the Snares Islands. However, during the incubation period trips are longer and the birds venture farther away from the colony. When measured, the maximum dive depth of the Snares penguin was 393 feet (119.8 m) (Mattern et al. 2009). They eat a mixture of fish, krill, and squid.

Molting

The premolting trip can last up to seventy days to allow enough time to recover from the loss of energy and mass during the breeding period and long fasts. Molting on land begins in late March to early April and lasts twenty-four to thirty days. The molting period suppresses 50 percent of the extra, heavy premolt weight. Non-breeding Snares penguins molt a few weeks earlier, and some are regularly sighted molting on Macquarie, Campbell, and Stewart Islands, among others in the sub-Antarctic.

Nesting

The Snares penguin builds a small, shallow nest of dried branches, twigs, bones, stone chips, and mud. They press the ground with their belly, rotating and using their feet, to establish or deepen the nest. Some Snares build nests utilizing holes in rock or under a broken branch with twigs and small stones placed as a rim.

They prefer nests to be shaded and choose to settle in the hilly, tree-covered parts of the Snares Island, but in other instances they use flat areas closer to the ocean. Colonies range in size between 10 and 1,200 and nests are set apart about fifteen inches (38.1 cm) (Williams 1995). Snares sometimes move their entire subcolony every few years, often after flooding or drying out of the bushes that supply cover.

Relationships and Vocalization

Snares penguins are less aggressive with each other compared to other crested penguins, and the majority of their fights take place early in the breeding cycle. Like other crested penguins, Snares will display vertical head quivering accompanied with a throbbing voice during bonding. Later the same movement is used with a different voice pattern to greet a mate prior to nest relief. After a longer separation, this call is very intense.

The couple's relationship is very emotional and involves bowing when both mates are present, as well as calling with a softer, lower voice. They may stay next to each other for hours crossing necks in a "penguin hug," preening, or bowing. The pair normally reunites after the long premolt trip to stand together by the nest during the molting period, and researchers noticed occasional copulation long after the chicks had fledged.

Most fights center around the nest and the materials required to build it. These occur between males, often when the old nest

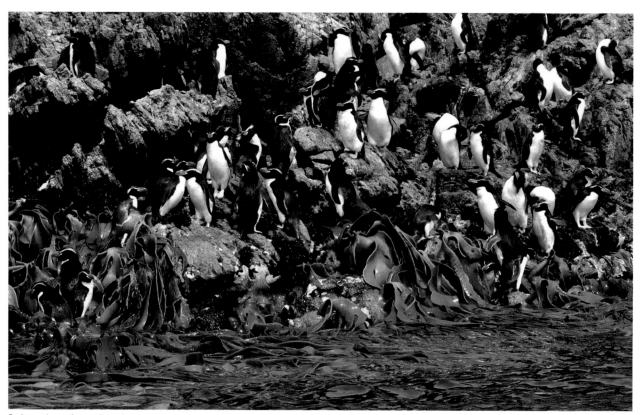

Drying and preening on the rocks

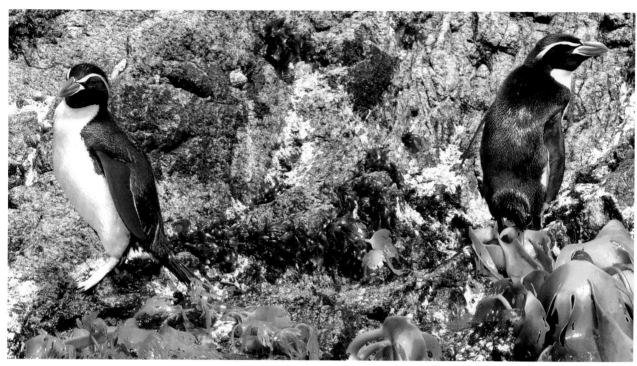

Standing in the vegetation on Snares Island, New Zealand

owner faces a younger penguin that is trying to claim the nest as its own or cause damage to it.

Females also fight, sometimes to assist their mate, but most female fights occur during the bonding period and center around a desired male being courted by two females. The male typically accepts the winner of the fight as his mate, which more often than not is his mate from the previous year.

Some of the worst offenders are failed breeders, who inexplicably hang about in the colony and behave in a very aggressive manner toward incubating females, sometimes causing them to abandon their nest.

Bill duels are common and many involve immature Snares returning to the colony. A short yell or two usually precedes the duel, and a hiss or a groan might sound the end of the fight. At times, a new duel may erupt seconds after the prior ended, as if no resolution was reached. Pecking can occur and might cause injury.

Breeding Snares that aren't seeking confrontation lower their shoulders with semi-open flippers, signaling appeasement or requesting safe passage when nearing another nest.

Dangers

Fur seals and New Zealand sea lions are both present on the Snares Islands but pose a low risk to Snares penguins. Leopard seals are more of a threat but fortunately are only occasional visitors to the islands. Gulls and skua attack eggs and chicks, but these attacks are less frequent than in other species of penguin, perhaps because of the large numbers of other available seabird

prey on the islands. Stale eggs and dead chicks can be found all around the colony during breeding season, and since hovering skua and gulls expend little effort to obtain prey they tend to leave the live chicks alone. However, during the fledging period giant petrels often attack the young as they head to sea.

Warham suspected that many of the dead chicks hatched from the second or larger egg died from exposure during the raw and lengthy storms that persist at the Snares Islands. Like other crested penguins, the biggest danger to Snares is the unpredictable flow of the cold-water currents near the Snares Islands and the occasional lack of prey close to the colony.

Conservation Efforts

The New Zealand government is unyielding in its prohibition of landing on the Snares Islands, as well as on several other islands where penguins breed. This helps the penguins by eliminating the threat of the introduction of foreign animals and weeds via public landings. While research projects are approved from time to time, not many are conducted on the Snares Penguins. Without accurate research data, any future conservation efforts are questionable at best.

Interesting Research

Understanding penguins' preferred prey is crucial to effectively mount conservation efforts. Many studies are done on different species' diets, the majority of which are based on capturing, flashing, and analyzing a penguin's stomach contents as it returns from the ocean.

Snares penguins are rarely researched; Mattern, Houston, and Lalas are among the very few researchers to study the species' diet in depth. The most interesting points in their study are not the results discussed regarding foraging and food, but rather the questions they raise. Penguin must digest food at a rapid pace, so the food clears the stomach quickly. It is possible that prey found in the penguin's stomach upon landing may not accurately represent the penguin's prey preference, especially from the early stages of its trip.

Mattern's doubts about stomach content began when almost all of the males he captured returning from a twelve- to fourteen-day foraging trip had almost empty stomachs—the contents included only squid beaks, fish otoliths, and some well-digested krill. Given that the birds had increased their body weight considerably during their absence, the researchers concluded that the males digested their entire catch prior to landing. The elements remaining were indigestible and would take longer to clear the stomach. Those elements indicated that the male's meal consisted mostly of fish, less squid, and little krill. However, when the female's stomach contents were studied, they consisted mostly of undigested krill, raising more questions.

How was it possible for females to have an entirely different diet than males? It can be assumed that the reason the female's stomach was full was that it carried the chick's provisions. Considering the empty stomachs of the males in conjunction with the possibility that females carry the chicks' provisions, this immediately drew into question the reliability of prior stomach content studies. There is no doubt that those contents recorded in other studies were in the penguin's stomachs, but who the food was intended for is an entirely different question. The fact that many studies concluded that krill is a major source of prey for adult penguins only serves to further increase doubt, because krill contains less energy than fish and squid.

It is possible that certain penguin species prefer to feed their chicks with a type of krill that Mattern noticed is high in growth hormones. It is also possible that many results of studies done on diet did not adequately factor in the chick's meal and assumed that the adults feed on the same prey instead of gathering it to feed their chick. More accurate data will be obtained if and when video cameras are attached to penguins to show what penguins really prey on and when. Stool analysis on penguins is gaining popularity, as well.

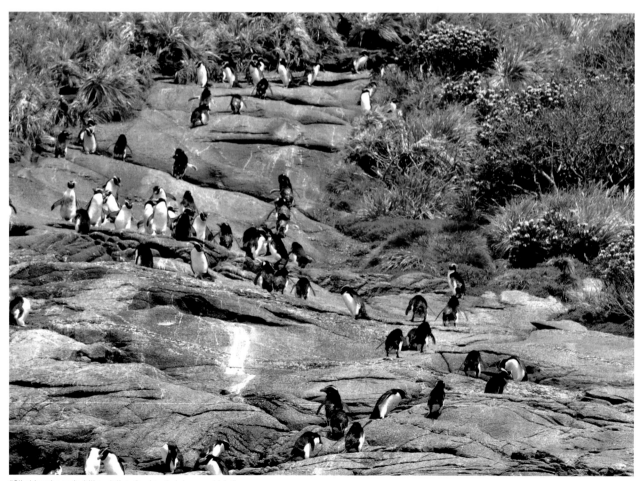

"Climbing the rocky hill to deliver food to their hungry chicks"

Charts

Weights	Source 1	Source 2, 3	Source 4
Breeding Male Arrival			7.3 lb/3.3 kg
Breeding Female Arrival			6.1 lb/2.8 kg
End Breeding Period Male	7.5 lb/3.4 kg		
End Breeding Period Female	6.0 lb/2.7 kg		
End Male Guard (Nov.) Male	5.7 lb/2.6 kg		
End Male Guard (Nov.) Female	5.5 lb/2.5 kg		
Premolt Male	9.5 lb/4.3 kg	9.3 lb/4.2 kg[2]	
Premolt Female	8.6 lb/3.9 kg	9.3 lb/4.2 kg[2]	
Postmolt Male		4.6 lb/2.1 kg[2]	
Postmolt Female		4.6 lb/2.1 kg[2]	
Fledging Chicks	6.4 lb/2.9 kg		4.0–6.6 lb/1.8–3.0 kg
Egg 1	0.22 lb/99.8 g	0.21 lb/95.3 g[3]	0.22 lb/99.8 g
Egg 2	0.28 lb/127.0 g	0.28 lb/127.0 g[3]	0.27 lb/124.7 g

Lengths	Source 1	Source 4	Source 5
Flipper Length Male	7.2 in/18.3 cm	7.2 in/18.3 cm	7.4 in/18.8 cm
Flipper Length Female	6.9 in/17.5 cm	7.0 in/17.8 cm	7.0–7.1 in/17.8–18.0 cm
Bill Length Male	2.3 in/5.9 cm	2.3 in/5.8 cm	2.2–2.3 in/5.6–5.8 cm
Bill Length Female	2.1 in/5.2 cm	2.1 in/5.3 cm	2.0–2.1 in/5.1–5.3 cm
Bill Depth Male			1.2–1.3 in/3.0–3.3 cm
Bill Depth Female			1.1–1.2 in/2.8–3.0 cm
Foot Length Male	3.7 in/9.4 cm	4.6 in/11.6 cm	
Foot Length Female	3.6 in/9.2 cm	4.3 in/10.9 cm	

Source 1: Warham 1974—Northeast Island, Snares Islands, New Zealand. Source 2: Croxall 1982—Snares Islands, New Zealand. Source 3: Massaro and Davis 2004, Massaro and Davis 2005—Snares Islands, New Zealand. Source 4: Stonehouse 1971—Snares Islands, New Zealand. Source 5: Miskelly 1997—Western Chain, Snares Islands, New Zealand.

Biology	Source 1, 2, 3	Source 4	Source 5
Age Begin Breeding (Years)	6[1]		
Incubation Period (Days)	33[2]	35	
Brooding (Guard) Period (Days)	15–21[2]		
Time Chick Stays in Crèche (Days)	50[2]		
Fledging Success (Chicks per Nest)	0.5–0.8[2]		
Mate Fidelity Rate	High[2]		
Date Male First Arrives At Rookery	Early Sept.[2]	Late Aug.	Sept.
Date First Egg Laid	Sept. 28–Oct. 2[2]	Late Sept.–Oct.	Oct.–Nov.
Chick Fledging Date	Jan.–Early Feb.[2]	Late Jan.	Late Feb.–Mar.
Premolting Trip Length (Days)	At Least 60[2]		
Date Adult Molting Begins	Mar. 25[2]	Late Feb.–Mar.	May–Jun.
Length Molting on Land (Days)	24–30[2]	21	
Juvenile Survival Rate First 2 Years	20–40%[2]		
Breeding Adults Annual Survival	85%[3]		
Deepest Dive on Record	393.7 ft/120 m[2]		
Farthest Dist. Swam From Colony	1491.29 mi/2400 km[2]		
Most Common Prey	Crustaceans[2]		
Second Most Common Prey	Cephalopods[2]		

Source 1: Warham 1974—Northeast Island, Snares Islands, New Zealand. Source 2: Houston 2007—Snares Islands, New Zealand. Source 3: Williams 1995—Snares Islands, New Zealand. Source 4: Stonehouse 1971—Snares Islands, New Zealand. Source 5: Houston, personal communication—Western Chain, New Zealand.

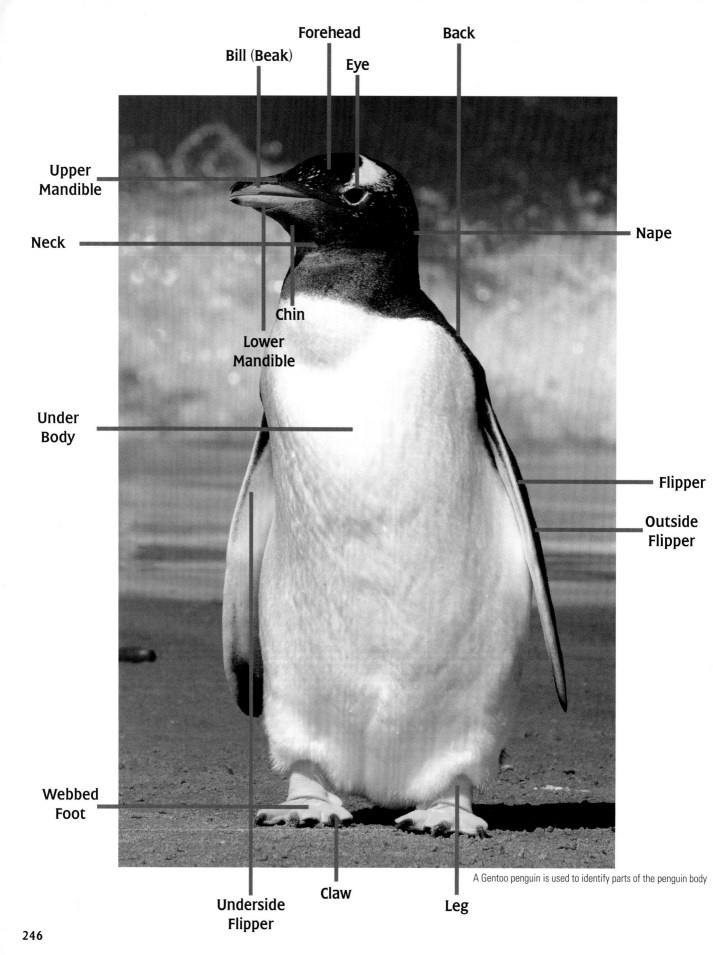

Forehead

Bill (Beak)

Eye

Back

Upper
Mandible

Neck

Nape

Chin

Lower
Mandible

Under
Body

Flipper

Outside
Flipper

Webbed
Foot

Underside
Flipper

Claw

Leg

A Gentoo penguin is used to identify parts of the penguin body

The Penguin Body
The Amazing Machine

Throughout their 70 million years of evolution, penguins have adapted to extreme conditions on land and in water. Their body and physiology have enabled them to outlive many events that other organisms could not possibly survive. The Emperor penguin, for example, is able to dive over 1,800 feet (548.6 m) deep, staying submerged for up to twenty-one minutes, and still it returns to the ocean surface before running out of oxygen, suffering from blood bubbles, or getting nitrogen poisoning. Still more impressive, on land this same penguin can find last year's nesting site, walk over forty miles (65 km) on ice, and stand on the ice fasting for 110 days. It can survive temperatures reaching -70° F (-56.7° C) during 110 mph (177 kmph) winds and somehow it still manages to reproduce, walk those forty miles (65 km) of ice back into the frigid waters, and find food. The penguin truly is an amazing miracle of nature!

This Chinstrap penguin is advertising in hopes of finding a mate

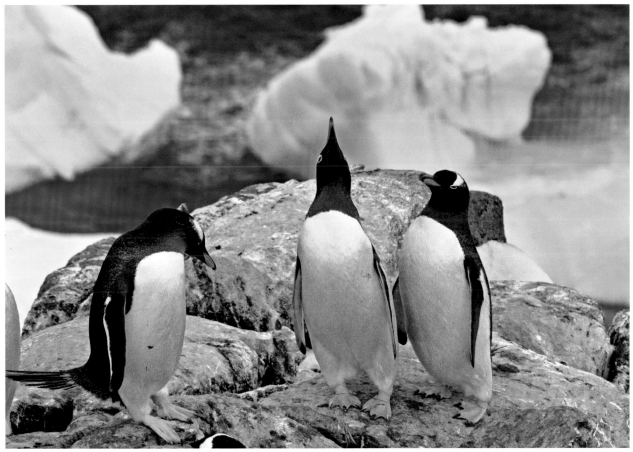

Gentoo penguins resting on the rocks by the sea

Physical Characteristics of the Family Spheniscidae

Length

The largest penguin, an Emperor male, is up to fifty-one inches (130 cm) long. This is three times the size of the shortest penguin, the Little penguin, which measures sixteen inches (41 cm) long. Like other birds and unlike humans, a penguin's body does not rise straight from its legs. Its lower section and tail curve backward behind its legs; therefore, its legs are not at the end of its body, and its height and length differ. In order to accurately measure a penguin's length, it must be laid down on a table.

Weight

Different species also tip the scale at different weights. Naturally, the tallest penguin, the Emperor, is also the heaviest. It would take nearly thirty fat Little penguins to balance a scale against just one Emperor penguin. Measuring a penguin's weight is no easy task because its weight fluctuates so frequently and drastically. Its weight on a given day depends on the breeding and molting cycles. In fact, it is not uncommon for an individual penguin to lose 25 to 30 percent of its weight after a month of fasting during a breeding cycle. It may then gain some or all of the weight back, only to lose it again during the next fast. Variation in weight from one month to the next is the essence of the penguin predicament.

All species also experience a spiral weight loss of 40 to 55 percent during the annual molt, when they lose their protective feathers and are unable to enter the water and hunt for food until the new ones grow in. Since their diet consists entirely of sea creatures and none of their prey can be found outside the water, penguins' breeding and molting biology requires that they spend extended periods of time on land and separates them from their food source, leaving them with no alternative to fasting.

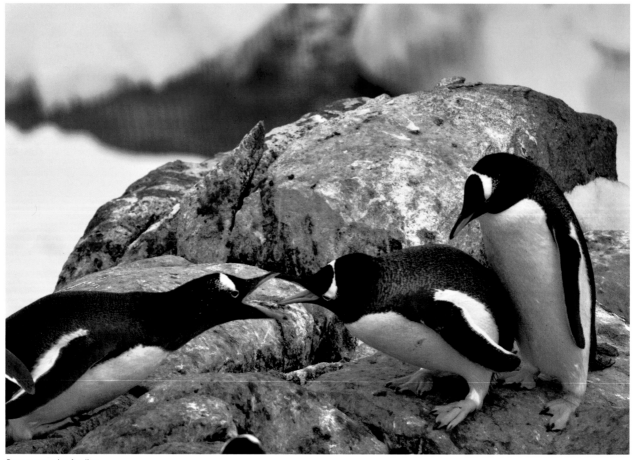

Gentoo penguins feuding

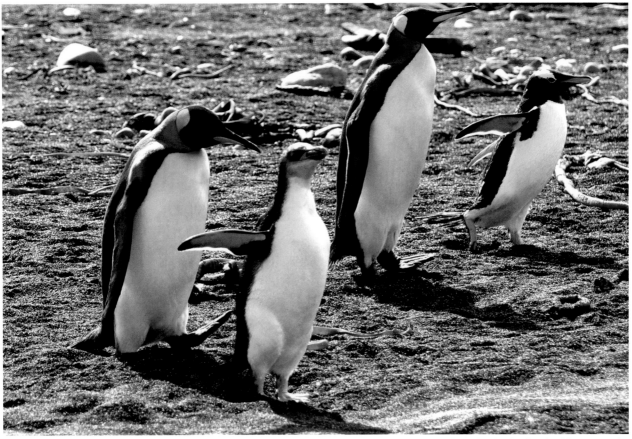

A rare meeting of three penguin species: the King, Royal and Gentoo penguins

Common Appearance

Species differ in size, length, weight, shape, color, and plumage pattern. However, within many species each individual bird's plumage is almost identical. This makes them indistinguishable from each other, even under meticulous visual inspection. Researchers believe that even the penguin cannot visibly recognize its own family members, though the penguins themselves do have other cues to identify their mates and their chicks. Gender identification can also be tricky; though there are size differences between individuals within a species and females are generally smaller than males, measurements of males and females regularly overlap, as there are smaller males and larger females. Sex organs are internal, further complicating the distinction between a male and a female. Yearlings and juveniles wear somewhat different plumage and can be distinguished from breeding adults, but not from each other.

All species share a basic "penguin" visual theme. They all have feathers, a well-built bill, and flippers. All penguins sport a black or very dark back and mostly white underbody. Striking color variations exist between the different species, but colors other than shades of black and white are restricted to small areas of the body like the throat, chin, head, bill, and feet.

The black back and white underbody comes in handy underwater. Looking up from deep in their diving territory the sky looks white, so the penguin's white underbody blends the penguin in with its surroundings and hides it from the view of potential predators swimming beneath. The bottom of the ocean, observed from above, looks darker the deeper you get. At certain depths it becomes black, again hiding the penguin from the searching enemies swimming above him.

On a crowded beach occupied by beautiful standing birds, penguins can be instantly recognized because of one particular body part: flippers. No other bird has flippers—therefore if it has flippers, it is certainly a penguin.

Flippers

Penguins do not have, nor do they need, wings. Instead, they have flippers. The primary function of flippers is locomotion during swimming and diving. Forward movement is achieved mostly by the use of the flippers in coordination with other body muscles. Flippers also make the famous jumps in and out of the water's surface, a movement called porpoising, possible. The superstructure of the flipper and its overall strength make the penguin the supreme diver that it is. Other sea birds that dive use their legs for propulsion, not their wings.

Many penguin species nest near other species of birds

Flippers are also used on shore, not just to slap an opponent or draw the attention of a mate, but also to enhance walking or sliding on ice, as well as assisting in building a nest. Like humans, as well as other birds, penguins raise their limbs while communicating vocally to reinforce or complement their vocal message. Just like we use our hands, penguins gesture with their flippers to express body language.

Bones

The penguin skeleton has not changed much over 40 million years, and it is completely different from that of any other bird. It is most recognizable by the bones of the flippers. To fly, a body needs extremely light bones and a wingspan large enough to produce lift. To reduce weight and enable flight, birds possess hollow bones. However, to support the penguin's vigorous diving, the bones of the flippers are very dense, heavy, and unusually short. These bones are solid and fused together, unlike the hollow bones of flying birds. The rest of the penguin's bones are similar, designed to support diving. With such heavy bones, a penguin could never lift off the ground, even if it did have wings!

A penguin's skeleton also differs from that of other birds in one more unique aspect. To add rigidity to the chest cavity, all penguins have an unusual bone around the curve of most ribs. This special bone looks like a bone spur and is up to a couple of inches long. It sits upright and almost touches the next rib. The duty of these bones is to prevent the collapse and flattening of the rib cage while the penguin is submerged under a high pressure of water, and they function much like the crossbeams of a large structural building.

Legs

The leg bones of the penguin, located far back structurally, are very short and include an upper and lower bone, as well as a knee. These short legs are not conducive to running on solid or icy ground; many species just slide on their belly ("tobogganing"), which conserves energy while propelling them quickly. The short, specially located legs carry the penguin in an unstable fashion when it walks, but underwater the back sweeping legs act as a rudder, easily and gracefully steering the penguin where it chooses. Unlike most other diving birds, penguins do not use their legs to create propulsion, but use them only to steer.

The upper part of each leg, unlike that of other birds, is horizontal and includes a knee. The knee and upper parts are hidden inside the penguin's abdomen and cannot be seen from

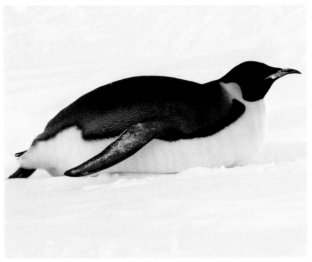

An Emperor tobagganing along the snow

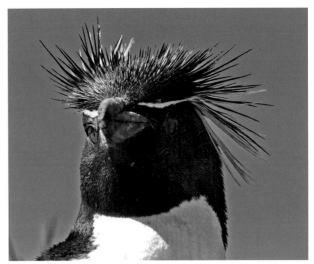

Rockhoppers have a prominent crest

the outside. This helps to reduce drag under water, and it also shifts the penguin's center of gravity forward, enabling it to walk rather than fall face down. The unique placement of the leg, only partially visible, represents the best possible compromise between diving and walking functionalities. The feet are webbed to ease friction underwater. The palmate feet have three forward-pointing toes and one smaller pointing sideways with sizable, sharp claws to help grip when walking.

Lungs, Breathing, and Gas Exchange System

All penguins are great divers. Oxygen management is critical in the extreme conditions in which penguins live, and their bodies are optimally designed for this task. The penguin's body readies itself for efficient oxygen use just like an experienced general readies his armies for battle. A penguin's respiration system includes a trachea, bronchii, and two lungs. Penguins are able to stock their bodies with large quantity of oxygen, and their lungs store much more air than those of humans or non-diving birds. Their blood vessels are proportionally larger, as is their blood volume. Their blood contains larger quantities of hemoglobin, the substance that attaches to oxygen and carries it in circulating blood from the lungs to the muscles. Their bodies also contain a substance called myoglobin, which stores even more oxygen inside the muscle cells—in fact, almost 50 percent of the oxygen present in the penguin's body resides in the muscles.

Penguins begin a dive stocked with a huge oxygen supply stored in different parts of their body. As their lungs stop receiving fresh air, their conservation plan takes over. First, their heart rate slows. In one study of Emperors, it slowed from the average of 175 beats per minute (bpm) before the start of a dive to 57 bpm at the bottom of the dive, unlike most animals, whose heart rate goes up with increased activity (Meir et al. 2008). The oxygen that remains in the lungs is only utilized for essential organs like the brain and heart. Digestion and other nonessential functions cease,

and the outer limbs are shut off from the core body. The body manages each and every oxygen molecule available and directs them where they are most needed. Amazingly, even when all those various methods are exhausted and oxygen levels plummet, the penguin's body continues to operate normally. Such low levels of oxygen would cause tissue damage in any other animal.

Extended deep-diving can cause nitrogen bubbles to form in the blood, which is a fatal condition for humans, but it is clear that penguins do not suffer from nitrogen poisoning. When diving to such depths, the penguin body must also somehow eliminate large lactic acid accumulation, which is the residue muscles produce while burning oxygen. Accumulation of lactic acid restricts the muscle movement and causes pain, but penguins produce a special enzyme called lactate dehydrogenase that eliminates the effects of such buildups. Their lactic acid levels are later reduced when the penguin resumes normal breathing.

Blood Circulation

A penguin's body possesses the ability to alter blood circulation in a very uncommon way when body temperatures are about to fall below the allowable band. Penguins have an unusual, valvelike muscular activity that greatly restricts the blood supply to the flippers, feet, and parts of the face at extreme temperatures. This reduces the temperature of extreme parts of the flippers in adults—for example, Emperors reduce their extreme parts to a mere 48° F (9° C)—without causing any irreversible damage to outer limb tissues (Williams 1995). Cutting the outer limbs off from the main blood system of the body enables the penguin to maintain the core body temperature of 100.4°F (38°C) required for all vital organs to function properly.

In addition, penguins utilize "counter-current heat exchange," a process in which the veins of the outer limbs pass over and in close proximity to the larger arteries just as they are leaving the heart (Williams 1995). Because the veins are much

smaller, they get warmer while not overcooling the arteries. This counter-current heat exchange system is also apparent in the nasal passages to lessen the loss of body heat when the penguin breathes cold air. Some of these unusual blood circulation tools are also used to combat very high temperatures, like those experienced by Humboldt and Galapagos penguins in their respective habitats.

Gastrointestinal System

Food enters through the open beak, but since penguins have no teeth they must swallow their prey whole. Special spikes on the tongue and the bill structure are helpful in preventing the prey from slipping away. Mucus from special glands acts as a lubricant for the food as it travels down a long esophagus. Penguins do not have a crop (the body part that stores food prior to digestion in other birds), and the stomach is separated into two compartments: the proventriculus and the gizzard. The proventriculus is where acidic, gastric juices flow in and the food starts its chemical breakdown. During breeding, it is in the proventriculus that the penguin stores food to later feed its chicks (Alterskjær et al. 2002). Before arriving on shore, and for some time after, the penguin is able to maintain a stomach pH of 6, which is less acidic than the pH of 5 that is maintained when normal digestion takes place (Thouzeau et al. 2004). Maintaining a higher pH keeps the chick food in its original state until it is delivered to the chick upon a parent's regurgitation.

The gizzard is where the food is ground and crushed. The gizzard has a thick muscular wall, and the internal part has a hard, grainy surface that feels like sandpaper. Penguin gizzards contain undigested parts of prey, also called grit, like bills, other hard parts, stones, and sand. A study done by Beaune et al. (2009) suggested that stones and sand are even found in chicks, and that the young either swallow the stones or receive them from their parents because they aid the gizzard in the crushing of food. As the crushed food continues to be pushed downward, it comes in contact with the bile produced by the penguin's liver and which passes through the gall bladder, and the sodium-bicarbonate secretions of the pancreas. Most of the digestion occurs in the relatively short small intestine where, with the aid of these special enzymes, most nutrients are absorbed. The remains are moved to the cloaca, and the greenish waste, in an almost liquid state, is expelled by a considerable push of muscle. Except for stones and larger hard pieces of prey that stay in the stomach for a long time, a penguin's digestive process is very quick and efficient. Most of the food exits the body within six to twenty-four hours, and this fast process enables penguins to digest 30 to 50 percent of their body weight in one good day at sea.

Kidney

Penguins have two kidneys that cleanse the body of the nitrogenous waste, as well as of other radical waste circulating in the blood. As with other birds, the urine exits with the food waste through the cloaca.

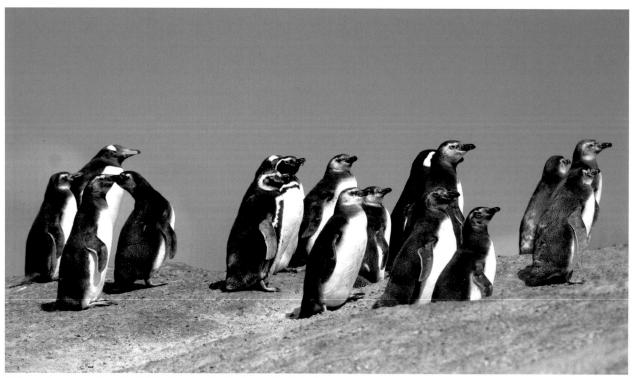

A Magellanic penguin crèche in the Falkland Islands, with a Gentoo sneaking in the background

A molting Rockhopper penguin

is what makes the penguin's outer skin look and feel like heavy-grain sand paper when stroked against the grain. Barbs are on both sides of the shafts and are responsible for keeping the skin watertight. Each feather is connected to a special muscle that moves the feather up or down to protect the penguin from cold and water.

Young chicks grow a thick, soft down cover that helps insulate their bodies through the first few weeks of their lives. This down sheds as the chick gets ready to forge into the sea after accumulating enough fat to insulate its body.

Insulation on Land

Penguins are warm-blooded animals, or homeotherms, so they must maintain a body temperature of about 100.4°F (38°C), almost the same as humans. Penguins are sometimes subjected to extreme temperatures and devastating winds that can make this temperature maintenance difficult. One defense mechanism penguins possess is a layer of body fat right under the skin. This particular feature differs from one species to the next, as smaller penguins possess less fat. Penguins also preen themselves, and the preening oil acts as an insulator, as well. However, most of their insulation while on land comes from their feathers. The invisible downy part is connected to special muscles which move in such a way that they trap a layer of air next to the skin. Air is a great insulator, and the air next to the skin protects the penguin from the cold air passing the exterior side of the feathers. Unfortunately, this mechanism does not function underwater, as the trapped air escapes under water pressure.

However, as in other instances when a penguin's physiology is pushed to the limit, their behavior aids their survival. For Emperor penguins, as well as King chicks, the last line of defense against the cold is huddling. They close on each other and stand so close that one penguin's body touches its neighbors' bodies, so they can use them as an insulator.

Penguins can also be exposed to heat, and for some species, like the Humboldt, critically hot temperatures can be quite high—up to 86°F (30°C). For most penguins, however, critical hot temperature is far lower, like 59°F (15°C) for Emperors (Luna-Jorquera 1996; Gilbert et al. 2006). To protect against high temperatures, penguins hide from direct sunlight in nesting burrows, opening their flippers if there is wind or taking a dip in the cool water. However, getting into the water is not possible during molting, and some species breed in areas where shade cannot be found. When other means fail, they use the exact same physiology that protects them against the cold to withstand the heat.

Temperature Regulation in Chicks

Unlike the amazing temperature regulation mechanisms the adult penguins possess, newly hatched chicks are not capable of maintaining a constant body temperature on their own. With no

Feathers

Birds have feathers attached to their skin, and these feathers are important in keeping their aerodynamic shape. Of course penguins do not fly, and from far away it is not clear that a penguin's body is covered with feathers at all, but despite appearances, it is covered head to toe in them. The density of a penguin's feathers is 193 to 250 per square inch (30 to 40 per cm²): almost three times the feather density of flying birds (Dawson et al. 1999). In fact, a penguin's feathers are unlike those of any other bird. Penguin feathers are not lined up in rows, but instead are packed in randomly while still covering the entire body, including the flippers.

Feathers consist of two distinct parts: a downy part and a stiff part. The downy part is closer to the body and remains partially under the skin except during molting, when newly grown feathers push the old ones out. For a while during this period penguins reveal their feathers entirely, causing them to look like any other bird. The stiff part of the feather is the visible portion, and this

A Rockhopper sheds its feathers during its molt

penguin's body to extreme limits. The biggest challenge during this period is the lack of food on shore in the face of large energy requirements. During molting, lack of energy can become acute because the penguin is growing so many new feathers. This requires large amounts of energy to build specific amino acids, which are the construction material of the feathers. As the old feathers are pushed out, the great insulating mechanism that penguins use to survive is interrupted and the watertightness of the penguin skin is compromised, making any dive impossible. All these factors force the poor penguin to remain on shore, standing on the beach looking haggard and feeling hungry.

To survive such adverse processes, the adult penguin must first be fit and extra fat to be ready for the start of the molting season. The premolt feeding period can be as short as two weeks for Adélie and Emperor penguins or up to ten weeks for the Snares. During this period a penguin must fatten up and gain 30 to 50 percent in weight. During the chick's feeding period the parent, in a lean food season, has the tragic choice of staying with its chick or leaving it to die to avoid the parent's own starvation. However, during the molt a penguin cannot go back into the water no matter how bad its physical condition or hunger gets.

The molting period is divided into three phases. The first occurs while the penguin is still at sea, when the growth of new feathers is initiated. The second phase continues on shore as the fasting period begins and new feathers push the old ones through the skin. At this point some feathers might start to fall, especially from the flippers. During the third phase, most old feathers fall off and the penguin spends time preening, waterproofing, and waiting to enter the water. This is the most critical stage because most fat reserves have been exhausted, and the penguin's body begins to chip away at proteins or body tissue to provide energy for survival.

other solution available, a parent must sit and cover the chick with its own warm body at all times, or the chick must hide inside the parent's pouch to survive the first week or two. Chicks could freeze or dehydrate to death if they remain exposed to outside temperatures for more than a few minutes.

Interestingly enough, chicks can survive large fluctuations in body temperature, but even those large swings have their limits. Within seven to ten days, the little chicks begin using intermediate tools to protect them while their adult physiology develops. A chick's down fully develops at an early age and adds insulation. However, the down only covers the chick's baby fat, which it rapidly accumulates and which acts as the main insulating arsenal chicks have. This fat is responsible for almost 50 percent of a chick's insulation. Irregular feeding can cause them to die from exposure and lack of insulation (when their young bodies do not have enough fat) before they die of starvation (Barré 1984).

Molting

All adult penguins molt at least once a year. The molting period on land lasts between two and five weeks, depending on species and climate. Molting takes place close to the breeding period, but there is a marked period that is used to regain body weight and fat between the two processes. A penguin's molting is somewhat like buying a new suit, but the process is rigorous and strains the

Metabolism

Penguins do not need to alter their metabolism to maintain their body temperature until outside temperatures move outside critical range, typically colder. On land, that critical temperature range can be around 32°F (0°C) for most penguins and down to -14° F (-25°C) for Emperors. If the outside temperature plummets below critical range, insulation and circulation alone are insufficient to maintain a core body temperature of 100.4°F (38°C). When this happens, the body goes into overdrive and increases its metabolic rate as its last line of defense. The metabolic rate goes up in stages. Shivering and internal burning of calories increase as the internal system works overtime to produce the heat necessary to ensure survival.

Like other land-based animals, penguins also combat hot temperatures with the same metabolic changes. The increase in metabolic rate is followed by respiration, which in turn increases the heat loss and cools the body down.

Metabolism and Body Mass Changes During Fasting

Penguins have no choice but to fast during some of their phases on land. For example, penguin chicks cannot catch prey on their own until they learn how to dive, so they must wait, fasting at times for weeks, for a parent to return from the sea with food. Adults must fast during the annual molt, yet for many species the longest fasting period is during their reproduction period, which includes courtship, incubation, and brooding.

Fasting periods vary widely among penguin species. Male Emperor penguins endure fasting for up to 115 days because they breed in rookeries that can be up to sixty miles (100 km) away from water. Adélie penguins fast up to thirty-seven days during reproduction, but Macaroni penguins, on the other hand, let the female fast up to forty-two days. African penguins try not to fast more than a few days during reproduction but still fast almost thirty days during molting.

Long fasts take their toll—male Emperors can lose 41 percent of their weight and females can lose up to 22 percent, as their fast is much shorter (Williams 1995). King penguins lose about 30 percent during their twenty-eight-day fast (Fahlman et al. 2004). Macaroni penguins may also lose almost 30 percent of their weight during their first breeding fast (Williams 1995). Even though most species fast longer during the breeding period, they lose much more weight when molting.

Adult penguins are not the only ones made to fast. King parents leave their chicks and force them to fast for up to one hundred days. These poor little chicks can lose 50 percent of their total body weight! One researcher showed that in captivity a baby King was left fasting for 166 days and was still alive but had lost 72 percent of its original body weight (Cherel et al. 1987).

In order to preserve energy during such long fasting periods, penguins undergo metabolic changes. As nonessential activities like digestion are shut down and physical activity is reduced, certain parts of the body are maintained at lower temperature (like the lower abdomen and limbs). However, as the fast continues and fat (insulation) is lost, penguins are required to once again increase their metabolism to maintain core body temperature (Fahlman et al. 2005).

Uropygial Gland and Preening

Penguins have a preen gland, called the uropygial gland, found near the base of their tail. The gland secretes preen oil, which consists of a diester wax, that penguins spread over their feathers

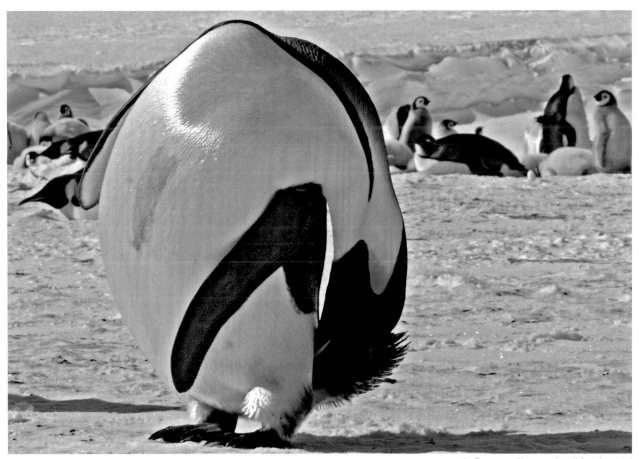

An Emperor pulling preening oil from its gland

when preening. The gland is shaped into two parts, and the oil from each part of the gland is secreted through the surface of the skin through something that looks like a nub.

The preen oil the penguins cover their feathers with has good insulating properties and seals their skin to keep the body watertight, helping to prevent heat from escaping. The insulating properties of preening oil are even more important underwater.

Preening starts with the penguin cleaning its body by removing sand or dirt. The bill is then used to reach the oil glands in the tail area and spread some of the oil over the feathers. This is accomplished by rubbing the bill against the gland and then up and down its body. Penguins spend hours each day spreading preening oil on themselves. During the mating and childrearing period, they also help preen their mate with loving movements. Penguins preen until they are covered from head to toe with this oil, which gives them a shiny, waxed appearance and prepares them to dip into the water.

Bill

All penguins have a hard, pointy bill. The bill is designed to catch small fish, squid, and krill. The bill hooks toward the end, and inside are small, spiky spines that point toward the throat, as well as a bristled tongue. These spikes and bristles make it very difficult for the small fish entering the mouth to escape. The bill also features special grooves that guide the excretions from the salt glands, which remove excess salt from the penguin's body, after they emerge from the nostril. The salt gland excretions exit out of the nostrils and down the grooves, giving the appearance of a runny nose. When penguins are far away from shore, sometimes for months at the time, the ability to extract salt from the only water source available is crucial to a penguin's survival.

The King penguin has the longest bill

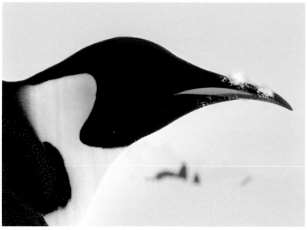

A close-up of an Emperor penguin

The size and thickness of the bill varies among species and depends on the main source of food. Those species that prefer krill tend to have a thicker bill, which helps the penguins crush the strong shell. Emperor and King penguins, which prey mostly on small fish, have a longer, thinner bill. The bill is also used for preening and to counter attacks by other animals, including fellow penguins, and is an important tool in nonverbal communication between penguins.

Desalination

In addition to the kidneys, penguins, like other marine birds, possess salt-secreting glands called supraorbital glands, which are located in the nasal passages near the bill. These glands function in a fashion similar to the kidney. When the blood's salt concentration increases, it activates the glands. They actively remove salt from the penguin's blood, restoring its salt concentration to a safe level and secreting the excess salt from the body. The concentration of the secreted fluid from the bill is far higher than the urine concentration of salt. The resulting excess salt is then passed through the nostrils and special grooves located in the bill and discharged. This is a necessary adaptation to life at sea, as the kidneys alone cannot cleanse the blood of high salt concentrations resulting from the salt water intake.

Eyes and Vision

Penguins must see well underwater and through air simultaneously. This presents a physical challenge because water and air have different properties. The red and yellow part of the light spectrum seems to disappear deep underwater, and instead, everything looks blue or green. To be able to maintain full color vision deep underwater, penguins have visual pigments in the retina that are concentrated at the magenta to blue area (Bowmaker and Martin 1985).

Water and air band light waves differently and cause the light to enter into the eyes in a different manner. For that reason, a

person diving becomes farsighted, while most aquatic animals are nearsighted when looking outside water. The penguin's body found a way to differentiate between both environments, and most researchers agree that it sees well in both mediums. Dr. Jackob Sivak has spent countless nights looking through Rockhoppers' eyes and taking pictures of their internal eye parts. He discovered that, in general terms, a penguin eye and a human eye are almost identical. A penguin has a cornea, an iris, and a lenslike mechanism to focus the light onto the retina, which is connected by an optic nerve to the brain. However, the penguin's cornea, which repairs the penguin's vision underwater, is very flat compared to a human's. The penguin's iris is controlled by a very powerful muscle that is able to drastically alter the shape of the lens attached to it. Depending on whether the penguin is in or out of the water, the iris compensates accordingly. The lens is comparatively larger than a human's and is also shaped differently. Interestingly, there was no evidence of eye problems in the group of penguins studied, apart from one incident of blindness due to injury (Howland and Sivak 1984).

Proficient sight in and out of the water allows a porpoising penguin to take advantage of a nearsighted seal outside the water, causing the seal to possibly miss or lose the penguin once he is in the air.

Ears and Hearing

Looking at a penguin, you may think it is missing ears. This is especially strange because penguins make lots of noise and seem to communicate and understand each other's sounds. The ear, of course, is not missing, just the earlobe. There are two small holes on the side of a penguin's head, and these holes contain the inner ear. A penguin does not have external ears as humans do, because this would cause unnecessary drag while diving. Penguins hear well through these two elusively small holes, which are covered with feathers.

The ability to hear is very important to penguins, and each penguin has a very distinctive voice. Partners recognize each other and their offspring through vocalization in colonies that can contain hundreds of thousands of identical-looking penguins. Though we are not sure what penguins say to each other, it is clear they have a lot to communicate.

Sex Organ

Males have a pair of testes that are located in the abdomen, and the female has ovaries. Both sexual organs are connected by a special duct to the cloaca, and sexual contact is achieved when both cloacae touch.

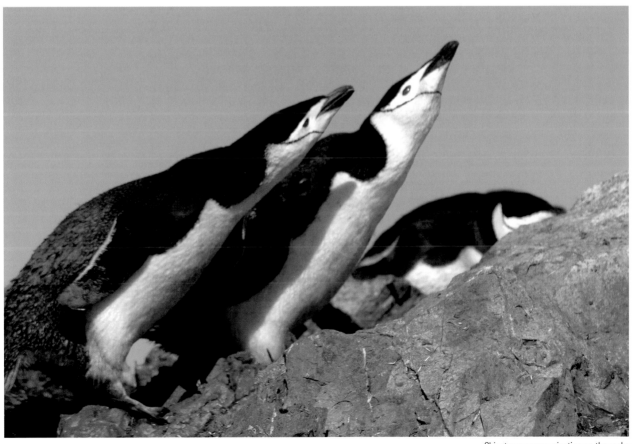

Chinstraps communicating on the rocks

Tail

All penguins have tails consisting of fewer than twenty harder, longer feathers that trail behind the feet. Most species have a short, stiff tail, but the brush-tailed penguins (Gentoo, Adélie, and Chinstrap) have a much larger and noticeable "birdy-looking" tail.

Disease and Causes of Death

The two main causes of death in penguins are predation and starvation. Starvation primarily affects chicks on their maiden foraging trip or adults during the molting period. Several species like the African, Humboldt, and Galapagos penguins can be exposed to starvation if water temperatures rise too drastically and their main prey moves away.

Predation at sea is most prevalent by seals, the leopard seal in particular, and much less by sea lions, killer whales, and other large sea animals. On land, adults fall prey to feral cats, dogs, and other animals introduced by man. Chicks are taken by skua, petrels, gulls, and other large birds.

Drowning is another cause of death, whether due to natural reasons like ice cover or manmade obstructions like fishing nets. Water pollution due to oil and other chemical spills is becoming a growing cause of death, as well; the increasing acidity of the oceans due to increases in carbon dioxide is also prevalent. Exposure and heat exhaustion can kill penguins during molting or when their fat reserves are low.

Penguins are usually healthy animals, but they can suffer from fungal diseases that affect their lungs, more commonly in zoos. They also suffer from tumors in the lungs, air sac area, and other parts of the body. Land-based parasites and flies infect them, particularly with malaria, whose vector is the mosquito (Hocken 2002).

A dead Magellanic chick, probably killed by a skua

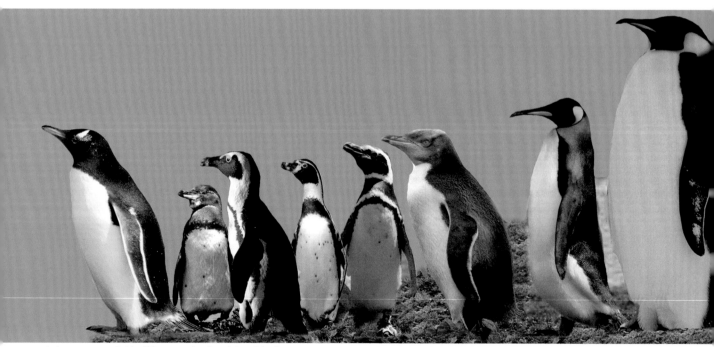

A photo montage of eight different species. From left to right: Gentoo, Galapagos, African, Humboldt, Magellanic, Yellow-eyed, King, and Emperor

Where to Find a Penguin in a Zoo

Captive Penguins in the United States				
Location	**City**	**State**	**Phone Number**	**Penguin Species**
Montgomery Zoo	Montgomery	AL	334- 241-4400	African
Little Rock Zoo	Little Rock	AR	501- 666-2406	African
Wildlife World Zoo and Aquarium	Litchfield Park	AZ	623-935-WILD	African
Monterey Bay Aquarium	Monterey	CA	831-648-4800	African, Magellanic
SeaWorld: San Diego	San Diego	CA	612-224-9800	Emperor, King, Adelie, Gentoo, Humboldt, Magellanic, Macaroni, Chinstrap
California Academy of Sciences: Steinhart Aquarium	San Francisco	CA	415-379-8000	African
San Francisco Zoo	San Francisco	CA	415- 753-7080	Magellanic
Santa Barbara Zoological Gardens	Santa Barbara	CA	805-962-5339	Humboldt
Six Flags Discovery Kingdom	Vallejo	CA	707- 644-4000	African
Cheyenne Mountain	Colorado Springs	CO	719-633-9925	African
Denver Zoo	Denver	CO	303-376-4800	Humboldt
Pueblo Zoo	Pueblo	CO	719-561-1452	African
Mystic Aquarium	Mystic	CT	860-572-5955	African
Jacksonville Zoo	Jacksonville	FL	904-757-4463	Magellanic
Jungle Island	Miami	FL	305-400-7000	African
SeaWorld: Orlando	Orlando	FL	407-351-3600	Magellanic, Macaroni, Rockhopper, Adelie, King, Gentoo
Tampa's Lowry Park Zoo	Tampa	FL	813-935-8552	African
Georgia Aquarium	Atlanta	GA	404-581-4000	African
Blank Park Zoo	Des Moines	IA	515-285-4722	Magellanic
Zoo Boise	Boise	ID	208-384-4260	Magellanic
Tautphaus Park Zoo	Idaho Falls	ID	208-612-8470	African
Brookfield Zoo	Brookfield	IL	708-688-8000	Humboldt
Lincoln Park Zoo	Chicago	IL	312-742-2000	Rockhopper, Chinstrap, King
Shedd Aquarium	Chicago	IL	312-939-2438	Rockhopper, Magellanic
Henson Robinson Zoo	Springfield	IL	217-753-6217	African
Fort Wayne Children's Zoo	Fort Wayne	IN	260-427-6800	African
Indianapolis Zoo	Indianapolis	IN	317- 630-2001	King, Gentoo, Rockhoppers
Tanganyika Wildlife Park	Goddard	KS	316-794-8954	African
Sedgwick County Zoo	Wichita	KS	316-660-9453	Humboldt
Louisville Zoo	Louisville	KY	502-459-2181	Rockhopper
Newport Aquarium	Newport	KY	859-261-7444	King, Gentoo, African
Audubon Aquarium of the Americas	New Orleans	LA	800-774-7394	African, Rockhopper

New England Aquarium	Boston	MA	617-973-5200	African, Rockhopper, Little
The Maryland Zoo in Baltimore	Baltimore	MD	410-366-5466	African
Maine Aquarium	Biddeford	ME	207-286-3474	Magellanic
Detroit Zoo	Detroit	MI	248-541-5717	King, Macaroni, Rockhopper
Potter Park Zoo	Lansing	MI	517-483-4222	Magellanic
Children's Zoo at Celebration Square	Saginaw	MI	989-759-1408	African
Minnesota Zoo	Apple Valley	MN	800-366-7811	African
Hemker Wildlife Park	Freeport	MN	320-836-2426	African
Como Park Zoo and Conservatory	St. Paul	MN	651- 487-8200	African
Saint Louis Zoo	St. Louis	MO	314-781-0900	Humboldt, King, Gentoo, Rockhopper
Roosevelt Park Zoo	Minot	ND	701- 857-4166	African
Lincoln Children's Zoo	Lincoln	NE	402-475-6741	Humboldt
Omaha's Henry Doorly Zoo	Omaha	NE	402-733-8400	King, Gentoo, Rockhopper
Adventure Aquarium	Camden	NJ	856-365-3300	African
Jenkinson's Boardwalk	Point Pleasant Beach	NJ	732-892-0600	African
Turtle Back Zoo	West Orange	NJ	973-731-5800	African
Binghamton Zoo	Binghamton	NY	607-724-5461	African
Bronx Zoo	Bronx	NY	718-220-5188	Magellanic
New York Aquarium	Brooklyn	NY	718-265-FISH	African
Central Park Zoo	New York	NY	212-439-6500	Gentoo, Chinstrap, King
Atlantis Marine World	Riverhead	NY	631-208-9200	African
Seneca Park Zoo	Rochester	NY	585-336-7200	African
Rosamond Gifford Zoo	Syracuse	NY	315- 435-8511	Humboldt
Akron Zoo	Akron	OH	330-375-2550	Humboldt
Cincinnati Zoo	Cincinnati	OH	513-281-4700	King
Columbus Zoo	Columbus	OH	800-MONKEYS	Humboldt
Toledo Zoo	Toledo	OH	419-385-5721	African
Tulsa Zoo	Tulsa	OK	918-669-6600	African
Oregon Zoo	Portland	OR	503-226-1561	Humboldt
Erie Zoo	Erie	PA	814-864-4091	African
Philadelphia Zoo	Philadelphia	PA	215-243-1100	Humboldt
Pittsburgh Zoo & PPG Aquarium	Pittsburgh	PA	412-665-3640	Gentoo, King, Macaroni
National Aviary	Pittsburgh	PA	412-323-7235	African
Lehigh Valley Zoo	Schnecksville	PA	610-799-4171	African
Roger Williams Park Zoo	Providence	RI	401-785-3510	Humboldt
Riverbanks Zoo and Garden	Columbia	SC	803-779-8717	Gentoo, King, Rockhopper
Bramble Park Zoo	Watertown	SD	605-882-6269	African

Tennessee Aquarium	Chattanooga	TN	800- 262-0695	Macaroni, Gentoo
Ripley's Aquarium of the Smokies	Gatlinburg	TN	888-240-1358	African
Knoxville Zoo	Knoxville	TN	865-637-5331	African
Dallas World Aquarium	Dallas	TX	214-720-2224	African, Little
Dallas Zoo	Dallas	TX	214-670-5656	African
Fort Worth Zoo	Fort Worth	TX	817-759-7500	African
Aquarium Pyramid at Moody Gardens	Galveston	TX	800-582-4673	King, Chinstrap, Rockhopper, Gentoo, Macaroni
SeaWorld: San Antonio	San Antonio	TX	210-674-1511	Rockhopper, Gentoo, Chinstrap, King, Macaroni, Magellanic
Caldwell Zoo	Tyler	TX	903-593-0121	African
Hogle Zoo	Salt Lake City	UT	801-582-1631	African
The Living Planet Aquarium	Sandy	UT	801- 355-3474	Gentoo
Metro Richmond Zoo	Moseley	VA	804-739-5666	African
Woodland Park Zoo	Seattle	WA	206-548-2500	Humboldt
New Zoo	Green Bay	WI	920-434-7841	African
Henry Vilas Zoo	Madison	WI	608-266-4732	African
Milwaukee County Zoo	Milwaukee	WI	414-256-5412	Humboldt, King, Rockhopper
Racine Zoo	Racine	WI	262- 636-9189	African

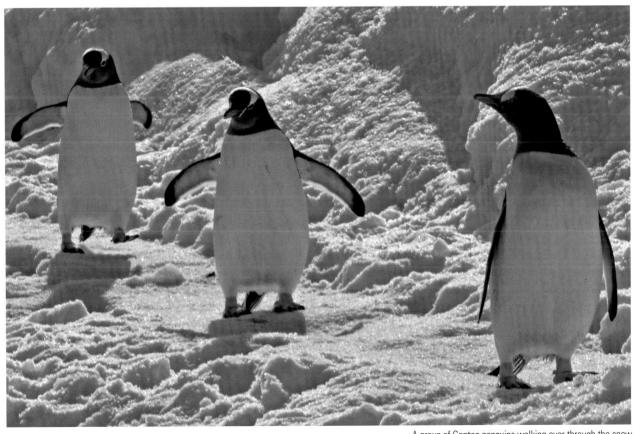

A group of Gentoo penguins walking over through the snow

Captive Penguins Around the World				
Location	City	Country	Phone Number	Penguin Species
Aquarium Mar Del Plata	Mar Del Plata	Argentina	54 223 467 0700	Magellanic, Rockhopper, King
Mundo Marino	San Clemente	Argentina	54 225 243 0300	Magellanic, Rockhopper
Melbourne Zoo	Melbourne	Australia	61 3 9285 9300	Little
Melbourne Aquarium	Melbourne	Australia	61 3 9923 5999	King, Gentoo
Perth Zoo	Perth	Australia	61 8 9474 0444	Little
Sea World	Queensland	Australia	61 7 5588 2222	Little
Taronga Zoo	Sydney	Australia	61 2 9969 2777	Little, Fiordland
Sydney Aquarium	Sydney	Australia	61 7 5519 6200	Little
Tiergarten Schönbrunn	Vienna	Austria	43 1 877 92940	Humboldt, King, Rockhopper
Zoo van Antwerpen	Antwerp	Belgium	32 3 407 186 105	King, Gentoo, Humboldt
Sea Life Blankenberge	Blankenberge	Belgium	32 50 42 43 00	Humboldt
Pairi Daiza	Brugelette	Belgium	32 68 250 850	African
Acqua Mundo	Guarujá	Brazil	55 13 3398 3000	Magellanic
Niteroi Zoo	Rio de Janerio	Brazil	55 21 2721 7069	Magellanic
Fundação Parque Zoológico de São Paulo	São Paulo	Brazil	55 11 5073 0811	Magellanic
West Edmonton Mall	Edmonton	Canada	780 444 5200	African
Biodome de Montreal	Montreal	Canada	514 868 3000	King, Gentoo, Rockhopper, Macaroni
Beijing Andover Tai Ping Yang Underwater World	Beijing	China	86 10 6871 4695	Humboldt
Harbin Polar Land	Harbin	China	86 451 8819 0909	Gentoo
Nanjing Andover Underwater World	Nanjing	China	86 25 84441119 210	Emperor
Shanghai Ocean Aquarium	Shanghai	China	86 21 58779988	African
Zoo Liberec	Liberec	Czech Republic	420 482 710 616	Humboldt
Prague Zoo Praha	Praha	Czech Republic	420 296 112 230	Humboldt
Zoo Zlín	Zlín	Czech Republic	420 577 914 180	Humboldt
Aalborg Zoo	Aalborg	Denmark	45 9631 2929	Humboldt
Copenhagen Zoo	Copenhagen	Denmark	45 72 200 200	Humboldt
Odense Zoo	Odense	Denmark	45 6611 1360	King, Rockhopper
London Zoo	London	England	44 20 7722 3333	African, Rockhopper
Zoo d'Amiens	Amiens	France	33 3 2269 6100	Humboldt
Marineland: Le must de la Côte d'Azur	Antibes	France	33 4 9333 4949	King, Humboldt, Macaroni, Gentoo, Rockhopper
Nausicaa Centre National de la Mer	Boulogne-sur-Mer Cedex	France	33 3 2130 9999	African
Océanopolis	Brest	France	33 2 9834 4040	King, Gentoo, Rockhopper
Bioparc Zoo de Doué	Doué la Fontaine	France	33 2 4159 1858	Humboldt

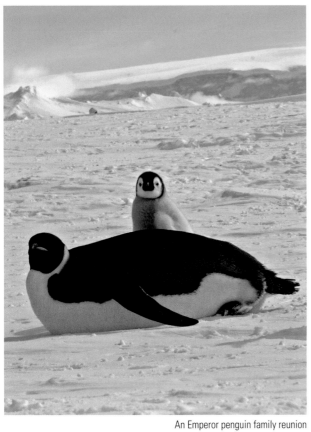

An Emperor penguin family reunion

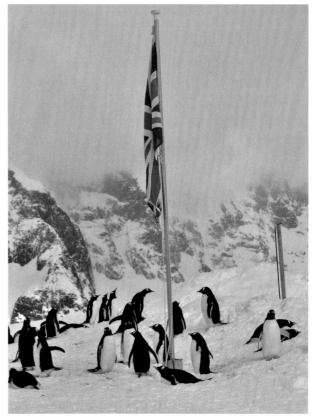

Gentoos Saluting the Union Jack

Océarium du Croisic	Le Croisic	France	33 2 4023 0244	African
Zoo De La Palmyre	Les Mathes	France	33 8 9268 1848	African
Zoo de Mulhouse	Mulhouse	France	33 3 6977 6565	African
Safari De Peaugres	Peaugres	France	33 4 7533 0032	African
Le Parc Des Oiseaux	Villars Les Dombes	France	33 3 7398 0554	Humboldt
Aachener Tierpark Euregiozoo	Aachen	Germany	49 241 5 93 85	African
Zoo Augsburg	Augsburg	Germany	49 821 5 671 490	Magellanic
Zoo Berlin	Berlin	Germany	49 30 254010	African, Humboldt, Rockhopper, King
Tierpark und Fossilium Bochum	Bochum	Germany	49 234 95029 0	Humboldt
Zoo Am Meer Bremerhaven	Bremerhaven	Germany	49 471 308 41 0	Humboldt
Kölner (Cologne) Zoo	Cologne	Germany	49 180 5 280101	Humboldt
Zoo Dortmund	Dortmund	Germany	49 231 50 28581	Humboldt
Zoo Dresden	Dresden	Germany	49 351 47 80 60	Humboldt
Zoo Duisburg	Duisburg	Germany	49 203 305590	African
Aquazoo Düsseldorf	Düsseldorf	Germany	49 211 89 96150	Gentoo
Zoo Eberswalde	Eberswalde	Germany	49 3334 2 27 33	Humboldt
Zoo Frankfurt	Frankfurt am Main	Germany	49 69 212 33735	Gentoo

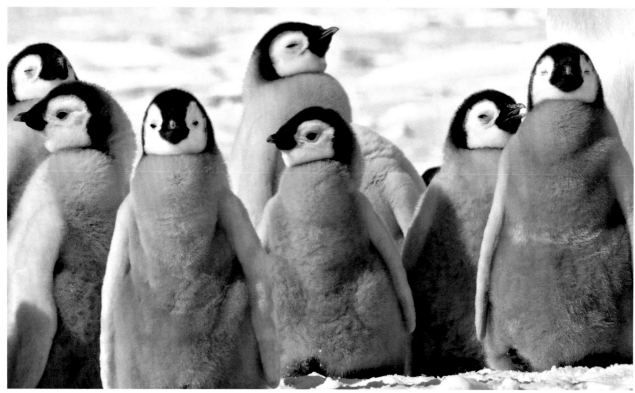

"Emperor chicks are the cutest and most adorable creatures"

Zoo Halle	Halle	Germany	49 345 5203 300	Humboldt
Erlebnis-Zoo	Hannover	Germany	49 511 856266200	African
Jaderpark	Jaderberg	Germany	49 04 454 9113 0	Humboldt
Karlsruhe Zoo	Karlsruhe	Germany	49 721 133 6815	Magellanic, Humboldt
Sea Life Konstanz	Konstanz	Germany	49 7531 128270	Gentoo
Zoo Krefeld	Krefeld	Germany	49 2151 955 20	Humboldt
Zii Landau in der Pfalz	Landau in der Pfalz	Germany	49 6341 12 7010	Humboldt
Tierpark Hellabrunn	Munich	Germany	49 8962 5080	King, Gentoo, Humboldt
Allwetterzoo Münster	Münster	Germany	49 2 51 89 04 0	African
Tiergarten Nuernberg	Nuernberg	Germany	49 911 5 45 46	African
Tierpark Nürnberg	Nürnberg	Germany	49 911 54546	African, Humboldt
Zoo Osnabrück	Osnabrück	Germany	49 541 951050	Humboldt
NaturZoo Rheine	Rheine	Germany	49 5971 16148 0	Humboldt
Zoo Rostock	Rostock	Germany	49 381 2082 0	Humboldt
Zoo Schwerin	Schwerin	Germany	49 385 39551 0	Humboldt
Tierpark Straubing	Straubing	Germany	49 9421 21277	African
Zoo Wilhelma	Stuttgart	Germany	49 711 5402 0	African
Welt Vogel Park	Walsrode	Germany	49 5161 60 44 0	Humboldt
Zoo Wuppertal	Wuppertal	Germany	49 202 563 36 00	King, Gentoo, African

Zoo Leipzig	Zeipzig	Germany	49 341 59 33 385	African
Budapest Zoo	Budapest	Hungary	36 1 273 4900	African
Belfast Zoo	Belfast	Ireland	353 28 9077 6277	Gentoo, Humboldt
Fota Wildlife Park	Carrigtwohill, Co.Cork	Ireland	353 21 4812678	Humboldt
Dublin Zoo	Dublin	Ireland	353 1 474 8900	Humboldt
Curraghs Wildlife Park	Ballaugh	Isle of Man	44 1624 897323	Humboldt
Ramat Gan Safari	Ramat Gan	Israel	972 3 6305325	African
Aquarium of Genoa	Genoa	Italy	39 10 2345666	Magellanic, Gentoo
Minami Chita Beach Land	Aichi	Japan	81 569 87 2000	King, Humboldt
Oga Aquarium	Akita	Japan	81 185 32 2220	Gentoo
Aquarium Asamushi	Aomori City	Japan	81 177 52 3377	Humboldt, Rockhopper
Asahiyama Zoo	Asahikawa, Hokkaid	Japan	81 166 36 1104	King, Gentoo, Humboldt, Rockhopper
Chiba Zoological Park	Chiba	Japan	81 43 252 1111	King, African
Tokyo Sea Life Park	Edogawa-ku, Tokyo	Japan	81 3 3869 5152	Little, Humboldt, Rockhopper
Enoshima Aquarium	Fujisawa-shi	Japan	81 466 29 9960	Humboldt
Fukuoka City Zoological Garden	Fukuoka	Japan	81 92 531 1968	Humboldt, King
Hitachi City Kamine Zoo	Hitachi City	Japan	81 294 22 5586	Humboldt

A Little penguin at the Dallas World Aquarium

Joetsu Municipal Aquarium	Joetsu	Japan	81 25 543 2449	Magellanic, Rockhopper
Sea World Kamogawa	Kamogawa	Japan	81 4 7092 2121	African, Gentoo, King, Macaroni, Rockhopper
Kobe Oji Zoo	Kobe	Japan	81 78 961 5624	Humboldt
Kumamoto Zoo	Kumamoto	Japan	81 96 368 4416	Humboldt
Kushiro Zoo	Kushiro	Japan	81 154 56 2121	Humboldt
Kyoto City Zoo	Kyoto	Japan	81 75 771 0210	Humboldt, Rockhopper
Marinepia Matsushima Aquarium	Matsushima	Japan	81 22 354 2020	Gentoo, Macaroni, King, Rockhopper
Nagasaki Penguin Aquarium	Nagasaki	Japan	81 95 838 3131	King, Gentoo, Macaroni, Rockhopper, Humboldt, African, Magellanic, Little
Biopark Nagasaki	Nagasaki	Japan	81 959 27 1090	Humboldt
Nagoya Higashiyama Zoo and Botanical Gardens	Nagoya	Japan	81 52 782 2111	King, Humboldt
Port of Nagoya Public Aquarium	Nagoya	Japan	81 52 654 7000	Gentoo, Adélie, Emperor, Chinstrap
Niigata Aquarium	Niigata	Japan	81 25 222 7500	Humboldt
Izu-Mito Sea Paradise	Numazu-shi	Japan	81 55 943 2331	Humboldt
Aqua World Ibaraki Prefectural Oarai Aquarium	Oarai	Japan	81 29 267 5151	Humboldt
Oga Aquarium	Oga	Japan	81 185 32 2221	Gentoo
Tennoji Zoo	Osaka	Japan	81 6 6771 8401	King, Rockhopper, Humboldt
Otaru Aquarium	Otaru	Japan	81 134 33 1400	Gentoo, Humboldt
Echizen Matsushima Aquarium	Sakai City	Japan	81 776 81 2700	King, Rockhopper
Sapporo Maruyama Zoo	Sapporo	Japan	81 11 621 1426	Humboldt
Ueno Zoo	Taito-ku, Tokyo	Japan	81 3 3828 5171	African, King
Sunshine International Aquarium	Tokyo	Japan	81 3989 3466	African, Macaroni, Rockhopper
Utsunomiya Zoo	Utsunomiya	Japan	81 286 65 4255	Magellanic
AdventureWorld	Wakayama	Japan	81 560 064481	Adélie, Emperor, Chinstrap, Gentoo, King
Yokohama Hakkeijima Sea Paradise	Yokohama	Japan	81 45 788 8888	African
Nogeyama Zoo	Yokohama	Japan	81 45 231 1696	Humboldt
Vogelpark Avifauna	Alphen aan den Rijn	Netherlands	31 172 487 575	Humboldt
DierenPark Amersfoort	Amersfoort	Netherlands	31 33 422 71 00	African
Natura Artis Magistra	Amsterdam	Netherlands	31 900 27 84 796	African
Burger's Zoo	Arnhem	Netherlands	31 26 442 45 34	African
Dierenpark Emmen	Emmen	Netherlands	31 591 850555	Humboldt
Aqua Zoo Friesland	Leeuwarden	Netherlands	31 511 431214	Humboldt
Ouwehands Dierenpark	Rhenen	Netherlands	31 317 650 200	Humboldt
Diergaarde Blijdorp	Rotterdam	Netherlands	31 10 443 14 95	King

Kelly Tarlton's Antarctic Encounter	Auckand	New Zealand	64 9 531 5065	King, Gentoo
International Antarctic Centre	Christchurch	New Zealand	64 3 353 7798	Little
Oamaru Blue Penguin Colony	Oamaru, Otago	New Zealand	64 3 433 1195	Little
Oceano De Lisboa	Lisbon	Portugal	351 21 891 7002	Magellanic, Rockhopper
Moscow Zoo	Moscow	Russia	7 495 255 5375	Humboldt
Edinburgh Zoo	Edinburgh	Scotland	44 131 334 9171	Gentoo, Rockhopper, King

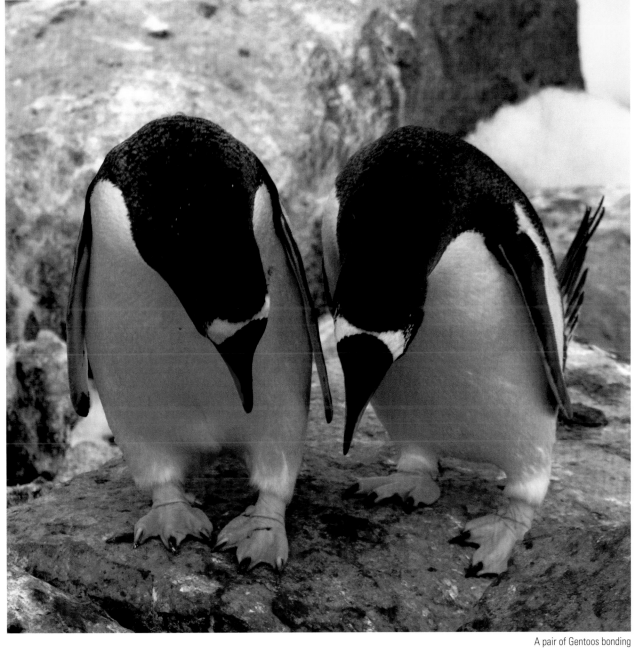

A pair of Gentoos bonding

Two Oceans Aquarium	Cape Town	South Africa	27 21 418 3823	King, Rockhopper, African
East London Aquarium	East London	South Africa	27 43 705 2637	African
Bester Birds and Animals Zoo Park	Pretoria	South Africa	27 12 807 4192	African
Zoo Barcelona	Barcelona	Spain	34 932 256 780	Humboldt
Loro Parque	Canary Islands	Spain	34 922 37 38 41	Humboldt, Gentoo, Rockhopper, Chinstrap, King
L' Oceanográfic	Valencia	Spain	34 902 100 031	Humboldt
Borås Djurpark	Borås	Sweden	46 33 35 3270	Humboldt
Kolmarden Zoo	Kolmarden	Sweden	46 11 15 7100	Humboldt
Taipei Zoo	Taipei	Taiwan	886 2 2938 2300	King, African
Siam Ocean World	Bangkok	Thailand	66 2687 2000	African
Chiang Mai Zoo	Chiang Mai	Thailand	66 5 322 1179	Humboldt
Dubai Aquarium	Dubai	UAE	971 4 448 5200	Gentoo
Amazon World Zoopark	Arrenton, Isle of Wight	UK	44 1983 867122	African
Drusillas Park	Alfriston	UK	44 1323 874100	Rockhopper, Humboldt
Twycross Zoo	Atherstone, Warwickshire	UK	44 844 474 1777	Humboldt

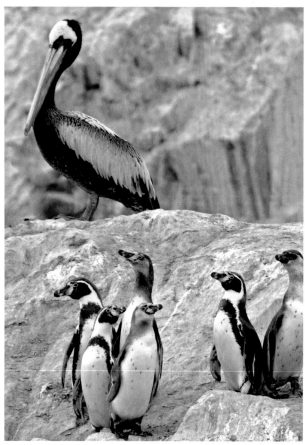

Adult and immature Humboldts resting by a pelican

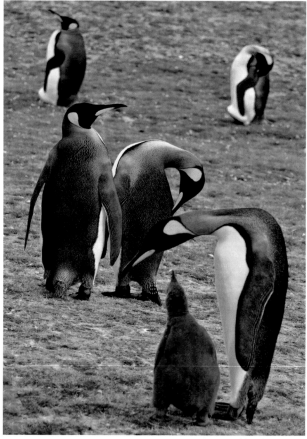

Kings going on their daily routine

Blackpool Zoo	Blackpool	UK	44 1253 830 830	Magellanic
Banham Zoo	Banham, Norfolk	UK	44 01953 887771	African
Birdland Park and Gardens	Bourton-on-the-Water, Glos	UK	44 1451 820480	King, Humboldt
Bristol Zoo	Bristol	UK	44 117 974 7399	African
Cotswold Wildlife Park and Gardens	Burford	UK	44 1993 823006	Humboldt
Blair Drummond Safari and Adventure Park	by Stirling	UK	44 1786 841 456	Humboldt
Chessington: World of Adventures	Chessington	UK	44 871 663 4477	Humboldt
Chester Zoo	Chester	UK	44 1244 380 280	Humboldt
Colchester Zoo	Colchester	UK	44 1206 331292	Humboldt
The National Seal Sanctuary	Cornwall	UK	44 871 423 2110	Humboldt
Welsh Mountain Zoo	Cowlyn Bay, North Wales	UK	44 0 1492 532 938	Humboldt
South Lakes Wild Animal Park	Cumbria	UK	44 1229 466086	Humboldt
Dudley Zoological Gardens	Dudley	UK	44 844 474 2272	Humboldt
Whipsnade Zoo	Dunstable	UK	44 1582 872171	Humboldt
Exmoor Zoo	Exmoor	UK	44 1598 763352	Humboldt
Sea Life Great Yarmouth	Great Yarmouth, Norfolk	UK	44 871 423 2110	Humboldt
Harewood Bird Garden	Harewood	UK	44 113 218 1010	Humboldt
Paradise Park and Jungle Barn	Hayle, Cornwall	UK	44 1736 751020	Humboldt
Paradise Wildlife Park	Herts	UK	44 1992 470490	Humboldt
Hunstanton Sea Life Sanctuary	Hunstanton, Norfolk	UK	44 1485 533576	Humboldt
Flamingo Land	Kirby Misperton, Malton	UK	44 871 9118000	Humboldt
Drayton Manor Theme Park	near Tamworth	UK	44 844 472 1950	African
Newquay Zoo	Newquay, Cornwall	UK	44 844 474 2244	Humboldt
Sea Life Scarborough	Scarborough, North Yorkshire	UK	44 871 423 2110	Humboldt
Sewerby Hall and Gardens	Sewerby, Bridlington	UK	44 1262 673769	Humboldt
Natureland Seal Sanctuary	Skegness, Lincolshire	UK	44 1754 764 345	African
Birdworld	Surrey	UK	44 1420 22838	Humboldt
Living Coasts	Torquay, Devon	UK	44 1803 202470	African, Macaroni
Sea Life Weymouth	Weymouth, Dorset	UK	44 871 423 2110	Humboldt
Marwell Wildlife	Winchester	UK	44 1962 777407	Humboldt
Blackbrook Zoo	Winkhill	UK	44 1538 308293	Humboldt

Where to Find a Penguin in the Wild

Argentina	
Mainland	
Cabo Virgenes	Magellanic 100,000s
Caleta Interna	Magellanic 10,000s
Peninsula Valdés; San Lorenzo and Smaller Colonies	Magellanic 100,000s
Punta Tumbo	Magellanic 100,000s
Tierra del Fuego; Several Locations	Magellanic 10,000s
Argentinean Coastal Islands	
Isla de los Estados (Staten Island)	Magellanic 100,000s; Rockhopper (Southern) 100,000s
Isla Pingüino	Magellanic 1,000s; Rockhopper (Southern) 100,000s
Isla Vernacci	Magellanic 10,000s
Martillo Island, near Ushaia in Tierra del Fuego	Magellanic 1,000s; Gentoo 10s

Chile	
Mainland	
Punta Lengua de Vaca	Humboldt 10s; Magellanic 100s
Seno Otway; near Punta Arenas Tierra del Fuego	Magellanic 1,000s
Southern Coast; Several Locations	Humboldt 100s; Magellanic 1,000s
Chilean Coastal Islands	
Barnevelt Island	Rockhopper (Southern) 10,000s
Diego Ramirez	Rockhopper (Southern) 10,000s; Macaroni 10,000s
Isla Chañaral	Humboldt 10,000s
Isla Ildefanso	Rockhopper (Southern) 100,000s; Macaroni 10,000s
Isla Noir	Rockhopper (Southern) 100,000s; Macaroni 1,000s
Isla Recalada	Rockhopper (Southern) 10,000s
Isla Terhalten	Rockhopper (Southern) 1,000s
Magdalena Island	Magellanic 10,000s
Metalqui Island	Magellanic 100s
Punihuil Islands	Magellanic 100s; Humboldt 100s

Magellanics wandering around at Punta Tombo

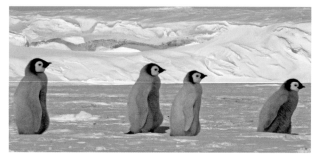

A crèche playing at Snow Hill

Peru	
Mainland	
Punta Caleta	Humboldt 100s
Punta Coles	Humboldt 100s
Punta San Juan	Humboldt 1,000s
Tres Puertas	Humboldt 100s
Peruvian Coastal Islands	
Hormillios Island	Humboldt 100s
Islas Ballestas	Humboldt 100s
La Foca Island	Humboldt 10s
Pachamac Island	Humboldt 100s
Punta San Fernando	Humboldt 100s
San Juanito Islet	Humboldt 100s

Ecuador (none on mainland)	
Galapagos Islands (About 500 Miles West of the Mainland)	
Isabela	Galapagos 1,000 or less
Bartolome and Santiago	Galapagos 10s
Fernanda	Galapagos 100s

Falkland Islands (Political Status Disputed)	
Barren Island	Gentoo 100s; Magellanic 1,000s
Beauchene Island	Rockhopper (Southern) 100,000s; Gentoo 100s
Beaver Island	Gentoo 1,000s
Bird Island	Rockhopper (Southern) 1,000s
Bleaker Island	Rockhopper (Southern) 1,000s; Magellanic 1,000s; Gentoo 1,000s
Carcass Island	Magellanic 1,000s; Gentoo 100s
East Island	King 1,000s; Gentoo 10,000s; Magellanic 1,000s
Jason Islands including Steeple Jason Island	Rockhopper (Southern) 100,000s; Gentoo 10,000s
Kidney Island	Magellanic 1,000s; Gentoo 1,000s; Rockhopper (Southern) 100s
Lively Island	Magellanic 1,000s; Gentoo 1,000s
New Island	Rockhopper (Southern) 10,000s; Gentoo 1,000s
Northern Island	Rochopper (Southern) 10,000s
Pebble Island	Rockhopper (Southern) 10,000s; Gentoo 1,000s; Magellanic 1,000s
Saunders Island	Rockhopper (Southern) 10,000s; Gentoo 1,000s; Magellanic 1,000s
Sea Lion Island	Rockhopper (Southern) 100s; Magellanic 1,000s; Gentoo 1,000s
Speedwell Island	Gentoo 1,000s
Weddell Island	Gentoo 1,000s; Magellanic 1,000s
West Island	Gentoo 1,000s; Magellanic 1,000s

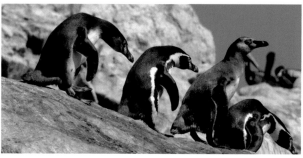

Humboldt on the run

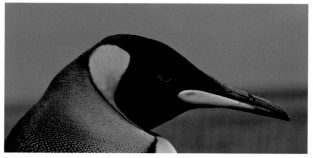

The King is thinking

Africa	
South Africa Mainland	
Boulders Beach	African 1,000s
Stony Point	African 1,000s
South African Coastal Islands	
Dassen Island	African 10,000s
Dyer Island	African 1,000s
Robben Island	African 1,000s
St. Croix Islad	African 10,000s
Namibia Coastal Islands	
Halifax Island	African 100s
Ichaboe Island	African 1,000s
Mercury Island	African 1,000s
Possession Island	African 100s

Australia	
Mainland	
Sydney (Victor Harbor)	Little 1,000s
Australian Coastal Islands	
Bowen Island	Little 1,000s
Curtis Island	Little 1,000s
Gabo Island	Little 10,000s
Granite Island	Little 100s
Hogan Island Group (e.g., Long Island, Round Island, East Island)	Little 100s
Kent Island Group (e.g., Eirth Island, Deal Island, Dover Island)	Little 1,000s
Lady Julia Percy Island	Little 1,000s
Montague Island	Little 1,000s
Penguin Island	Little 100s
Phillip Island	Little 1,000s
Rodondo Island Group (e.g., Rodondo Island, East Moncoer Island)	Little 100s

New Zealand	
Mainland North Island	
Bay of Plenty	Little 100s
Hauraki Gulf	Little 10s
Wellington (Tarakena Bay)	Little 100s
Mainland South Island	
Banks Peninsula	Little 100s
Haast	Little 100s
Jackson Head	Fiordland 100s
Lake Moeaki Beach	Fiordland 10s
Nelson	Little 100s
Oamaru	Little 1,000s; Yellow-eyed 10s
Otagu Peninsula	Little 100s; Yellow-eyed 100s
Preservation Point	Fiordland 10s
Wekakura	Little 100s
Yaet Point	Fiordland 10s
New Zealand Coastal Islands	
Chatham Islands	Little 1,000s
Motuara Island	Little 100s
Open Bay Island	Fiordland 100s
Solander Island	Fiordland 100s
Stewart Islands	Fiordland 100s; Yellow-eyed 100s

New Zealand and Australia Sub-Antarctic Islands	
Antipodes Islands	Erect-crested 100,000s; Rockhopper (Southern) 1,000s
Auckland Islands (e.g., Disappointment Island, Enderby Island)	Yellow-eyed 100s; Rockhopper (Southern) 1,000s
Bounty Islands	Erect-crested 10,000s; Rockhopper (Southern) 1,000s
Campbell Island	Yellow-eyed 100s; Rockhopper (Southern) 10,000s
Macquarie Island	Royal 1,000,000s; King 100,000s; Rockhopper (Southern) 10,000s; Gentoo 10,000s
Snares Islands	Snares 10,000s

Indian Ocean Above 60°S	
Islands	
Amsterdam Island	Rockhopper (Northern) 10,000s; Gentoo 100s
Crozet Islands (e.g., Possession, Penguin, Pig, and East Islands)	Macaroni 1,000,000s; King 100,000s; Gentoo 1,000s; Rockhopper (Southern) 100,000s
Heard and McDonald Islands	Macaroni 1,000,000s; King 10,000s; Gentoo 10,000s; Rockhopper (Southern) 10,000s; Rockhopper (Northern) 10,000s
Kerguelen Islands	Macaroni 1,000,000s; King 100,000s; Gentoo 10,000s;
Rockhopper (Southern) 10,000s	Snares 10,000s
Prince Edward Islands (Marion Islands)	King 100,000s; Gentoo 1,000s; Rockhopper (Southern) 100,000s; Macaroni 100,000s; African 1,000s
Saint Paul Island	Rockhopper (Northern) 1,000s
Possession Island	African 100s

Atlantic Ocean Island Groups above 60° S	
Islands	
Bouvet Island	Chinstrap 1,000s; Macaroni 1,000s
South Georgia Island	Macaroni 1,000,000s; Chinstrap 100,000s; Gentoo 1,000s; King 100,000s; Adélie 10,000s
South Orkney Islands	Adélie 1,000s; Chinstrap 100,000s; Gentoo 1,000s
South Sandwich Islands	Chinstrap 1,000,000s; Gentoo 1,000s; Macaroni 100,000s; Adélie 10,000s
Tristan da Cunha Islands	
Gough Island	Rockhopper (Northern) 100,000s
Inaccessible Island	Rockhopper (Northern) 10,000s
Middle Island	Rockhopper (Northern) 100,000s
Nightingale Island	Rockhopper (Northern) 10,000s
Tristan da Cunha Island	Rockhopper (Northern) 100,000s
Falkland Islands (See Countries)	

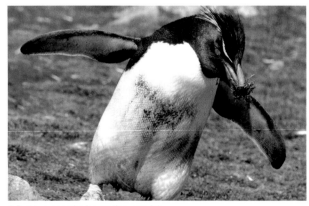

A Rockhopper gathering nesting materials

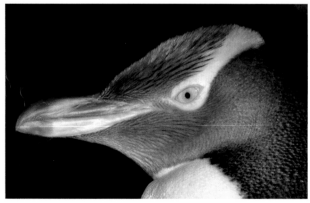

A Yellow-eyed portrait

Antarctic Below 60° S	
Antarctica Mainland	
Adélie Land (Terre Adélie) (Including Point Géologie)	Adélie 100,000s; Emperor 1,000s
Amundsen Bay	Emperor 1,000s
Auster	Emperor 10,000s
Ellsworth Land	Adélie 1,000s
Enderby Land	Adélie 1,000s
Lützow-Holm Bay	Adélie 10,000s
MacRobertson Land	Adélie 100,000s
Marie Byrd Land	Adélie 100,000s
Princess Elizabeth Land	Adélie 100,000s
Ross Sea (e.g., Cape Roget, Cape Crozier, Cape Washington, Cape Adare, Cape Hallett, Cape Cotter, Cape Bird, Cape Royd, and Cape Colbeck)	Emperor 10,000s; Adélie 1,000,000s
Taylor Glacier	Emperor 10,000s
Victoria Land	Adélie 1,000,000s; Emperor 10,000s
Wilkes Land	Adélie 100,000s; Emperor 1,000s
Emperor colonies are on ice near the locations listed above	
Mainland Coastal and Nearby Islands	
Balleny Islands	Adélie 1,000s; Chinstrap 100s
Beaufort Island	Adélie 100,000s; Emperor 1,000s
Christine Island	Adélie 1,000s
Coulman Island	Emperor 10,000s
Dellbridge Island	Chinstrap 1,000s
Donovan Islands (e.g., Chappel, Grinnel, and Glaspal Islands)	Adélie 10,000s; Emperors 100s
Franklin Island	Adélie 100,000s; Emperor 10s
Frazier Islands (e.g., Chariton, Dewart, and Nelly Islands)	Adélie 10,000s
Ross Island	Adélie 100,000s
Windmill Ilands	Adélie 1,000,000s
Emperor colonies are on ice near the locations listed above	
Antarctic Peninsula	
Cape Kater	Adélie 100,000s
Errera Channel Area	Chinstrap 1,000s
Graham land	Adélie 100,000s; Chinstrap 100,000s
North Bay	Gentoo 1,000s
Palmer Land	Adélie 100,000s
Antarctic Peninsula Islands	
Anvers Island	Adélie 1,000s; Chinstrap 1,000s; Gentoo 100s
Christine Island	Adélie 1,000s
Cuverville Island	Gentoo 1,000s

D'Urville Island (in Joinville Island Group)	Emperor 1,000s; Adélie 10,000s
Danco Island	Gentoo 1,000s
Dion Island	Emperor 1,000s
Gourdin Island	Adélie 1,000s; Chinstrap 1,000s; Gentoo 1,000s
Hope Bay (Esperanza Base)	Gentoo 1,000s; Adélie 100,000s
Paulet Island	Adélie 100,000s
Seymour Island	Adélie 10,000s
South Shetland Islands	
Clearance Island	Gentoo 1,000s; Chinstrap 1,000s
Deception Island	Adélie 10,000s; Chinstrap 10,000s
Elephant Island	Chinstrap 1,000s; Gentoo 1,000s
Half Moon Island	Chinstrap 1,000s
King George Island	Chinstrap 100,000s; Gentoo 10,000s
Livingston Island	Gentoo 100s; Chinstrap 1,000s
Nelson Island	Chinstrap 100s
Penguin Island	Gentoo 1,000s; Chinstrap 1,000s; Adélie 10,000s
Peterman Island	Adélie 100s; Gentoo 1,000s
Seal Island	Gentoo 10,000s; Chinstrap 10,000s

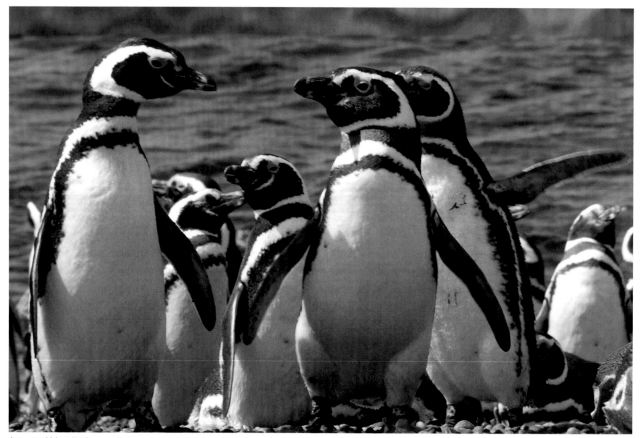

A group of Magellanic penguins returning to their colony from sea

Glossary

Measurement Conversions

Weight

1 Gram = 0.035 Ounces	1 Gram = 0.0022 Pounds	1 Gram = 0.001 Kilograms
1 Ounce = 28.3 Grams	1 Ounce = 0.063 Pounds	1 Ounce = 0.028 Kilograms
1 Pound = 453.6 Grams	1 Pound = 16 Ounces	1 Pound = 0.4536 Kilograms
1 Kilogram = 1,000 Grams	1 Kilogram = 35.27 Ounces	1 Kilogram = 2.205 Pounds

Length

1 Millimeter = 0.0393 Inches	1 Millimeter = 0.00328 Feet	1 Millimeter = 0.1 Centimeters
1 Centimeter = 0.3937 Inches	1 Centimeter = 0.0328 Feet	1 Centimeter = 10 Millimeters
1 Inch = 2.54 Centimeters	1 Inch = 25.4 Millimeters	1 Inch = 0.0254 Meters
1 Foot = 0.305 Meters	1 Foot = 30.48 Centimeters	1 Foot = 304.8 Millimeters
1 Meter = 1,000 Millimeters	1 Meter = 100 Centimeters	1 Meter = 39.37 Inches
1 Inch = 0.083 Feet	1 Foot =12 Inches	1 Meter = 3.28 Feet
1 Millimeter = 0.001 Meters	1 Centimeter = 0.01 Meters	

Speed

1 Mile per Hour = 1.609 Kilometers per Hour
1 Kilometer per Hour = 0.621 Miles per Hour
1 Meter per Second = 2.24 Miles per Hour

Terms

Advertising Display—A display (see below) performed by an unpaired male to attract females and to assert dominance over his nesting territory; the bird stretches its body tall, raises its head in the air, and points its bill toward the sky. Females might respond with a similar display.

Agonistic Behavior—Aggressive social behavior exhibited by penguins, associated with competition, fighting, and escape; behaviors observed that cause, threaten to cause, or seek to reduce physical damage.[1]

Alloparental Behavior—When an adult penguin performs parental duties for a chick that is not its own, most commonly feeding.

Basal—A term similar to "primitive" that is used to describe an earlier ancient animal from which the current species evolved. The basal is similar to, but not exactly like, the animal we see today.

Breeding—The act of reproduction; the process of producing offspring. Penguins' entire breeding cycle takes place on land. *See Copulation.*

Brood—The number of eggs laid at one time.

Brooding—A word describing when an adult penguin parent sits atop its eggs in order to keep them warm. This term is also used when referring to a parent protecting and warming its chick.

Brood Patches—A patch of featherless skin that appears on adult birds during nesting season. The exposed, blood vessel–rich skin allows the bird to more easily transfer heat to the egg when incubating.

Call—A series of vocal projections or songs produced in different situations and accompanied by different postures. Penguins use calls to identify their spouse and chicks.

Cephalopods—The most commonly referenced cephalopods are squid and octopus. They are bilateral marine animals that are members of the molluscan class Cephalopoda, whose name means head-foot.

Cloaca—The posterior orifice or anus, through which penguins excrete urine, feces, and also sperm; during reproduction, the male cloaca must touch the female cloaca to transfer sperm because penguins do not have exterior sexual organs.

Colonial—Species that nest and breed in colonies, meaning in close proximity to several or many other couples; all penguins are colonial.

Congeners—Organisms belonging to the same taxonomic genus.

Copulation—Refers to the act of sexual intercourse; in the case of penguins, the union of the male and female's cloacae, due to their lack of external sexual organs, for the insemination and internal fertilization of the female; also known as coitus. *See Breeding*.

Crustacean—A large group of mostly free-living aquatic arthropods which possess exoskeletons that they must molt to grow. This group includes krill, shrimp, crabs, and lobsters. Crustaceans, especially krill, are a very important part of the penguin's diet.

Crest—Crownlike, prominent feathers located on the bird's head, generally used for display purposes.

Display—Movements performed by a penguin, such as moving its head, flippers, or bill, which signals information to another bird; similar to body language.

DNA Research—Research on the DNA within the chromosomes and genes of different living beings, to better understand the makeup and functions of those beings. DNA contains the genetic makeup or "blueprints" of every living being, and each cell within one's body contains the exact same DNA. DNA is made from a combination of the parents' DNA.

Down—A layer of small, fluffy, cotton-like feathers that cover chicks' bodies soon after hatching to insulate their bodies until their adult feathers grow in. The down is shed before fledging.

Ecstatic Display—A display (see above) performed by a penguin couple before and during courting, for maintenance of their relationship, and with nest changes.

El Niño—A global weather occurrence also known as Southern Oscillation or ENSO; an unexplained increase in the surface water temperature of the eastern Pacific Ocean, occurring irregularly but annually for a few weeks to a month. Every several years, it lasts for multiple months, having a large effect on marine life in the area affected. El Niño causes stormy weather and unusual amounts of rain to fall in some parts of the world and very dry seasons in others. It also changes the movement of fish and disperses penguins' prey (food) to locations farther away from their colonies.

Endemic—In this case, referring to species that belong to/are only found in a particular geographic area. A penguin is endemic to an area if it can only be found breeding in that specific area.

Feral—A once-domesticated animal that has escaped from its domestic or captive state and returned, at least in part, to its wild state, sometimes leading to ecosystem disruptions when it is foreign to the natural area to which it escapes.

Fledging (Fledge)—The point in a chick's life when it is able to become independent and no longer needs parental assistance to survive. For penguins, independence means being able to dive and catch their own prey. All penguin chicks enter the ocean upon fledging and stay there for a long amount of time, in most cases about one year. If a chick reaches fledging it counts as a successful breeding.

Flipper Patting—The repeated touching or patting of one penguin's flippers on another's; generally a precursor to copulation.

Flipper Slapping—An aggressive use of the flipper to forcefully hit an opponent or annoying penguin.

Foraging—The act of searching for prey or food provisions; in the case of penguins, foraging is conducted by diving.

GPS Locator—A small, waterproof device that can be attached to the backs of penguins. The devices send or record information about the penguin's location and speed. They are a smaller, waterproof version of the GPS (global positioning system) used in automobiles.

Guano—Bird excrement that accumulates over rocks or dirt. Penguins do not have separate solid and liquid excrement; rather, all waste emerges together in the form of guano, which is harvested for its extremely good plant fertilization properties.

Homeothermic—Warm-blooded; organisms that can maintain body temperature on their own, regardless of ambient (outside) temperature.

Immature—A young penguin that has molted its down and fledged but has yet to attain the complete plumage of a breeding adult; it looks somewhat different from an adult, and in most penguins it takes a year and one regular molt until the immature attains the adult plumage.

Introduced Species (Alien Species)—A species of organism that is living outside of its normal, native habitat and that was transferred to the new location due to human activity.

IUCN: International Union for Conservation of Nature—A global organization dedicated to finding solutions for most environmental and developmental challenges. IUCN publishes the Red List.[2]

IUCN Red List of Threatened Species—A list published and updated by the IUCN intended to classify the popu-

lation status and well-being of different species.[3] The "least concern" ranking is given to species with a steady population trend. Once a species suffers a population decline of at least 30 percent over three generations it is classified as "vulnerable." More severe population declines have more serious classifications.

Juvenile—An independent, non-breeding young penguin that has already attained adult plumage; depending on the species, it can range from the age of one year and up.

Krill—The most abundant marine creature; shrimp-like marine crustaceans belonging to the order Euphausicea, also called euphausiids. They are a very common prey of penguins, other fish, and marine mammals.

Metabolism—Chemical processes that happen continuously within the living cell or body to maintain life. The metabolism process includes the breaking down and synthesizing of substances to provide energy and other essentials necessary to maintain life.

Migrant Birds—Birds that take a seasonal journey away from their breeding colony but return in time for the breeding season.

Molting (Moulting)—A process by which a bird replaces its current feathers with new ones. For most birds this is an ongoing process. For penguins, the molting of all feathers takes place at once. The new feathers grow under the old and push them out of the skin. During a molt, penguins lose their waterproofing properties and cannot enter the water; therefore, they must fast.

Monogamy—The act of staying together with the same mate over several breeding seasons.

Monophylogeny—Organisms that have descended from a single common ancestor and are classified in the same taxon.

Natal Colony—The colony where a penguin was born.

Nest Fidelity (Philopatry)—The tendency of a penguin to return to its same exact nest year after year. With penguins, the nest is "owned" by the male; therefore, in a divorce the female will change nests.

Nest Success Rate—The average number of chicks that survive to fledge per nest. The rate is calculated by dividing the number of chicks that fledged by the applicable number of nests.

Nocturnal—To be active at night.

Pelagic Fish—Species of fish that are migratory and swim in groups, normally higher in the water column.

Plumage—The layer of feathers that covers the bird's body and their color, pattern, or arrangement; the penguin's body is fully covered by feathers.

Porpoising—The act of leaping and plunging in and out of the water like a porpoise. This less energy efficient way of swimming is done so the penguin can continuously breathe and possibly confuse predators.

Preening—The act of smoothing and cleaning one's feathers; in the case of penguins, during preening they waterproof their feathers as well by secreting oil from their uropygial gland and distributing it over their feathers.

Regurgitate—The method used by a penguin parent to feed its chick. It is done by expulsion of partially digested food, temporally stored for the chick in the parent stomach, through the mouth.

Rookery—Also called a colony; a place where penguins nest and breed on land.

Salt Glands (Supraorbital Gland)—Special nasal glands that actively remove salt from the penguin's blood in order to keep salt concentration to a safe level and secret the excess salt from the body.

Schooling Fish—Fish that swim in dense groups in the same coordinated direction for social reasons.

Sedentary—Non-migratory; birds that stay all year round or most of the year near their colony.

Shoaling Fish—Fish that swim in dense groups for social reasons.

Synchronized Behavior—An entire colony or group of penguins following the same pattern of behaviors at the same time, e.g., breeding or molting

Thermal Independence—The point at which an animal can regulate its own body temperature without the assistance of a parent.

Tobogganing—The act of a penguin lying on its belly and sliding, using its flipper to control and propel itself, usually on ice.

Underwater Data Loggers—Instrumentation used by researchers that attaches to the penguins to track their foraging distance and path traveled, as well as their diving depths and patterns.

Uropygial Gland—A gland located at the base of penguins' tails. The gland secretes preen oil, which is spread by the penguins all over the body to waterproof the feathers.

Source 1: McGlone, John J
Source 2: "About IUCN."
Source 3: "About IUCN Red List of Threatened Species."

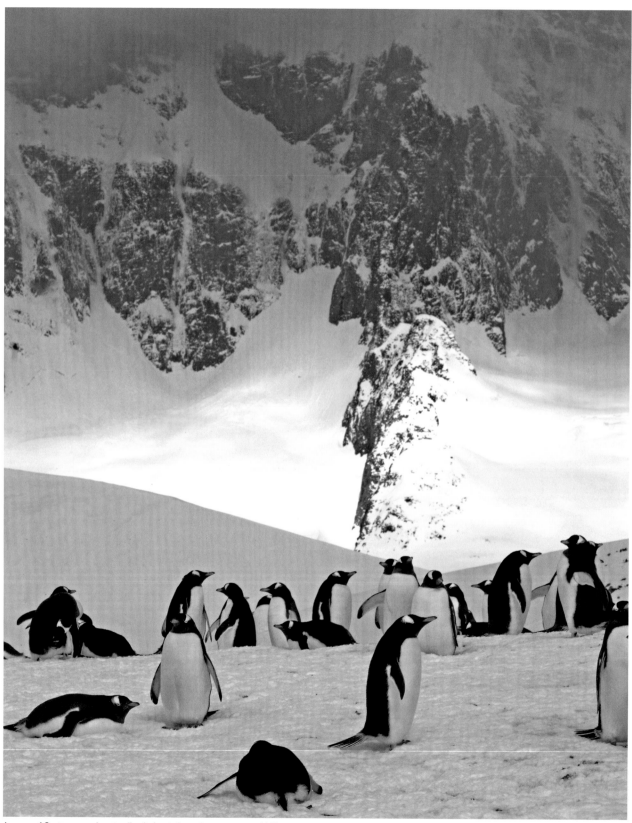

A group of Gentoo penguins standing in front of a rocky, snow-covered hill

Bibliography

Adélie

Ainley, D. G., G. Ballard, K. J. Barton, B. J. Karl, G. H. Rau, C. A. Ribic, and R. P. Wilson. 2003. "Spatial and Temporal Variation of Diet within Presumed Metapopulation of Adélie Penguins." *The Condor* 105:95–106.

Ainley, D. G. and D. P. Demaster. 1980. "Survival and Mortality in a Population of Adélie Penguins, Pygoscelis adeliae." *Ecology* 61:522–30.

Ainley, D. G. and R. P. Schlatter. 1972. "Chick Raising Ability in Adélie Penguins." *The Auk* 89:559–66.

Angelier, F., C. A. Bost, M. Giraudeau, G. Bouteloup, S. Dano, and O. Chastel. 2008. "Corticosterone and Foraging Behavior in a Diving Seabird: The Adélie Penguin, Pygoscelis adeliae." *Journal and Comparative Endocrinology* 156:134–44.

Barbosa, A., S. Merino, J. Benzal, J. Martínez, and S. García-Fraile. 2007. "Population Variability in Heat Shock Proteins Among Three Antarctic Penguin Species." *Polar Biology* 30:1239–44.

Beaulieu, M., A. Dervaux, A. M. Thierry, D. Lazin, Y. Le Maho, Y. Ropert-Coudert, M. Spée, T. Raclot, and A. Ancel. 2010. "When Sea-Ice Clock Ahead of Adélie Penguins' Clock." *Functional Ecology* 24:93–102.

Beaulieu, M., A. M. Thierry, Y. Le Maho, Y. Ropert-Coudert, and A. Ancel. 2009. "Alloparental Feeding in Adélie Penguins: Why is it Uncommon?" *Journal of Ornithology* 150:637–43.

Boersma, P. D. and L. S. David. 1997. "Feeding Chases and Food Allocation in Adélie Penguins, Pygoscelis adeliae." *Animal Behavior* 54:1047–52.

Boersma, P. D. and G. Guncay. 2009. "Adélie Penguin." The Penguin Project. Penguin Sentinels. Accessed 28 Oct 2010. http://mesh.biology.washington.edu.

Borboroglu, P. G. 2010. "Adélie Penguin Pygoscelis adeliae." *The Global Penguin Society.* Accessed 8 Dec 2010. http://www.globalpenguinsociety.org/.

Bricher, P. K., A. Lucieer, and E. J. Woehler. 2008. "Population Trends of Adélie Penguin (Pygoscelis adeliae) Breeding Colonies: a Apatial Analysis of the Effects of Snow Accumulation and Human Activities." *Polar Biology* 31:1397–407.

Carlini, A. R., N. R. Coria, M. M. Santos, M. M. Libertelli, and G. Donini. 2007. "Breeding Success and Population Trends in Adélie Penguins in Areas with Low and High Levels of Human Disturbance." *Polar Biology* 30:917–24.

Chappell, M. A., D. N. Janes, V. H. Shoemaker, T. L. Bucher, and S. K. Maloney. 1993. "Reproductive Effort in Adélie Penguins." *Behavioral Ecology and Sociobiology* 33:173–82.

Cherel, Y. 2008. "Isotopic Niches of Emperor and Adélie Penguins in Adélie Land, Antarctica." *Marine Biology* 154:813–21.

Clarke, J. R. 2001. "Partitioning of Foraging Effort in Adélie Penguins Provisioning Chicks at Béchervaise Island, Antarctica." *Polar Biology* 24:16–20.

Clarke, J., B. Manly, K. Kerry, H. Gardner, E. Franchi, S. Corsolini, and S. Focardi. 1998. "Sex Differences in Adélie Penguin Foraging Strategies." *Polar Biology* 20:248–58.

Clarke, J., K. Kerry, C. Fowler, R. Lawless, S. Eberhard, and R. Murphy. 2003. "Post-Fledging and Winter Migration of Adélie Penguins Pygoscelis adeliae in the Mawson Region of East Antarctica." *Marine Ecology Progress* Series 248:267–78.

Clarke, J., K. Kerry, L. Irvine, and B. Phillips. 2002. "Chick Provisioning and Breeding Success of Adélie Penguins at Béchervaise Island over Eight Successive Seasons." *Polar Biology* 25:21–30.

Clarke, J., L. M. Emmerson, A. Townsend, and K. R. Kerry. 2003. "Demographic Characteristics of the Adélie Penguin Population on Béchervaise Island after 12 Years of Study." *CCAMLR Science* 10:53–74.

Davis, L. S. 1988. "Coordination of Incubation Routines and Mate Choice in Adélie Penguins (Pygoscelis adeliae)." *The Auk* 105:428–32.

Giese, M. 1996. "Effects of Human Activity on Adélie Penguin Pygoscelis adeliae Breeding Success." Biological Conservation 75:157–64.

Hunter, F. M., R. Harcourt, M. Wright, and L. S. Davis. 2000. "Strategic Allocation of Ejaculates by Male Adélie Penguins." *Proceedings: Biological Sciences* 267:1541–45.

Irvine, L. G., J. R. Clarke, and K. R. Kerry. 2000. "Low Breeding Success of the Adélie Penguin at Béchervaise Island in the 1998–1999 Season." *CCAMLR Science* 7:151-167.

Jenouvrier, S., C. Barbraud, and H. Weimerskirch. 2006. "Sea Ice Affects the Population Dynamics of Adélie Penguins in Terre Adélie." *Polar Biology* 29:413–23.

Kato, A., A. Yoshioka, and K. Sato. 2009. "Foraging Behavior of Adélie Penguins During Incubation Period in Lützow-Holm Bay." *Polar Biology* 32:181–86.

Kato, A., Y. Watanuki, and Y. Naito. 2003. "Annual and Seasonal Changes in Foraging Site and Diving Behavior in Adélie Penguins." *Polar Biology* 26:389–95.

Kerry, K. R., J. R. Clarke, S. Eberhard, H. Gardner, R. M. Lawless, R. Trémont, and B. C. Wienecke. 1997. "The Foraging Range of Adélie Penguins— Implications for CEMP and Interactions with the Krill Fishery." *CCAMLR Science* 4:75–87.

Lynnes, A. S., K. Reid, and J. P. Croxall. 2004. "Diet and Reproductive Success of Adélie and Chinstrap Penguins: Linking Response of Predators to Prey Population Dynamics." *Polar Biology* 27:544–54.

Marion, R. 1999. *Penguins: A Worldwide Guide*. 103–5. New York, New York: Sterling Publishing Company.

Marks, E. J., A. G. Rodrigo, and D. H. Brunton. 2010. "Using Logistic Regression Models to Predict Breeding Success in Male Adélie Penguins (Pygoscelis adeliae)." *Polar Biology* 33:1083–94.

Meyer-Rochow, V. B. and J. Gal. 2003. "Pressures Produced when Penguins Pooh—Calculations on Avian Dafaecation." *Polar Biology* 27:56–58.

Norman, F. I. and S. J. Ward. 1993. "Foraging Group Size and Dive Duration of Adélie Penguins Pygoscelis adeliae at Sea off Hop Island, Rauer Group, East Antarctica." *Marine Ornithology* 21:37–47.

Olsen, M. A., R. Mykleburst, T. Kaino, V. S. Elbrond, and S. D. Mathiesen. 2002. "The Gastrointestinal Tract of Adélie Penguins—Morphology and Function." *Polar Biology* 25:641–49.

Penney, R. L. 1967. "Molt in the Adélie Penguin." *The Auk* 84:61–71.

Rodary, D., B. C. Wienecke, and C. A. Bost. 2000. "Diving Behaviour of Adélie Penguins (Pygoscelis adeliae) at Dumont D'Urville, Antarctica: Nocturnal Patterns of Diving and Rapid Adaptations to Changes in Sea-Ice Condition." *Polar Biology* 23:113–20.

Rombolá, E., E. Marschoff, and N. Coria. 2003. "Comparative Study of the Effects of the Late Pack-Ice Break-Off on Chinstrap and Adélie Penguins' Diet and Reproductive Success at Laurie Island, South Orkney Islands, Antarctica." *Polar Biology* 26:41–48.

Ropert-Coudert, Y., R. P. Wilson, K. Yoda, and A. Kato. 2007. "Assessing Performance Constraints in Penguins with Externally-Attached Devices." *Marine Ecology Progress Series* 333:281–89.

Sladen, W. J. L. 1958. "The Pygoscelid Penguins." *Falkland Islands Dependencies Survey: Scientific Reports* 17:1–122.

Salihoglu, B., W. R. Fraser, and E. E. Hofmann. 2001. "Factors Affecting Fledging Weight of Adélie Penguin (Pygoscelis adeliae) Chicks: a Modeling Study." *Polar Biology* 24:328–37.

Takahashi, A., K. Sato, J. Nishikawa, Y. Watanuki, and Y. Naito. 2005. "Synchronous Diving Behavior of Adélie Penguins." *Journal of Ethology* 22:5–11.

Takahashi, A., Y. Watanuki, K. Sato, A. Kato, N. Arai, J. Nishikawa, and Y. Naito. 2003. "Parental Foraging Effort and Offspring Growth in Adélie Penguins: Does Working Hard Improve Reproductive Success?" *Functional Ecology* 17:590–97.

Tierney, M., L. Emmerson, and M. Hindell. 2009. "Temporal Variation in Adélie Penguin Diet at Béchervaise Island, East Antarctica and its Relationship to Reproductive Performance." *Marine Biology* 156:1633–45.

Vleck, C. M. and D. Vleck. 2002. "Physiological Condition and Reproductive Consequences in Adélie Penguins." *Integrative and Comparative Biology* 42:76–83.

Watanuki, Y., A. Kato, K. Sato, Y. Niizuma, C. A. Bost, Y. Le Maho, and Y. Naito. 2002. "Parental Mass Change and Food Provisioning in Adélie Penguins Rearing Chicks in Colonies with Contrasting Sea-Ice Conditions." *Polar Biology* 25:672–81.

Watanuki, Y., A. Kato, Y. Naito, G. Robertson, and S. Robinson. 1997. "Diving and Foraging Behaviour of Adélie Penguins in Areas with and without Fast Sea-Ice." *Polar Biology* 17:296–304.

Whitehead, M. S. 1989. "Maximum Diving Depths of the Adélie Penguin, Pygoscelis adeliae, During the Chick Rearing Period." *Polar Biology* 9:329-332.

Williams, T. D. 1995. *In The Penguins,* 169–178. New York: Oxford University Press.

Wilson, R. P. 1989. "Diving Depths of Gentoo Pygoscelis papua and Adélie P. adeliae Penguins at Esperanza Bay, Antarctic Peninsula." *An International Journal of Marine Ornithology* 17:1–8.

Yoda, K., and Y. Ropert-Coudert. 2007. "Temporal Changes in Activity Budgets of Chick-Rearing Adélie Penguins." *Marine Biology* 151:1951–57.

African

Adams, N. J., and C. R. Brown. 1990. "Energetics of Molt in Penguins." *In Penguin Biology.* edited by L. S. Davis, J. T. Darby. San Diego: Academic Press.

Boersma, D. and J. Banfill. 2009. "African Penguin." The Penguin Project. Penguin Sentinels, 2009. <http://mesh.biology.washington.edu>. Accessed 28 Oct 2010.

Cooper, J. 1977. "Energetic Requirements for Growth of the Jackass Penguin." *African Zoology* 12:20–23.

Cordes, I., R. J. M. Crawford, A. J. Williams, and B. M. Dyer. 1999. "Decrease of African Penguins at the Possession Island Group, 1956–1995: Contrasting Trends for Colonial and Solitary Breeders." *Marine Ornithology* 27:129–38.

Crawford, R. J. M. 2007. "Food, Fishing and Seabirds in the Benguela Upwelling System." *Journal of Ornithology* 48:253–60.

Crawford, R. J. M. and H. G. V. D. Boonstra. 1994. "Counts of Moulting and Breeding Jackass Penguins Spheniscus demersus: a Comparison at Robben Island, 1988–1993." *Marine Ornithology* 22:213–19.

Crawford, R. J. M., L. G. Underhill, L. Upfold, and B. M. Dyer. 2007. "An Altered Carrying Capacity of the Benguela Upwelling Ecosystem for African Penguins (Spheniscus demersus)." *ICES Journal of Marine Science* 64:570–76.

Crawford, R. J. M., L. J. Shannon, and P. A. Whittington. 1999. "Population Dynamics of the African Penguin Spheniscus demersus at Robben Island, South Africa." *Marine Ornithology* 27:139–47.

Crawford, R. J. M., M. Hemming, J. Kemper, N. T. W. Klages, R. M. Randall, L. G. Underhill, A. D. Venter, V. L. Ward, and A. C. Wolfaardt. 2006. "Molt of the African Penguin, Spheniscus demersus, in Relation to its Breeding Season and Food Availability." *Acta Zoologica Sinica* 52:444–47.

Crawford, R. J. M., P. J. Barham, L. G. Underhill, L. J. Shannon, J. C. Coetzee, B. M. Dyer, T. M. Leshoro, and L. Upfold. 2006. "The Influence of Food Availability on Breeding Success of African Penguins Spheniscus demersus at Robben Island, South Africa." *Biological Conservation* 132:119 –25.

Cunninghan, G. B., V. Strauss, and P. G. Ryan. 2008. "African Penguins (Spheniscus demersus) can Detect Dimethyl Sulphide, a Prey Related Odour." *Journal of Experimental Biology* 211:3123–27.

Hockey, P. A. R., W. R. J. Dean, and P. G. Ryan, eds. 2005. Roberts—Birds of Southern Africa, VIIth ed. Cape Town: The Trustees of the John Voelcker Bird Book Fund.

International Union for Conservation of Nature and Natural Resources. 2010. "Spheniscus demersus." In: IUCN 200. IUCN Red List of Threatened Species. Version 2010.4. Accessed 1 November 2010. www.iucnredlist.org.

Kemper, J., J. P. Roux, and L. G. Underhill. 2008. "Effect of Age and Breeding Status on Molt Phenology of Adult African Penguins (Spheniscus demersus) in Namibia." *The Auk* 125:809–19.

La Cock, G. D. and C. Hanel. 1987. "Survival of African Penguins Spheniscus demersus at Dyer Island, Southern Cape, South Africa." *Journal of Field Ornithology* 58(3):284–87.

Marion, R. 1999. *Penguins: A Worldwide Guide.* New York, New York: Sterling Publishing Company. 103–5.

Nimon, A. J., R. C. Schroter, and K. C. Oxenham. 1996. "Artificial Eggs: Measuring Heart Rate and Effects of Disturbance in Nesting Penguins." *Physiology & Behavior* 60:1019–22.

Owre, O. T. 1987. Untitled. *The Wilson Bulletin* 99:298–301.

Peterson, S. L., P. G. Ryan, and D. Gremillet. 2006. "Is Food Availability Limiting African Penguins Spheniscus demersus at Boulders? A Comparison of Foraging Effort at Mainland and Island Colonies." *Ibis* 48:14–26.

Randall, R. M. 1983. "Biology of the Jackass Penguin Spheniscus demersus (L.) at St. Croix Island, South Africa." PhD diss., University Port Elizabeth.

———. 1989. "Jackass Penguins." in Payne, A.I.L., Crawford RJM (Eds). *Oceans of Life off Southern Africa*, 244–56. Cape Town: Vlaeberg Publishers.

Randall, R. M. and B. M. Randall. 1981. "The Annual Cycle of the Jackass Penguin Spheniscus demersus at St Croix Island, South Africa." in Proc. Symp. *Birds of the Sea & Shore,* ed. by J. Cooper, 427–50. Cape Town: African Seabird Group.

Randall, R. M., B. M. Randall, J. Cooper, G. D. La Cock, and G. J. B. Ross. 1987. "Jackass Penguin Spheniscus demersus Movements, Inter-Island Visits, and Settlement." *Journal of Field Ornithology* 58:445–55.

Roux, J. P., J. Kemper, P. A. Bertlett, B. M. Dyer, and B. L. Dundee. 2003. "African Penguins Spheniscus demersus Recolonise a Formerly Abandoned Nesting Locality in Namibia." *Marine Ornithology* 31:203–5.

Seddon, P. J. and Y. van Heezik. 1991. "Effects of Hatching Order, Sibling Asymmetries, and Nest Site on Survival Analysis of Jackass Penguin Chicks." *The Auk* 108:548–55.

———. 1993. "Parent-Offspring Recognition in the Jackass Penguin." *Journal of Field Ornithology* 64:27–31.

Seddon, P. J., Y. van Heezik, and J. Cooper. 1991. "Observations of Within-Colony Breeding Synchrony in Jackass Penguins." *The Wilson Bulletin* 103:480–485.

Thumser, N. N. and M. S. Ficken. 1998. "A Comparison of Vocal Repertoires of Captive Spheniscus Penguins." *Marine Ornithology* 26:41–48.

Whittington, P. A. 1999. "The Contribution Made by Cleaning Oiled African Penguins Spheniscuz demersus to Population Dynamics and Conservation of the Species." *Marine Ornithology* 27:177–80.

Whittington, P. A., B. M. Dyer, and N. T. W. Klages. 2000. "Maximum Longevities of African Penguins Spheniscus demersus Based on Banding Records." *Marine Ornithology* 28:81–82.

Whittington, P. A., N. Klages, R. Crawford, A. Wolfarrdt, and J. Kemper. 2005. "Age at First Breeding of the African Penguin." *Ostrich* 76:14–20.

Wilkinson, C. P., D. A. Esmonde-White, L. G. Underhill, and P. A. Whittington. 1999. "African Penguins Spheniscus dermsus along with KwaZulu–Natal Coast, 1981–1999." *Marine Ornithology* 27:111–13.

Williams, A. J. and J. Cooper. 1984. "Aspects of the Breeding Biology of the Jackass Penguin Spheniscus demersus." *Proceedings of the Fifth Pan-African Ornithological Congress.* South African Ornithological Society, Johannesburg, South Africa. 84–853.

Williams, T. D. 1995. In *The Penguins,* 238–45. New York: Oxford University Press.

Wilson, R. P. 1985. "The Jackass Penguin (Spheniscus demersus) as a Pelagic Predator." *Marine Ecology Progress Series* 25:219–27.

Wilson, R. P. and D. Grémillet. 1996. "Body Temperatures of Free-Living African Penguins (Spheniscus demersus) and Bank Cormorants (Palacrocorax neglectus)." *The Journal of Experimental Biology* 199:2215–23.

Wolfaardt, A. C., L. G. Underhill, and R. J. M. Crawford. 2009. "Comparison of Moult Phenology of African Penguins, Spheniscus demersus at Robben Island and Dassen Islands." *African Journal of Marine Science* 3:9–29.

Wolfaardt, A. C., L. G. Underhill, R. J. M. Crawford, and P. A. Whittington. 2009. "Review of the Rescue, Rehabilitation and Restoration of Oiled Seabirds in South Africa, Especially African Penguins Spheniscus demersus and Cape Gannets Morus capensis, 1983–2005." *African Journal of Marine Science* 31:31–54.

Chinstrap

Amat, J. A., L. M. Carrascal, and J. Moreno. 1996. "Nest Defence by Chinstrap Penguins Pygoscelis antarctica in Relation to Offspring Number and Age." *Journal of Avian Biology* 27:177–79.

Amat, J. A., J. Viñuela, and M. Ferrer. 1993. "Sexing Chinstrap Penguins (Pygoscelis antarctica) by Morphological Measurements." *Colonial Waterbirds* 16:213–15.

Barbosa, A., S. Merino, J. Benzal, J. Martínez, and S. García-Fraile. 2007. "Population Variability in Heat Shock Proteins among Three Antarctic Penguin Species." *Polar Biology* 30:1239–44.

Barbosa, A., J. Moreno, J. Potti, and S. Merino. 1997. "Breeding Group Size, Nest Position and Breeding Success in the Chinstrap Penguin." *Polar Biology* 18:410–14.

Boersma, D., and C. Gentry. 2009. "Chinstrap Penguin." The Penguin Project. Penguin Sentinels. Accessed 28 Oct 2010. http://mesh.biology.washington.edu.

Borboroglu, P. G. 2010. "Chinstrap Penguin Pygoscelis antarctica." The Global Penguin Society. Accessed 8 Dec 2010. http://www.globalpenguinsociety.org.

Bustamante, J., and R. Márquez. 1996. "Vocalizations of the Chinstrap Penguin Pygoscelis antarctica." *Colonial Waterbirds* 19:101–10.

Croll, D. A., D. A. Demer, R. P. Hewitt, J. K. Jansen, M. E. Goebel, and B. R. Tershy. 2005. "Effects of Variability in Prey Abundance on Reproduction and Foraging in Chinstrap Penguins (Pygoscelis antarctica)." *Journal of Zoology* 269:506–13.

Croll, D. A., J. K. Jansen, M. E. Goebel, P. L. Boveng, and J. L. Bengtson. 1996. "Foraging Behavior and Reproductive Success in Chinstrap Penguins: The Effects of Transmitter Attachment." *Journal of Field Ornithology* 67:1–9.

Croll, D. A., S. D. Osmek, and J. L. Bengston. 1991. "An Effect of Instrument Attachment on Foraging Trip Duration in Chinstrap Penguins." *The Condor* 93:777–79.

Croxall, J. P. 1982. "Energy Costs of Incubation and Moult in Petrels and Penguins." *Journal of Animal Ecology* 51:177–94.

Culik, B. M., and R. P. Wilson. 1994. "Underwater Swimming at Low Energetic Cost by Pygoscelid Penguins." *Journal of Experimental Biology* 197:65–78.

Fargallo, J. A., J. A. Dávila, J. Potti, A. de León, and V. Polo. 2004. "Nest Size and Hatchling Sex Ratio Chinstrap Penguins." *Polar Biology* 27:339–43.

Fargallo, J. A., V. Polo, L. de Neve, J. Martín, J. A. Dávila, and M. Soler. 2006. "Hatching Order and Size-dependent Mortality in Relation to Brood Sex Ratio Composition in Chinstrap Penguins." *Behavioral Ecology* 17:772–78.

Forcada, J., P. N. Trathan, K. Reid, E. J. Murphy, and J. P. Croxall. 2006. "Contrasting Population Changes in Sympatric Penguin Species in Association with Climate Warming." *Global Change Biology* 12:411–23.

Golombek, D. A., J. A. Calcagno, and C. M. Luquet. 1991. "Circadian Activity Rhythm of the Chinstrap Penguin of Isla Media Luna, South Shetland Islands, Argentine Antarctica." *Journal of Field Ornithology* 62:293–98.

Hinke, J. T., K. Salwicka, S. G. Trivelpiece, G. M. Watters, and W. Z. Trivelpiece. 2007. "Divergent Responses of Pygoscelis Penguins Reveal a Common Environmental Driver." *Oecologia* 153:645–855.

Jansen, J. K., R. W. Russell, and W. R. Meyer. 2002. "Seasonal Shifts in the Provisioning Behavior of Chinstrap Penguins, Pygoscelis antarctica." *Oecologia* 131:306–18.

Lipsky, Jessica D., ed. 2007. *AMLR 2006/2007 Field Season Report.* La Jolla, California: National Oceanic and Atmospheric Administration.

Lishman, G. S., and J. P. Croxall. 1983. "Diving Depths of Chinstrap Penguins Pygoscelis antarctica." *British Antarctic Survey Bulletin* 61:21–25.

Lynnes, A. S., K. Reid, and J. P. Croxall. 2004. "Diet and Reproductive Success of Adélie and Chinstrap Penguins: Linking Response of Predators to Prey Population Dynamics." *Polar Biology* 27:544–54.

Marion, R. 1999. *Penguins: A Worldwide Guide.* New York, New York: Sterling Publishing Company. 82–85.

Martín, J., L. de Neve, J. A. Fargallo, V. Polo, and M. Soler. 2004. "Factors Affecting the Escape Behavior of Juvenile Chinstrap Penguins, Pygoscelis antarctica, in Response to Human Disturbance." *Polar Biology* 27:775–81.

Martín, J., L. de Neve, V. Polo, J. A. Fargallo, and M. Soler. 2006. "Health-dependent Vulnerability to Predation Affects Escape Responses of Unguarded Chinstrap Penguin Chicks." *Behavioral Ecology and Sociobiology* 60:778–84.

Metcheva, R., L. Yurukova, S. Teodorova, and E. Nikolova. 2006. "The Penguin Feathers as Bioindicator of Antarctica Environmental State." *Science of the Total Environment* 362:259–65.

Meyer, W. R., J. L. Bengston, J. K. Jansen, and R. W. Russell. 1997. "Relationships between Brood Size and Parental Performance in Chinstrap Penguins during the Chick Guard Phase." *Polar Biology* 17:228–34.

Meyer-Rochow, V. B., and J. Gal. 2003. "Pressures Produced when Penguins Pooh—Calculations on Avian Defaecation." *Polar Biology* 27:56–58.

Miller, A. K., and W. Z. Trivelpiece. 2008. "Chinstrap Penguins Alter Foraging and Diving Behavior in Response to the Size of Their Principal Prey, Antarctic Krill." *Marine Biology* 154:201–08.

Mínguez, E., J. Belliure, and M. Ferrer. 2001. "Bill Size in Relation to Position in the Colony in the Chinstrap Penguin." *Waterbirds: The International Journal of Waterbird Biology* 24:34–38.

Mínguez, E., J. A. Fargallo, A. de León, J. Moreno, and E. Moreno. 1998. "Age-related Variations in Bill Size of Chinstrap Penguins." *Colonial Waterbirds* 21:66–68.

Moreno, J., A. Barbosa, A. de León, and J. A. Fargallo. 1999. "Phenotypic Selection on Morphology at Independence in the Chinstrap Penguin Pygoscelis antarctica." *Journal of Evolutionary Biology* 12:507–13.

Moreno, J., L. Boto, J. A. Fargallo, A. de León, and J. Potti. 2000. "Absence of Extra–pair Fertilization in the Chinstrap Penguin Pygoscelis antarctica." *Journal of Avian Biology* 31:580–83.

Moreno, J., A. de León, J. A. Fargallo, and E. Moreno. 1998. "Breeding Time, Health and Immune Response in the Chinstrap Penguin Pygoscelis antarctica." *Oecologia* 115:312–19.

Moreno, J., and J. J. Sanz. 1996. "Field Metabolic Rates of Breeding Chinstrap Penguins (Pygoscelis antarctica)." *Physiological Zoology* 69:586–98.

Moreno, J., J. Viñuela, J. Belliure, and M. Ferrer. 1998. "Effect of Brood Size on Growth in the Chinstrap Penguin: A Field Experiment." *Journal of Field Ornithology* 69:269–75.

Mori, Y. 1997. "Dive Bout Organization in the Chinstrap Penguin at Seal Island, Antarctica." *Journal of Ethology* 15:9–15.

Mori, Y. 2001. "Individual Diving Behavior, Food Availability and Chick Growth Rates in Chinstrap Penguins." *Waterbirds: The International Journal of Waterbird Biology* 24:443–45.

Penteriani, V., J. Viñuela, J. Belliure, J. Bustamante, and M. Ferrer. 2003. "Causal and Functional Correlates of Brood Amalgamation in the Chinstrap Penguin Pygoscelis antarctica: Parental Decision and Adult Aggressiveness." *Polar Biology* 26:538–44.

Reidarson, T. H., J. F. McBain, and D. Denton. 1999. "The Use of Medroxyprogesterone Acetate to Induce Molting in Chinstrap Penguins (Pygoscelis antarctica)." *Journal of Zoo and Wildlife Medicine* 30:278–80.

Rombolá, E., E. Marschoff, and N. Coria. 2006. "Interannual Study of Chinstrap Penguin's Diet and Reproductive Success at Laurie Island, South Orkney Islands, Antarctica." *Polar Biology* 29:502–09.

Sander, M., T. C. Balbão, E. S. Costa, C. R. dos Santos, and M. V. Petry. 2006. "Decline of the Breeding Population of Pygoscelis antarctica and Pygoscelis adeliae on Penguin Island, South Shetland, Antarctica." *Polar Biology* 30:651–54.

Sander, M., T. C. Balbão, M. J. Polito, E. S. Costa, and A. P. B. Carneiro. 2007. "Recent Decrease in Chinstrap Penguin (Pygoscelis antarctica) Populations of Two of Admirality Bay's Islets on King George Island, South Shetland Islands, Antarctica." *Polar Biology* 30:659–61.

Takahashi, A., M. J. Dunn, P. N. Trathan, J. P. Croxall, R. P. Wilson, K. Sato, and Y. Naito. 2004. "Krill-feeding Behaviour in a Chinstrap Penguin Pygoscelis antarctica Compared with Fish-eating in Magellanic Penguins Spheniscus magellanicus: A Pilot Study." *Marine Ornithology* 32:47–54.

Trivelpiece, W. Z., J. L. Bengtson, S. G. Trivelpiece, and N. J. Volkman. 1986. "Foraging Behavior of Gentoo and Chinstrap Penguins as Determined by New Radiotelemetry Techniques." *The Auk* 103:777–81.

Trivelpiece, W. Z., S. Buckelew, C. Reiss, and S. G. Trivelpiece. 2007. "The Winter Distribution of Chinstrap Penguins from Two Breeding Sites in the South Shetland Islands of Antarctica." *Polar Biology* 30:1231–37.

Trivelpiece, W., and N. J. Volkman. 1979. "Nest–Site Competition between Adélie and Chinstrap Penguins: An Ecological Interpretation." *The Auk* 96:675–81.

Van Cise, Amy M., ed. 2008. *AMLR 2007/2008 Field Season Report.* La Jolla, California: National Oceanic and Atmospheric Administration.

Williams, T. D. 1995. *The Penguins.* New York: Oxford University Press. 178–85.

Wilson, R. P., and G. Peters. 1999. "Foraging Behaviour of the Chinstrap Penguin Pygoscelis antarctica at Ardley Island, Antarctica." *Marine Ornithology* 27:69–79.

Woehler, E. J., and J. P. Croxall. 1997. "The Status and Trends of Antarctic and Sub-Antarctic Seabirds." *Marine Ornithology* 25:43–66.

Emperor

Ancel, A., M. Beaulieu, Y. Le Maho, and C. Gilbert. 2009. "Emperor Penguin Mates: Keeping Together in the Crowd." *Proceedings of the Royal Society* 276:2163–69.

Angelier, F., C. Barbraud, H. Lormée, F. Prud'homme, and O. Chastel. 2006. "Kidnapping of Chicks in Emperor Penguins: a Hormonal By-Product?" *Journal of Experimental Biology* 209:1413–20.

Barber-Meyer, S. M., G. L. Kooyman, and P. J. Ponganis. 2007. "Estimation of the Relative Abundance of Emperor Penguins at Inaccessible Colonies Using Satellite Imagery." *Polar Biology* 30:1565–70.

Boersma, D., D. Richards. "Emperor Penguin." The Penguin Project. Penguin Sentinels. Accessed 28 Oct 2010. http://mesh.biology.washington.edu.

Bried, J., D. Pontier, and P. Jouventin. 2003. "Mate Fidelity in Monogamous Birds: a re-Examination of the Procellariiformes." *Animal Behaviour* 65:235–46.

Burger, J. and M. Gochfeld. 2007. "Responses of Emperor Penguins (Aptenodytes forsteri) to Encounters with Ecotourists while Commuting to and from their Breeding Colony." *Polar Biology* 30:1303–13.

Burns, J. M. and G. L. Kooyman. 2001. "Habitat Use by Weddell Seals and Emperor Penguins Foraging in the Ross Sea, Antarctica." *American Zoology* 41:90–98.

Cherel, Y. 2008. "Isotopic Niches of Emperor and Adélie Penguins in Adélie Land, Antarctica." *Marine Biology* 154:813–21.

Cherel, Y. and G. Kooyman. 1998. "Food of Emperor Penguins (Aptenodytes forsteri) in the Western Ross Sea, Antarctica." *Marine Biology* 130:335–44.

Davis, L. S., and M. Renner. 2003. *Penguins.* New Haven: Yale University Press.

Gilbert, C., G. Robertson, Y. Le Maho, and A. Ancel. 2008. "How do Weather Conditions Affect the Huddling Behaviour of Emperor Penguins?" *Polar Biology* 31:163–69.

Gilbert, C., S. Blanc, Y. Le Maho, and A. Ancel. 2008. "Review: Energy Saving Processess in Huddling Emperor Penguins; From Experiments to Theory." *Journal of Experimental Biology* 211:1–8.

Gilbert, C., Y. Le Maho, M. Perret, and A. Ancel. 2006. "Body Temperature Changed Induced by Huddling in Breeding Male Emperor Penguins." *The American Journal of Physiology—Regulatory, Integrative and Comparative Physiology* 292:176–85.

Groscolas, R., and Y. Cherel.1992. "How to Molt while Fasting in the Cold: The Metabolic and Hormonal Adaptations of Emperor and King Penguins." *Ornis Scandinavica* 23: 328–334.

Jenouvrier, S., H. Caswell, C. Barbraud, M. Holland, J. Strœve, and H. Weimerskirch. 2009. "Demographic Models and IPCC Climate Projections Predict the Decline of an Emperor Penguin Population." *Proceedings of the National Academy of Science of the United States of America* 106:1844–47.

Jouventin, P., C. Barbraud, and M. Rubin. 1995. "Adoption in the Emperor Penguin, Apenodytes forsteri." *Animal Behavior* 50:1023–29.

Jouventin, P., K. J. McGraw, M. Morel, and Célerier. 2007. "Dietary Carotenoid Supplementation Affects Orange Beak but not Foot Coloration in Gentoo Penguins., Pygoscelis papua." *Waterbirds* 30:573–78.

Jouventin, P., P. M. Nolan, J. Örnborg, and F. S. Dobson. 2005. "Ultraviolet Beak Spots in King and Emperor Penguins." *The Condor* 107:144–50.

Kirkwood, R. and G. Robertson. 1997. "The Foraging Ecology of Female Emperor Penguins in Winter." *Ecological Monographs* 67:155–76.

Kooyman, G. L., D. B. Siniff, I. Stirling, and J. L. Bengston. 2004. "Moult Habitat, pre- and post-Moult Diet and post-Moult Travel of Ross Sea Emperor Penguins." *Marine Ecology Progress Series* 267:281–90.

Kooyman, G. L. and J. L. Mullins. 1990. "Ross Sea Emperor Penguin Breeding Populations Estimated by Aerial Photography." *In Antarctic Ecosystems: Ecological Change and Conservation,* edited by K. R. Kerry and G. Hempel, 169–76, Berlin: Springer-Verlag.

Kooyman, G. L. and P. J. Ponganis. 2008. "The Initial Journey of Juvenile Emperor Penguins." *Aquatic Conservation: Marine and Freshwater Ecosystems* 17:37–43.

Meir, J. U., T. K. Stockard, C. L. Williams, K. V. Ponganis, and P. J. Ponganis. 2008. "Heart Rate Regulation and Extreme Bradycardia in Diving Emperor Penguins." *Journal of Experimental Biology* 211:1169–79.

Ponganis, P. J., L. N. Starke, M. Horning, and G. L. Kooyman. 1999. "Development of Diving Capacity in Emperor Penguins." *Journal of Experimental Biology* 202:781–86.

Ponganis, P. J., M. L. Costello, L. N. Starke, O. Mathieu-Costello, and G. L. Kooyman. 1997. "Structural and Biochemical Characteristics of Locomotory Muscles of Emperor Penguins, Aptenodytes forsteri." *Respiration Physiology* 109:73–80.

Ponganis, P. J., T. K. Stockard, J. U. Meir, C. L. Williams, K. V. Ponganis, R. P. van Dam, and R. Howard. 2007. "Returning on Empty: Extreme Blood O2 Depletion Underlies Dive Capacity of Emperor Penguins." *Journal of Experimental Biology* 210:4279–85.

Robertson, G., R. Williams, K. Green, and L. Robertson. 1994. "Diet Composition of Emperor Penguin Chicks Aptenodytes forsteri at two Mawson Coast Colonies, Antarctica." *Ibis* 136:19–31.

St. Clair, C. C. and M. S. Boyce. 2009. "Icy Insights from Emperor Penguins." *Proceedings of the Nation Academy of Sciences of the United States of America* 106:1691–92.

Sato, K., P. J. Ponganis, Y. Habara, and Y. Naito. 2005. "Emperor Penguins Adjust Swim Speed According to the Above-Water Height of Ice Holes Through Which They Exit." *Journal of Experimental Biology* 208:2549–54.

Tamburrini, M., S. G. Condò, G. di Prisco, and B. Giardina. 1994. "Adaption to Extreme Environments: Structure-Function Relationships in Emperor Penguin Haemoglobin." *Journal of Molecular Biology* 237:615–21.

Van Dam, R. P., P. J. Ponganis, K. V. Ponganis, D. H. Levenson, and G. Marshall. 2002. "Stroke Frequencies of Emperor Penguins Diving Under Sea Ice." *Journal of Experimental Biology* 205:3769–74.

Wienecke, B., G. Robertson, R. Kirkwood, and K. Lawton. 2007. "Extreme Dives by Free-Ranging Emperor Penguins." *Polar Biology* 30:133–42.

Wienecke, B., R. Kirkwood, and G. Robertson. 2004. "Pre-Moult Foraging Trips and Moult Locations of Emperor Penguins at the Mawson Coast." *Polar Biology* 27:83–91.

Williams, T. D. 1995. In *The Penguins,* 152–60. New York: Oxford University Press.

Zimmer, I., R. P. Wilson, C. Gilbert, M. Beaulieu, A. Ancel, and J. Plötz. 2008. "Foraging Movements of Emperor Penguins at Point Géologie, Antarctica." *Polar Biology* 31:229–43.

Erect-Crested

Boersma, D. "Erect-Crested Penguin." The Penguin Project. Penguin Sentinels. Accessed 28 Oct 2010. http://mesh.biology.washington.edu.

Richdale, L. E. 1941. "The Erect-Crested Penguin (Eudyptes sclateri) Buller." *Emu* 41:25–53.

Warham, J. 1972. "Aspects of the Biology of the Erect-Crested Penguin Eudyptes sclateri." *Ardea* 60:145–84.

Warham, J. and B. D. Bell. 1979. "The Birds of Antipodes Island, New Zealand." *Notornis* 26:121–69.

Williams, T. D. 1995. In The Penguins, 206–11. New York: Oxford University Press.

Williams, T. D. and S. Rodwell. 1992. "Annual Variation in Return Rate, Mate and Nest-Site Fidelity in Breeding Gentoo and Macaroni Penguins." *The Condor* 94:636–45.

Fiordland-Crested

Boersma, D. "Fiordland Crested Penguin." The Penguin Project. Penguin Sentinels. Accessed 28 Oct 2010. http://mesh.biology.washington.edu.

Croxall, J. P. 1982. "Energy Costs of Incubation and Moult in Petrels and Penguins." *Journal of Animal Ecology* 51:177–94.

———. 1995. "Sexual Dimorphism in Seabirds." *Oikos* 73:399–403.

Desser, S. S. and F. B. Allison. 1979. "Aspects of the Sporogonic Development of Leucocytozoon tawaki of the Fiordland Crested Penguin in Its Primary Vector, Austrosimulium ungulatum: An Ultrastructural Study." *The Journal of Parasitology* 65:737–44.

Dubois, F., F. Cézilly, and M. Pagel. 1998. "Mate Fidelity and Coloniality in Waterbirds: A Comparative Analysis." *Oecologia* 116:433–40.

Grau, C. R. 1982. "Egg Formation in Fiordland Crested Penguins (Eudyptes pachyrhynchus)." *Condor* 84:172–77.

Johnson, K., J. C. Bednarz, and S. Zack. 1987. "Crested Penguins: Why Are First Eggs Smaller?" *Oikos* 49:347–49.

McLean, I. G. 2000. "Breeding Success, Brood Reduction and the Timing of Breeding in the Fiordland Crested Penguin (Eudyptes pachyrhynchus)." *Notornis* 47:57–60.

McLean, I. G. and S. D. Kayes. 2000. "Genetic Monogamy Mirrors Social Monogamy in the Fiordland Crested Penguin."

Murie, J. O., L. S. David, and I. G. McLean. 1991. "Identifying the Sex of Fiordland crested Penguins by Morphometric Characters." *Notornis* 38:233–38.

St. Clair, C. C. 1992. "Incubation Behavior, Brood Patch Formation and Obligate Brood Reduction in Fiordland Crested Penguins." *Behavioral Ecology and Sociobiology* 31:409–16.

St. Clair, C. C., I. McLean, J. O. Murie, S. M. Phillipson, and B. J. S. Studholme. 1999. "Fidelity to Nest Site and Mate in Fiordland Crested Penguins Eudyptes pachyrhynchus." *Marine Ornithology* 27:37–41.

St. Clair, C. C. and R. C. St. Clair. 1992. "Weka Predation on Eggs and Chicks of Fiordland Crested Penguins." *Notornis* 39:60–63.

Studholme, B. J. S., R. B. Russ, and I. G. McLean. 1994. "The Fiordland Crested Penguin Survey: Stage IV, Stewart and Offshore Islands and Solander Island." *Notornis* 41:133–43.

Van Heezik, Y. M. 1989. "Diet of the Fiordland Crested Penguin During the Post-Guard Phase of Chick Growth." *Notoris* 36:151–56.

Warham, J. 1974. "The Fiordland Crested Penguin Eudyptes pachyrhynchus." *Ibis* 116:1–27.

Williams, T. D. 1995. In *The Penguins*, 195–200. New York: Oxford University Press.

Galapagos

Beck, R. H. 1904. "Bird Life Among the Galapagos Islands." *The Condor* 6:5–11.

Boersma, D. "Galapagos Penguin." The Penguin Project. Penguin Sentinels. Accessed 28 Oct 2010. http://mesh.biology.washington.edu.

Boersma, P. D. 1974. "The Galapagos Penguin: A Study of Adaptations for Life in an Unpredictable Environment." PhD diss., Ohio State University.

———. 1976. "An Ecological and Behavioral Study of the Galápagos Penguin." *Living Bird* 15:43–93.

———. 1978. "Breeding Patterns of the Galápagos Penguins as an Indicator of Oceanographic Conditions." *Science* 200:1481–83.

———. 1998. "Population Trends of the Galápagos Penguin: Impacts of El Niño and La Niña." *The Condor* 100:245–53.

———. 2000. "Penguins as Marine Sentinels." *BioScience* 58:597–607.

Boersma, P. D., H. Vargas, and G. Merlen. 2005. "Living Laboratory in Peril." *Science* 308:925.

Harris, M. P. 1973. "The Galápagos Avifauna." *The Condor* 75:265–78.

Marion, R. 1999. *Penguins: A Worldwide Guide.* New York, New York: Sterling Publishing Company. 109–12.

Mills, K. 1998. "Multispecies Seabird Feeding Flocks in the Galápagos Islands." *The Condor* 100:277–85.

———. 2000. "Diving Behaviour of two Galápagos Penguins Spheniscus mendiculus." *Marine Ornithology* 28:75–79.

Nims, B. D., F. H. Vargas, J. Merkel, and P. G. Parker. 2008. "Low Genetic Diversity and Lack of Population Structure in the Endangered Galápagos Penguin (Spheniscus mendiculus)." *Conservation Genetics* 9:1413–20.

Palacios, D. M. 2004. "Seasonal Patterns of Sea-Surface Temperature and Ocean Color Around the Galápagos: Regional and Local Influences." *Deep-Sea Res II* 51:43–57.

Parque Nacional Galapagos. 2005. "Analysis of the Population Viability and the Galapagos Penguin Habitat (*Spheniscus mendiculus*)." Workshop. Santa Cruz, Ecuador.

Rosenberg, D. K., C. A. Valle, M. C. Coulter, and S. A. Harcourt. 1990. "Monitoring Galapagos Penguins and Flightless Cormorants in the Galapagos Islands." *The Wilson Bulletin* 102:525–32.

Schreer, J. F., K. M. Kovacs, R. H. O. Hines. 2001. "Comparative Diving Patterns of Pinnipeds and Seabirds." *Ecological Monographs* 71:137–62.

Steinfurth, A., F. H. Vargas, R. P. Wilson, M. Spindler, and D. W. Macdonald. 2008. "Space Use by Foraging Galápagos Penguins During Chick Rearing." *Endangered Species Research* 4:105–12.

Townsend, C. H. 1927. "The Galapagos Penguin in Captivity." *The Auk* 44:509–12.

Travis, E. K., F. H. Vargas, J. Merkel, N. Gottdenker, R. E. Miller, and P. G. Parker. 2006. "Hematology, Serum Chemistry, and Serology of Galapagos Penguins (Spheniscus mendiculus) in the Galapagos Islands, Ecuador." *Journal of Wildlife Disease* 42: 625–632

Valle, C. A. and M. C. Coulter. 1987. "Present Status of the Flightless Cormorant, Galapagos Penguin and Greater Flamingo Populations in the Galapagos Islands, Ecuador, after the 1982–83 El Niño." *The Condor* 89:276–81.

Vargas, H., C. Lougheed, and H. Snell. 2005. "Population Size and Trends of the Galápagos Penguin Spheniscus mendiculus." *Ibis* 147:367–74.

Vargas, F. H., R. C. Lacy, P. J. Johnson, A. Steinfurth, R. J. M. Crawford, P. D. Boersma, and D. W. Macdonald. 2007. *Biological Conservation* 137:138–48.

Vargas, F. H., S. Harrison, S. Rea, and D. W. Macdonald. 2006. "Biological Effects of El Niño on the Galapagos Penguin." *Biological Conservation* 127:107–14.

Williams, T. D. 1995. In *The Penguins,* 258–63. New York: Oxford University Press.

Gentoo

Adams, N. J. and C. R. Brown. 1983. "Diving Depths of the Gentoo Penguin (Pygoscelis papua)." *The Condor* 85:503–4.

Barbosa, A., S. Merino, J. Benzal, J. Martínez, and S. García-Fraile. 2007. "Population Variability in Heat Shock P among Three Antarctic Penguin Species." *Polar Biology* 30:1239–44.

Bevan, R. M., P. J. Butler, A. J. Woakes, and I. L. Boyd. 2002. "The Energetic of Gentoo Penguins, Pygoscelis papua, during the Breeding Season." *Functional Ecology* 16:175–90.

Bingham, M. 1998. "The Distribution, Abundance and Population Trends of Gentoo, Rockhopper and King Penguins at the Falkland Islands." *ORYX* 32:223–32.

Boersma, D. "Gentoo Penguin." The Penguin Project. Penguin Sentinels. Accessed 28 Oct 2010. http://mesh.biology.washington.edu.

Bost, C. A., K. Pütz, and J. Lage. 1994. "Maximum Diving Depth and Diving Patterns of the Gentoo Penguin Pygoscelis papua at the Crozet Islands." *Marine Ornithology* 22:237–44.

Clausen, A., A. I. Arkhipkin, V. V. Laptikhovsky, and N. Huin. 2005. "What is Out There: Diversity in Feeding of Gentoo Penguins (Pygoscelis papua) around the Falkland Islands (Southwest Atlantic)." *Polar Biology* 28:653–62.

Clausen, A. P. and K. Pütz. 2002. "Recent Trends in Diet Composition and Productivity of Gentoo, Magellanic and Rockhopper Penguins in the Falkland Islands." *Aquatic Conservation: Marine and Freshwater Ecosystems* 12:51–61.

———. 2003. "Winter Diet and Foraging Range of Gentoo Penguins (Pygoscelis papua) from Kidney Cove, Falkland Islands." Polar Biology 26:32–40.

Cobley, N. D. and J. R. Shears. 1999. "Breeding Performance of Gentoo Penguins (Pygoscelis papua) at a Colony Exposed to High Levels of Human Disturbance." *Polar Biology* 21:355–60.

Copeland, K. E. 2008. "Concerted Small-Group Foraging Behavior in Gentoo Penguins Pygoscelis papua." *Marine Ornithology* 36:193–94.

Coria, N., M. Libertelli, R. Casaux, and C. Darrieu. 2000. "Inter-Annual Variation in the Autumn Diet of the Gentoo Penguin at Laurie Island, Antarctica." *The International Journal of Waterbird Biology* 23:511–17.

Crosbie, K. 1999. "Interactions Between Skuaas Catharacta sp. and Gentoo Penguins Pygoscelis papua in Relation to Tourist Activities at Cuverville Island, Antarctic Peninsula." *Marine Ornithology* 27:195–97.

Cuervo, J. J., M. J. Palacios, and A. Barbosa. 2009. "Beak Colouration as a Possible Sexual Ornament in Gentoo Penguins: Sexual Dichromatism and Relationship to Body Condition." *Polar Biology* 32:1305–14.

Culik, B., R. Wilson R, and R. Bannasch. 1994. "Underwater Swimming at Low Energetic Cost by Pygoscelid Penguins." *Journal of Experimental Biology* 197:65–78.

Davis, R. W., J. P. Croxall, and M. J. O'Connell. 1989. "The Reproductive Energetics of Gentoo (Pygoscelis papua) and Macaroni (Eudyptes chrysolophus) Penguins at South Georgia." *Journal of Animal Ecology* 58:59–74.

Ghys, M. I., A. R. Rey, and A. Schiavini. 2008. "Population Trend and Breeding Biology of Gentoo Penguin in Martillo Island, Tierra Del Fuego, Argentina." *Waterbirds* 31:625–31.

Hinke, J. T., K. Salwicka, S. G. Trivelpiece, G. M. Watters, and W. Z. Trivelpiece. 2007. "Divergent Responses of Pygoscelis Penguins Reveal a Common Environmental Driver." O*ecologia* 153:645–55.

Holmes, N. D. 2007. "Comparing King, Gentoo, and Royal Penguin Responses to Pedestrian Visitation." *The Journal of Wildlife Management* 71:2575–82.

Holmes, N. D., M. Giese, H. Achurch, S. Robinson, and L. K. Kriwoken. 2006. "Behaviour and Breeding Success of Gentoo Penguins Pygoscelis papua in Areas of Low and High Human Activity." *Polar Biology* 29:399–412.

Lescroël, A., C. Bajzak, and C. A. Bost. 2009. "Breeding Ecology of the Gentoo Penguin Pygoscelis papua at Kerguelen Archipelago." *Polar Biology* 32:1495–1505.

Lescroël, A., V. Ridoux, and C. A. Bost. 2004. "Spatial and Temporal Variation in the Diet of Gentoo Penguin (Pygoscelis papua) at Kerguelen Islands." *Polar Biology* 27:206–16.

Lynch, H. J. 2011. "The Gentoo Penguin." in *Biology and Conservation of the World's Penguins* edited by P.D. Boersma and P.G. Borboroglu, Seattle: University of Washington Press.

Metcheva, R., V. Bezrukov, S. E. Teodorova, and Y. Yankov. 2008. " 'Yellow Spot'—A New Trait of Gentoo Penguins Pygoscelis papua ellsworthii in Antarctica." *Marine Ornithology* 36:47–51.

Meyer-Rochow, V. B. and A. Shimoyama. 2008. "UV-Reflecting and Absorbing Body Regions in Gentoo and King Penguins: Can They Really be Used by the Penguins as Signals for Conspecific Recognition?" *Polar Biology* 31:557–60.

Nimon, A. J., R. C. Schroter, and R. K. C. Oxenham. 1996. "Artificial Eggs: Measuring Heart Rate and Effects of Disturbance in Nesting Penguins." *Physiology and Behavior* 60:1019–22.

Otley, H. M., A. P. Clausen, D. J. Christe, and K. Pütz. 2005. "Aspects of the Breeding Biology of the Gentoo Penguin Pygoscelis papua at Volunteer Beach, Falkland Islands, 2001/01." *Marine Ornithology* 33:167–71.

Peterson, S. L., G. M. Branch, D. G. Ainley, P. D. Boersma, J. Cooper, and E. Woehler, 2005. "Is Flipper Banding of Penguins a Problem?" *Marine Ornithology* 33:75–79.

Polito, M. J. and W. Z. Trivelpiece. 2008. "Transition to Independence and Evidence of Extended Parental Care in the Gentoo Penguin (Pygoscelis papua)." *Marine Biology* 154:231–40.

Pütz, K., J. Ingham, J. G. Smith, and J. P. Croxall. 2001. "Population Trends, Breeding Success and Diet Composition of Gentoo Pygoscelis papua, Magellanic Spheniscus magellanicus and Rockhopper Eudyptes chrysocome Penguins in the Falkland Islands." *Polar Biology* 24:793–807.

Quintana, R. D. and V. Cirelli. 2000. 'Breeding Dynamics of a Gentoo Penguin Pygoscelis papua Population at Cierva Point, Antarctic Peninsula." *Marine Ornithology* 28:29–35.

Reid, K. 1995. "Oiled Penguins Observed at Bird Island, South Georgia." *Marine Ornithology* 23:53–57.

Reilly, P. N., and J. A. Kerle. 1981. "A Study of the Gentoo Penguin Pygoscelis papua." *Notornis* 28: 189–202.

Renner, M., J. Valencia, L. S. Davis, D. Saez, and O. Cifuentes. 1998. "Sexing of Adult Gentoo Penguins in Antarctica Using Morpohmetrics." *Colonial Waterbirds* 21:444–49.

Stonehouse, B. 1970. "Geographic Variation in Gentoo Penguins." *Ibis* 112:52–57.

Takahashi, A., N. Kokubun, Y. Mori, and H. C. Shin. 2008. "Krill-Feeding Behaviour of Gentoo Penguins as Shown by Animal-Borne Camera Loggers." *Polar Biology* 31:1291–94.

Tanton, J. L., K. Reid, J. P. Croxall, and P. N. Trathan. 2004. "Winter Distribution and Behavior of Gentoo Penguins Pygoscelis papua at South Georgia." *Polar Biology* 27:299–303.

Trivelpiece, W. Z., J. L. Bengtson, S. G. Trivelpiece, N. J. Volkman. 1986. "Foraging Behavior of Gentoo and Chinstrap Penguins as Determined by New Radiotelemetry Techniques." *The Auk* 103:777–81.

Williams, T. D. 1995. In *The Penguins,* 160–69. New York: Oxford University Press.

Wilson, R. P. 1989. "Diving Depths of Gentoo Pygoscelis papua and Adélie P.adeliae Penguins at Esperanza Bay, Antarctic Peninsula." *An International Journal of Marine Ornithology* 17:1–8.

Wilson, R. P., B. Alvarrez, L. Latorre, D. Adelung, B. Culik, and R. Bannasch. 1998. "The Movements of Gentoo Penguins Pygoscelis papua from Ardley Island, Antarctica." *Polar Biology* 19:407–13.

Glossary

"About IUCN." IUCN. International Union for Conservation of Nature, July 30, 2010. Accessed 16 November 2010. http://www.iucnredlist.org.

———. IUCN Red List of Threatened Species. International Union for Conservation of Nature, October, 2010. Accessed 16 November 2010. http://www.iucnredlist.org.

McGlone, J. J. 1986. "Agonistic Behavior in Food Animals: Review of Research and Technique." *Journal of Animal Science* 62:1130–39.

Humboldt

Araya, B. 1988. "Status of the Humboldt Penguin in Chile following the 1982–83 El Niño." *Spheniscus Penguin Newsletter* 1:8–10.

BirdLife International 2011. IUCN Red List for birds. Accessed 2 February 2011. http://www.birdlife.org.

Boersma, D. "Humboldt Penguin." The Penguin Project. Penguin Sentinels. Accessed 28 Oct 2010. http://mesh.biology.washington.edu.

Bunting, E. M., N. A. Madi, S. Cox, T. Martin-Jimenez, H. Fox, and G. V. Kollias. 2009. "Evaluation of Oral Itraconazole Administration in Captive Humboldt Penguins (Spheniscus humboldti)." *Journal of Zoo and Wildlife Medicine* 40:508–18.

Cooper, J., A. J. Williams, and P. L. Britton. 1984. "Distribution, Population Sizes and Conservation of Breeding Seabirds in the Afrotropical Region." In *Status and Conservation of the World's Seabirds*, edited by J. P, Croxall, P. G. H. Evans, and R. W. Schreiber, 403–19. Cambridge: ICBP.

Costantini, V., A. C. Guaricci, P. Laricchiuta, F. Rausa, and G. M. Lacalandra. 2008. "DNA Sexing in Humboldt Penguins (Spheniscus humboldti) from Feather Samples." *Animal Reproduction Science* 106:162–67.

Culik, B. M., and G. Luna-Jorquera. 1997a. "Satellite Tracking of Humboldt Penguins (Spheniscus humboldti) in Northern Chile." *Marine Biology* 128:547–56.

———. 1997b. "The Humboldt Penguin Spheniscus humboldti: a Migratory Bird?" *Journal für Ornithologie* 138:325–30.

Culik, B. M., J. Hennicke, and T. Martin. 2000. "Humboldt Penguins Outmaneuvering El Niño." *The Journal of Experimental Biology* 203:2311–22.

Ellenberg, U., T. Mattern, P. J. Seddon, G. L. Jorquera. 2006. "Physiological and Reproductive Consequences of Human Disturbance in Humboldt Penguins: The Need for Species-Specific Visitor Management." *Biological Conservation* 133:95–106.

Hall, H. D. (Director) 2008. Endangered and Threatened Wildlife and Plants; 12-Month Finding on a Petition to List Five Penguin Species Under the Endangered Species Act, and Proposed Rule To List the Five Penguin Species. Arlington, Virginia.

Herling, C., B. M. Culik, and J. C. Henniche. 2005. "Diet of the Humboldt Penguin (Spheniscus humboldti) in Northern and Southern Chile." *Marine Biology* 147:13–25.

Jouventin, P., C. Couchoux, and F. S. Dobson. 2009. "UV Signals in Penguins." *Polar Biology* 31:513–414.

Luna-Jorquera, G. and B. M. Culik. 1999. "Diving Behaviour of Humboldt Penguins Spheniscus humboldti in Northern Chile." *Marine Ornithology* 27:67–76.

Luna-Jorquera, G., B. M. Culik, and R. Aguilar. 1996. "Capturing Humboldt Penguins Spheniscus humboldti with the Use of an Anaesthetic." *Marine Ornithology* 24:47–50.

Mattern, T., U. Ellenburg, G. Luna-Jorquera, and L. S. Davis. 2004. "Humboldt Penguin Census on Isla Chañaral Chile: Recent Increase or Past Underestimate of Penguin Numbers?" *Waterbirds* 27:368–76.

Paredes, R. and C. B. Zavalaga. 2001. "Nesting Sites and Nest Types as Important Factors for the Conservation of Humboldt Penguins (Spheniscus humboldti)." *Biological Conservation* 100:199–205.

Paredes, R., C. B. Zavalaga, and D. J. Boness. 2002. "Patterns of Egg Laying and Breeding Success in Humboldt Penguins (Spheniscus humboldti) at Punta San Juan, Peru." *The Auk* 119:244–50.

Paredes, R., C. B. Zavalaga, G. Battistini, P. Majluf, and P. McGill. 2003. "Status of the Humboldt Penguin in Peru, 1999–2000." *Waterbirds* 26:126–38.

Schlosser, J. A., J. M. Dubach, T. W. J. Garner, B. Araya, M. Bernal, A. Simeone, K. A. Smith, and R. S. Wallace. 2009. "Evidence for Gene Flow Differs from Observed Dispersal Patterns in Humboldt Penguin, Spheniscus humboldti." *Conservation Genetics* 10:839–49.

Scholten, C. J. 1999. "Iris Colour of Humboldt Penguins Spheniscus humboldti." *Marine Ornithology* 27:187–94.

Schwartz, M. K., D. J. Boness, C. M. Schaeff, P. Majluf, E. A. Perry, and R. C. Fleischer. 1999. "Female-Solicited Extra-Pair Matings in Humboldt Penguins Fail to Produce Extrapair Fertilizations." *Behavioral Ecology* 10:242–50.

Skewgar, E., A. Simeone, and P. D. Boersma. 2009. "Marine Reserve in Chile would Benefit Penguins and Ecotourism." *Ocean and Coastal Management* 52:487–91.

Simeone, A., B. Araya, M. Bernal, E. N. Biebold, K. Grzybowski, M. Michaels, H. A. Teare, R. S. Wallace, and M. J. Willis. 2002. "Oceanographic and Climatic Factors Influencing Breeding and Colony Attendance Patterns of Humboldt Penguins Spheniscus humboldti in Central Chile." *Marine Ecology Progress Series* 227:43–50.

Simeone, A., G. Luna-Jorquera, and R. P. Wilson. 2004. "Seasonal Variations in the Behavioural Thermoregulation of Roosting Humboldt Penguins (Spheniscus humboldti) in North-Central Chile." *Journal of Ornithology* 145:35–40.

Simeone, A., L. Hiriart-Bertrand, R. Reyes-Arriagada, M. Halpern, J. Dubach, R. Wallace, K. Pütz, and B. Lüthi. 2009. "Heterospecific Pairing and Hybridization between Wild Humboldt and Magellanic Penguins in Southern Chile." *The Condor* 111:544–550.

Smith, K. M., W. B. Karesh, P. Majluf, R. Paredes, C. Zavalaga, A. H. Reul, M. Stetter, W. E. Braselton, H. Puche, and R. A. Cook. 2008. "Health Evaluation of Free-Ranging Humboldt Penguins (Spheniscus humboldti) in Peru." *Avian Diseases* 52:130–35.

Taylor, S. S. and M. L. Leonard. 2001. "Foraging Trip Duration Increases for Humboldt Penguins Tagged with Recording Devices." *Journal of Avian Biology* 32:369–71.

Taylor, S. S., M. L. Leonard, and D. J. Boness. 2001. "Aggressive Nest Intrusions by Male Humboldt Penguins." *The Condor* 103:162–65.

Taylor, S. S., M. L. Leonard, D. J. Boness, and P. Majluf. 2002. "Foraging by Humboldt Penguins (Spheniscus humboldti) during the Chick-Rearing Period: General Patterns, Sex Differences, and Recommendations to Reduce Incidental Catches in Fishing Nets." *Canadian Journal of Zoology* 80:700–7.

———. 2004. "Humboldt Penguins Spheniscus humboldti Change Their Foraging Behaviour Following Breeding Failure." *Marine Ornithology* 32:63–67.

Teare, J. A., E. N. Diebold, K. Grzybowski, M. G. Michaels, R. S. Wallace, and M. J. Willis. 1998. "Nest Site Fidelity in Humboldt Penguins (Spheniscus humboldti) at Algarrobo, Chile." *Penguin Conservation* 11:22–23.

UNEP &WCMC. 2003. "Report on the Status and Conservation of the Humboldt Penguin." *UNEP World Conservation Monitoring Centre* 1:1–13.

Van Buren, A. N. and P. D. Boersma. 2007. "Humboldt Penguins (Spheniscus humboldti) in the Northern Hemisphere." *The Wilson Journal of Ornithology* 119:284–88.

Villouta, G., R. Hargreaves, and V. Rtveros. 1997. "Haematological and Clinical Biochemistry Findings in Captive Humboldt Penguins (Spheniscus humboldti)." *Avian Pathology* 26:851–58.

Wallace, R. S., J. Dubach, M. G. Michaels, N. S. Keuler, E. D. Diebold, K. Grzybowski, J. A. Teare, and M. J. Willis. 2008. "Morphometric Determination of Gender in Adult Humboldt Penguins (Spheniscus humboldti)." *Waterbirds* 31:448–53.

Weichler, T., S. Garthe, G. Luna-Jorquera, and J. Moraga. 2004. "Seabird Distribution on the Humboldt Current in Northern Chile in Relation to Hydrography, Productivity, and Fisheries." *Journal of Marine Science* 61:148–54.

Williams, T. D. 1995. In *The Penguins*, 245–49. New York: Oxford University Press.

Zavalaga, C. B. and R. Paredes. 1997. "Sex Determination of Adult Humboldt Penguins Using Morphometric Characters." *Journal of Field Ornithology* 68:102–12.

King

Bried, J., F. Jiguet, and P. Jouventin. 1999. "Why do Aptenodytes Penguins have High Divorce Rate?" *The Auk* 116:504–12.

Brodin, A., O. Olsson, and C. W. Clark. 1998. "Modeling the Breeding Cycle of Long-lived Birds: Why Do King Penguins Try to Breed Late?" *The Auk* 115:767–71.

Cherel, Y., J. C. Stahl, Y. Le Maho. 1987. "Ecology and Physiology of King Penguin Chicks." *The Auk* 104:254–62.

Cherel, Y., K. A. Hobson, F. Bailleul, and R. Groscolas. 2005. "Nutrition, Physiology, and Stable Isotopes: New Information from Fasting and Molting Penguins." *Ecology* 86:2881–88.

Cherel, Y. and Y. Le Maho. 1985. "Five Months of Fasting in King Penguin Chicks: Body Mass Loss and Fuel Metabolism." *American Journal of Physiology* 249:387–92.

Corbel, H., F. Morlon, S. Geiger, R. Groscolas. 2009. "State-Dependent Decisions during the Fledging Process of King Penguin Chicks." *Animal Behavior* 78:829–38.

Côté, S. 2000. "Aggressiveness in King Penguins in Relation to Reproductive Status and Territory Location." *Animal Behaviour* 59:813–21.

Croxall, J. P. 1982. "Energy Costs of Incubation and Moult in Petrels and Penguins." *Journal of Animal Ecology* 51:177–94.

Culik, B. M., K. Pütz, R. P. Wilson, D. Allers, J. Lage, C. A. Bost, and Y. L. Maho. 1996. "Diving Energetics in King Penguins (Aptenodytes patagonicus)." *The Journal of Experimental Biology* 199:973–83.

Delord, K., C. Barbraud, and H. Weimerskirch. 2004. "Long-Term Trends in the Population Size of King Penguins at Crozet Archipelago: Environmental Variability and Density Dependence?" *Polar Biol.* 27:793–800.

Descamps, S., C. Le Bohec, Y. Le Maho, J. P. Gendner, and M. Gauthier-Clerc. 2009. "Relating Demographic Performance to Breeding-Site Location in the King Penguin." *The Condor* 111:81–87.

Descamps, S., M. Gauthier-Clerc, J. P. Gendner, and Y. Le Maho. 2002. "The Annual Breeding Cycle of Unbanded King Penguins Aptenodytes patagonicus on Possession Island (Crozet)." *Avian Science* 2:87–98.

Dobson, S. F., P. M. Nolan, M. Nicolaus, C. Bajzak, A. S. Coquel, and P. Jouventin. 2008. "Comparison of Color and Body Condition Between Early and Late Breeding King Penguins." *Ethology* 114:925–33.

Froget, G., P. J. Butler, A. J. Woakes, A. Fahlman, G. Kuntz, Y. Le Maho, and Y. Handrich. 2004. "Heart Rate and Energetics of Free-Ranging King Penguins (Aptenodytes patagonicus)." *Journal of Experimental Biology* 207:3917–26.

Gauthier-Clerc, M., Y. Le Maho, J. P. Gendner, J. Durant, and Y. Handrich. 2001. "State-Dependent Decisions in Long-Term Fasting King Penguins, Aptenodytes patagonicus, During Courtship and Incubation." *Animal Behaviour* 62:661–669.

Halsey, L. G., C. R. White, A. Fahlman, Y. Handrich, and P. J. Butler. 2007. "Onshore Energetic in Penguins: Theory, Estimation and Ecological Implications." *Comparative Biochemistry and Physiology* 147:1009–14.

Jouventin, P., D. Capdeville, F. Cuenot-Chillet, and C. Boiteau. 1994. "Exploitation of Pelagic Resources by a Non-Flying Seabird: Satellite Tracking of the King Penguin Throughout the Breeding Cycle." *Marine Ecology Progress Series* 106:11–19.

Kooyman, G. L., Y. Cherel, Y. Le Maho, J. P. Croxall, P. H. Thorson, V. Ridoux, and C. A. Kooyman. 1992. "Diving Behavior and Energetics During Foraging Cycles in King Penguins." *Ecological Monographs* 62:143–63.

Le Bohec, C., M. Gauthier-Clerc, and Y. Le Maho. 2005. "The Adaptive Significance of Crèches in the King Penguin." *Animal Behaviour* 70:527–38.

Marion, R. 1999. In *Penguins: A Worldwide Guide*, 32–37. New York, New York: Sterling Publishing Company.

Moore, G. J., B. Wienecke, and G. Robertson. 1999. "Seasonal Change in Foraging Areas and Dive Depths of Breeding King Penguins at Heard Island." *Polar Biology* 21:376–84.

Olsson, O. 1996. "Seasonal Effects of Timing and Reproduction in the King Penguin: A Unique Breeding Cycle." *Journal of Avain Biology* 27:7–14.

———. 1998. "Divorce in King Penguins: Asynchrony, Expensive Fat Storing and Ideal Free Mate Choice." *OIKOS* 83:574–81.

Olsson, O. and A. Brodin. 1997. "Changes in King Penguin Breeding Cycle in Response to Food Availability." *The Condor* 99:994–97.

Olsson, O. and A. W. North. 1997. "Diet of King Penguins Aptenodytes patagonicus during Three Summers at South Georgia." *Ibis* 139:504–12.

Olsson, O. and H. P. van der Jeugd. 2002. "Survival in King Penguins Aptenodytes patagonicus: Temporal and Sex-Specific Effects of Environmental Variability." *Oecologia* 132:509–26.

Olsson, O., J. Bonnedehl, and P. Anker-Nilssen. 2001. "Mate Switching and Copulation Behavior in King Penguins." *Journal of Avian Biology* 32:139–45.

Punt, S. and D. Boersma. "King Penguin." The Penguin Project. Penguin Sentinels. Accessed 28 Oct 2010. http://mesh.biology.washington.edu.

Pütz, K. 2002. "Spatial and Temporal Variability in the Foraging Areas of Breeding King Penguins." *The Condor* 104:528–38.

Pütz, K. and C. A. Bost. 1994. "Feeding Behaviour of Free-Ranging King Penguins Aptenodytes patagonicus." *Ecology* 75:489–97.

Stonehouse, B. 1956. "The King Penguin of South Georgia." *Nature* 178:1424–26.

———. 1960. "The King Penguin Aptenodytes patagonicus of South Georgia I. Breeding Behaviour and Development." *Scientific Report of the Falkland Islands Dependencies Survey* 23:1–81.

Surai, P. F., B. K. Speake, F. Decrock, and R. Groscolas. 2001. "Transfer of Vitamins E and A from Yolk to Embryo during Development of the King Penguin (Aptenodytes patagonicus)." *Physiological and Biochemical Zoology* 74:928–36.

Van Der Hoff, J., R. J. Kirkwood, and P. B. Copley. 1993. "Aspects of the Breeding Cycle of King Penguins Aptenodytes patagonicus at Heard Island." *Marine Ornithology* 21:49–55.

Weimerskirch, H., J. C. Stahl, P. Jouventin. 1992. "The Breeding Biology and Population Dynamics of King Penguins Aptenodytes patagonicus on the Crozet Islands." *Ibis* 134:107–17.

Williams, T. D. 1995. In *The Penguins*, 143–52. New York: Oxford University Press.

Little

Arnould, J. P. Y., P. Dann, and J. M. Cullen. 2004. "Determining the Sex of Little Penguins (Eudyptula minor) in Northern Bass Strait Using Morphometric Measurements." *Emu* 104:261–65.

Banks, J. C., A. D. Mitchell, J. R. Waas, and A. M. Paterson. 2002. "An Unexpected Pattern of Molecular Divergence within the Blue Penguin (Eudyptula minor) Complex." *Notornis* 49:29–38.

Banks, J. C., R. H. Cruickshank, G. M. Srayton, and A. M. Paterson. 2008. "Few Genetic Differences Between Victorian and Western Australian Blue Penguins, Eudyptula minor." *New Zealand Journal of Zoology* 25:265–70.

Bethge, P., S. Nicol, B. M. Culik, R. P. Wilson. 1997. *Journal of Zoology London* 242:483–502.

Billing, T. M., P. J. Guay, A. J. Peucker, and R. A. Mulder. 2007. "Isolation and Characterization of Polymorphic Microsatellite Loci for the Study of Paternity and Population Structure in the Little Penguin Eudyptula minor." *Molecular Ecology Notes* 7:425–27.

Boggs, D. F., R. V. Baudinette, P. B. Frappell, and P. J. Butler. 2001. "The Influence of Locomotion on Air-Sac Pressures in Little Penguins." T*he Journal of Experimental Biology* 204:3581–86.

Bull, L. 2000. "Fidelity and Breeding Success of the Blue Penguin Eudyptula minor on Matiu-Somes Island, Wellington, New Zealand." *New Zealand Journal of Zoology* 27:291–98.

Chiaradia, A. F. and K. R. Kerry. 1999. "Daily Nest Attendance and Breeding Performance in the Little Penguin Eudyptula minor at Phillip Island, Australia." *Marine Ornithology* 27:13–20.

Chiaradia, A., J. McBride, T. Murray, and P. Dann. 2007. "Effect of Fog on the Arrival Time of Little Penguins Eudyptula minor: a Clue for Visual Orientation?" *Journal of Ornithology* 148:229–33.

Chiaradia, A. F., Y. Ropert-Coudert, A. Kato, T. Mattern, and J. Yorke. 2007. "Diving Behaviour of Little Penguins from Four Colonies across Their Whole Distribution Range: Bathymetry Affecting Diving Effort and Fledging Success." *Marine Biology* 151:1535–42.

Choong, B., G. Allinson, S. Salzman, R. Overeem. 2007. "Trace Metal Concentrations in the Little Penguin (Eudyptula minor) from Southern Victoria, Australia." *Bulletin of Environmental Contamination and Toxicology.* 78:48–52.

Collins, M., J. M. Cullen, and P. Dann. 1999. "Seasonal and Annual Foraging Movements of Little Penguins from Phillip Island, Victoria." *Wildlife Research* 26:705–21.

Croxall, J. P. 1982. "Energy Costs of Incubation and Moult in Petrels and Penguins." *Journal of Animal Ecology* 51:177–94.

Cullen, J. M., L. E. Chambers, P. C. Coutin, and P. Dann. 2009. "Predicting Onset and Success of Breeding in Little Penguins Eudyptula minor from Ocean Temperatures." *Marine Ecology Progress Series* 378:269–78.

Daniel, T. A., A. Chiaradia, M. Logan, G. P. Quinn, and R. D. Reina. 2007. "Synchronized Group Association in Little Penguins, Eudyptula minor." *Animal Behaviour* 74:1241–48.

Dann, P. 1988. "An Experimental Manipulation of Clutch Size in the Little Penguin Eudyptula minor." *Emu* 88:101–3.

———. 1994. "The Abundance, Breeding Distribution, and Nest Sites of Blue Penguins in Otago, New Zealand." *Notornis* 41:157–66.

Dann, P. and F. I. Norman. 2006. "Population Regulation in Little Penguins (Eudyptula minor): The Role of Intraspecific Competition for Nesting Sites and Food during Breeding." *Emu* 106:289–96.

Dann, P., I. Norman, and P. Reily. 1995. In *The Penguins: Ecology and Management*, 39–55. NSW, Australia: Surrey Beatty & Sons Pty Limited.

Dann, P., M. Carron, B. Chambers, L. Chambers, T. Dornom, A. McLaughlin, B. Sharp, M. E. Talmage, R. Thoday, and S. Unthank. 2005. "Longevity in Little Penguins." *Marine Ornithology* 33:71–72.

Department of Environment and Climate Change. 2007. *Status of the Endangered Population of Little Penguins, Eudyptula minor at Manly*. Government of New South Wales, Australia. 1–21.

Gales, R. 1985. "Breeding Seasons and Double Brooding of the Little Penguin Eudyptula minor in New Zealand." *Emu* 85:127–130.

Gales, R. and B. Green. 1990. "The Annual Energetics Cycle of Little Penguins (Eudyptula minor)." *Ecology* 71:2297–2312.

Grabski, V. and D. Boersma. "Little Penguin." The Penguin Project. Penguin Sentinels. Accessed 28 Oct 2010. http://mesh.biology.washington.edu.

Green, J. A., P. B. Frappel, T. D. Clark, and P. J. Butler. 2006. "Physiological Response to Feeding in Little Penguins." *Physiological and Biochemical Zoology* 79:1088–97.

———. 2008. "Predicting Rate of Oxygen Consumption from Heart Rate while Little Penguins Work, Rest and Play." *Comparative Biochemistry and Physiology* 150:222–30.

Heber, S., K. J. Wilson, and L. Molles. 2008. "Breeding Biology and Breeding Success of the Blue Penguin (Eudyptula minor) on the West Coast of New Zealand's South Island." *New Zealand Journal of Zoology* 35:63–71.

Hocken, A. G. 2000a. "Cause of Death on Blue Penguins (Eudyptula m. minor) in North Otago, New Zealand." *New Zealand Journal of Zoology* 27:305–9.

———. 2000b. "Internal Organ Weights of the Blue Penguin Eudyptula minor." *New Zealand Journal of Zoology* 27:299–304.

Hocken, A. G. and J. J. Russell. 2002. "A Method for Determination of Gender from Bill Measurements in Otago Blue Penguins (Eudyptula minor)." *New Zealand Journal of Zoology* 29:63–69.

Hoskins, A. J., P. Dann, Y. Ropert-Coudert, A. Kato, A. Chiaradia, D. P. Costa, and J. P. Y. Arnould. 2008. "Foraging Behaviour and Habitat Selection of the Little Penguin Eudyptula minor during Early Chick Rearing in Bass Strait, Australia." *Marine Ecology Progress Series* 366:293–303.

Hull, C. L., M. A. Hindell, R. P. Gales, R. A. Meggs, D. I. Moyle, and N. P. Brothers. 1998. "The Efficacy of Translocating Little Penguins Eudyptula minor during an Oil Spill." *Biological Conservation* 86:393–400.

Kato, A., Y. Ropert-Coudert, and A. Chiaradia. 2008. "Regulation of Trip Duration by an Inshore Forager, the Little Penguin (Eudyptula minor), during Incubation." *The Auk* 125:588–93.

Kemp, A. and P. Dann. 2001. "Egg Size, Incubation Periods and Hatching Success of Little Penguins Eudyptula minor." *Emu* 101:249–53.

Miyazaki, M. and J. R. Waas. 2003. "Acoustic Properties of Male Advertisement and Their Impact on Female Responsiveness in Little Penguins Eudyptula minor." *Journal of Avian Biology* 34:229–32.

Morgan, I. R., H. A. Westbury, and J. Campbell. 1985. "Viral Infections of Little Blue Penguins (Eudyptula minor) Along the Southern Coast of Australia." *Journal of Wildlife Diseases* 21:193–98.

Nisbet, I. C. T. and P. Dann. 2009. "Reproductive Performance of Little Penguins Eudptula minor in Relation to Year, Age, Pair-Bond Duration, Breeding Date and Individual Quality." *Journal of Avian Biology* 40:296–308.

Numata, M., L. S. Davis, and M. Renner. 2000. "Prolonged Foraging Trips and Egg Desertion in Little Penguins (Eudyptula minor)." *New Zealand Journal of Zoology* 27:277–89.

———. 2004. "Growth and Survival of Chicks in Relation to Best Attendance Patterns of Little Penguins (Eudyptula minor) at Oamaru and Motuara Island, New Zealand." *New Zealand Journal of Zoology* 31:263–69.

Overseem, R. L., A. J. Peucker, C. M. Austin, P. Dann, and C. P. Burridge. 2008. "Contrasting Genetic Structuring between Colonies of the World's Smallest Penguin, Eudyptula minor (Aves: Spheniscidae)." *Conservation Genetics* 9:893–905.

Perriman, L., D. Houston, H. Steen, and E. Johannesen. 2000. "Climate Fluctuation Effects on the Breeding of Blue Penguins (Eudyptula minor)." *New Zealand Journal of Zoology* 27:261–67.

Perriman, L. and H. Steen. 2000. "Blue Penguin (Eudyptula minor) Nest Distribution and Breeding Success on Otago Peninsula, 1992 to 1998." *New Zealand Journal of Zoology* 27:269–275.

Peucker, A. J., P. Dann, and C. P. Burridge. 2009. "Range-Wide Phylogeography of the Little Penguin (Eudyptula minor): Evidence of Long-Distance Dispersal." *The Auk* 126:397–408.

Preston, T. J., Y. Roper-Coudert, A. Kato, A. Chiaradia, R. Kirkwood, P. Dann, and R. D. Reina. 2008. "Foraging Behaviour of Little Penguins Eudyptula minor in an Artificially Modified Environment." *Endangered Species Research* 4:95–103.

Reilly, P. N. and J. M. Cullen. 1981. "The Little Penguin Eudyptula minor in Victoria, II: Breeding." *Emu* 81:1–19.

Rogers, T. and C. Knight. 2006. "Burrow and Mate Fidelity in the Little Penguin Eudyptula minor at Lion Island, New South Wales, Australia." *Ibis* 148:801–806.

Ropert-Coudert, Y., A. Chiaradia, and A. Kato. 2006. "An Exceptionally Deep Dive by a Little Penguin Eudyptula minor." Marine Ornithology 34:71–74.

Sidhu, L. A., E. A. Catchpole, and P. Dann. 2007. "Mark-Recapture-Recovery Modeling and Age-Related Survival in Little Penguins (Eudyptula minor)." *The Auk* 124:815–827.

Stevenson, C. and E. J. Woehler. 2007. "Population Decrease in Little Penguins Eudyptula minor in Southeastern Tasmania, Australia, Over the Past 45 years." *Marine Ornithology* 35:71–76.

VGDSE (Victorian Government Department of Sustainability and Environment). 2009. "Baywide Little Penguin Monitoring Program: Quarterly Report (Jan–Mar 2009)." Victoria Island: VGDSE.

Watanuki, Y., S. Wanless, M. Harris, J. R. Lovvorn, M. Miyazaki, H. Tanaka, and K. Sato. 2006. *The Journal of Experimental Biology* 209:1217–1230.

Williams, T. D. 1995. In *The Penguins*, 230–238. New York: Oxford University Press.

Macaroni

Bernstein, N. P. and P. C.Tirrell. 1981. "New Southerly Record for the Macaroni Penguin (Eudyptes chrysolophus) on the Antarctic Peninsula." *The Auk* 98:398–99.

Boersma, D. "Macaroni Penguin." The Penguin Project. Penguin Sentinels. Accessed 28 Oct 2010. http://mesh.biology.washington.edu.

Bost, C. A., J. B. Thiebot, D. Pinaud, Y. Cherel, and P. N. Trathan. 2009. "Where do Penguins go during the Inter-Breeding Period? Using Geolocation to Track the Winter Dispersion of the Macaroni Penguin." *Biology Letters* 5:473–76.

Brown, C. R. 1987. "Traveling Speed and Foraging Range of Macaroni and Rockhopper Penguins at Marion Island." *Journal of Field Ornithology* 58:118–25.

Cherel, Y. and K. A. Hobson. 2007. "Geographical Variation in Carbon Stable Isotope Signatures of Marine Predators: A Tool to Investigate their Foraging Areas in the Southern Ocean." *Marine Ecology Progress Series* 329:281–87.

Cherel, Y., K. A. Hobson, C. Guinet, and C. Vanpe. 2007. "Stable Isotopes Document Seasonal Changes in Trophic Niches and Winter Foraging Individual Specialization in Diving Predators from the Southern Ocean." *Journal of Animal Ecology* 76:826–36.

Clark, B. D. and W. Bemis. 1979. "Kinematics of Swimming Penguins at the Detroit Zoo." *Journal of Zoology London* 188:411–28.

Cresswell, K. A., J. Wiedenmann, and M. Mangel. 2008. "Can Macaroni Penguins Keep up with Climate- and Fishing-Induced Changes in Krill?" *Polar Biology* 31:641–49.

Croxall, J. P. 1982. "Energy Costs of Incubation and Moult in Petrels and Penguins." *Journal of Animal Ecology* 51:177–94.

Croxall, J. P., R. W. Davis, and M. J. O'Connell. 1988. "Diving Patterns in Relation to Diet of Gentoo and Macaroni at South Georgia." *The Condor* 90:157–67.

Davis, L. S. and M. Renner. 2003. *Penguins*. New Haven: Yale University Press.

Davis, R. W., J. P. Croxall, and M. J. O'Connell. 1989. "The Reproductive Energetics of Gentoo (Pygoscelis papua) and Macaroni (Eudyptes chrysolophus) Penguins at South Georgia." *Journal of Animal Ecology* 58:59–74.

Dobson, S. F. and P. Jouventin. 2003. "Use of the Nest Site as a Rendezvous in Penguins." *Waterbirds* 26:409–15.

Green, J. A., C. R. White, and P. J. Butler. 2005. "Allometric Estimation of Metabolic Rate from Heart Rate in Penguins." *Comparative Biochemistry and Physiology* 142:478–484.

Green, J. A., P. J. Butler, A. J. Woakes, and I. L. Boyd. 2002. "Energy Requirements of Female Macaroni Penguins Breeding at South Georgia." *Functional Ecology* 16:671–81.

———. 2003. "Energetics of Diving Macaroni Penguins." *The Journal of Experimental Biology* 206:43–57.

Green, J. A., P. J. Butler, A. J. Woakes, and I. L. Boyd. 2004. "Energetics of the Moult Fast in Female Macaroni Penguins Eudyptes chrysolophus." *Journal of Avian Biology* 35:153–61.

Green, J. A., R. Williams, and M. G. Green. 1998. "Foraging Ecology and Diving Behaviour of Macaroni Penguins Eudyptes chrysolophus at Heard Island." *Marine Ornithology* 26:27–34.

Green, J. A., R. P. Wilson, I. L. Boyd, A. J. Woakes, C. J. Green, and P. J. Butler. 2009. "Tracking Macaroni Penguins during Long Foraging Trips Using 'Behavioural Geolocation'." *Polar Biology* 32:645–53.

Gwynn, A. M. 1953. "The Egg-Laying and Incubation Periods of Rockhopper, Macaroni and Gentoo Penguins." *Australian National Antarctic Research Expedition Report, Ser.* B 1:1–19.

Lynnes, A. S., K. Reid, and J. P. Croxall. 2004. "Diet and Reproductive Success of Adélie and Chinstrap Penguins: Linking Response of Predators to Prey Population Dynamics." *Polar Biology* 27:544–54.

Lynnes, A. S., K. Reid, J. P. Croxall, and P. N. Trathan. 2002. "Conflict or Co-Existence? Foraging Distribution and Competition for Prey Between Adélie and Chinstrap Penguins." *Marine Biology* 141:1165–74.

Oehler, D. A., S. Pelikan, W. R. Fry, L. Weakley Jr., A. Kusch, and M. Marin. 2008. "Status of Crested Penguin (Eudyptes spp.) Populations on Three Islands in Southern Chile." *The Wilson Journal of Ornithology* 120:575–81.

Ropert-Coudert, Y., A. Kato, R. P. Wilson, and M. Kurita. 2002. "Short Underwater Opening of the Beak Following Immersion in Seven Penguin Species." *The Condor* 104:444–48.

Sato, K., K. Shiomi, Y. Watanabe, Y. Watanuki, A. Takahashi, and P. J. Ponganis. 2010. "Scaling of Swim Speed and Stroke Frequency in Geometrically Similar Penguins: They Swim Optimally to Minimize Cost of Transport." *Proceeding of the Royal Society of Britain* 277:707–14.

Williams, A. J., W. R. Siegfried, A. E. Burger, and A. Berruti. 1977. "Body Composition and Energy Metabolism of Moulting Eudyptid Penguins." *Comp. Biochem. Physiol.* 56:27–30.

Williams, T. D. 1980. "Offspring Reduction in Macaroni and Rockhopper Penguins." *The Auk* 97:754–59.

———. 1989. "Aggression, Incubation Behavior and Egg-Loss in Macaroni Penguins, Eudyptes chrysolophus, at South Georgia." *Oikos* 55:19–22.

———. 1990. "Growth and Survival in Macaroni Penguin, Eudyptes chrysolophus, A- and B-Chicks: Do Females Maximise Investments in the Large B-Egg?" *Oikos* 59:349–54.

———. 1995. In *The Penguins*, 211–20. New York: Oxford University Press.

Williams, T. D. and S. Rodwell. 1992. "Annual Variation in Return Rate, Mate and Nest-Site Fidelity in Breeding Gentoo and Macaroni Penguins." *The Condor* 94:636–45.

Woehler, E. J. 1993. "The Distribution and Abundance of Antarctic and sub-Antarctic Penguins." Cambridge: Scientific Committee on Antarctic Research.

Wyk, J. C. P. 1995. "Unusually Coloured Penguins at Marion Island, 1993–1994." *Marine Ornithology* 23:58–60.

Magellanic

Akst, E. P., P. D. Boersma, and R. C. Fleischer. 2002. "A Comparison of Genetic Diversity between the Galápagos Penguin and the Magellanic Penguin." *Conservation Genetics* 3:375–83.

Bertellotti, M., J. L. Tella, J. A. Godoy, G. Blanco, M. G. Forero, J. A. Donázar, and O. Ceballos. 2002. "Determining Sex of Magellanic Penguins Using Molecular Procedures and Discriminant Functions." *Waterbirds* 25:479–84.

Boersma, D. "Magellanic Penguin." The Penguin Project. Penguin Sentinels. Accessed 28 Oct 2010. http://mesh.biology.washington.edu.

Boersma, P. D. 2008. "Penguins as Marine Sentinels." *Bioscience* 58:597–607.

Boersma, P. D., D. L. Stokes, and P. M. Yorio. 1990. "Reproductive Variability and Historical Change of Magellanic Penguins (Spheniscus magellanicus) at Punta Tombo, Argentina." In *Penguin Biology*, edited by L. S. Davis and J. T. Darby, 15–43. San Diego: Academic Press.

Boersma, P. D., G. A. Rebstock, and D. L. Stokes. 2004. "Why Penguin Eggshells are Thick." *The Auk* 121:148–55.

Boersma, P. D., G. A. Rebstock, E. Frere, and S. E. Moore. 2009. "Following the Fish: Penguins and Productivity in the South Atlantic." *Ecological Monographs* 79:59–76.

Borboroglu, P. G., P. D. Boersma, V. Ruoppolo, L. Reyes, G. A. Rebstock, K. Griot, S. R. Heredia, A. C. Adornes, and R. P. de Silva. 2006. "Chronic Oil Pollution Harms Magellanic Penguins in the Southwest Atlantic." *Marine Pollution Bulletin* 52:193–98.

Borboroglu, P. G., P. Yurio, P. D. Boersma, H.D. Valle, and M. Bertellotti. 2002. "Habitat Use and Breeding Distribution of Magellanic Penguins in Northern San Jorge Gulf, Patagonia, Argentina." *The Auk* 119:233–39.

Bouzat, J. L., B. G. Walker, and P. D. Boersma. 2009. "Regional Genetic Structure in the Magellanic Penguin(Spheniscus magellanicus) Suggests Metapopulation Dynamics." *The Auk* 126:326–34.

Clausen, A. P. and K. Pütz. 2002. "Recent Trends in Diet Composition and Productivity of Gentoo, Magellanic and Rockhopper Penguins in the Falkland Islands." *Aquatic Conservation: Marine and Freshwater Ecosystems* 12:51–61.

Fonseca, V. S. D. S., M. V. Petry, and A. H. Jost. 2001. "Diet of Magellanic Penguin on the Coast of Rio Grande do Sul, Brazil." *Waterbirds* 24:290–93.

Forero, M. G., J. L. Tella, K. A. Hobson, M. Bertellotti, and G. Blanco. 2002. "Conspecific Food Competition Explains Variability in Colony Size: A Test in Magellanic Penguins." *Ecology* 83:3466–75.

Fowler, G.s 1999. "Behavioral and Hormonal Responses of Magellanic Penguins (Spheniscus magellanicus) to Tourism and Nest Site Visitation." *Biological Conservation* 90:143–49.

Frere, E., P. Gandini, and P. D. Boersma. 1992. "Effects of Nest Type and Location on Reproductive Success of the Magellanic Penguin Spheniscus magellanicus." *Marine Ornithology* 20:1–6.

Green, J. A., I. L. Boyd, A. J. Woakes, C. J. Green, and P. J. Butler. 2005. "Do Seasonal Changes in Metabolic Rate Facilitate Changes in Diving Behaviour?" *The Journal of Experimental Biology* 208:2581–93.

Otley, H. M., A. P. Clausen, D. J. Christie, and K. Pütz. 2004. "Aspects of the Breeding Biology of the Magellanic Penguin in the Falkland Islands." *Waterbirds* 27:396–405.

Peters, G., R. P. Wilson, A. Scolaro, S. Laurenti, J. Upton, and H. Galleli. 1998. "The Diving Behavior of Magellanic Penguins at Punta Norte, Peninsula Valdés, Argentina." *Colonial Waterbirds* 21:1–10.

Pinto, M. B. L. C., S. Siciliano, A. P. M. Beneditto. 2007. "Stomach Contents of the Magellanic Penguin Spheniscus magellanicus from the Northern Distribution Limit on the Atlantic Coast of Brazil." *Marine Ornithology* 35:77–78.

Potti, J., J. Moreno, P. Yorio, V. Briones, P. G. Borboroglu, S. Villar, and C. Ballesteros. 2002. "Bacteria Divert Resources from Growth for Magellanic Penguin Chicks." *Ecology Letters* 5:709–14.

Pütz, K., A. Schiavini, A. R. Rey, B. H. Lüthi. 2007. "Winter Migration of Magellanic Penguins (Spheniscus magellanicus) From the Southernmost Distributional Range." *Marine Biology* 152:1227–35.

Radl, A. and B. M. Culik. 1999. "Foraging Behaviour and Reproductive Success in Magellanic Penguins (Spheniscus magellanicus): A Comparative Study of Two Colonies in Southern Chile." *Marine Biology* 133:381–93.

Rafferty, N. E., P. D. Boersma, and G. A. Rebstock. 2005. "Intraclutch Egg-Size Variation in Magellanic Penguins." *The Condor* 107:921–26.

Renison, D., P. D. Boersma, A. N. Van Buren, M. B. Martella. 2006. "Agonistic Behavior in Wild Male Magellanic Penguins: When and How do They Interact?" *Journal of Ethology* 24:189–93.

Renison, D., D. Boersma, and M. Martella. 2002. "Winning and Losing: Causes for Variability in Outcome of Fights in Male Magellanic Penguins (Spheniscus magellanicus)." *Behavioral Ecology* 13:462–66.

———. 2003. "Fighting in Female Magellanic Penguins: When, Why, and Who Wins?" *Wilson Bull* 115:58–63.

Scolaro, J. A. and A. M. Suburo. 1995. "Timing and Duration of Foraging Trips in Magellanic Penguins Spheniscus magellanicus." *Marine Ornithology* 23:231–35.

Scolaro, J. A., M. A. Hall, and I. M. Ximénez. 1983. "The Magellanic Penguin (Spheniscus magellanicus): Sexing Adults by Discriminant Analysis of Morphometric Characters." *The Auk* 100:221–24.

Simeone, A., L. Hiriart-Bertrand, R. Reyes-Arriagada, M. Halpern, J. Dubach, R. Wallace, K. Pütz, and B. Lüthi. 2009. "Heterospecific Pairing and Hybridization between Wild Humboldt and Magllanic Penguins in Southern Chile." *The Condor* 111:544–50.

Simeone, A. and R. P. Wilson. 2003. "In-Depth Studies of Magellanic Penguin (Spheniscus magellanicus) Foraging: Can We Estimate Prey Consumption by Perturbations in the Dive Profile?" *Marine Biology* 143:825–31.

Stokes, D. L. and P. D. Boersma. 1999. "Where Breeding Magellanic Penguins Spheniscus magellanicus Forage: Satellite Telemetry Results and Their Implications for Penguin Conservation." *Marine Ornithology* 27:59–65.

———. 2000. "Nesting Density and Reproductive Success in a Colonial Seabird, the Magellanic Penguin." *Ecology* 81:2878–91.

Takahashi, A., M. J. Dunn, P. N. Trathan, J. P. Croxall, R. P. Wilson, K. Sato, and Y. Naito. 2004. "Krill-Feeding Behavior in a Chinstrap Penguin (Pygoscelis antarctica) Compared with Fish-Eating in Magellani Penguins (Spheniscus magellanicus): A Pilot Study." *Marine Ornithology* 32:47–54.

Walker, B. G., J. C. Wingfield, and P. D. Boersma. 2005. "Age and Food Deprivation Affects Expression of the Glucocorticosteroid Stress Response in Magellanic Penguin (Spheniscus magellanicus) Chicks." *Physiological and Biochemical Zoology* 78:78–89.

Walker, B. G. and P. D. Boersma. 2003. "Diving Behavior of Magellanic Penguins (Spheniscus magellanicus) at Punta Tombo, Argentina." *Canadian Journal of Zoology* 81:1471–83.

Walker, B. G., P. D. Boersma, and J. C. Wingfield. 2004. "Physiological Condition in Magellanic Penguins: Does it Matter if you Have to Walk a Long Way to your Nest?" *The Condor* 106:696–701.

Walker, B. G., P. D. Boersma, and J. C. Wingfield. 2005a. "Field Endocrinology and Conservation Biology." *Integrative Comparative Biology* 45:12–18.

———. 2005b. "Physiological and Behavioral Differences in Magellanic Penguin Chicks in Undisturbed and Tourist-Visited Locations of a Colony." *Conservation Biology* 19:1571–77.

———. 2006. "Habituation of Adult Magellanic Penguins to Human Visitation as Expressed through Behavior and Corticosterone Secretion." *Conservation Biology* 20:146–54.

Williams, T. D. 1995. In *The Penguins*, 249–58. New York: Oxford University Press.

Wilson, R. P. 1996. "Foraging and Feeding Behaviour of a Fledgling Magellanic Penguin Spheniscus magellanicus." *Marine Ornithology* 24:55–56.

Wilson, R. P., J. A. Scolaro, D. Grémillet, M. A. M. Kierspel, S. Laurenti, J. Upton, H. Gallelli, F. Quintana, E. Frere, G. Müller, M. T. Straten, and I. Zimmer. 2005. "How Do Magellanic Penguins Cope with Variability in Their Access to Prey?" *Ecological Monographs* 75:379–401.

Wilson, R. P., J. A. Scolaro, F. Quintana, U. Siebert, M. thor Straten, K. Mills, I. Zimmer, N. Liebsch, A. Steinfurth, G. Spindler, and G. Müller. 2004. "To the Bottom of the Heart: Cloacal Movement as an Index of Cardiac Frequency, Respiration and Digestive Evacuation in Penguins." *Marine Biology* 144:813–27.

Wilson, R. P., J. M. Kreye, K. Lucke, and H. Urquhart. 2004. "Antennae on Transmitters on Penguins: Balancing Energy Budgets on the High Wire." *The Journal of Experimental Biology* 207:2649–62.

Wilson, R. P. and N. Liebsch. 2003. "Up-Beat Motion in Swinging Limbs: New Insight into Assessing Movement in Free-Living Aquatic Vertebrates." *Marine Biology* 142:537–47.

Wilson, R. P., S. Jackson, and M. T. Straten. 2007. "Rate of Food Consumption in Free-Living Magellanic Penguins Spheniscus magellanicus." *Marine Ornithology* 35:109–11.

Yorio, P., P. G. Borboroglu, J. Potti, and J. Moreno. 2001. "Breeding Biology of Magellanic Penguins Spheniscus magellanicus at Golfo San Jorge, Patagonia, Argentina." *Marine Ornithology* 29:75–79.

Penguin History and Research

Baker, A. J., S. L. Pereira, O. P. Haddrath, and K. A. Edge. 2006. "Multiple Gene Evidence for Expansion of Extant Penguins out of Antarctica Due to Global Cooling." *Proceedings of the Royal Society* 273:11–17.

Jenkins, R. J. F. 1974. "A New Giant Penguin From the Eocene of Australia." *Paleontology* 17:291–310.

Lowe, P. R. 1939. "Some Additional Notes on Miocene Penguins in Relation to Their Origin and Systematic." *Ibis* 3:281–94.

O'Hara, R. J. 1989. "Systematics and the Study of Natural History with an Estimate of the Phylogeny of the Living Penguins (Aves: Spheniscidae)." PhD diss., Harvard University.

Simpson, G. G. 1976. *Penguins Past and Present, Here and There.* New Haven, Connecticut: Yale University Press.

Slack, K. E., C. M. Jones, T. Andos, G. L. Harrison, R. E. Fordyce, U. Arnason, and D. Penny. 2006. "Early Penguin Fossils, Plus Mitochondrial Genomes, Calibrate Avian Evolution." *Molecular Biology and Evolution* 26:1144–55.

Rockhopper

Birdlife International 2010. "Rockhopper Penguins: A Plan for Research and Conservation Action to Investigate and Address Population Changes." Proceedings of an International Workshop, Edinburgh 2008. 1–126.

Boersma, D. "Northern Rockhopper Penguin." The Penguin Project. Penguin Sentinels. Accessed 28 Oct 2010. http://mesh.biology.washington.edu.

———. "Southern Rockhopper." The Penguin Project. Penguin Sentinels. Accessed 28 Oct 2010. http://mesh.biology.washington.edu.

Brown, C. R. 1987. "Traveling Speed and Foraging Range of Macaroni and Rockhopper Penguins at Marion Island." *Journal of Field Ornithology* 58:118–25.

Clausen, A. P. and K. Putz. 2002. "Recent Trends in Diet Composition and Productivity of Gentoo, Magellanic and Rockhopper Penguins in the Falkland Islands." *Aquatic Conservation* 12:51–61.

Clausen, A. P. and N. Huin. 2003. "Status and Numerical Trends of King, Gentoo, and Rockhopper Penguins Breeding in the Falkland Islands." *Waterbirds* 26:389–402.

De Dinechin, M., G. Pincemy, and P. Jouventin. 2007. "A Northern Rockhopper Penguin Unveils Dispersion Pathways in the Southern Ocean." *Polar Biology* 31:112–15.

De Dinechin, M., R. Ottvall, P. Quillfeldt, and P. Jouventin. 2009. "Speciation Chronology of Rockhopper Penguins Inferred from Molecular, Geological and Palaeoceanographic Data." *Journal of Biogeography* 36:693–702.

Guinard, E., H. Weimerskirch, and P. Jouventin. 1998. "Population Changes and Demography of the Northern Rockhopper Penguin on Amsterdam and Saint Paul Islands." *Waterbirds* 21:222–28.

Huin, N. 2007. *Falkland Islands Penguin Census 2005/2006.* Falkland Islands, Falkland Conservation. 1–31.

Hull, C. L., M. Hindell, K. Le Mar, P. Scofield, J. Wilson, and M. A. Lea. 2004. "The Breeding Biology and Factors Affecting Reproductive Success in Rockhopper Penguins Eudyptes chrysocome at Macquarie Island." *Polar Biology* 27:711–20.

Jackson, A. L., S. Bearhop, and D. R. Thompson. 2005. "Shape Can Influence the Rate of Colony Fragmentation in Ground Nesting Seabirds." *Oikos* 111:473–78.

Jouventin, P., R. J. Cuthbert, and R. Ottvall. 2006. "Genetic Isolation and Divergence in Sexual Traits: Evidence for the Northern Rockhopper Penguin Eudyptes moseleyi Being a Sibling Species." *Molecular Ecology* 15:3413–23.

Kirkwood, R., K. Lawton, C. Moreno, J. Valencia, R. Schlatter, and G. Robertson. 2007. "Estimates of Southern Rockhopper and Macaroni Penguins Numbers at the Ildefonso and Diego Ramírez Archipelagos, Chile, Using Quadrat and Distance-Sampling Techniques." *Waterbirds* 30:259–67.

Lamey, T. C. 1993. "Territorial Aggression, Timing of Egg Loss, and Egg Size Differences in Rockhopper Penguins, Eudyptes c. chrysocome, on New Island, Falkland Islands." *Oikos* 66:293–97.

Liljesthröm, M., S. D. Emslie, D. Frierson, and A. Schiavini. 2008. "Avian Predation at a Southern Rockhopper Penguin colony on Staten Island, Argentina." *Polar Biology* 31:465–74.

Oehler, D. A., S. Pelikan, W. R. Fry, L. Weakley Jr., A. Kusch, and M. Marin. 2008. "Status of Crested Penguin (Eudyptes spp.) Populations on Three Islands in Southern Chile." *The Wilson Journal of Ornithology* 120:575–81.

Oehler, D. A., W. R. Fry, L. A. Weakley Jr., and M. Marin. 2007. "Rockhopper and Macaroni Penguin Colonies Absent from Isla Recalada, Chile." The *Wilson Journal of Ornithology* 119:502–6.

Poisbleau, M., L. Demongin, F. Angelier, S. Dano, A. Lacroix, and P. Quillfeldt. 2009. "What Ecological Factors Can Affect Albumen Corticosterone Levels in the Clutches of Seabirds? Timing of Breeding, Disturbance and Laying Order in Rockhopper Penguins (Eudyptes chrysocome chrysocome)." *General and Comparative Endocrinology* 162:139–45.

Poisbleau, M., L. Demongin, I. J. Strange, H. Otley, and P. Quillfeldt. 2008. "Aspects of the Breeding Biology of the Southern Rockhopper Penguin Eudyptes c. chrysocome and New Consideration on the Intrinsic Capacity of the A-Egg." *Polar Biology* 31:925–32.

Pütz, K., A. P. Clausen, N. Huin, and J. P. Croxall. 2003. "Re-evaluation of Historical Rockhopper Penguin Population Data in the Falkland Islands." *Waterbirds* 26:169–75.

Pütz, K., A. R. Rey, N. Huin, A. Schiavini, A. Pütz, and B. H. Lüthi. 2006. "Diving Characteristics of Southern Rockhopper Penguins (Eudyptes c. chrysocome) in the Southwest Atlantic." *Marine Biology* 149:125–37.

Pütz, K., A. R. Rey, A. Schiavini, A. P. Clausen, and B. H. Lüthi. 2006. "Winter Migration of Rockhopper Penguins (Eudyptes c. chrysocome) Breeding in the Southwest Atlantic: is Utilisation of Different Foraging Areas Reflected in Opposing Population Trends?" *Polar Biology* 29:735–44.

Rey, A. R. and A. Schiavini. 2005. "Inter-Annual Variation in the Diet of Female Southern Rockhopper Penguin (Eudyptes chrysocome chrysocome) at Tierra del Fuego." *Polar Biology* 28:132–41.

Rey, A. R., K. Pütz, G. Luna-Jorquera, B. Lüthi, and A. Schiavini. 2009. "Diving Patterns of Breeding Female Rockhopper Penguins (Eudyptes chrysocome): Noir Island, Chile." *Polar Biology* 32:561–68.

Schiavini, A., and R. A. Rey. 2004. "Long Days, Long Trips: Foraging Ecology of Female Rockhopper Penguins *Eudyptes chrysocome chrysocome* at Tierra del Fuego." *Marine Ecology Progress* Series 275: 251–262.

Searby, A. and P. Jouventin. 2005. "The Double Vocal Signature of Crested Penguins: is the Identity Coding System of Rockhopper Penguins Eudyptes chrysocome Due to Phylogeny or Ecology?" *Journal of Avian Biology* 36:449–60.

St. Clair, C. C. 1996. "Multiple Mechanisms of Reversed Hatching Asynchrony in Rockhopper Penguins." *Journal of Animal Ecology* 65:485–94.

Tremblay, Y. and Y. Cherel. 2000. "Benthic and Pelagic Dives: a New Foraging Behaviour in Rockhopper Penguins." *Marine Ecology Progress Series* 204:257–67.

Warham, J. 1963. "The Rockhopper Penguin, Eudyptes chrysocome, at Macquarie Island." *The Auk* 80:229–56.

Williams, T. D. 1995. In *The Penguins,* 185–94. New York: Oxford University Press.

Royal

Halsey, L. G., C. R. White, A. Fahlman, Y. Handrich, and P. J. Butler. 2007. "Onshore Energetic in Penguins: Theory, Estimation and Ecological Implications." *Comparative Biochemistry and Physiology* 147:1009–14.

Holmes, N. D. 2007. "Comparing King, Gentoo, and Royal Penguin Responses to Pedestrian Visitation." *The Journal of Wildlife Management* 71:2575–82.

Holmes, N. D., M. Giese, and L. K. Kriwoken. 2005. "Testing the Minimum Approach Distance Guidelines for Incubation Royal Penguins Eudyptes schlegeli." *Biological Conservation* 126:339–50.

Hull, C. L. 1997. "The Effect of Carrying Devices on Breeding Royal Penguins." *The Condor* 99:530–34.

———. 1999. "Comparison of the Diets of Breeding Royal (Eudyptes schlegeli) and Rockhopper (Eudyptes chrysocome) Penguins on Macquarie Island over Three Years."

———. 2000. "Comparative Diving Behaviour and Segregation of the Marine Habitat by Breeding Royal Penguins, Eudyptes schlegeli, and Eastern Rockhopper Penguins, Eudyptes chrysocome filholi, at Macquarie Island." *Canadian Journal of Zoology* 78:333–45.

Hull, C. L. and J. Wilson. 1996a. "The Effect of Investigators on the Breeding Success of Royal, Eudyptes schlegeli, and Rockhopper Penguins, E. chrysocome, at Macquarie Island." *Polar Biology* 16:335–37.

———. 1996b. "Location of Colonies in Royal Penguins Eudyptes schlegeli: Potential Costs and Consequences for Breeding Success." *Emu* 96:135–38.

Hull, C. L., J. Wilson, and K. Le Mar. 2001. "Moult in adult Royal Penguins, Eudyptes schlegeli." *Emu* 101:173–76.

Hull, C. L., M. A. Hindell, and K. Michael. 1997. "Foraging Zones of Royal Penguins during the Breeding Season, and Their Association with Oceanographic Features." *Marine Ecology Progress Series* 153:217–28.

Kooyman, G. L. 2002. "Evolutionary and Ecological Aspects of Some Antarctic and Sub-Antarctic Penguin Distributions." *Oecologia* 130:485–95.

Marchant, S. and P. J. Higgins. 1990. *Handbook of Australian, New Zealand and Antarctic Birds. Vol. 1.* Melbourne: Oxford University Press.

Shaughnessy, P. D. 1970. "Ontogeny of Haemoglobin in the Royal Penguin Eudyptes chrysolophus schlegeli." *Journal of Embryology and Experimental Morphology* 24:425–28.

Shirihai, H. 2002. *The Complete Guide to Antarctic Wildlife.* Princeton, New Jersey: Princeton University Press.

St. Clair, C. C., J. R. Waas, R. C. St. Clair, and P. T. Boag. 1995. "Unfit Mothers? Maternal Infanticide in Royal Penguins." Animal Behavior 50:1177–85.

Waas, J. R., M. Caulfield, P. W. Colgan, and P. T. Boag. 2000. "Colony Sound Facilitates Sexual and Agonistic Activities in Royal Penguins." *Animal Behaviour* 60:77–84.

Warham, J. 1971. "Aspects of Breeding Behaviour in the Royal Penguin." *Notornis* 18:91–115.

Williams, T. D. 1995. In *The Penguins,* 220–24. New York: Oxford University Press.

Snares

Banks, J. C. and A. M. Paterson. 2005. "Multi-Host Parasite Species in Cophylogenetic Studies." *International Journal for Parasitology* 35:741–46.

Beverly, Paul. 2009. *Implementation of the Marine Protected Areas Policy in the Territorial Seas of the Subantarctic Biogeographic Region of New Zealand.* New Zealand. Subantarctic Marine Protection Planning Forum.

Boersma, D. "Snares-Crested." The Penguin Project. Penguin Sentinels. Accessed 28 Oct 2010. http://mesh.biology.washington.edu.

Croxall, J. P. 1982. "Energy Costs of Incubation and Moult in Petrels and Penguins." *Journal of Animal Ecology* 51:177–94.

Cummings, B., A. Orahoske, and K. Siegel. 2006. *Before the Secretary of the Interior Petition to List 12 Penguin Species Under the Endangered Species Act.* Center for Biological Diversity. Joshua Tree, California.

Davis, L. S. and J. T. Darby. 1988. "First International Conference on Penguins: Abstracts of Presented Papers and Posters." *Cormorant* 16:120–37.

Ellis, S. 1999. "The Penguin Conservation Assessment and Management Plan: a Description of the Process." *Marine Ornithology* 27:163–69.

Houston, D. 2007. "Snares Crested." New Zealand Penguins. Accessed 9 Dec 2010. http://www.penguin.net.nz.

Massaro, M. and L. S. Davis. 2004. "Preferential Incubation Positions for Different Sized Eggs and Their Influence on Incubation Period and Hatching Asynchrony in Snares Crested (Eudyptes robustus) and the Yellow-Eyed Penguins (Megadyptes antipodes)." *Behavioral Ecology and Sociobiology* 56:426–34.

———. 2005. "Differences in Egg Size, Shell Thickness, Pore Density, Pore Diameter and Water Vapour Conductance between First and Second Eggs of Snares Penguins Eudyptes robustus and Their Influence on Hatching Asynchrony." *Ibis* 147:251–58.

Mattern, T. 2006. "Marine Ecology of Offshore and Inshore Foraging Penguins: the Snares Penguin Eudyptes robustus and Yellow-Eyed Penguin Megadyptes antipodes." PhD diss., University of Otago, Dunedin, New Zealand.

Mattern, T., D. M. Houston, C. Lalas, A. N. Setiawan, and L. S. Davis. 2009. "Diet Composition, Continuity in Prey Availability and Marine Habitat: Keystones to Population Stability in the Snares Penguin (Eudyptes robustus)." *Emu* 109:204–13.

McGraw, K. J., M. Massaro, T. J. Rivers, and T. Mattern. 2009. "Annual, Sexual, Size- and Condition-Related Variation in the Colour and Fluorescent Pigment Content of Yellow Crest-Feathers in Snares Penguins (Eudyptes robustus)." *Emu* 109:93–99.

Miskelly, C. M. 1997. "Biological Notes on the Western Chain, Snares Islands 1984–1985 and 1985–1985." *New Zealand Department of Conservation* 4–6.

Miskelly, C. M., A. J. Bester, and M. Bell. 2006. "Additions to the Chatham Islands' Bird List, with Further Records of Vagrant and Colonising Bird Species." *Notornis* 53:213–28.

Miskelly, C. M. and M. Bell. 2004. "An Unusual Influx of Snares Crested Penguins (Eudyptes robustus) on the Chatham Islands, with a Review of Other Crested Penguin Records from the Islands." *Notornis* 51:235–37.

Miskelly, C. M., P. M. Sagar, A. J. D. Tennyson, and R. Scofield. 2001. "Birds of the Snares Islands, New Zealand." *Notornis* 48:1–40.

Stonehouse, B. 1971. "The Snares Island Penguin Eudyptes Robustus." *Ibis* 113:1–7.

Warham, J. 1974. "The Breeding Biology and Behaviour of the Snares Crested Penguin." *Journal of the Royal Society of New Zealand* 4:63–108.

Williams, T. D. 1995. In *The Penguins*, 200–206. New York: Oxford University Press.

The Penguin Body: The Amazing Machine

Alterskjær, O. M., R. Myklebust, T. Kaino, V. S. Elbrønd, and S. Disch Mathiesen. 2002. "The Gastrointestinal Tract of Adélie Penguins: Morphology and Function." *Polar Biology* 25(9):641–49.

Barré, H. 1984. "Metabolic and Insulative Changes in Winter- and Summer-Acclimatized King Penguin Chicks." *Journal of Comparative Physiology* 154:317–24.

Beaune, D., C. Le Bohec, F. Lucas, M. Gauthier-Clerc, and Y. Le Maho. 2009. "Stomach Stones in King Penguin Chicks." *Polar Biology* 32:593–97.

Bowmaker, J. K. and G. R. Martin. 1985. "Visual Pigments and Oil Droplets in the Penguin, Spheniscus humboldti." *Journal of Comparative Physiology* 156:71–77.

Cherel, Y., J. C. Stahl, and Y. Le Maho. 1987. "Ecology and Physiology of King Penguin Chicks." *The Auk* 104:254–62.

Dawson, C., J. F. V. Vincenta, G. Jeronimidisa, G. Riceb, and P. Forshaw. 1999. "Heat Transfer through Penguin Feathers." *Journal of Theoretical Biology* 199:291–95.

Fahlman, A., A. Schmidt, Y. Handrich, A. J. Woakes, and P. J. Butler. 2005. "Metabolism and Thermoregulation During Fasting in King Penguins, Aptenodytes patagonicus, in Air and Water." *The American Journal of Physiology—Regulatory, Integrative and Comparative Physiology* 289:R680–R687.

Fahlman, A., Y. Handrich, A. J. Woakes, C. A. Bost, R. L. Holder, C. Duchamp, and P. J. Butler. 2004. "Effect of Fasting on the O2-fh Relationship in King Penguins, Aptenodytes patagonicus." *The American Journal of Physiology—Regulatory, Integrative and Comparative Physiology* 287:870–R877.

Gilbert, C., Y. Le Maho, M. Perret, and A. Ancel. 2006. "Body Temperature Change Induced by Huddling in Breeding Male Emperor Penguins." *The American Journal of Physiology—Regulatory, Integrative and Comparative Physiology* 292:176–85.

Hocken, A. G. 2002. "Post-Mortem Examination of Penguins." *DOC Science Internal Series* 65:5–25.

Howland, H. C. and J. G. Sivak. 1984. "Penguin Vision in Air and Water." *Vision Research* 24:1905–9.

Janes, D. N. 1997. "Energetics, Growth and Body Composition of Adélie Penguin Chicks, Pygoscelis adeliae." *Physiological Zoology* 70:237–43.

Lindeboom, H. J. 1984. "The Nitrogen Pathway in a Penguin Rookery." *Ecology* 65:269–77.

Luna-Jorquera, G. and B. M. Culik. 2000. "Metabolic Rates of Swimming Humboldt Penguins." *Marine Ecology Progress Series* 203:301–9.

Luna-Jorquera, G., B. M. Culik, and R. Aguilar. 1996. "Capturing Humboldt Penguins Spheniscus humboldti with the Use of an Anaesthetic." *Marine Ornithology* 24:47–50.

Meir, J. U., T. K. Stockard, C. L. Williams, K. V. Ponganis, and P. J. Ponganis. 2008. "Heart Rate Regulation and Extreme Bradycardia in Diving Emperor Penguins." *The Journal of Experimental Biology* 211:1169–79.

Paster, M. B. 1992. "A Brief Overview: The Avian Crop." *Journal of the Association of Avian Veterinarians* 6:229–30.

Thouzeau1, C., G. Peters, C. Le Bohec, and Y. Le Maho. 2004. "Adjustments of Gastric pH, Motility and Temperature during Long-Term Preservation of Stomach Contents in Free-Ranging Incubating King Penguins." *The Journal of Experimental Biology* 207:2715–24.

Williams, T. D. 1995. *The Penguins.* New York: Oxford University Press.

Yellow-Eyed

Alexander, R. R., and D. W. Shields. 2003. "Using Land as a Control Variable in Density-Dependent Bioeconomic Models." *Ecological Modelling* 170:193–201.

Boessoenkool, S., T. M. Kning, P. J. Seddon, and J. M. Waters. 2008. "Isolation and Characterization of Microsatellite Loci from the Yellow-Eyed Penguin (Megadyptes antipodes)." *Molecular Ecology Resources* 8:1043–45.

Browne, T., C. Lalas, T. Mattern, and Y. Van Heezik. 2011. "Chick Starvation in Yellow-Eyed Penguins: Evidence for Poor Diet Quality and Selective Provisioning of Chicks from Conventional Diet Analysis and Stable Isotopes." *Austral Ecology* 36: 99–108.

Cummings, B., A. Orahoske, and K. Siegel. 2006. *Before the Secretary of the Interior Petition to List 12 Penguin Species Under the Endangered Species Act.* Center for Biological Diversity. Joshua Tree, California.

Darby, J. T. and S. M. Dawson. 2000. "Bycatch of Yellow-Eyed Penguins (Megadyptes antipodes) in Gillnets in New Zealand Waters 1979–1997." *Biological Conservation* 93:327–32.

Edge, K. A., I. G. Jamieson, and J. T. Darby. 1999. "Parental Investment and the Management of an Endangered Penguin." *Biological Conservation* 88:367–78.

Efford, M., J. Darby, and N. Spencer. 1996. *Population Studies of Yellow-Eyed Penguins, 1992–94 Progress Report.* Department of Conservation. Wellington, New Zealand.

Ellenburg, U., A. N. Setiawan, A. Cree, D. M. Houston, and P. J. Seddon. 2007. "Elevated Hormonal Response and Reduced Reproductive Output in Yellow-Eyed Penguins Exposed to Unregulated Tourism." *Genreal and Comparative Endocrinology* 152:54–63.

Ellenberg, U., T. Mattern, and P. J. Seddon. 2009. "Habituation Potential of the Yellow-Eyed Penguins Depends on Sex, Character and Previous Experience with Humans." *Animal Behaviour* 77:289–96.

Ellis, S. 1999. "The Penguin Conservation Assessment and Management Plan: a Description of the Process." *Marine Ornithology* 27:163–69.

Hubert, L. and D. Boersma. "Yellow-Eyed Penguin." The Penguin Project. Penguin Sentinels. Accessed 28 Oct 2010. http://mesh.biology.washington.edu.

Lalas, C., H. Ratz, K. McEwan, and S. McConkey. 2007. "Predation by New Zealand Sea Lions (Phocarctos hookeri) as a Threat to the Viability of Yellow-Eyed Penguins (Megadyptes antipodes) at Otago Peninsula, New Zealand." *Biological Conservation* 35:235–46.

Lalas, C., P. R. Jones, and J. Jones. 1999. "The Design and Use of a Nest Box for Yellow-Eyed Penguins Megadyptes antipodes—a Response to a Conservation Need." *Marine Ornithology* 27:199–204.

Massaro, M., A. N. Setiawan, and L. S. Davis. 2007. "Effects of Artificial Eggs on Prolactin Secreation, Steroid Levels, Brood Patch Development, Incubation Onset and Clutch Size in the Yellow-Eyed Penguin (Megadyptes antipodes)." *General and Comparative Endocrinology* 151:220–29.

———. 2002. "Investigation of Interacting Effects of Female Age, Laying Dates, and Egg Size in Yellow-eyed Penguins (Megadyptes antipodes)." *The Auk* 199:1137–41.

Massaro, M. and L. S. Davis. 2004a. "Preferential Incubation Positions for Different Sized Eggs and Their Influence on Incubation Period and Hatching Asynchrony in Snares Crested (Eudyptes robustus) and the Yellow-Eyed Penguins (Megadyptes antipodes)." *Behavioral Ecology and Sociobiology* 56:426–34.

———. 2004b. "The Influence of Laying Date and Maternal Age on Eggshell Thickness and Pore Density in Yellow-eyed Penguins." *The Condor* 106:496–505.

Massaro, M., L. S. Davis, and J. T. Darby. 2003. "Cartenoid-Derived Ornaments Reflect Parental Quality in Male and Female Yellow-Eyed Penguins (Megadyptes antipodes)." *Behavioral Ecology and Sociobiology* 55:169–75.

Massaro, M., L. S. Davis, J. T. Darby, G. J. Robertson, and A. N. Setiawan. 2004. "Intraspecific Variation of Incubation Periods in Yellow-Eyed Penguins Megadyptes antipodes: Testing the Influence of Age, Laying Date and Egg Size." *Ibis* 146:526–30.

Massaro, M., L. S. Davis, and R. S. Davidson. 2006. "Plasticity of Brood Patch Development and its Influence on Incubation Periods in the Yellow-Eyed Penguin Megadyptes antipodes: an Experimental Approach." *Journal of Avian Biology* 37:497–06.

McKay, E., R. Lalas, C. McKay, and S. McConkey. 1999. "Nest-Site Selection by Yellow-Eyed Penguins Megadyptes antipodes on Grazed Farmland." *Marine Ornithology* 27:29–35.

McKinlay, B. 2001. *Hoiho (Megadyptes antipodes) Recovery Plan: 2000–2025.* Department of Conservation. Wellington, New Zealand.

Moore, P. J. 1999. "Foraging Range of Yellow-Eyed Penguin Megadyptes antipodes." *Marine Ornithology* 27:49–58.

Moore, P. J. and M. D. Wakelin. 1997. "Diet of Yellow-eyed Penguin Megadyptes antipodes, South Island, New Zealand, 1991–1992." *Marine Ornithology* 25:17–29.

Ratz, H. and C. Thompson. 1999. "Who is Watching Whom? Check for Impacts of Tourists on Yellow-Eyed Penguins Megadyptes antipode." *Marine Ornithology* 27:205–10.

Reid, W. V. 1988. "Age Correlations within Pairs of Breeding Birds." *The Auk* 105:278–85.

Richdale, L. E. 1947. "Seasonal Fluctuations in Weights of Penguins and Petrels." *The Wilson Bulletin* 59:160–71.

———. 1949. "The Effect of Age on Laying Dates, Size of Eggs, and Size of Clutch in the Yellow-eyed Penguin." *The Wilson Bulletin* 61:91–98.

Seddon, P. J. and R. J. Seddon. 1991. "Chromosome Analysis and Sex Identification of Yellow-Eyed Penguins." *Marine Ornithology* 19:144–47.

Setiawan, A. N., J. T. Darby, and D. M. Lambert. 2004. "The Use of Morphometric Characteristics to Sex Yellow-Eyed Penguins." *Waterbird*s 27:96–101.

Setiawan, A. N., M. Massaro, J. T. Darby, and L. S. Davis. 2005. "Mate and Territory Retention in Yellow-Eyed Penguins." *The Condor* 107:703–9.

Van Heezik, Y. 1990. "Patterns and Variability of Growth in the Yellow-Eyed Penguins." *The Condor* 92:904–12.

Wakelin, M., M. E. Douglas, B. McKinlay, D. Nelson, and B. Murphy. 1995. "Yellow-Eyed Penguin Foraging Study, South-Eastern New Zealand. 1991–1993." *Science and Research Series* No. 83. Department of Conservation, New Zealand.

Williams, T. D. 1995. In *The Penguins*, 225–30. New York: Oxford University Press.

Gentoos watching the sunset in the Falkland Islands

PENGUIN-
PEDIA